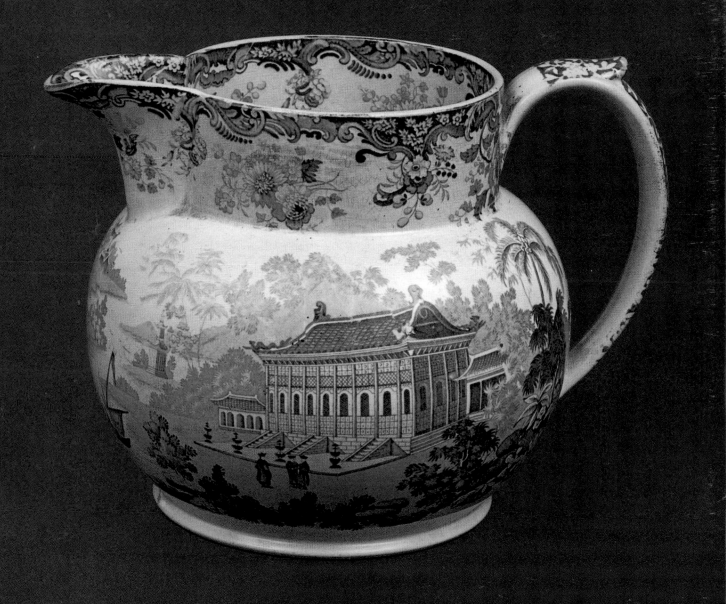

Frontispiece. "Chinese Marine." Morton. Printed title mark with a winged dragon, the words "COLLECTION" and the initial 'M'. Jug 6½ ins. 17cm.

The Dictionary
of
Blue and White
Printed Pottery 1780~1880

A.W. COYSH and R.K. HENRYWOOD

Antique Collectors' Club

© 1982 A.W. Coysh and R.K. Henrywood
First published 1982

World copyright reserved

ISBN 0 907462 06 5

British Library CIP Data
Coysh, A.W.
 The dictionary of blue and white printed pottery,
1780-1880
1. Pottery — Dictionaries 2. Blue and white transfer
ware — Dictionaries
I. Title II. Henrywood, R.K.
738.3'7 NK3770

Published for the Antique Collectors' Club
by the Antique Collectors' Club Ltd.

The endpapers show the grounds of Nuneham Courtenay, Oxfordshire, as landscaped by Capability Brown with a rustic bridge and lock-keeper's cottage. They were widely described and illustrated in contemporary guide books. This view was used by many 19th century potters who described it as the "Wild Rose" pattern after a floral border.

Printed in England by Baron Publishing, Woodbridge, Suffolk

Antique Collectors' Club

The Antique Collectors' Club was formed in 1966 and now has a five figure membership spread throughout the world. It publishes the only independently run monthly antiques magazine *Antique Collecting* which caters for those collectors who are interested in increasing their knowledge of antiques, both by greater awareness of quality and by discussion of the factors which influence the price that is likely to be asked. The Antique Collectors' Club pioneered the provision of information on prices for collectors and still leads in the provision of detailed articles on a variety of subjects.

It was in response to the enormous demand for information on ''what to pay'' that the price guide series was introduced in 1968 with the first edition of *The Price Guide to Antique Furniture* (completely revised 1978), a book which broke new ground by illustrating the more common types of antique furniture, the sort that collectors could buy in shops and at auctions, rather than the rare museum pieces which had previously been used (and still to a large extent are used) to make up the limited amount of illustrations in books published by commercial publishers. Many other price guides have followed, all copiously illustrated, and greatly appreciated by collectors for the valuable information they contain, quite apart from prices. The Antique Collectors' Club also publishes other books on antiques, including horology and art reference works, and a full book list is available.

Club membership, which is open to all collectors, costs £9.95 per annum. Members receive free of charge *Antique Collecting,* the Club's magazine (published every month except August), which contains well-illustrated articles dealing with the practical aspects of collecting not normally dealt with by magazines. Prices, features of value, investment potential, fakes and forgeries are all given prominence in the magazine.

Among other facilities available to members are private buying and selling facilities, the longest list of ''For Sales'' of any antiques magazine, an annual ceramics conference and the opportunity to meet other collectors at their local antique collectors' club. There are nearly eighty in Britain and so far a dozen overseas. Members may also buy the Club's publications at special pre-publication prices.

As its motto implies, the Club is an amateur organisation designed to help collectors to get the most out of their hobby: it is informal and friendly and gives enormous enjoyment to all concerned.

For Collectors — By Collectors — About Collecting

The Antique Collectors' Club, 5 Church Street, Woodbridge, Suffolk

Contents

Colour Plates

Acknowledgements

This Dictionary is an attempt to gather together in one volume as many facts as possible about blue and white printed pottery, with the single exception of American subjects which have been extensively documented elsewhere. No work of this nature can be produced without reference to the efforts made by previous researchers and we are grateful to all who have worked in this field. Information has been gathered from many sources and we have been privileged to study many collections and to photograph chosen pieces. For their generous help and encouragement we should like to thank the following:

Col. Peter Ball; Meriel Bayne; Dr. Steven Bayne; James Bell; F. van den Berge; Brian J.R. Blench; Ramsey and Sylvia Bowes; Q.M. Burgess; Dr. Peter Carter; G. Cassidy; Martin Christidis; Christie's; Richard Clements; David Collins; Graeme Cruickshank; Sir John Cuthbert; M.J. Edmonds; David Evans; J.P. Fuller; P.J. Gates (Photography) Ltd.; Mr. and Mrs. Cliff Gazely; George Gibb; Geoffrey A. Godden; Catherine M. Gordon; Ronald Govier; Helena Grubert; Robin Gurnett; Ian T. Henderson; Mr. and Mrs. S.R. Henrywood; Prof. and Mrs. K. Hill; David Jamieson; M. Jonker; Dr. Roger Kemp; Harvey Kitto; John Leslie; Margaret Lind; D.M. Little; Roger McAslam; Patricia Malley; G.W. Martin; Maurice Milbourn; Anne Morris; Dorothy Mugleston; Muriel Nicholson; Simon Olding; Gabriel Olive; Osmond, Tricks & Son (Bristol); Bert H. Plimer; Martin and Rosalind Pulver; G. Quail; J.B. Reid; Nora Richardson; Ivor and Dorothy Robertshaw; Pamela Russell; Alison Rutherford; Kenneth R. Skerry; the late Alan Sole; Bryan Spooner; Mr. and Mrs. John F. Strong; Styles of Hungerford; Nancy Thomas; Margaret Tite; Joy Warren; E. Winderspoon; Anna Wolsey; Dr. Roger Wootton; Cleo Witt; N. Wright.

We have also received the most courteous assistance from the staff of the Cecil Higgins Art Gallery, Bedford; the City of Bristol Museum and Art Gallery; the Courtauld Institute of Art, London; the Glasgow Museums and Art Galleries; the Huntly House Museum, Edinburgh; and the Library of the Victoria and Albert Museum, London.

There will inevitably be omissions in this Dictionary and further research will reveal new facts. The authors will be very grateful for any information which may help to throw new light on the subject.

A Century of
Blue and White Printed Pottery
1780-1880

A new technique can transform an industry. The discovery that prints could be transferred to porcelain and pottery certainly helped to transform the ceramic industry.

The idea was simple but a combination of skills was required to produce a quality product. Firstly, a design had to be chosen and engraved on a flat copper plate. This was used to make a print on a sheet of soft, pliable, but very strong tissue paper using a warm oily ink. This printed paper was then pressed, with the wet ink downwards, on to the ceramic surface with a felt pad, thus transferring the design to the porcelain or pottery body. The next step was to immerse the ware, with paper still attached, in cold water. The ink stiffened and the paper floated off, leaving the design on the ceramic surface.

The process was first used in the 1750s on wares that had already been glazed, on-glaze printing as it is called. It was possible to fix such a print to the glaze by heating at a relatively low temperature. The method was employed in the porcelain works at Bow and at Worcester, and also in potteries at Leeds and Liverpool. Some Staffordshire wares were sent to Liverpool for decoration by Sadler and Green, a firm which specialised in this work. Unfortunately, these on-glaze prints were really only suitable for decorative pieces since daily use on tea wares or dinner wares would damage or even completely remove the print. This drawback led naturally to attempts to print on the biscuit wares before glazing so that the print could be protected by the glaze. However, the heat of the glost furnace was much greater than that used to fix on-glaze prints and this gave rise to early difficulties. Nevertheless, reasonable success was achieved at Worcester and at Caughley in Shropshire.

A porcelain dinner service in the 18th century was an expensive item and it was natural that the potters should look for new markets by producing underglaze printed services in pottery. Attempts to do so were successful though we shall probably never know where the first under-glaze dinner service was made. We do know that Staffordshire potters soon realised the possibilities opened up by this advance in technique and by the 1780s several works had established blue-printing departments. At this early date blue was the only colour available that remained stable in the heat of the glost furnace. From this time ceramic underglaze printing advanced in stages.

1780-1800 The Chinoiserie Period

This was a period of recruitment and experiment. Skilled staff were required for the new process, particularly engravers, printers, and transferrers. It became, in fact, a co-operative craft and some of the finer pieces of blue-printed ware may be regarded as minor works of art. Recruitment was mainly from Worcester and Caughley, particularly the latter. Thomas Davis, a Worcester printer, joined Ralph Baddeley at Shelton and William Davis of Worcester and Caughley was taken on by William Adams at Cobridge. Thomas

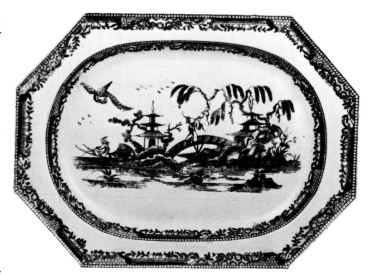

An early line-engraved chinoiserie pattern by John Turner showing typical pagodas, boat, bridge and willow tree. Impressed "TURNER". Octagonal dish 10¾ ins:27cm.

Lucas, an engraver, and James Richards, a printer, went to the Spode works at Stoke. Thomas Minton moved from Caughley to London where he engraved for the Spode works, and one of his apprentices, Greatbach, became an engraver at the same factory and later managed the printing department. John Ainsworth, an engraver and printer from Caughley joined John Yates at Hanley.

One of the main problems in these early years, when skills were slowly being established, was the selection of a good design. Since some of the finest ceramics in use in Britain had for many years been imported from China it is not surprising that Chinese wares were used for inspiration. Chinese designs were either copied or adapted by the engravers using simple line engraving techniques, and a very rare octagonal dish with a line-engraved chinoiserie pattern by John Turner is shown opposite. The copper plates often held a great deal of ink and the prints produced were dark and sometimes slightly blurred. Dinner plates and dishes were usually made without footrims and the glazes were uneven and rippled.

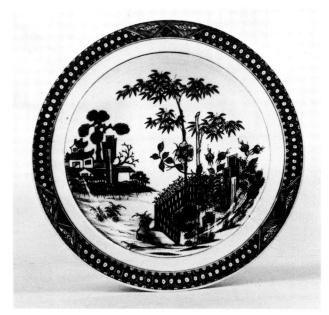

Chinese plate with the design used by Wedgwood as a basis for the Blue Bamboo pattern. Plate 8 ¾ ins:22cm.

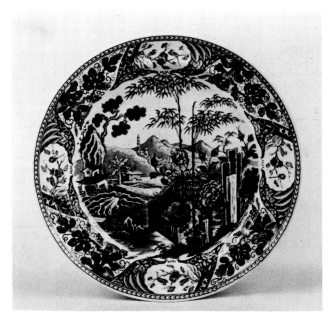

Blue Bamboo pattern. Wedgwood. Impressed maker's mark. Plate 9 ¾ ins:25cm.

1800-1815 The First Transitional Period

As skills improved line engraving was combined with stipple and it became possible to introduce more light and shade to print scenes with clouds in the sky. It is not possible to date the introduction of stipple engraving with any accuracy but a Herculaneum dish dated 1807 has a chinoiserie design showing skilled use of the stipple technique.

Although potters were still using Chinese designs there were clear indications that a breakaway was imminent and European features started to intrude. A Palladian arch would appear on a Chinese pagoda, hills were inserted behind a Chinese scene, and flowers began to feature in borders. It is interesting to compare a Wedgwood plate of this period with the original Chinese design from which the pattern was adapted, see above. Chinoiserie designs became more and more standardised and the well-known standard Willow pattern emerged, a pattern which has been produced by British potters ever since. However, the search for more

interesting subjects had begun. An obvious source was the illustrated book and topographical engravings with views of Italy, Asia Minor and India became prime sources. Prints of flowers from such publications as the *Botanical Magazine* were also used.

By this time Staffordshire was by no means the only centre producing blue-printed wares. The technique had been adopted at Swansea, at Leeds and other Yorkshire potteries, and had also spread to works on the Tyne and the Wear and in Scotland.

1815-1835 The Vintage Years

The end of the Napoleonic Wars resulted in a boom in the manufacture of blue-printed earthenwares. Vast markets opened up in North America, in Europe, and even in India and other eastern countries. The home market also expanded and there were very few potters who were not engaged in this profitable trade. The demand for designs was considerable since many of the potters made dinner services with a different pattern on each shape. Enoch Wood & Sons used over fifty different designs on one of their dinner services. Such designs can therefore conveniently be grouped in series.

Curiously enough, it was a Hampshire clergyman who had helped to create the most useful source for designs. William Gilpin (1724-1804) toured Britain and wrote a number of books on scenery, illustrating them with his own aquatints. These do not appear to have been used directly on pottery but Gilpin had stimulated an interest in what came to be known as 'the cult of the picturesque' which led to a flood of illustrated topographical books. Attention was focused on his ideas by the publication of a series of doggerel verses by William Coombe in the *Poetical Magazine* between 1809 and 1811. They lampooned the tours of Gilpin under the title *Doctor Syntax in Search of the Picturesque* and were so popular that they were later published in three volumes with aquatints by Thomas Rowlandson. These were used as patterns for a dinner service but, more important, they gave currency to the ideas of William Gilpin and the potters took advantage of their popular appeal. Dinner services were produced with series of patterns under such titles as "Antique Scenery", "British Views", "Metropolitan Scenery" and "Picturesque Scenery". Many of the views were based on engravings after some of the finest contemporary artists — W.H. Bartlett, Thomas Bewick, Thomas and William Daniell, Edward Finden, Henry Gastineau, Thomas Shepherd and William Westall. An Irish artist, W.G. Wall, was even commissioned to travel to America to draw scenes which could be used on export wares.

The patterns were almost invariably framed in borders which decorated the rims of plates and dishes and the edges of tureens, mugs, jugs, etc. They were mainly floral, often with subsidiary designs within medallions. The same border pattern was used for a complete dinner service and makers appear to have regarded these borders as a kind of trade mark. It is true that such borders are often a useful guide to the maker although, as with the central designs, they were sometimes pirated.

1835-1845 The Second Transitional Period

By 1835 potting techniques had advanced considerably. Glazes were clear and smooth and it was possible to use colours other than blue with some confidence. Green, sepia and mulberry became popular and some services were even printed in two colours. However, dinner services last for some years and the middle class market was beginning to reach saturation point. Services had to be produced more cheaply to come within the reach of the farm labourer and the mill worker. As a result the quality of potting declined and patterns became standardised. The standard Willow pattern, a floral design titled "Asiatic Pheasants", and a landscape with a "Wild Rose" border soon dominated the market.

This period also saw the introduction of flow-blue wares which were later to become so popular, particularly for export. These were wares in which the print was encouraged to spread into the glaze like ink on blotting paper, an effect achieved by introducing powdered chemicals into the kiln before firing.

1845-1860 The Romantic Period

The Copyright Act of 1842 was a serious blow to the makers of printed wares. This provided

for the registration of original designs to protect them from piracy for a period of three years, with an option of renewal. It also, however, prevented the potters from copying engravings from books, previously a major source of inspiration, and they were forced to look elsewhere for patterns. The result was a shift in emphasis to romantic scenes for which the engravers tended to follow a definite formula. Most of these imaginary scenes show a stretch of water, sometimes a lake, sometimes a river, as a central feature. On one side of the water stands a pagoda, mosque, castle or classical building. On the other side is a prominent tree beneath which is a fountain, an urn, or a pillared balcony. There are mountains in the distance and often a group of people in the foreground, perhaps with a dog. Some of these imaginary scenes bear the title of an actual river or town although they seldom resemble in any way the named place. Typical examples are ''Cologne'', ''Lozere'', ''Rhine'' and ''Verona''. Other patterns seem to bear titles inspired by topical events in distant lands. ''Scinde'', for example, appeared when this part of India was annexed after Napier's campaign of 1845.

1860-1880 The Final Decline

Despite the lack of imagination used in many of the romantic patterns the quality of some of the wares was still surprisingly high. The second half of the 19th century, however, was to see the final decline of blue-printed pottery. The Willow pattern was still in production and the ''Asiatic Pheasants'' design was continued in ever decreasing quality but relatively few new patterns appeared. White dinner services with decorative printed borders began to replace the all-over printed designs. Brightly coloured wares were in demand and the market dictated change. Thus ended a century of potting endeavour, the results of which are now delighting collectors all over the world.

Abbreviations and Conventions

Abbreviations

*	Indicates a cross reference to an illustration under the appropriate entry.
c.	*circa.* An approximate date.
fl.	*floruit* — flourished, and used here to indicate the period when a firm or craftsman was in business.
Ill:	Illustrated in. This is followed by a book reference and the number of the illustration in the book, or the page number, e.g. p.204.
(qv)	*quod vide* — which see.
(sic)	Thus or so. Indicates an exact quotation though its incorrectness suggests that it is not. It is used particularly when a printed title on wares has been spelt wrongly or in a manner that is not generally accepted today.

Book References

Book references which occur frequently are given by stating only the name of the author, and where relevant followed by the number of the illustration or page. Books referred to in this way are as follows:

Arman	D. and L. Arman, *Historical Staffordshire.*
Arman S.	D. and L. Arman, *Historical Staffordshire, First Supplement.*
Atterbury	P. Atterbury (Ed.), *English Pottery and Porcelain.*
Copeland	R. Copeland, *Spode's Willow Pattern.*
Coysh 1	A.W. Coysh, *Blue and White Transfer Ware, 1780-1840.*
Coysh 2	A.W. Coysh, *Blue-Printed Earthenware, 1800-1850.*
FOB	Friends of Blue Bulletin (bulletin no. given).
Godden BP	G.A. Godden, *British Pottery: An Illustrated Guide.*
Godden I	G.A. Godden, *An Illustrated Encyclopaedia of British Pottery and Porcelain.*
Godden M	G.A. Godden, *Encyclopaedia of British Pottery and Porcelain Marks.*
Jewitt	L. Jewitt, *The Ceramic Art of Great Britain.*
Laidacker	S. Laidacker, *Anglo-American China, Part II.*
Lawrence	H. Lawrence, *Yorkshire Pots and Potteries.*
Little	W.L. Little, *Staffordshire Blue.*
Lockett	T.A. Lockett, *Davenport Pottery and Porcelain, 1794-1887.*
May	J. and J. May, *Commemorative Pottery, 1780-1900.*
Moore	N.H. Moore, *The Old China Book.*
Nance	E.M. Nance, *The Pottery and Porcelain of Swansea and Nantgarw.*
Rice	D.G. Rice, *The Illustrated Guide to Rockingham Pottery and Porcelain.*
Shaw	S. Shaw, *History of the Staffordshire Potteries.*
Smith	A. Smith, *The Illustrated Guide to Liverpool Herculaneum Pottery.* Second Edition.
Whiter	L. Whiter, *Spode: A History of the Family, Factory and Wares from 1733-1833.*
P. Williams	P. Williams, *Staffordshire Romantic Transfer Patterns.*
S.B. Williams	S.B. Williams, *Antique Blue and White Spode.* (Illustration numbers refer to the third edition.)

References to other books and publications are given by stating the name of the author(s), title, illustration or page number.

Full details of all book references are listed in the bibliography at the end of the Dictionary.

Pattern Names

When pattern names are marked on the wares they are given within quotes, e.g. ''Medina''. Where any other title is given it is either an authentic factory name which was not marked on the wares or a name which is in general use by dealers or collectors, usually because the pattern has been illustrated in a book or journal. In a few cases a title has been adopted to draw attention to its most prominent feature. Where series titles are marked on wares they are also given in quotes, e.g. ''Antique Scenery''. In other cases series have, where possible, been given names used by previous authors, although in a few cases a more appropriate title has been adopted.

It should be noted that when more than one potter used the same title, it does not necessarily mean that the patterns are the same.

Place Names

Some titles use the name of a place in a variety of forms, i.e. Windsor, ''Windsor Castle'', ''Windsor Castle, Berkshire''. In such cases, any indication of the architecture or history of the place will be included in the last reference.

Sizes

Dimensions are given to the nearest quarter inch and the equivalent in centimetres. Unless otherwise stated, the measurements of examples refer to diameter of plates and length of dishes.

"Abbey"

A widely used design which shows the ruins of an abbey. It is known on marked wares by Samuel Keeling & Co., R.A. Kidston & Co., Livesley, Powell & Co., Pountney & Allies, Powell & Bishop, and John Pratt & Co. The title is found in a standard cartouche of C-scrolls. The pattern was also used by the Dutch firm of Petrus Regout of Maastricht whose name appears beneath the cartouche. The title "Abbey" was not translated into Dutch.

Some 20th century examples are marked with the date "1790".

"Abbey." *Powell & Bishop. Printed scroll cartouche with title and maker's initials. Child's chamber pot diam. 5½ins:14cm.*

"Abbey Gate of St. Edmundsbury, Suffolk"

Maker unknown. "Antique Scenery" Series. Dessert dish with moulded flower handles 10ins:25cm.

The Abbey Gateway at Bury St. Edmunds was built c.1330. It is a broad embattled structure in the precinct wall. The source print is in W. Marshall's *Select Views in Great Britain*, Part II, (1825).

"Abbey Mill"

Minton. Minton Miniature Series. Various miniature dishes between 4ins:10cm and 5ins:13cm long.

With such a general title it has not yet proved possible to locate the view.

"Abbey Ruins"

Thomas Mayer. A design printed in light blue on dinner wares.

"Abbotsford, Sir Walter Scott's"

Belle Vue Pottery. Belle Vue Views Series. Dish 15ins:38cm.

Walter Scott acquired an estate at Abbotsford, near Melrose, and built a fine house using William Atkinson and Edward Blore as his architects. It was completed in 1818. The house is open to the public in the summer.

Abbott & Mist fl.1806-1809

China retailers and decorators of 82 Fleet Street, London. Andrew Abbott and James Underhill Mist formed a partnership in 1806, continuing as "Potters to the Prince of Wales", a title used by their predecessors Abbott & Newbury and Andrew Abbott while he was trading on his own. The partnership continued until about 1809 after which the business was continued by Mist alone. Among the makers of blue-printed wares sold through their warehouse in 1808 were John & Edward Baddeley, John Davenport, Charles Harvey, John Heath, John Mare and John & George Rogers.

See: Hillier, *The Turners of Lane End*, p.64.

"Abergeldee" (sic)

J. & M.P. Bell & Co.

Abergeldie Castle is on the River Dee six miles above Ballater and two miles below Balmoral. It belongs to the Royal Family and consists of a tower built in about 1550 with some 19th century additions.

Absalom's Pillar

A Wedgwood pattern which was introduced in 1822. The name is widely accepted although it has also been called Absalom's Tomb and it was known within the works as the Pavilion pattern. It is said to be based on three engravings by Luigi Mayer in his *Views in Palestine* (1804). The copper plates for the design were probably engraved by William Brookes. It was used for dinner services and one extensive service can be seen in the Georgian House in Charlotte Square, Edinburgh.

Two other titled views of the monument are known. The Ottoman Empire Series by an unknown maker included a view named "Pillar of Absalom", whereas Thomas Mayer used another in his "Illustrations of the Bible" Series under the longer title "Tomb of Absalom, Village of Siloan the Brook, Kedron".

Absalom's Pillar is at Petra in the Valley of Kedron, east of Jerusalem.

"Abbey Gate of St. Edmundsbury, Suffolk." *Maker unknown. "Antique Scenery" Series. Printed title mark. Moulded dish 10ins:25cm.*

Acanthus
A stylised leaf of the plant *Acanthus spinosus* used as decoration on both furniture and ceramics. It was a popular motif for use in floral borders.

"Achilles"
J. & M.P. Bell & Co. A title used for a romantic pattern.

The swift-footed Achilles led his troops against the Trojans but fell in battle before Troy was taken. He is the principal hero of the *Iliad*.

Acorn and Oak Leaf Border Series
Two potters produced dinner services printed with views inside a border of acorns and oak leaves. Although the two borders are very similar the stringing at the inner and outer edges is distinctly different and the printed marks used to contain the view titles also differ. Plates from the series by Ralph Stevenson have fewer acorns in the border, and the inner stringing is reminiscent of the meteorological representation of an occluded front with alternating semi-circles and triangles. The views in this series are listed in the entry Stevenson's Acorn and Oak Leaf Border Series.

The second series, by an unknown maker, bears a printed mark with a crown over an octagonal panel containing the view title and flanked by two conifer sprays. The inner stringing is a continuous line of diamonds containing small circles. Examples sometimes also have an impressed crown mark and the views are listed in the entry Crown Acorn and Oak Leaf Border Series.

According to Laidacker a similar border was also used by John Geddes at the Verreville Pottery, Glasgow, for a series of which York Minster is the only identified view.

"Acropolis"
(i) G.L. Ashworth & Bros.

(ii) Maker unknown. A romantic view of the Acropolis in Athens titled in an architectural cartouche.

An acropolis was a fortified hill or rock in ancient Greece. There are well-known examples at both Athens and Corinth.

The Adams Family
A family of potters established in the 16th century in Burslem. The first potter was a William Adams (1550-1617) and the christian name was used frequently in succeeding generations. The first Adams to make blue-printed wares was William Adams (1746-1805) of Tunstall. Thereafter the attribution of wares becomes almost impossible. In the year he died there were six living Williams engaged in the pottery industry. Only one Adams, Benjamin, used his initial on marks. The rest of the family, if they marked at all, used simply the name "ADAMS". The early family history has been covered in Turner, *William Adams, an Old English Potter;* Adams, *A History of the Adams Family;* Nicholls, *Ten Generations of a Potting Family.*

The Adams potters are listed below in chronological order and in relation to the works they operated.

Adams, William, fl.1770-c.1820
of Brick House, Burslem and Cobridge
Probably produced blue-printed wares with chinoiserie patterns early in the 1780s although it is doubtful if they were marked. The history of his various factories is confused since they were sometimes let to other potters. Two of the Cobridge works were let, one in 1813 and another to James & Ralph Clews in 1817. He gave up pottery making in about 1820, some years before his death in 1831.

Adams, William, fl.c.1779-1805(1809)
of Greengates, Tunstall
The newly built Greengates pottery was started in 1779 following a period at smaller works in Burslem. The manufacture of blue-printed wares started immediately — the first pottery in Tunstall to do so. The early patterns were probably mainly unmarked chinoiseries. William Adams himself died in 1805, and the works were operated for some years by trustees. In 1809 his son Benjamin came of age and assumed responsibility.

Adams, William, of Stoke-on-Trent fl.1804-1819
The pottery at Stoke-on-Trent was set up after a partnership with Lewis Heath at the Hadderidge pottery, Burslem. It was probably during this partnership that William Adams gained experience of the production of blue-printed wares which were to become the main product of the Cliff Bank works. Large quantities were made, not only for the home market but also for the export trade with America. One of the American subjects is a view of Mitchell & Freeman's China and Glass Warehouse in Boston, which must have handled a large quantity of the export wares. The firm prospered and in 1810 the eldest son, William, was taken into partnership, to be followed shortly afterwards by three other sons. At this stage the style of the company became William Adams & Sons.

Adams, Benjamin, fl.1809-1820
of Greengates, Tunstall
While Benjamin Adams was operating the Greengates pottery the impressed mark "B. ADAMS" was used. One of his best known blue-printed patterns was after a painting by Claude Lorraine and is said to have been engraved by William Brookes (qv). Pierced dessert wares with this pattern are illustrated in Little 4; Godden I 7.

Adams, William, & Sons fl.1819 to present
When William Adams died in 1829 the eldest son, also William, became the senior partner. On his marriage in 1834 the Greenfield pottery was acquired for the firm. The Stoke factory was closed in 1863 but the Greenfield establishment continued and the Greengates pottery was again acquired by the family in 1858. The style William Adams & Sons was used for many years and is still retained today.

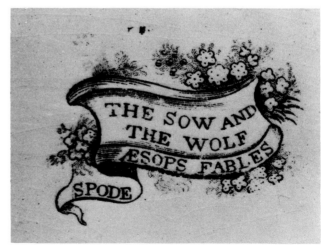

"Aesop's Fables" Series. *Spode. Typical printed mark with impressed maker's mark.*

"**Aetna from the Augustines.**" *Don Pottery. Named Italian Views Series. Printed title below view. Printed and impressed maker's marks. Tureen length 13ins:33cm.*

"Adelaide's Bower"

Maker unknown. A romantic scene with tall pagoda-like buildings amongst trees, all within a border of large floral medallions. Ill: Atterbury p.170; P. Williams p.179.

This title may have been intended as a compliment to Queen Adelaide, wife of William IV, who died in 1849.

"The Advertisement for a Wife"

James & Ralph Clews. Doctor Syntax Series. Various dishes and stands. Ill: Arman 64; Laidacker p.27; Moore 31.

"Aesop's Fables" Series

A series introduced at the Spode factory in 1832 or early in 1833 and continued by their successors, Copeland & Garrett. The designs are based on engravings in Samuel Croxall's *Fables of Aesop,* published in two volumes in 1793. This was a popular book which was already in its seventeenth edition by 1805. Examples are marked with a printed floral scroll which contains the name of the individual scene above the series title. The name "SPODE" appears in the mark on early examples but has clearly been erased from the mark on some Copeland & Garrett pieces. Several colours were used, green being the most common.

The following titles have been recorded in blue:
"The Ass, the Lion and the Cock"
"The Crow and the Pitcher"
"The Dog in the Manger"
"The Dog and the Shadow"
"The Dog and the Sheep"
"The Dog and the Wolf"
"The Fox and the Goat"
"The Fox and the Lion"
"The Fox and the Sick Lion"
"The Fox and the Tiger"

"The Hare and the Tortoise"
"The Horse and the Loaded Ass"
"The Lion in Love"
"The Mountains in Labour"
"The Oak and the Reed"
"The Sow and the Wolf"
"The Wolf and the Crane"
"The Wolf and the Lamb"
"The Wolf, the Lamb and the Goat".

"Aetna from the Augustines"

Don Pottery and Joseph Twigg, Newhill Pottery. Named Italian Views Series. Tureen 13ins:33cm.

Augustine, now called Augusta, lies to the south of Mount Etna on the east coast of Sicily. This pattern shows the smoke from the volcano rising to fill the sky. For a different view in the Byron Views Series by Copeland & Garrett see the entry "Mount Etna".

"Agra"

J. & M.P. Bell & Co. A romantic view with a large mosque or palace.

Agra, on the River Jumna, is about one hundred miles south by east of Delhi. It is best known for the Taj Mahal, the marble tomb built by Shah Jehan for his favourite wife. There are other fine buildings in the city including the Moti Masjid or Pearl Mosque, and the Jama Masjid or Great Mosque. Which of these buildings is represented on the wares it is difficult to determine.

During the Indian Mutiny a column under Brigadier-General Greathead was ordered to relieve Agra, a mission accomplished in October, 1857. This could well have been the date when the pattern was introduced.

"Agra." J. & M.P. Bell & Co. Printed title mark with maker's initials. Plate 10ins:25cm.

"Agricultural Vase"
Ridgway, Morley, Wear & Co. and their successors Ridgway & Morley and Francis Morley & Co. The design shows a large two-handled lidded vase with a river scene in the background. Ill: P. Williams p.57.

"Agriculture"
Davenport. A romantic view showing two-horse ploughing within a sheet pattern border. Ill: P. Williams p.469.

Agrigento
Two of the patterns in the Named Italian Views Series by the Don Pottery and the Newhill Pottery of Joseph Twigg bear titles "Ruins near Agrigenti" and "Tomb of Theron at Aggrigentum" (sic).

Agrigento was founded by Greeks in the 6th century B.C. It flourished under the autocratic ruler Theron who extended the influence of the city between 488 and 473 B.C. Many temples were built and it became a centre of great splendour but the prosperity was short-lived. In later years it became the Roman town of Agrigentum. Today Agrigento is the provincial capital of the south west of Sicily, one of the poorest parts of Italy. The tomb of Theron is still to be seen.

Ainslie, Sir Robert c.1730-1812
British Ambassador to Constantinople, 1776-92. He was a keen collector of coins and illustrations of Eastern life. He commissioned Luigi Mayer to make drawings of places in the Ottoman Empire which were engraved by Thomas Milton and published by R. Bowyer in 1810. The engravings were used by an unknown maker for the views in the Ottoman Empire Series (qv).

Ainsworth, John
A Caughley workman who moved to Shelton in Staffordshire in about 1784 to work for John Yates on blue-printed wares.

"Albion"
A common pattern name used by several different potters:

(i) Sampson Hancock & Co. A light blue design used on dinner wares.

(ii) Robert Maling. A romantic river scene within a border of vignettes separated by ferns. Ill: Bell, *Tyneside Pottery*, p.96.

(iii) George Patterson.

(iv) William Ridgway & Co. A floral spray design. Ill: P. Williams p.25.

(v) G.R. Turnbull. Similar to the Maling design listed above. Ill: Bell, *Tyneside Pottery*, p.110.

(vi) John Wood.

Albion, the ancient name of Britain, is said to have been derived from the Latin *albus,* meaning white, on account of the white chalky cliffs on the coast. The name was in common use in Victorian times in patriotic songs.

Alcock, John fl.1853-1861
Cobridge, Staffordshire. Amongst printed designs used by John Alcock was a pattern titled "Priory" (qv). A marked printed earthenware jug, typical of the period is illustrated in Godden I 2, although the colour is not stated. Printed marks were used with the name in full accompanied by the town name — "Cobridge".

Alcock, John & George fl.1839-1846
Cobridge, Staffordshire. Printed or impressed marks are known with either the name in full "J. & G. ALCOCK" or the initials J. & G.A. A meat dish with the initial mark has been noted with an additional printed mark of the American importers Wright & Pike.

Alcock, Samuel, & Co. fl.1828-1859
Cobridge and Hill Pottery, Burslem, Staffordshire. The marks of this firm often include the initials S.A. & Co. Amongst other patterns they produced a dinner service for the Orange Society decorated with the equestrian figure of William III and marked with the title "Japanese" which was presumably the name of the border. Ill: Coysh 1 18; Godden I 13.

"Alfred as a Minstrel"
Jones & Son. "British History" Series. Dish 8½ins:22cm.

King Alfred was a cultured king who tried to communicate to his people a love of literature and song. He learned the old songs of his race by heart and had them taught in the palace school. He particularly loved the music of the psalms.

"Alhambra"
John Thomson & Sons. A dark flown-blue pattern with a Moorish design.

The name refers to the ancient royal palace and fortress in Spain, one of the finest examples of Moorish art in the world, which stands on a hill overlooking the city of Granada.

Alicata
A seaport on the south coast of Sicily which is known today as Licata. It has been described as "the Leocata of the ancients, a town of Noto, in Sicily, remarkable for corn and good wine" (1810). One of the patterns in the Named Italian Views Series by the Don Pottery and the Newhill Pottery of Joseph Twigg bears the title "View in Alicata".

"All Souls College and St. Mary's Church, Oxford"
John & William Ridgway. Oxford and Cambridge College

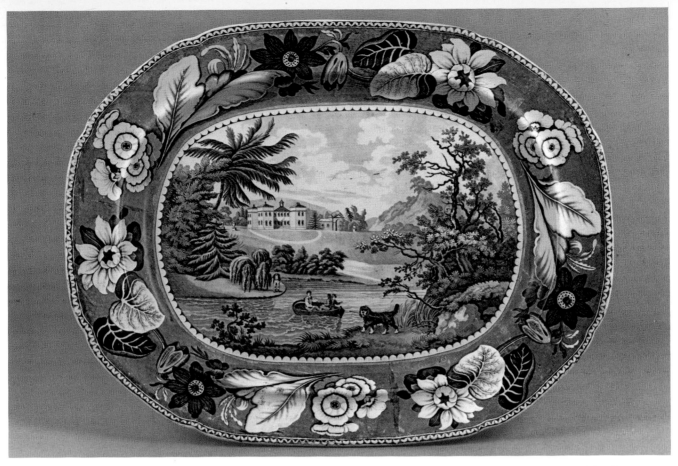

Colour Plate I. "British Views" Series. *Maker unknown. Unidentified view. Printed series title mark. Dish 21¼ ins:54cm.*

Colour Plate II. "British Views." *Henshall & Co. Fruit and Flower Border Series. Printed title mark. Dish 19ins:48cm.*

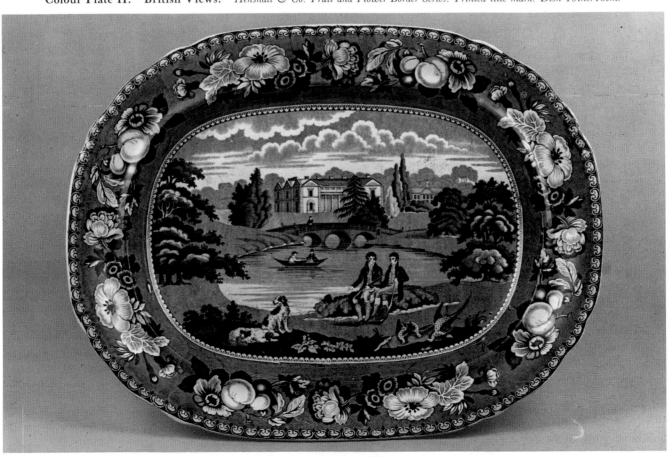

Series. Dish 20ins:51cm, and drainer. Ill: Moore 43.

These buildings stand side by side in Oxford High Street. The front quadrangle of All Souls which abuts on the High Street was built between 1838 and 1843. St. Mary's Church is in the Perpendicular style. It was here that university ceremonies were held before the building of the Sheldonian Theatre.

Allen & Hordley fl.c.1830-1840
A firm of engravers known to have provided copper plates for blue-printed patterns used at the Wedgwood factory.

Allerton, Brough & Green fl.c.1831-1859
Park Works, Lane End, Longton, Staffordshire. Blue-printed wares were made at this factory with initial marks A.B. & G. The firm was succeeded by Charles Allerton & Sons.

Allerton, Charles, & Sons fl.1859-1942
Park Works, Lane End, Longton, Staffordshire. According to Little, this company made large quantities of blue-printed ware. It has been stated that early wares were unmarked (Godden M p.30) and this seems to have continued until about 1890.

Allman, Broughton & Co. fl.1861-1868
Overhouse Works, Burslem, Staffordshire. The usual printed mark is A.B. & Co.

All-Over Pattern
See: Sheet Pattern.

Allsup, John fl.c.1832-1858
London retailer at 16 St. Paul's Church Yard. Printed marks with the name J. (or I.) Allsup and the above address are relatively common. Examples have been noted on Mason's Ironstone and on china armorial wares which may have been produced at Coalport. Similar marks have also been recorded on Grainger Worcester wares.

"Almacen de Gamba y Co."
A very dark blue plate decorated with a map of Cuba and a Spanish poem praising the beautiful girls of Cuba is illustrated in Coysh 2 129. The printed mark includes the inscription "La Cafetera, Almacen de Gamba y Co., Havana". La Cafetera is Spanish for The Coffee-pot and the plate is almost certainly part of a special order for use in a Havana coffee house.

"Alnwick Castle." *Maker unknown. Passion Flower Border Series. Printed title mark. Plate 8½ins:22cm.*

"Alnwick Castle"
(i) Maker unknown. Flower Medallion Border Series. Soup plate 9ins:23cm.

(ii) Maker unknown. Passion Flower Border Series. Plate 8½ins:22cm.

Alnwick Castle, Northumberland
William Adams and James & Ralph Clews both produced an untitled view on plates (10ins:25cm) in their Foliage and Scroll Border Series. Ill: Little 7.

Alnwick Castle has been the seat of the Percy family since Norman times but Robert Adam gave it a 'Gothick' image in the 18th century. A guide book dated 1822 describes it as "in the gayest and most elegant style of Gothic architecture". This is the castle depicted on the blue-printed wares since a new tower was built and there was much other reconstruction in the 1850s. The castle is open to the public in summer.

"The Alps"
Copeland & Garrett. Seasons Series.

This pattern, with the usual large vase in the foreground bearing the inscription "February", is probably imaginative rather than a truly topographical scene.

The Alps consist of several groups and ranges of mountains which lie across the south of central Europe. The highest peak is Mont Blanc at 15,781 feet. Various alpine resorts were required stops on the Grand Tour.

"Alton Abbey, Earl of Shrewsbury's Seat"
Careys. Titled Seats Series.

"Alton Abbey, Staffordshire, England"
Ralph Hall. "Picturesque Scenery" Series. Dish 13ins:33cm.

Alton Abbey was built between 1810 and 1852. The house, which is now known as Alton Towers, is largely unused and

Alnwick Castle, Northumberland. *William Adams. Foliage and Scroll Border Series. Untitled. Impressed maker's eagle mark. Plate 10ins:25cm.*

"The Alps." *Copeland & Garrett. Seasons Series. Printed title mark with maker's name and address and impressed maker's mark. Soup plate 10ins:25cm.*

some parts are in poor repair. However, the gardens are noted for the many buildings including an orangery, cottage, conservatory, loggia, pagoda, fountain and bridges. They are open to the public.

"Alva"
John Hulme & Sons.

Ambleside
Ambleside is a market town at the northern end of Lake Windermere in Westmorland, now Cumbria. Elkin, Knight & Co. included a view titled "Mill at Ambleside" in their Rock Cartouche Mark Series.

"American Marine"
Francis Morley & Co. and their successors G.L. Ashworth & Bros.

This title was used for patterns of sailing boats within a border of four medallions containing further marine views in rope framework. It was made over a long period in blue and other colours and enamelled examples are also known. Ill: Coysh 2 65; P. Williams p.601.

"Amicitia, Amor et Veritas"
A motto which means: friendship, love and truth. See the entries "Grand United Order of Oddfellows" and "Independent Order of Oddfellows".

"Amoy"
(i) Davenport. A flown-blue chinoiserie design with two ladies seated beneath a parasol. Ill: Lockett 33.

(ii) Dillwyn of Swansea. An entirely different chinoiserie pattern showing a lady in Chinese dress receiving tea from a Chinese servant. A man smoking a long-stemmed pipe stands nearby. Ill: Nance LXXIIc.

(iii) William Ridgway. A romantic scene printed on ironstone dinner wares.

The Chinese port of Amoy was captured by the British in 1841 and became a treaty port in 1842. Lockett's example is

dated 1844 and the town was obviously in the news when these patterns were made. It stands on the island of Hsiamen at the mouth of the Lung-kiang, just across the straits from Formosa (Taiwan).

"Amport House, Hampshire"
Maker unknown. Crown Acorn and Oak Leaf Border Series. Pierced dessert plate. Ill: FOB 22.

There have been three manor houses at Amport, near Andover in Hampshire. Very little is known of the first. The second was built in 1806 and the third in 1857.

"Ampton Hall, Suffolk"
Andrew Stevenson. Rose Border Series. Lid for soup tureen.

The view shown on this item can no longer be seen. The original building was destroyed by fire in 1885 and then rebuilt.

Anchor Mark
Blue-printed wares are occasionally encountered with an impressed anchor mark and it seems to have become common practice to attribute all such pieces to the Davenport factory. Certainly Davenport did use an impressed anchor but the mark is also known on wares by the Careys and by Thomas Fell. In all these cases the anchor appears together with the appropriate potter's name. It has also been found impressed alone on a plate with a printed Ralph Stevenson mark. In view of the fact that several potters are known to have used the impressed anchor it is dangerous to attribute wares to any factory on the basis of this type of mark alone. It could well have been used by several factories.

Ancient Bath at Cacamo
Spode. Caramanian Series. Plate 7½ins:19cm.
See: Cacamo.

Ancient Bath at Cacamo. *Spode. Caramanian Series. Impressed maker's mark. Plate 7½ins:19cm.*

"Ancient Cistern Near Catania"

Don Pottery and Joseph Twigg, Newhill Pottery. Named Italian Views Series. Plate 6½ ins:16cm.

Catania lies on a gulf on the east coast of Sicily where the slopes of Mount Etna reach the sea. It has suffered in the past from earthquakes and lava flows but is now the most prosperous town on the island.

Ancient Granary at Cacamo

Spode. Caramanian Series. Plate 6¼ ins:16cm and sauce tureen. Ill. Coysh 2 91-92; Whiter 93; S.B. Williams 58-60.

This pattern has also been recorded on a larger Spode plate with a border of long leaves, small daisy-like flowers, and open flowers with either four or ten petals. This border is not known on any other blue-printed pattern.

See: Cacamo.

"Ancient Greece"

Ralph Stevenson & Williams. A classical ruins pattern of relatively early date. The title appears on a printed drape, sometimes accompanied by the initials R.S.W. Some examples are known with a gadrooned edge and the impressed mark "STEVENSON" has also been noted.

"Ancient Rome"

Maker unknown. A classical scene with ruins and figures seen through arches. The title appears on a printed panel. An untitled example has been reported with an impressed mark "CAREY & SONS" but confirmation is desirable.

"Ancient Ruins"

Maker unknown. A romantic scene with a fountain and Gothic ruins. A man stands before a large ruined arch. Ill: P. Williams p.184.

"Ancient Tomb at Boglipore"

Maker unknown. "Oriental Scenery" Series. Cup plate 4¾ ins:12cm.

The early spelling of Indian names is often phonetic rather than exact and Boglipore is now spelt Bhagalpur. It lies in northern India on the River Ganges, to the east of both Patna and Varanasi (Benares).

"Andalusia"

(i) William Adams & Sons. A series title for scenes which have either horses or dogs together with romantic follies or gazebos. Items are usually in pink but blue examples are known. Ill: Laidacker p.10; P. Williams pp.185, 736.

(ii) John Thomson. A typical romantic scene with Spanish figures praying at a monument. The border has a different romantic vignette alternating with sprays of convolvulus on a stippled ground. The printed mark shows a vase with "Stone Ware", the initials J.T. and the title in script beneath.

Andalucia, the modern spelling, is a region in southern Spain with many historic towns including Cadiz, Granada and Seville.

"Anemone"

Lockhart & Arthur.

The anemone is a small plant, one variety of which is called the wind-flower.

"Angoulie" (sic)

Minton & Boyle. A romantic scene.

The title is almost certainly derived from the French cathedral town of Angouleme on the Charente river, the birthplace of Margaret of Navarre.

Ancient Granary at Cacamo. *Spode. Caramanian Series. Impressed maker's mark. Rare floral border in place of the usual series border of Indian animals. Plate 8¼ ins:21cm.*

The Angry Lion

Maker unknown. A name which is used for a pattern which features a prominent lion in the foreground. The lion appears to be venting his wrath on two running figures who appear in front of unusual buildings on the right of the scene. On the left is a curving road on which is a horse and rider. The border consists of a series of scrolled medallions which are separated by flowers. The pattern is known on both dinner and dessert wares, including an impressive supper set. Ill: FOB 27.

Angus Seats Series

This is a series of untitled views of houses in England and Scotland printed within a square or rectangular frame with cusped corners. The border consists of small vignettes surrounded by large bunches of flowers. Examples are very rarely marked although at least one plate is known with the lower case impressed mark "Ridgway". This could have been used by either John Ridgway, who potted alone at Albion Street, Shelton, or by John and William Ridgway who succeeded their father at Cauldon Place, Shelton. An earlier similar mark "Ridgway & Sons" is known and this suggests that the makers may have been the two brothers shortly after their father's death. Certainly the appearance of examples, taking into account the potting and the engraving technique, would seem to support a date shortly after 1814 when Job Ridgway died.

Most of the views in this series were based on prints contained in *Seats of the Nobility and Gentry in Great Britain and Wales in a collection of Select Views engraved by W. Angus from Pictures and Drawings by the most Eminent Artists with descriptions of each view.* This book was dated 1787 but was first published in 1797, with a second edition issued in 1815 supplemented with fifteen extra prints. It was published by W. Angus of Gwynnes Buildings, Islington. The views which have been identified are

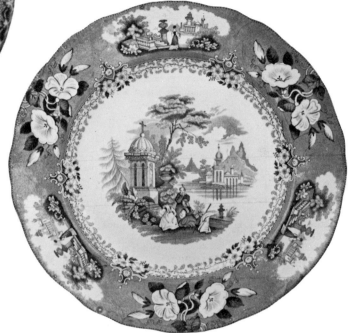

"**Ancient Tomb at Boglipore.**" *Maker unknown. "Oriental Scenery" Series. Printed titles mark. Cup plate 4¾ ins:12cm.*

"**Andalusia.**" *John Thomson. Printed vase mark with title and maker's initials. Plate 10¼ ins:26cm.*

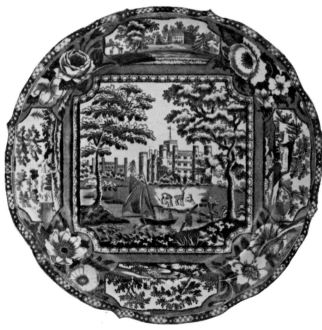

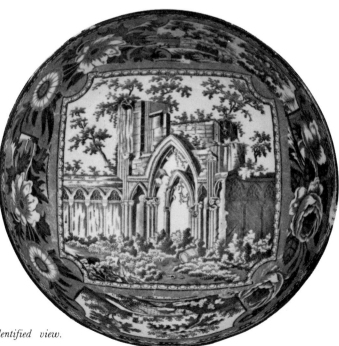

Angus Seats Series. *John & William Ridgway. Unidentified view. Rare impressed mark "Ridgway". Plate 9¾ ins:25cm.*

Angus Seats Series. *John & William Ridgway. Unidentified view. Unmarked. Bowl 9½ ins:24cm.*

listed below, together with the number of the plate in the Angus book in cases where they were taken from that source:

Comb Bank, Kent (Angus 4)
Cusworth, Yorkshire (Angus 16)
Gunnersbury House, Middlesex (Angus 46)
Lanercost Priory, Cumberland
Lee, Kent (Angus 43)
Lumley Castle, Durham (Angus 37)
Melville Castle, Midlothian (Angus 29)*
Newnham Court, Oxfordshire (Angus 38)*
Raby Castle, Durham (Angus 25)
Sheffield Place, Sussex (Angus 26)
Tong Castle, Shropshire (Angus 20)*

There are several views which have not been identified and some which were not taken from Angus. The only identified view not from Angus, that of Lanercost Priory, is copied from a print from *The Beauties of England and Wales* (1800-10) by Britton & Brayley. In addition to the complete views listed above, some details were taken from other plates in the Angus book. These included:

Figures on a dish from Duffryn Alled, Denbighshire (Angus 48)
A boat on a dinner plate from Lacy House, Middlesex (Angus 36)*
A church on a ladle from Nettlecombe Court, Somersetshire (Angus 33)
Figures and a stile on a dish from Theobalds, Hertfordshire (Angus 31)

Much of the above information is based on the study of a dinner service by Dr Roger Kemp. See: FOB 7.

"Animal Prize Fight"
Thomas Mayer. "Olympic Games" Series. Dish 17½ ins: 44cm, and a soup tureen. Ill: P. Williams p.513.

"Antelope"
David Lockhart & Co.

In addition to the above titled pattern, the antelope appears on a soup plate in the "Quadrupeds" Series by John Hall (Ill: FOB 14), and on a sauce tureen cover in the Sporting Series by Enoch Wood & Sons. Neither maker titled these patterns.

Anthemion
A stylised honeysuckle motif, based on the flower of the acanthus.

Antique Fragments at Limisso
Spode. Caramanian Series. Dish 16½ ins:42cm. Ill: S.B. Williams 42-43.

Limassol, as it is now known, is on the south coast of Cyprus in the eastern Mediterranean. It has a 15th century castle. The correct Cypriot name is Lemesós.

"Antique Scenery" Series
An extensive series of landscape views, mainly of castles and abbeys, by an unknown maker. The printed mark includes both the series title and the name of the individual view, and the border has large and small flowers with leafy scrolls on a geometric stippled ground. Some of the views were based on prints in *The Antiquities of Great Britain, illustrated in Views of Monasteries, Castles and Churches now existing. Engraved by W. Byrne from drawings by Thomas Hearne.* The two volumes were published by William Byrne, London (1807). The source print of "Abbey Gate at St. Edmundsbury, Suffolk" is in W. Marshall's *Select Views in Great Britain,* Part II (1825). The plate numbers are given where the source print has been identified. The following views have been recorded:

"Abbey Gate of St. Edmundsbury, Suffolk"*
"Arundel Castle, Sussex"

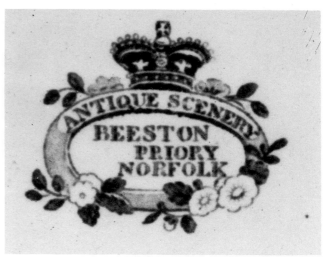

"Antique Scenery" Series. *Maker unknown. Typical printed mark.*

"Beeston Priory, Norfolk"*
"Biddulf Castle, Staffordshire"* (sic)
"Byland Abbey, Yorkshire"
"Caister Castle, Norfolk"*
"Cathedral Church of Glasgow"* (Plate XIII)
"Craigmillar Castle, Edinburgh" (Plate XXXVI)
"Fountains Abbey" (Plate XXXIX)
"Hexham Abbey"
"Jedburgh Abbey"
"Kirkstall Abbey"
"Kirkstall Abbey, Yorkshire" (a different view)*
"Lanercost Priory"*
"North East View of Lancaster"*
"St. Albans Abbey, Hertfordshire"
"Stirling Castle" (Plate XXXI)*
"Stratford upon Avon, Warwickshire"
"Wingfield Castle, Suffolk" (Plate XXX)

"Antique Subjects"
Pountney & Goldney.

"Antique Vases"
Joseph Clementson.

Apotheosis of Nelson
See: Neptune Pattern.

Apple Gatherers
See: Picking Apples.

"Arabian Nights"
Middlesbrough Pottery. This title appears in capitals within a printed scroll cartouche. Examples with an impressed maker's mark are known.

"Arabic"
James Edwards & Son. A floral pattern which bears a printed registration diamond mark.

"Arcadia"
J. & M.P. Bell & Co.

"Arcadian Chariots"

Maker unknown. A design very similar to J. & M.P. Bell & Co's "Triumphal Car" with a chariot drawn by two horses, one black and the other white. The pattern is known on vases. Ill: P. Williams p.60.

Arcading

A term used to describe a type of pierced rim usually found on dessert wares. The edges are moulded and pierced in the form of a series of rounded arches and there is usually additional moulding in the form of basketweave. Arcaded rims are most often associated with the stands for pierced baskets which may be either round or oval in form. Sets of small dessert plates with arcaded rims were also made, typically about 8ins. in diameter. The technique was widely used, especially in Staffordshire.

"The Arch of Janus"

Enoch Wood & Sons. "Italian Scenery" Series. Plate 5¾ins:15cm, and sauce tureen stand 5¼ins:13cm.

The arch of Janus in Rome, which is said to have been built by Numa, was always open in times of war and closed in times of peace. Janus was a Latin god who was invoked at openings.

"Archers"

Baker, Bevans & Irwin. A pattern which shows a man and a woman, both with bows, in a landscape which includes a river, bridge, temple and castle. It is recorded on a water ewer. Ill: Coysh 1 129.

"Archery"

Herculaneum. A series of open patterns with archery scenes within floral borders. Ill: P. Williams p.471 (two examples).

The Archery Lesson

An untitled and unmarked early line-engraved design which shows a man instructing two lady archers. Little considered the pattern to be "almost certainly by William & John Turner of Lane End" and the same design is known on marked Turner stoneware jugs. Ill: Little 68.

Arcading. *Plate with a rural scene which embodies many features commonly found on blue and white printed wares — a castellated mansion, country cottages, a bridge over a stream, cows, and a group of figures with a dog. Unmarked. 7¾ins:20cm.*

"Archipelago"

This title is found with the initials B. & M., probably for Brougham & Mayer of Tunstall.

The title may have been taken from the name often given to the Aegean Sea. There was great interest in this area in the early 19th century.

"Arctic Scenery"

An unattributed series marked with the title in an igloo and iceberg cartouche. The individual scenes are not titled but all show explorers and eskimos against a background of icebergs and pack ice. Examples are known in brown, green and pink in addition to light blue. The central scenes are printed within a border which consists of floral panels alternating with differing animal vignettes.

The following central scenes have been recorded:

(i) A sledge bearing eskimos being drawn by huskies with two ships, *Griper* and *Hecla,* in the background. Ill: Coysh 2 148.

(ii) Two men by a sledge with covered longboats in the background. Ill: P. Williams p.192.

(iii) A scene with dogs and a sledge together with a group of huntsmen by a makeshift tent. Ill: FOB 26.

(iv) Eskimos building igloos while men with rifles stand by. Birds in the sky.

(v) A man with gun, two eskimos, dogs, and a partly built igloo in the background.

Other scenes are known to exist.

It has been possible to identify both the source of the central

The Archery Lesson. *Maker unknown. Unmarked. Plate 9¾ins:25cm.*

"Arctic Scenery" Series. *Maker unknown. Printed igloo cartouche with series title. Plate 10¾ ins:27cm.*

"Arctic Scenery" Series. *Maker unknown. Printed igloo cartouche with series title. Plate 9½ ins:24cm.*

"Arctic Scenery" Series. *Maker unknown. Printed igloo cartouche with series title. Soup plate 10½ ins:27cm.*

scenes and the original prints from which the animals in the border were copied. The central scenes represent episodes in the travels of the explorer Sir Edward William Parry in efforts to discover the north-west passage around the north of Canada. They are taken from books describing the journeys and many are composite views. As an example the first item listed above is based on two engravings:

(a) The main scene is from an engraving by W. Westall R.A. from a sketch made by Lieutenant Beechey published in the *Journal of a Voyage for the Discovery of a North-West Passage to the Pacific in His Majesty's ships Hecla and Griper under the orders of Lieut. William Edward Parry R.N., F.R.S.* (1821).

(b) The eskimos with sledge and dogs in the foreground are from an engraving based on drawings made by Capt. G.F. Lyon on Melville Peninsula in 1822. This was published in Parry's *Journal of a Second Voyage for the Discovery of a North-West Passage* (1824).

The animals in the borders are copied from two different sources. Some are from Bewick's *General History of Quadrupeds* (1790) while others are from William Jardine's *Natural History* (1833-43). A large number of different animals were used. The wares could not have been made before 1834 since some of the animal prints were not available before this date.

Examples of the series are by no means common in Britain and it is possible that it was produced primarily for export to Canada.

Argil
A potter's name for clay.

"Argyle"
Maker unknown. A flown-blue pattern.

Argyll
A vessel with a spout, a handle and an inner compartment or outer lining designed to be filled with hot water. It was used to keep gravy warm and the designs are such that the contents can be poured without spilling the warm water. Argylls are so named because they are said to have been invented in the mid-18th century by the third Duke of Argyll. Blue-printed examples are by no means common.

"Armidale, Invernessshire" (sic)
William Adams. Flowers and Leaves Border Series. Plate 8½ ins:22cm.

Armadale Castle on the Isle of Skye is the seat of Lord Macdonald. It was built in 1815 in the Gothic style with two octagonal towers.

"Armitage Park, Staffordshire"
Enoch Wood & Sons. Grapevine Border Series. Small plates 3½ ins:9cm to 5½ ins:14cm.

An 18th century house begun by Nathaniel Lister in 1760. It was purchased in 1839 by the widow of Josiah Spode III. It is now known as Hawkesyard Priory.

"Armley House, Yorkshire"
Maker unknown. Foliage Border Series. Soup tureen.

A mansion built for Benjamin Gott by Sir Robert Smirke at Armley, Leeds in about 1820. It is now the headquarters of a golf club.

Armorial Wares
From time to time the makers of blue-printed ware were commissioned to make services decorated with coats-of-arms. Many of these dinner or dessert services were ordered by civic authorities or livery companies although some were made for individual families. All known examples are listed in this dictionary under the motto which usually appears beneath the arms.

The following examples of civic authorities and livery companies are listed individually with their mottoes:

City of Bristol: "Virtute et Industria"*
City of London: "Domine Dirige Nos"*
Drapers' Company: "Unto God Only Be Honour and Glory"*
Ironmongers' Company: "God is Our Strength"*
Newcastle-upon-Tyne: "Fortiter Defendit Triumphans"*
Salters' Company: "Sal Sapit Omnia"*
Skinners' Company: "To God Only Be All Glory"

A useful book to consult in the case of the livery companies is J. Bromley's *The Armorial Bearings of the Guilds of London* (1960).

Examples made for individual families are often of porcelain but the following earthenware productions have been noted:

Cavendish: "Cavendo Tutus"
Copeland: "Benigno Numine"*
Glover: "Inspe Crescentis"*
See: Mottoes.

"Artichoke Tavern, Blackheath"
A mug bearing this title has been noted with an impressed mark "New Stone China".

"Arundel Castle, Sussex"
Maker unknown. "Antique Scenery" Series. Round sauce tureen and rectangular tureen stand.

This view shows the Norman castle with Gothic additions which were made between 1790 and 1815. The castle was partly rebuilt after 1890. It is the ancestral home of the Dukes of Norfolk and is open to the public during the summer.

"As You Like It, Act 2, Scene 2"
John Rogers & Son and Pountney & Goldney. "The Drama" Series.

"As You Like It, Act 4, Scene 2"
John Rogers & Son and Pountney & Goldney. "The Drama" Series.

Shakespeare's comedy *As You Like It* was written in about 1600 but it did not appear in print until the folio collection was issued in 1623.

"Ashby"
This name has been noted added to the pattern on a Copeland & Garrett plate with Spode's Italian design. Its significance is not known but it is probably the name of the original owner.

Ashet
The name used in Scotland for a meat dish, charger or platter (from the French *assiette*).

"Ashton Hall"
Maker unknown. Passion Flower Border Series. Sauceboat.

A Somerset house near Bristol which was owned by the Smythe family, Bristol merchants. It has been reconstructed and added to many times, notably in 1805.

Ashworth, George L., & Bros. fl.1862-1883
Ashworth became a partner of Francis M. Morley in 1859 and acquired the Broad Street business in Hanley, Staffordshire, c.1861. Marks have been noted which include the words "for Stiffel Bros., Odessa" indicating that the firm exported blue-printed wares to Russia. The main output was polychrome ironstones, the original Mason's moulds and patterns having been acquired, but some blue-printed patterns were introduced and some older ones continued.

"Asiatic Pheasants." *Podmore, Walker & Co. Printed title mark with maker's initials. Plate 10ins:25cm.*

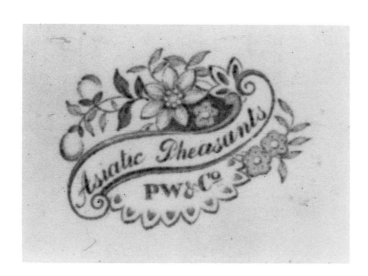

"Asiatic Marine"

F. & R. Pratt. A romanticised eastern scene with figures in front of ornate buildings and shipping in the far distance. The printed cartouche mark is circular in form and has the title and the makers' initials around a sailing ship. Ill: Godden BP 319.

"Asiatic Palaces"

William Ridgway, Son & Co. A typical romantic scene.

The same title can be found on marked wares from Ridgways of Shelton but these were produced after 1880.

"Asiatic Pheasants." *Typical printed title mark with the initials of Podmore, Walker & Co., the maker who claimed to have originated this popular pattern.*

"Asiatic Pheasants"

With the exception of the standard Willow pattern this was probably the most popular of all blue-printed designs in the second half of the 19th century, and even into Edwardian times. It was usually marked with a floral scroll, often with the maker's initials. The pattern was printed in a pale blue and shows a pheasant, or pheasants, amongst flowers and foliage within an undistinguished floral border. Wedgwood & Co. of Tunstall claim on their wares to be "The Original Manufacturers, Asiatic Pheasants", a claim which relates to their predecessors Podmore, Walker & Co. The pattern was, however, very widely copied and the following makers are known to have used it prior to 1880:

Ambrose, Walker & Co., Thornaby, Yorkshire
Harvey Adams & Co., Longton, Staffordshire
G.L. Ashworth & Bros., Hanley, Staffordshire
T. & R. Boote, Burslem, Staffordshire
T.G. Booth, Tunstall, Staffordshire
Bovey Tracey Pottery Co., Bovey Tracey, Devon
Burgess & Leigh, Burslem, Staffordshire
John Carr & Sons, Newcastle-upon-Tyne, Northumberland
E. & C. Challinor, Fenton, Staffordshire
Clyde Pottery Co., Greenock, Scotland
Cork & Edge, Burslem, Staffordshire
Doulton, Lambeth, London
Edge, Malkin & Co., Burslem, Staffordshire
Ralph Hall, Tunstall, Staffordshire
Ralph Hammersley, Tunstall, Staffordshire
Hampson & Broadhurst, Longton, Staffordshire
Hancock, Whittingham & Co., Burslem, Staffordshire
Heath, Blackhurst & Co., Burslem, Staffordshire
Robert Heron & Son, Kirkcaldy, Scotland
Hollinshead & Kirkham, Tunstall, Staffordshire
J. & J. Jackson, Burslem, Staffordshire
Livesley, Powell & Co., Hanley, Staffordshire
C.T. Maling, Newcastle-upon-Tyne, Northumberland
T.J. & J. Mayer, Burslem, Staffordshire
John Meir & Son, Tunstall, Staffordshire
Andrew Muir & Co., Greenock, Scotland
Old Hall Earthenware Co. Ltd., Hanley, Staffordshire
Patterson & Co., Newcastle-upon-Tyne, Northumberland
Podmore, Walker & Co., Tunstall, Staffordshire
Powell & Bishop, Hanley, Staffordshire
James Reeves, Fenton, Staffordshire
John Tams & Sons Ltd., Longton, Staffordshire
Wedgwood & Co., Tunstall, Staffordshire
J.F. Wileman, Fenton, Staffordshire

"Asiatic Scenery"

(i) Careys. Romanticised Eastern scenes with large mosques and boats in the foreground. There is an open border of flowers and scrolls. The printed mark is a small vignette with a building which includes both the title and the name "CAREYS". Ill: FOB 5; P. Williams p.92.

(ii) Joseph Harding. This title has been recorded on a plate with an Eastern scene marked in a scroll cartouche with the name "J. HARDING" beneath. The plate is heavily potted and the scene appears within a floral border with passion flowers. A typical vase is included in the foreground. The scene is copied from a print by Thomas and William Daniell in *Oriental Scenery* (Part I, 9) which is titled "Gate of the Tomb of the Emperor Akbar at Secundra, near Agra". The building was completed in 1613, the first mausoleum in Northern India to be furnished with minarets. The tent in the foreground with heavily engraved guy ropes is one of many which appear in the print. It was part of the encampment to which the Daniells attached themselves. It is possible that this plate bears one of a series of such views. Reports of other pieces would be of interest.

"Asiatic Views"

Francis Dillon. A view of an Oriental domed pavilion with arches and pillars. The border has scrolled vignettes with camels. Ill: P. Williams p.95.

Asparagus Servers

Flat tapering servers with vertical sides, sometimes known as asparagus shells, within which asparagus stalks rested.

"The Ass, the Lion and the Cock"

Spode/Copeland & Garrett. "Aesop's Fables" Series.

An ass and a cock were feeding together when they spied a lion. This beast has an aversion to the crowing of a cock so he took to his heels. The ass, fancying that he fled for fear of him, in the bravery of his heart pursued the lion until they were out of hearing of the cock. The lion then turned about and seized the ass and was ready to tear him to pieces. "Fool that I was by an affected courage to throw myself into the jaws of death," said the ass, "when I might have remained secure and unmolested".

Fools will be meddling.

"Athenian"

John Thomson. A romantic scene which is titled in a scroll cartouche with the initials J.T.

"Athens"

A title used by several potters for different patterns:

(i) William Adams & Sons. A scene with classical buildings, a central fountain and a lake with swans. The design was registered on 3rd January, 1849.

(ii) David Lockhart & Co.

(iii) Charles Meigh. A pattern printed in light blue on dinner wares.

(iv) John Rogers & Son. A generic title for a group of scenes of classical ruins within a border of flowers and scrolls. Ill: Coysh 1 93; FOB 22.

Athens was a small town until 1834 when it became the capital of the new kingdom of Greece. It is particularly noted for the Parthenon on the Acropolis but there are very many ancient buildings and ruins.

Audley End, Essex

This house has been identified on dinner wares by an unknown maker. The view is notable for the reflection of the house in water in the foreground. There is an arched bridge over a stream on the right and a tower on a hill in the background. On the bank in the foreground are some cows and a family group with a dog. A man is standing with his wife and young son and is pointing with his stick. The identical foreground can

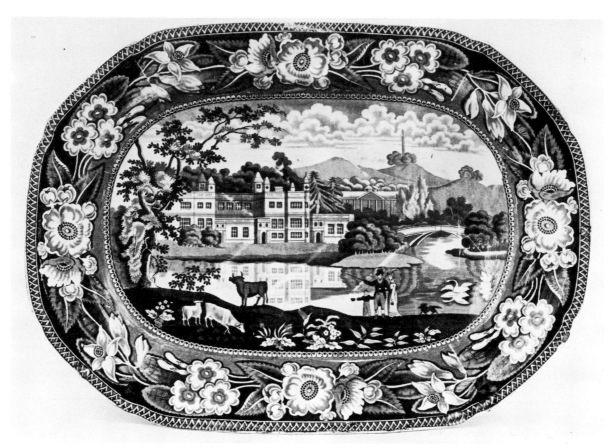

Audley End, Essex. *Maker unknown. Unmarked dish with gravy channels. 18¾ins:48cm.*

be found on a moulded dish in the "British Scenery" Series (qv). The border is of leaves and flowers on a stippled ground and is also a copy, this time of the border found on the Europa pattern by John & Richard Riley (Ill: Coysh 1 75).

"Audley End, Essex"
Andrew Stevenson. Rose Border Series. Hexagonal cover for vegetable dish.

Audley End, just to the west of Saffron Walden, is a large Jacobean mansion which was begun in 1603 on the site of a Benedictine Abbey. It was restored by Vanburgh in the 18th century and is now in the care of the Department of the Environment. It is open to the public on most days throughout the summer.

Austin, Felix fl.c.1844
The signature of this engraver followed by "Sc" appears below a view of "Cobham Hall" on a plate by Knight, Elkin & Co. in their "Baronial Halls" Series. The design was registered in 1844. Felix Austin may have been a young relative of Jesse Austin.

Austin, Jesse 1806-1879
A very skilled engraver and designer who was apprenticed to William Davenport and was probably responsible for many of the Davenport blue-printed patterns during the 1830s. In 1846 he joined the staff of F. & R. Pratt where he worked on experimental multi-colour printing on earthenwares. His initials can be found as part of the design on several of the patterns found on the famous Pratt pot-lids.

It is interesting to note that the Davenport factory produced some fine three-colour printing on dinner services as early as 1836. It has been suggested that Jesse Austin was involved in these early products and that he may have taken the technique with him when he moved to Pratts.

"Australia"
(i) Robert Cochran & Co.
(ii) James Jamieson & Co.

Australia was first visited by the Englishman William Dampier in 1688 but it was not considered of interest until the arrival of Captain Cook in 1780. The first settlement was made in New South Wales in 1788 and there was considerable development after 1813. The gold mining era of 1851 led to the discovery of copper, coal, silver and tin, and mining became of major importance: The Commonwealth of Australia was formed in 1900.

Aviary
An aviary was featured by James & Ralph Clews on a 10ins:25cm plate in their "Zoological Gardens" Series. The design shows one of the aviaries at the London Zoo which was opened in 1828.

"Aysgill Force in Wensleydale"
James & Ralph Clews. "Select Scenery" Series. Covered entrée dish.

Wensleydale is the upper valley of the River Ure in Yorkshire. Aysgill Force was the early name for a waterfall now called Aysgarth Force. It spills over the rocks in three stages just above the village of Aysgarth, some seven miles west of Leyburn.

Bacchanalian Cherubs.
*Patterson & Co. Printed oval
cartouche with maker's name. Cup
and saucer. Diam. of saucer
5¼ ins:13cm.*

Bacchanalian Cherubs
Patterson & Co. A design, printed on teawares, with a group of inebriated cherubs picking and eating grapes.

Backstamp
A name sometimes given to the impressed and printed marks on ceramics, particularly in America.

The Baddeley Family
John Baddeley, who had a pottery at Broad Street, Shelton, Staffordshire, had four sons — Ralph, John, Thomas and Edward. When the father died in 1772, Ralph took over the Broad Street works which he operated until 1795 in partnership with his younger brother John. John also helped with a nearby pottery, co-operating with Edward. It appears that Thomas became an engraver.

Baddeley, Edward Gerard fl.1834-1889
An engraver of Wheatley Place, Hanley, Staffordshire. He is known to have worked for Wedgwood at Etruria between 1852 and 1877 and was probably the son of Thomas Baddeley (qv).

Baddeley, John & Edward fl.1784-1806
Shelton, Staffordshire. The firm recruited Thomas Radford from Derby to help in the development of transfer printing. They were succeeded by Hicks & Meigh. Rare impressed marks B or I.E.B.

Baddeley, Ralph & John fl.1772-1807
Shelton, Staffordshire. Ralph Baddeley experimented with transfer printing with the help of William Smith, an engraver from Liverpool, and Thomas Davis from Worcester. Impressed marks "BADDELEY" with or without the initials R. & J.

Baddeley, Thomas fl.1800-1834
An engraver and printer of Chapel Field, Hanley, Staffordshire.

"Badminton"
Maker unknown. Foliage Border Series. Dish 19½ ins:50cm.

 A 17th century house in Gloucestershire, built in the reign of Charles II for the first Duke of Beaufort. Many changes were made by William Kent in the 18th century when Capability Brown was brought in to landscape the grounds.

Baggaley & Vodrey fl.c.1810-c.1816
A Tunstall firm reported to have made blue-printed wares. See: Little p.48.

Baggerley & Ball fl.1822-1836
St. James' Place, Longton, Staffordshire. Maker of blue-printed wares including jugs which were printed in outline and coloured with overglaze enamels. A dated example of 1823 is illustrated in Godden I 25. Printed marks often have the initials B. & B. with or without the initial L for Longton. They sometimes include the words "Opaque China".

Bagshaw & Meir fl.c.1802-1808
Burslem, Staffordshire. It is not clear whether the second partner's name was Meir or Maier. The firm is believed to have used the printed or impressed initials B. & M. but these were certainly used by other potters at a later date.
 See: Brougham & Mayer.

Bagster, John Denton fl.c.1823-1828
High Street, Hanley, Staffordshire. A company named Phillips & Bagster took over David Wilson's pottery in about 1820. The partnership lasted only a short time and J.D. Bagster continued alone from about 1823 to 1828. The factory was then bought by Joseph Mayer and was eventually taken over by William Ridgway & Co.

 According to Little p.49, John Denton Baxter made blue-printed wares and used the marks "BAXTER", I.D.B. and J.D.B. However, the spelling Bagster occurs in marks on moulded jugs made by both Phillips & Bagster and J.D. Bagster. The name Bagster also appears in a Staffordshire directory of 1828-29.
 See: "Vignette" Series.

Bailey & Neale
China retailers of 8 St. Paul's Church Yard, London.
 See: Neale & Bailey.

Baker, Bevans & Irwin fl.1813-1838
Glamorgan Pottery, Swansea.
 See: Swansea's Glamorgan Pottery.

Balfour, Alexander & Co. fl.1874-1904
North British Pottery, Glasgow, Scotland.

Ball Clay
A plastic clay from Dorset and Devon, sometimes called blue clay. The name derives from the fact that it was sold in balls weighing 30-35 lb.

"Balloch Castle, Dumbartonshire" (sic)

John & Richard Riley. Large Scroll Border Series. Circular soup tureen. Ill: Laidacker p.68.

Balloch Castle was once a seat of the Earls of Lennox. It was built in the Gothic style by Robert Lugar in 1809 and is one of the finest examples of the Gothic revival in Scotland. It was acquired in 1915 by the Corporation of Glasgow.

Balloon

Maker unknown. A pattern which shows a gas balloon over a Georgian crescent with onlookers in the foreground. The scene is printed within a border of grapes on a continuous running vine. The plate illustrated is printed in green but the pattern is known in blue. See: Godden BP 317.

The central scene appears to be taken from the print illustrated. It is titled simply "BALLOON", with the letter "N" reversed, and does not bear the usual name of the publisher and date. As a result the source book and details of the scene remain unknown.

Balloon. *Source print for the Balloon pattern taken from an unidentified book. The caption reads simply "BALLOON" with the letter "N" reversed.*

Balloon. *Maker unknown. Unmarked. Green-printed plate 10¼ ins:26cm.*

"Bamborough Castle, Northumberland."
William Adams. Bluebell Border Series. Printed title mark and impressed maker's crown mark. Plate 10ins:25cm.

"Bamboo"
John & William Ridgway.

Another untitled pattern, made by Wedgwood, is usually called Blue Bamboo (qv).

Bamboo is a motif frequently used in chinoiserie patterns.

Bamboo and Peony
Davenport. An accepted name for a design with a fence amidst bamboo, peonies and other flowers, all within a border of geometric motifs and stylised flowers. The pattern is found on dinner wares. Ill: Coysh 1 29.

"Bamborough Castle, Northumberland"
William Adams. Bluebell Border Series. Plate 10ins:25cm. Ill: Little 8.

A medieval castle made habitable in 1757 to provide accommodation for schools, an infirmary and hospitality for shipwrecked sailors. Today the spelling used is Bamburgh.

"Bandana"
John & William Ridgway. A design with exotic birds. Ill: P. Williams p.608.

The name was also used for an earthenware body introduced by C.J. Mason & Co. and used for some wares at the Great Exhibition of 1851.

The word means a richly coloured handkerchief, originally made only of silk, and is of Hindu derivation.

"Bank of England"
Enoch Wood & Sons. "London Views" Series. Dish 13ins:33cm, and vegetable dish. Ill: Little 77.

"Bank of England, London"
William Adams. Regents Park Series.

The existence of this item is in some doubt. It is listed by Nicholls in *Ten Generations of a Potting Family*, but does not appear in either Laidacker or Moore.

The Bank of England was first built by Sampson in 1732-34, added to by Sir Robert Taylor between 1766 and 1783, and largely rebuilt by Sir John Soane between 1788 and 1833. This would be the building depicted. It has since been demolished and rebuilt for a second time.

"The Bans Forbidden"
James & Ralph Clews. Doctor Syntax Series. Cover for soup tureen.

Barker, John, Richard & William fl.c.1786-c.1800
Lane End (probably Flint Street), Staffordshire. An early blue-printed pierced basket has been noted with the impressed mark "BARKER". The date corresponds to this family partnership.

Barker, Samuel, & Son fl.1834-1893
Don Pottery, Swinton, Yorkshire. This firm continued to use the Don Pottery lion mark with the name "BARKER" added. Other marks bore the initials S.B. & S. after 1851 when the son was taken into partnership; an example has been noted on a "Wild Rose" plate. A soup plate with a printed title "FLORAL SCENERY" together with the name "Barker" (Ill: Coysh 1 147) may be by this pottery.

Barker, Sutton & Till fl.1834-c.1846
Sytch Pottery, Burslem, Staffordshire. Printed marks include the initials B.S. & T. One such example bears the "Royal Cottage" pattern.

Barker & Till fl.c.1846-1850
Sytch Pottery, Burslem, Staffordshire. Successors to Barker, Sutton & Till. Printed marks are known with the initials B. & T.

Barker, W., & Son fl.1850-1860
Hill Works, Burslem, Staffordshire. The "Royal Cottage" pattern has been noted with the impressed mark "W. BARKER & SON". The initials B. & S. are also often attributed to this firm. They are most commonly found on a version of the "Chinese Marine" pattern (qv).

"**Barlborough Hall, Derbyshire.**" *Source print for the Grapevine Border Series taken from John Preston Neale's "Views of the Seats of Noblemen and Gentlemen in England and Wales, Scotland and Ireland".*

"Barlborough Hall, Derbyshire"

(i) Enoch Wood & Sons. Grapevine Border Series. Plate 8¼ ins:21cm.

(ii) Maker unknown. Morning Glory Border Series. Saucer.

Barlborough Hall is an Elizabethan mansion, eight miles north east of Chesterfield.

"Barnard Castle, Durham"

Maker unknown. Pineapple Border Series. Dish approximately 19ins:48cm.

Barnard Castle lies in ruins on a rock by the River Tees. It was built in about 1120 by Barnard de Baliol, great-grandfather of John Baliol, King of Scots. In 1630 it was completely dismantled by Sir Henry Vane who wanted the materials for other buildings.

"Baronial Halls"

(i) Knight, Elkin & Co. A design with this title was registered by Knight & Elkin on 15th August, 1844 with a view of "Cobham Hall". This may well be one of a series since another view with the sub-title "Chip Chase" has been noted printed in light blue and grey. Examples bear an impressed mark in the form of a shield with "Opaque Felspar China" and the initials K.E. & Co. The printed title mark consists of a plumed helmet and breastplate with "Baronial Halls" together with a scroll bearing the name of the particular hall.

(ii) T.J. & J. Mayer. A series printed in light blue on both tea and dinner wares with figures in period costume in front of various untitled buildings. The printed shield-shaped mark includes the title and the makers' name surrounded by weapons. Ill: P. Williams p.194 (two examples).

"Baronial Views"

S. Keeling & Co. A series of views of country houses. The series title appears on the printed mark across a shield surmounted by a crown (Godden M 2249). The name of the view is on the ribbon below. "Clumber" and "Stratfield Saye" have been recorded. They bear the initial mark S.K. & Co.

"Barrington Hall"

Andrew Stevenson. Rose Border Series. Plate 8¾ ins:22cm, and soup plate 8½ ins:22cm.

An 18th century house in Hatfield Broad Oak, Essex. The view today differs from the original building of 1735 due to neo-Jacobean alterations in 1863.

"**Barlborough Hall, Derbyshire.**" *Enoch Wood & Sons, Grapevine Border Series. Printed title mark and impressed maker's mark. Plate 8¼ ins:21cm.*

Basin

A basin made to allow water to drain away through a fitted metal plughole, usually fitted into a fixed wooden stand. The name is also given to the bowl supplied with a matching ewer for use in the bedroom on a side table or washstand. Some such basins have a foot rim an inch or more deep designed to fit into a circular hole cut into the wooden surface. They are more appropriately called washbowls (qv).

Basket

Decorative dishes with pierced or woven sides usually supplied with a matching tray or stand. They were used for serving chestnuts or fruit.

The name is also used for one of the earliest Wedgwood blue-printed designs introduced in 1805.

Basket of Flowers

A name used for a Wedgwood pattern introduced in about 1820.

Basket and Vase Floral Pattern

James & Ralph Clews. A design with a prominent basket of flowers. It is marked with a pseudo-Chinese seal bearing the name "CLEWS" and the wording "WARRANTED IRONSTONE CHINA". Ill: Coysh 1 23.

Basketweave Moulding

A type of moulding designed to resemble basketwork. It is often associated with arcading (qv) and is found particularly on pierced dessert wares.

"Batalha, Portugal"

Maker unknown. A pattern showing a large monastery with figures in the foreground within a floral border. Ill: Laidacker p.117; P. Williams p.195.

Batalha is a small town about fifty miles north of Lisbon and a few miles from the coast. It has a large Dominican monastery which contains the tomb of Henry the Navigator.

Bates, Elliott & Co. fl.1870-1875

Dale Hall Works, Burslem, Staffordshire. This pottery made blue-printed wares including flown blue. Printed marks incorporate the initials B.E. & Co.

"Battle Between a Buffalo and a Tiger." *Spode. Indian Sporting Series. Printed and impressed maker's marks. Dish 9¼ ins:23cm.*

Bates, Walker & Co. fl.1875-1878
Dale Hall Works, Burslem, Staffordshire. Continued with a similar output to their predecessors Bates, Elliott & Co.

Bathwell & Goodfellow fl.1818-1823
Upper House Works, Burslem, Staffordshire. This firm also had a pottery at Tunstall from 1820 to 1822. The main blue-printed series was called "Rural Scenery" (qv) which was only occasionally impressed with the maker's name. Spode's Castle and Bridge of Lucano patterns were also produced here. Impressed marks have been recorded with "BATHWELL & GOODFELLOW" in the form of an oval. Ill: Coysh 2 7.

Batkin, Walker & Broadhurst fl.1840-1845
Church Street, Lane End, Staffordshire. Printed marks include the initials B.W. & B. A pattern named "Versailles" is illustrated by H. Wakefield in *Victorian Pottery* (1962), 3.

"Battle Between a Buffalo and a Tiger"
Spode. Indian Sporting Series. Dish 9¼ ins:23cm. Ill: S.B. Williams 23-24.

"Battle of Waterloo"
Jones & Son. "British History" Series. Dish 18½ ins:47cm, and drainer.

The Battle of Waterloo took place in 1815, and Wellington's victory culminated in the banishment of Napoleon to St. Helena.

Baxter, John Denton
See: Bagster, John Denton.

"Bay of Naples"
Copeland & Garrett. Byron Views Series. Dish 16ins:41cm. Ill: FOB 15.

"The Bay of Naples is one of the finest in the world, about thirty miles in diameter, shut out from the Mediterranean by the island of Caprea, and three parts of it sheltered by a circuit of woods and mountains" (1810).

"The Beach at Brighton"
Enoch Wood & Sons. Shell Border Series. Plate and soup plate, both 10ins:25cm, and bowl 11½ ins:29cm. Ill: Arman 141.

The beach at Brighton became a noted bathing place when George III entered the water on a Sunday in 1789 and the band struck up the national anthem as the king ducked his head beneath the waves. Bathing was at first undertaken solely for health reasons but by the 1820s people were flocking to Brighton to bathe for pleasure.

Beaded Frame Mark Series
A series of views in England, Wales and Scotland by an unknown maker who used a printed mark with the view title in an octagonal frame made by a string of tiny circles. Examples are often found on which the floral border has been clobbered with coloured enamels, occasionally with a gilt rim. The quality of individual pieces is very variable. The series includes the following views:
- "Bysham Monastery"
- "Kirkham Abbey"
- "Linlithgow Palace"*
- "Llangothlen" (sic)
- "Lymouth, North Devon" (sic)*
- "Monmouth"
- "Near Caernarvon"
- "Netley Abbey"
- "Powder Mill, Hastings"* (Colour Plate IV)

continued

Beaded Frame Mark Series. *Maker unknown. Typical printed mark.*

"Richmond"
"Rippon" (sic)
"Thorp, Derbyshire" (sic)*
"Tyburn Turnpike"
"Windsor"
Some examples exist with no printed mark.

Several attributions have been suggested but no real evidence has as yet appeared to determine the maker.

Bear Cages
Bear cages were featured by James & Ralph Clews on a dish in their "Zoological Gardens" Series. The design shows the bear cages at the London Zoo which was opened in 1828. Ill: Laidacker p.35.

"Bear Forest, Ireland"
Maker unknown. Morning Glory Border Series. Teaset creamer.

This house is close to the River Lee near Cork. It was described in 1825 as "a modern villa" with a semi-circular pillared portico, three bays, and a vestibule at one end.

Beardmore & Edwards fl.1856-1858
Union Square, Longton, Staffordshire. Rare printed marks are known with the initials B. & E.

"Beatrice"
David Methven & Sons.

This name was chosen to mark the birth in 1857 of Princess Beatrice, youngest daughter of Queen Victoria.

"Beaumont Lodge"
Henshall & Co. Fruit and Flower Border Series. Dish 12ins:30cm.

This would appear to be a view of Beaumont Grange at Hest Bank, Lancashire, an early castellated mansion. It is on Morecambe Bay, three and a half miles north north west of Lancaster.

"Beauties of England & Wales"
Maker unknown. A series of views which bear the title in a large cartouche but are not individually named. One of the views has been identified as the Monnow Bridge and Gatehouse at Monmouth.

A series of books with the title *The Beauties of England & Wales or Delineations Topographical, Historical and Descriptive* by John Britton and Edward Wedlake Brayley were published between 1801 and 1808, some twenty-six volumes in all with 684 plates. The books were issued by Vernon, Hood & Sharpe of Poultry, London, and may well have been the source for the views in this series. One unidentified view has been recorded with the

Beaded Frame Mark Series. *Maker unknown. Unidentified view. Unmarked. Plate 6ins:15cm.*

name "ERIN" let into the border. Its significance is not yet known.
See: "Erin".

"Beckenham Place, Kent"
William Adams. Bluebell Border Series. Plate 6ins:15cm.
Beckenham lies two miles north west of Bromley in Kent.

Bed Pan
Blue-printed bed pans are rare. Three examples with identifiable patterns have been noted: an unmarked bed pan decorated with the "Warwick Vase" pattern (qv), one by the Herculaneum Pottery with a "View in the Fort of Madura" (Ill: Smith 159), and the third with a view of "Fonthill Abbey, Wiltshire" in James and Ralph Clews' Bluebell Border Series.

Bed Pan. *"Warwick Vase" pattern. Maker unknown. Unmarked. Diam. 10½ins:27cm.*

Bee Catcher. *Maker unknown. Unmarked teapot. Height 5½ ins:14cm.*

"Bedfords, Essex"

(i) Enoch Wood & Sons. Grapevine Border Series. Vegetable dish.

(ii) Maker unknown. Crown Acorn and Oak Leaf Border Series. Entrée dish.

Bedfords is a seat at Havering-atte-Bower, about three miles north of Romford in Essex. It is noted for its magnificent views.

Bee Catcher

Maker unknown. An untitled pattern recorded on a small teapot. It features a prominent beehive surrounded by flowers. In the left background is a farmhouse, and on the right a man reaches out with his hat to catch a large bee.

Beehive

William Ridgway & Co. A romantic scene with a prominent beehive in the foreground and a vase of flowers behind. The border consists of flowers and C-scrolls on an open ground. Examples are known impressed "Opaque Granite China".

A variant of the pattern was used on teawares by William Adams. Ill: P. Williams p.609.

Beehive and Vases

Maker unknown. An untitled design with a beehive amongst flowers in a central reserve. This is surrounded by a broad border of vases which alternate with acanthus scroll medallions, each containing various flowers and leaves.

Beehive. *William Ridgway & Co. Impressed shield between a lion and a unicorn bearing the inscription "OPAQUE GRANITE CHINA, W.R. & CO." Saucer 4½ ins:11cm.*

Beehive and Vases. *Maker unknown. Unmarked dish with combed base 14¾ ins:38cm.*

The Beemaster. *The pattern known as the Beemaster is based on this 18th century watercolour by the artist George Robertson (1742-88) which has the title "Swarm of Bees, Autumn". The original is in the Cecil Higgins Art Gallery, Bedford.*

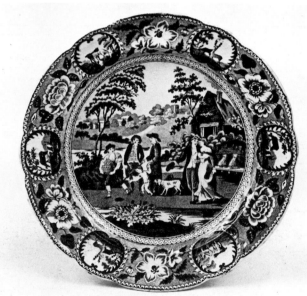

The Beemaster. *Maker unknown. Unmarked. Plate 8½ ins:22cm.*

The Beemaster

Maker unknown. A widely accepted name for a rural scene which shows a countryman carrying a beehive watched by three men, a woman and a child. The border consists of a series of small animal medallions separated by large flowers on a stippled ground. The pattern was used for dinner wares. Ill: Coysh 1 155; FOB 3; P. Williams p.474.

The scene is based on a watercolour called "Swarm of Bees, Autumn" by George Robertson (1742-88). The original is now in the Cecil Higgins Art Gallery, Bedford.

The wares are commonly attributed to William Adams but no marked examples have been recorded.

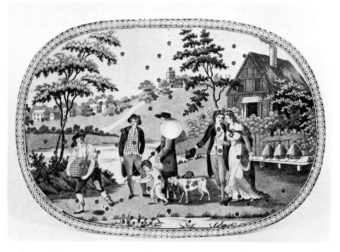

The Beemaster. *Maker unknown. Unmarked. Drainer 13¼ ins:34cm.*

"Beeston Priory, Norfolk"

Maker unknown. "Antique Scenery" Series. Plate and moulded dessert dish both 8¾ ins:22cm.

The remains of this 13th century Augustinian priory are close to the church at Beeston Regis, two miles from Cromer.

Belfield & Co. fl.c.1836-1941
Prestonpans Pottery, near Edinburgh, Scotland.

Bell, Cook & Co. fl.c.1859-1860
Phoenix Pottery, Ouseburn, Newcastle-upon-Tyne.

Printed and impressed marks have been noted on "Wild Rose" pattern plates.

Bell, J. & M.P., & Co. fl.1842-1928
Glasgow Pottery, Dobbies Loan, Glasgow, Scotland.

This pottery was founded by John Bell (d.1880) and Matthew Preston Bell (d.1869). Their most successful design

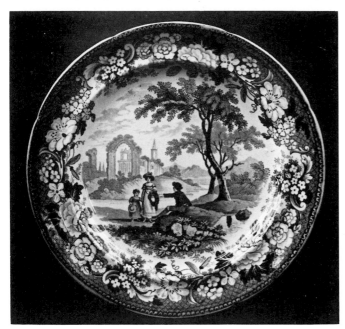

"Beeston Priory, Norfolk." *Maker unknown. "Antique Scenery" Series. Printed titles mark. Plate 8¾ ins:22cm.*

was entitled "Triumphal Car" (qv). The firm also produced wares printed with a portrait of Jenny Lind, the Swedish singer who aroused great enthusiasm in Britain after her first appearance in London in 1847 (Ill: Godden I 39).

Bell Tower

Herculaneum. A rather romantic-looking scene in which a bell tower surmounted by a small pennant is a prominent feature. Although untitled, it could well have been copied from a contemporary print. Examples of the pattern are known with the impressed name "HERCULANEUM" in the shape of a horseshoe.

"Bellagio, Lago di Como"

Copeland & Garrett. Byron Views Series. Dishes 9ins:23cm and 10½ins:27cm, and comport 11ins:28cm.

Bellagio is a popular resort on the promontory which divides the two arms of Lake Como in Italy.

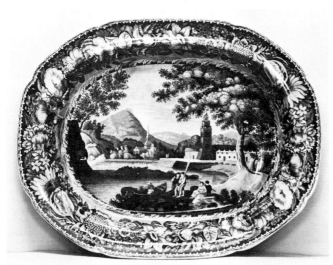

Bell Tower. *Herculaneum. Impressed maker's mark. Large dish.*

Belle Vue Pottery fl.c.1802-1841

Myton, Hull, Yorkshire. This pottery appears to have been operated until 1826 by partnerships which involved Job and George Ridgway, when it was taken over by William Bell. The works closed down in 1841. Printed wares sometimes bear printed or impressed marks with two bells and the name of the pottery. See J. Bartlett and D. Brooks, *Hull Pottery,* Kingston upon Hull Museums Bulletin, No. 5 (1972).

Belle Vue Views Series

A series of English and Scottish views produced by the Belle Vue Pottery, Hull. Items are also known in pink, purple and sepia, and examples have been recorded in combined colours. The views are titled in script between two ribbons, the lower one marked "BELLE VUE". The scenes include:

"Abbotsford, Sir Walter Scott's"
"Blytheswood on the Clyde" (sic)
"Cambusnethan on the Clyde"
"Carstairs on the Clyde"
"Durham Cathedral"
"Hinchingbrooke, Huntingdon"
"Lee House on the Clyde"

"Bellinzona"

Henshall & Co. Fruit and Flower Border Series. Dish 15ins:38cm.

Bellinzona is in the Swiss canton of Ticino and commands the route from the St. Gotthard Pass into Italy.

"Belsay Castle, Northumberland"

Enoch Wood & Sons. Grapevine Border Series. Dish 9½ins:24cm.

Belsay Castle, near Newcastle, is described by Pevsner as "one of the most impressive castles in Northumberland". An early 17th century house adjoins the tower.

"Belvoir Castle." *Maker unknown. Passion Flower Border Series. Printed title mark. Soup plate 10ins.25cm.*

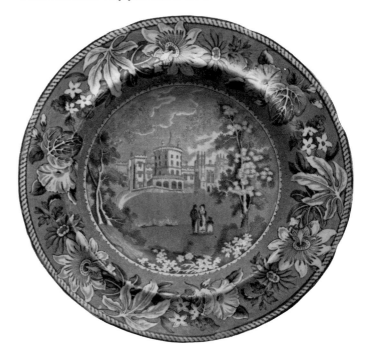

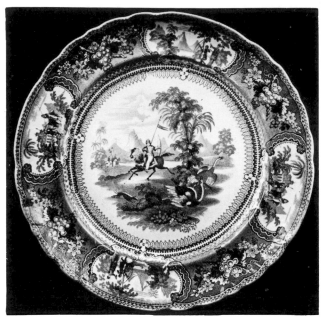

"Belzoni." *Enoch Wood & Sons. Printed title mark with maker's initials and the word "PATENT". Plate 10½ins:27cm.*

"Benigno Numine." *Arms of the Copeland and Yates families. Spode. Printed and impressed maker's marks. Dish 16½ins:42cm.*

"Belvoir Castle"

(i) Ralph Stevenson. Stevenson's Acorn and Oak Leaf Border Series. Plate and soup plate, both 10ins: 25cm.

(ii) Enoch Wood & Sons. Grapevine Border Series. Plate 7½ins:19cm.

(iii) Maker unknown. Passion Flower Border Series. Plate and soup plate, both 10ins:25cm.

"Belvoir Castle, Leicestershire, Duke of Rutland's Seat"

Careys. Titled Seats Series. Plate and soup plate, both 10ins:25cm.

"Belvoir Castle, Rutlandshire"

Maker unknown. Flower Medallion Border Series. Plate 8½ins:22cm.

Several castles have been built on this hill site since the 11th century. The one depicted on the wares was built by James Wyatt for the fifth Duke of Rutland between 1808 and 1813, and completed in 1816 after Wyatt's death. During 1816 a fire partly destroyed the new castle which was restored by 1830.

It has been the home of the Dukes of Rutland since the reign of Henry VIII. The castle is open to the public on certain days in the summer.

"Belzoni"

Enoch Wood & Sons. Complete dinner and tea services were produced using this generic title for a series of hunting scenes. Most examples include hunters on horseback using bows and arrows and carrying pennants. The scenes are printed within a border of medallions containing figures, mostly mounted, separated by bunches of grapes and flowers. The patterns are also known in other colours. The printed title cartouche includes initials E.W. & S. and also the word "PATENT". Ill: P. Williams pp.98-99 (four examples).

The title is difficult to explain. It is almost certainly a reference to Giovanni Battista Belzoni (1778-1823), an Italian who settled in England in 1803. He was a keen traveller and Egyptologist and was the organiser of an exhibition of antiquities held in London in 1821. However, this fact would not seem to be directly relevant to these designs which appear to be of a somewhat later date.

"Benigno Numine"

Under propitious influence. A motto used by several families including the Copelands, associated for very many years with the famous Spode factory.

A blue-printed dish decorated with the coat-of-arms of William Taylor Copeland conjoined with those of the Yates family is illustrated with the border from the Geranium pattern. This marked Spode piece was probably part of a dinner service made on, or shortly after, the marriage of William Taylor Copeland to Sarah Yates in 1826 or 1827. The same arms can be seen on a covered china cup in Whiter 169.

See: Armorial Wares.

Bentley, Wear & Bourne fl.1815-1822

Engravers and printers. Vine Street, Shelton, Staffordshire.

The firm engraved copper plates for printed wares. The full name appears on plates made by C.J. Mason & Co. Ill: Coysh 2 55; Little 39. In 1822 Bourne left the partnership and the firm became Bentley & Wear.

Bentley & Wear fl.1822-1833

This partnership followed Bentley, Wear & Bourne and was dissolved in 1833. A new partner was involved very briefly and soon took over the firm which became Wilding & Allen (qv).

"Berkley Castle, Gloucestershire" (sic)

William Adams. Flowers and Leaves Border Series. Vegetable dish.

Berkeley Castle is over eight hundred years old and was the scene of the murder of Edward II in 1327. It is open to the public in the summer.

"Berlin Roses"

Maker unknown. This title has been noted in an ornate cartouche mark on Stone China teawares with gadrooned edges. The printed mark is surmounted by a heraldic lion.

"Berlin Wreath"

John Ridgway.

"Bertie's Hope"

This pattern on a jug shows a boy, seated on a large bale, watching a three-masted ship at sea. There is a border of anchors. A rope cartouche encloses the title with the initials A.B. & Co. beneath. This initial mark was used by Allman, Broughton & Co. of Burslem (fl.1861-68) and Alexander Balfour of Glasgow (fl.1874-1904).

The only well known 'Bertie' at the period when this jug was made was Edward, Prince of Wales, but he was already a man in his thirties. Bertie is also a family name but it would seem to have been used as a christian name in this context.

Bevington, T. & J. (& Co.) fl.1817-1824

Cambrian Pottery, Swansea, Wales. Timothy and John Bevington were father and son. For several years, after working for Dillwyn & Co., they were partners in the firm, and in 1817 they rented the works and formed their own company with other partners. From 1821 they carried on alone until 1824. An impressed mark "BEVINGTON & CO SWANSEA" has been noted on blue-printed wares.

See: Swansea's Cambrian Pottery.

"Bertie's Hope." Rope cartouche with title and maker's initials (probably Alexander Balfour & Co.).

"Bertie's Hope." Probably Alexander Balfour & Co. Printed title mark with maker's initials. Two sides of a jug. Height 8½ ins: 22cm.

THE STAG

The Bewick Stag. *Source print in the form of a woodcut titled "The Stag" by Thomas Bewick from "A General History of Quadrupeds".*

The Bewick Stag

Maker unknown. A pattern found on dinner wares featuring a very prominent stag as the central design. Behind are three smaller stags and in the background the land rises steeply to a castle. The border is made up with several other animals including a squirrel, a horned sheep and a bull.

The central stag is based on a woodcut by Thomas Bewick from his *General History of Quadrupeds* (1790). The same source was used for some, if not all, of the animals in the border.

Bewick, Thomas 1753-1828

Thomas Bewick was apprenticed to the Newcastle engraver Ralph Beilby at the age of fourteen. He developed a particular skill at engraving wood blocks for illustrations in books and received a prize for his efforts from the Society for the Encouragement of the Arts. He spent a short time in London following the completion of his apprenticeship but soon returned to Newcastle where he set up in partnership with his old employer. He developed the art of wood engraving and became its foremost exponent.

It is perhaps natural that some of Bewick's work should have been copied by the potters for use on printed wares. Many animal and bird patterns were derived from two particularly famous books: *A General History of Quadrupeds* (1790) and *A History of British Birds* (1797-1804). At least one pattern, with a design of Kite-Flying (qv), was copied from one of the celebrated Bewick tail-pieces.

"Bickley, Kent"

(i) John & Richard Riley. Large Scroll Border Series. Sauce tureen.

(ii) Enoch Wood & Sons. Grapevine Border Series. Plate 5½ins:14cm.

The gatehouse at Bickley Hall was originally constructed as a water tower for the use of the estate.

"Biddulf Castle, Staffordshire" (sic)

Maker unknown. "Antique Scenery" Series. Soup plate 10ins: 25cm.

The Bewick Stag. *Maker unknown. Unmarked. Dish 16¾ins:43cm.*

"Biddulph Castle, Staffordshire"

Ralph Hall. "Select Views" Series. Plate 10ins: 25cm. Ill: Coysh 1 45.

Biddulph Castle, of which little remains, was an Elizabethan mansion sacked in the Civil War. It is now referred to as Biddulph Old Hall, which is strictly a late 17th century house attached to the old castle.

Bidet

Several bidets have been recorded including marked examples by Clews, Spode and Wedgwood. They were made to fit into wooden stands and had a metal drain plug at one end. The decoration was restricted to the inside. An example by Clews with an American view is illustrated in Arman 1j, p.12.

"Biddulf Castle, Staffordshire." *Maker unknown. "Antique Scenery" Series. Printed titles mark. Soup plate 10ins:25cm.*

Bird's Nest. *Dawson & Co. Teabowl and saucer. Impressed maker's mark on saucer. Diam. of saucer 4¾ins:12cm.*

Birds and Flowers. *Harvey. Impressed maker's mark. Plate 10ins:25cm.*

Birds and Willow. *Andrew Stevenson. Ornithological Series. Impressed mark: "Stevenson" above a three-masted ship. Plate 8¼ins:21cm.*

Bird Cages

Bird cages were featured by James & Ralph Clews on plates 10ins:25cm and 10¾ins:27cm in their "Zoological Gardens" Series. The design shows the bird cages at the London Zoo which was opened in 1828.

Bird Fountain

A title originally given by Coysh to a pattern on wares by Robert May with a prominent fountain. Ill: Coysh 2 56. This pattern is now known to have been titled simply "Fountain" (qv).

Bird's Nest

Dawson & Co. A pattern found on teawares which depicts a seated boy showing a bird's nest to a standing girl accompanied by her dog. Examples are known impressed either "DAWSON" or "DAWSON & CO." See illustration on previous page.

Birds and Flowers

Harvey. An untitled design of exotic birds amongst stylised flowers. There is no formal border but the design is framed by several simple sprays of flowers. See illustration on previous page.

"Birds and Fruits"

Lowndes & Beech. A pattern marked with the initials L. & B.

Birds of Prey

A title used for the pattern on a dish 19ins:48cm in the Ornithological Series by Andrew Stevenson. Ill: Coysh 2 109.

Birds and Willow

A title used for the pattern on a plate 8¼ins:21cm in the Ornithological Series by Andrew Stevenson. This is the only pattern which has so far been recorded marked with the maker's name. Ill: Coysh 2 105. See illustration on previous page.

Biscuit

Sometimes called bisque. A first firing of the clay body which, in the case of earthenwares, is usually carried out at a slightly higher temperature than the glost firing which fixes the glaze.

Bisham Abbey, Berkshire

A Davenport pattern illustrated in Coysh 1 31 with the attributed title Tudor Mansion. It probably shows Bisham Abbey with its stepped gables. The design is also known in grey and in red.

Bisham Abbey lies seven miles east of Henley-on-Thames. The house was an abbey for only three years from 1537 to 1540. After the Dissolution it was granted to Sir Philip Hoby in 1553.

"Black Swan"

Don Pottery. This printed name appears on the bases of a pair of small oval pots decorated inside with the border from the Named Italian Views Series.

It may be that they were made for the Black Swan coaching inn at Helmsley in Yorkshire.

Blackwell, John & Andrew fl.c.1802-1818

Cobridge, Staffordshire. A partnership stated to have made blue-printed wares. See: Little p.50.

"Blaise Castle, Gloucestershire"

William Adams. Flowers and Leaves Border Series. Plate 5¾ins:15cm.

Another view of this castle was made in the Minton Miniature Series under the title "Entr. to Blaize Castle" (sic).

Blaise Castle is an 18th century house near Bristol which is now a museum. It is open to the public in the afternoon throughout the year.

"Blenheim, Oxfordshire"

(i) William Adams. Flowers and Leaves Border Series. Plate 10¼ins:26cm. Ill: Coysh 2 4.

(ii) Henshall & Co. Fruit and Flower Border Series. Plate and soup plate, both 10ins:25cm.

(iii) Maker unknown. Foliage Border Series. Plate and soup plate, both 10ins:25cm. Ill: Laidacker p.41.

Blenheim Palace was built as a national monument. Queen Anne presented the funds for the building to John Churchill, Duke of Marlborough, as a token of gratitude from the nation for his defeat of the French at Blenheim in 1704. The architect was John Vanbrugh who produced a great baroque palace.

"Black Swan." Don Pottery. Named Italian Views Series. Printed mark of a tavern or inn and an impressed star. Pair of deep oval pots. Length 3½ins:9cm.

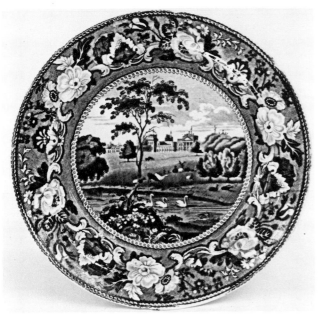

"Blenheim, Oxfordshire." William Adams. Flowers and Leaves Border Series. Printed title mark and impressed maker's eagle mark. Plate 10¼ ins:26cm.

Blue Rose. Spode. Printed mark "Spode's Imperial". Circular gadrooned stand. 7½ ins:19cm.

Blind Boy

John & William Ridgway. An attractive rural scene which shows a woman holding the hand of a boy seated on a basket with a dog at their feet. Ill: P. Williams p.726.

One example, a tureen, has been recorded with the rare impressed lower case mark "Ridgway". The attribution of this mark to John & William Ridgway is discussed elsewhere.

See: Ridgway; Angus Seats Series.

Blistering

Sometimes bubbles remain in the glaze when it is hardening. This is due to escaping gas when the firing of the glost furnace is badly controlled. If these bubbles burst they give rise to imperfections in the glaze.

"Blossom"

David Methven & Sons. A floral design used on toilet wares.

Blücher, G.B. von 1742-1819

A Prussian field-marshall who marched with his troops to the assistance of Wellington at Waterloo and by his intervention turned the defeat of the French into a headlong rout. His name and portrait appear on wares made to commemorate Wellington's victory at the famous battle.

Blue Bamboo

Wedgwood. This is one of the earliest patterns used at Etruria and was introduced in 1805. Blue Bamboo is known to be the factory name though it was referred to by Coysh as the Chinese Vase pattern, reflecting the central feature of the design. The vase is decorated with a seated figure playing a stringed instrument and stands on a plinth amongst clumps of bamboo. There is a prominent flower to the right of the vase. The central pattern is framed by wide, fence-like stringing and there is a border of leaves and flowers. Ill: Coysh 1 133.

Blue Birdcage

A name used for a Wedgwood design introduced in 1829 and used on moulded wares.

Blue Claude

Wedgwood. A pattern engraved by Thomas Sparkes showing a harbour scene with classical buildings after Claude Lorraine. It dates from 1822. (See Colour Plate XV.) Ill: Coysh 2 124; Little 73.

Blue Pheasants

G.M. & C.J. Mason. A widely accepted name for a pattern used on Patent Ironstone China and found on both dinner and dessert wares. It shows two exotic birds, presumably pheasants, perched amongst large flowers, the most prominent of which appear to be peonies. The border is a development of the earlier chinoiserie-type borders with various flowers superimposed on scrolls and with different geometric grounds. A rare complete supper set decorated with this pattern is illustrated by Godden in *Mason's Patent Ironstone China*, 84. Versions are known clobbered with overglaze enamels. Ill: Coysh 1 59; Little 38; P. Williams p.100. The same border can be found on a special order dinner service with a central view of King's College Chapel, Cambridge (qv).

Blue Rose

A Spode floral pattern. Ill: Whiter 55.

This name is also widely used to describe a border pattern introduced by Wedgwood.

Blue Rose Border

A border which was introduced by Wedgwood in 1824 for use with a series of views known within the factory as the Landscape patterns. The border consists of a series of prominent roses together with dark leaves superimposed on a stippled light blue ground. The central views are framed with the irregular edge of the border, there being no inner stringing. A very similar border was used by Thomas Mayer on the "Cattle Scenery" pattern, by Ralph Stevenson & Williams on the "Pastoral" pattern, and by an unknown maker on a series of named views listed as the Light Blue Rose Border Series. It is also possible that some of the marked Wedgwood patterns with this border are by Podmore, Walker & Co. Ill: Coysh 2 125.

Blue Rose Border Series

A series of landscape views made by the Wedgwood factory from 1824 and used over a long period. The central scenes appear to include some Italianate views and some scenes of British origin, two of which have been positively identified. The items noted to date are:

(i) A view of The Rookery, Surrey, found on a dish and a drainer. Similar views were made by Adams and Riley.

(ii) A view of Kirkstall Abbey, found on a dish. This is a copy in reverse of a view in the "Antique Scenery" Series by an unknown maker.

(iii) A harbour scene found on a soup plate. This design has a prominent sailing ship and in the background is a volcano, possibly Mount Etna. Ill: Coysh 1 136 (as the Sicilian pattern).

(iv) A river scene found on a dessert plate. There is a boat on the river and a man fishing from the near bank. In the background is a house with a roof of projecting tiles. Ill: Coysh 2 125.

(v) An estuary scene found on a dinner plate. There is a country house in the background and a horseman, woman and dog in the foreground.

(vi) A country house and river scene found on a tea plate. There is a curved wall running from the house to the river bank and a boy is leaning over the wall to fish in the river. A woman and girl stand beside him. See below.

(vii) A scene with a river and church with tower.

This series was generally marked with the impressed name "WEDGWOOD". Earlier examples tend to have a pair of impressed letters such as GG or HH. The later wares can often be recognised by the presence of impressed date marks in the form of three letters in a group.

See: The Wedgwood Factory.

Bluebell Border Series. *William Adams. Typical printed mark with impressed maker's crown mark. This printed mark was also used by James & Ralph Clews, but inverted.*

Bluebell Border Series

An identical border with prominent bluebell flowers was used by both William Adams and James & Ralph Clews on topographical scenes. As a general rule the Adams pieces are printed in a rich dark blue whereas Clews used a much softer medium blue. With the exception of "St. Mary's Abbey, York" no view was used by both potters, and even this one exception was used on different articles. In this dictionary the term Bluebell Border is only used in association with the name of the relevant potter. The two potters used a similar mark with an oval frame decorated with small flowers and leaves. The Adams version is illustrated. The Clews version has the cartouche inverted.

The list of vews used by William Adams is as follows:
"Bamborough Castle, Northumberland"*
"Beckenham Place, Kent"
"Bothwell Castle, Clydesdale"
"Branxholm Castle, Roxburghshire"
"Brecon Castle, Brecknockshire"
"Bywell Castle, Northumberland"
"Caister Castle, Norfolk"
"The Chantry, Suffolk"
"Dilston Tower, Northumberland"
"Hawthornden, Edinburghshire"
"Jedburgh Abbey, Roxburghshire"
"Ludlow Castle, Salop"
"Lyme Castle, Kent" (sic)
"Melrose Abbey, Roxburghshire"
"Morpeth Castle, Northumberland"
"St. Mary's Abbey, York"
"Scaleby Castle, Cumberland"
"Windsor Castle, Berkshire"*
"Wolvesey Castle, Hampshire"
Bluebell Border views used by James & Ralph Clews include:
"Dunfermline Abbey, Fifeshire"
"Dulwich Castle"
"Fonthill Abbey, Wiltshire" (distant view)
"Fonthill Abbey, Wiltshire" (near view)*

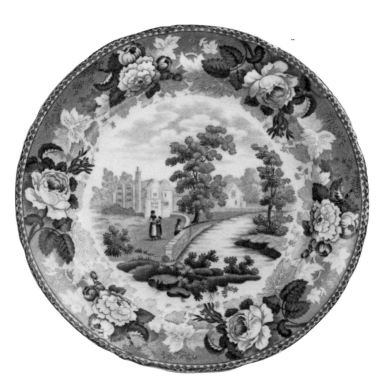

Blue Rose Border Series. *Wedgwood. Unidentified view. Impressed maker's mark. Plate 6½ ins: 16cm.*

"Gloucester Cathedral"
"Lumley Castle, Durham"
"Palace of Linlithgow, West Lothian"
"Remains of the Church, Thornton Abbey"
"Rothesay Castle, Buteshire"
"St. Mary's Abbey, York"
"Stratford-on-Avon, Warwickshire"
"Tintern Abbey, Monmouthshire"
"Warkworth Castle, Northumberland"
"Wells Cathedral"

"Blytheswood on the Clyde" (sic)
Belle Vue Pottery. Belle Vue Views Series. Dish 12½ ins:32cm. Ill: Laidacker p.19.

Blythswood House was built by James Gillespie Graham for Sir Archibald Campbell, Bart. in about 1820. It was demolished in 1929.

Body
The composite material from which the potter's clay is made. It may contain a mixture of several types of clay together with non-clay materials such as ground flint, sand or stone.

"Bohemia"
J. & M.P. Bell & Co. A scene with classical buildings and a lake. In the foreground a couple dance to music played by a man with a mandolin or similar stringed instrument.

Bohemia is now a province in the west of Czechoslovakia. It forms the most important part of the country and includes the capital Prague.

"Bologna"
(i) William Adams & Sons. A series of romantic scenes showing gondolas within a border of scenic and floral vignettes on a geometric ground, known also in pink and purple. Ill: Laidacker p.11; P. Williams p.201 (two examples).
(ii) Copeland & Garrett. Byron Views Series. Plate 10ins:25cm, comport and pierced stand. Ill: FOB 15.

Bologna lies at the foot of the Apennines in Italy, twenty-two miles south east of Modena. It was noted in the 19th century for its trade in silks and velvet. Almost all travellers on the Grand Tour spent time in the city.

Bolton, James & Fletcher fl.c.1797-1812
Warrington, Lancashire. Jewitt states that the output of this pottery included blue and white printed wares. The firm depended largely on an export trade to America which ceased with the war of 1812 when the works closed. According to Little very few wares appear to have been marked.

Boon, Joseph fl.c.1784-1814
Shelton and Hanley, Staffordshire. Two brief partnerships included Boon & Ridgway (1802-5) and Boon & Hicks (1805-8). Thereafter he potted on his own.

Boote, T. & R. fl.1842-1906
Waterloo Pottery, Burslem, Staffordshire. Blue-printed wares were made by this firm, including flown-blue pieces. The Waterloo Pottery closed in 1906.

Borders
Pictorial patterns and some general designs on flatware needed to be framed. In most cases the flattened rim of a plate or dish provides a suitable surface for the purpose. In the early chinoiseries geometrical motifs and Chinese symbols were combined to form a border, often closely following the Chinese prototype. By about 1810, floral borders, said to have been derived from contemporary wallpaper patterns, became popular and have persisted even to the present day. Distinctive borders were designed to go with each dinner service, regardless of whether the wares carried a single pattern or a series of patterns. Indeed, makers seem to have tried to ensure that their borders were not pirated by other makers, regarding them as a kind of trade mark. However, since there were no copyright restrictions until 1842 this was not always possible and both patterns and borders were sometimes copied. It is unwise, therefore, to attribute unmarked wares to a particular maker solely because the border is known to have been used by a maker who marked his wares, though a border can be a

"Bologna." *Source print for the Byron Views Series taken from Finden's "Landscape and Portrait Illustrations to the Life and Works of Lord Byron".*

"Bologna." *Copeland & Garrett. Byron Views Series. Printed title and maker's mark and impressed maker's mark. Plate 10ins:25cm.*

Boston State House. *Rogers. Impressed maker's mark. Stand 10ins:25cm, pierced basket 9¾ ins:25cm.*

useful pointer. A Bluebell border was used by William Adams, but was also used on a similar series by James & Ralph Clews. An unknown maker used an Acorn and Oak Leaf border which is almost indistinguishable from Ralph Stevenson's Acorn and Oak Leaf border.

Borders are often separated from the central pattern by a line of stringing, so providing an obvious and separate frame. In some cases, however, the borders and views are merged. Trees in the border hang over buildings in the view. Sometimes it almost seems that one is viewing a landscape through a gap in woodland or from the mouth of a cave. Such borders are sometimes known as grotto borders.

"Boreham House, Essex"
Andrew Stevenson. Rose Border Series. Plate 6ins:15cm, and cup plates.

Boreham House was built in 1728 by James Gibb for Benjamin Hoare. It was altered in 1812 by Thomas Hopper who redesigned the wings and laid out impressive carriageways.

"Borneo"
Holland & Green. A scene of a tiger hunt with elephants within a border which includes animal medallions. The printed title appears in a scroll cartouche.

"Bosphorus"
(i) John Hawley & Co. A design used after 1889 by Barkers & Kent, probably from purchased copper plates.
(ii) J.T. Hudden. A mosque scene within a medallion border.
(iii) James Jamieson & Co. Another mosque scene but with a border of flowers and leaves. Ill: Coysh 2 9; P. Williams p.101.

"The Bosphorus"
(i) Thomas Fell & Co. A scene with a gondola-like boat and classical buildings. Ill: Bell, *Tyneside Pottery,* p.60.
(ii) Ralph Hall & Co. A lady sits in a boat which is punted on a lake by a man wearing a turban. The border includes distinctive ears of barley. This design was also printed in lavender. Ill: P. Williams p.202.

The Bosphorus, also spelt Bosporus, is a narrow channel joining the Black Sea to the Sea of Marmora. Together with the Dardanelles it separates Europe from the area once called Asia Minor, now the Near East. The name Bosporus means 'ox ford'.

"Boston Mails"
James & Thomas Edwards. A series of patterns registered on 2nd September, 1841 which show various cabin scenes aboard steamships. The central scenes bear titles such as "Gentlemen's Cabin" and "Saloon". The border consists of medallions which feature four steamships titled "Acadia", "Britannia", "Caledonia" and "Columbia". The printed mark shows another steamship with the title "BOSTON MAILS" above and the name "EDWARDS" below. Examples are recorded in blue, black, brown and purple and combined colours are also known. Ill: Arman 563; Godden I 261; P. Williams pp.475-476 (three examples).

Boston State House
An export pattern by John Rogers & Son. This firm did not compete with the major Staffordshire exporters in the North American trade but confined themselves to this single view which was made on complete dinner services. It is included here since it appears to have been sold on the home market and also in Italy. Items are not uncommon in Britain. Ill: Arman 442; Coysh 1 94; Little 55.

"Botanical Beauties"
Elkin & Newbon. A series of patterns with stylised flowers as a central motif within a border of flower sprays on a stippled ground.

Items with the same title have been recorded on wares with the impressed mark "TURNER" and with the printed initials C.R. & S. and on other items with the initials R. & D. Neither of these initials have been identified. The first of them, C.R. & S., are known on other patterns and have been seen on marked Davenport wares so they may relate to a retailer rather than a potter.

Botanical Magazine
William Curtis (1746-99) of Alton, Hampshire, was apprenticed to his grandfather, an apothecary surgeon. He moved to London and acquired his own practice which he later sold to devote his life to the study of natural science. In 1787 he started *The Botanical Magazine* which was the source of many of the prints used by Wedgwood for their Botanical patterns.

"Botanical Beauties." *Elkin & Newbon. Printed title mark with maker's initials. Plate 10½ ins:27cm.*

Botanical Patterns. *Spode. Botanical Series. Printed and impressed maker's marks. Drainer 12¾ ins:32cm.*

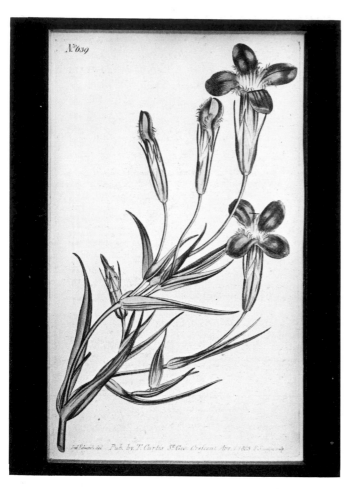

Botanical Patterns

Two major series of botanical patterns were produced by Spode and Wedgwood.

The Spode series consists of sprays of flowers against an all-blue background within a matching floral border. Examples are also known in green and pink. Ill: Coysh 1 119-120; Whiter 54, 96. See illustration on previous page.

The Wedgwood Series was introduced in 1810 and reflected the personal horticultural interests of John Wedgwood. The prints were mainly adapted from William Curtis' *Botanical Magazine* (qv) and have a very simple border of interlacing ovals. See: Coysh 2 120-121. Prints on the earlier issues often bear small numbers by the base of the flower stems, the highest so far noted being 47. They were probably used as identification marks for the various species shown. A later series with a border of convolvulus used the same central prints. See: FOB 17.

"Bothwell Castle"

John Meir & Son, "Northern Scenery" Series.

"Bothwell Castle, Clydesdale"

William Adams. Bluebell Border Series. Dish 11½ ins:29cm, and vegetable dishes.

Bothwell Castle lies eight miles east of Glasgow, close to the River Clyde. It was founded in the 14th century and still presents imposing ruins. The name is now used for an unpretentious Queen Anne mansion.

Botanical Patterns. *Source print for the Wedgwood Botanical Series taken from Curtis's "Botanical Magazine" (1803).*

Botanical Patterns. *Wedgwood. Botanical Series. Impressed maker's mark. Plate 8ins:20cm.*

Botanical Patterns. *Wedgwood wares, all with impressed maker's marks. Oval stand 8ins:20cm; dessert dish 7ins:18cm; shell dish 13¼ins:34cm; plate 9¾ins:25cm; covered dish 9ins:23cm.*

Bottle Kiln

Until relatively recent times when the electrical furnace was introduced, pottery was fired in bottle shaped kilns, a characteristic sight in pottery towns. The centre of the kiln was stacked with wares, mainly in saggars, or cases made of fireclay. The fires were placed round this central area and gases and smoke escaped through the neck of the bottle. Wares were heated in the bottle kiln for up to three days before they

POTTERY

Vertical Section.

Bottle Kiln. *Cross-section of a typical bottle kiln used to fire earthenware. Print from a book dated 1814.*

attained the biscuit state. Operation of the kilns was a very skilled job. Different effects could be obtained by utilising the differing heats achieved at the top or the bottom of the stacked wares. Incorrect firing could destroy thousands of pieces.

"Boughton House, Northamptonshire"
Ralph Hall. "Select Views" Series. Dish 13ins:33cm.

Boughton House, three miles north of Kettering, is a Tudor monastic building enlarged around seven courtyards in the French style. It is open to the public in the summer.

Bourdaloue
A toilet vessel made to be carried by ladies against an 'emergency' during a long church service. The name comes from that of a French Jesuit preacher, Louis Bourdaloue (1632-1704), noted for his long sermons. See: N. Mitford. *The Sun King* (1966), p.71.

Bourdaloues were also used on long coach journeys. In the 19th century they were called 'coach pots' or, in the age of the crinoline, 'crinoline slippers'. An example bears the title "Parisian Basket" with the initials C. & R. which may refer to Chesworth & Robinson or Chetham & Robinson.

Bourne, Baker & Bourne fl.c.1818-1840
Fenton, Staffordshire. This firm operated two potteries in Fenton. A large jug (28ins:71cm high) in the Victoria and Albert Museum decorated with the "Wild Rose" pattern was made for the London retailers Bailey, Neale & Co. of St. Paul's Church Yard.

Bourne, William fl.c.1804-1818
Bell Works, Burslem, Staffordshire. This firm is said to have made large quantities of blue-printed ware (Little p.51). No marked pieces have been recorded.

Bovey Tracey Pottery Co. fl.1842-1894
Bovey Tracey, Devon. Previously known as the Folly Pottery, these works were run by two partners named Buller and Divett. Jewitt states that blue-printed wares were amongst their products which were "principally supplied to the home markets in the West of England and to Mediterranean ports". It is quite possible that the firm made naval mess plates since many examples are known with the mark of their successors, the Bovey Pottery Co. Ltd. The firm used the initials B.T.P. Co. printed or impressed.

"Bow Bridge"
Goodwins & Harris. "Metropolitan Scenery" Series. Plate 8¾ins: 22cm.

Bow Bridge, between Whitechapel Church and Stratford, crossed the larger streams of the River Lea which split here into several courses

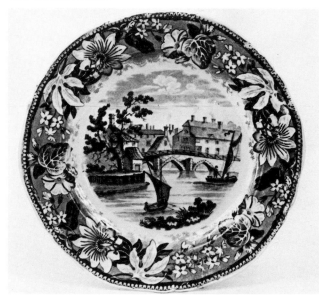

"Bow Bridge." *Goodwins & Harris. "Metropolitan Scenery" Series. Printed titles mark. Plate 8¾ins:22cm.*

Bourdaloue. *Chesworth & Robinson or Chetham & Robinson. "Parisian Basket" pattern. Printed title mark with maker's initials. Length 10¼ins:26cm.*

Boy Piping. *Maker unknown. Unmarked. Plate 9¾ ins:25cm.*

Bowpot
Spode. A floral pattern with three decorative vases, introduced c.1812. Enamelled versions are known. Ill: Whiter 42.

Boy Piping
Maker unknown. A name used for a scene in which a boy is seated beneath a tree playing a pipe to his sheep. A basket and a shepherd's crook lie in the foreground. The border is of heartsease and primroses.

Boyle, Zachariah (& Son) fl.1823-1850
Hanley and Stoke, Staffordshire. In 1828 Boyle formed a partnership with his son. Marks may include the full surname "BOYLE" or the initials Z.B. (until 1828) or Z.B. & S. (after 1828). Zachariah died in 1841 and the business was then continued by his son. The printed mark "Boyle & Son, Stoke, Manufacturers" has been reported on blue-printed wares by Little, p.52. He also illustrates a plate with the impressed "BOYLE" mark bearing the well-known Spode Italian pattern (Little 13).

Boys Fishing
Brameld. A pattern showing boys fishing which has been noted on toilet wares. It is shown on a washbowl and a dog dish. It can also be seen on a toothstick box in Lawrence p.52 and on a mug in Little 100.

See: Dog Dish.

"Bradfield"
Henshall & Co. Fruit and Flower Border Series. Plate and soup plate, both 8ins:20cm.

There are a number of villages and hamlets which bear this name. It has not yet proved possible to identify the scene with any certainty.

"Bramber Church, Sussex"
Ralph Hall. "Select Views" Series. Sauce tureen.

The church of St. Nicholas at Bramber was intended as a chapel to the castle. It started as a Norman building, was used as a base for attacking the castle in 1642, and was roughly restored in the late 18th century.

Boys Fishing. *Brameld. Impressed maker's mark. Washbowl diam. 14ins:36cm, depth 5ins:13cm.*

"Bradfield." *Henshall & Co. Fruit and Flower Border Series. Printed title mark. Soup plate 8ins:20cm.*

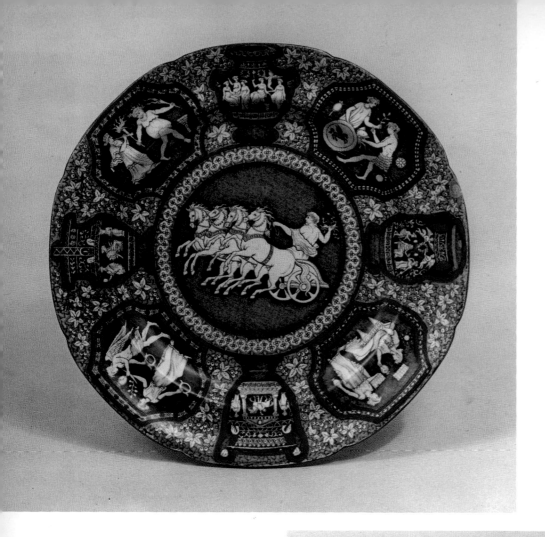

Colour Plate III. Clobbering. *Plate by Spode printed with the Greek pattern. The design is clobbered with red enamel. Impressed maker's mark and red-painted No. "1310". Diameter 9¾ ins:25cm.*

Colour Plate IV. Clobbering. *Soup plate with a view of "Powder Mill, Hastings" from the Beaded Frame Mark Series. The border is clobbered with pink, orange, green and yellow enamels. Printed title mark. Diameter 9¾ ins:25cm.*

Brameld & Co. fl.1806-1842

Swinton Old Pottery, near Rotherham, Yorkshire. This pottery was operated by the Leeds firm of Hartley, Greens & Co. from 1787 to 1806 when it was taken over by John Brameld and his son William who had been associated with the Leeds owners. From 1826 it was known as the Rockingham Works and this name was used on porcelains from that date. The most notable printed patterns were the "Don Quixote" Series used on dinner services in blue, green and black, the Returning Woodman, and a titled view, "Castle of Rochefort, South of France". Several floral patterns were made, generally rather undistinguished.

The Bramelds exported considerable quantities of both earthenware and porcelain to the Baltic and other European countries. It was due to a failure in obtaining payment for large consignments to Russia that the firm found it necessary in 1826 to appeal to Lord Fitzwilliam for further funds in order to avoid bankruptcy.

See: Plus Marks.

"Bramham Park, Yorkshire"

William Adams. Flowers and Leaves Border Series. Plate 8ins:20cm.

Bramham Park, five miles south of Wetherby, was built by Lord Bingley in the Italian style in 1698. The famous garden and grounds were probably laid out at the beginning of the 18th century. The grounds, garden and house are open to the public in the summer.

"Brancepeth Castle, Durham"

Enoch Wood & Sons. Grapevine Border Series. Dish 19ins:48cm. Ill: Laidacker p.93.

The castle, once the seat of Viscount Boyne, is four miles south west of Durham.

Brandon, D.

Wares have been noted with the printed mark "Manufactured for D. Brandon, Kingston, Jamaica". Two printed plates bearing this mark and portraits of Queen Victoria and Prince Albert are illustrated in May 99-100.

"Branxholm Castle, Roxburghshire"

William Adams. Bluebell Border Series. Plate 7ins:18cm. Ill: Moore 63.

According to earlier writers, this view is always mismarked "Melrose Abbey, Roxburghshire" and vice versa, presumably due to an engraver's error.

The castle was an early stronghold of the Barons of Buccleuch. It is the scene of the principal incidents of Walter Scott's *Lay of the Last Minstrel* (1805).

Brecknock

A meat dish with a pattern entitled "View of Brecknock" was included in the "Diorama" series by an unknown maker. Brecknock lies at the confluence of the Rivers Hoddey and Usk. It is known today as Brecon and is the county town.

"Brecon Castle, Brecknockshire"

William Adams, Bluebell Border Series. Plate 9ins:23cm.

Brecon Castle was built by Newmarch with materials taken from the Roman camp at Gaer. Today it is an ivy-clad ruin.

"Bretton Hall, Yorkshire"

John & Richard Riley. Large Scroll Border Series. Dish 17ins:43cm.

An early 18th century house built for Sir William Wentworth. It was completely remodelled in 1815 for Colonel Beaumont and a porch with four Doric columns was added. This is seen in the view on the dish.

"Bretton Hall, Yorkshire." *John & Richard Riley. Large Scroll Border Series. Printed title mark with maker's name. Dish 17ins:43cm.*

"Bride of Lammermoor." *Davenport. "Scott's Illustrations" Series. Printed titles mark and impressed maker's anchor mark for 1856. Dish 16½ins:42cm.*

"Bride of Lammermoor"

Davenport. "Scott's Illustrations" Series. Dish 16½ins:42cm. Ill: P. Williams p.520.

A dark blue saucer by an unknown maker also bears this title printed beneath the design. See Laidacker p.118.

The Davenport design is based on Edwin Landseer's "Ravenswood saving Sir William Ashton and Lucy from the Wild Bull" (1830) and was probably taken from a print published by Robert Cadell in the Magnum Opus edition of Scott's works (1829-33).

Bridge of Lucano

This is best known as a Spode pattern. According to S.B. Williams and Whiter this view is based upon an engraving in Merigot's *Views of Rome and its Vicinity* (1796-98). On close examination, however, the resemblance is slight. It corresponds much more closely to a print entitled "The Tomb of Plautius Lucanus" engraved by A.H. Payne after a painting by H. Bibby. This was published by Brain & Payne of 12

Bridge of Lucano. *Spode. Impressed maker's mark. Plate 9½ins:24cm.*

Bridge of Lucano. *Printed title mark on a plate by an unknown maker. The pattern is identical in every respect to the Spode design.*

Paternoster Row, London but the print is not dated. The view was used by a number of potters:

(i) Bathwell & Goodfellow.

(ii) Dillwyn & Co. Second Period, 1823-1831. Ill: Nance LX(A).

(iii) Pountney & Allies.

(iv) Spode. Ill: Coysh 1 105; Whiter 68.

(v) Maker unknown. This is the only version which bears a title. It is marked "Bridge of Lucano, Italy" on a ribbon surmounted by a crown.

"The Bridge of Martoviele"
Henshall & Co. Fruit and Flower Border Series. Dish 19ins:48cm.

It has not proved possible to locate this scene with certainty. It could well be a bridge on the River Marta which flows into the Mediterranean about fifty miles north west of Rome.

Bridge and Pagoda
Careys. A late chinoiserie design with a castellated bridge and a three-storey pagoda with steps and a verandah. There are two prominent palm trees and a background of mountains. The border is of strip form with scenes based on the central pattern. The design was used on both pearlware and Careys' "Saxon Stone" body, the latter with a gadrooned edge. Ill: Coysh 2 15.

Bridge Pattern
Maker unknown. A dark blue pattern with the attributed title Bridge pattern is illustrated in Coysh 2 141. Despite being relatively common, no marked examples have been recorded.

Brighton
One of the views in the Shell Border Series by Enoch Wood & Sons is titled "The Beach at Brighton" (qv). Ill: Arman 141.

"Bristol"
Pountney & Allies/Pountney & Goldney. Bristol Views Series. Dish 20½ins:52cm, well-and-tree dish 24ins:61cm, drainer 14¼ins:36cm, bowl 9¾ins:25cm, washbowl and ewer.

This view was also used on a chamber pot* once owned, and presumably used, by a former Lord Mayor of Bristol.

"Bristol Hot Wells"
Pountney & Allies/Pountney & Goldney. Bristol Views Series. Well-and-tree dish and dish, both 18ins:46cm and drainer 13ins:33cm. Ill: Little 94.

Bristol Views Series
Two series, one of views near Bristol and the other of places on the course of the River Thames, were produced by Pountney & Allies and their successors Pountney & Goldney. Although the same border was used there is no evidence to suggest whether or not they were all from a single dinner service or from two separate services.

The views in the Bristol area include:

"Bristol"*

"Bristol Hot Wells"*

"Chepstow Castle"*

"Clifton"

"Clifton Rocks"*

"Cook's Folly"*

"Reach of the River Avon, Roman Encampments"

"St. Vincent's Rocks"

"View near Bristol, River Avon"*

In addition there is a view entitled "Temple House". There was a Temple House in Bristol and also on the Thames near Marlow; this view has tentatively been included in the "River Thames" Series (qv).

The view called simply "Bristol" shows the harbour, Redcliffe Church and the ship *David,* which belonged to the pottery proprietors. According to Pountney in *Old Bristol Potteries* "she was used for bringing to the pottery the Welsh coal, the Cornish and Dorsetshire (Poole) clay, and for taking pottery goods to Wales and South of England".

The view marked "Bristol Hot Wells" shows the River Avon with a prominent packet boat, and is taken from an aquatint published by E. Wallis of Skinner Street, Snow Hill, London (c.1823). The print was entitled "Bristol Hot-Wells, on the Avon, with steam packets". The packets shown on the

"Bristol." *Same view as above on a drainer 14¼ ins: 36cm.*

"Bristol Hot Wells." *Pountney & Allies/Pountney & Goldney.
Bristol Views Series. Unmarked. Drainer 13ins: 33cm.*

print were the *George IV,* a Bristol vessel which started a weekly
run to Ilfracombe and Cork in April 1822, and the *St. Patrick,*
an Irish vessel. The engraver omitted one vessel, the Bristol
packet, and retained the Irish ship.

It has also proved possible to identify the source for the
"View near Bristol, River Avon". It is based on a print
engraved by J. Storer after a drawing by F. Nicholson for *The
Beauties of England and Wales* by Britton & Brayley, published by
Vernon, Hood & Sharpe of Poultry, London in 1800.

See: "River Thames" Series.

Bristol Views Series. *Pountney & Allies/Pountney & Goldney.
Typical printed mark.*

Britannia

This British symbol appears on several patterns but most prominently on one by John Rogers & Son. Britannia is seated facing two flags, a girl, and some ships. The border includes a union wreath in which the thistle predominates. Ill: FOB 2.

A pattern in the "Etruscan" Series by Elkin, Knight & Bridgwood also shows the seated figure of Britannia. In this version she is in the company of three attendant maidens. Ill: Coysh 1 39.

British Cobalt Blue

A high quality blue pigment prepared for transfer printing by the British Cobalt Smelting Company. Amongst the potters known to have used it are James & Ralph Clews, Hicks & Meigh, John Mare, C.J. Mason, John Rogers & Son, Josiah Wedgwood and John Yates.

"British Flowers"

Edward & George Phillips. A series of fruit and flower designs printed on "Opaque China".

The title is also used for floral patterns produced at the Spode factory, although it is not marked on the wares. One of the centres used can also be found in the Spode Botanical Series.

"British Flowers." *Edward and George Phillips. Printed title mark with makers' name. Eight-sided dish.*

"British History" Series

This series by Jones & Son of Hanley is unique among British blue-printed wares and, as the firm was only in existence from c.1826 to 1828, may have been the only dinner service they made. The scenes from British history are framed in a border in which groups of military accoutrements alternate with a crown and mitre set against a union wreath. The elaborate printed mark consists of a Gothic screen with the series title above and the name of the individual scene below it. Against the screen rests a shield with the makers' name "JONES & SON". To the right is Britannia and to the left a young woman holding a scroll.

The scenes used include:
"Alfred as a Minstrel"
"Battle of Waterloo"
"Canute Reproving His Courtiers"*
"Caractacus Before Claudius"*
"Charles I Ordering the Speaker to Give up the Five Members"*

"Coronation of George IV"*
"Cromwell Dismissing the Long Parliament"*
"Death of General Wolfe"*
"Death of Lord Nelson"*
"Elizabeth Addressing the Troops"
"Hamden Mortally Wounded" (sic)*
"Interview of Wallace and Bruce"*
"Landing of Wm. of Orange"*
"The Seven Bishops Conveyed to the Tower"
"Signing of Magna Charta"*

One plate has been noted of lower than usual quality and of later appearance on which the printed cartouche had been modified to read simply "JONES". The item also bore an impressed cartouche mark with the wording "JONES/ SUPERIOR/STAFFORDSHIRE/WARE". This tends to suggest that the little known firm of Jones & Son was continued after 1828, still under the surname, but the subsequent history remains a mystery.

"British History" Series. *Jones & Son. Typical printed mark.*

"British Lakes"

A title known to have been used by at least two potters:
(i) C.J. Mason & Co. A series of named views in the Lake District within a floral border.
(ii) Ralph Stevenson & Son. Moore states that this firm "probably began a series of views of the English lake scenery, for one such view is found with a very ornate flower and scroll border. It is marked "British Lakes, R.S. & S." and is identified as Lake Windermere". Another example from the same series with an unidentified view is illustrated in P. Williams p.205.

"British Lakes" Series

A series of views in the Lake District by C.J. Mason & Co. The scenes are printed within a border of inner leafy tracery with an outer stippled ground. Examples bear a printed mark with "British Lakes" in script over a crown, beneath which are the words "NEW STONE CHINA", the name of the individual view, also in script, and the initials C.J.M. & Co. It appears that the initials are not always present and some doubt has been cast on the accuracy of the titles found on some pieces. The following views are known:
"Derwentwater"
"Elterwater"
"Loweswater"

"Thirlmere"
"Ullswater"
"Windermere"

"British Marine"

Maker unknown. This title appears on a printed mark with a ribbon surmounted by a rider on a prancing horse. It is a series title used on pictures of sailing ships and steamers, rowing boats, lighthouses, etc. The individual patterns are not titled. The border is of sea shells and roses and the edges of the wares are gadrooned. Ill: FOB 4, 25.

British Nankin

A term used for a body by Miles Mason of Lane Delph. It was advertised to "repair existing omissions in Oriental dinner services".

"British Palaces"

Maker unknown. This title has been noted in a floral cartouche mark which includes a crown. It is probably a series of patterns.

Laidacker (p.78) refers to "British Palaces" as a title on a plate (8½ins:22cm) in Ralph Stevenson's "Lace Border" Series (qv). P. Williams (p.206) illustrates a cup plate with the same title.

"British Rivers"

Shards with this title and with the initials A.M. for Andrew Muir have been recovered from the site of the Clyde Pottery at Greenock in Scotland. The pattern does not appear to have been used after 1840.

"British Scenery" Series

The series title "British Scenery" was used by an unknown maker on a series of country scenes marked with a ribbon cartouche. The scenes appear within a border of flowers alternating with two different groups of three leaves, one with prominent white veins. Only one of the scenes has been identified to date but they all appear to be views of actual places. The following have been recorded:

(i) The Watermill. A watermill with a wooden bridge to the left and ruins on a hill in the right background. Moulded dessert dish 10ins:25cm.

(ii) Riverside Cottages. Cottages on the far bank of a river with an arched bridge and two horses in the foreground. Wavy edge tureen stand 8¼ins:21cm.

(iii) The Windmill. A smock mill next to the mill house with a covered wagon in the foreground. Plate 7¼ins:18cm, and sauce tureen stand. Ill: FOB 20; P. Williams p.207.

(iv) Tintern Abbey. The ruined abbey amongst cottages with a woman talking to a mounted man next to a cow in the foreground. Well-and-tree dish 21ins:53cm, and drainer 15ins:38cm. Ill: FOB 10.

(v) Village Fishermen. A scene almost identical to the Handley design (Ill: Coysh 1 170) but with no cows and some sheep. Dish 17ins:43cm.

(vi) Palladian Mansion. Large house on hills behind a lake with a man, woman and child, a dog and three cows in the foreground as in a view of Audley End, Essex (qv). Moulded dessert dish 9¼ins:24cm.

(vii) Thatched Barns. A row of thatched barns on the left with cows in front and two farmers with rakes walking in the foreground. Plate 7¼ins:18cm.

(viii) Cottages and Castle. A row of thatched cottages on the left and a sailing boat on the right in front of a distant castle on a hill. Two cows and farmer with hoe in right foreground. Plate 9¾ins:25cm and puzzle jug (Colour Plate XXVII).

The same border was used on the Country Church pattern (qv) which was produced in the north east by both Cornfoot, Colville & Co. and Davies, Cookson & Wilson. Ill: Coysh 1 25.

"British Scenery" Series. *Maker unknown. Printed series mark.*

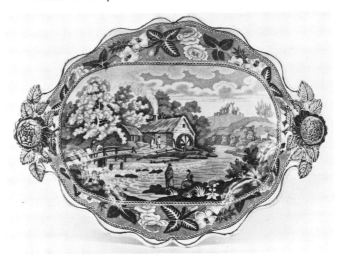

"British Scenery" Series. *The Watermill. Maker unknown. Printed series title mark. Moulded dish length 10ins:25cm.*

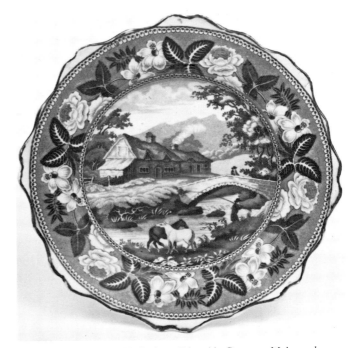

"British Scenery" Series. *Riverside Cottages. Maker unknown. Printed series title mark. Tureen stand with shaped edge 8¼ins:21cm.*

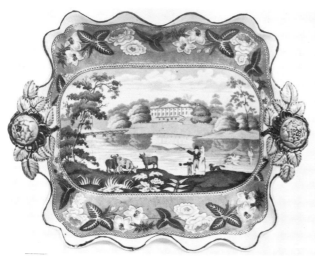

"British Scenery" Series. *Palladian Mansion. Maker unknown. Printed series title mark. Moulded dish length 9¼ ins: 24cm.*

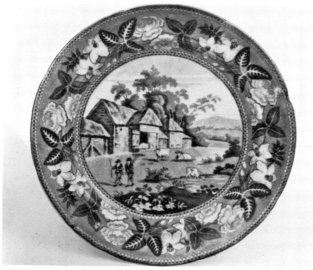

"British Scenery" Series. *Thatched Barns. Maker unknown. Printed series title mark. Plate 7¼ ins: 18cm.*

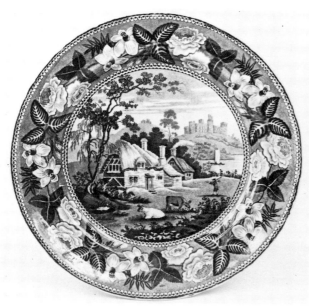

"British Scenery" Series. *Cottages and Castle. Maker unknown. Printed series title mark. Plate 9¾ ins: 25cm.*

"British Star"
Joseph Clementson.

"British Views"
(i) Henshall & Co. Fruit and Flower Border Series (qv). Different views on a dish 19ins:48cm (Colour Plate II), dish 14ins:36cm, plate 9¾ins:25cm, plate 8½ins:22cm.
(ii) Maker unknown. A series of views of country houses within a border of prominent polyanthus leaves, described below as the "British Views" Series.

"British Views." *Henshall & Co. Fruit and Flower Border Series. Printed title mark and rare impressed maker's mark. Plate 9¾ ins: 25cm.*

"British Views" Series
A series by an unknown maker with attractive views of country houses within a border of large flowers and polyanthus leaves on a stippled ground. The title "BRITISH VIEWS" is printed on a ribbon with a bow and leaf sprays at each end. Nine scenes have been recorded to date, two of which have been identified:
(i) St. Woolston's, Kildare. A rather square house amongst trees with a man and woman in a carriage and pair in the foreground. Soup plate 9¾ins:25cm.
(ii) Claremont House, Surrey. A country house in the distance with a man and woman talking to a kneeling woman and child while a groom attends to a horse and chaise in the foreground. This is reputed to show Princess Charlotte and Prince Leopold. See: May p.28. Plate 10ins:25cm
(iii) A Georgian country house with two men in the foreground, one standing and one mounted, both with canes and toppers. Plate 8¼ins:21cm.
(iv) A mansion with three storeys and battlements reflected in a lake in the foreground. Plate 6½ins:16cm.
(v) A three-storey mansion with carriage house behind a river. In the right foreground a man stands talking to a seated companion. Sauce tureen stand 8ins:20cm.
(vi) Large house on a hill behind a lake. In the left foreground is a flower bed with a curved retaining wall. Vegetable dish.
(vii) Large house nestles beneath hills with a sailing boat with furled sails on a lake or river in the foreground. Dish 18½ins:47cm. Ill: FOB 22.

continued

"British Views" Series. *Maker unknown. Printed series mark.*

"British Views" Series. *Maker unknown. Unidentified view. Printed series title mark. Plate 8¼ ins:21cm.*

"British Views" Series. *Maker unknown. View identified as St. Woolston's, Kildare. Printed series title mark. Soup plate 9¾ ins:25cm.*

"British Views" Series. *Maker unknown. Unidentified view. Printed series title mark. Plate 6½ ins:16cm.*

"British Views" Series. *Maker unknown. Unidentified view. Printed series title mark. Sauce tureen stand 8ins:20cm.*

"British Views" Series. *Maker unknown. View identified as Claremont House, Surrey. Printed series title mark. Plate 10ins:25cm.*

(viii) A house on hills to the left with a bridge crossing a river to some cottages. Two men, one seated and one standing, with their dog are on the bank of a stream in the foreground. Dish 19¼ins:49cm. Ill: FOB 33.

(ix) A distinctive house with four corner 'wings' and a semi-circular drive. In the foreground a shaggy dog with a stick in its mouth overlooks three men in a rowing boat. Dish 21¼ins:54cm (Colour Plate I). Ill: FOB 22.

It is clear that other items would have been made to complete the dinner service. The source of the views has not been identified but the view of St. Woolston's, Kildare, was also used by Ralph Hall in his "Picturesque Scenery" Series (qv).

The border from this series was also used for dinner wares made for use at Trinity College, Cambridge, with a central picture of the college fountain. The title "HUDSON, TRINITY COLLEGE" appears on the face.

See: Hudson.

"Broadlands, Hampshire"
Ralph Hall. "Picturesque Scenery" Series. Sauce tureen and stand, cup plate 3¾ins:10cm.

This house, at Romsey, dates from the 17th century but was altered by the second Viscount Palmerston in the 18th century. In recent times it was the seat of the late Earl Mountbatten.

"Broke Hall, Suffolk"
(i) Tams & Co. Tams' Foliage Border Series. Dish 10¾ins:27cm, pierced stand 9¾ins:25cm.

(ii) Maker unknown. Foliage Border Series. Dish 11ins:28cm.

The original Broke Hall was built in the 16th century. It was replaced by a castellated building in the 19th century.

Brookes, William fl.c.1800-1838
A freelance engraver who lived at Port Vale, Wolstanton in Staffordshire, and worked at Tunstall and later at Burslem. Shaw credits him with having originated the idea of decorating the borders of wares with strip patterns similar to those being used on wallpapers, a practice which was widely adopted in the first decade of the 19th century. He is known to have worked for William and Benjamin Adams and for Davenport. He also engraved the Wedgwood Blue Bamboo pattern in 1805.

Broseley Pattern
A chinoiserie design which includes a willow tree, two men on a bridge, and an extensive pagoda-like temple. The pattern is similar to the common Willow pattern but in mirror image. It was used by many potters on porcelain and china wares, particularly tea services. The Spode version is illustrated in Whiter 18. Examples on earthenware are less common but known makers include Davenport, Rogers and Wedgwood. Unmarked miniature items are also to be found.

Brougham & Mayer fl.1853-1855
Newfield, Tunstall, Staffordshire. Printed marks are known with the firm's name in full. Initial marks B. & M. may have been used but they could relate to other potters.

Brownfield, William (& Son or & Sons) fl.1850-1891
Cobridge, Staffordshire. Printed marks including the initials W.B. were in use from 1850-71. In 1871 the elder son was taken into partnership and marks became either W.B. & S. or W.B. & Son. Marks with the initials W.B. & Sons are subsequent to 1876. Jewitt states that "many of the printed patterns are well designed" and that "the firm enjoyed a large home trade, as well as an export one to Denmark, France, Germany, Holland, Russia, Italy, Spain, Portugal and the United States".

"Brundisium"
Don Pottery. Named Italian Views Series. Tureen length 13ins:33cm.

This title is badly printed and difficult to read but appears to be as quoted. Brundisium is the old name for Brindisi.

"Brundisium." *Don Pottery. Named Italian Views Series. This title, below the pattern, is badly printed and difficult to read but would appear to be "Brundisium". Printed and impressed maker's marks. Tureen length 13ins:33cm.*

Bucharest
A view by an unknown maker in the Ottoman Empire Series was titled "Near Bucharest" (qv).

Buffalo
A pattern name given to a chinoiserie design showing Lao-Tzŭ, the Chinese philosopher, mounted on a buffalo, on his way to 'the regions beyond'. He taught the 'way', affirming that action should be free from selfish motives, and was the founder of Taoism, a philosophy based on compassion and humility. The pattern is said to have been engraved by Thomas Minton and was used, with slight variations, by many potters including Spode (Ill: Whiter 20) and Turner. Marked pieces are not common. A version by Joshua Heath is illustrated in Little 31-32, as is a version attributed to Leeds, Little 97. The many versions of this pattern are discussed by Copeland, Chapter 11.

Buffalo. *Spode. Impressed and printed maker's marks. Dish 17¾ins:45cm.*

Buffalo and Ruins

Another version of the Buffalo pattern, by David Dunderdale & Co. of the Castleford Pottery, in which an original pagoda is replaced by a Gothic tower, and there is a figure carrying a parasol crossing a bridge. This pattern was also printed in brown. Ill: Coysh 2 16; Lawrence p.52; Little 104.

Buffalo and Ruins. *David Dunderdale & Co. Impressed mark "D.D.& CO./CASTLEFORD/POTTERY". Plate 9¼ ins:24cm.*

"Bull Fight"

See: "Olympic Games" Series.

Burn

The impressed mark "BURN" in large capitals has been noted on early chinoiserie wares with a pattern similar to examples from the Herculaneum and Spode factories. It has not proved possible to trace any potter of this name in the first quarter of the 19th century and the mark could relate to a retailer.

Burn, John fl.c.1822-1834

John Burn is listed as a China, Glass & Earthenware Dealer in the London Directories at 27 Newport Market. The address sometimes includes either Newport Street or Clare Market. His mark is known on special order dinner wares with Masonic symbols in the border in the form "John Burn, Newport Market, London. J.J. Cuff". The significance of the name "J.J. Cuff" is not known.

See: Freemasonry.

Burn, Joseph, & Co. fl.1852-1860

Stepney Bank Pottery, Ouseburn, Newcastle-upon-Tyne. This firm made the common Willow and "Wild Rose" patterns. An impressed mark "J. BURN &·CO." was used and also a printed armorial cartouche similar to one used by Fell & Co.

"Burns' Cotter"

Brameld. A miniature plate bearing this title together with an impressed mark "BRAMELD" is in the Sheffield City Museum. It depicts the hero of Burns' poem *The Cotter's Saturday Night* who is shown standing at the door of his cottage with his wife, two daughters, and their dog. G. Wooliscroft Rhead in *British Pottery Marks* (1910) mentions a Carey pattern called "The Cottar's Saturday Night", based on the same poem.

Burns' Monument, Edinburgh

James Jamieson & Co. "Modern Athens" Series.

As with other items from the series this view is not titled. The monument stands on the slopes of Calton Hill. It was built in 1830 to contain a marble statue of the poet by Flaxman and is in the form of a circular temple surrounded by twelve Corinthian columns which support an entablature and cornice. Above this is a cupola. The Flaxman statue has since been removed to the Scottish Portrait Gallery.

Burslem

A North Staffordshire pottery town on the Grand Trunk Canal. As early as the 17th century it was the chief seat of English earthenware production and has been called the "Mother of the Potteries". Josiah Wedgwood (1735-1805) was born and died here. To commemorate the connection of Wedgwood with Burslem a public monument was erected in the form of an institute in 1869. Amongst other famous potters who worked in the town were William Adams and Enoch Wood.

Burton, Samuel & John fl.1832-1845

New Street Pottery, Hanley, Staffordshire. This partnership succeeded James Keeling who had made several innovations in blue-printing processes. Examples of the standard Willow pattern have been noted with the initials S. & I.B. printed below a shield containing the words "Iron Stone China".

"Butterfly"

J. & M.P. Bell & Co. A pattern name.

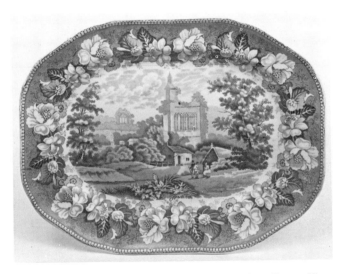

Byland Abbey, Yorkshire. *John Rogers & Son. Rogers Views Series. Untitled. Impressed maker's mark. Dish 12½ ins:32cm.*

"Byland Abbey, Yorkshire"

(i) Elkin, Knight & Co. Rock Cartouche Series. Plate 10ins:25cm. Ill: P. Williams p.209.

(ii) Maker unknown. "Antique Scenery" Series. Vegetable dish.

In addition a third, untitled, view is known by John Rogers & Son in the Rogers Views Series.

Byland Abbey lies about eight miles east of Thirsk in Yorkshire. It was founded by Roger de Mowbray in 1138 for Cistercian monks driven out of Calder Abbey by David, King of Scots, in a raid into Northumberland. The ruins show the long nave and short transepts in outline, forming a Latin cross.

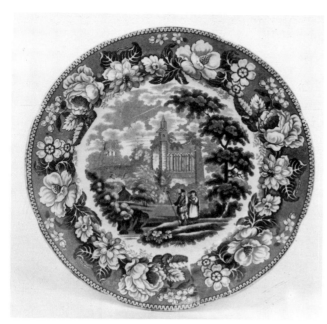

"Byland Abbey, Yorkshire." *Knight, Elkin & Co. Rock Cartouche Series. Printed title mark and impressed eagle mark. Plate 10ins:25cm.*

Byrne, William
An engraver and publisher of 69 Wells Street, Oxford Street, London. Several of his engravings were used as a source for patterns on blue-printed wares.

"Byron Gallery"
(i) Goodwins & Harris. A series of scenes depicting "Bride of Abydos", "Don Juan", "The Dream", "Hebrew Melodies" and "Maleppa". In each case the printed mark bears the series title, the title of the individual scene, four lines of verse from the relevant poem, and the makers' initials, either G. & H. or G.H. & G. These relate to the partnerships of Goodwins & Harris and Goodwin, Harris & Goodwin. Pieces are common in brown, but Chaffers reports a dish printed in blue.

(ii) Maker unknown. A series discussed in some detail by Anthony Oliver in *The Victorian Staffordshire Figure* (1971). He has identified the source print for the pattern titled "Bride of Abydos", one example of which has been noted with a black centre within a blue border. Another similar item bears the scene "Manfred".

"Byron's Illustrations"
A moulded punch bowl by John Meir, illustrated in Coysh 2 57, bears the titles "Byron's Illustrations" and "Simplon". The view of the Simplon is taken from the same source as the Copeland & Garrett view in their Byron Views Series (qv).

Byron Views Series
Copeland & Garrett produced this series of views on dinner services based on engravings in Finden's *Landscape and Portrait Illustrations to the Life and Works of Lord Byron* (1832-34), published in three volumes by Murray. The series has a distinctive border with acanthus scrolls. The views are titled on a printed ribbon beneath "COPELAND & GARRETT" arranged in a circle around "LATE SPODE". Examples are also known in brown, green, pink and puce. The views recorded include:
"Bay of Naples"
"Bellagio, Lago di Como"
"Bologna"*
"Cintra" (two views)
"Franciscan Convent, Athens"
"The Hague"
"Interlachen" (sic)
"Lachin y Gair"
"Lausanne"*
"Mount Etna"
"Mount Olympus"
"Patrass" (sic)
"Rhodes"
"Salamis"
"Sicily"
"The Simplon"
"Soracte"*
"Spoleto"
"Thun" (Colour Plate XXIII)
"The Tiber"
"Tivoli"
"Tomb of Cecilia Metella"
"Venice"
"Yanina"

The views are from various European countries including Greece, Holland, Italy, Portugal, Scotland and Switzerland, and are all associated with the famous poet. The illustrations by Edward and William Finden were based on pictures by contemporary artists such as George Cattermole, Clarkson Stanfield, Copley Fielding, Henry Gastineau, and J.M.W. Turner. Many of the places were visited by young men on the fashionable Grand Tour.

A jug from this series without a title mark is illustrated in Little 63 and may be the view of "Mount Olympus" which has been noted on a similar item.

"Bysham Monastery"
(i) Minton. Minton Miniature Series. Tureen 5½ ins:14cm.
(ii) Maker unknown. Beaded Frame Mark Series.

These views are assumed to show Bisham Abbey, Berkshire (qv).

"Bywell Castle, Northumberland"
William Adams. Bluebell Border Series. Dish 13ins:33cm, vegetable dishes and soup tureen stand.

Bywell Castle is a castellated and turreted 15th century tower house and gateway. It lies close to the River Tyne, about eight miles east of Hexham.

"Bysham Monastery." *Minton Miniature Series. Printed title mark. Tureen length 5½ ins:14cm.*

Byron Views Series. *Copeland & Garrett. Typical printed mark with impressed maker's mark.*

Byron Views Series. *Below left: "The Simplon". Source print from Finden's "Landscape and Portrait Illustrations to the Life and Works of Lord Byron" (1832).*

Byron Views Series. *Below: "Mount Etna". Source print from Finden's "Landscape and Portrait Illustrations to the Life and Works of Lord Byron" (1832).*

Byron Views Series. *Copeland & Garrett. Sauce tureen and stand with three views: "Mount Etna" (stand); "The Simplon" (tureen); "Cintra" (lid). Each piece has a printed title and maker's mark. The stand and tureen have impressed maker's marks. Tureen height 6¼ ins:16cm, stand diam. 7½ ins:19cm.*

"Cabul"
Thomas Shirley & Co.

This title presumably refers to Kabul, in Afghanistan. The name may have been chosen during the First Afghan War when British forces entered Kabul in 1843.

Cacamo
A locality which is mentioned in several of Luigi Mayer's prints which were copied by Spode for patterns in the Caramanian Series. The actual place has not been identified with certainty. It is referred to as having "a spacious harbour...into which flows a small river". It is also described as being "opposite Castel Rosso". The sarcophagi which feature in several of the patterns are known in Lycia, a mountainous district in the south west of Turkey.

"Caerfilly Castle, Glamorganshire" (sic)
Maker unknown. Pineapple Border Series. Plate 7¼ ins:18cm.

The castle at Caerphilly was built by Earl Gilbert de Clare to protect the Glamorgan lands which he conquered in 1266. It was the largest castle in Wales, even larger than those built by Edward I. The remains cover some thirty acres.

"Caernarvon Castle"
Herculaneum. Cherub Medallion Border Series. Plate 7½ ins:19cm. Ill: Little 111.

Built between 1283 and 1322, Caernarvon was the most important of Edward I's castles. It is the chosen site for the investiture of the Princes of Wales.

"Caister Castle, Norfolk"
(i) William Adams. Bluebell Border Series.

(ii) Maker unknown. "Antique Scenery" Series. Soup tureen 13¾ ins:35cm. (with the view "Abbey Gate of St. Edmundsbury, Suffolk" inside).

Caister is a moated brick built castle of c.1432, approached by a fine gatehouse. The highest feature is a stair turret which rises from a circular tower. The castle was the home of Shakespeare's Sir John Falstaff from 1432 to 1435 and of the Paston family between 1459 and 1599. It lies three miles north of Yarmouth and is open to the public in the summer.

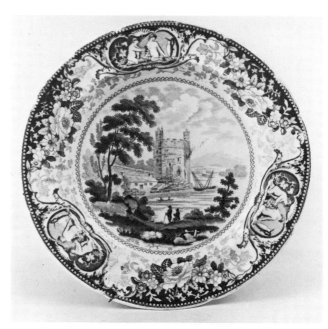

"*Caernarvon Castle.*" *Herculaneum. Cherub Medallion Border Series. Printed title mark and impressed "HERCULANEUM". Plate 7½ ins:19cm.*

"Caius College, Cambridge"
John & William Ridgway. Oxford and Cambridge College Series. Oval soup tureen.

Caius College as it now exists was founded by Dr. Caius, a wealthy doctor who was President of the College of Physicians. He took over an earlier establishment known as Gonville Hall. The building dates from the 1560s and is noted for its four gateways — the Gate of Humility, the Gate of Virtue, the Gate of Wisdom and the Gate of Honour.

Cake Stand
A broad, shallow comport, usually circular, and slightly larger than a dinner plate.

"Calcutta"
John & Richard Riley. Dish 20¾ ins:53cm, marked "SEMI CHINA".

Another view was produced by Enoch Wood & Sons in their Shell Border Series under the title "Near Calcutta" (qv).

Calcutta lies about one hundred miles from the mouth of the Hooghly River. It is described in an 1810 gazetteer as "the

"*Caister Castle, Norfolk.*" *Maker unknown. "Antique Scenery" Series. Printed titles mark. Soup tureen with scallop handles, length 13¾ ins:35cm. The view printed inside (right) is of the "Abbey Gate of St. Edmundsbury, Suffolk".*

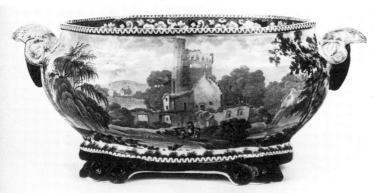

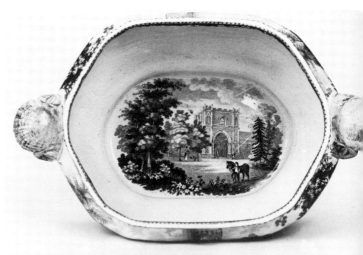

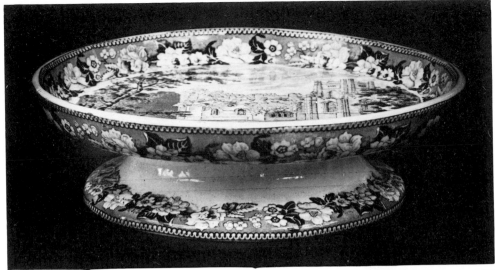

emporium of Bengal, and seat of the Governor General of India...an extensive city supposed to contain 500,000 inhabitants. The houses are variously built, some of bricks, others of mud and a greater number with bamboos and mats''.

"Caledonia"

(i) William Adams & Sons. A series of Scottish scenes with kilted huntsmen within a medallion border. They were also printed in pink and purple. Ill: Laidacker p.12; P. Williams pp.210-211 (three examples).

(ii) Isaac Wilson & Co.

Caledonia was the Roman name for the part of Scotland which lies north of the firths of Clyde and Forth. It has since become widely used to refer to the whole of Scotland.

"Caledonian"

(i) Andrew Muir. A romantic pattern with a horseman inside a wide border of curved acanthus and flowers. Printed title mark with initials A.M. Ill: FOB 28.

(ii) Ridgway, Morley, Wear & Co. A tartan pattern.

See: Caledonia.

Caledonian Pottery, Glasgow fl.1807-1840

A pottery managed by a Staffordshire potter, Josiah Rowley. It took over the moulds, patterns and plant of the Delftfield factory in 1811.

See: Rowley.

"California"

(i) James Jamieson & Co.

(ii) Charles Meigh, Son & Pankhurst.

(iii) Podmore, Walker & Co. A design with a lake and mountains registered on 2nd April, 1849. The oval strap cartouche mark also bears the name "WEDGWOOD". Ill: P. Williams p.212.

(iv) Maker unknown. A pattern noted on a jug which shows a man kneeling by a river panning for gold.

California came into the news in 1848 with the discovery of gold and the rush of prospectors hoping to make their fortunes.

Calland, John F. & Co. fl.1852-1856

Landore Pottery, Swansea, Wales. Printed and impressed marks of various forms were used, sometimes with the name of the pottery or "SWANSEA".

"Cambria"

Charles Heathcote & Co.

Cambria, the Latin name for Wales, is derived from the Celtic *Cymru.*

"Cambrian"

Wallace & Co.

"Cambrian Argil"

An impressed name used for a ceramic body by C.J. Mason & Co. The clay was said to have come from Wales though some reports suggest that the name may have been given to a local clay.

Cambrian Border

The name used by the Cambrian Pottery, Swansea, for the chinoiserie pattern which included a moth in the border. See: Nance, footnote p.50.

"Cambrian Bridges"

Maker unknown. A print with this title is known on a mug which shows one of the two bridges built by Thomas Telford to carry the Ellesmere Canal over valleys in North Wales.

Telford was appointed sole agent, engineer and architect of the Ellesmere Canal project which was designed to connect the Mersey, the Dee and the Severn. This involved two major bridges, the first at Chirk to span the valley of the Ceiriog and the second at Pont Cysyllte over the River Dee. The first of these had only ten arches but the second had nineteen, in each case supporting a trough of cast iron plates to carry the water of the canal. The work was completed in 1805.

Cambrian Pottery
See: Swansea; Swansea's Cambrian Pottery.

"Cambridge"
(i) Harvey. Cities and Towns Series. Two-handled bowl 5½ins:14cm, sauce tureen stand 8¾ins:22cm. Ill: FOB 16.

(ii) Herculaneum. Two-handled bowl or soup tureen 11¾ins:30cm. Ill: Smith 169.

These two views are very similar, both showing King's College Chapel from the river.

"Cambusnethan on the Clyde"
Belle Vue Pottery. Belle Vue Views Series. Plate 8½ins:22cm.

Cambusnethan is in North Lanarkshire, just over a mile north east of Wishaw. Cambusnethan Priory was built by Gillespie Graham as a large medieval-style monastic house.

Camel
The camel is featured on a number of blue-printed patterns. Those by known makers include:

(i) James & Ralph Clews. A camel, together with a cow and a gnu, was used on a dish (18ins:46cm) in the "Zoological Gardens" Series.

(ii) John Hall. A camel in a group of animals was used on the soup tureen in the "Quadrupeds" Series.

(iii) John & Richard Riley. A design showing a dromedary with three pyramids in the distance. Ill: Coysh 1 73. This pattern was copied by Pountney & Goldney of Bristol.

(iv) John Rogers & Son. A design commonly called the Camel pattern which was based on an aquatint by Thomas Daniell from his *Oriental Scenery* titled "Gate Leading to a Musjed, at Chunar Ghur" (qv). Ill: Coysh 1 84.

In addition to these marked patterns, one design by an unknown maker features a camel together with a giraffe within a chinoiserie border. It is usually called the Giraffe and Camel Willow Pattern (qv).

Candlestick. *Round foot candlestick by Spode in the Tower pattern. Printed maker's mark. Height 6ins:15cm.*

"Cambridge." *Harvey. Cities and Towns Series. Printed title mark. Sauce tureen stand 8¾ins:22cm.*

"Campanie"
John Maddock. A typical romantic scene with a large vase and an ornate castle in the background. There is an open floral border and the pattern is titled in a crowned scroll cartouche with the single initial M. Ill: FOB 10.

Candlestick
Blue-printed candlesticks are uncommon and the few known marked examples are all by Spode, including the two examples shown. The tall shape is called a round foot candlestick in the Spode shape book, the small chamberstick being called a flat candlestick. See: Whiter pp.104-107. They are printed with the Tower and Lanje Lijsen patterns respectively and another tall candlestick has been noted with the Queen Charlotte pattern.

See: Smoker's Set.

"Cannon Hall, Yorkshire"
John & Richard Riley. Large Scroll Border Series. Plate 8¾ins:22cm.

"Cannon, Yorkshire"
Maker unknown. Foliage Border Series. Plates 5½ins:14cm and 6½ins:16cm. Laidacker records two slight variants of this view.

The Hall is a late 17th century house which was extended in the 1760s and heightened in 1804-5. It lies about five miles west of Barnsley.

Candlestick. *Flat candlestick by Spode in the Lanje Lijsen pattern. Printed maker's mark. Diam. 6ins:15cm.*

"Canova"

(i) J. & M.P. Bell & Co.

(ii) Thomas Mayer. A series of patterns known also in pink and purple. The central scenes all include a large urn and the border consists of scenic vignettes alternating with floral reserves. The designs were used on both dinner and tea wares. Ill: Laidacker p.59; P. Williams pp.214-215 (five examples).

(iii) David Methven & Sons.

(iv) George Phillips.

Some of these patterns may have been named after the Italian painter Antonio Canova (1757-1822) who visited England in 1815.

"Canterbury"

(i) Harvey. Cities and Towns Series. Dish.

(ii) Herculaneum. Cherub Medallion Border Series. Plate 9ins:23cm.

Another view in the Grapevine Border Series by Enoch Wood & Sons was titled "City of Canterbury" (qv).

Canterbury has existed since Roman times when it was a military centre. It was here that Thomas Becket was murdered and the city became the destination for many pilgrimages.

Canterbury Cathedral

Two untitled views of Canterbury Cathedral have been identified:

(i) James & Ralph Clews produced a view on a plate (10ins:25cm) in their untitled Foliage and Scroll Border Series.

(ii) Ralph Stevenson used a view in his series titled "Panoramic Scenery".

The Cathedral was founded in 597 by St. Augustine using an old Roman church which was eventually destroyed by fire in 1067. The new cathedral was built by Lanfranc, Anselm and Prior Conrad beginning in 1070. There were extensive modifications and extensions leading to the completion of the building as it is today in 1495. It became famous throughout Christendom after the murder of Archbishop Becket in 1170 when he was hailed as a martyr. His shrine has since been visited by pilgrims from all over the country.

"Canton"

(i) Robert Heron & Son.

(ii) Maker unknown. A flown-blue design on teawares.

Canton was the first and, except for Macao, the only Chinese port open to foreign traders before 1842. It was the scene of incidents leading to the Anglo-Chinese wars of 1839

"Cannon Hall, Yorkshire." John & Richard Riley. Large Scroll Border Series. Printed title mark with maker's name. Plate 8¾ ins:22cm.

and 1856. The estuary on which it stands has long been known for the manufacture and export of pottery. It was no doubt well known by British potters who admired and often copied the wares.

"Canton Views"

Elkin, Knight & Bridgwood. An idealised Chinese-style scene printed on gadrooned edge dinner wares. It is very similar to the common "Chinese Marine" design made by Minton and others. The printed mark includes the words "Opaque China" in addition to the title and the makers' initials E.K.B. Some examples have been noted with an impressed mark "ELKIN/KNIGHT & CO." Ill: P. Williams p.104.

"Canute Reproving His Courtiers"

Jones & Son. "British History" Series. Sauce tureen, cover and stand.

Canute is said to have sat on the seashore when the tide was coming in and commanded the waves to come no nearer. When the tide reached him he rebuked his courtiers for their flattery saying that he could not stop the tide despite them calling him king.

"Canute Reproving His Courtiers." Jones & Son. "British History" Series. Printed titles and maker's mark. Tureen height 5¾ ins:15cm, length 7½ ins:19cm, stand length 8¼ ins:21cm.

"**Caractacus Before Claudius.**" *Jones & Son.*
"British History" Series. Printed titles and maker's mark.
Soup plate 10ins:25cm.

"Cape Coast Castle on the Gold Coast, Africa"

Enoch Wood & Sons. Shell Border Series. Dishes
15½ins:39cm and 16½ins:42cm. Ill: Arman 126.

"Caractacus Before Claudius"

Jones & Son. "British History" Series. Soup plate 10ins:25cm
and cake stand 12ins:30cm.

Caractacus was the British king who led the resistance to the
Romans. He sought refuge with the Queen of the Brigantes
but she handed him over to the Romans. He was sent to Rome
and brought before the Emperor Claudius who, respecting his
courage, granted him an honourable captivity.

Caramania

A name for a region in Asia Minor described in a gazetteer of
1810 as "a province of Natolia, which comprehends the
ancient Pamphylia and a great part of Cilicia, Pisidia and
Cappadocia". The capital of Caramania was Cogni, 260 miles
south east of Constantinople, a town known by the Romans as
Iconium, and today as Konya. This region is all part of
modern-day Turkey, and it is interesting to note that not far to
the south of Konya is a small town called Karaman. Natolia is
now Anatolia.

The name Caramania is well known to collectors of Spode
blue-printed wares. Many of the scenes in the so-called
Caramanian Series depict antiquities in this region.

Caramanian Series

A highly collected series by Spode produced from about 1809,
usually with the earlier impressed lower case mark "Spode".
The central scenes were based on engravings in Luigi Mayer's
Views in Egypt (1801), *Views in the Ottoman Empire, chiefly in
Caramania, a part of Asia Minor hitherto unexplored* (1803), and
Views in Palestine (1804). The series border is made up of
animals copied from Capt. Thomas Williamson's *Oriental Field
Sports, Wild Sports of the East* (1807), which was later used by
Spode for the Indian Sporting Series (qv).

The wares are not titled but include:
Ancient Bath at Cacamo*
Ancient Granary at Cacamo*
Antique Fragments at Limisso

The Castle of Boudron
Citadel near Corinth
City of Corinth
Colossal Sarcophagus near Castle Rosso*
The Harbour at Macri
Necropolis or Cemetery of Cacamo
Principal Entrance of the Harbour of Cacamo*
Sarcophagi at Cacamo*
Sarcophagi and Sepulchres at the Head of the Harbour at
 Cacamo*
Triumphal Arch at Tripoli in Barbary (Colour Plate XVI).
Some of these scenes are recorded in more than one variant.
The titles are taken from the original source prints, most of
which are illustrated by S.B. Williams.

One example of the Ancient Granary at Cacamo has been
recorded with a Spode mark but with a completely unrecorded
floral border, not known on any other Spode patterns.

Carey, Thomas & John fl.1823-1842

Anchor Works, Lane End, Staffordshire. Although earlier
records of the Careys exist, it was this main partnership that
flourished. At one time they seem to have operated three
potteries. Marks commonly include the name "CAREY'S"
with or without an anchor. Three series were produced — the
Cathedral Series, the "Irish Views" Series and the Titled
Seats Series. A "Lady of the Lake" single pattern dinner
service was made and there were several later romanticised
views such as "Asiatic Scenery". Examples of the "Irish
Scenery" Series, usually associated with Elkins & Co., have
been seen with an impressed Carey's mark.

"Carlton Club"

A gadrooned edge cake stand, probably part of a special order
dessert service, bears the crest of the Carlton Club. Decorated
with the border from Spode's first two Union Wreath patterns
(Whiter 56, 57), it is marked "Spode's Imperial" (Whiter
mark 20). The wreath has been replaced with a heraldic crest
within two concentric circles containing the words
"CARLTON CLUB".

The Carlton Club was formed in 1832 by the Duke of
Wellington following the election defeat of the Tories. Under

Colour Plate V. Filled-In Transfers. *Left: Jug by Lockett & Hulme decorated with red, orange, yellow and green enamels. Printed maker's initial mark. Height 4¼ ins: 11cm. Right: Jug by Spode decorated with red and brown enamels and gilding. Printed maker's "Stone China" seal mark. Height 5½ ins: 14cm.*

the chairmanship of the Marquess of Salisbury it was used as a centre for Tory organisation, and today it is still the leading Conservative club. The original premises were in Pall Mall, between the Liberals' Reform Club and the Royal Automobile Club. This site was destroyed during the blitz in 1941 and the club has since occupied 69 St. James's Street, just off Piccadilly.

The use of the Imperial body as late as 1832 is interesting. It was introduced in 1822 as a new white earthenware which used much less blue cobalt in the glaze. It would appear to have been superseded by the New Fayence body which appeared in 1831. Unfortunately the Club has no records to trace the wares since their possessions were lost in World War II air raids.

"Carlton Club." *Spode. Union Wreath Border. Printed mark "Spode's Imperial". Cake stand diam. 11ins:28cm.*

"Carolina"
Ralph Hall. A light blue pattern recorded also in black, green, pink, purple and sepia. A typical 1830s design featuring a prominent vase in a romantic setting. Ill: Laidacker p.51; P. Williams p.218.

Caroline
See: Queen Caroline.

Carpet Bowls
The game of carpet bowls was popular in Victorian times and was played with a set of coloured earthenware balls. The patterns were very crude, mainly simple stripes or tartans, printed in various colours to aid identification during the game. The balls were frequently damaged by over-enthusiastic play, and sets are by no means common, although odd single specimens are sometimes found, usually chipped.

The Carr Family of North Shields fl.1844-c.1890
This family operated the Low Lights Pottery near the fish quay at North Shields, Northumberland, for over fifty years. There is no clear information on the various partnerships and dates

but the following styles were used:

John Carr & Co.	c.1844-c.1850
John Carr & Son	c.1854-c.1855
John Carr & Sons	c.1861-1890 +
Carr Bros.	c.1858 and c.1874-75
Carr Bros. & Carr	c.1887-88

There would appear to have been two distinct businesses towards the end of this period. Thereafter the family continued, mainly as fire-brick manufacturers.

Printed marks sometimes include a bell with the name "CARR" within two sprays of leaves, although several other marks are known with a variety of names (and initials) such as "J. CARR & Co.", "J. CARR & SON" and "JOHN CARR & SONS". The firm is known to have exported to Scandinavia and the Mediterranean.

Carr & Patton fl.c.1847-1848
Phoenix Pottery, Ouseburn, Northumberland. A brief partnership between John Carr, who was also involved in the Low Lights Pottery at North Shields, and John Patton. The Phoenix Pottery was continued by John Patton alone until about 1856.

"Carrickfergus Castle & Town"
Careys. "Irish Views" Series. Dish 21ins:53cm.

Carrickfergus is the county town of Antrim in Northern Ireland. Lying on the northern shore of Belfast Lough, it has a noted 12th century castle which is preserved as an ancient monument.

"Carstairs on the Clyde"
Belle Vue Pottery. Belle Vue Views Series. Plate. Ill: P. Williams p.219.

"Carstairs, Lanarkshire"
William Adams. Flowers and Leaves Border Series. Plate 8¾ins:22cm.

Carstairs is three and a half miles east of Lanark. The house was built by William Burn in 1821 in the Tudor style with false gables and tall chimneys.

"Carrickfergus Castle & Town." *Careys. "Irish Views" Series. Printed titles mark with maker's name. Dish 21ins:53cm.*

Cartouche

An architectural term meaning a tablet, often shield shaped or imitating a scroll, with an elaborate border, used to contain an inscription or coat-of-arms. In ceramics it is used to describe any printed mark of decorative form used to contain a pattern title, maker's name or initials, or both.

Cartwright & Edwards fl.c.1869-1955

Borough Pottery, Longton, Staffordshire. Jewitt states that these works were extensive and built as a "model factory". Printed marks including the initials C. & E. are known on a blue-printed jug and other wares, although these initials were also used by Cork & Edge of Burslem (qv).

"Cascade de Gresy, pres Chambery"

Enoch Wood & Sons. French Series. Plate 7¾ ins:20cm. Ill: Arman 192.

Chambery, in eastern France not far from Grenoble, is a historic regional centre with a castle. The Cascade de Gresy is a tourist attraction three miles north of the town.

"Cascade at Isola"

Don Pottery and Joseph Twigg, Newhill Pottery. Named Italian Views Series. Dish 17ins:43cm.

The "Cascade at Isola" is at Isola del Liri, thirty miles to the north of Cassino, between Rome and Naples. It is described by Sir R. Colt Hoare, Bart. in *A Classical Tour through Italy and Sicily* (1819). He went to the junction of the rivers Liris and Filrenus, below the baronial castle of the Duke of Sora where the Liris "divides itself into two streams, one of which rushes down a precipitous cataract".

"Cashiobury, Hertfordshire"

(i) Ralph Hall. "Picturesque Scenery" Series. Plate 7½ ins:19cm.

(ii) Enoch Wood & Sons. Grapevine Border Series. Plate 8½ ins:22cm.

Cashiobury, on the outskirts of Watford, was an Elizabethan mansion remodelled by Hugh May in 1674-75, and by James Wyatt in 1800. It was the seat of the Earl of Essex but was demolished in 1922.

"Cashiobury, Hertfordshire." Enoch Wood & Sons. Grapevine Border Series. Printed title mark and impressed maker's mark. Plate 8½ ins:22cm.

"Cashmere"

Ridgway & Morley. Flown-blue pattern.

The Indian province of Cashmere was noted for the manufacture of shawls which were exported to all parts of Asia and also to Africa and Europe. Each shawl required the hair of at least seven goats.

"Cassino"

William Adams & Sons. Romantic patterns used on dinner wares showing church buildings within a border of thin concentric circles. Ill: P. Williams p.221 (two examples).

Cassino is an Italian town at the foot of the hill on which stood the Monastery of Monte Cassino, now rebuilt since its destruction in World War II. However, these romantic scenes bear little resemblance to the named town.

Castello St. Angelo, Rome

This building, which at various times has served as fortress, Catholic meeting place and prison, appears on at least three designs. Spode's Tiber pattern (also known as the Rome pattern) shows the castle and bridge with the addition of Trajan's Column and St. Peters. Ill: Coysh 1 106; Whiter 69; S.B. Williams 73-78. The Don Pottery used a similar view on a plate (10ins:25cm) in their Landscape Series. Ill: Coysh 2 28.

Enoch Wood & Sons also included "Castle of St. Angelo, Rome" in their "Italian Scenery" Series.

Castle

The famous Castle pattern was introduced by Spode and copied by other potters including James & Ralph Clews of Cobridge and Timothy & John Bevington of Swansea between 1817 and 1824. The Swansea version is referred to by Nance as the Castled Gateway. Spode productions are usually found in a paler blue than most Spode printed wares. Ill: Coysh 1 104; Little 60; Whiter 66, Colour Plate III; S.B. Williams 79-83.

The pattern is based on an aquatint by Merigot entitled "The Gate of Sebastian" (1796), with the foreground taken from another aquatint from the same year titled "Ponte Molle".

"Castle of Beaucaire"

Wood & Challinor. A scene within a border of flowers and scrolls recorded on a deep saucer 7½ ins:19cm.

Beaucaire is a French town on the Rhône, at the head of the Rhône-Sèlé canal. The 13th century castle, or chateau, is now a ruin.

The Castle of Boudron

Spode. Caramanian Series. Oval dish 18ins:46cm. Ill: S.B. Williams 39-41.

Boudron, now spelt Budrum, is a Turkish seaport on the Gulf of Cos, one hundred miles to the south of Izmir. The castle was built by the Knights of St. John who took over the nearby ancient city of Halicarnassus in 1402. The name Budrum is the Turkish for St. Peter, the name given to the castle by its builders.

Castle and Bridge

Henshall & Co. An early pattern showing a castle and bridge amongst twisted trees. Marked examples are rare. It has been suggested that the scene may represent St. Albans in Hertfordshire. Ill: Coysh 1 154; Little 35.

"Castle Forbes, Aberdeenshire"

Enoch Wood & Sons. Grapevine Border Series. Plate 6½ ins:16cm, and cup plate.

Castle Forbes, built of granite, was the ancestral seat of the chiefs of the Clan Forbes. Rebuilding was started in 1814 by Archibald Simpson and the structure was completed by John Smith.

Castle and Bridge. *Henshall & Co. Unmarked. Sauce tureen stand 8½ ins:22cm.*

"Castle of Beaucaire." *Wood & Challinor: Printed title mark with maker's initials. Deep saucer 7½ ins:19cm.*

"Castle Freke, Cork, Ireland, Lord Carbery's Seat." *Careys. Titled Seats Series. Unmarked. Drainer 12¼ ins:31cm.*

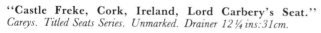

"Castle of Lavenza." *Enoch Wood & Sons. "Italian Scenery" Series. Printed titles mark. Plate 10¼ ins:26cm.*

"Castle Freke, Cork, Ireland, Lord Carbery's Seat"
Careys. Titled Seats Series. Dish 19ins:48cm, and drainer 12¼ins:31cm. Ill: Laidacker p.20.

Castle Freke lies three miles south east of Ross in County Cork. It is in wooded country on the east side of Ross Carbery Bay.

"Castle of Furstenfeld"
Henshall & Co. Fruit and Flower Border Series. Plate 9ins:23cm.

Furstenfeld is in Austria, thirty miles east of Graz and not far from the borders with Hungary and Yugoslavia.

Castle Gateway
Maker unknown. A name given by Coysh to a pattern on a bourdaloue showing a view of a castle in a scrolled frame with an extensive floral border. Ill: Coysh 2 142.

"Castle Huntley, Perthshire" (sic)
Enoch Wood & Sons. Grapevine Border Series. Plates 6½ins:16cm, and 7½ins:19cm.

Castle Huntly, in east Perthshire, is a house with turrets and battlements. It was completed in 1792.

"Castle of Lavenza"
Enoch Wood & Sons. "Italian Scenery" Series. Plate 10¼ins:26cm, soup plate 9ins:23cm, dish 14½ins:27cm. Ill: Laidacker p.97.

It has not yet proved possible to trace this castle.

"Castle of Nepi, Italy"
Enoch Wood & Sons. "Italian Scenery" Series. Leaf dish.

Nepi is an old walled town in central Italy, north of Rome and eighteen miles south east of Viterbo. The 16th century castle is in ruins.

"Castle Prison, St. Albans, Hertfordshire"
Ralph Hall. "Select Views" Series.

A rather strange choice for a blue-printed pattern, probably prompted by some contemporary event.

"Castle of Rochefort, South of France"
Brameld. This pattern was used for complete dinner services (See: Rice pp.17-18). Most pieces carry an impressed mark with the name "BRAMELD" in a small cartouche, but only occasionally is the printed title mark found. Ill: Coysh 1 78; Lawrence p.52.

Rochefort is a French seaport in the Bay of Biscay at the mouth of the River Charente. It was developed as a fortified port by Colbert (1619-83). Admiral Cochrane attempted to destroy the French fleet at Rochefort in 1809 and it was the port from which Napoleon sailed in the *Bellerophon* in 1815.

"Castle of St. Angelo, Rome"
Enoch Wood & Sons. "Italian Scenery" Series. Dish 11ins:28cm.

See: Castello St. Angelo, Rome.

"Castle Street & St. George's Crescent, Liverpool"
Herculaneum. Liverpool Views Series. Dish 20½ins:52cm, and very large jug. Ill: Little 112; Smith 175, 179, 180.

This view was based on an engraving by E. Wallis from a drawing by T. Harwood published in *Lancashire Illustrated* (London, 1832). Pieces are also known in sepia and black, and an impressed Liver Bird mark was used in addition to the printed title mark.

"Castle Toward"
Laidacker lists this view on teawares made by one of the Hall firms.

Castle Toward, in Argyllshire, was built by David Hamilton in 1821 for Kirkman Finlay, a wealthy merchant who became Lord Provost of Glasgow. It is a Gothic building with a "multiplicity of towers".

Castleford Pottery
See: Dunderdale, David.

"Cathedral Church of Glasgow"
Maker unknown. "Antique Scenery" Series. Dish 19ins:48cm. Ill: FOB 16.

"Cathedral Church of Glasgow." Source print for the "Antique Scenery" Series taken from Byrne's "The Antiquities of Great Britain".

"Cathedral Church of Glasgow." Maker unknown. "Antique Scenery" Series. Printed titles mark under rim. Dish with combed base 19ins:48cm.

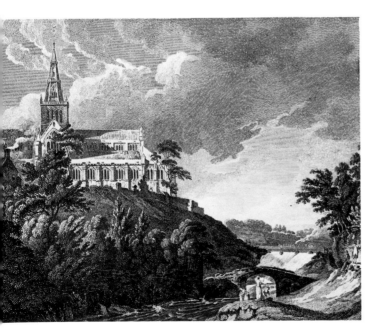

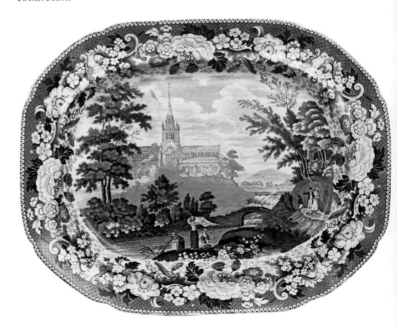

"Cathedral of Glasgow"

Maker unknown. A similar view to the "Antique Scenery" item noted above but with a border of flowers and scrolls not known on any other pieces. It is titled in a cartouche beneath a crown. Ill: FOB 1.

The cathedral of St. Mungo is early English with lancet windows and was founded in 1197 to replace a still earlier church. It was enlarged to its present form in the 15th century. The original design was cruciform but the transepts were never completed. Extensive repairs and renewals were made in 1854.

Cathedral Series

A relatively uncommon series by Careys showing various cathedrals within an elaborate Gothic arch border, each arch containing a Tudor rose. Items are of decorative shapes with gadrooned edges and are made in an ironstone-type body called "Saxon Stone China". The printed mark includes the view name on a decorative panel surmounted by a Bishop's mitre, all over a ribbon bearing the makers' name and the name of the body. The only views so far recorded are:

"Chichester Cathedral"
"Litchfield Cathedral" (sic)*
"St. Paul's Cathedral"
"York Cathedral"*

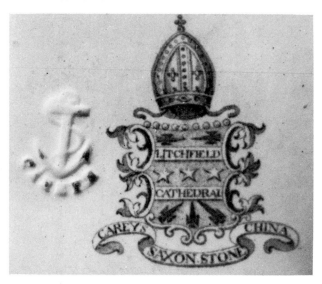

Cathedral Series. *Careys. Typical printed mark with impressed maker's anchor mark.*

"Cathedral at York"

Enoch Wood & Sons. Grapevine Border Series. Plates 6½ins:16cm, and 7ins:18cm.

The Cathedral Church of St. Peter, or York Minster, was founded in 626 but the present building was reconsecrated in 1472 following rebuilding. There were serious fires in 1829 and 1840. Much restoration work has been done in recent years.
See: "York Cathedral"; "York Minster".

Cattle and River Pattern

Charles Heathcote & Co. A view which shows an extensive but as yet unidentified country mansion. Ill: Coysh 1 49; Little 30.

"Cattle Scenery"

Thomas Mayer. A rural scene with a group of cattle within a floral border with large roses, very similar to the well-known Blue Rose Border (qv) introduced by Wedgwood in 1824. The scene is titled within a cartouche of oak leaves and acorns and examples are known with a circular impressed mark including the name Mayer and town Stoke. Ill: FOB 14.

Caudle Cup

A lidded two-handled cup standing in a matching saucer. It was used to serve caudle, a warm alcoholic gruel made with eggs, bread or oatmeal and spices mixed with wine or ale. Caudle was prepared for invalids, and especially for women about to give birth.
See: Posset Pot.

Caughley Works fl.1775-1799

The Caughley pottery near Broseley in Shropshire was acquired in 1772 by Thomas Turner, a draughtsman and engraver from Worcester. He built a new factory for the production of porcelain in 1775 and wares were made and decorated in underglaze blue with chinoiserie designs. It is said that he produced the first Willow pattern, engraved by Thomas Minton, but there has long been discussion as to whether blue-printed pottery was made. What happened in the early years between 1772 and 1775? Was the manufacture of earthenware continued and were experiments made in blue-print on such wares? Early line-engraved plates marked only with an eight-pointed star and printed in the steely-blue typical of Caughley porcelain are so very like the porcelain designs that one may fairly ask "Could they have been made at Caughley?" A blue-printed earthenware dish with a C-mark depicting a pagoda, a fence and a lady with a parasol has been recorded in a private collection.

Blue-printed earthenware shards have been found on the Caughley site. See W.J. Grant Davidson, *Excavations at Caughley*, Transactions of the English Ceramic Circle, Part 3 (1967).

"Cave Castle, Yorkshire"

(i) Ralph Stevenson. Stevenson's Acorn and Oak Leaf Border Series. Plate and soup plate, both 8½ins:22cm.
(ii) Enoch Wood & Sons, Grapevine Border Series. Plate 8½ins:22cm. Ill: Coysh 2 128.

Cave Castle, at South Cave, ten miles north east of Hull, was built in 1804 by Henry Hakewell. It is of yellow brick with angle turrets and battlements.

Cattle and River Pattern. *Charles Heathcote & Co. Impressed "HEATHCOTE & Co." Soup plate 8½ins:22cm.*

"Cave Castle, Yorkshire." *Ralph Stevenson. Stevenson's Acorn and Oak Leaf Border Series. Printed title mark. Plate 8½ ins: 22cm.*

"Cavendish"
John Thomson.
 Cavendish is a relatively common family name.
 See: "Cavendo Tutus".

"Cavendo Tutus"
Safe by being cautious. A motto which is a play on the name Cavendish, the family name of the Dukes of Devonshire. It has been noted printed between concentric circles surrounding the Duke's crest in the centre of a plate printed with the Tendril pattern (qv).

Celtic China
A name used by John Denton Bagster, Enoch Wood & Sons and other potters to indicate that Welsh clay was used in making the earthenware body.

The Chalees Satoon in the Fort of Allahabad on the River Jumna
An aquatint published in July 1795 based on a drawing and engraving by Thomas Daniell, in his *Oriental Scenery* (Part I, 6).
 It was used to provide the main building for a pattern in the India Series (qv), attributed to the Herculaneum Pottery, within a floral border including wild roses. Other details in the pattern were taken from similar prints. An elephant with howdah in the foreground is from "The Punj Mahalla Gate, Lucnow" (Part III, 5); a building in the middle distance is crudely copied from "View of Mutura, on the River Jumna" (Part III, 22); and, as with all this series, the background is based on a "View in the Fort of Tritchinopoly" (Part II, 21).
 The pattern is illustrated in S.B. Williams 171 on a supper set segment, and on a 4¼ ins:11cm cup plate in P. Williams p.126.
 The Chalees Satoon was a "Hall of Forty Pillars". It was a pleasure pavilion designed to catch the breeze which was cooled by fountains and water channels in the building.

Challice, A.
The name "A. CHALLICE" has been noted in a small reserve in the border of a large dish bearing a view of Lancaster from Elkin, Knight & Co.'s Rock Cartouche Border Series.

Challinor, E. & C. fl.1862-1891
Fenton Pottery, Fenton, Staffordshire. Printed marks include either the initials E. & C.C. or the name in full, sometimes with a Staffordshire knot or the Royal Arms.

Challinor, E. & Co. fl.1845-1862
Fenton Pottery, Fenton, Staffordshire. It is not known whether there was any connection between this firm and the Tunstall company listed below. Printed marks are known with the name in full. The firm was succeeded by E. & C. Challinor (qv).

Challinor, Edward fl.1842-1867
Pinnocks Works and Unicorn Pottery, Tunstall, Staffordshire. Originally a partner in the firm of Wood & Challinor, Edward Challinor potted alone in Tunstall from 1842. Printed marks are known with the initials E.C., sometimes in a Staffordshire knot, or the name "E. CHALLINOR" in full, often with a pattern name.

Chamber Pot
The chamber pot was an essential part of all blue-printed toilet sets, and most examples date from Victorian times. An early example, said to have been owned by a Lord Mayor of Bristol, is known with the view of "Bristol" by Pountney & Allies. Small versions were made for children including one with the "Abbey" pattern and another in the "Northern Scenery" Series by John Meir & Son.

"Chantillian"
Read, Clementson & Anderson. A typical romantic scene.

"Chantilly"
John Thomson.

Chantilly Sprig
A pattern name given to a sparse floral design by Spode. An example with a central carnation is illustrated in Whiter 39.
 Chantilly, a French town in the department of the Oise, was noted for the Prince of Condé's château. It has a park, gardens and stables, and was thought to be the most beautiful town in France. Fine porcelain decorated with floral patterns was made in Chantilly.

Chamber Pot. *Pountney & Allies/Pountney & Goldney. Bristol Views Series. "Bristol" pattern. Unmarked.*

"The Chantry, Suffolk"
(i) William Adams. Bluebell Border Series.
(ii) Andrew Stevenson. Rose Border Series. Plate 7½ins:19cm.

With such an unspecific title it is difficult to be sure, but this view may show Sproughton Chantry, a subject which was also used by Enoch Wood & Sons in their Grapevine Border Series. It is a late 18th century house on a hill to the east of Ipswich which was extended in 1853-54. The Chantry has given its name to a large housing estate immediately to the south

"Chapelle de Guillaume Tell"
Enoch Wood & Sons. French Series. Plate 6ins:15cm. Ill: Arman S 193.

William Tell is a legendary hero of Switzerland. He is remembered for his courage in leading the struggle against the Hapsburgs and, of course, for his success in shooting an apple in two from his son's head, at a distance of eighty paces, using a single arrow.

"Chapoo"
Ralph Hall & Co. Light blue designs printed on several different dishes and plates with the initial mark R.H. & Co. The central view on the plate shows a pagoda and a river, and three Oriental figures on a bridge in the foreground. The border consists of many fine concentric lines. Ill: P. Williams pp.105-106 (two examples).

The name "Chapoo" is almost certainly a version of Chapu, a small town near Nankin in China.

"Charenton, near Paris"
Maker unknown. Pineapple Border Series. Dish 9½ins:24cm.

This locality was also featured by Enoch Wood & Sons, a view in the French Series being titled "Moulin sur la Marne a Charenton". Charenton-le-Pont is now a suburb of Paris, at the confluence of the Seine and the Marne.

Charger
A large dish or platter for meat or poultry. The name derives from that of a medieval servant or 'charger' who carried food to the table.
See: Poultry Dish; Well-and-Tree Dish.

"Chariot"
John Thomson.

"Charenton, near Paris." Maker unknown. Pineapple Border Series. Printed title mark. Dish 9½ins:24cm.

"Charles I Ordering the Speaker to Give up the Five Members"
Jones & Son. "British History" Series. Vegetable dish and cover.

In 1641 John Pym introduced a statement in Parliament, known as the Grand Remonstrance, which alleged unconstitutional acts by Charles I. In 1642 he was one of five members for the arrest of whom Charles I came in person to Westminster. The other four were Denzil Holles, Sir Arthur Haselrig, William Strode and John Hampden. This was one of the incidents which led to the Civil War.

Charlotte
Princess Charlotte Augusta, the only child of George, Prince of Wales, died in 1817. Thomas Fell of Newcastle made blue-printed tea wares showing a mother and child weeping at a tomb, believed to be Charlotte's. Fell started his pottery in the year of her death.

Another pattern, by an unknown maker, shows a portrait of the Princess and bears the caption: "In Commemoration of the late and much lamented Princess Charlotte of Saxe-Coburg who departed this life November 6th, 1817".

"Charles I Ordering the Speaker to Give up the Five Members." Jones & Son. "British History" Series. Printed titles and maker's mark. Vegetable dish and cover length 11¾ins:30cm height 6¾ins:17cm.

Cheetah Pattern. *Attributed to Dillwyn & Co. Unmarked. Plate 9¾ins:25cm.*

"Chase after a Wolf"
Spode. Indian Sporting Series. Soup plate 9¾ins:25cm. Ill: Coysh 1 96; Little 62; S.B. Williams 1, 3.

Chasing a Tiger across a River
This engraving taken from Williamson's *Oriental Field Sports, Wild Sports of the East* (1807), the source of Spode's Indian Sporting Series (qv), was used by an unknown maker for part of the scene on a dish. It was combined with part of another print titled "A Tiger Hunted by Wild Dogs" Ill: S.B. Williams 36-38.

"Chateau de Chillon"
Enoch Wood & Sons. "Italian Scenery" Series. Sauce tureen stand.
This château is a 13th century castle at the eastern end of Lake Geneva in Switzerland. It was drawn to the attention of the British public by the publication of Byron's *The Prisoner of Chillon* (1816).

"Cheddar, Somersetshire"
James & Ralph Clews. "Select Scenery" Series. Plate 9ins:23cm.
The small town of Cheddar lies at the entrance to the impressive Cheddar Gorge. The gorge is famous for its high cliffs and underground caves sculptured from the limestone rock of the Mendip Hills.

Cheese Coaster
A boat-shaped stand designed to hold a complete cheese on its side. Examples are commonly made in wood but rarely in earthenware. A blue-printed cheese coaster in the Norwich Castle Museum, decorated with the Spode Italian pattern is marked "MARE" impressed.

Cheetah Pattern
This pattern, illustrated in Coysh 2 146, has also been called the Leopard and Deer pattern. An example with a different border but with an impressed mark of Dillwyn & Co. of Swansea is to be found in the Kildare S. Meager Bequest in the Glynn Vivian Art Gallery, Swansea. A similar but unmarked example is illustrated.

"Chen Si"
Maker unknown. This title has been recorded on flown-blue teawares marked with initials I.M. They could relate to John Meir of Tunstall but he traded as John Meir & Son after 1836 and flown-blue wares are typically of slightly later date.

"Chepstow Castle" Pountney & Allies. Bristol Views Series. Printed title mark and impressed maker's mark. Dish 13ins:33cm.

Cherub Medallion Border Series. *Herculaneum. Typical printed mark with impressed maker's mark.*

"Chepstow Castle"
Pountney & Allies/Pountney & Goldney. Bristol Views Series. Dish 13ins:33cm. Ill: FOB 16.
 Lying on the west bank of the River Wye, Chepstow Castle overlooks the bridge, and its Great Tower dates from the late 11th century.

Cherub
A decorative motif in the form of a chubby winged child. See: Putti.

Cherub Medallion Border Series
A series of views, mostly of cities, by the Herculaneum Pottery. They are characterised by a distinctive border which includes medallions, three on plates and four on dishes, each containing two cherubs. Most examples bear a title cartouche but some are marked "Stone China". Views known to exist are:
 "Caernarvon Castle"*
 "Cambridge"
 "Canterbury"
 "Chester"
 "Cluny Castle"
 "Edinburgh"
 "Lancaster"*
 "Oxford" (Colour Plate XXI)
 "Shrewsbury"
 "Worcester"
 "York"

Chesapeake and Shannon
See: Shipping Series.

"Chester"
 (i) Herculaneum. Cherub Medallion Border Series. Pierced stand 11½ins:29cm.
 (ii) Enoch Wood & Sons. "English Cities" Series. Dish 12½ins:32cm.
 Chester is an ancient walled market and cathedral town with many half-timbered buildings. It is famous for The Rows, streets of shops on two levels.

Chestnut Basket
Small oval baskets on stands, usually about 9ins:23cm in length, are commonly thought to have been used for serving chestnuts. Most are decorated with piercing and mouldings but some are made of woven clay.

Chesworth & Robinson fl.1825-1840
Lane End, Staffordshire. A partnership which is believed to have used printed marks with the initials C. & R., and this gives rise to confusion with another firm, Chetham & Robinson (qv).

Chetham (& Son) fl.1810-1834
Commerce Street, Longton, Staffordshire. This firm was operated by Ann Chetham, a widow, who presumably continued the works after the death of her husband who was in the partnership of Chetham & Woolley (qv). The style became Chetham & Son in 1818. There is some overlap with the succeeding partnership of Chetham & Robinson (qv). The impressed mark "CHETHAM" has been recorded on a pierced stand with an impressive pattern of assorted fruit. Ill: FOB 15.

Chetham & Robinson fl.1822-1837
Commerce Street, Longton, Staffordshire. Marks with the initials C. & R. within a Staffordshire knot are known to have been used by this firm following excavations on the site. The Parkland Scenery pattern (Ill: Coysh 2 7; Little 15) has been positively identified by shards found during the excavations. Other C. & R. marks are not so readily attributed.
 See: Chesworth & Robinson.

Chetham & Woolley fl.1796-1810
Commerce Street, Longton, Staffordshire. Early chinoiserie wares have been recorded (See: FOB 17). The firm used an impressed mark "CHETHAM & WOOLLEY". When the partnership was dissolved Richard Woolley took over Turner & Co.'s pottery at Lane End.

"Chevy Chase"

A dinner service with this title was reported in FOB 31. It shows scenes from the border battle of this name which is said to have taken place at Otterburn between hunters of the Percy and Douglas families. The dinner plate view shows the hunters and dogs resting in a wood, the soup plate a hunter holding a white horse and blowing a horn, the tureen shows two hunters setting out with hounds and the lid shows a stag. The dessert plate depicts a hunter returning from the chase in triumph. The printed marks show shields with the Percy and Douglas crests. Below the shields the title "Chevy Chase" appears above the word "STONEWARE" and D.

"Chichester"

Enoch Wood & Sons. "English Cities" Series.

Chichester, a Roman, medieval and Georgian city, is now the administrative centre for West Sussex. It has a fine cathedral founded in the 11th century.

"Chichester Cathedral"

(i) Careys. Cathedral Series. Plate 9ins:23cm.

(ii) An untitled view by Ralph Stevenson is recorded in the "Panoramic Scenery" Series. Dish 16½ins:42cm.

The cathedral, built between the 11th and 16th centuries, replaced an earlier wooden structure. Today's impressive spire replaced one which fell in 1861.

Child, Smith fl.1763-1790

Newfield, Tunstall, Staffordshire. An impressed mark "CHILD" has been recorded.

See: "Quails".

Children's Plates

Many potters produced special small plates for children. Cheap printed decoration was the rule, often with very crude enamelling. The edges of the plates were frequently moulded in the form of daisies, and alphabet plates with the letters A to Z moulded around the border were also popular. These small plates were also used for commemorative transfers. See: May, *Commemorative Pottery*.

"Chile"

David Methven & Sons.

Chile was discovered by the Spaniards in the 16th century and continued under Spanish rule until 1818 when it became an independent republic. Trade with Chile was largely based on minerals, particularly natural nitrate.

China Clay

A white clay found in Devon and Cornwall resulting from the decomposition of granite. It is usually used for making porcelain but is sometimes added to other clays for earthenwares.

China Glaze

A proprietary term used by Copeland & Garrett on the Seasons Series.

Chinaman

The name given to a retailer selling porcelain and pottery. It derives from the fact that early porcelain was imported from China and the importers became known as chinamen. Towards the end of the 18th century the duty on imported Chinese porcelain started to become prohibitive for all but the well-to-do and the retailers were forced to look elsewhere for trade. At this time, thanks largely to the increased quality of wares of Josiah Wedgwood, William Adams, Josiah Spode and others, the output from Staffordshire was sufficiently good to substitute for the imported wares and many of the chinamen simply transferred their custom to the home factories. The name, however, had become too well established as meaning a seller of china, and as such remained in use well into the 19th century.

The Chinaman of Rank

A very rare Spode pattern known. A marked example is illustrated.

"Chinese"

Thomas Dimmock. A flown-blue chinoiserie pattern with a mark which includes the words "KAOLIN WARE" and the initial D.

"Chinese Bells"

Maker unknown. A pattern used on a miniature dinner service showing two Chinese boys, one holding a set of eight bells.

The Chinaman of Rank. *Spode. Printed and impressed maker's marks. Egg stand.*

"Chinese Bells." *Maker unknown. Printed oval mark with title in script. Miniature plate 3¼ins:8cm.*

Chinese Bird Catchers

Ralph Stevenson & Williams. A Chinese scene of pagodas and sailing boats. In the foreground are two figures, one of which has a basket and two birds hanging from a stick over his shoulder. The pattern is illustrated on an interesting moulded bowl with four pad feet and added gilding. The printed mark is in the form of the pre-Victorian Royal Arms and includes the name of the body, "ROYAL STONE CHINA", and the maker's initials.

"Chinese Dragon"

Maker unknown. A pattern similar to prints used by Spode (Whiter 27) and Masons (Coysh 1 58) with a rather ferocious dragon. The printed cartouche mark includes the word "Opaque", a reference to the body used. Ill: FOB 5.

Chinese Figure

Ferrybridge Pottery. Lawrence (p.157) mentions this title for a pattern produced during the Reed, Taylor & Co. period.

Chinese Flowers

Spode. An untitled design which shows the outline of flowers which were clearly intended to be filled in with coloured enamels. It dates from c.1815. Ill: Whiter 45.

"Chinese Fountains"

Elkin, Knight & Bridgwood. A romantic pattern with a central gazebo within an open border of birds and flower sprays. It is found on gadrooned edge dinner wares marked with a title cartouche and the initials E.K.B. Ill: P. Williams p.110.

A very similar design has been noted with the initial P in the title cartouche, frequently attributed to Pountney & Allies of Bristol.

Chinese Garden Scene

Davenport. An untitled scene which shows two Chinese figures in front of a single-storey house, all within a border of flowers and C-scrolls. A teapot is illustrated in Lockett 30.

"Chinese Marine"

A series of patterns with stylised Chinese landscapes which were almost certainly introduced by Minton and were copied later by several other potters (see Frontispiece). The Minton pieces bear a printed floral cartouche with C-scrolls which includes the title and a cursive initial M below the words "OPAQUE CHINA". The various potters used the same mark but inserted their own initials. Examples noted include B (unattributed), B. & S. (probably Barker & Son), F (thought to be Ferrybridge), G (found on shards excavated at Belle Vue Pottery, Hull), O (unattributed), and no letter at all (Thomas Fell & Co. amongst others). The Minton examples are usually of superior quality to the other potters' products. The patterns were printed in blue on wares with gadrooned edges, but some

"Chinese Dragon." *Maker unknown. Printed mark of a dragon with "CHINESE" on one wing, "OPAQUE" on the other and "DRAGON" on the body. Plate 9¾ ins:25cm.*

"Chinese Marine." *Minton. Printed title mark with a winged dragon, the words "OPAQUE CHINA", and a cursive initial M. Gadrooned plate 10½ ins:27cm.*

Chinese Bird Catchers. *Ralph Stevenson & Williams. Printed royal arms (pre-1837) with maker's initials and "ROYAL STONE CHINA". Square moulded bowl with gilt rim and four pad feet 9½ ins:24cm.*

pieces have been recorded in puce. Ill: Coysh 1 64, 65 (Minton); Bell, *Tyneside Pottery*, p.117 (Fell & Co.).

Other manufacturers made very similar patterns, examples of which are "Canton Views" by Elkin, Knight & Bridgwood and "Chinese Porcelain" by John Rogers & Son.

Chinese Market Stall

A transitional pattern by an unknown maker showing Chinese figures at a market stall. The border is of strip form including rococo motifs. Examples are known both with and without the name "Wear Sc." at the end of a fence in the design. This pattern is very similar in both style and layout to the Chinese Traders pattern by Stevenson (Ill: Coysh 2 104), which is also known with the Wear signature.

Chinese Market Stall. *Maker unknown. Unmarked. Plate 8¼ ins:21cm.*

Chinoiserie Ruins. *Job Ridgway. Impressed mark: "J.RIDGWAY" over a beehive. Soup plate 9½ ins:24cm.*

"Chinese Pagoda"

Maker unknown. This title is included in a printed cartouche mark.

"Chinese Porcelain"

John Rogers & Son. Ill: Godden BP 321. A pseudo-Chinese scene, very similar to the "Chinese Marine" designs, found on dinner wares with a gadrooned edge. The use of the word "Porcelain" is a misnomer, the pattern was produced only on earthenware.

Chinese River Scene

Davenport.
 See: View of the Imperial Park at Gehol.

Chinese Rose

Dillwyn, Swansea. A pattern showing a central bunch of roses within a floral border. It is not clear whether the wares are titled.

Chinese Scene after Pillement

 See: Precarious Chinaman.

"Chinese Temple"

John Meir & Son. A typical romantic Chinese-style scene with a large vase in the foreground. The pattern is titled together with the maker's initials within an oval frame surrounded by a small scenic vignette.

The same title has also been used for a pattern produced by Brameld at Swinton (Lawrence p.89), but it is not clear whether the wares are titled.

Chinese Traders

Andrew Stevenson. A Chinese scene showing traders carrying produce across a bridge. The plate illustrated in Coysh 2 104 is marked with a ship surmounted by the name "Stevenson" (Godden M 3700 without frame), and the print includes the signature "Wear Sc." A dish is shown in S.B. Williams 173 and a plate marked "New Canton" is illustrated in Atterbury p.189. Relatively few items decorated with this pattern have the engraver's signature and many pieces are unmarked. The impressed mark noted above is now generally accepted to refer to Andrew Stevenson.

"Chinese Views"

 (i) Edward & George Phillips. A typical pseudo-Chinese scene within a border which is very similar to that used by Spode on the Filigree pattern. Ill: Coysh 2 68.
 (ii) Robinson & Wood. Printed mark with the initials R. & W.
 (iii) Dillwyn & Co., Swansea. Printed mark with the title enclosed in a cartouche of C-scrolls and small flowers. Also known in black.

"Ching-Tien"

Allerton, Brough & Green. A design marked with initials A.B. & G.

The title may refer to Ching-tê Chên, a town in the Chinese province of Kiangsi, famed for its porcelain. The Kaoling hills in this area gave their name to kaolin, or china clay.

Chinoiserie

A widely used term meaning an imitation of Chinese art.

Chinoiserie Bridgeless Pattern

Davenport. A Willow pattern style design but without the willow tree or bridge. In addition to dinner and dessert wares a miniature dinner service has been recorded with this pattern, although without maker's mark. Ill: Coysh 1 27.

Chinoiserie Ruins. *John Rogers. Impressed maker's mark. Octagonal plate 8ins:20cm.*

Chinoiserie High Bridge
Davenport. A Chinese scene showing two pagodas joined by a distinctive high bridge crossing a river. There are three figures in the foreground. Ill: Coysh 1 30.

Chinoiserie Palm
Cambrian Pottery, Swansea. A typical Chinese scene with a pagoda and a very prominent palm tree. Ill: Coysh 2 112-113.

Chinoiserie Ruins
This pattern was probably introduced by Job Ridgway in about 1805. It is illustrated on a plate which bears an impressed J. Ridgway beehive mark. It was later produced in large quantities by John Davenport on dinner and dessert wares. Examples are illustrated in Coysh 1 26; Godden I 190; Little 22. A rare plate with this pattern and an impressed mark "ROGERS" is illustrated above. This could be a case of either Davenport buying Rogers wares in the white or Rogers borrowing the copper plates from Davenport. It is worth remembering that both these potters worked in Longport. Another rare example impressed "STEVENSON" is shown in Colour Plate XXVIII. A very similar pattern with an almost identical border was made by Dillwyn & Co. of Swansea. Ill: Coysh 2 114; Nance XLVIII.

"Chip Chase"
Possibly Knight, Elkin & Co. See: "Baronial Halls".

Chip Chase is the name of a hamlet in Northumberland which has both a hall and a castle.

"Chiswick on the Thames"
Enoch Wood & Sons. Shell Border Series. Stands for sauce tureen and pierced basket. Ill: Arman 128.

As with other items from this series, this view shows a shipping scene. In the foreground are a prominent sailing boat and a man, woman and child.

"Christ Church, Oxford"
John & William Ridgway. Oxford and Cambridge College Series. Plate 9¾ins:25cm (Ill: Laidacker p.64), and sauce tureen stand with a different view.

Christ Church was founded by Cardinal Wolsey in 1525.

The famous Tom Tower was completed by Wren in the 17th century and the Cathedral Church of Christ is the college chapel. It is predominantly Norman and Transitional but many changes have been made over the years.

"Christ and the Woman of Samaria"
Enoch Wood & Sons. Scriptural Series. Soup plate 10ins:25cm. Ill: Moore 18.

"Then saith the woman of Samaria unto him, How is it that thou, being a Jew, asketh drink of me, which am a woman of Samaria? for the Jews have no dealings with the Samaritans. Jesus answered and said unto her. If thou knowest the gift of God, and who it is that saith to thee, Give me a drink; thou wouldest have asked of him, and he would have given the living water." John 4, 9-10.

This scene is similar to a print after a painting by W. Hamilton R.A., although the figures have been reversed. The print was used as an illustration in *The Self-Explanatory Family Bible* (1847), published by Thomas Kelly of Paternoster Row, London, but there may well have been an earlier version available for Enoch Wood & Sons to use.

"Christianburg, Danish Settlement on the Gold Coast, Africa"
Enoch Wood & Sons. Shell Border Series. Dishes 18½:47cm, 20ins:51cm, 21ins:53cm. Ill: Arman 129; Laidacker p.102.

As with other items from this series, this view shows a shipping scene. Figures in the foreground look out at two sailing ships in a bay with a fort flying a prominent flag in the background. The former Danish fort and settlement near Accra was ceded to Great Britain in 1840 and became the official residence of the Governor-General. The Gold Coast became Ghana on independence in 1957.

"Christmas Eve"
James & Ralph Clews. "Wilkie's Designs" Series. Plates and teawares. Ill: Arman 87; Arman S 87.

"Christ Church, Oxford." *John & William Ridgway. Oxford and Cambridge College Series. Printed title and makers' mark. Plate 9¾ins:25cm.*

"Christ and the Woman of Samaria." *Biblical source print used by Enoch Wood & Sons in their rare Scriptural Series.*

"Church of England Missionary College, London"
William Adams. Regent's Park Series. Soup tureen.

A plain, substantial, useful building in Islington designed by the architect William Brooks who was also responsible for the London Institution.

"The Church of Resina at the Foot of Vesuvius"
Don Pottery and Joseph Twigg, Newhill Pottery. Named Italian Views Series.

Resina stands on the Gulf of Naples, at the south west base of Vesuvius and only four and a half miles south east of Naples, itself. It is built on the lava streams covering the ruins of Herculaneum.

"Church of St. Charles and Polytechnic School, Vienna, Germany" (sic)
Ralph Hall. "Select Views" Series. Dish 19ins:48cm.

An unusual choice to include in a series with only one other foreign view. Either the church or the school must have been in the news for some reason when the series was designed. They are on the southern side of the city in an area called Wieden. At the time the pattern was made Vienna was in the Austro-Hungarian Empire; it is now the capital of Austria.

"Chusan"
Joseph Clementson. A flown-blue pattern.

Chusan is the principal island of an archipelago of the same name off the Chinese coast, about eighty miles south of Shanghai. It was regarded as the key to China.

"Cialka Kavak"
Maker unknown. Ottoman Empire Series. Plate 8½ ins:22cm. Ill: P. Williams p.228.

This is a scene which shows a log house. In the foreground is a woman carrying a bucket in one hand and balancing a bundle on a stick with the other.

"Cintra"
Copeland & Garrett. Byron Views Series. Sauce tureen cover and circular drainer with different views.

The modern spelling for this resort in south west Portugal is Sintra. It was the summer residence of the Portuguese kings. An 1810 gazetteer refers to Cintra as "a cape of Portuguese Estremadura, otherwise called the Rock of Lisbon, on the north side of the entrance to the Tajo. Near it is a town of the same name".

"Circassia"
John & George Alcock. A light blue pattern.

Circassia was an area north of the Caucasus Mountains between the Black Sea and the Caspian Sea. The people had no written laws. By the early 19th century the Circassians had become subject to Russian rule.

Citadel near Corinth
Spode. Caramanian Series. Supper set and dish 11½ ins:29cm with transfers reversed. Ill: Coysh 2 90; S.B. Williams 51.

According to S.B. Williams this scene is not copied from the source book used for the rest of the series. It shows the citadel in the background in front of which is a river crossed by a three-arch humped bridge. There is a group of figures in the foreground.

Cities and Towns Series
A series of views of towns and cities in the British Isles made by Charles Harvey & Sons of Longton. The border consists of two alternating flower groups within scroll framing. Relatively few pieces bear the impressed makers' mark "HARVEY" although the titles are found on a leafy ribbon cartouche. The known views are:

"Cambridge"*
"Canterbury"
"Dublin"
"Edinburgh"*
"Gloucester"*
"Greenwich"*
"Oxford"
"Richmond"
"York"

The Cambridge view has been noted marked "Greenwich" in error.

Cities and Towns Series. *Harvey. Typical printed mark.*

"City of Benares"
John Hall & Sons. "Oriental Scenery" Series. Plate
6¼ ins:16cm.

"City of Benwares" (sic)
Maker unknown. "Oriental Scenery" Series. Small deep dish.

Benares is an ancient town in northern India on the River
Ganges. It is a holy city of Hinduism and a centre of the Siva
culture. The modern name is Varanasi.

"City of Canterbury"
Enoch Wood & Sons. Grapevine Border Series. Vegetable
dish.
 See: "Canterbury".

City of Corinth
Spode. Caramanian Series. Soup plate 10ins:25cm, and dishes
12½ ins:32cm and 13½ ins:34cm. Ill: Coysh 2 88 and S.B.
Williams 46-52.

There are two versions of this pattern, one on dishes with
figures in the foreground which include a man leaning on a
stick and carrying an axe, and the other on soup plates with
horsemen and a dog in the foreground.

Corinth is a town in southern Greece on the isthmus which
joins Morea to the mainland. At the nearby ancient city of
Corinth are important ruins at the acropolis, or citadel, of
Acrocorinth.

"Clare Hall, Cambridge"
John & William Ridgway. Oxford and Cambridge College
Series. Plate 8ins:20cm.

In 1326 Richard Badew, Chancellor of the University,
founded a college in Milne Street called University Hall. In
1338 it was refounded by his wife, daughter of Gilbert de
Clare, as Clare Hall. It was rebuilt in 1638 but not completed
until 1715. This explains the mixture of architectural styles.

"Claremont"
 (i) Beardmore & Edwards. A pattern name found with the
initials B. & E.
 (ii) Minton. A floral pattern illustrated on a toast-rack. A
printed scroll cartouche contains the words "Claremont/Stone
China" and a cursive M.

"Claremont, Surrey"
Enoch Wood & Sons. Grapevine Border Series. Dish
10½ ins:27cm.

In addition to this titled view, one of the untitled views in the
"British Views" Series (qv) is reputed to show Claremont with
Prince Leopold and Princess Charlotte in the foreground (See:
May p.28). There are also some unattributed teawares which
carry a medallion print of the house with two figures by the
entrance, presumably the Prince and Princess.

Claremont House was built on the site of an earlier house by
Henry Holland in partnership with Capability Brown who laid
out the gardens. It was given by the Prince Regent to Princess
Charlotte and Prince Leopold of Saxe Coburg. The Princess
died in 1817. Claremont House is now a school and the famous
landscape garden is in the possession of the National Trust.

"Clarence House"
William Adams. Regent's Park Series. Sucrier 7½ ins:19cm.

Clarence House, not far from Buckingham Palace, is linked
to St. James's Palace. It was built by Nash in 1825-27 for the
Duke of Clarence, before he became William IV, and enlarged
in 1873.

"Clarence Star"
Zachariah Boyle. An open pattern with leaves and stars noted
on a small ewer and basin. The printed title mark includes the
maker's initials Z.B.

"Classical Antiquities" Series. *Joseph Clementson. Typical
printed mark. Note the registration diamond for 13th March, 1849. See:
Registration Mark.*

"Clarence Terrace, Regent's Park"
Enoch Wood & Sons. "London Views" Series. Dish
13ins:33cm.

"Clarence Terrace, Regent's Park, London"
William Adams. Regent's Park Series. Dish 10½ ins:27cm.

Named after His Royal Highness the Lord High Admiral of
England, and designed by Burton, this terrace was one of the
smallest in the Park.

"Classical Antiquities" Series
A series by Joseph Clementson which shows scenes from the
classics printed in white on a blue ground although examples in
brown are known. The central figures appear within a string of
running ivy and the border consists of groups of ancient vases
framed by acanthus scrolls. The patterns were registered on
13th March, 1849 and are marked with an ornate cartouche
which includes the series title, the name of the individual
scene, the maker's name, and the registration diamond. The
scenes appear on dinner wares, each item with a different
pattern. The following have been recorded:
 "Diomed Casting His Spear Against Mars"
 "Nestor's Sacrifice"
 "Phemius Singing to the Suitors"*
 "Ulysses at the Table of Circe"

Classical Landscape
Masons (probably C.J. Mason & Co.). A pattern showing a
view of ruins in an octagonal frame with a border of
architectural fragments. Examples usually bear an impressed
mark "MASON'S CAMBRIAN ARGIL" but some are
known on the standard ironstone body. Plates are illustrated in
Coysh 2 55; Little 39. The latter example has the engravers'
name "Bentley, Wear & Bourne Scpt" within the border.

The view is remarkably similar to that on a print in
Bowyer's *Historic Gallery* (1812) which is titled "Sepulchre of
Rachel".

Classical Ruins

An untitled classical scene which shows a man on a tomb in front of a pyramid-shaped wall. There is a bridge in the right background behind which is a cottage. In the foreground is a shepherd boy with a sheep. The pattern is known by two makers:

(i) John Dawson & Co. The central design covers the whole of the ware with only a blue line on the edges. Ill: Shaw, *Sunderland Ware*, p.15.

(ii) Thomas Lakin. The scene is printed within a strip border of trees and cottages. Examples are sometimes impressed "Lakin" in lower case letters and there are several variations in detail of the scene. Ill: Little 40.

Claude Lorraine 1600-1682

Born in Nancy, this artist spent most of his life in Italy and by 1630 had already acquired a reputation as a landscape painter. His compositions usually show a large group of trees on one side with a smaller group on the other. In the middle distance is a feature, such as a building or a bridge, and in the far distance are mountains or rivers. He also painted port scenes in a similar style.

Several patterns based on paintings by Claude Lorraine are known. An example by Benjamin Adams is illustrated in Godden I 7; Little 4.

See: Scene after Claude Lorraine (Leeds Pottery and John & Richard Riley); Ponte Molle (maker unknown); Blue Claude (Wedgwood).

Clementson, Joseph fl.c.1839-1864

Phoenix Works, Shelton, Hanley, Staffordshire. This firm made printed wares for the home market but also exported to Canada and the U.S.A. Printed marks include either the initials J.C. or I.C. or the full name "J. Clementson". Many printed wares were made in colours other than blue. Some of the wares were of very good quality, well potted and clearly printed. Gadrooned edges were used.

Clews, James & Ralph fl.1815-1834

Cobridge Works, Cobridge, Staffordshire. The Clews brothers rented these works from William Adams. They specialised in blue-printed wares and produced several series of patterns including some for the American and Russian export trade. They produced three series of British views, one titled "Select Scenery", one with the Bluebell Border also used by William Adams, and the third within a foliage and scroll border, once again used by Adams but this time also using the same untitled views.

Three unusual series were made, the Doctor Syntax Series, the "Wilkie's Designs" Series, and the Don Quixote Series. Another later production was the "Zoological Gardens" Series. These were all exported to America.

The main mark consists of the words "CLEWS WARRANTED STAFFORDSHIRE" impressed usually between concentric circles surrounding a crown. Other known marks include simply "CLEWS" impressed and a printed pseudo-Chinese seal mark with the name "CLEWS" and the words "Stone China" beneath.

Clews pirated Spode's Castle pattern and also some of the Indian Sporting patterns. The latter were almost certainly made only for export to America, several examples having been recorded with a printed mark of the New York importer John Greenfield.

Most existing references state that the partnership did not begin until 1818 or 1819 but documentary evidence proves that they were operating in November 1815 under the style R. & J.

"**Clifton Rocks.**" *Pountney & Allies/Pountney & Goldney. Bristol Views Series. Printed title mark. Dish 9½ ins:24cm.*

Clews which was also used at the end of their partnership.

In 1837 James Clews went to America and joined the Indiana Pottery Company as one of its three principals. He stayed for five years.

"Clifton"

Pountney & Allies/Pountney & Goldney. Bristol Views Series. Dish 14ins:36cm.

Clifton is now a suburb of Bristol, famous particularly for the Clifton Gorge on the River Avon and Brunel's suspension bridge. It was originally a watering place in Gloucestershire.

"Clifton Rocks"

Pountney & Allies/Pountney & Goldney. Bristol Views Series. Dish 9½ins:24cm.

A view looking up the River Avon from the gorge to the New Hotwells House with Princes Buildings and Windsor Terrace.

Clive, John Henry fl.1802-1811

Newfield, Tunstall, Staffordshire. According to Little, Clive is reputed to have been one of the earliest and most successful pioneers in the introduction of ornamental engravings into the blue-printed trade. He is also said to be the first potter to use repeat borders on printed wares, a process suggested by William Brookes. The only recorded mark is "CLIVE" impressed.

Clobbering

A number of underglaze blue-printed patterns can be found touched up with enamels applied over the glaze. The Spode Greek pattern was occasionally enamelled in this way with the reserves outlined in red (see Colour Plate III), and a similar treatment was also used on the borders of the Spode India and Italian patterns. This is known as clobbering. The most notable example of this process is found on items from the Beaded Frame Mark Series on which the flowers and leaves in the border are frequently coloured pink, reddish-brown, yellow and green. The rims are coloured reddish-brown or gilded (see Colour Plate IV). Two other designs on which the process was often used are the Mason's Blue Pheasants and Rose patterns.

The clobbering of rims was not uncommon. Swansea and Herculaneum are known to have produced wares with ochre rims and Shorthose teawares are often clobbered with an orange colour. This practice was almost certainly used at several other factories.

Clobbering as a technique is distinct from the practice of designing prints with areas intended to be filled in with enamels.

See: Filled-in Transfers.

"Clumber"
S. Keeling & Co. "Baronial Views" Series.
Clumber Park is near Worksop in Nottinghamshire.

"Cluny Castle"
Herculaneum. Cherub Medallion Border Series. Sauce tureen stand.
This castle in Aberdeenshire was rebuilt in 1836 by John Smith as a castellated mansion.

Clyde Pottery Co. fl.1857-1872
Greenock, Scotland. This company succeeded Thomas Shirley & Co. and the firm had a considerable export trade to Canada. Marks include the word "Clyde". Initial marks were also used in the forms G.C.P. Co. or simply C.P. Co.

Cobalt
A metal similar to nickel which, in the form of cobalt oxide, was used to produce the blue printing inks. The cobalt ores used in the pottery industry were mainly imported from Germany although some came from Cornwall. The ores were converted into cobalt oxide by a roasting process, the result being known as zaffre. Spode plates are known with a printed inscription which records the use of British cobalt from Cornwall.
See: Wheal Sparnon Mine Inscription.

"Cobham Hall"
Knight, Elkin & Co. "Baronial Halls" Series. This view has the name of the engraver "Felix Austin Sc." incorporated in the design.
Cobham Hall is at the village of Cobham in Kent, four miles south of Gravesend. It is famous for its woods and is a mixture of Gothic and Renaissance architecture, dating from 1587. It has a fine interior by James Wyatt. Originally the seat of the Earl of Darnley, it is now a girl's public school.

Cobridge
A parish of Burslem. Amongst the potteries in the parish were those run by John & George Alcock, James & Ralph Clews, the Godwin family, both Andrew and Ralph Stevenson, and Jones & Walley.

Cochran, Robert & Co. fl.1846-1918
Verreville Pottery, Glasgow. This pottery produced blue-printed wares when operated by John Geddes, and after a partnership as Kidston & Price, it was taken over by Robert Cochran and operated under the above name. It was located at Finnieston on the north bank of the Clyde. The firm also operated the Britannia Pottery at St. Rollox, Glasgow. Printed or impressed marks include the initials R.C. & Co. or the name in full.

Cockle Plates
Small plates were specially made for use on market stalls selling seafood in coastal towns. A Swansea example from the Cambrian Pottery bears a cockle shell design and is marked "DILLWYN" impressed. Ill. Coysh 1 127. Similar small plates were used for serving eels.
See: Eel Plates.

Cockson & Harding fl.1856-1862
New Hall Works, Shelton, Staffordshire. This firm succeeded the various Hackwood partnerships, specifically Thomas Hackwood. They were in turn succeeded by W. & J. Harding (qv). They marked their wares C. & H., sometimes with the addition of the words "LATE HACKWOOD". There is often some confusion between this firm and Harding & Cockson (qv) of Cobridge.

"Coke Thorpe, Oxfordshire"
Maker unknown. Foliage Border Series. Plate 6¾ins:17cm, and leaf dish.

"Cokethorpe Park, Oxfordshire"
Enoch Wood & Sons. Grapevine Border Series. Sauce tureen stand.
Cokethorpe Park, which lies two and a half miles south east of Witney, was begun in 1709 by Sir Simon Harcourt. There were, however, later 18th century additions including a new entrance with an Ionic porch on the south side.

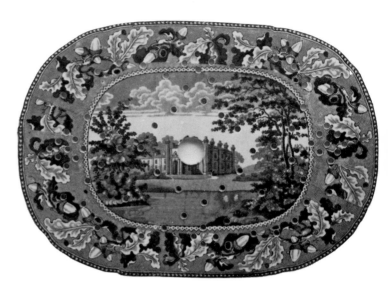

"Cole Orton Hall, Leicestershire." Maker unknown. Crown Acorn and Oak Leaf Border Series. Printed title mark. Drainer 11¾ins:30cm.

"Cole Orton Hall, Leicestershire"
Maker unknown. Crown Acorn and Oak Leaf Border Series. Drainer 11¾ins:30cm, and dessert dish.
Cole Orton Hall was built in the Gothic style by George Dance the Younger between 1804 and 1808 for Sir George Beaumont. He was a friend of many artists and poets including Coleridge, Constable, Landseer and Wordsworth. A second floor was added in 1862.

"Coliseum"
Enoch Wood & Sons. "Italian Scenery" Series. Dish 10ins:25cm.
This celebrated amphitheatre in Rome was begun by Vespasian and completed in A.D. 80 by Titus. It was originally known as the Flavian amphitheatre but the word Coliseum was first used by Bede because of its size. It was used as an arena for gladiators and is estimated to have seated 87,000 people with standing room for another 20,000.

"The Coliseum"
William Adams. Regent's Park Series. Sauce tureen stand.

"The Coliseum, Regent's Park"
Enoch Wood & Sons. "London Views" Series. Plate 6½ins:16cm.
This sixteen-sided building with a Doric portico and surmounted by a vast cupola, was designed by Burton. It was intended to house a panoramic view of London taken from the top of St. Paul's Cathedral by a surveyor named Hornor.

"Cologne." Ralph Stevenson & Son. Printed title mark with maker's initials. Plate 9½ ins:24cm.

"Cologne." Rock cartouche with title and maker's initials.

Colnebrook (sic)
A scene entitled "View near Colnebrook" was included in the "Metropolitan Scenery" Series by Goodwins & Harris. An almost identical view of Colnbrook, generally referred to as the Cows Crossing Stream pattern (qv), was made by Dillwyn of Swansea but without a title mark.

"Cologne"
(i) John Alcock. A typical romantic scene with a Gothic church and a castle in the background. Ill: P. Williams p.234.

(ii) John & George Alcock. The same pattern as above. One example has been recorded with an American importer's mark "Wright & Pike/Importers/North 3rd Street/Philadelphia".

(iii) Ralph Stevenson & Son. Another romantic scene with a round castellated tower as the main feature. The wares bear a rock cartouche. One example has been noted with a printed mark of the Norwich retailer Lovick (qv). Ill: P. Williams p.235.

"Colonna"
Thomas Goodfellow. A pattern printed in light blue on ironstone wares.

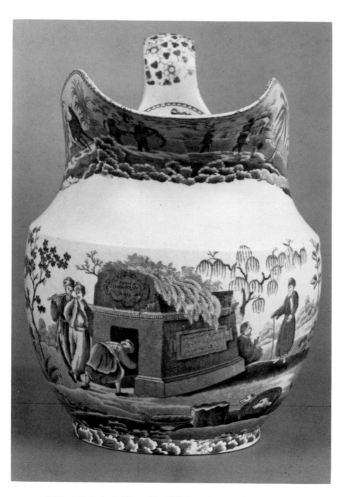

Colossal Sarcophagus near Castle Rosso

(i) Spode. Caramanian Series. Soup tureen, butter stean, scent jar, candlestick and water ewer. Ill: Whiter 93; S.B. Williams 64-65.

(ii) Maker unknown. The same basic pattern as the Spode design printed on dinner wares with a simple edge of stringing.

For some reason Spode used this design for many of the most uncommon items in the Caramanian Series. The second version by an unknown maker was probably copied from the source print rather than the Spode wares since it is closer to the original engraving.

The pattern shows robbers entering a tomb. It was not uncommon in the Near East for thieves to rob tombs of gold, silver, bronze or copper found with the funerary equipment.

See: Cacamo.

"Columbia"

(i) William Adams & Sons. A romantic scene printed in light blue on ironstone dinner wares. Ill: P. Williams p.237.

(ii) John & William Ridgway. A design of stylised flowers with a central circular motif.

(iii) John Wedg Wood. A light blue dinner service decorated with romantic scenes registered on 23rd August, 1848. Ill: P. Williams p.238.

Columbia is a name with many American connections. It is the name of a river in Washington state, a district which includes the American capital of Washington, and of cities or towns in Pennsylvania, South Carolina and Missouri.

"Columbian"

George Phillips.

Colossal Sarcophagus near Castle Rosso. *Spode. Caramanian Series. Printed maker's mark. Ewer height 9¼ ins:24cm. to top of handle.*

Colossal Sarcophagus near Castle Rosso. *Maker unknown. Unmarked. Dish 21ins:53cm.*

"Columbia." *John & William Ridgway. Printed shield mark with title, "STONE CHINA", and maker's initials "J.W.R.". Gadrooned soup plate 10ins:25cm.*

"Columbus"
William Adams & Sons. A series of imaginative scenes in the adventures of Christopher Columbus following his landing in America, contained within a border of floral sprays and medallion views with animals. Wares are also printed in blue-green, pink, black, sepia and purple. Ill: Laidacker p.12; Moore 61; P. Williams p.480 (two examples).

Comb Bank, Kent
John & William Ridgway. Angus Seats Series. Sauce tureen, sauce tureen stand and lid for vegetable dish.

In common with all items in this series the view is not titled and marked pieces are very rare.

Combe Bank is three quarters of a mile north east of Brasted in West Kent. The above title, without the final e, is taken from the source print by Angus.

Combermere
A blue-printed mug by an unknown maker bears the figure of Lord Combermere on horseback. The same pattern is known but with the mounted figure of Lord Hill. Both designs show the Duke of Wellington on the reverse. Ill: May p.107 (all three patterns).

Combermere commanded the cavalry division in the Peninsular War and in 1826 besieged and took Bharatpur, a fort regarded as impregnable.

Combing
The clay on the base of dishes has sometimes been combed to produce a ridged surface. This was done to reduce the likelihood of the dishes sliding about on the smooth marble, slate or stone slabs used to keep food cool in 19th century pantries.

"The Coming of the Wise Men"
Enoch Wood & Sons. Scriptural Series.

"Now when Jesus was born in Bethlehem of Judaea in the days of Herod the King, behold, there came wise men from the east to Jerusalem. Saying, where is he that is born King of the Jews? for we have seen his star in the east, and are come to worship him." Matthew 2, 1-2.

Commemorative Wares
Since commemorative wares were of their very nature produced over a short period they have long been of special interest to collectors. However, examples are rare and keenly sought after. They are fully discussed by May.

"Commerce"
Edward & George Phillips. A pattern which is marked with the initials E. & G.P.

The same title was used for a series of trading scenes by Samuel Alcock but it is not clear whether they were printed in blue. Ill: P. Williams pp.481-482 (three examples).

Commissions
The potters of blue-printed wares received many special commissions to produce individual items or services with particular decoration. Amongst these were Armorial Wares (qv) for civic authorities, livery companies and important families, dinner and dessert services for colleges and other organisations (see, for example, the "Carlton Club"), marked wares for use in particular inns, and presentation pieces, usually mugs or jugs, marked with the names of private individuals. There is even one service printed on the reverse with music so that diners could pick up their plates and sing grace!

"Commodore MacDonnough's Victory" (sic)
Enoch Wood & Sons. Shell Border Series. Teawares and various size plates. Ill: Arman 130; Little 80.

This pattern shows a fleet of sailing ships at battle, one of which has many prominent holes in its sails. Thomas Macdonough (1783-1825) was an American naval commander. In 1814 he was in command of a fleet of freshwater ships on Lake Champlain which engaged Sir George Prevost's forces. The resulting American victory led to questions about Prevost's leadership as Commander-in-Chief.

"Common Wolf Trap"
Spode. Indian Sporting Series. Plate 8½ins:22cm, dished plate 7¼ins:18cm and egg stand. Ill: Coysh 1 99-100; S.B. Williams 6-7.

"Como"
John Meir & Son.

Como is an Italian lake with a town of the same name at its southern end. It was here that the younger Pliny was born.

"**Compton Verney, Warwickshire.**" *Enoch Wood & Sons. Grapevine Border Series. Printed title mark and impressed maker's eagle mark. Plate 8¾ ins:22cm.*

"Compton Verney"
(i) Henshall & Co. Fruit and Flower Border Series.
(ii) Ralph Stevenson. Stevenson's Acorn and Oak Leaf Border Series. Dish 11½ ins:29cm, and pierced stand.

"Compton Verney, Warwickshire"
Enoch Wood & Sons. Grapevine Border Series. Dish 11ins:28cm, and plate 8¾ins:22cm. Ill: P. Williams p.240.

The house at Compton Verney was built in 1714 by an unknown architect for George Verney, Dean of Windsor. In 1760 Robert Adam was called in to reconstruct the building but the result is somewhat lacking in unity. The gardens, however, were laid out with great taste with a lake, cedar trees and a three-arch bridge, all of which can be seen on the printed wares.

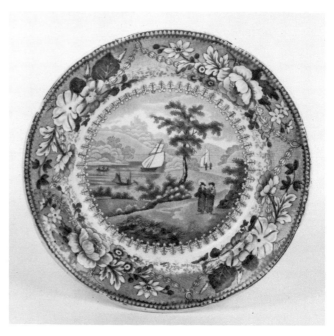

"**Cook's Folly.**" *Pountney & Allies/Pountney & Goldney. Bristol Views Series. Printed title mark and impressed P. Plate 8½ ins:22cm.*

"Continental Cathedrals"
Thomas Shirley & Co. A series of romantic scenes marked with the potters' initials, a beehive and an anchor. They are imaginary scenes printed within a border of vignettes separated by scrolls and geometric panels. Ill: P. Williams p.241.

"Continental Scenes"
Copeland & Garrett.

Conversation Pattern
Joshua Heath. An early chinoiserie pattern in which two men face one another on a one-arch bridge, apparently in earnest conversation. Ill: Coysh 1 8.

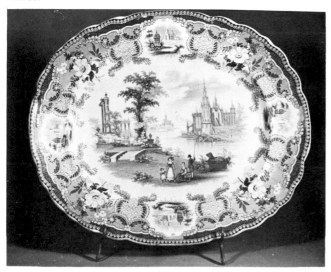

"**Continental Cathedrals.**" *Thomas Shirley & Co. Printed title mark with maker's initials. Dish.*

"**Continental Cathedrals.**" *Beehive and anchor title mark with maker's initials.*

"Conway Castle, Caernarvonshire, Wales"

Ralph Hall. "Select Views" Series. Dish 15½ins:39cm.

The town and castle of Conway, now called Conwy, was planned by Edward I in 1283 to command the Conway ferry. The eight-towered castle, although cramped and smaller than other major fortresses, is one of the most perfect medieval castles. The building was basically completed at great speed and the expense bankrupted half the banking-system of Europe.

"Cook's Folly"

Pountney & Allies/Pountney & Goldney. Bristol Views Series. Plate 8½ins:22cm.

Cook's Folly is on the north west side of Bristol near the Sea Walls of Durdham Down. It is an ivy-clad tower, once attached to a house which has given place to a castellated villa. The tower was built about 1696 as an ornament to the residence of John Cooke, an ex-Master of the Merchant Venturers' Society and Treasurer of the Corporation of Bristol. The e is dropped from his name when used in association with the folly.

Copeland & Garrett fl.1833-1847

Spode Works, Stoke, Staffordshire. William Copeland was a partner in the Spode business from 1805, and his son, William Taylor Copeland, joined the partnership in 1824. The works were taken over completely by the son in 1833 when he was joined by a new partner, Thomas Garrett. There was a considerable element of continuity and many of the old patterns continued to be made alongside new designs. One of the most significant changes in the sphere of printed wares was the development of printing in new colours, particularly green. The "Aesop's Fables" series provides a good example of this trend. Some blue services were made by Spode before 1833 but when Copeland & Garrett took over most of the dinner wares in the series were printed in green. Another notable production, the Byron Views Series, was printed in large quantities in green, although blue wares are common and other colours were also used. The period of blue printing virtually ended with the Spode regime, although some of the earlier lines were continued for many years.

Printed and impressed marks usually include the name in full, often with the addition of the words "Late Spode". Unlike the earlier Spode designs, pattern titles were widely used.

Copeland, W.T. (& Sons) fl.1847 et seq.

Spode Works, Stoke, Staffordshire. William Taylor Copeland took over the famous Spode Works from Copeland & Garrett in 1847 and continued to use the Spode name as part of many marks, usually with the name Copeland. The style became W.T. Copeland & Sons in 1867 and this continued until relatively recently, the style now having reverted to Spode. Some of the early Spode and Copeland & Garrett designs were continued and a few are still produced to this day. A few new patterns were introduced but they have been neglected by collectors in favour of the earlier wares.

Copper Plate

Printed wares are produced by engraving the design on a flat copper plate and transferring the ink from the engraved plate via a special form of tissue paper to the biscuit pottery. Copper was not a cheap metal and many of the plates were either sold for scrap when designs were discontinued or re-engraved for a new pattern. A few such plates are in private collections and others are preserved in surviving factories. An example is shown in Shaw *Sunderland Ware*, 8.

See: "Wild Rose".

"Coral Border." *Pountney & Goldney. Printed mark "STONE WARE/CORAL BORDER". Impressed "POUNTNEY & GOLDNEY" about a cross. Plate 10ins:25cm.*

Copyright

Until 1842 there was no law to prevent potters from copying patterns from illustrations in books. By far the majority of the earlier views found on blue-printed wares were based on engravings, including prints from topographical books which were in great vogue. When the 1842 Copyright Act was passed it became illegal to pirate any material from such a book for forty-two years after first publication. Thus, one of the main sources of patterns for ceramics dried up, and this explains the general decline into romantic or idealised views for the later wares.

"Coral Border"

(i) Thomas Dimmock. A design of stylised flowers and leaves within a border of similar sprays framed by coral branches. It is marked with the initial D and the word "Stoneware". Ill: P. Williams p.619.

(ii) Goodwins & Harris. An example of the above design by Thomas Dimmock but with the impressed mark "GOODWINS & HARRIS" is illustrated in Coysh 2 38 under an attributed title of Stylised Flowers. It is not known whether other examples bear a printed title.

(iii) Pountney & Goldney. The title has been recorded on a marked dinner plate in the Bristol Museum.

"Corean"

Podmore, Walker & Co. A flown-blue design printed on ironstone dinner wares.

See: Marine Archaeology.

"Corf Castle" (sic)

Minton. Minton Miniature Series. Tureen 4¼ins:11cm.

Corfe Castle in Dorset was destroyed by gunpowder by the Cromwellians as a reprisal for the support given to Charles I in the Civil War. The sheer strength of the building made this no easy task, and the walls were not completely destroyed but only tilted to a drunken angle, much as they can be seen today.

Corigliano

Patterns entitled "On the Heights of Corigliano", and "View of Corigliano" were included in the Named Italian Views Series by the Don Pottery and Joseph Twigg of the Newhill Pottery

Corigliano, a town in Calabria near the Gulf of Otranto, is noted for a fine castle.

"Corinthia"

(i) Edward Challinor. A pattern printed in light blue.

(ii) Minton. A floral pattern. The border has four separated floral sprays. "Opaque China" mark with title and cursive M.

(iii) Wedgwood & Co. A romantic castle scene with a border of scrolled medallion vignettes. Ill: Coysh 2 126; P. Williams p.244.

"Corinthian"

Maker unknown. A romantic open-style pattern showing a ruined temple within a border of flowers and scrolls. The title is printed in script within a pair of leafy tendrils with the initial B. beneath. This initial was used by several potters between 1830 and 1860.

Cork & Edge fl.1846-1860

Newport Pottery, Burslem, Staffordshire. Printed marks include either the name in full or the initials C. & E., often with the name of the body used. They were succeeded by Cork, Edge & Malkin (qv).

Cork, Edge & Malkin fl.1860-1871

Newport Pottery, Burslem, Staffordshire. Printed marks with the initials C.E. & M. refer to this firm. Amongst many other designs they produced a miniature dinner service with the printed title "Fishers".

Cornfoot Partnerships fl.c.1829-c.1847

Low Lights Pottery, North Shields, Northumberland. Three partnerships including the name Cornfoot ran this pottery.

Cornfoot, Colville & Co. took over the factory in c.1829 and were followed by Cornfoot, Patton & Co. By 1834 the firm had become Cornfoot, Carr & Patton but by 1847 they were trading as Carr & Patton. The impressed mark "CORNFOOT, COLVILLE & CO." has been recorded on blue-printed wares and no doubt all the partnerships produced such wares.

Cornucopia Flower Border Series

Davenport. An uncommon series of country scenes printed in a fairly dark blue on dinner wares. The border consists of various flowers, including roses and daffodil-like blooms, and includes a prominent feature of flowers and leaves in the form of a pair of cornucopia. The example illustrated shows the most common scene with an unidentified country house in the background, but others are known.

"Cornwall Terrace, Regent's Park, London"

William Adams. Regent's Park Series. Dish 19ins:48cm.

Cornwall Terrace was named after the ducal title of George IV when he was Prince Regent. The Corinthian buildings were designed by Decimus Burton.

"Coronation"

James & Ralph Clews. A floral pattern used on dinner wares. The printed cartouche mark includes a garter and crown and bears the maker's name, the title, and the words "STONE CHINA". A round handled sauce tureen with this pattern is in the Norwich Castle Museum. Ill: Coysh 1 21; P. Williams p.620.

"Coronation of George IV"

Jones & Son. "British History" Series. Soup tureen.

George IV was crowned in 1820 in an extravagant ceremony which apparently met with little public enthusiasm. It has been suggested that the "British History" Series was made to commemorate this event but since Jones & Son were not in existence until 1826 it appears to be pure speculation.

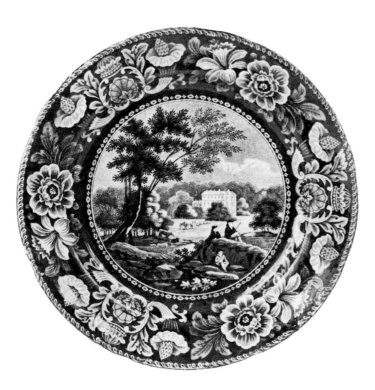

Cornucopia Flower Border Series. *Davenport. Country scene. Impressed maker's anchor mark. Plate 8ins:20cm.*

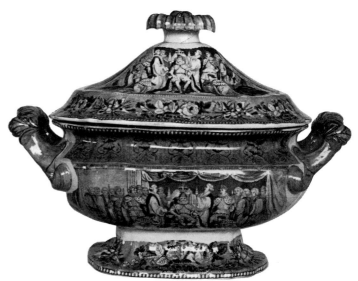

"Coronation of George IV." *Jones & Son. "British History" Series. Printed titles and maker's mark. Tureen length 14¼ins:36cm, height 15¾ins:29cm.*

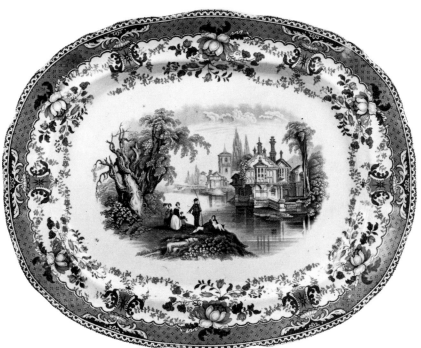

"**Cottage Scenery.**" *William Emberton & Co.*
Ornate printed mark with a cottage, the title and
maker's initials. Dish 17½ ins: 44cm.

"Corsica"

Wood & Challinor. A romantic scene with ruined pillars and figures within an elaborate border of geometrical patterns and medallions with baskets of flowers and scenic vignettes. Ill: Coysh 1 139.

"Cottage"

Benjamin Godwin. An Italianate country scene printed on toy tea services. Some pieces have the initials B.G. as part of the printed mark, others have simply B.

The Cottage Girl

Baker, Bevans & Irwin. A pattern found on jugs and teawares showing a girl water-carrier with a dog in front of a cottage. The design is taken from an engraving by W. Finden which was based on a painting by H. Howard R.A. and published by James Robus & Co. of London in 1831. Ill: P. Williams p.483.

Cottage and Vase

Leeds Pottery. An untitled pattern showing a central cottage with a prominent vase in the left foreground, all within a narrow floral border. Ill: Lawrence p.52.

"Cottage Scenery"

William Emberton & Co. A typical romantic scene with ornate buildings within an open floral border.

Cottage in the Woods

Enoch Wood & Sons. A dark blue pattern with a trefoil border found on cup plates. It has also been called Ruggles House. Ill: Laidacker p.107.

Cotton & Barlow fl.1850-1855

Commerce Street, Longton, Staffordshire. The initials C. & B. appear as part of printed marks.

Coughton Court, Alcester

A view of this building forms the background to one of the patterns which bear the printed title "Etruscan & Greek Vases". The foreground includes a prominent classical vase.

Coughton Court, at Alcester in Warwickshire, has been the home of the Throckmorton family since 1409. The central gatehouse dates from 1509 and there are two mid-Elizabethan half-timbered wings.

Country Church. *Davies, Cookson & Wilson. Impressed circular maker's mark. Plate 9¼ ins: 23cm.*

Country Church

A pattern showing a church with a spire in a rural setting, all contained in a floral border. The same border was also used on a series titled "British Scenery" by an unknown maker. The Country Church pattern is known on marked wares by both Cornfoot, Colville & Co. (Ill: Coysh 1 25), and Davies, Cookson & Wilson of the Stepney Bank Pottery.

Country Scene

A name given by Whiter to a rare Spode pattern which shows cows standing in a stream with a stone barn with a square tower in the background. There is a simple, narrow border of geometric form. Ill: Whiter 62.

"Country Scenery"

Lockhart & Arthur of Glasgow.

Coursing Scene

Maker unknown. A hare coursing scene on a plate with no formal border but only a narrow band of stringing at the edge is illustrated in Little 118. This particular scene is based on a print after Howitt published in 1798 and republished by Edward Orme of Bond Street, London, in 1812. The two greyhounds are called Czarina and Maria. The pattern is one of a series of hunting scenes printed on dinner wares.

"Covent Garden Theatre, London"

Tams & Co. Tams' Foliage Border Series. Plate 7½ ins:19cm.

Covent Garden Theatre was built in 1732 but this pattern shows it after considerable alterations which were carried out in 1792. In 1847 it was named the Royal Italian Opera House. The building was destroyed by fire in 1856 but quickly replaced by a new theatre in 1858. It is now generally known as the Royal Opera House, Covent Garden.

"Coventry"

Enoch Wood & Sons. "English Cities" Series.

Coventry is best known for the events surrounding Lady Godiva and Peeping Tom and for the modern cathedral built in 1951.

"Cowes"

Thomas Dimmock & Co. "Select Sketches" Series. Dish 12½ ins:32cm.

"Cowes Harbour"

Enoch Wood & Sons. Shell Border Series. Plate 6¾ ins:17cm. Ill: Arman S 132.

As with other items from this series the view is a shipping scene. It shows sailing ships with a rowing boat in the foreground and a windmill on a hill in the background. Cowes is a town at the mouth of the Medina river on the Isle of Wight. It has been a ship-building centre for many years but is now best known for its annual sailing regatta called Cowes Week. One of two forts built in 1540 still stands.

The Cowman

A widely accepted name for a pattern by an unknown maker found on dinner wares. The scene shows a cow in the foreground with a man standing just behind a bank on the right under a tree. On the left is a small thatched cottage amongst trees. The distinctive border consists of a string of large flowers superimposed on a scalloped frame inside which the ground is stippled in light blue and outside which the ground is a brilliant dark blue. Ill: FOB 5; P. Williams p.707.

Cows Crossing Stream

Cambrian Pottery, Swansea. An accepted name for a common pattern which was produced throughout the Dillwyn, Bevington, and Evans & Glasson periods. As the name implies, there are some cattle crossing a stream in the foreground below a small wooden bridge, with a mill and a cottage in the background. The same central view was used by Goodwins & Harris in the "Metropolitan Scenery" Series with the title "View near Colnebrook" (sic). Compare also with the "Antique Scenery" view of "Hexham Abbey" (Coysh 2 134) which uses the identical foreground.

Nance states that "it is generally accompanied by one or the other of two elaborate floral borders (one for bowls and one for flat pieces), but sometimes by a third border of vine-leaves, tendrils and grapes reserved in white on a deep blue ground". Ill: Nance XLVIII; FOB 3; Godden BP 314.

The common floral border used with this design is very similar to borders used by John Rogers & Son for the Rogers Views Series (qv) and by Elkin, Knight & Co. for their Rock Cartouche Series (qv).

The Cowman. *Maker unknown. Unmarked. Plate 8½ ins:22cm.*

Cracked Ice and Prunus

See: Marble.

"Craig Castle"

Elkin, Knight & Co. Rock Cartouche Series. Dish 12ins:30cm.

Craig Castle is in Aberdeenshire, Scotland. Some 'Jacobean' additions were made to the original building in the 1830s by Archibald Simpson.

"Craigmillar Castle, Edinburgh"

Maker unknown. "Antique Scenery" Series. Dish 15ins:38cm.

Craigmillar Castle, now in ruins, was a favourite residence of Mary Queen of Scots.

Crane Pattern

Wedgwood. A fanciful design showing two cranes in a pool amongst enormous flowers, all within a border of flowers and exotic birds superimposed on a frame of Gothic arches. Ill: Coysh 2 123.

Cows Crossing Stream. *Attributed to the Cambrian Pottery, Swansea. Unmarked. Drainer 9¾ ins:25cm.*

"Cray Place, Kent." *Maker unknown. Printed title C-scroll cartouche. Jug 3 ¼ ins: 8cm.*

"Cromwell Dismissing the Long Parliament." *Jones & Son. "British History" Series. Printed titles and maker's mark. Dish 16 ½ ins: 42cm.*

"Cray Place, Kent"

Maker unknown. This view has been recorded on a jug marked simply with the title in a cartouche.

Cray Place, sometimes known as Foots Cray Place, was built for Bouchier Cleeve. It was burnt down in 1949.

Crazing

A network of fine cracks in earthenware glazes due to the unequal expansion or contraction of glaze and body. It is often caused in dinner wares by excessive heat and is noticeable on plates and dishes which have been placed in an oven and allowed to cool too quickly.

Cress Dish

A bowl fitted with a shallow, pierced inner dish. It was used to drain and serve cress.

Crimean War

The end of the Crimean War in 1856 was commemorated by a jug made by David Methven & Sons of the Kirkcaldy Pottery, Fife. It is marked with the title "Peace" (qv).

"Croe House" (sic)

Ralph Hall. "Picturesque Scenery" Series. Sauce tureen and stand.

This is possibly Crowe Hall at Stutton, East Suffolk or, the Crowe Hall which was one mile south east of Bath in Somerset, a building which was burned down in 1926.

"Crognall Priory, Hamstead" (sic)

Laidacker lists this title on a bowl in the Morning Glory Border Series. It is presumably a misprint for Frognall Priory, Hampstead, which is no longer standing.

"Crome Court, Worcester" (sic)

Ralph Hall. "Picturesque Scenery" Series. Pierced basket 11 ½ ins: 29cm.

Croome Court, near Severn Stoke in Worcester, is now used as a school.

"Cromford"

Maker unknown. Found on a medium blue dinner plate.

Cromford is a small town in Derbyshire, not far from Matlock Bath. It is the site of the first cotton mill in the county, erected by Sir Richard Arkwright in 1776.

"Cromwell Dismissing the Long Parliament"

Jones & Son. "British History" Series. Dish 16 ½ ins: 42cm.

The Long Parliament sat almost continuously from 1640 to 1653. In 1648 Cromwell got rid of all supporters of the King leaving the 'Rump' which voted the execution of Charles I. In 1653 he finally dismissed the Parliament for which he had no further use.

"The Crow and the Pitcher"

Spode/Copeland & Garrett. "Aesop's Fables" Series.

A thirsty crow saw a pitcher but finding that he could not reach the water in it, he tried to overturn it only to realise that he was not strong enough. Seeing some pebbles, he cast them one by one into the pitcher until the water rose to the brim and he could satisfy his thirst.

Necessity is the mother of invention.

Crown Acorn and Oak Leaf Border Series

A series of English and Scottish views by an unknown maker in a border of acorns and oak leaves, not to be confused with the very similar series issued by Ralph Stevenson. In this case the distinctive printed mark consists of a crown over an octagonal panel containing the view title and flanked by two conifer sprays. Examples sometimes also have an impressed crown mark. The following views have been noted:

"Amport House, Hampshire"
"Bedfords, Essex"
"Cole Orton Hall, Leicestershire"*
"Dalguise, Perthshire"*
"Gorhambury, Hertfordshire"*
"Hylands, Essex"*
"Kincardine Castle, Perthshire"*
"Lambton Hall, Durham"*
"Lindertis, Forfarshire"
"Lowther Castle, Westmorland"*
"Luscombe, Devon"

continued

Crown Acorn and Oak Leaf Border Series. *Maker unknown. Typical printed mark with impressed crown.*

"Spetchley, Worcestershire"
"Tewin Water, Hertfordshire"
"Wakefield Lodge, Northamptonshire"*

A clue to a possible maker of this series is a comport decorated with the view of "Wakefield Lodge, Northamptonshire" and of a very distinctive shape. Another comport of identical shape decorated with the River Fishing pattern (Ill: Coysh 1 61) bears the impressed mark "MEIR" for John Meir of Tunstall.

Crown Mark

Collectors are often faced with pieces which, although by an unknown maker, bear some distinctive mark. One particular example is an impressed crown often encountered on patterns from the Crown Acorn and Oak Leaf Border Series (see left), the Pineapple Border Series, and occasionally on the "Oriental Scenery" Series. It is difficult to believe that these scenes are from the same factory since the various wares are very different in character.

It has been suggested that an impressed crown mark was used by the Middlesbrough Pottery, but it is unwise to attribute wares on the basis of this type of mark. It could well have been used at several different factories.

C.R.S.

These initials are reported on wares bearing the marks of Davenport and Turner (Little, p.103). No maker or retailer's name with these initials has so far been traced.

"Crusaders"

Deakin & Bailey. A romantic pattern which shows two horses, one dark and ridden by a man and the other white and ridden side saddle by a woman, in a landscape with trees and castles. The border consists of floral sprays on a half white and half stipple ground. The design is known on a bowl and a dish. The cartouche mark, which includes the title and the firm's name in full, is illustrated in Little 19. Ill: P. Williams p.484.

"Crystal Palace"

(i) J. & M.P. Bell & Co. A view of the famous building with many figures in the foreground. The printed mark shows a robed woman with her left arm supporting a shield. This pattern is known on a dinner plate.

(ii) Thomas Godwin. A different view within a border of musical and agricultural accoutrements.

(iii) Robert Cochran & Co. A scene very similar to the pattern by J. & M.P. Bell & Co. listed above but in this case titled "Exhibition".

(iv) Maker unknown. An untitled view with many figures

"Crystal Palace." *Thomas Godwin. Printed title and maker's mark. Plate 10½ ins:27cm.*

"Crystal Palace." *Maker unknown. Unmarked. Hot water plate 10¼ ins:26cm.*

and carriages in the foreground on a hot-water plate.

The Crystal Palace was built for the Great Exhibition of 1851. This was planned as the first international event of its kind to exhibit the 'Works of Industry of all Nations'. The building, designed by Joseph Paxton, was erected in Hyde Park and the event, sponsored by Prince Albert, was an enormous success. The Crystal Palace itself was dismantled and moved to Sydenham where it was reopened by Queen Victoria in 1854. It was tragically destroyed by fire on 30th November, 1936 but the site survives as the Crystal Palace Recreation Centre.

"Cuba"
Dillwyn and Evans & Glasson of Swansea. A romantic design on jugs with a building and a lake. Almost certainly made in the 1840-60 period when the copper trade between Swansea and Cuba was flourishing. That some pieces were intended for export to the island is indicated by the occasional item marked with the name of a Cuban company "Acacio Velez y Co."

Cuba Pattern
See: "Almacen de Gamba y Co."

"Culford Hall, Suffolk"
(i) Ralph Hall. "Picturesque Scenery" Series. Pierced stand 11½ins:29cm.
(ii) Andrew Stevenson. Rose Border Series. Plate 10¼ins:26cm, and soup plate 10ins:25cm. Ill: Coysh 1 125; Laidacker p.72.

Culford Hall was built for the first Marquess of Cornwallis in about 1790. A large portico with eight columns was added in 1807-8 but has since been removed.

"Culzean Castle, Ayrshire"
Enoch Wood & Sons. Grapevine Border Series. Plates 8¼ins:21cm and 9ins:23cm.

Culzean Castle was built by Adam in the Gothic style at Maybole, twelve miles south west of Ayr. It was built for the Earl of Cassillis between 1770 and 1792 and the design includes battlements, towers and turrets. Accommodation in the castle was placed at the disposal of General Eisenhower after World War II. It is now owned by the National Trust for Scotland and is open to the public in the summer.

"Cumberland Terrace, Regent's Park"
Enoch Wood & Sons. "London Views" Series. Dish 18¾ins:48cm.

A row of mansions just to the south of the East Gate to Regent's Park, designed by the famous architect John Nash.

"Cup at Doncaster"
Maker unknown.
See: Sporting Mug.

Cup Plates
In the first half of the 19th century it is said to have been a common practice in America to decant tea from the cup into the saucer to cool. The empty cup was then placed on a small cup plate, some 3 or 4 ins. in diameter, so that table linen or the surfaces of polished furniture should not be marked. They were included in tea services that were exported but were not used in Britain. It is difficult to explain, however, why these small plates were also included in dinner services. Could they have been stands for other drinking vessels or even custard cups? In America cup plates are now keenly collected. R.H. & V.A. Wood in a privately circulated publication, *Historical China Cup Plates* (undated but c.1975), illustrate 134 examples with American scenes and patterns.

"Culzean Castle, Ayrshire." Enoch Wood & Sons. Grapevine Border Series. Printed title mark and impressed maker's eagle mark. Plate 8¼ins:21cm.

Cupid Patterns

Laidacker records two dark blue series of patterns which feature cupids, one by William Adams and the other by Enoch Wood & Sons, and a further similar pattern by an unknown maker. None of these wares bears titles but Laidacker lists the following designs:

(i) William Adams: Cupid; Cupid and Roses; Cupid and Virgin. Ill: Little 9.

(ii) Enoch Wood & Sons: The Bride (young girl with veil — bars at right); Cupid Imprisoned. Ill: Laidacker p.89; Cupid's Escape; Girl reaching through bars getting grapes; The Young Philosopher (child with book).

(iii) Maker unknown: Cupid Reclining (border with flowers and urns).

Custard Cup. *Maker unknown, possibly Spode. Net pattern. Unmarked. Height 3 ¼ ins:8cm.*

Curling Palm. *Attributed to Job Ridgway. Unmarked. Soup plate 9½ ins:24cm.*

Curling Palm

A widely accepted name for an early chinoiserie design by Job Ridgway. It shows large ornate pagodas at either end of a sloping and curved multi-arched bridge. At the higher end to the right, the pagodas are shaded by a prominent palm tree with a very curling trunk. The border is typical of the early chinoiserie designs, with a variety of scrolls, a geometric patterned ground, and the usual moths. Many examples of the pattern are unmarked but a few are known with "J. Ridgway" impressed in a curve over a beehive. Ill: FOB 1.

Custard Cup

Up to and including the early 19th century it was common practice to serve custard as part of a sweet course in separate little glass cups with handles. Pottery custard cups, some of which have lids, are not uncommon and examples are known from major factories such as Spode and Wedgwood. These cups were made in a variety of shapes; one is shaped like a comma. See: FOB 8.

"Customs House, London"

Tams & Co. Tams' Foliage Border Series. Dish 14ins:36cm.

The Customs House in Lower Thames Street, London, was built between 1812 and 1817 but was rebuilt by Smirke in 1825. The east wing was damaged during World War II but it has been restored in the same style.

Cusworth, Yorkshire

John & William Ridgway. Angus Seats Series. Dish 10ins:25cm, and sauce tureen.

In common with all items from this series the view is not titled and marked pieces are very rare.

Cusworth Hall was built in 1740 and altered by James Paine within a few years. It stands on an eminence in a well wooded park some two miles west of Doncaster.

"Dacca"

(i) John Carr & Co.

(ii) Minton & Boyle.

Dacca, on a branch of the River Ganges, is now the capital of Bangladesh. It was the centre of Muslim rule in the 18th century. A gazetteer of 1810 states "It has large manufactories of the finest muslins and silks".

Daffodil Pattern

John Turner. A dark blue pattern consisting of sprigs of flowers, notably daffodils, within a simple blue band of stringing. Ill: Coysh 2 115.

Dagger Border

A term used to describe a border which features a string of dagger-like motifs, frequently in association with a band of geometric pattern. Such borders are found with chinoiserie designs.

See: Dagger Border Chinoiserie; Trophies.

Dagger Border Chinoiserie

Enoch Wood & Sons. A typical chinoiserie pattern with a temple, a bridge, and various islands and trees, similar in layout to the standard Willow pattern. The geometrical border includes a band of prominent dagger-like motifs. Ill: Coysh 2 127.

Dagger Landscape

Spode produced two early chinoiserie patterns on pearlware which are referred to by this title. Dagger Landscape, First (Ill: Whiter 4) is a Chinese landscape with a very large pagoda. Dagger Landscape, Second (Ill: Whiter 6) is a sparser landscape with buildings, trees and a boatman. Whiter's illustration shows a reproduction plate made from an original engraving, and he states: "it is to be hoped that an authentic Spode piece of this pattern will one day come to light".

"Daisy"

Goodwin, Bridgwood & Orton. A pattern which is marked with the initials G.B.O.

The name is also used for a sheet floral design produced by Spode. Ill: Whiter 35.

"Dalberton Tower, Wales"

Maker unknown. Pineapple Border Series. Plate 8¾ ins:22cm.

Dalberton is the early 19th century spelling of Dolbadarn. The ruins of Dolbadarn Castle include a prominent round tower. The castle, on Llyn Peris Lake, eight miles south east of Caernarvon, was the key to Snowdonia and played an important part in defending the mountainous districts.

"Dalguise, Perthshire"

(i) Enoch Wood & Sons. Grapevine Border Series. Plate 10ins:25cm.

(ii) Maker unknown. Crown Acorn and Oak Leaf Border Series. Plate 10¼ ins:26cm. Ill: Coysh 1 148.

Dalguise is a seat close to the River Tay, about four and a half miles north west of Dunkeld.

"Dalberton Tower, Wales." *Maker unknown. Pineapple Border Series. Printed title mark. Plate 8¾ ins:22cm.*

"Dalguise, Perthshire." *Maker unknown. Crown Acorn and Oak Leaf Border Series. Printed title mark and impressed crown. Plate 10¼ ins:26cm.*

"Damascus"
(i) J. & M.P. Bell & Co.
(ii) Robert Cochran & Co.
(iii) David Methven & Sons.
All three of these potters operated in Scotland.

Damascus is said to be the oldest continuously inhabited city in the world. It was held by the Romans, the Arabs, and the Turks during its long history but is now the capital of Syria.

"Damask Border"
South Wales Pottery. A pull from a copper plate with this pattern and mark is shown in Godden I 528. It shows a romantic scene within a border which is edged with scrolled alternate reserves containing a hunter with dogs and a reindeer pulling a sleigh.

Daniell, Thomas 1749-1840
An artist who became a distinguished archaeologist. He spent ten years in India with his nephew, William, also an artist, during which time they made many drawings of Indian buildings and scenery. On their return they prepared a remarkable work in six volumes under the title *Oriental Scenery*, Thomas Daniell being solely responsible for the first two parts. It was published between 1795 and 1808 and contained 144 aquatints. Smaller editions were published later and one edition was engraved under their direction and published by themselves in 1816. The Daniells were also responsible for *A Picturesque Voyage to India by the Way of China* (1810). Many of the illustrations in these volumes were later used by other engravers and published as *Views in Hindoostan* (1798 and 1805) or in the *English Annual* (1834-38).

A full list of the published work of the Daniells and of engravings based on their work is given by Thomas Sutton in a comprehensive appendix to *The Daniells, Artists and Travellers* (1954). A later book by Mildred Archer, *Early Views of India*, (1980) deals solely with the Indian journeys and reproduces the prints from their *Oriental Scenery*.

The Daniell prints were the source of many patterns on blue-printed wares. Amongst the potters known to have copied them were the Herculaneum Pottery of Liverpool, Bevington & Co. of Swansea, John & Richard Riley of Burslem, and John Rogers & Son of Longport. Identified patterns are listed under the titles of the original prints.

Daniell, William 1769-1837
A nephew of Thomas Daniell who was also a landscape artist and engraver. In addition to the work done in collaboration with his uncle he produced some notable views in Britain. One particularly impressive project was undertaken with Richard Ayton and published under the title *A Voyage Round Great Britain*. It was published in eight volumes between 1814 and 1825 and contained 309 aquatints. Daniell was responsible for all the drawings and even completed the text for the later parts following the death in Scotland of his co-worker Ayton.

"Darting"
Thomas Mayer. "Olympic Games" Series. Dish 11ins:28cm.

"Darting" was presumably an early form of throwing the javelin.

"Dartmouth"
Enoch Wood & Sons. Shell Border Series. Plates 8½ins:22cm and 9¼ins:23cm. Ill: Arman 133.

As with other items from this series, this view is a shipping scene. Dartmouth was described in 1810 as having "a safe haven, capable of sheltering 500 sail of ships...and here is a large quay inhabited by some considerable merchants. Dartmouth has a considerable trade to Italy, Spain, Portugal etc. and to Newfoundland. Its pilchard and foreign fisheries employ nearly 3,000 men".

Date Marks
Although by far the majority of blue-printed wares cannot be dated with any accuracy, a few can be dated to the year, and sometimes the month, of potting by virtue of impressed date marks. The following dating systems are known:

(i) A small symbol impressed on Minton wares made after 1841 represents the year of potting. See: Minton.

(ii) A set of three impressed letters on Wedgwood wares made after 1850 represent both the month and year of potting. See: The Wedgwood Factory.

(iii) The final two numbers from the date of potting impressed on either side of the anchor used in Davenport marks.

(iv) A relatively standard impressed mark in which the month and year of manufacture are given in number form, e.g. 7.62 would mean July 1862. The numbers may be impressed in a line or may be the month over the year. This system became fairly widely used in the late 19th century, but it is very occasionally found on much earlier wares, a few examples from the 1820s being found in the Fruit and Flower Border Series (qv) by Henshall & Co.

Davenport fl.1794-1887
Longport, Staffordshire. John Davenport started his potting career as a workman with Mr. Kinnersley in Newcastle before joining Thomas Wolfe at Stoke in 1785. He became a partner with Wolfe at the Islington China Works in Liverpool before leaving to set up on his own in Brindley's Longport factory in 1794. The firm produced glass as well as pottery and was financially a great success. It is not clear when Davenport started producing blue-printed wares but known marked examples would appear to date from about 1810, although it is quite possible that unmarked pieces were made earlier.

John Davenport retired in 1830 and the firm was continued until 1835 by his two sons, Henry and William. Following Henry's death the style became William Davenport & Co. until William himself died in 1869. The factory continued in poor financial state under William's son, Henry, eventually becoming a limited company in 1881 but finally failing in 1887.

The blue-printed wares followed fashion throughout the life of the firm. The earliest marked examples are transitional chinoiserie designs such as the Chinoiserie Ruins pattern or pure chinoiseries such as the Chinoiserie Bridgeless pattern. There followed an early topographical design, now thought to represent Bisham Abbey, Berkshire (qv), and other foreign and rural scenes. There was a slow drift into the romantic style patterns which became so common during and after the 1830s but with a few notable exceptions including the "Scott's Illustrations" Series.

The firm seems to have been meticulous in marking its wares. The standard impressed mark consisted of the name Davenport curving above an anchor, with the name in lower case letters up to about 1815 but thereafter in capitals. After about 1830 numbers were impressed on either side of the anchor to give the date of potting, 3 and 8, for example, representing 1838. A very wide variety of printed marks were used after 1830, almost invariably including simply the surname Davenport rather than any identifying initials. The place Longport also appears in later marks. The style of the printed cartouches, as with the patterns, tended to follow current fashion.

The factory's history and wares are discussed in detail by Lockett.

The Dead Hog. *Spode. Indian Sporting Series. Untitled. Printed and impressed maker's marks. Sauce tureen overall length 7½ ins:19cm.*

Davies, Cookson & Wilson fl.1822-1833
Stepney Bank Pottery, Newcastle-upon-Tyne. This pottery is known to have produced the Country Church pattern, also made by Cornfoot, Colville & Co. at North Shields.

Davies, Richard & Co. fl.1833-1844
Tyne Main Pottery, Salt Meadows, Gateshead. This firm is thought to have exported wares to Norway. The rare mark "DAVIES & CO." has been found on small plates and a Willow pattern drainer.
 See: Eel Plates.

Davis, D. fl.1839-c.1859
Daniel Davis started in business in 1839 as a China, Glass and Earthenware Dealer at 7 Church Lane, Whitechapel, London. By 1846 he had moved and was operating from two different addresses, 45 Blackfriars Road and 62 Newington Causeway. The business closed in about 1859.
 A dish with the "Wild Rose" pattern has been noted with a large printed cartouche bearing the legend:
BOT. OF D. DAVIS
Noted Cheap
Glass & China Bazarr
45 Blackfriars Road
62 Newington Causeway
7 Church Lane
COMMERCIAL ROAD
A similar mark in which the line '7 Church Lane' was missing has been noted on a plate with a pseudo-Chinese landscape, a pattern known to exist on wares marked by Gordon's Pottery of Prestonpans. The latter example of the mark can be dated to a period following the move from Church Lane.

Davis, Thomas
A printer from Worcester who joined Ralph Baddeley of Shelton in the 1780s to help with his experiments in underglaze printing.

Davis, William
First employed at Worcester and then at Caughley in Shropshire. He was then taken on by William Adams of Cobridge to help with the development of underglaze printing.

Dawson, John & Co. fl.c.1799-1837
Low Ford Pottery, South Hylton, Sunderland, Co. Durham. Tea wares are known with the impressed mark "DAWSON & CO." and also "DAWSON" which has also been reported on dinner wares. Printed marks include the name in various forms and sometimes the name of the pottery.

Dawson, Thomas & Co. fl.1837-1864
Successors to John Dawson & Co. as above. Presumably the same wares were continued by the new partnership.

"De Gaunt Castle"
Minton. Minton Miniature Series. Plate 3¼ ins:8cm.
 This is thought to be Pontefract Castle which was fortified by John of Gaunt, Duke of Lancaster, in 1385.

The Dead Hog
Spode. Indian Sporting Series. Sauce tureen (two different shapes). Ill: S.B. Williams 33-35.
 This is one of the designs from the series which is not titled on the wares.

Deakin & Bailey fl.c.1828-1830

Lane End, Staffordshire. One printed pattern with the title "Crusaders" is known marked with the name of this firm in full. Another design, titled "Villa Scenery", bears the initials D. & B. and may have come from this pottery.

Dean Bridge, Edinburgh

James Jamieson & Co. "Modern Athens" Series. Dish 14ins:36cm.

As with other items from the series this view is not titled. Dean Bridge was built by Thomas Telford and opened in 1831. The money was provided by Lord Provost Learmouth who wanted to develop an estate at Dean, north of the Water of Leith.

Dean Bridge, Edinburgh. *James Jamieson & Co. "Modern Athens" Series. Printed series title and maker's mark. Impressed maker's mark. Dish 14ins:36cm.*

"Death of the Bear." *Spode. Indian Sporting Series. Printed title and maker's mark. Circular fluted dish 9½ ins:24cm.*

"Death of General Wolfe." *Jones & Son. "British History" Series. Printed titles and maker's mark. Well-and-tree dish 21ins:53cm.*

"Death of Lord Nelson." *Jones & Son. "British History" Series. Printed titles and maker's mark. Dish 14½ ins:37cm.*

"Death of Abel"
Enoch Wood & Sons. Scriptural Series.

"...and it came to pass, when they were in the field, that Cain rose up against Abel his brother and slew him. And the Lord said unto Cain, Where is Abel thy brother? And he said: I know not: Am I my brother's keeper? And he said, What hast thou done? The voice of thy brother's blood crieth unto me from the ground". Genesis 4, 8-10.

"Death of the Bear"
Spode. Indian Sporting Series. Plate 10ins:25cm, and circular fluted dish 9½ins:24cm. Ill: Coysh 1 97; Whiter 72; S.B. Williams 4-5.

"Death of General Wolfe"
Jones & Son. "British History" Series. Dish, and well-and-tree dish, both 21ins:53cm. Ill: Laidacker p.55.

General Wolfe was given the task by William Pitt of destroying French rule in North America. He entered the St. Lawrence and anchored below Quebec where Montcalm commanded the French forces. Wolfe took a line of boats to the bank of the river below the Heights of Abraham which were scaled by his troops, taking Montcalm by surprise. During the charge which broke the French line, Wolfe was shot and died. When he was told that the French were in retreat he murmured "Then I die happy!"

"Death of Lord Nelson"
Jones & Son. "British History" Series. Dish 14½ins:37cm, and comport 11¼ins:29cm (with "Charles I Ordering the Speaker to Give Up the Five Members" on the sides). Ill: Coysh 1 53-54.

Horatio Nelson was killed in action at the Battle of Trafalgar on Monday, 21st October, 1805. As he died he is reputed to have said "Kiss me Hardy" to his ship's Captain.

See: Nelson.

"Death of Punch"
James & Ralph Clews. Doctor Syntax Series. Sauce tureen stand. Ill: Arman 63; Little 19.

Decoy Elephants Leaving the Male Fastened to a Tree
Spode. Indian Sporting Series. Hot water vegetable dish. Ill: FOB 10.

This is one of the designs from the series which is not titled on the wares. It is particularly rare.

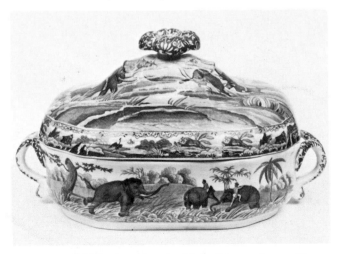

Decoy Elephants Leaving the Male Fastened to a Tree.
Spode. Indian Sporting Series. Untitled. Printed maker's mark. Hot water vegetable dish overall length 12½ins:32cm.

Deer
Deer were a common feature on country scenes and appear in the grounds of many of the houses featured on named views. Two particularly good examples of untitled scenes with deer are the Osterley Park pattern by Ridgway and the Fallow Deer pattern by John Rogers & Son, later copied by Wedgwood. A cup with a design featuring deer by an unknown maker is illustrated in Coysh 1 163. James & Ralph Clews used a scene with deer on a dish (18ins:46cm) in their "Zoological Gardens" Series, and Ralph Hall included one design in his "Quadrupeds" Series on a plate (7½ins:19cm) and a dish (14½ins:37cm). Enoch Wood & Sons used a deer hunting scene in their Sporting Series on a plate (10ins:25cm) and a stand.

See: Stag; The Bewick Stag.

"Delaware"
John Ridgway. A light blue romantic scene on ironstone, clearly not meant to be the American state. Also known in mulberry.

"Delft"
Minton. This title has been noted on a printed globe mark together with date marks for 1872.

"Delhi, Hindoostan." *Thomas & Benjamin Godwin. Indian Scenery Series. Printed title mark with maker's initials and impressed mark "T. & B.G./NEW WHARFE". Drainer 10ins:25cm.*

"Delhi, Hindoostan"
Thomas & Benjamin Godwin. Indian Scenery Series. Drainer 10ins:25cm, and soup tureen stand. Ill: P. Williams p.122.

The city of Delhi, in northern India, is considered to be the gateway to the Ganges plain. The old city was the ancient capital of various Hindu and Muslim dynasties and also the Moghuls. The new city was the capital of British India until 1947 and now serves the same function for the Republic of India.

"Denon's Egypt"
(i) Elijah Jones.

(ii) C.T. Maling. A design recorded on a bowl with a romantic scene which includes an obelisk rather similar to Cleopatra's Needle and an Egyptian-style monument. Ill: Bell, *Tyneside Pottery*, p.83.

The Baron Dominique Vivant Denon (1747-1825) was a French government official who eventually became the director general of French museums, including the Louvre. He was also a painter and archaeologist and is known to have travelled

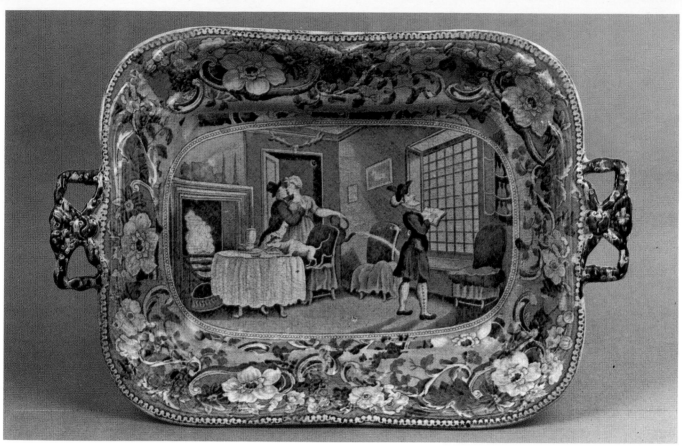

Colour Plate VI. "Doctor Syntax Copying the Wit of the Window." *James & Ralph Clews. Doctor Syntax Series. Printed title mark and impressed maker's crown mark. Tray 11¾ ins: 30cm.*

Colour Plate VII. "Doctor Syntax Copying the Wit of the Window." *Source print for the above title in the Doctor Syntax Series, taken from "The Tour of Doctor Syntax in Search of the Picturesque".*

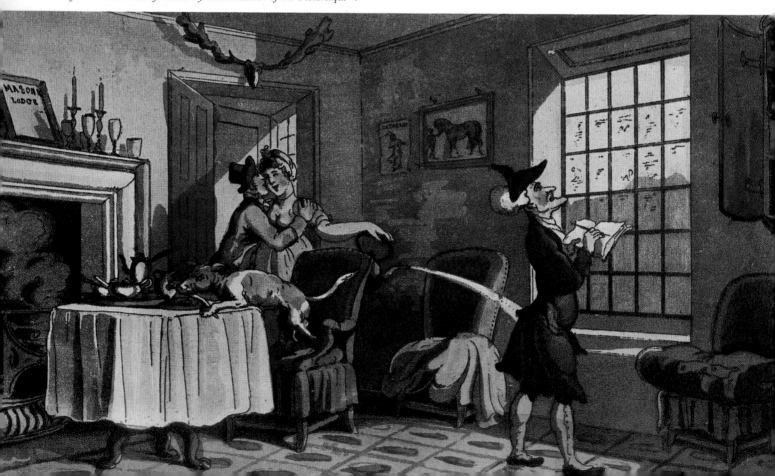

widely in Egypt, including travels with Napoleon during his Egyptian campaign. It appears likely that these patterns were copied from Denon's paintings, probably taken from one of his books — either *Travels in Upper and Lower Egypt* (1803) or *Egypt Delineated* (1819).

"Denton Park"
Maker unknown. Light Blue Rose Border Series. Dessert plate.

"Denton Park, Yorkshire"
(i) William Adams. Flowers and Leaves Border Series. Dish 17¼ins:44cm.

(ii) John & Richard Riley. Large Scroll Border Series. Dish 14¾ins:37cm, and jug. Ill: Coysh 1 77.

(iii) Maker unknown. Morning Glory Border Series. Large teapot. Ill: Laidacker p.43.

In addition to these titled views, another by William Adams has been identified in the Rocks and Foliage Border Series. Ill: Laidacker p.6.

Denton Hall was built by John Carr in about 1770. The frontage included giant Ionic columns with a pediment, and there were recessed pavilions with a pyramid roof and cupola. These features can be clearly seen on the wares.

"Derwentwater"
C.J. Mason & Co. "British Lakes" Series.

Derwentwater, in the old county of Cumberland, is a lake in the course of the River Derwent. At the lower (northern) end is the market town of Keswick overlooked by Skiddaw. At the southern end is the remarkable Floating Island which sometimes rises to the surface.

"The Deserter, Scene 1"
John Rogers & Son and Pountney & Goldney. "The Drama" Series. Plate 6½ins:16cm. Ill: Coysh 1 79.

This title was used for at least two different plays and the scene could be from either:

(i) *The Deserter* by Charles Dibdin (1745-1814). This 'New Musical Drama' as it was called was first produced in 1773. Dibdin was known for his sea songs which included *Tom Bowling*.

(ii) *Le Deserteur*, a French play by Mercier. This was adapted for the English stage by Charles Kemble (1775-1854) when he returned to England to take over the management of Covent Garden in 1822 after a spell in France.

"Deus Dabit Vela"
A motto meaning God will fill the sails. It has been noted on a mug decorated with a marine coat-of-arms together with an intriguing collection of tools.

See: "Mariners Arms".

"Devon"
Minton & Boyle. A romantic scene of a church with two men fishing. The title cartouche includes the initials M. & B. The name of the body "IMPROVED STONE CHINA" within an octagonal seal mark is sometimes impressed. Ill: Coysh 2 63. The scene would appear to have no connection with the English county of Devon. The pattern was later printed in sepia by the Middlesbrough Pottery.

"Dews Hall, Essex"
William Adams. Flowers and Leaves Border Series. Plate 7ins:18cm.

Dillon, Francis fl.1834-1843
Cobridge, Staffordshire. Little states that this company is recorded as having made blue-printed earthenwares, including some scriptural designs. Known marks consist of "DILLON" impressed or the initials F.D. as part of printed marks.

"Denton Park, Yorkshire." *William Adams. Flowers and Leaves Border Series. Printed title mark and impressed maker's eagle mark. Dish 17¼ins:44cm.*

Dillwyn & Co.
See: Swansea; Swansea's Cambrian Pottery.

"Dilston Tower, Northumberland"
William Adams. Bluebell Border Series. Soup plate 10ins:25cm.

Dilston Tower, or Dilston Castle, is seen in the background of this scene in which a river flows from beneath a bridge towards the foreground where there are two figures, one fishing. The tower house, dating from the reign of Elizabeth I, is about two and a half miles south east of Hexham and is now mainly in ruins.

Dimmock & Smith fl.1826-1833 and 1842-1859
Tontine Street, Hanley, Staffordshire. Plates bearing the same patterns as John Hall's "Quadrupeds" Series are known with the added initials D. & S. on the printed cartouche mark. Other items with the same initials are known. Dimmock & Smith may have acquired the "Quadrupeds" copper plates when the Hall factory closed in 1832.

Dimmock, Thomas & Co. fl.1828-1859
Shelton and Hanley, Staffordshire. This was a large firm with more than one factory. The most important were probably at Tontine Street, Shelton (c.1830-50) and at Albion Street (c.1828-59). Printed marks which include the initial D are relatively common and may relate to this firm since Godden records one such mark used by Dimmock on a registered design of 1844. A distinctive monogram was also used, either impressed or as part of printed marks. They made one series of views entitled "Select Sketches" (qv).

Dinner Services
Many of the pieces illustrated in this book are from dinner services. Blue printing provided a quick and cheap way of decorating mass-produced wares, and in the early part of the 19th century dinner services were extensive. A typical service, listed on an invoice illustrated by Smith 190, was made up as follows:

4 doz. dinner plates
1 doz. soup plates
3 doz. supper plates
2 doz. tart plates
2 doz. cheese plates

continued

15 dishes (various sizes)
2 gravy dishes
4 baking dishes
1 salad bowl
4 covered dishes (probably vegetable dishes)
4 sauce tureens complete
4 sauce boats
1 soup tureen with stand and ladle
1 vegetable dish with water pan
1 fish drainer
1 set pickles (diamond shape)
2 fruit baskets and stands
2 shell comportiers

The total cost was £7 16s. 6d. A similarly extensive service in green with the "Don Quixote" designs by Brameld is illustrated with its component parts by Rice.

"Diomed Casting His Spear Against Mars"
Joseph Clementson. "Classical Antiquities" Series. Octagonal dish. Ill: P. Williams p.65.

Diomedes was, next to Achilles, the bravest hero of the Greek army. He fought against the Trojans and even the gods who espoused their cause.

"Diorama" Series
A series of views by an unknown maker. The scenes are printed with a light centre within a darker border which descends into the well of the plates and consists mainly of star-like flowers. The series title and name of view are printed in a wreath of leaves. The English scenes recorded include:
"View of Brecknock"
"View of Houghton Conquest House, Bedfordshire"
"View of Lichfield Cathedral"*
"View of Rosedale"
"View of Southampton, Hants"
"View of York"*

One other example has been noted clearly marked "View of Rosedoe" which is probably an engraver's mistake for Rosedale. Laidacker (p.110) describes some railway and shipping scenes with the same border which he includes with this series. They do not bear titles and at least some of them appear to be American scenes.

The series title "Diorama" is derived from the panoramic pictures shown by Daguerre and Bouton in Park Square, London, in the early 19th century. In *Metropolitan Improvements,* the author Elmes writes of "the Diorama, where the powerful pictorial illusions of Messrs. Bouton and Daguerre have so often delighted the amateurs and cognoscenti of the metropolis".

"Diorama" Series. *Maker unknown. Typical printed mark.*

"The Discuss" (sic)
Thomas Mayer. "Olympic Games" Series. Plate 10½ ins:27cm.

A discus was a circular plate or stone used for hurling over the greatest possible distance as a sport among the Greeks and Romans. It was included in the pentathlon of the Olympic Games and is, of course, still used today.

"Dix Cove on the Gold Coast, Africa"
Enoch Wood & Sons. Shell Border Series. Soup tureens, comport and vegetable dish cover. Ill: Arman S 134.

Dixon, Austin & Co. fl.c.1820-1840
Garrison Pottery, Sunderland, Co. Durham. This firm existed for a short period under the name Dixon, Austin, Phillips & Co. Impressed marks are known with either name in full and similar printed marks are recorded. One printed mark used includes the title "DRESDEN OPAQUE CHINA". Amongst other wares, the firm seems to have produced a fair number of eel plates as many examples have survived.

"Docility"
John Dawson & Co. A pattern printed in a fairly dark blue on teawares with an impressed mark "DAWSON".

Doctor Franklin's Maxims
Benjamin Franklin (1706-90) was a publisher in his early years and in 1732 he started a paper called *Poor Richard's Almanac.* This became famous in the American colonies for Franklin's pithy maxims on the virtues of thrift and hard work. These were used widely on series of children's plates in various colours in mid-Victorian times. The usual layout was a picture with the relevant maxims above and below, all surmounted by the title in various forms such as "Dr. Franklin's Maxims", "Poor Richard's Maxims", or simply "Franklin's Maxims". Patterns are also known in mulberry and black. Some of the later examples are marked B.W. & Co. which may refer to Buckley, Wood & Co. or Bates, Walker & Co., both of which were established in 1875. Some of the earlier examples are of quite good quality but later ones tend to be rather crude. Ill: FOB 6.

See: "Franklin's Morals" Series; "Flowers That Never Fade".

Doctor Syntax Series
This series was made by James & Ralph Clews mainly for the American market. The patterns were based on the drawings by Thomas Rowlandson published in the *Poetical Magazine* between 1809 and 1811 which illustrated doggerel verses by William Coombe, an inmate of the King's Bench debtors prison for some forty-three years. The prints were later published in book form in three volumes: *Doctor Syntax in Search of the Picturesque* (1815), *Second Tour of Doctor Syntax in Search of Consolation* (1820), and *In Search of a Wife* (1821). The printed marks give the title in a rectangle decorated on each side with motifs which include small circles. The complete series of thirty-one patterns are titled:
"The Advertisement for a Wife". Ill: Arman 64; Laidacker p.27; Moore 31
"The Bans Forbidden"
"Death of Punch". Ill: Arman 63; Little 19
"Doctor Syntax Amused with Pat in the Pond". Ill: Arman 52; Atterbury p.168
"Doctor Syntax and the Bees". Ill: Arman 53
"Doctor Syntax and a (or with the) Blue Stocking Beauty". Ill: Arman 57; Moore 32
"Doctor Syntax Bound to a Tree by Highwaymen". Ill: Arman 37
"Doctor Syntax Copying the Wit of the Window". (Colour Plates VI and VII). Ill: Arman 39

continued

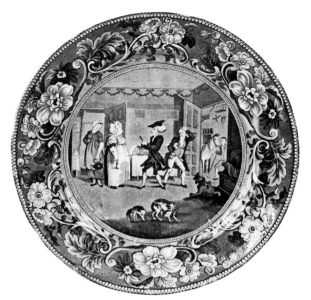

Doctor Syntax Series. *Left: "Doctor Syntax Disputing his Bill with the Landlady." James & Ralph Clews. Printed title mark and impressed maker's crown mark. Plate 10ins:25cm.*

Doctor Syntax Series. *Centre left: "Doctor Syntax Painting a Portrait." James & Ralph Clews. Printed title mark and impressed maker's crown mark. Plate 10ins:25cm.*

Doctor Syntax Series. *Bottom left: "Doctor Syntax Sells Grizzle." Reproduction of a pattern in the Doctor Syntax Series. Printed title mark. Plate 10½ins:27cm. Note the much darker printing than in the original Clews' versions, in the preceding illustrations.*

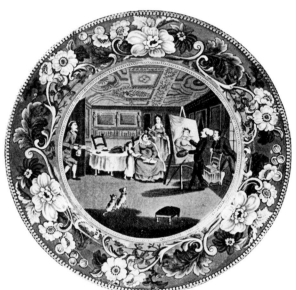

Doctor Syntax Series. *James & Ralph Clews. Typical genuine printed mark with impressed maker's mark.*

Doctor Syntax Series. *Printed mark from a reproduction.*

"Doctor Syntax and the Dairy Maid". Ill: Arman 46

"Doctor Syntax Disputing his Bill with the Landlady"*. Ill: Arman 38

"Doctor Syntax Drawing from (or after) Nature". Ill: Arman 44

"Doctor Syntax Entertained at College". Ill: Arman 40

"Doctor Syntax and the Gypsies". Ill: Arman 51

"Doctor Syntax Making a Discovery". Ill: Arman 55

"Doctor Syntax Mistakes a Gentleman's House for an Inn". Ill: Arman 42

"Doctor Syntax Painting a Portrait"*

"Doctor Syntax Presenting a Floral Offering". Ill: Arman 58

"Doctor Syntax Pursued by a Bull". Ill: Arman 41

"Doctor Syntax Reading his Tour". Ill: Arman 47; Atterbury p.203

"Doctor Syntax Returned from his Tour". Ill: Arman 48

"Doctor Syntax Sells Grizzle"*

"Doctor Syntax Setting Out on His First Tour". Ill: Arman 35

"Doctor Syntax Setting Out on His Second Tour"

"Doctor Syntax Sketching the Lake"

"Doctor Syntax Star Gazing". Ill: Arman 61

"Doctor Syntax Stopt by Highwaymen". Ill: Arman 36

"Doctor Syntax Taking Possession of His Living". Ill: Arman 49

"Doctor Syntax Turned Nurse". Ill: Arman 56

"The Garden Trio". Ill: Arman 60

"The Harvest Home". Ill: Arman 59; P. Williams p.497

"The (or a) Noble Hunting Party". Ill: Arman 65

There is no agreement in previous books on three of the above titles. The variants have been indicated in parentheses.

Examples of the above have been noted marked "Adams, Tunstall", a mark which occurs on the wares of that firm after 1896. Such later reproduction plates are now collected in their own right. There is little doubt, however, that some of the apparently earlier pieces are deliberate fakes. Even those with the impressed Clews mark should be viewed with caution.

It is fairly easy to distinguish between the originals and the reproductions. The originals are printed in medium blue with a rippled blue glaze and the double foot rims are narrow. The reproductions are usually in a much darker blue with a smooth clear glaze and noticeably wider foot rims. The circle motifs are missing on the reproduction printed marks. The common items are dinner plates and the originals measure 10ins:25cm and weigh about 15½ oz., whereas the reproductions are larger at over 10½ ins:27cm and also much heavier at 22oz.

Dog

Dogs appear on many patterns, particularly on hunting scenes, some of which show working dogs such as the springer spaniel. John Hall used two designs in his "Quadrupeds" series which are usually referred to as Dog and Rabbit and simply Dog (See: P. Williams p.661). One of the designs in Enoch Wood & Sons' Sporting Series features a pointer hunting quail (Ill: Laidacker p.105). A particularly shaggy dog appears prominently in the foreground on a dish in the "British Views" Series (qv).

Dog Dish

Blue-printed dog dishes are rare. They are very heavily potted to prevent them slipping on floors and it is this aspect which betrays their function. Examples have been noted from the Spode factory decorated with the Tower and Forest Landscape patterns. The only other factory known to have made them is Brameld; and the example illustrated from the Glasgow Museum is printed with Brameld's Boys Fishing pattern.

"The Dog in the Manger"

Spode/Copeland & Garrett. "Aesop's Fables" Series. Dish 19ins:48cm. Ill: Whiter 90.

A dog was lying in a manger full of hay. An ox, being hungry, came near and offered to eat the hay but the envious, ill-natured cur snarled at him and would not suffer him to touch it.

Envy is the most unnatural and unaccountable of all the passions.

"The Dog and the Shadow"

Spode/Copeland & Garrett. "Aesop's Fables" Series. Ewer and baking dish 9ins:23cm. Ill: Coysh 2 103; Whiter 89.

A dog, crossing a rivulet with a piece of flesh in his mouth, saw his own shadow in the stream. Believing it was another dog with another piece of flesh he caught at it but dropped the piece he had in his mouth which sank to the bottom and was lost.

Grasp at the shadow and lose the substance.

"The Dog and the Sheep"

Spode/Copeland & Garrett. "Aesop's Fables" Series. Plate 8ins:20cm, and entrée dish. Ill: Whiter 89; P. Williams p.597.

The dog sued the sheep for a debt, of which the kite and the wolf were to be judges. They, without debating long on the matter, gave sentence for the plaintiff who immediately tore the poor sheep to pieces and divided the spoils with the unjust judges.

One foul sentence doth more hurt than many foul examples.

Dog Dish. *Brameld. Boys Fishing Pattern. Unmarked. 9½ ins:24cm.*

"The Dog and the Wolf"
Spode/Copeland & Garrett. "Aesop's Fables" Series. Sauce tureen.

A half-starved wolf met a well-fed mastiff and asked him why he was able to live so well. "Because I guard the house at night and keep it from thieves," replied the dog. "You have nothing more to do but follow me." On the way the wolf saw a ridge on the dog's neck. "I am tied up in the daytime," says the dog "if I sleep then I watch better at night." "Well," says the wolf, "you can keep your happiness to yourself; I would not be a king on the terms you mention."

The lowest condition of life, with freedom attending it, is better than the most exalted station under restraint.

"Domestic Cattle"
A series by an unknown maker with a border of birds' nests and flowers. Four examples have so far been recorded.

(i) A shepherd with dog and sheep. Ill: Little 90.

(ii) Two adults and a child in front of a tent, two donkeys and a sheep. Ill: P. Williams p.487.

(iii) A man filling a trough, two horses and a dog. Ill: FOB 13.

(iv) Three sheep, a cow and a bull.

All these examples are marked with a printed cartouche with the title on a ribbon across a flower garland. The word cattle is used in its widest sense as livestock.

"Domine Dirige Nos"
O Lord, direct us. A motto, associated with the arms of the City of London, which can be traced back to ancient times. They have a central shield in silver bearing the cross of St. George in red together with a red sword in the uppermost left quarter. The sword is the emblem of the city's patron, St. Paul, being the instrument of his martyrdom.

The city's arms can be found on two patterns. One is an armorial design within a border of crowns, roses and thistles which can be seen on another pattern, also by an unknown maker, in Coysh 1 166. See: "The Guildhall, London." The other pattern shows a steamship and is titled "London and Edinburgh Steam Packet Company" (qv). The arms are printed in the border, alternating with those of the Scottish city.

Don Pottery (Greens Period) fl.1790-1834
Swinton, near Rotherham, Yorkshire. This pottery was established by members of the Green family from the Leeds Old Pottery. They operated the works until 1834 when it was sold to Samuel Barker of the Mexborough Old Pottery. The factory produced considerable quantities of blue-printed ware but the most notable patterns were those in the Named Italian Views Series (qv). Impressed marks included the name "DON POTTERY", sometimes with the addition of the family name "GREEN". The most common printed mark shows a demi-lion rampant holding a flag bearing the word "DON", with the word "POTTERY" beneath the lion. An uncommon variant of this mark includes a circular garter.

A good selection of Don Pottery wares may be seen in the Doncaster Museum.

"Domine Dirige Nos." *Arms of the City of London below a three-storey building. Maker unknown. Unmarked. Oval dish 10¾ ins: 27cm.*

Don Pottery. *Unusual pattern with sailing boats within a vermicelli border. Printed and impressed maker's marks. Tea bowl and saucer. Diam. of saucer 5½ ins:14cm.*

"Don Quixote." *Brameld. Printed mark with series title and initial B. Soup plate with moulded edge 10ins:25cm.*

Don Pottery (Barker Period) fl.1834-1893

Swinton, near Rotherham, Yorkshire. The Don Pottery was taken over by Samuel Barker & Son in 1834, and blue-printed wares continued to be made although the quality declined. Some open patterns such as "Floral Scenery" were introduced and the common "Wild Rose" pattern was also used. The lion rampant printed mark was continued with the addition of the name "BARKER" but other printed marks were used with the initials S.B. & S.

"Don Quixote"

A series of scenes based on the Don Quixote story made by Brameld. Some extensive dinner services were produced and examples are commonly found in green, although both blue and black were also used. A service in green is illustrated in Rice 27 a-g. The title "Don Quixote" is given in a printed shield superimposed on a spear, but the scenes are not given individual titles.

Don Quixote Series

A series of Don Quixote scenes made primarily for the American market by James & Ralph Clews. The scenes were based on illustrations to the Miguel de Cervantes story by Robert Smirke and Charles Westall. Very few examples are found in England. The following list of scenes is based largely on American literature:

"Don Quixote's Attack Upon the Mills"
"Don Quixote's Library"
"Don Quixote and the Princess". Ill: Arman 86
"Don Quixote and Sancho Panza"
"Don Quixote and the Shepherdess(es)". Ill: Arman 85
"(The) Enchanted Bark"
"(The) Knight of the Wood Conquered"
"Knighthood Conferred (Confer'd) on Don Quixote"
"Mambrino's Helmet"
"(Meeting of) Don Quixote and Sancho Panza"
"The Meeting of Sancho and Dapple"
"Peasant Girl Mistaken for (the) Lady Dulcinea"

"Don Quixote." *Brameld. Printed series mark.*

"Repose in the Wood"
"Sancho Panza at the Boar Hunt"
"Sancho Panza's Debate with Teresa"
"Sancho Panza and the Duchess"
"Sancho Panza Hoisted in the Blanket"
"Sancho and the Priest and the Barber"
"(The) Shepherd Boy Rescued"
"Teresa Panza and the Messenger"
"Yanguesian Conflict"

There is disagreement about some of the actual titles. Where doubt exists, the alternatives have been identified by parentheses.

Donaldson's Hospital, Edinburgh

James Jamieson & Co. "Modern Athens" Series.

As with other items from the series this view is not titled. This hospital was designed by William H. Playfair (1789-1857) who was responsible for many public buildings in the city.

"Donemark Mill"

James & Ralph Clews. "Select Scenery" Series. Plate 7¾ins:20cm.

Donemark is a small river in County Cork, Ireland which flows into Bantry Bay.

"Donington Park"

Minton. Minton Miniature Series. Dish 4¼ins:11cm.

Donington Hall, now Manor Farm at Donington-le-Heath, south west of Coalville in Leicestershire, was the oldest manor house in the county, dating from about 1280. Many changes have been made over the years and little remains of the original structure.

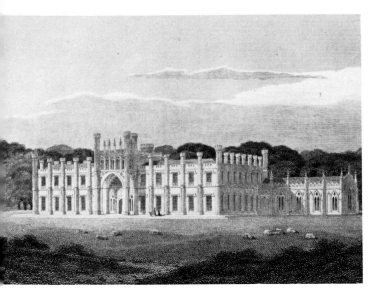

"Donington Park." *Source print for the Minton Miniature Series taken from Britton & Brayley's "The Beauties of England and Wales".*

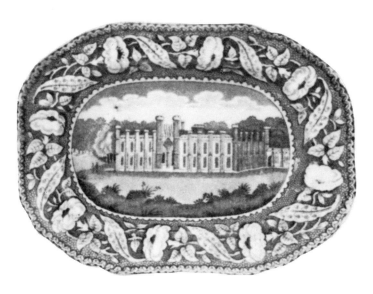

"Donington Park." *Minton Miniature Series. Printed title mark. Miniature dish 4 ¼ ins:11cm.*

Donovan, James fl.1770-1829

A Dublin glass and china merchant and decorator with premises at George's Quay. He was described locally as 'the Emperor of China'. Donovan is known to have sold blue-printed wares and an example decorated with an early chinoiserie pattern and impressed "DONOVAN". See illustration on next page. He sometimes painted his own name on wares which he had decorated. The example shown here appears on saucers with a rim enamelled in dark red.

Donovan, James. *Dragon and key pattern saucer by an unknown maker enamelled red on the rim with "DONOVAN" painted in the same colour on the base. Diam. 5 ½ ins:14cm.*

"Dooreahs Leading Out Dogs"

Spode. Indian Sporting Series. Dish 18ins:46cm. Ill: Whiter 94; S.B. Williams 14-15.

The full title of the source print in Williamson's *Oriental Field Sports, Wild Sports of the East* (1807) was "Dooreahs or Dog Keepers Leading Out Dogs".

"Doria"

John Ridgway & Co. A light blue design with a mansion amongst trees registered on 20th July, 1844 and used on ironstone wares. The border consists of fine concentric lines. Ill: P. Williams p.253.

"Doric Villa in Regent's Park"

Enoch Wood & Sons. "London Views" Series. Plate 7 ½ ins: 19cm.

An imposing residence with four Doric columns and a pediment on the central block, but with two rather uninspiring wings.

Donovan, James. *Name painted in red on the base of a saucer with a red-enamelled rim.*

Donovan, James. *Maker unknown. Early chinoiserie design supplied through the Dublin chinaman. Impressed "DONOVAN". Plate 9½ins:24cm.*

"Dorney Court." *Maker unknown. Passion Flower Border Series. Printed title mark. Soup plate 10¼ins:26cm.*

"Downing College, Cambridge." *John & William Ridgway. Oxford and Cambridge College Series. Printed title and maker's mark. Plate 6ins:15cm.*

"Dorney Court"

(i) Ralph Stevenson. Stevenson's Acorn and Oak Leaf Border Series. Vegetable dish base and square salad bowl. Ill: Camehl, *The Blue China Book.*

(ii) Maker unknown. Passion Flower Border Series. Soup plate 10¼ins:26cm.

"Dorney Court, Buckinghamshire"

Enoch Wood & Sons. Grapevine Border Series. Deep dish 11ins:28cm, and pierced stand.

Dorney Court is a Tudor brick and timber manor house about two and a half miles north west of Eton, and across the Thames from Windsor Castle. It has been in the Palmer family since Sir James Palmer, art adviser to Charles I, married into the owner's family in the early 17th century. It was at Dorney that the first pineapple was grown in England and given to Charles II. It is open to the public at certain times during the summer.

"Douglas, Act 5, Scene 1"

John Rogers & Son and Pountney & Goldney. "The Drama" Series. Plate 8½ins:22cm. Ill: FOB 4.

The play *Douglas* was written by John Home (1722-88) and was first produced in Edinburgh in 1756 and in London in 1757. Home was a minister at Athelstaneford, East Lothian, but his ministerial life was brought to an end by the action of the Church Courts as a result of the play. Nevertheless, it was an immense success which provoked a flood of publications both for and against it.

Dover

A view of the cliffs at Dover was used by Enoch Wood & Sons on teawares printed in dark blue. A teapot is illustrated in Laidacker p.106.

"Downing College, Cambridge"

John & William Ridgway. Oxford and Cambridge College Series. Plates 6ins:15cm and 6½ins:16cm.

Downing College, in Regent Street, was founded in 1800 but the building, to a plan by William Wilkins, was not started

Drainer. *Wedgwood. Botanical pattern. Impressed maker's mark. Length 13¼ ins:34cm. The piercing is typical of Wedgwood.*

until 1807. It was in the neo-Grecian style built around a large court. By 1821 it was still incomplete and it was not until over fifty years later, in 1873, that Edward Barry was commissioned to continue the work. Buildings were added to the college as late as 1963.

Dragons
See: "Chinese Dragons".

Drainer
A flat slab pierced with a pattern of small drain holes and usually one larger central hole, made to fit into the well of a dish. They were intended for serving boiled fish so that excess water could drain into the dish beneath, but were probably also used for serving meat. There would often be two sizes in a dinner service, typically to fit 16ins. and 18ins. dishes. Some examples have a very distinctive pattern of holes and it may be that this characteristic could be used for attribution but, as with all shapes, this must be treated with caution. They are sometimes also called strainers or dish strainers.

"The Drama" Series
A series of scenes from plays made by John Rogers & Son and later copied by Pountney & Goldney of Bristol. The scenes are contained within a border which has groups of theatrical accoutrements and musical instruments on a background of flowers and leaves. At first sight pieces from the two potteries appear to be the same but closer examination will show that the border of the Rogers series includes a distinctive mask which has been replaced by three small flowers in the Bristol border.

The name of the play together with act and scene numbers is printed beneath the pattern. The series title is printed in a circular wreath. The following list of patterns was taken from a Rogers dinner service:
"As You Like It, Act 2, Scene 2"
"As You Like It, Act 4, Scene 2"
"The Deserter, Scene 1"
"Douglas, Act 5, Scene 1"
"Henry IV, Act 5, Scene 4"
"Henry VI, Act 2, Scene 2"
"Love in a Village, Act 1, Scene 4"*
"Love's Labour's Lost, Act 4, Scene 1"
"The Maid at the Mill, Act 1, Scene 1"
"Merchant of Venice, Act 4, Scene 1"
"Merchant of Venice, Act 5, Scene 4"
"Merry Wives of Windsor, Act 5, Scene 5"
"Midas, Act 1, Scene 3"
"Much Ado about Nothing" (no reference to Act or Scene)
"The Quaker, Act 2, Scene 2"
"The Revenge" (no reference to Act or Scene)
"The Taming of the Shrew, Act 4, Scene 1"
"The Taming of the Shrew, Act 4, Scene 3"
"The Tempest, Act 1, Scene 2"
"Two Gentlemen of Verona, Act 5, Scene 4"*
"Winter's Tale, Act 4, Scene 3"
It appears reasonable to assume that the Pountney & Goldney series was identical except for the border. In addition to the above, two titles, "The Adopted Child" and "Maypole", are mentioned by Little p.94, and may form part of this series. The

"The Drama" Series. *Printed series mark with impressed "ROGERS". The same printed mark was used by Pountney & Goldney.*

"Douglas" design has been seen printed in red. The only designs for which the source has been positively identified are "Merry Wives of Windsor" and "Winter's Tale". They are from paintings by Robert Smirke, R.A. (1752-1845) and William Hamilton, R.A. (1751-1801) which were commissioned for the Boydell Shakespeare Gallery. This was a notable project which opened in Pall Mall in 1789 but was eventually forced to close with the paintings sold at auction in 1805. A total of some two hundred paintings were made and many of these were engraved for a folio edition of Shakespeare's works published in nine volumes in 1802. "The Drama" Series patterns were almost certainly copied from the engravings.

"Dreghorn House, Scotland"
Ralph Hall. "Picturesque Scenery" Series. Plate 6½ ins:16cm.

Normally called Dreghorn Castle, this house dates from the 1600s but was twice enlarged in the 19th century. It is in the Colinton district of Edinburgh, near the foot of the Pentland Hills, and in recent years it has become a school.

"Dresden"
The pattern title "Dresden" appears on more than one design. One floral cartouche printed by an unknown maker bears the title together with the words "Semi-China". The same title, this time with the words "Opaque China", is attributed by Godden in *Mason's Patent Ironstone China* (1971) to Clews. Exactly the same words were used by Dixon, Austin & Co. of Sunderland. Attributions must therefore be treated with caution.

Dresden Borders
The title for a simple Spode design with a central geometrical motif and similar interlaced border. The print is restricted to a relatively small area. Ill: Whiter 71.

"Dresden Flowers"
Minton. A floral pattern used on a miniature dinner service. In addition to the title, the printed mark includes the name of the body, "Opaque China", and a cursive M. Examples have also been noted in green.

"Dresden Opaque China"
Maker unknown. A floral pattern.
 See: "Dresden".

"Dresden Sprigs"
Robert Cochran & Co.

"Dresden Vase"
Maker unknown. A floral pattern with a large vase and some vine leaves at its base. It is an open design with only a narrow band of stringing for a border. The printed title cartouche includes the name of the body — "Opaque China".

"Dresden Flowers." *Minton. Printed scroll cartouche with Prince of Wales' feathers and the title in script. There is a cursive M at the base and "OPAQUE CHINA" on a ribbon beneath. Miniature plate 3¼ ins:8cm.*

'Dresden Views." *Middlesbrough Pottery. Printed title mark and impressed maker's mark in shape of a horseshoe. Sauce tureen stand 6¾ ins:17cm.*

"Dresden Views"
Middlesbrough Pottery. A typical romantic scene within a geometric border of fern leaves and scrolls.

"Driving a Bear out of Sugar Canes"
Spode. Indian Sporting Series. Dish 16½ ins:42cm, drainers 15ins:38cm, 12¾ ins:32cm, and a salad bowl. Ill: FOB 33; S.B. Williams 16-18.

"**Driving a Bear out of Sugar Canes.**" *Spode. Indian Sporting Series. Printed title and printed and impressed maker's marks. Dish 16½ ins:42cm.*

Dromedary

A design in which a man holds the halter of a dromedary, with a background of date palms and pyramids, was introduced by John & Richard Riley. Ill: Coysh 1 73. Examples usually bear a printed mark with the words ''RILEY'S Semi-China'' on an oval buckled strap. The pattern was copied by Pountney & Allies of Bristol who also used the border for an armorial service with the arms of Bristol. Ill: Little 92. The border was also used by John Rogers & Son for their Elephant pattern.

Drover. *Dillwyn & Co. Unmarked Swansea jug. Height 4¾ ins:12cm.*

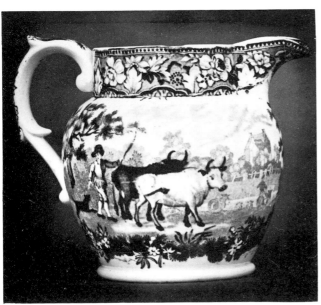

Drover

Dillwyn & Co. An accepted name for a Swansea design which is also sometimes called the Herdsman pattern. It shows a rural scene with a young man driving some cows within a border of flowers and scrolls. It was introduced in the Lewis Weston Dillwyn period after 1824 but lasted for a long period since a mug with the design is known with the inscription ''Wm. Cock, 1848''.

Drug Jar

A jar, usually baluster shaped, used by an apothecary to store drugs. These jars have the name of the contents printed on them, and sometimes have additional decoration. Blue-printed jars are not common but a Spode jar with Union Wreath decoration is in the possession of the Pharmaceutical Society. It is illustrated by Griselda Lewis in *A Collector's History of English Pottery* (1969), 276.

"Drury Lane Theatre, London"

Tams & Co. Tams' Foliage Border Series. Plate 9ins:23cm. Ill: Little 71.

The Drury Lane Theatre was built between 1810 and 1812 by Benjamin Wyatt. A porch with Doric pillars was added by James Spiller in 1820 and a colonnade with cast-iron columns by Samuel Beazley in about 1831.

Du Croz, John C. fl.c.1811-1837

An art and glass manufacturer of 7 Skinner Street, Snow Hill, London, who also ran a china warehouse. He first appears in an 1812 directory as a 'Glass and Chinaman' but subsequent entries list him under various titles ranging from simply 'Glass Cutter' to the grander 'Glass Cutter & Importer of French Porcelain' in 1820. In 1827 he sold a specially commissioned armorial dinner service to the Salter's Company of London. Examples bear a mark with his name and address added to the royal arms used by Hicks, Meigh & Johnson.

From about 1837 he opened new premises at 138 Regent

Du Croz. *The mark of the London chinaman combined with the royal arms mark of Hicks & Meigh. This is found on an armorial plate made for the Salters' Company. See: "Sal Sapit Omnia".*

"Dulwich College, Essex." *Andrew Stevenson. Rose Border Series. Printed title mark and impressed maker's circular crown mark. Dish with combed base 12½ ins:32cm.*

Street and went into partnership as Du Croz & Millidge (qv). A print used by Tallis in *London Street Views* (1838-40) shows the new premises.

Du Croz & Millidge
The name Millidge first appears in the partnership of Pike & Millidge which shared the Skinner Street premises with Du Croz in 1833. Millidge was probably a relation of Du Croz since a William Millidge married an Ann Du Croz in 1814. The partnership became Du Croz & Millidge in 1837 when Du Croz opened new premises of his own in Regent Street.

"Dublin"
Harvey. Cities and Towns Series. Jug 12ins:30cm, and dish 21ins:53cm.

Two other views, "Four Courts, Dublin" and "Post Office, Dublin" are to be found in the Tams' Foliage Border Series (qv). In addition, Enoch Wood & Sons included "View of Dublin" in their Shell Border Series.

Dublin is the capital of the Republic of Ireland. It lies on the east coast at the mouth of the River Liffey and has many fine Georgian squares. It is also a seaport, a university city, and the home of three cathedrals.

"Dublin from Phoenix Park"
R.A. Kidston & Co. "United Kingdom" Series.

Phoenix Park is a magnificent open space in Dublin, the home of the zoological gardens.

"Duchess"
Robert Cochran & Co.

Dugald Stewart's Monument and Princes Street from Calton Hill, Edinburgh
James Jamieson & Co. "Modern Athens" Series.

As with other items from the series this view is not titled. Dugald Stewart (1753-1828) was a philosopher and friend of Scott. Amongst his pupils were Palmerston, Russell and Lansdowne.

Duke of Wellington
See: Wellington.

Duke of York
A fine punch bowl showing the Duke of York on horseback commanding the British forces in Flanders in 1793-94 is illustrated in May, colour plate 2. Beneath the scene are the words "His Royal Highness FREDERICK DUKE OF YORK" and the border is of ornate chinoiserie style, typical of the period. The bowl is attributed to Swansea.

"Dulwich Castle"
James & Ralph Clews. Bluebell Border Series. Plate.

This title is given in Laidacker, p.23. It may have been meant to read "Dulwich College".

"Dulwich College, Essex" (sic)
Andrew Stevenson. Rose Border Series. Dish 12½ ins:32cm.

Dulwich College, or the College of God's Gift, was founded in 1619 by the actor Edward Alleyn. The old college chapel has served as the parish church, whereas the quadrangle became offices and almshouses. The college was rebuilt in the Italian style by Sir Charles Barry between 1866 and 1870, and the lower school became Alleyn's School. The college was, of course, in Surrey and not Essex.

Dunderdale, David (& Co.) fl.c.1790-1820
Castleford Pottery, Castleford, Yorkshire. This firm was founded by David Dunderdale but he turned his firm into a company in 1803. Although the pottery is best known for its moulded stoneware teapots some blue-printed wares were produced including early chinoiseries. One example is an unusual Buffalo and Ruins pattern. Some rural scenes with floral borders have also been noted. When marked, the wares are impressed "D.D. & Co./CASTLEFORD/POTTERY"

"Dunfermline Abbey, Fifeshire"
James & Ralph Clews. Bluebell Border Series. Plate 7ins:18cm.

This Benedictine Abbey combines architecture from many different periods ranging from the Norman nave to the Gothic tower of the 1820s.

"Dunkeld"

R.A. Kidston & Co. "United Kingdom" Series. Sauceboat.

Dunkeld stands on the River Tay, fifteen miles north west of Perth in Perthshire. Its main attraction is a ruined 12th century Cathedral.

"Dunolly Castle, near Oban"

John Meir & Son. "Northern Scenery" Series. Mug. Ill: Coysh 2 59.

Dunolly Castle stands in ruins on a bluff overlooking the Firth of Lorne. Built in the 11th or 12th centuries it was a stronghold of the McDougalls.

"Dunraven Castle, Honorable Wm. Wyndham Quin's Seat"

Careys. Titled Seats Series. Dish approximately 14ins:36cm.

Wyndham-Quin is the family name of the Earls of Dunraven.

"Dunraven, Glamorgan"

Enoch Wood & Sons. Grapevine Border Series. Plate 6½ins:16cm.

Dunraven House, nine miles south east of Cowbridge, stands on a high rocky headland projecting a considerable distance into the sea. Many parts of the building have the appearance of a religious antiquity rather than a castle.

"Dunsany Castle, Ireland"

Ralph Hall. "Picturesque Scenery" Series.

Dunsany Castle was originally built in the 12th century. It became the property of Sir Christopher Plunket in the reign of Henry VI and he was created Lord Dunsany. There was also a later building in the form of a castellated mansion in the Gothic style.

"Durham"

Enoch Wood & Sons. "English Cities" Series. Dish 18ins:46cm.

Another untitled view of the city has been identified in the Rogers Views Series (qv). Ill: Coysh 2 139.

Durham stands on the River Wear, fifteen miles south of Newcastle-upon-Tyne. It is an ancient city with a university, a castle dating from 1069, and a famous cathedral.

"Durham Cathedral"

Belle Vue Pottery. Belle Vue Views Series. Soup plate 10ins:25cm.

Durham Cathedral was built by Bishop Carilef starting in 1093. The Norman work is some of the finest in existence. The two western towers were completed in the 13th century but the central tower dates from the 15th century.

Durham Ox Series

Two pictures of the Durham Ox were used as patterns in a dinner service which includes several other farming scenes. They are all printed within a border of floral tracery which is separated from the central scene by a wide band of geometric stringing. No marked pieces have yet been recorded and the maker remains unknown. The patterns recorded include:

(i) The Durham Ox facing right being watched by his owner John Day, holding a cane. Well-and-tree dish 19½ins:50cm, and strainer. Ill: Little 88.

(ii) The Durham Ox facing left with two cows in the distance. Dinner plate 10ins:25cm. Ill: Little 89.

(iii) A drover with two cows. Dessert plate 8¾ins:22cm.

(iv) A general view which includes a quarry. Dish.

(v) A cowman on horseback driving cows towards a stream. Sauce tureen stand.

"Dunkeld." *R.A. Kidston & Co. "United Kingdom" Series. Printed titles mark with maker's initials. Heavily potted and poorly printed sauceboat. Length 6¾ins:17cm.*

(vi) Two cows with a cowman sitting beneath a tree. Sauce tureen with four short blue-glazed legs.

(vii) Two cows, one in the foreground and the other standing in a stream. Lid for sauce tureen.

It has been possible to locate the source for only one of the patterns. The scene of the Durham Ox with John Day is taken from an engraving by J. Whessell after a painting by T. Boultbee, published in 1802.

The Durham Ox belonged to Charles Colling who farmed at Barmpton, three miles north east of Darlington. He and his brother were keen breeders of Shorthorn cattle and in those days success was judged by size. Thomas Bewick described it as "the rage for fat cattle". So much interest was shown in the breed that Colling sold his Durham Ox in 1801 for £250 and its new owner, John Day, had a special carriage made for it so that it could be toured for public exhibition. For nearly six years it was taken through England and Scotland until one day it slipped and died shortly afterwards, leaving a carcass of nearly 34cwt.

The full story of the Durham Ox is told in an article in *Country Life* (24 July, 1980) in which several contemporary prints are reproduced.

Illustrations overleaf.

"Duston Hall"

Andrew Stevenson. Rose Border Series. Sauce tureen and cover.

This view presumably shows Duston House, an early 19th century building in Duston Main Road, Northampton.

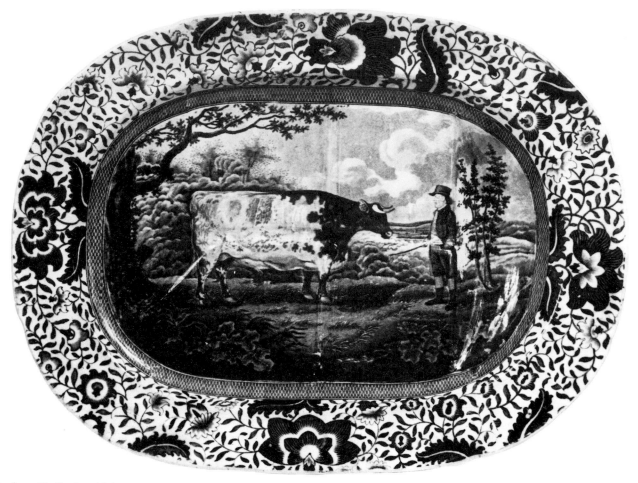

Durham Ox Series. *Maker unknown. All pieces unmarked. Above: Durham* **Ox** *with* **John** *Day. Dish with gravy well 19½ ins:50cm. Left: Durham Ox. Plate 10ins:25cm. Right: Drover. Plate 8¾ ins:22cm.*

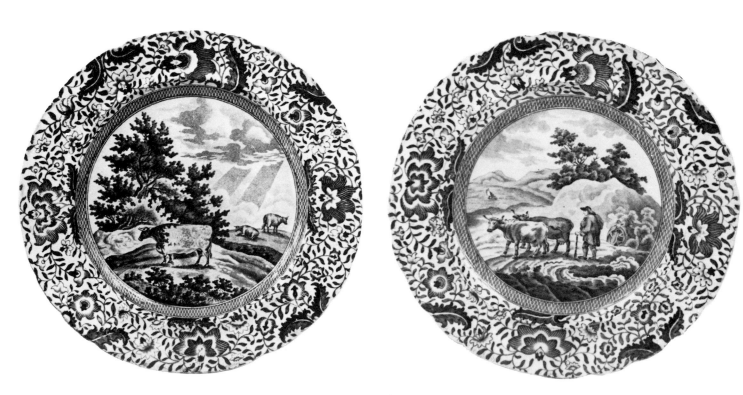

Eagle

The American eagle, a bird with wings outstretched, was adopted as the Seal of the United States in 1786. It was used by several potters to form the basis of patterns on export wares, and some factories used it in printed or impressed marks on items bound for America. The eagle is often shown with a shield bearing stars and stripes in front of its body, and occasionally with a ribbon bearing the American motto *E Pluribus Unum*. Potters using such marks included William Adams, Andrew Stevenson and Enoch Wood & Sons.

"Eashing Park, Surrey"

Ralph Hall. "Select Views" Series. Plate 7½ ins:19cm.

This house at Eashing, one and a half miles west of Godalming, was built between 1729 and 1736. It was demolished in 1957.

"East Cowes, Isle of Wight"

Enoch Wood & Sons. Shell Border Series. Dish 11ins:28cm, vegetable dish and pierced basket. Ill: Arman 135.

As with other items from the series, this view is a shipping scene. East and West Cowes are divided by the River Medina and East Cowes has three great houses: East Cowes Castle, built by Nash in 1798, has gone; Norris Castle, built by James Wyatt in 1799 for Lord Henry Seymour, is a fine Norman-style building with a round tower and stair turret; Osborne House was started in 1845 but not completed until 1851, after Enoch Wood & Sons had ceased to operate.

"East Gate, Regent's Park"

Enoch Wood & Sons. "London Views" Series.

This gate, according to the text in *Metropolitan Improvements* (1827), was due to be called either Chester Gate or Gloucester Gate, names used today for entrances on the east side of Regent's Park.

"East View of La Grange, the Residence of the Marquis Lafayette"

Enoch Wood & Sons. French Series. Vegetable dish, dish 10ins:25cm, and plate 9ins:23cm. Ill: Arman 194.

See: Lafayette; "La Grange".

Eastern Gate of the Jummah Musjid at Delhi

An aquatint published in March 1795 based on a drawing and engraving by Thomas Daniell, in his *Oriental Scenery* (Part I, 1).

Although not used for the major part of any pattern, this print provided important features for designs by two makers. The foreground of the print includes a prominent procession which was used in simplified form for the Indian Procession pattern (Ill: Coysh 2 140). The major feature is, however, taken from "Mausoleum of Sultan Purveiz, near Allahabad" (qv) (Part I, 22). The same procession provided figures and a horseman for the foreground of the Musketeer pattern by John Rogers & Son (Ill: Coysh 1 85), which features "View in the Fort, Madura" (Part II, 14) but with other additions. A Jama Masjid (the modern spelling) is a Great Mosque.

See: Musketeer.

Eastern Street Scene

John & Richard Riley. An attributed title for a scene now known to be a composite of two prints by T. and W. Daniell from their *Oriental Scenery* (Parts I and II).

The tree on the left is from "The Sacred Tree of the Hindoos at Gyah, Bahar" (Part I, 15). The buildings to the right are from "View on the Chitpore Road, Calcutta" (Part II, 2). The pattern was also used by Samuel Alcock who took over the Riley pottery in 1829 and presumably inherited some of the copper plates. Ill: Coysh 1 74; Little 54.

"Eaton Hall"

Ralph Stevenson. "Lace Border" Series. Dishes 17ins:43cm, 18ins:46cm, 19ins:48cm.

"Eaton Hall, Cheshire, Earl Grosvenor's Seat"

Careys. Titled Seats Series. Dish 21ins.53cm.

This house was built for Sir Thomas Grosvenor in 1675-83 but was rebuilt between 1803 and 1812. Wings were added in 1823-25 and the Careys view shows the completely rebuilt Gothic mansion. It was demolished in 1972.

"The Eddistone Lighthouse" (sic)

Enoch Wood & Sons. Shell Border Series. Dish 9½ ins:24cm, pierced basket and rectangular vegetable dish. Ill: Arman 142.

This view, with the lighthouse in the background behind a prominent sailing ship, shows the third Eddystone lighthouse built by Smeaton in 1756-59. A new lighthouse was built in 1882 and Smeaton's lighthouse was re-erected on Plymouth Hoe.

Edge, Barker & Co. fl.1835-1840

Fenton and Lane End, Staffordshire. This firm used the initial mark E.B. & Co. Between 1836 and 1840 they were called Edge, Barker & Barker and used the initials E.B. & B.

Edge, Malkin & Co. fl.1871-1903

Middleport and Newport Potteries, Burslem, Staffordshire. This firm succeeded Cork, Edge & Malkin and continued some of their designs. A variety of marks were used including the name in full or the initials E.M. & Co., sometimes with an added B for Burslem. Where pattern names appear, they are usually found within a scroll cartouche.

Edge, William & Samuel fl.1841-1848

Market Street, Lane Delph, Staffordshire. The initial mark W. & S.E. was used.

Edinburgh

In addition to the titled views of Edinburgh, a series of untitled wares was produced by James Jamieson & Co. under the general title "Modern Athens" (qv).

"Edinburgh"

(i) Harvey. Cities and Towns Series. Dish 16¾ins:43cm.

(ii) Herculaneum. Cherub Medallion Border Series. Dish 18ins:46cm.

(iii) R.A. Kidston & Co. "United Kingdom" Series. Two different views were produced, one on a plate titled "Edinburgh", the other on a dish titled "Edingburgh" (sic) (qv). This view was taken from a print entitled "Edinburgh from the Stone Quarries, Queen's Ferry Road" in *Twenty Views of the City and Environs of Edinburgh* drawn by T.M. Baynes, London (1823).

(iv) Enoch Wood & Sons. "English Cities" Series. Plates 6½ins:16cm and 9ins:23cm.

In addition to the above, several other titled views of the city are known. Examples include "Holyrood House, Edinburgh" by Enoch Wood & Sons in the Grapevine Border Series and

"Edinburgh." Harvey. Cities and Towns Series. Printed title mark and rare impressed maker's mark. Dish 16¾ ins: 43cm.

"Edinburgh from Port Hopetoun." *Watson's Pottery. Washbowl with view inside and a rectangular title mark on base, typical of this pottery.*

Colour Plate VIII. "Groom Leading Out." *Spode. Indian Sporting Series. Printed title and printed and impressed maker's marks (plate). Printed maker's mark (sauceboat). Plate 6ins:15cm. Sauceboat 7¼ins:18cm.*

Colour Plate IX. Syces or grooms leading out horses. *Source print for the above design in the Indian Sporting Series taken from Williamson's "Oriental Field Sports, Wild Sports of the East".*

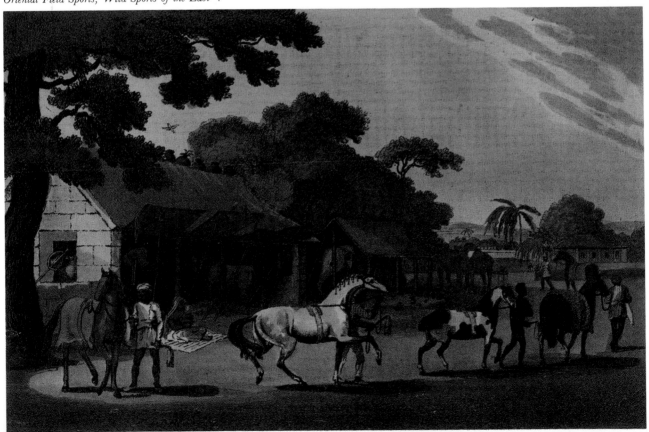

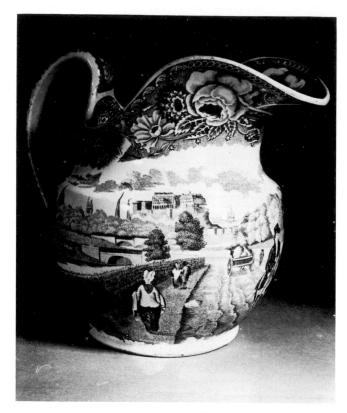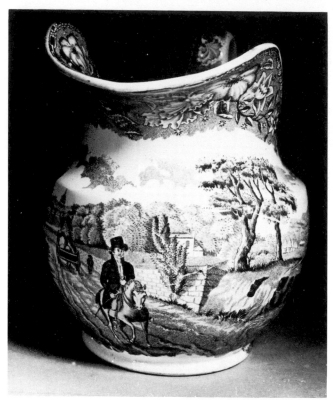

Edinburgh (distant view). Watson's Pottery. Two aspects on the same ewer of a panoramic view of the road to Edinburgh.

"Edingburgh". R.A. Kidston & Co. "United Kingdom" Series. Printed titles mark with maker's initials. Dish 15¼ ins:39cm.

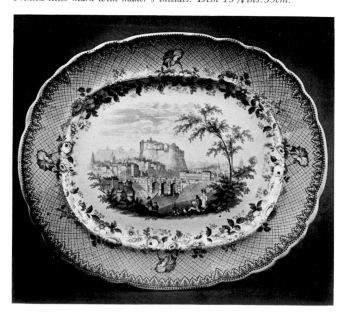

"Craigmillar Castle, Edinburgh" by an unknown maker in the "Antique Scenery" Series. The jug above by Watson & Co. was almost certainly made to accompany the washbowl illustrated on page 122. It shows a distant view of Edinburgh.

Edinburgh, as a cathedral city and capital of Scotland, has many famous buildings and landmarks, mostly with historical connections. It was previously the county town of Midlothian but now serves a similar function for the Lothian Region.

"Edinburgh from Port Hopetoun"
Watson & Co. A view of Edinburgh on a washbowl, which shows the Castle and the Union Canal, is marked with a cartouche typical of the Watson Pottery although the maker's name is not always present.

The Union Canal was completed in 1822 to carry goods and passengers between Edinburgh and Glasgow. The Edinburgh terminus at Fountainbridge was called Port Hopetoun.

"Edingburgh" (sic)
R.A. Kidston & Co. "United Kingdom" Series. Dish 15¼ ins:39cm.

Edwards, James (& Son) fl.1842-1882
Dale Hall, Burslem, Staffordshire. James Edwards took over the Dale Hall Pottery from John Rogers & Son in 1842. His son Richard was taken into partnership in 1851, and despite the father's death in 1867, the firm traded as James Edwards & Son until 1882. Blue-printed wares were made and several different printed and impressed marks were used. After 1851 marks bore either the full name or the initials J.E. & S., often with the place name Dale Hall or further initials D.H. One earlier mark was "JAS. EDWARDS/PORCELAIN", which was actually used on earthenware.

See: "The Roby Day and Sunday Schools".

Eel Plates. *Davies & Co. Impressed maker's mark. Plate 4½ ins: 11cm.*

Edwards, James & Thomas fl.1839-1841

Kilncroft Works and Sylvester Street, Burslem, Staffordshire. A short-lived partnership known to have produced printed wares by virtue of a design registered in 1841 under the title "Boston Mails" (qv). The printed mark includes only the surname "EDWARDS".

Egg Cups. *Ring-shaped egg cup by an unknown maker with an Arctic scene. A band of shells and interlaced branches covers the inner walls. Height 1⅝ ins: 4cm.*

Edwards, Thomas fl.c.1841

Burslem, Staffordshire. Thomas Edwards is recorded by Jewitt as having owned both the Waterloo Pottery and the Swan Bank Pottery although in neither case are any dates quoted. Presumably he continued potting at these works when the partnership of James & Thomas Edwards ended. An impressed mark "T. EDWARDS" has been noted on a plate with the "Abbey" pattern. Ill: P. Williams p.173.

Eel Plates

Small plates for serving eels, or cockles, were made by Richard Davies & Co. of Gateshead and Dixon, Austin & Co. of Sunderland. A pair of plates by the latter firm showing a rural scene with a woman carrying a wooden tub on her head are illustrated by Shaw in *Sunderland Ware*, 31.

See: Cockle Plates; Cup Plates.

Egg Cups and Stands

Blue-printed egg cups can be found in two shapes, the usual modern cup with a pedestal foot and an earlier design which is ring-shaped and can be used either way up. Egg stands may be found in circular or oval form to hold four or six eggs and usually formed the centre section of supper sets (qv), or breakfast sets. These stands were sometimes supplied complete with fitted egg cups and examples are known which fit into a covered dish.

"Eglintoun" (sic)

Ridgway, Morley, Wear & Co. A design which features a group of tournament accoutrements within a very simple border of minute fleur-de-lis. Ill: Coysh 2 76.

This pattern was almost certainly produced as a result of the intense public interest aroused in 1839 by the Eglinton Tournament staged by the Earl of Eglinton at his Gothic castle in Ayrshire. A full account of the event, which was beset by torrential rain, is given by Ian Anstruther in *The Knight and the Umbrella* (1963).

Egypt

Egypt was in the news at the time blue-printed patterns were made by virtue of Nelson's victory at the Battle of the Nile in 1798 and the attentions of Napoleon. For some reason the country did not feature strongly on printed wares although a pattern by Elijah Jones, later copied by C.T. Maling, was made with the title "Denon's Egypt" (qv). There were also at least three biblical scenes produced under the title "The Flight into Egypt" (qv).

"Egyptian Scene"

Pountney & Allies

Elephant

Elephants were seldom seen, even in London, until the early 19th century and then only in rather squalid private menageries. When the Zoological Gardens opened in Regent's Park in 1828 a single Indian elephant was on view. In 1831 an old elephant named Jack joined him and lived for sixteen years. Elephants became very popular and it is not surprising to find that they appeared on contemporary blue-printed patterns. As far as can be determined no pottery used the name for a title but the following potters made wares with the animal as a main feature:

(i) John Rogers & Son. A rather fanciful design produced in quantity on dinner wares. The main feature is an elephant with its keeper in a pseudo-Chinese garden looking like an Oriental zoo. The floral border was also used by John & Richard Riley for their Dromedary pattern. This Rogers

Elephant. *John Rogers & Son. Impressed "ROGERS". Dish 10ins:25cm.*

Elephant. *A pattern made at Swansea (Haynes, Dillwyn & Co.), having no direct connection with elephants. Impressed "SWANSEA". Plate 9½ins:24cm.*

Elephant. *Enoch Wood & Sons. Sporting Series. Impressed maker's mark. Dish 15ins:38cm.*

design was reproduced by the Haggeridge Pottery, Staffordshire, in the 20th century but examples are clearly marked as reproductions. Ill: Coysh 1 82; Little 58; P. Williams p.664.

(ii) John Turner. An early line-engraved chinoiserie pattern with a pagoda and a man holding a parasol, seated on an elephant. The usual mark is the name "TURNER" beneath impressed Prince of Wales' feathers. Ill: Coysh 2 116.

(iii) Wedgwood & Co. Another early line-engraved chinoiserie pattern featuring an elephant with howdah in a Chinese landscape with a pagoda and several figures. The usual impressed mark "WEDGWOOD & CO." indicates that it was made by Ralph Wedgwood at the Knottingley or Ferrybridge Pottery, Yorkshire. Ill: Coysh 2 34.

(iv) Enoch Wood & Sons. An elephant was featured on a pattern used for a dish in their Sporting Series.

In addition to these four designs, the Herculaneum Pottery made at least three patterns using designs from Daniell aquatints in the India Series (qv) which feature a prominent elephant in the foreground. The titles of the original prints are:

The Chalees Satoon in the Fort of Allahabad
Mausoleum of Sultan Purveiz, near Allahabad
View in the Fort, Madura

A pattern made at Swansea which is often called the Elephant pattern has no direct connection with the animal. It is a chinoiserie design with two rocks which are shaped rather like elephants. Ill: Coysh 2 111.

Elgin Pottery, Glasgow fl.1855-1868
This pottery in Davidson Street, Glasgow, produced wares printed with the Broseley pattern and marked with the initials E.P. and a square cartouche enclosing the words "Semi-China". Some pieces also bear the initials C.P., possibly those of Charles Purves who managed the works.

"Elizabeth Addressing the Troops"
Jones & Son. "British History" Series. Sauceboat.

On the approach of the Spanish Armada in 1588, Queen Elizabeth I made a speech to her troops at Tilbury during which she spoke the famous words: "I know I have the body of a weak and feeble woman, but I have the heart and stomach of a king, and of a king of England too; and think foul scorn that Parma or Spain, or any Prince of Europe, should dare to invade the borders of my realm."

Elkin, Knight & Bridgwood fl.1822-1846
Foley Potteries, Fenton, Staffordshire. This factory was run by various partnerships between the principals, many of which appear to have overlapped. The trading names used, together with initials used and the dates of operation, were as follows:

Elkin, Knight & Co., initials E.K. & Co.	1822-1826
Elkin, Knight & Bridgwood, initials E.K.B.	c.1827-1840
Knight, Elkin & Bridgwood, initials K.E.B. or K.E. & B.	c.1829-1840
Knight, Elkin & Co., initials K.E. & Co.	1826-1846
Knight & Elkin, initials K. & E.	1826-1846

Some of the partnerships used their full style in marks in addition to initial marks. Overlap in the partnerships is confirmed by items which bear the impressed mark "ELKIN/KNIGHT & Co." beneath a small crown together with printed marks including the initials E.K.B.

Patterns commonly encountered include "Canton Views", "Etruscan", "Moss-Rose" and the Rock Cartouche Series.

Elkin & Newbon fl.c.1844-1845
Stafford Street, Longton, Staffordshire. A short-lived firm which used the initials E. & N. One series of blue-printed flower patterns has been recorded with the title "Botanical Beauties" (qv).

Elkins & Co. fl.c.1822-1830
Lane End. According to Little (p.62) the partners in this factory were Elkin, Knight & Elkin. The name Elkins & Co. is most commonly found on wares from the so-called "Irish Scenery" Series (qv). Other partnerships were operating at the new establishment called the Foley Potteries at Fenton.
See: Elkin, Knight & Bridgwood.

Elsmore & Forster fl.1853-1871
Clayhills Pottery, Tunstall, Staffordshire. This firm marked their wares with the full name, sometimes with a version of the Royal Arms.

"Elterwater"
C.J. Mason & Co. "British Lakes" Series. Sauce tureen. Ill: Haggar and Adams, *Mason Porcelain and Ironstone 1796-1853*, 112.

Elterwater is one of the smaller lakes in the Lake District, not far from Ambleside and the northern end of Lake Windermere.

"Ely"
Enoch Wood & Sons. "English Cities" Series. Plates 10ins:25cm, and 7½ins:19cm. Ill: Moore 22.

A city and market town in the Isle of Ely, part of Cambridgeshire. The main feature is the cathedral, begun in 1083 and embracing styles of architecture from Early Norman to Late Perpendicular.

"Elysian"
Maker unknown. A romantic scene used on toilet wares. The word means ideally happy and comes from the Greeks' mythical heaven, Elysium.

"Embdon Castle"
Minton. Minton Miniature Series. Vegetable dish.

It has not yet proved possible to trace the castle depicted, although there was a seat called Endon in Worcestershire.

Emberton, William (& Co.) fl.c.1846-1869
Highgate Pottery, Brownhills, Tunstall, Staffordshire. This firm started as William Emberton & Co. in about 1846, but from 1851 it traded simply as William Emberton. Initial marks W.E. & Co. and W.E. are known.

Emery, Francis J. fl.1878-1893
Bleak Hill Works, Burslem, Staffordshire. Printed marks are known with the name "F.J. EMERY".

"Empress"
(i) Robert Cochran & Co.
(ii) Edge, Malkin & Co. A flown-blue pattern with birds, butterflies and flowers.

Enamel
A coloured paint used for overglaze decoration on printed wares. The wares are subjected to an additional firing process to fix the enamel on the glaze.
See: Clobbering; Filled-in Transfers.

"The Enchanted Bark"
James & Ralph Clews. Don Quixote Series. Vegetable dish and dish 11½ins:29cm. The prefix "The" may be missing from the marked title.

"Endsleigh Cottage"
(i) Ralph Stevenson. Stevenson's Acorn and Oak Leaf Border Series. Plate 9¾ins:25cm.
(ii) Maker unknown. Passion Flower Border Series. Square salad bowl.

This Devonshire "cottage" was designed by the fashionable

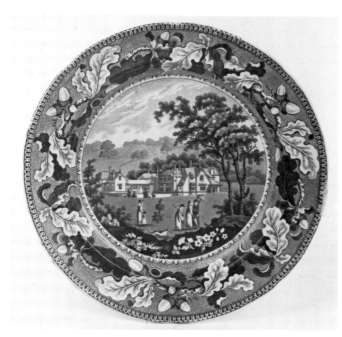

"**Endsleigh Cottage.**" *Ralph Stevenson. Stevenson's Acorn and Oak Leaf Border Series. Printed title mark. Plate 9¾ ins:25cm.*

"**English Cities**" Series. *Enoch Wood & Sons. Two typical printed marks.*

architect Sir Jeffry Wyatville for the Dowager Duchess of Bedford in 1810. The grounds, which slope down to the Tamar River, were laid out by Humphry Repton.

"English Cities" Series

A series of views typical of the 1830s, made by Enoch Wood & Sons in light blue but also printed in black and sepia. Items are moulded with a gadrooned edge and are made in an ironstone-like body named "Celtic China". The ornate printed mark includes the name of the body, the series title imposed on a bishop's mitre and mace, the name of the individual view, and the maker's initials E.W. & S. Slight variations in the design of the mark are known.

The city views, with the exception of Edinburgh and Leeds, were based on *Picturesque Views of the English Cities* (1828) published and edited by J. Britton of Burton Street, London. The designs for the printed mark are derived from the same source. The mitre and mace are based on the frontispiece design by J. Britton, engraved on wood by S. Williams.

The extensive list of views recorded includes:

"Chester"
"Chichester"
"Coventry"
"Durham"
"Edinburgh"
"Ely"
"Exeter"
"Hereford"

"**English Cities**" Series. *Title page of Britton's "Picturesque Views of the English Cities", the source book used by Enoch Wood & Sons for this series.*

"Leeds"
"Lincoln"
"Litchfield" (sic)
"Liverpool" (two views)
"London"
"Norwich"
"Oxford"* (two views)
"Peterborough"
"Rochester"
"Salisbury"
"Wells"
"Worcester"
"York"

Several examples are known on which the wrong title has been printed.

"English Scenery"
Maker unknown. A series of scenic views within an irregular border of scrolls and small flowers. The scenes nearly always have water with a sailing boat in the foreground. The printed mark includes the series title and the wording "SEMI-CHINA" on a draped scroll. Examples have been noted with the impressed pseudo-Chinese seal mark "Improved Stone China" (qv).

One view has been positively identified as Ripon in Yorkshire. It is identical to' one of the views by an unknown maker in the Passion Flower Border Series (qv).

English Sprays
A Spode floral pattern, introduced c.1829, with several sprays of flowers and a simple edge stringing. Ill: Whiter 44.

Engravers
The task of engraving designs on to copper plates used for printing was very skilled. The larger factories employed their own engravers but smaller firms would make use of specialists who might engrave the same patterns for more than one customer. Even the major factories such as Spode and Wedgwood are known to have used outside engravers,

including Thomas Sparks and William Brookes. A very comprehensive list is given by Mankowitz and Haggar in *The Concise Encyclopaedia of English Pottery and Porcelain*, pp.276-288.

"Entr. to Blaize Castle"
Minton. Minton Miniature Series. Plate 2¾ins:7cm.

This title almost certainly relates to Blaise Castle in Gloucestershire, an 18th century house near Bristol which is now a museum.

"Entrance to the Liverpool & Manchester Railway"
Maker unknown. Jug 5ins:13cm.

See: Railway Commemoratives.

"Enville Hall, Staffordshire"
Andrew Stevenson. Rose Border Series. Dish 11½ins:29cm, and vegetable dish.

Enville Hall is an 18th century house with two fronts, one a typical Georgian example with pediment and the other with turrets and battlements. There was a serious fire in 1904 after which a large porch was added. The grounds were superbly landscaped with a lake and fountain.

"Environs de Chambery"
Enoch Wood & Sons. French Series. Vegetable dish with cover.

Chambery is in France, lying to the south west of Geneva. It was the capital of the Duchy of Savoy and was not definitely secured by France until 1860. There is a castle and a 14th century cathedral.

"Erin"
The word "ERIN" has been recorded let into the border of a large dish from the "Beauties of England & Wales" Series (qv). This item may have been part of a special order but the significance of the word is not known. Erin is the ancient name for Ireland.

"Erith on the Thames"
Enoch Wood & Sons. Shell Border Series. Dish 13ins:33cm, tureen stands and vegetable dish. Ill: Arman 136.

As usual with items from this series, the view shows mainly boats, in this case a sailing ship with two smaller vessels. Erith is in Kent, on the southern bank of the Thames, some fourteen miles downstream from central London.

"English Scenery." Maker unknown. View identified as Ripon in Yorkshire. Printed series title mark. Cake stand 10¾ins:27cm.

"English Scenery." Maker unknown. Printed series mark.

"Esholt House, Yorkshire." *Enoch Wood & Sons. Grapevine Border Series. Printed title mark. Plate 10¼ins:26cm.*

"The Errand Boy"
James & Ralph Clews. "Wilkie's Designs" Series. Various dinner wares and custard cup. Ill: Arman 89; Laidacker p.33.

"The Escape of the Mouse"
James & Ralph Clews. "Wilkie's Designs" Series. Plates 8½ins:22cm, and 10¼ins:26cm, vegetable dish and square comport. Ill: Arman 90; Atterbury p.203.

"Esholt Hall, Yorkshire"
John & Richard Riley. Large Scroll Border Series. Covered dish.

"Esholt House, Yorkshire"
Enoch Wood & Sons. Grapevine Border Series. Plate 10¼ins:26cm.

Esholt is a village five and a half miles north of Bradford. The Hall was built for Sir Walter Calverley between 1706 and 1709.

"Eski Estamboul"
Maker unknown. Ottoman Empire Series. Dish.

This pattern possibly depicts Eski Emarut Camii in Istambul, the word Camii meaning mosque. It is the former church of the monastery of Christ Pantepopte (the All-Seeing), built by Anna Delassena before 1087. It stands in a prominent position looking across the Golden Horn and its southern facade is noted for the beautiful ceramic decoration. It is now used as a Koran school for students from Anatolia.

Etaya
This is the present day Etawah which lies between Delhi and Kanpur. Two potters featured nearby tombs on blue-printed patterns. John Hall & Sons used a view titled "Tombs of Etaya" in the "Oriental Scenery" Series, and a view in the Indian Scenery Series (qv) bears the title "Tombs near Etaya on the Jumna River".

Etna
See: "Aetna from the Augustines"; "Mount Etna".

"Eton College"
This is a title used on a scenic pattern with a man, woman and child in the foreground, a lake or river with a sailing boat in the middle distance, and a large building on a hillside in the background. It is doubtful if it was intended to be a view of the college. Items are common and known makers include Edward & George Phillips (Ill: P. Williams p.488), George Phillips (Ill: Little 47), Nicholson & Wood and George F. Smith of Stockton-on-Tees. It was almost certainly made at several other potteries.

Eton College Chapel
The distinctive chapel at Eton College has been noted on a plate in the Tams' Foliage Border Series although, as with many items from the series, the plate was not titled and no other examples are known. Goodwins & Harris used another view entitled "View of Eton Chapel" in their "Metropolitan Scenery" Series.

Etruria
The famous Wedgwood factory at Etruria, near Burslem, was started in 1769 on the Ridgehouse Estate. Josiah Wedgwood himself built a house called Etruria Hall nearby using Joseph Pickwood as architect. The Hall was eventually sold in 1844 but the factory continued in use until 1949, when new works at Barlaston were completed. The name Etruria can be found as part of many of the later Wedgwood marks. It was originally an area in central Italy, the home of the Etruscans.

"Etruscan"
This pattern title was used by a number of potters including Elkin, Knight & Bridgwood of Staffordshire, and Lockhart & Co. of Glasgow. The Elkin partnership used the name for a series title on light blue prints with groups of classical figures within a border of acanthus scrolls. One is illustrated here and two appear in Coysh 1 39-40. The individual designs are not titled but one has been identified as the figure of Britannia with three maidens.

The Herculaneum Pottery produced a series of designs which are usually referred to as Etruscan patterns. They are very similar to the Spode Greek patterns and can often be recognised by their ochre rims, though they are not marked. However, the attribution is commonly accepted. Ill: Coysh 1 152; Smith 160-161.

In the early years of the 19th century Etruscan became a magic word. The Etruscans were a highly developed people who lived in the area known as Etruria, north of the Tiber and between the Apennines and the west coast of Italy between the 6th and 4th centuries B.C. Their influence spread to Rome, Lombardy and the Adriatic.

Sir William Hamilton, British envoy to Naples from 1764 to 1800, was a keen archaeologist and collector of Etruscan relics. He took great interest in the excavations at Herculaneum and Pompeii, which were visited by many travellers on their Grand Tour. The publication of illustrations of his collection intensified interest, and it is not surprising that designs based on Etruscan relics should be used on transfer printed wares.

"Etruscan & Greek Vases"
Maker unknown. This pattern title occurs on a dish 19½ins:49cm. It has a large vase on the left and a country house which has been identified as Coughton Court, near Alcester in Warwickshire, printed in a lighter blue in the right background. The printed title cartouche includes a large vase. Another example has been noted with a view which is believed to be Warwick Castle and a vase assumed to be the "Warwick Vase" (qv).

"Etruscan." Elkin, Knight & Bridgwood. *Printed series title mark with maker's initials. Soup plate 10½ ins:27cm.*

"Etruscan Vase"

Enoch Wood & Sons. A romantic scene with a dominant two-handled covered vase on a stone base. A border of continuous foliated scrolls frames the view which is known on dinner wares. Ill: P. Williams p.67.

Laidacker records the same title used by T.J. & J. Mayer of Longport on a light blue and sepia dish.

"Etruscan Ware"

A trade name used on printed marks by Dillwyn at the Cambrian Pottery, Swansea.

"Etruscan & Greek Vases." Maker unknown. *View identified as Coughton Court near Alcester. Printed series title mark. Dish 19½ ins:49cm.*

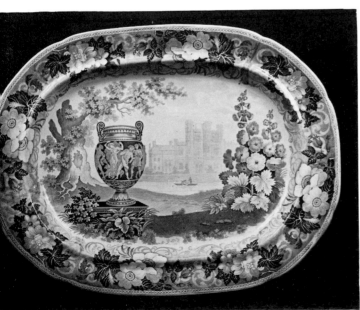

"Etruscan." Elkin, Knight & Bridgwood. *Printed series mark.*

"Ettington Hall, Warwickshire"

John & Richard Riley. Large Scroll Border Series. Round sauce tureen.

Ettington Park was completely remodelled in the Gothic style between 1858 and 1862 with the result that this view by Riley can no longer be seen.

"Eugenie"

Minton.

This title was probably adopted after the name of Eugenie Marie de Montijo de Guzman (1826-1920) who became Empress of France following her marriage to Napoleon III in January 1853. She acted as Regent during his absences in 1859, 1865 and 1870 and fled to England on the downfall of the Empire. She was befriended by Queen Victoria.

"Etruscan & Greek Vases." Maker unknown. *Printed series mark.*

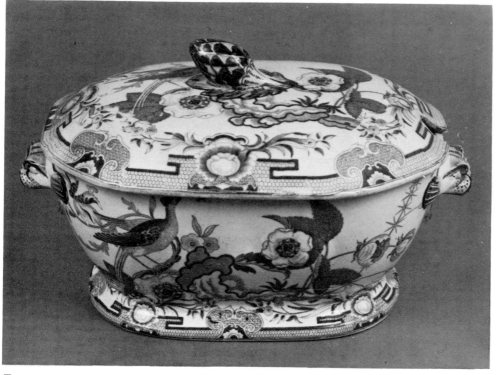

Exotic Birds. *Hicks, Meigh & Johnson. Printed octagonal mark with "STONE CHINA" around a crown. Tureen, with gilt pineapple finial, overall length 11½ ins:29cm.*

Europa
John & Richard Riley. A widely accepted title for a pattern which shows a lady mounted on a bull and attended by three maidens in the foreground of a romantic but typically English rural scene. Ill: Coysh 1 75.

The pattern appears to tell the story of Europa, daughter of Agenor, to whom Zeus was attracted. In order to gain access to her Zeus took the form of a tame bull. Europa found him so gentle that she climbed on his back and he swam with her to Crete.

Evans, D.J. & Co. fl.c.1862-1870
Cambrian Pottery, Swansea, Wales. The full name was used on printed marks, often with a pattern title. Impressed marks do not appear to have been used.

Evans & Glasson fl.1850-c.1862
Cambrian Pottery, Swansea, Wales. This partnership continued many of the designs used by their predecessors Dillwyn & Co. The name is found on both printed and impressed marks, although the quality of such items is generally poor.
See: Swansea; Swansea's Cambrian Pottery.

Ewer and Basin (or Bowl)
The production of ewer and basin sets for bedroom washstands must have provided staple work for several potteries. Most examples date from mid-Victorian times although earlier pieces can be found.

"Excelsior"
Samuel Moore & Co. A light blue romantic scene showing boats on a river with a fairyland castle in the background, all within a geometrical border with floral medallions. Ill: Little 114.

"Exeter"
Enoch Wood & Sons. "English Cities" Series. Cover of vegetable dish.
A cathedral city and the county town of Devon.

"Exhibition"
Robert Cochran & Co. A view of the Crystal Palace very similar to another produced by J. & M.P. Bell & Co. It was almost certainly made to commemorate the Great Exhibition of 1851.
See: "Crystal Palace".

Exotic Birds
The use of designs with exotic birds amongst flowers was quite popular in the 1820s and 1830s. Several typical examples follow:
(i) Hicks & Meigh. Exotic Birds and Flowers. Ill: Coysh 1 51.
(ii) Hicks, Meigh & Johnson. Exotic Bird. Ill: Coysh 2 44.
(iii) Harvey. Exotic Bird and Floral pattern. Ill: Little 29.
(iv) G.M. & C.J. Mason. Peony flowers and exotic birds. This pattern is usually referred to as the Blue Pheasants pattern (qv). Ill: Coysh 1 59; Little 38.

Eye Bath
A medical item rather like a small oval egg cup, used for bathing the eyes. Blue-printed examples are known but are not common.

"The Eye of the Master Will Do More Work than Both His Hands"
Davenport. "Franklin's Morals" Series. Dish 14½ ins:37cm. Ill: Laidacker p.39.
A rural scene showing the master giving instructions to his workers. Benjamin Franklin used this maxim twice in *Poor Richard's Almanack*. The first appearance was in 1744 in the form "The Eye of a Master, will do more Work than his Hand" but the later variant in 1755 was "The Master's Eye will do more Work than both his Hands".

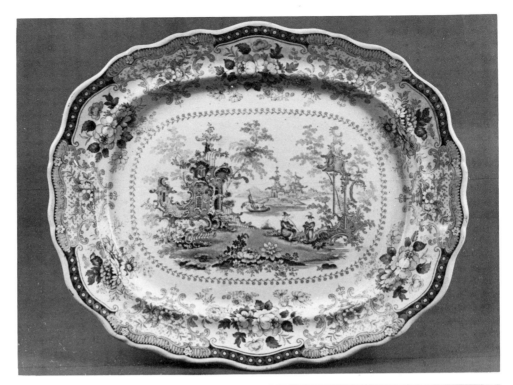

"**Fairy Villas.**" *Maddock &*
Seddon. Printed title mark with
maker's initials. Dish
19½ ins: 50cm.

"Fairy Villas"

Maddock & Seddon/John Maddock. A series of romantic
Chinese scenes with highly ornate pagodas, sailing boats,
figures and flowers, all printed within a border of flowers and
scrolls. The patterns were used on stone china dinner wares
with a wavy edge. Ill: Coysh 1 63. See also Godden M 2460.

"Fakeer's Rock"

John Hall & Sons. "Oriental Scenery" Series. Cup plate. Ill:
P. Williams p.154.

T. and W. Daniell engraved two views of "Fakeer's Rock in
the River Ganges, near Sultaungunge", dated 1800, in their
Oriental Scenery (Part 5), although they are not the source for this
view. The rock is a mass of grey granite which is now an island
separated from the bank. It is one of the most sacred Hindu
places on the Ganges. A building looks over the rock which is
carved with many figures.

"Falcon"

A plate printed with the "Tomb of Theron at Aggrigentum"
from the Don Pottery Named Italian Views Series (qv) is
known with an overglaze red-printed scroll mark on the base
bearing the name "FALCON". The significance of the name
is not known although it may relate to an inn or a ship, several
of which ordered specially marked wares.

"Falconer"

James Jamieson & Co.

Fallow Deer

John Rogers & Son. A rural scene printed on dinner wares. It
shows two prominent deer in front of snow covered thatched
farm buildings with a church in the background. The floral
border consists of two different groups of small flowers which
alternate with a third group of crocus-like blooms which make
the design appear to flow around the rims. The pattern was not
titled by Rogers but the name appears on later 19th century
reproductions made by Wedgwood which are clearly marked
as such. Ill: Coysh 1 88; P. Williams p.623.

"**Falcon.**" *Overglaze printed scroll with the name "FALCON" on a*
Don Pottery plate in the Named Italian Views Series.

Fallow Deer. *John Rogers & Son. Impressed "ROGERS". Plate*
8½ ins: 22cm.

Falmouth Packet. *Maker unknown. View of Falmouth Harbour. The printed mark is slightly obscured but reads "...SHIP CARN BRAE CASTLE". Dish 21ins:53cm.*

Falmouth Packet

Maker unknown. A view of Falmouth harbour with a prominent packet boat which appears on a large dish 21ins:53cm. The scene is printed with a border consisting of elongated oak leaves with artefacts at the bottom and a sprig of seaweed at the top. The dish bears a badly printed mark in the form of a small shipping scene vignette over which is curved the title "...SHIP CARN BRAE CASTLE". Carn Brae Castle is presumably the name of the ship depicted since Carn Brae is near Redruth, some ten miles north west of Falmouth.

Family and Mule

A widely accepted name for a pattern by an unknown maker used on dinner wares. The scene shows a woman leading a mule on which is seated a young boy, accompanied by two other children and a dog. There is a small bridge over a stream which they have just crossed and impressive ruins in the background. The border consists of large flowers and leaves on a stippled ground alternating with sections composed of smaller flowers on a darker ground bordered by a prominent acanthus leaf and other scrolls. Ill: FOB 5.

"Fan Border"

Maker unknown. A later design with a small central picture of a group of vases within a border including fan-shaped motifs. The example noted had a poorly printed cartouche mark and the maker's initials were unreadable.

"Fancy Vase"

Pountney & Allies. A typical romantic scene c.1830, with a large urn on a stand decorated with classical figures. In the distance are sailing ships and classical buildings. There are similar repeated scenes in the border and the complete design is decked with flowers. The printed circular cartouche mark includes the title and the initials P. and A. above and below. Ill: Coysh 2 70.

"Faulkbourn Hall"

Andrew Stevenson. Rose Border Series. Plates and soup plates between 8ins:20cm and 10¼ins:26cm. Ill: Arman 418; Moore 81.

Faulkbourn Hall is described by Nikolaus Pevsner as "the most impressive 15th century brick mansion in this country". It is about five miles south east of Braintree in Essex.

Family and Mule. *Maker unknown. Impressed mark W. Plate 10ins:25cm.*

"Faulkbourn Hall." *Andrew Stevenson. Rose Border Series. Printed title mark and impressed maker's circular crown mark. Plate: 10¼ins:26cm.*

Feeding Bottle

A flattened bottle for feeding babies. It has a central hole for filling and a spout for feeding and is similar to later examples made in glass. Blue-printed examples were produced by several factories including Spode, Ridgway and Wedgwood. Examples by William Ridgway and by Wedgwood illustrated in Coysh 2 75 and 1 138.

Feeding Bottle. *Maker unknown. Country scene. Unmarked. Length 7ins:18cm.*

Feeding Bottle. *Maker unknown. Floral pattern. Unmarked. Length 7¼ins:18cm.*

Feeding Cup

A cup fitted with a spout and half covered so that the liquid does not spill when the cup is tilted. They were used for feeding babies and invalids. The handle is usually, but not always, fitted to one side. Amongst known makers are Davenport, Spode and Wedgwood and examples by Copeland & Garrett are relatively common. Ill: Coysh 2 143.

Feeding Turkeys

Maker unknown. An attributed title given to a pattern found on a child's plate showing a woman and girl feeding several birds. Ill: Coysh 2 153.

"Felix Hall"

Andrew Stevenson. Rose Border Series. Vegetable dishes.

Felix Hall, at Kelvedon in Essex, was built in 1760. Only the centre block remains.

Fell, Thomas (& Co.) fl.1817-1890

St. Peter's Pottery, Newcastle-upon-Tyne. Existing texts disagree on the date when the style became Fell & Co., but it is generally thought to have been about 1830. Most printed or impressed marks include either "FELL" or "FELL & Co." but initial marks and full address marks are known. In earlier days the factory seemed to specialise in tea wares but production broadened as business developed. Amongst the printed patterns in use were the common Willow and "Wild Rose" designs. Other titles include "Bosphorus", "Corinth", "Chinese Marine", and a copy of the Spode Woodman pattern. Marks often include an anchor.

Felspar

A mineral which weathers to become china clay. The name is frequently found on china wares, the term Felspar Porcelain being used by Spode, Coalport and Worcester. Felspar is sometimes spelt feltspar, and the Chinese name is *petuntse*. The name Felspar was used on earthenwares by Thomas & John Carey. A body called Felspar China or Felspar Porcelain was used by Minton between 1822 and 1836.

Fence

A title given to a Spode chinoiserie pattern which includes a prominent fence amongst flowers and bamboo plants in a simple beaded border. It was also used with a floral border. Ill: Coysh 2 97; Whiter 38; S.B. Williams 132.

Feeding Cup. *Davenport. "Muleteer" pattern. Printed title mark with maker's name. Diam. 5ins:13cm.*

Feeding Cup. *Wedgwood. Blue Rose Border Series. Impressed maker's mark. Height 2½ins:6cm.*

Fenton

A pottery town three miles to the east of Stoke, in Staffordshire, into which it has now been absorbed. The most important resident firm producing blue-printed wares was almost certainly the Elkin, Knight & Bridgwood partnership of the Foley Potteries.

See: Lane Delph.

"Ferrara"

A Wedgwood pattern with sailing ships in a harbour, introduced in 1832 and said to have been engraved by William Brookes. It was used over a long period, especially on tea wares, and was printed in blue, brown and purple. The printed title may be found on the later examples. A liqueur bottle with this pattern made for Humphrey Taylor of London, Distillers of Liqueurs, has been noted with a date mark for 1906. In *The Dictionary of Wedgwood*, Reilly and Savage state that the pattern "depicts an Italian harbour scene with the castle of the Dukes of Este to the left, a canal which connects the harbour with the river Po, and a group of shipping which was taken from a set of engravings published in 1832 under the title *Lancashire Illustrated*". The same group of ships was used by Herculaneum Pottery on one of their views of Liverpool, and the original engraving is illustrated in Smith 181.

Ferry over the River Mersey at Birkenhead

Herculaneum. Liverpool Views Series. Bowl 10½ ins:27cm. Ill: Smith 182.

It is not clear whether this item bears a title.

Ferrybridge Pottery fl.1792 to present

This pottery, near Pontefract in Yorkshire, was known as the Knottingley Pottery until 1804. The various partnerships were as follows:

Established by Tomlinson, Foster & Co.	1793
Tomlinson, Foster, Wedgwood & Co.	1798
William Tomlinson & Co.	1801
Tomlinson, Plowes & Co.	1804
William Tomlinson	1828
Edward Tomlinson	1830
Reed & Taylor, and later Reed, Taylor & Co.	1832
Ferrybridge Pottery Co.	1841
Benjamin Taylor & Son	1848
Lewis Woolf	1851

One of the most significant changes in the history of the pottery was the arrival in 1798 of Ralph Wedgwood, nephew of Josiah Wedgwood. He came from Burslem and introduced some blue-printed wares including an Elephant pattern (Ill: Coysh 2 34) and other chinoiseries. However, his experiments were costly, and he left after only two and a half years, by which time the production of blue-printed ware was established. Pieces made during Ralph Wedgwood's time at the pottery are impressed "WEDGWOOD & Co.", although it is thought that this mark may have been used for two or three years after his departure, possibly until 1804. One of the most interesting series of patterns used during this period was of Etruscan figures, and a pattern book including transfer pulls of this series still exists in the Wedgwood archives. Wares impressed "FERRYBRIDGE" date from 1804.

"Field Sports" Series

A series by the Herculaneum Pottery depicting hunting and shooting scenes within a floral border. The above title is found on at least one of the patterns (See: Smith 173B), and examples bear the impressed Liver Bird mark. The scenes were also printed in black. Laidacker lists the scenes to be found (p.52)

and the updated list is as follows:

"Field Sports" (mounted huntsman with pack of hounds). Ill: Smith 173
Fox head and horn
Hunting scene, two hunters with dog
Two duck hunters with boat
Two hunters and two pointers flushing birds. Ill: Smith 167
Two men fishing below falls, mill in background

A very similar pattern bearing a slightly different border is illustrated in Little 109. It shows a seated huntsman with his dogs, and bears the impressed mark "HERCULANEUM". It is an earlier piece and probably the inspiration for the above series.

Filigree

A relatively late Spode floral pattern introduced in about 1823. The central design shows a basket of flowers and the very wide border has a detailed floral background and six reserved panels, three with floral sprays and the other three with different baskets of flowers. Ill: Coysh 1 121; Whiter 47.

A very similar pattern has a different basket for the central design and all six border panels have floral sprays. This pattern is usually marked with a printed three-masted ship above which is a ribbon with the words "SEMI-NANKEEN CHINA", all surmounted by a crown, a thistle and a rose (Godden M 3702). One such plate has been noted with the impressed mark "MINTON" and a date mark for 1862. It is possible that the Minton firm acquired copper plates and used them at a later date; certainly most examples appear to be earlier, probably c.1825-30. The plates with only the printed mark and the marked Minton example have wide double footrims, suggesting that they may have come from the same factory. Several examples have been noted with the impressed seal mark "Improved Stone China" (qv) which is also known on other marked Minton wares. There appears to be little reason to agree with the earlier attribution of this design to Andrew Stevenson. Ill: Coysh 1 123.

Filled-In Transfers

Sometimes a design would be printed in blue in outline only, then glazed and subsequently painted by hand in coloured enamels over the glaze, using the blue outline as a guide. This method made it possible to produce coloured wares using relatively unskilled labour, often children, in the paint shop. The patterns are often of Chinese style, with figures in a landscape, or what are generally known as 'Japan' patterns, extensively produced on ironstone wares. Some attractive floral designs were also made in this way. (Colour Plate V.)

Some firms seem to have specialised in this type of work, including the Mason and Ridgway factories. Other potters used the technique at various periods, among them the Cambrian and Glamorgan Potteries at Swansea; Bailey & Batkin, Lockett & Hulme and Mayer & Newbold, all of Lane End; Thomas Lakin of Stoke; William Ratcliffe of Hanley; and Andrew Muir of the Clyde Pottery at Greenock.

"Finborough Hall, Suffolk"

Maker unknown. Morning Glory Border Series. Small teapot.

Finborough Hall was built in 1795 by F. Sandys. It has a long bow window and a colonnade of six Tuscan columns.

"Finsbury Chapel"

Enoch Wood & Sons. "London Views" Series. Plate 5¾ ins:15cm.

Finsbury Chapel was built from a design by William Brookes, the architect of the London Institution. It was erected by a congregation of Protestant Dissenters.

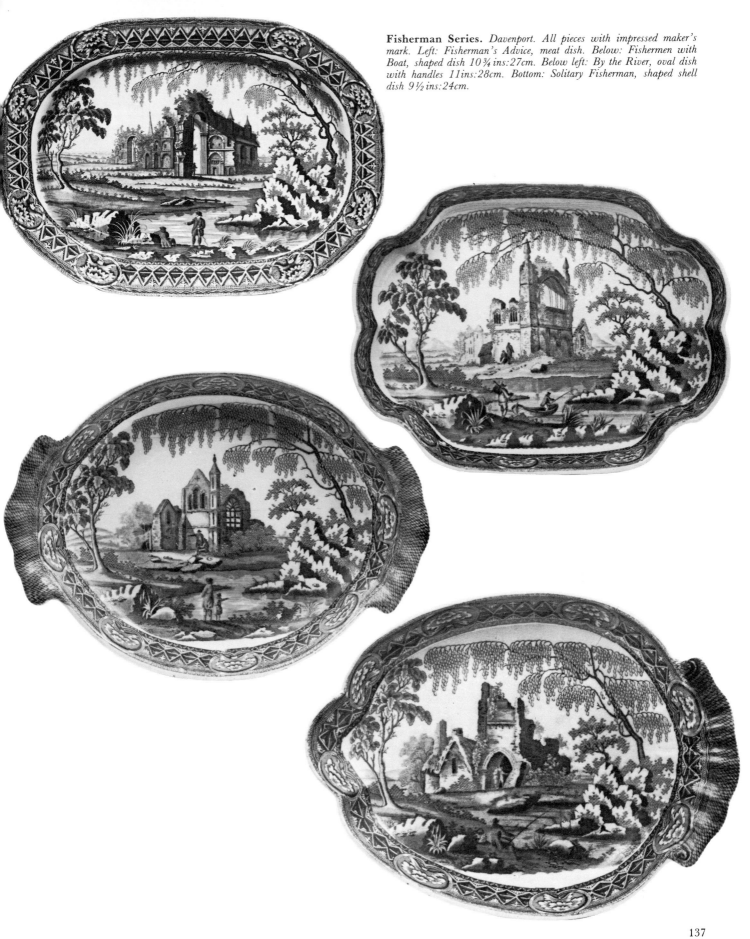

Fisherman Series. *Davenport. All pieces with impressed maker's mark. Left: Fisherman's Advice, meat dish. Below: Fishermen with Boat, shaped dish 10¾ ins:27cm. Below left: By the River, oval dish with handles 11ins:28cm. Bottom: Solitary Fisherman, shaped shell dish 9½ins:24cm.*

Firewood Pattern

A pattern which has been given this title was included by Bathwell & Goodfellow in their "Rural Scenery" Series on a plate 9½ins:24cm. The scene shows a villager carrying poles approaching a woman with a basket and a child on the ground. In common with all items in this series, the scene is not titled. Ill: Coysh 2 7.

Fish Dish

Most boiled fish was served on a drainer fitted into an ordinary meat dish but special long, narrow dishes, designed to take a single large fish such as a salmon, are occasionally found. An early chinoiserie example by Joshua Heath has been recorded (Ill: Coysh 1 4). Copeland illustrates a Spode dish on which the central pattern consists of two fish (Chapter 5, 26).

Fisherman Pattern

A famous design used by Caughley on porcelains, see Godden I 96. A very similar design but in reverse with five small riverside scenes around it was produced by an unknown maker on earthenware. An example shown in Coysh 2 145 is on a plate with blue feather edging.

Fisherman Series

A series of rural scenes by John Davenport which all show fishermen by a river with ruins in the background. The standard border is of chevrons and oval medallions. The series is interesting in that the scenes differ only in the central design of figures and ruins; they are all framed by an identical setting of rocks and trees, one of which grows from the right and extends across the sky. Lockett illustrates four examples, all on dessert wares and states that they are "comparatively rare". Three further dessert pieces are illustrated together with one scene on a large meat dish so it appears that dinner wares were also made. The scenes recorded to date are:

Fisherman and Fence. Pierced dessert plate. Ill: Lockett 26
Fisherman and Friend. Pierced basket. Ill: Lockett 27
Fisherman's Advice. Meat dish.
Fisherman's Tale. Supper set quandrant. Ill: Lockett 25
Fishermen with Boat. Dessert dish.
By the River. Oval dessert dish.
Solitary Fisherman. Shell dish and pierced basket stand. Ill: Lockett 27

Fisherman's Hut

Maker unknown. A title which has become accepted for a design which shows a fisherman with equipment on his back standing outside his hut. In the foreground a woman with a child in her arms kneels by some large fish. On the right is the bow of a sailing ship with prominent masts and in the background is a large country house. The scene is printed in a brilliant dark blue within a floral border. Several examples of the pattern have appeared recently in Britain but they can all be traced back to the United States and the design was probably made originally for export.

"Fisherman's Island, Lago Maggiori" (sic)

Enoch Wood & Sons. "Italian Scenery" Series. Plates 8½ins:22cm and 9¼ins:23cm.

Lake Maggiore lies on the border between northern Italy and southern Switzerland. Its ancient name was Lacus Verbanus.

Fishermen with Nets

A scene showing a man in a boat and two men handling a net hung on a tree on the nearby bank. There is an English-looking temple on an island in the background. An example with the impressed mark "HAMILTON/STOKE" is shown in Coysh 1 48, whereas another example with only a printed cursive letter N is illustrated in Little 41. Other examples are known with a printed mark of Tams & Co.

"Fishers"

Cork, Edge & Malkin. A pattern printed on miniature dinner wares marked with the initials C.E. & M.

Fishing Scene

Brameld. This title is sometimes used for a design which is more usually called Boys Fishing (qv).

Fitzhugh

The modern name for a Spode pattern still in production. Whiter states that the authentic name is "Dagger Border and Trophy Centre", although this is usually shortened to Trophies-Dagger pattern. Ill: Whiter 30.

"Fives Court"

Maker unknown.

The Fives Court in London was a rendezvous for boxing matches. In an edition of *Sporting Anecdotes* (1825) there is a fold-out plate by Robert Cruikshank entitled "A Visit to the Fives Court" showing Spring and Neat fighting before a group of spectators.

See: Sporting Mug.

Flacket, Toft & Robinson fl.1857-1858

Church Street, Longton, Staffordshire. A brief partnership known to have used the initials F.T. & R. on printed title marks:

Flasks

These are rare. A round flattened bottle or flask is illustrated. It has a view of a country tavern and carries an underglaze incised mark: "H. Carr 1825". Similar flasks are known with a loop on either side of the neck so that they could be suspended by cords from the shoulder. They are usually known as pilgrim flasks.

Fisherman's Hut. *Maker unknown. Unmarked. Plate 10ins:25cm.*

Flasks. Maker unknown. View of a country tavern. Incised underglaze mark "H. Carr 1825". Diam. 5½ins:14cm.

Flatware
A term used in the pottery trade for flat articles such as plates, dishes, drainers and saucers.
See: Sizes.

Fletcher, Thomas fl.1786-1810
An engraver and printer of Shelton in Staffordshire. Examples of black prints on creamware with the signature Fletcher & Co. are known. At this period it is almost certain that he would also have engraved copper plates for blue-printed wares although it is unlikely that any signed prints exist.

Fleur-de-Lis
The fleur-de-lis is an iris flower, but is more particularly a heraldic lily. It forms part of the arms of the French royal family but the motif is widely used elsewhere. It can often be found as part of printed borders and was occasionally used to make up the stringing printed between central design and border or at the edge of the rim.

"Fleurs, Roxburgheshire" (sic)
William Adams. Flowers and Leaves Border Series. Dish 15ins:38cm. Ill: Nicholls, *Ten Generations of a Potting Family,* Plate XLIII.

Floors Castle, as it is now known, is the home of the Duke and Duchess of Roxburghe. It overlooks the River Tweed at Kelso, and was built by William Adam in 1721-26. It is open to the public in summer.

"The Flight into Egypt"
(i) Herculaneum. Plate 10ins:25cm. Ill: Smith 166. The central design showing Joseph leading Mary and Jesus on a donkey is contained in a border of scrolled medallions, each with a cross, a book and a lamb. It appears to be the same as the Enoch Wood & Sons border.

(ii) Thomas Mayer. "Illustrations of the Bible" Series. Plate 5ins:13cm. This scene is titled simply "Flight into Egypt".

(iii) Enoch Wood & Sons. Scriptural Series. Plate 9ins: 23cm.

"And when they were departed, behold, the angel of the Lord appeareth to Joseph in a dream, saying, Arise and take the young child and his mother, and flee into Egypt, and be thou there until I bring thee word: for Herod will seek the young child to destroy him. When he arose he took the young child and his mother by night, and departed into Egypt". Matthew, 2, 13-14.

"Flora"
(i) Minton.
(ii) Maker unknown. A pattern with vase, fruit and flowers noted on a ewer. The title is printed on a ribbon and some examples have an impressed crown.

"Floral"
(i) Thomas Shirley & Co.
(ii) Spode. A series of patterns each with a single spray of flowers within a border of flowers and floral medallions. They were introduced in about 1830 and bear the only floral cartouche title mark used in the Spode period, Whiter mark 23, p.226. Ill: Whiter 48, 95; P. Williams p.39.

"Floral Scenery"
Attributed to Samuel Barker & Son. A typical romantic scenery pattern with an urn in the foreground. The printed cartouche title mark has the word "BARKER" beneath. Ill: Coysh 1 147.

Floral Sprays
Leeds Pottery. A pattern name used by Lawrence for a design with separately printed floral sprays within a continuous border of similar flowers. Ill: Lawrence p.52.

"Florence"
(i) William Adams & Sons. A light blue design.
(ii) Robert Heron & Son.
(iii) David Methven & Sons.
(iv) John Rogers & Son. A typical romantic scene with Italian buildings, a three-arch bridge and a gondola, all within a border of scrolled medallions. Ill: Coysh 2 80.
(v) Enoch Wood & Sons. "Italian Scenery" Series. Soup tureen, vegetable dish and jug. Another pattern from the same series is titled "View near Florence" (qv).

Florence is the capital of Tuscany in central Italy. It is one of the world's great art centres, associated with the Medicis, Dante, and many great painters such as Botticelli and Giotto. The Italian name is Firenze.

"Florentine"
(i) G.L. Ashworth & Bros. See Godden M 141.
(ii) George Gordon. The title, together with the words "OPAQUE CHINA", appears on a floral cartouche showing a dove holding an olive branch.
(iii) Podmore, Walker & Co. A pattern printed in light blue.
(iv) G.F. Smith & Co. A title noted on a ewer in a cartouche with the full name. The example was also marked with impressed initials G.F.S. & Co.

"Florentine Fountain"
Davenport. A typical romantic scene in the rococo style with a fountain, bridge, buildings, and a statue of Neptune with his trident. The floral border features several butterflies. Ill: Coysh 2 24.

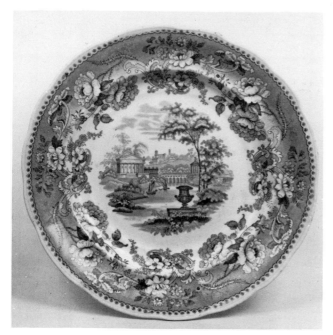

"**Florentine Villas.**" *Job & John Jackson. Printed scroll cartouche with title and "Jackson's Warranted" below. Plate 10½ ins:27cm.*

"Florentine Villas"
(i) Job & John Jackson. Scenes with temples within a floral border which were also printed in other colours. Ill: P. Williams p.263.
(ii) James Jamieson & Co.

"Flosculous"
William Ridgway & Co. A floral design marked with the initials W.R. & Co. but with a rather strange title. *The Oxford Dictionary* defines the word flosculous as "having florets, composite-flowered". The pattern has several groups of idealised blooms radiating from a central rococo scroll motif. There is no separate border. Ill: P. Williams p.629.

Flow Blue (Flown Blue)
These terms are used to describe a blue print in which the ink has been allowed to run into the glaze, producing a blurred or halo effect. It is produced by introducing a chemical such as lime or ammonium chloride into the glost oven. It was very popular in Victorian times and export wares are now collected in America. This dictionary covers only examples which are commonly found in Britain today. Three books by Petra Williams deal with the subject in more detail, including the export wares: *Flow Blue China. An Aid to Identification* (1971); *Flow Blue China II* (1973); *Flow Blue China and Mulberry Ware* (1975). All three books are published by Fountain House East, P.O. Box 99298, Jeffersontown, Kentucky 40299, U.S.A.

Flower Cross
A name used for a Spode pattern of stylised flowers arranged in the form of a cross with a border of trailing plants. The pattern is usually printed in a rather dark blue and most examples are on dessert wares. Whiter states that "examples of this unusual pattern are very rare" and several items without any mark are known. Ill: Coysh 1 159; Whiter 34.

"Flower Girl"
Maker unknown. A pattern found on teawares marked with the title in a circular cartouche. It was also printed in black.

Flow Blue. *Davenport. "Persian Bird" pattern. Printed title mark with a bird and the maker's name. Impressed maker's anchor mark for 1844. Soup plate 10½ ins:27cm.*

"Flower Groups"
Brameld. A pattern with a floral spray and a butterfly found on moulded wares. The printed floral cartouche mark includes the title and the wording "GRANITE CHINA" but does not always appear on the wares. Ill: Rice, 20, 24. The mark is illustrated by Eaglestone and Lockett in *The Rockingham Pottery* (revised 1973), mark 28.

Flower Medallion Border Series
An uncommon series by an unknown maker in which the flower medallions in the border create a scalloped edge to the central view. Examples are in dark blue and were probably made for export to America. The following views have so far been recorded:
"Alnwick Castle"
"Belvoir Castle, Rutlandshire"
"Glemham Park, County Suffolk"
"Hallow Park, Worcestershire"
"Hanover Lodge, Regent's Park, London"
"Kenilworth Castle, Warwickshire"
"Sherborne Castle, Dorsetshire"*
"Sussex Place, Regent's Park, London"
"Whitney, Oxfordshire" (sic)
The views of Hanover Lodge and Sussex Place, both in Regent's Park, are based on prints by Thomas Shepherd in

Flower Medallion Border Series. *Maker unknown. Typical printed mark.*

Flowers and Leaves. *Henshall & Co. Rare impressed maker's mark. Supper set comport. Height: 8 ¾ ins:22cm.*

Metropolitan Improvements or London in the Nineteenth Century (1827). Other untitled views are known.

"Floweret"
Minton. An undistinguished floral pattern bearing the title in a printed cartouche above the cursive initial M.

"Flowers"
Maker unknown. A pattern recorded on a Stone China vegetable dish printed with scattered flowers. One spray with a large tulip, a wild rose and birds predominates.

Flowers and Leaves
A name used for an all-over pattern of flowers and leaves with no distinct border but a simple edge of stringing. The same pattern is known with marks of two different potteries. A plate with the rare mark "HENSHALL & CO." is illustrated in

Flowers and Leaves Border Series. *William Adams. Typical printed mark with impressed maker's eagle mark.*

Coysh 2 41, whereas a dish marked "HERCULANEUM" is shown in Smith 151. Henshall & Co. are known to have sold wares through the Duke Street Warehouse, owned by Herculaneum, in Liverpool. It is possible that some Staffordshire patterns were pirated by the Liverpool concern. See: Smith, pp.55-56.

Flowers and Leaves Border Series
A series of British views by William Adams with a border of flowers, leaves and scrolls. The above series title is used by Laidacker. Items usually bear the name of the view on a printed mark although several views are known with no title. Examples are known both with and without an impressed maker's mark. The list of named views includes:

"Armidale, Invernessshire"
"Berkley Castle, Gloucestershire" (sic)
"Blaise Castle, Gloucestershire"
"Blenheim, Oxfordshire"*
"Bramham Park, Yorkshire"
"Carstairs, Lanarkshire"
"Denton Park, Yorkshire"*
"Dews Hall, Essex"
"Fleurs, Roxburgheshire" (sic)
"Fonthill Abbey"
"Glanbran, Carmarthenshire"
"Gracefield, Queen's County, Ireland"
"Murthly, Perthshire"
"Normanton Park, South View, Rutlandshire"*
"Pishobury, Hertfordshire" (sic)*
"Plasnewydd, Anglesey"
"Rode Hall, Cheshire"
"The Rookery, Surry" (sic)*
"Sunning Hill Park, Berkshire"
"Tixall, Staffordshire"
"Wellcombe, Warwickshire" (sic)*
"Wells Cathedral"
"Wilton House, Wiltshire"*

Laidacker also lists "Blaise Castle, Lancastershire" and "Beckham Place, Kent", each on a 6ins:15cm plate. The

former is suspect since the county is incorrect whereas the latter is thought to be an error for "Beckenham Place, Kent" which exists in the Bluebell Border Series by the same maker.

Many of the examples examined are rather poorly printed.

"Flowers That Never Fade"
A title to be found on a series of unmarked children's plates, all with a moulded border. The decoration also includes one or other of the maxims written by Benjamin Franklin. An example with a maxim titled "Good Humour" runs: "Good humour is the greatest charm that children can possess; It makes them happy, and what's more, it gives them power to bless". Ill: Camehl, *The Blue China Book*.

See: Doctor Franklin's Maxims.

Flown Blue
See: Flow Blue.

Floyd, Charles fl.c.1834-c.1839
A very large display jug has been noted bearing the inscription:
CHARLES FLOYD
EARTHENWARE &
CHINA DEALER
LONDON
1835
It was almost certainly produced for display in the window of Floyd's shop. The decoration consisted of a series of romantic scenes placed all over the outer surface, apparently using the centres from designs for plates and dishes. There was a typical flower and scroll border around the neck. Unfortunately, it did not bear a maker's mark.

Charles Floyd is listed as a china, glass and earthenware dealer at 15 Smith's Buildings, City Road, in 1834 and 1835. Between 1836 and 1839 his address became 31 Bartholomew Terrace, still in City Road, but by 1840 the directory entries cease.

Flying Pennant
An early Spode chinoiserie design with a pagoda, two men on a bridge, and a boat with a flying pennant. Ill: Copeland p.90, plate 34; Whiter 13.

The same pattern was produced at the Herculaneum Pottery. A dish with a date mark for 1807 is illustrated in Coysh 1 14 under the name "Two man/two arch" pattern.

Folch, Stephen fl.c.1819-1830
Church Street, Stoke, Staffordshire. Folch produced blue-printed ironstone wares very similar to those made by the Masons factory. Items have been recorded with an elaborate royal arms printed mark and also the legend "Folch's Genuine Stone China". Similar marks bear no maker's name but "Improved Ironstone China, Stoke Works". Examples with overglaze enamels are also known.

"Foliage"
Maker unknown.

Foliage Border Series
A series of views, mainly in England, by an unknown maker. The scenes are printed in dark blue within a border of foliage edged by a narrow band of stringing. Examples are marked with a title cartouche, usually printed under the rim on plates, but no item with a maker's mark has yet been recorded. Laidacker attributes the series to Hall and states that articles are scarce. Very few pieces are found in Britain and, as with many of these dark blue series of views, they were probably made mainly for export to America. Known views include:
"Armley House, Yorkshire"
"Badminton"

Foliage Border Series. *Maker unknown. Typical printed mark.*

"Blenheim, Oxfordshire"
"Broke Hall, Suffolk"
"Cannon, Yorkshire"
"Coke Thorpe, Oxfordshire"
"Fonthill Abbey, Wiltshire"
"Gayhurst, Buckinghamshire"
"Gorhambury, Hertfordshire"
"Gunton Hall, Norfolk"*
"Holme Pierrepont, Nottinghamshire"
"Lindertis, Forfarshire"
"Maxstoke Castle, Warwickshire"
"Milnes Bridge House, Yorkshire"
"Moditonham House, Cornwall"
"Rode Hall, Cheshire"
"Shugborough, Staffordshire"
"Tixall, Staffordshire"
"West Acre House, Norfolk"
"Wistow Hall, Leicestershire"

Foliage and Scroll Border Series
A series of untitled views with the same border issued by both William Adams and James & Ralph Clews. Since the major potters do not appear to have copied each other's wares as extensively as some of the lesser firms, it must be considered unlikely that items from both these potteries were on sale at the same time. It may be that Clews took over some copper plates when they rented one of the Adams potteries in 1818 although this seems too early for items from this series. It is more likely that Adams bought some of the Clews engravings when they closed in 1834. According to Nicholls in *Ten Generations of a Potting Family*, p.112, "this has been proved to be so from the books still extant at Greenfield".

Laidacker states that "this is one of the few instances where two potters used the same border and, in this series, the same views on the same articles of the identical size". However, he lists only two views by Adams as against eight by Clews. Identified views by Adams include:
Alnwick Castle, Northumberland*
Melrose Abbey
St. Catherine's Hill, near Guildford*
The corresponding known views by Clews include:
Alnwick Castle, Northumberland
Canterbury Cathedral
Greenwich
Melrose Abbey
Nottingham
Rochester Castle
St. Catherine's Hill, near Guildford
Windsor Castle

"Fonthill Abbey." *Maker unknown. Passion Flower Border Series. Printed title mark. Dish 12½ ins: 32cm.*

"Fonthill Abbey, Wiltshire." *James & Ralph Clews. Bluebell Border Series. Printed title mark and impressed maker's crown mark. Plate 10¼ ins: 26cm.*

"Fonthill Abbey, Wiltshire." *Enoch Wood & Sons. Grapevine Border Series. Printed title mark. Plate 8ins: 20cm.*

143

"The Font"

This printed title beneath a fountain has been noted on the wares of both Thomas Rathbone & Co. of Portobello and Wood & Challinor of Staffordshire. It relates to the pattern also used by Spode and often referred to as Girl at the Well (qv).

"Fonthill Abbey"

(i) William Adams. Flowers and Leaves Border Series. Plate 6ins:15cm.

(ii) Maker unknown. Passion Flower Border Series. Dish 12½ins:32cm.

"Fonthill Abbey, Wiltshire"

(i) James & Ralph Clews. Bluebell Border Series (distant view). Dish 17ins:43cm. Ill: Coysh 2 18.

(ii) James & Ralph Clews. Bluebell Border Series (near view). Plates 8ins:20cm and 10¼ins:26cm and a bed pan.

(iii) Enoch Wood & Sons. Grapevine Border Series (distant view). Plate 8ins:20cm.

(iv) Enoch Wood & Sons. Grapevine Border Series (near view). Plates 8ins:20cm and 10ins:25cm.

(v) Maker unknown. Foliage Border Series. Dish 17ins:43cm.

In addition to all the above titled views, the abbey has been identified on untitled wares in two other series. Ralph Stevenson included one view in his "Panoramic Scenery" Series on a dish 14ins:36cm and a plate 9ins:23cm (Ill: Laidacker p.78). The so-called "Irish Scenery" Series made by both Elkins & Co. and Careys also included a view of the abbey on a large dish.

Fonthill Abbey attracted great public interest in the years between 1810 and 1825. It was built by William Thomas Beckford (1768-1844), who inherited the Fonthill estate from his father together with a vast fortune. He decided to build a large Gothic 'abbey' with a 275 foot tower and commissioned James Wyatt to design it. In 1800 he held a party in honour of Lord Nelson in the part that had been completed. He moved in himself in 1807 and continued building until 1813 although the Abbey was never completed. Beckford became known as the Caliph of Fonthill, although in 1823 he sold it, and in 1825 the great tower collapsed and destroyed much of the Abbey. The foundations had never been designed to support such a vast tower. For the history of Fonthill see Compton Russell's *William Beckford* (1980).

A source of prints was *Delineation of Fonthill and its Abbey* (1823) by J. Rutter of Shaftesbury. The drawings were by George Cattermole.

Food Warmer (Veilleuse)

A cylindrical pottery device made in three parts for keeping food warm. There is a base which can be used with a night light as a source of heat, a pedestal which fits into the base, and a covered bowl which fits on top for the food. A simpler type of food warmer is described under Hot Water Plate.

Foot Bath

A large vessel, usually oval in shape with two handles. Earlier examples were relatively simple with straight vertical sides, later examples became more decorative with bowed sides and gadrooning. An earlier type by John Mare with the Italian pattern is illustrated in Godden I 373, and another of similar date by Wedgwood with the Water Lily pattern is shown by Reilly and Savage in *The Dictionary of Wedgwood*. A very unusual foot bath shaped rather like a wide wellington boot, made by Spode and bearing the Lanje Lijsen pattern is shown in Whiter 101.

"Foot of Mount Sinai"

Thomas Mayer. "Illustrations of the Bible" Series. Bowl. Ill: P. Williams p.296.

Footrim or Foot Ring

A raised rim around the base of flatwares. Early plates and dishes seldom have a footrim and it was difficult to make them so that some did not spin round on the table. Footrims prevented this unsteadiness. Where footrims exist they tend to be of three basic types, single, double or rounded, all illustrated in Coysh 1 p.8. Variations are sometimes found.

Ford, Challinor & Co. fl.c.1865-1880

Lion Works, Sandyford, Tunstall, Staffordshire. This firm was also known as Ford & Challinor and produced general earthenwares for both the home and overseas markets. Various printed marks include the initials F. & C. or F.C. & Co.

"Fords of the Jordan"

Thomas Mayer. "Illustrations of the Bible" Series. Dish 15½ins:39cm.

"(Ehud) said unto them, Follow after me: for the Lord hath delivered your enemies the Moabites into your hand, and they went down after him and took the fords of Jordan towards Moab, and suffered not a man to pass over. And they slew of Moab at that time about ten thousand men". Judges 3, 28-29.

Fordy, J. & Co. fl.c.1824-1827

Sheriff Hill Pottery, Gateshead, Northumberland. This firm was succeeded by Fordy & Patterson.

Fordy & Patterson fl.c.1827-1833

Sheriff Hill Pottery, Gateshead, Northumberland. A circular impressed mark with the full name and address of this partnership is illustrated by Bell in *Tyneside Pottery*, p.141. It has been recorded on a dish with the standard Willow pattern.

"Foremark, Derbyshire, The Seat of Sir Franˢ Burdett, Bart"

Maker unknown. This title has been noted on a small plate, but it is *not* part of the Titled Seats Series by Careys which always springs to mind when the name of the owner is included in the title. The border is very similar to that found on another view by an unknown maker entitled "View of the Town and Harbour of Liverpool from Seacombe" (qv).

The mansion at Foremark was built in 1762 with grounds extending to the bank of the River Trent. It was the seat of the Burdett family. Sir Francis Burdett (1770-1844) was a Member of Parliament from the age of twenty-six until his death. He denounced flogging in the army and corruption in Parliament and was twice imprisoned on political charges.

Forest-Landscape

An early chinoiserie pattern produced by the Spode factory in two distinct versions. The scene features a large temple amongst trees with a man steering a partially covered boat in the foreground. The earlier Forest-Landscape First is illustrated in Copeland p.82; Whiter 7. The later Forest-Landscape Second can be seen in Copeland p.83; Whiter 8.

"Forfarshire"

Brameld.

This steamship was owned by the Dundee & Hull Steam Packet Co. which must have placed a special order for crockery with the Brameld pottery near Swinton, Yorkshire. A meat dish with a print of the vessel is in the Dundee Museum. This was the ship from which Grace Darling and her father William rescued nine people when it was wrecked near Longstone lighthouse in September 1838. Commemorative wares of the rescue are known.

"Formosa"
T.J. & J. Mayer. A dark flown-blue pattern used on dinner wares.

Forrester, George fl.c.1818-c.1830
Market Place, Lane End, Staffordshire. Shaw states that this works was "The first in which a regular plan for the arrangement of the separate places for the distinct processes was adopted." It is assumed that the initials G.F. were used. These have been noted on a chinoiserie pattern.

"Fort of Allahabad"
Maker unknown. "Oriental Scenery" Series. Dessert plate.

The fort at Allahabad, part fortress and part palace, was started by Akbar in 1583. It stands at the junction of the Ganges and the Jumna River. Relatively little now remains.

"Forth"
James Jamieson & Co. It is not surprising that this firm should use the name "Forth" for a title since their pottery was located on the Firth of Forth.

"Fortiter Defendit Triumphans"
A motto which is variously translated into: She bravely defends and triumphs, or Triumphing, it bravely defends. It forms part of the arms of the City of Newcastle-upon-Tyne which were recorded and confirmed in 1575.

The arms are known on blue-printed wares within the border from the Spode Greek patterns. The example illustrated was made by Spode and is believed to be part of a service supplied for the Mansion House, Newcastle-upon-Tyne, in 1815 through the local retailer Alexander Reed.

See: Armorial Wares.

Foss, James
A plate in Mason's Patent Ironstone China with the early impressed mark has been noted with a large printed mark "JAMES FOSS". He was probably a retailer although no dealer of that name appears at the appropriate time in the London directories.

"Fountain"
(i) Alexander Balfour & Co.

(ii) Thomas Fell & Co. Dinner wares.

(iii) Robert May. This title has been noted in a scroll cartouche on plates with an impressed maker's mark. Ill: Coysh 2 56.

(iv) David Methven & Sons. Tea wares bearing a lakeside scene.

"The Fountain"
Enoch Wood & Sons. A typical romantic scene with a very prominent fountain in the foreground, printed within a border of scrolls and floral sprays. It was used on dinner wares and can also be found in pink. Ill: Laidacker p.109; P. Williams p.264.

"Fountain Scenery"
(i) William Adams & Sons. A series of romantic scenes each featuring a fountain. They were printed in blue but are found more frequently in pink. Ill: Laidacker p.57; P. Williams p.265.

(ii) Maker unknown. A romantic scene within a flowery scroll border printed in light blue.

The Fountain, Trinity College, Cambridge
This fountain is the subject of two untitled views:

(i) John & William Ridgway. Oxford and Cambridge College Series. Pierced baskets. Ill: Coysh 2 73-74.

(ii) Maker unknown. A view printed within the border from the "British Views" Series with the caption "HUDSON — TRINITY COLLEGE". See: Hudson.

This fountain was built by Thomas Neville in 1602. Until the end of the 19th century it was used by Trinity College and the King's Hall as their principal water supply.

Forrester, George. *Attributed to George Forrester. Chinoiserie design. Impressed initials "G.F.". Plate 7¼ ins:18cm.*

"Fortiter Defendit Triumphans." *Arms of the City of Newcastle. Spode. Printed and impressed maker's marks. Soup plate 9½ ins:24cm.*

"**Fountains Abbey, Yorkshire.**" *Elkin, Knight & Co. Printed ribbon title mark. Cake stand 10½ins:27cm.*

"Fountains Abbey"

(i) James & Ralph Clews. "Select Scenery" Series. Plate 10ins:25cm. Ill: Godden I 155; Laidacker p.32.

(ii) Maker unknown. "Antique Scenery" Series.

"**Fountains Abbey, Yorkshire.**" *Elkin, Knight & Co. Printed title ribbon found on this view which would otherwise appear to fit in the Rock Cartouche Series.*

"Fountains Abbey, Yorkshire"

Elkin, Knight & Co. This view is known on a cake stand and a ewer and basin, all bearing the scene within a border which appears to be the same as that used by the firm on their Rock Cartouche Series (qv). The cake stand illustrated bears no maker's mark but the basin noted was impressed "ELKIN/KNIGHT & CO." beneath a crown. The printed title appears within a floral ribbon cartouche.

Fountains is one of the finest ruined abbeys in the country. It was founded in 1132 by monks from St. Mary's Abbey in York and joined the Cistercian order. The ruins were landscaped following their incorporation into Studley Royal House in 1768.

"Four Courts, Dublin"

Tams & Co. Tams' Foliage Border Series. Dish 20ins:51cm.

The Courts of Justice, known as the Four Courts, are on the north side of the River Liffey facing King's Inn Quay, and are the seat of the Supreme Court and the High Court. The buildings were designed by James Gandon and built between 1786 and 1802 in the neo-Classical style. The frontage is 450 feet in length with two large wings, a Corinthian portico surmounted by a statue of Moses with Justice and Mercy on either side, and a central dome. The buildings were badly damaged during the Civil War in 1922 but were restored and reopened in 1931.

"Fourth." *Mark sometimes found on wares with Wedgwood Botanical prints.*

Fourdrinier, Henry 1766-1854

A papermaker who specialised in making tissues for transfer-printing on ceramics. He produced these at Frogmore in Berkshire from 1803, but the demand in Staffordshire became so great that he set up a works at Hanley in 1827 — the Ivy House Paper Mill.

"Fourth"

A printed mark "FOURTH" in brown slanting capitals appears on some plates bearing Wedgwood Botanical prints. No evidence has yet been traced to suggest whether this is a retailer's mark, a customer's name, or a factory mark of some kind.

Fowler, Thompson & Co. fl.c.1820-1840

Watson's Pottery, Prestonpans, Scotland. The full name is known in both printed and impressed marks.

Fox

A fox was featured on a sauce tureen stand by Ralph Hall in his "Quadrupeds" Series, and foxes were included in the "Zoological Gardens" Series by James & Ralph Clews. Neither potter titled the individual patterns. A pattern described as Fox head and horn was used by Herculaneum in their "Field Sports" Series. The fox naturally also made several appearances in the "Aesop's Fables" Series.

"The Fox and the Goat"

Spode/Copeland & Garrett. "Aesop's Fables" Series. Dish 16ins:41cm.

A fox tumbled into a well and could not get out again. At last a goat came along and, wanting to drink, asked Reynard if the water was good. "So sweet I am afraid I have surfeited myself," said the fox. Whereupon the goat jumped in and, taking advantage of his horns, the fox leapt out, leaving the goat to shift for himself.

Consider who advises you before you take advice.

"The Fox and the Lion"

Spode/Copeland & Garrett. "Aesop's Fables" Series. Plate 10ins:25cm. Ill: Whiter 75.

The first time the fox saw the lion, he fell down at his feet, and was ready to die with fear. The second time he took courage and could even bear to look upon him. The third time he had the impudence to come up to him, to salute him, and to enter into familiar conversation with him.

Familiarity breeds contempt.

"The Fox and the Sick Lion"

Spode/Copeland & Garrett. "Aesop's Fables" Series.

This pattern has not yet been confirmed in blue although it is known in green.

The lion was sick and expected the other beasts to visit him. The fox was not among them. The lion sent him a message asking why he had so little charity and respect when he lay so very ill. "Why," replied the fox, "pray present my duty to his majesty, and tell him that I have the same respect for him as ever, but I am frightened when I see the footprints of my fellow subjects all pointing forwards and none backwards. I have not the resolution to enter in." The truth of the matter was, that the lion's sickness was only a sham to draw beasts to his den, the more easily to devour them.

He that cannot see well, let him go softly.

"The Fox and the Tiger"

Spode/Copeland & Garrett. "Aesop's Fables" Series.

A skilful archer coming into the woods directed his arrows so successfully that he slew many wild beasts. At last the tiger said that he alone would brave the enemy to revenge their wrongs, but an arrow pierced his ribs and hung by its barbed point in his side. A fox approaching him inquired who it was that could have the strength and courage to wound so mighty and valorous a beast. "Ah," says the tiger, "I was mistaken in my reckoning: it was that invincible man yonder."

There is no man so daring that some time or other he meets his match.

"Franciscan Convent, Athens"

Copeland & Garrett. Byron Views Series. Drainer and circular soup tureen stand. Ill: FOB 15.

"Franklin's Maxims"

See: Doctor Franklin's Maxims.

"Franklin's Morals" Series

A series by Davenport showing scenes representative of the moral maxims written by Benjamin Franklin. The scenes are printed within an ornate border of fruit, flowers and leafy scrolls and are marked with both the series title and individual names. Only three designs have been noted to date:

"The Eye of the Master Will Do More Work Than Both His Hands"
"Many a Little Makes a Mickle"
"No Gains Without Pains"

Freemasonry

Occasional pieces are found with the symbols of freemasonry. A plate from a dinner service shows a four-storey building with a balcony above the first storey and an overhanging top storey. The border has various masonic symbols. Before the house is a coach, a white horse and rider, and a crocodile of children. This is almost certainly a view of a masonic meeting place or a masonic school. A similar dish (14ins:36cm) has been recorded with a printed mark in the form of a chamfered tablet with the

Freemasonry. *Maker unknown. View of a four-storey building within a border of masonic symbols. Unmarked. Plate 10ins:25cm.*

French Series. *Enoch Wood & Sons. Typical printed mark with impressed maker's eagle mark.*

inscription: "John Burn, Newport Market, London. J.J. Cuff." John Burn was a china retailer.
See: Burn, John.

"French Groups"
Davenport. A floral design with exotic birds, very similar in style to the common "Asiatic Pheasants" pattern (qv).

"French Scenery"
Herculaneum. A typical open romantic series of scenes, mostly with the inevitable vase in the foreground. They were also printed in sepia and some examples are known with overglaze enamelling. Ill: Smith 171, 174; P. Williams p.266.

French Series
A series of dark blue views in France by Enoch Wood & Sons. Unlike most other foliage borders, this one is carefully placed so that the flowers are seen below the view as though one were looking through a gap in a garden border, and bunches of grapes hang down from the sky as if from an overhead vine. The series was made primarily for the American market to mark the return visit of the Marquis de Lafayette to America in 1824, though items are occasionally found in Britain. The series may well also have been exported to France. The views include:

"Cascade de Gresy, pres Chambery"
"Chapelle de Guillaume Tell"
"East View of La Grange, the Residence of the Marquis Lafayette"
"Environs de Chambery"
"Hermitage en Dauphine"
"La Grange, the Residence of the Marquis Lafayette"
"Maison de Raphael"
"Moulin sur la Marne a Charenton" (two views)
"Moulin pres de Royat, Dept. du Puy de Dome"
"N.W. View of La Grange, the Residence of the Marquis Lafayette"
"S.W. View of La Grange, the Residence of the Marquis Lafayette"
"Vue d'une Ancienne Abbaye"*
"Vue du Chateau de Coucy"
"Vue du Chateau Ermenonville"
"Vue de la Porte Romaine a Andernach"
"Vue Prise aux Environs de Francfort"
"Vue Prise en Savoie"
"Vue du Temple de Philosophie, Ermenonville"

"Friburg"
(i) Davenport. A romantic scene with a chalet within a border which has a climbing plant enclosing rose sprays against a lined background. The printed mark bears the title "FRIBURG" encircled by a garter with the word "IRONSTONE", all surmounted by a crown. The design is shown on a hexagonal teapot in Lockett 32, and in *Mason's Patent Ironstone China* (1971) Godden illustrates a dinner plate (108) and the mark (p.65).
(ii) George Phillips. The pattern was registered on 5th May, 1846. The border is almost identical to the Davenport version but the central views differ.

Frog Mug
A mug made with a pottery frog inside, intended for practical joking. A full mug would be handed to the unsuspecting drinker who would not see the frog until he had nearly finished his beer.

Frognall Priory, Hampstead
An incorrectly titled view of this priory in the Morning Glory Border Series by an unknown maker is known as "Crognall Priory, Hamstead" (sic) (qv).

Fruit Basket
An alternative name for a chestnut basket (qv), usually only applied to the larger examples.

"Fruit Basket"
William Smith & Co. This title was used for a pattern on dinner wares with a multi-coloured central print showing a basket of fruit and flowers. The blue-printed border consists of swirling panels of fruit and flowers. The title is printed on a basket of fruit beneath which are the initials W.S. & Co. An example impressed "W.S. & Co's/WEDGEWOOD" is shown in Coysh 2 83.

Fruit and Flower Border Series

A series of views in Britain and Europe by Henshall & Co. of Longport. Items are very seldom marked, though occasionally they are found with the impressed mark "HENSHALL & CO." The border, a very attractive combination of fruit and flowers, was also used for some American views. Known views include:

"Beaumont Lodge"
"Bellinzona"
"Blenheim, Oxfordshire"
"Bradfield"*
"The Bridge of Martoviele"
"British Views" (several different landscapes) (Colour Plate II)
"Castle of Furstenfeld"
"Compton Verney"
"Halstead, Essex"
"Hanover Place"
"The Harbour of Messina"
"Hollywood Cottage"
"Kimberley Hall"
"Langley Park"
"Milford Green"
"Old Castle of Martigny"
"Ostend Gate at Bruges"
"St. Cloud"
"Saxham Hall"
"A Scene in Campania, Rome"
"Spring Hall"
"The Temple of Friendship"*
"Tweekenham, Surrey" (sic)
"Vale House"
"Vevay"
"York Minster"*

The view titled "Vevay" is often considered to be Vevay in Indiana and may hence be an American view, although it could be Vevey in Switzerland.

A number of items from this series have been noted with impressed fractional marks such as $\frac{8}{23}$ or $\frac{11}{25}$. These are probably date marks for August 1823 and November 1825 respectively. Similar marks are also known on other Henshall patterns.

"Fruit and Flowers"

Hicks, Meigh & Johnson. An open light blue pattern with the title in lower case letters on a printed cornucopia, below which are the initials H.M.J. Ill: Coysh 2 45.

The same title has been used for at least three untitled patterns made by different potters:

(i) John Rogers & Son. A pattern clearly based on a painting by Van Huysum, a Dutch artist. Ill: Coysh 2 79; a painted version on a Spode china tray, is illustrated in Whiter 209.

(ii) Spode. A pattern name used to refer particularly to a border. It is shown with a central design of flowers in a vase by Whiter 46.

(iii) Stubbs & Kent. A dark blue pattern named in Laidacker p.81. The same design is shown under the attributed title Peach and Cherry Pattern in Coysh 1 126.

"Fruit Garden"

Maker unknown. This title has been noted on a printed cartouche bearing the initial H. This may possibly relate to one of the potters named Hackwood.

"Fulham Church, Middlesex"

Ralph Hall. "Picturesque Scenery" Series. Plate 8¾ins:22cm, and bowl 8½ins:22cm.

The view shows the church in the background with a man rowing a boat on the River Thames in the foreground.

Fruit and Flower Border Series. *Henshall & Co. Typical printed mark.*

"Furness Abbey, Lancashire"

Maker unknown. Pineapple Border Series. Dish 16¾ins:43cm.

In addition to this titled view the same Abbey has been identified on untitled wares by William Mason. Ill: Coysh 2 50; Godden I 389.

Furness Abbey, near Barrow, was founded in 1123 and in its early years was run by Savignacs. It became Cistercian in 1147 and became second only to Fountains Abbey amongst this order. Located in a sheltered valley, it is now a fine ruin.

Furnival, Jacob & Co. fl.c.1845-1870

Cobridge, Staffordshire. A company which is known to have exported blue-printed wares to America. Printed marks bear the initials J.F. & Co.

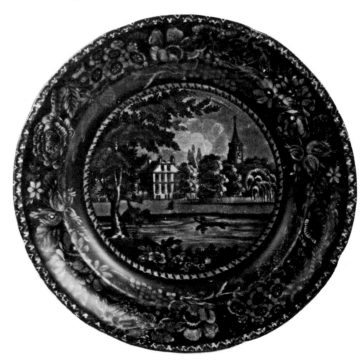

"Fulham Church, Middlesex." *Ralph Hall. "Picturesque Scenery" Series. Printed titles and maker's mark. Plate 8¾ins:22cm.*

Gadrooning

A moulded decoration of radiating lobes used on the edge of wares. It was copied from the decoration on some 17th and 18th century silver and is believed to have been introduced on ceramics by John & William Ridgway of Cauldon Place in 1821. They certainly made extensive use of gadrooned rims on dinner wares, for example on their "India Temple" design. The Spode company followed the fashion very quickly on dinner and dessert wares, both in earthenware and china, and by the late 1820s they were making large quantities of gadrooned teawares. See: Whiter p.129.

"Game Keeper"

Maker unknown. A fine early rural scene showing a gamekeeper with raised arm, four hunting dogs, and a large country house in the distance. The view is framed in a floral border and the title is printed on a buckled belt or strap. The pattern is known on dinner wares and an oval comport.

"The Garden Trio"

James & Ralph Clews. Doctor Syntax Series. Plate 6ins:15cm, and cup plate. Ill: Arman 60.

"Garland"

David Methven & Sons.

Garner, Robert fl.c.1786-c.1821

Lane End, Staffordshire. This firm was started by Robert Garner in about 1786 following earlier partnerships with other potters. He died three years later but the firm was continued by his son, also named Robert, until about 1821. The impressed mark "Garner" has been recorded on a tea plate bearing an early chinoiserie pattern very similar to the Spode design known as Temple Landscape First (qv). Ill: FOB 17. The initial mark R.G. is also known.

Garrison Pottery

A Sunderland pottery operated by various Dixon partnerships between 1813 and 1865. Although noted mainly for lustre jugs with black transfer prints, the firms also produced a good deal of blue-printed ware.

Gate Leading to a Musjed, at Chunar Ghur

An aquatint published in January 1797 based on a drawing and engraving by Thomas Daniell in *Oriental Scenery* (Part I, 24).

"Game Keeper." *Printed title mark in the form of a buckled belt.*

"Game Keeper." *Maker unknown. Printed title mark. Sauce tureen stand length 8 ¾ ins:22cm.*

It was used by John Rogers & Son to form the major part of their Camel pattern. The camel and other details in the foreground were copied in reverse from another print titled "The Western Entrance of Shere Shah's Fort, Delhi" (Part I, 13). As with other similar patterns by Rogers the central scene extends onto the rims of plates and there is a narrow band of stringing around the edge. Ill: Coysh 1 84.

A very similar design, but without the camel, was used by Dixon, Austin & Co. on toilet wares.

A masjid (the modern spelling) is a mosque.

Gate of a Mosque Built by Hafiz Ramut, Pillibeat
An aquatint published in April 1802 based on a drawing and engraving by Thomas and William Daniell in *Oriental Scenery* (Part III, 10).

It was used almost in its entirety for a pattern on a dish by the Herculaneum Pottery, the only addition being the background which, as with other similar patterns, was based on a print titled "View in the Fort of Tritchinopoly" (Part II, 21). Ill: FOB 19.

Gate of the Tomb of the Emperor Akbar at Secundra, near Agra
An aquatint published in November 1795 based on a drawing and engraving by Thomas Daniell, in *Oriental Scenery* (Part I, 10).

It was used by Joseph Harding to form the basis of a pattern which is titled only "Asiatic Scenery" (qv). The design is adorned with a typical vase in the foreground and is printed within a border of passion flowers and other blooms.

"Gateway & Tomb of Secundra"
Maker unknown. Parrot Border Series. Well-and-tree dish and dish 19ins:48cm.

This scene is probably copied from the Daniell aquatint listed in the previous entry. The mausoleum shown was built by Jahangir, the son of the Emperor Akbar, and was completed in 1613. It was the first time that minarets were used on a mausoleum in northern India.

"Gayhurst, Buckinghamshire"
Maker unknown. Foliage Border Series. Entree dish cover.

Gayhurst House is two and a half miles north west of Newport Pagnell. It is of several periods: Tudor, Elizabethan and Queen Anne, and was the residence of Sir Everard Digby. Sir Kenelm Digby, his son, was born there in 1603.

Gazebo
Pettys & Co. A country scene including a gazebo and several cows, and a border with passion flowers. Ill: Coysh 2 66.

"Gazelle"
Samuel Moore & Co. A pattern found on tea wares which shows a seated girl holding a flower, with a gazelle lying behind her. The border consists of floral medallions linked by drapes. Ill: Coysh 2 64.

Geddes, John (& Son) fl.c.1806-1827
Verreville Pottery, Glasgow, Scotland. A company which exported blue-printed wares to America, including at least one American view. The firm acquired skilled potters from Staffordshire and the quality of the wares was high. The style became John Geddes & Son in 1824.
See: Verreville Pottery, Glasgow.

Gehol
See: View of the Imperial Park at Gehol.

"The Gem"
(i) Bovey Tracey Pottery Co. This title has been recorded on a two handled mug (see overleaf). On one side is a harvesting scene; the other has a group of dancers by a maypole. The inside rim bears a border of fruit and flowers. It is marked with an oval garter and crown cartouche with the title on a ribbon and the initials B.T.P. Co. beneath.

(ii) Minton & Boyle. A pattern re-registered by Mintons in 1896 but the later wares use the original Minton & Boyle floral scroll cartouche mark (Godden M 2693a).

"Geneva"
Joseph Heath. A typical romantic scene printed in light blue in which a castle is seen between tall trees. The printed cartouche mark includes both the title "GENEVA" and the potter's name "J. HEATH". One small dished plate examined also bore the impressed mark "HEATH". Ill: P. Williams p.271.

Geneva is a city on the Rhône at the south western extremity of Lake Geneva in Switzerland. It was traditionally a haven from persecution and is now the headquarters of several international organisations such as the Red Cross and United Nations agencies.

"Genevese"
Minton. A pattern featuring alpine chalets in a romantic setting. The title is printed in a floral cartouche with C-scrolls which includes the words "Opaque China" and a cursive initial M. The design was revived in Edwardian times on toilet wares. Ill: Coysh 2 61.

The pattern was also used on stone china by Thomas & Benjamin Godwin and much later by Edge, Malkin & Co. with a printed trade mark (Godden M 1445).

"Genoa"
(i) William Adams & Sons. A light blue romantic pattern with a waterfall used on ironstone wares. Ill: P. Williams p.276.

(ii) Robert Cochran & Co.

(iii) Enoch Wood & Sons. "Italian Scenery" Series. Dish 13ins:33cm, and vegetable dish.

Genoa is an important Mediterranean seaport with long seafaring traditions. It was the birthplace of Columbus and after the defeat of Napoleon in 1815 it became a duchy of the Kingdom of Sardinia, and eventually part of a united Italy.

George III
A number of commemorative plates were made to mark the death of George III in 1820. A moulded example (Ill: Little 113) shows a bust of the King in a wreath of oak leaves with the words "Sacred to the Memory of George III" above, and "Who died 29 Jany 1820" below. Another shows a child kneeling before the King who is handing him a bible (Ill: May 50). Beneath the picture are the words "I hope that the time will come when every poor child in my Dominions will be able to read the Bible". Blue and white dinner services were also made with the King's head in the centre of each piece and a wide union wreath border of roses, thistles and shamrocks (Ill: May 51). The central design is identical with the illustration in Little mentioned above.

"The Gem." Bovey Tracey Pottery Co. Oval garter and crown mark with title and maker's initials. Two handled mug height 4ins:10cm.

George Heriot's Hospital, Edinburgh

James Jamieson & Co. "Modern Athens" Series.

As with other items from the series this view is not titled. George Heriot (1563-1624) was a wealthy Edinburgh goldsmith. Heriot's Hospital was founded under his will in 1628 as a residential school for fatherless sons of burgesses. It later became a public school for day boys. The school is frequently mentioned in Sir Walter Scott's *Fortunes of Nigel.*

Geranium

A Spode floral pattern introduced in about 1818. The centre shows a rather idealised sprig of geranium flowers and leaves; the border has a wide geometric pattern within two narrower bands. Ill: Whiter 51.

The border was popular for use with armorial centres and similar special commissions. Three examples are shown in Whiter 78, 80 and 81, the last of which bears the arms of the Worshipful Company of Skinners. It was also used to enclose the arms of William Taylor Copeland and Sarah Yates whom he married in 1826. The border was not restricted to earthenware, at least one china plate exists with a family coat-of-arms.

See: "Benigno Numine".

"German Stag Hunt"

David Methven & Sons.

Ghaut

An Indian name to describe a riverside landing place, often with a stairway. It occurs in several blue-printed titles such as "Ghaut of Cutwa" and "Surseya Ghaut, Khanpore".

"Ghaut of Cutwa"

John Hall & Sons, "Oriental Scenery" Series. Plate 8¾ins:22cm. Ill: Laidacker p.44.

"Gilrad House, Lancashire"

Maker unknown. Morning Glory Border Series. Sucrier and cover.

It has not yet proved possible to locate this building.

"Gipsy"

Maker unknown. A series of rectangular scenes printed on dinner wares. Two have been noted, one showing a covered wagon outside an inn and the other showing a group of gipsies with a church spire in the background (Ill: P. Williams p.495). The scenes are framed with a pattern of vines and rosettes and are printed within a border of interlacing scrolls enclosing a mottled ground.

"Giraffe"

John Ridgway. A pattern published on 30th August, 1836 which shows three giraffes, two standing and one lying down, attended by two keepers in Arabian dress. The border consists of flowers and scrolls framing a geometric ground. Ill: P. Williams p.633.

The scene is taken from part of a coloured lithograph by G. Scharf dated 1836 which shows four giraffes destined for the London Zoo. They were captured in the Sudan by M. Thibaut, a French trader, and were brought to London via Malta in May 1836. The original print is reproduced together with the full story in Wilfred Blunt's *The Ark in the Park* (1976), p.81.

Girl at the Well. *John Heath.*
Impressed mark "HEATH".
Plate 10ins:25cm.

Girl at the Well. *Harvey.*
Impressed mark "HARVEY".
Sauce tureen length 8¼ins:21cm.

153

Giraffe and Camel Willow Pattern

Maker unknown. A chinoiserie pattern which features a camel (or dromedary) and a giraffe. The border is typical of the later chinoiserie wares with scrolls and geometric shapes on a variety of cellular grounds. Ill: Coysh 2 147.

Girl Musician

John & Richard Riley. A pattern used for dinner wares showing a rural scene with a country house, a river and waterfall. In the foreground a boy herdsman kneels before a girl playing a pipe with a second girl standing behind her. There is a border of flowers on a shaded ground. There are at least two variants of this pattern with detail changes such as number of sheep, number of trees, flowers in the foreground and details of the figures. Ill: Coysh 1 76.

Girl at the Well

This title appears to have been used first by S.B. Williams nearly forty years ago and is so widely known that it would seem unwise to discard it. It refers to a Spode pattern in which a girl is filling her ewer at a well, though there is no handle to the pump. This may well be the pattern referred to by Jewitt as "Font", since shards have recently been excavated from the site of the Rathbone works at Portobello in Scotland with the same pattern but a printed mark with the title "THE FONT". The same pattern is also known by other potters and was certainly popular.

(i) Charles Harvey & Sons. Impressed "HARVEY".

(ii) John Heath. Impressed "HEATH". Ill: Coysh 2 40.

(iii) Thomas Rathbone & Co. Impressed circular mark including the initials T.R. & Co. and a printed fountain above the words "THE FONT". See: *Scottish Pottery Historical Review*, No. 5, 1980, pp.59-60.

(iv) Spode. Almost certainly the originators of the pattern. Impressed and printed "SPODE". Ill: Coysh 1 116; Whiter 59; S.B. Williams 160.

(v) Wood & Challinor. Printed mark W. & C. within a Staffordshire knot and the single word "FONT".

All these potters used the standard border with three open garlands of flowers. The same border was used by Spode on their Union Wreath Third pattern. Ill: Whiter 58.

It is interesting to note that Pountney & Allies of Bristol used the same border and main pattern but with the girl and the well replaced by some Gothic ruins. Ill: Coysh 1 67.

"Glanbran, Carmarthenshire"

William Adams. Flowers and Leaves Border Series. Plate 10ins:25cm.

Glanbran was a seat about four miles north east of Llandovery. It was built in the 1770s but was demolished in 1930.

Glasgow

There are several known views of Glasgow. The "Antique Scenery" Series by an unknown maker included one view entitled "Cathedral Church of Glasgow". Another very similar view but in a different border has been noted on dinner wares with a title "Cathedral of Glasgow". A general view of the city by an unknown maker shows the Cathedral Church and a pottery in a panoramic landscape on a lidded jug. it appears to have the same border as the "British Scenery" Series.

Glaze

A special kind of glass which will adhere to a clay body and can be formed by heat in a glost furnace. Cobalt was sometimes added to the glaze for blue-printed wares to help obtain the effect of the white ground. It tends to stain the glaze which

Glasgow. *Maker unknown. Untitled view including the cathedral within the border from the "British Scenery" Series. Unmarked. Lidded jug height 7½ ins:19cm.*

often shows blue or green where it has run thickly against a footrim.

Gleaners

Two patterns show women gleaners, both by unknown makers:

(i) Two women with bundles of gleaned corn stand over a girl who is seated playing with a dog. The border consists of fruit, flowers and scrolls. This design was used on dinner services. Ill: Coysh 1 164.

(ii) A woman stoops to pick up ears of corn watched by a reaper with a sickle. They are working in a field with stooks of corn. This design appears on a loving cup, height 4½ ins:11cm.

Gleaning was traditional when corn was cut with the sickle. Women were allowed to collect the ears left by the reapers after the fields had been cleared. Cottagers often managed to gather enough corn to provide flour for the rest of the year.

"Glemham Park, County Suffolk"

Maker unknown. Flower Medallion Border Series. Dish 10ins:25cm.

The original house was built by Sir Henry Glemham in the late 16th century but this view probably shows the present house which was built in 1814 with grounds planned by Humphrey Repton. Glemham House is at Great Glemham, between Framlingham and Saxmundham.

Gleaners. *Maker unknown. Unmarked.*
Dish 14¾ins:37cm.

"Gloucester." *Harvey. Cities and Towns Series.*
Printed title mark. Dish 10¾ins:27cm.

Glengyle
A scene entitled "View in Glengyle" was included on a plate in the "Select Scenery" Series by James & Ralph Clews. Glen Gyle lies about five miles north east of Inversnaid, and the river falls into the western end of Loch Katrine. The scenery is described by Sir Walter Scott in *The Lady of the Lake*.

Glost Furnace
A special furnace or oven into which pottery is placed to fire the glaze. The wares were placed in saggars or clay boxes to prevent damage from the flames and gases.

Gloucester
A name given to a Spode pattern which consists of small floral sprays against a plain white background. The border consists of a thin blue band with a dentil line. The pattern is still in use today and the name Gloucester is its modern title; no earlier title is known.

"Gloucester"
Harvey. Cities and Towns Series. Dish 10¾ins:27cm.
This view shows the cathedral from the opposite bank of the River Severn.

"Gloucester Cathedral"
James & Ralph Clews. Bluebell Border Series. Dish 21ins:53cm.
The city of Gloucester is dominated by the Cathedral with its mid-15th century Perpendicular tower. It started life as the church of a Benedictine monastery and became a cathedral in 1541 when Gloucester became a separate see. The building is substantially Norman.

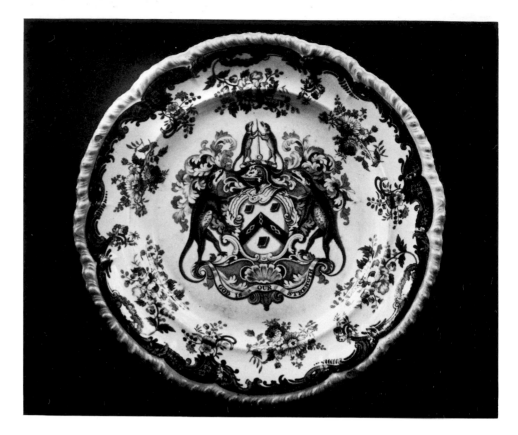

"God Is Our Strength." *Arms of the Ironmongers' Company. Minton. Printed title cartouche from the "Chinese Marine" pattern with cursive initial M. Impressed "MINTON". Gadrooned plate 10¼ ins:26cm.*

"Goat"

(i) John & Robert Godwin. A pattern printed on teawares showing a kneeling woman feeding a goat from a basket, with a thatched cottage in the background. The printed cartouche mark includes the title and the initials J. & R.G. Also known in green. Ill: Godden I 275; P. Williams p.496.

(ii) James Jamieson & Co.

Goats

James & Ralph Clews included a pattern featuring goats on a plate in their "Zoological Gardens" Series. The Wedgwood company also used goats on a pattern introduced in 1842.

"God Is Our Strength"

A motto used by the Worshipful Company of Ironmongers of the City of London. Their arms were granted in 1455 and confirmed in 1560.

The Worshipful Company of Ironmongers is one of the London tradesmen's guilds. A dinner service decorated with the Company's coat-of-arms within the border commonly used on the "Chinese Marine" pattern (qv) was made by Minton, probably in the period 1822-36. The armorial bearings include salamanders, which are alleged to have the capacity to withstand great heat without harm. Most examples are unmarked but one dinner plate has been noted with the usual "Chinese Marine" cartouche mark. This particular piece was probably a replacement since it also bears the impressed mark "MINTON" and an impressed date mark for 1865.

This dinner service would appear to have been replaced in the 1870s since the same coat-of-arms is known within the "Asiatic Pheasants" border. These later wares are marked with the initials H. & A. which probably relate to Hammersley & Asbury of Longton (1872-75) or Hulse & Adderley, also of Longton (1869-75).

See: Armorial Wares.

Godwin, Benjamin E. fl.1834-1841
Cobridge, Staffordshire. Printed marks bear the initials B.G. See: Godden I 275.

Godwin, John & Robert fl.1834-1866
Sneyd Green, Cobridge, Staffordshire. This partnership used the initials J. & R.G. Among other wares they seemed to have produced a large number of toy or children's tea services. Two items bearing the initial mark are illustrated in Godden I 275.

Godwin, Rowley & Co. fl.1828-1831
Market Place, Burslem, Staffordshire. A dinner plate decorated with the standard Willow pattern has been noted with a printed mark of a crown over a ribbon bearing the words "STAFFORDSHIRE" and "STONE CHINA", above the initials G.R. & Co. Although they may relate to an earlier partnership Godwin, Rathbone & Co., this design is more likely to have been made by the later firm.

Godwin, Thomas fl.1834-1854
Canal Works, Navigation Road, Burslem, Staffordshire. Thomas Godwin continued to operate after his partnership with Benjamin. He produced many printed designs including some American scenes. Many of his productions were in other colours, particularly brown and green. Marks sometimes give the full name, i.e. "THOS. GODWIN", but most printed marks give initials T.G., often with the word "WHARF" or "NEW WHARF", referring to the wharf on the canal. Two examples are shown in Godden I 275, 277. The latter is printed in brown but another dish from the same series printed in blue is illustrated in Coysh 2 36

Colour Plate X. Monopteros. *John Rogers & Son. Impressed "ROGERS". Plate 9¾ ins: 25cm.*

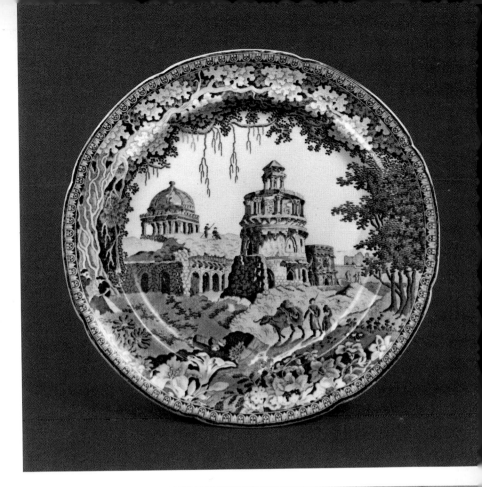

Colour Plate XI. Remains of an Ancient Building near Firoz Shah's Cotilla, Delhi. *Source print for the Monopteros pattern taken from Thomas Daniell's "Oriental Scenery".*

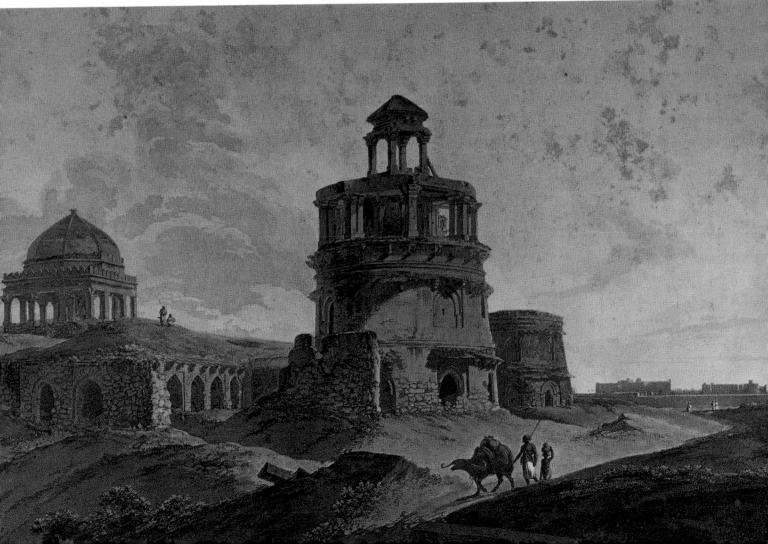

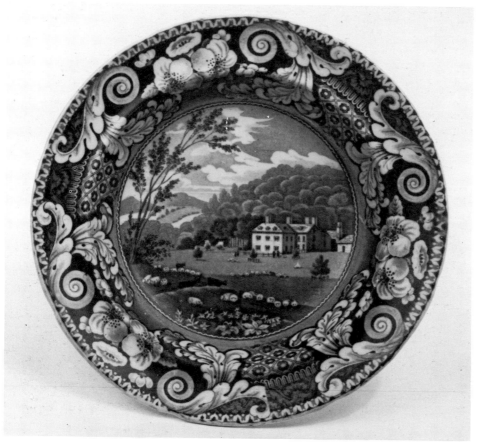

"Goggerddan,
Cardiganshire." *John &
Richard Riley. Large Scroll Border
Series. Printed title mark with
maker's name. Soup plate
10ins:25cm.*

Godwin, Thomas & Benjamin fl.c.1809-1834

New Basin Pottery, Burslem, and later at the New Wharf
Pottery, Burslem, Staffordshire. This partnership made blue-
printed wares and used the initial marks T. & B.G. and
T.B.G. The impressed mark "T. & B. GODWIN" has also
been recorded. The company was continued by Thomas
Godwin after 1834.

"Goggerddan, Cardiganshire"

John & Richard Riley. Large Scroll Border Series. Plate
10¼ins:26cm, and soup plate 10ins:25cm.

 Goggerddan is a seat three miles north east of Aberystwyth.

"Going to Market"

J. & M.P. Bell & Co. A view based on an engraving by
William Finden of A.W. Calcott's painting "Returning from
Market". Note the change of title from the original. The
border has shield-shaped medallions with an equestrian scene
alternating with a seascape with sailing ships.

 Sir Augustus Wall Calcott RA was a friend of J.M.W.
Turner. He was knighted in 1837 and in 1849 was made
Conservator of the Royal Pictures.

Goldfinch

Maker unknown. An untitled pattern which shows a goldfinch
singing on the branch of a rose tree with a butterfly perching
on leaves above his head. Both the central design and the floral
border are printed on a stippled blue ground.

 The bird appears to have been adapted from a wood
engraving by Thomas Bewick in *A History of British Birds* (1797,
1804). The alternative names of Goldspink and Thistle Finch
are also quoted.

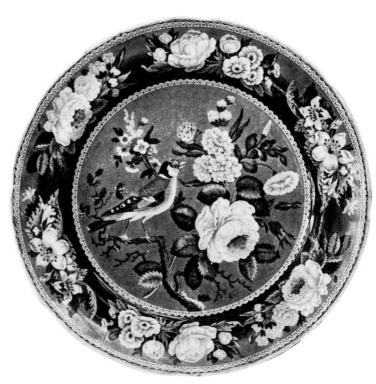

Goldfinch. *Maker unknown. Unmarked. Plate 9¾ ins:25cm.*

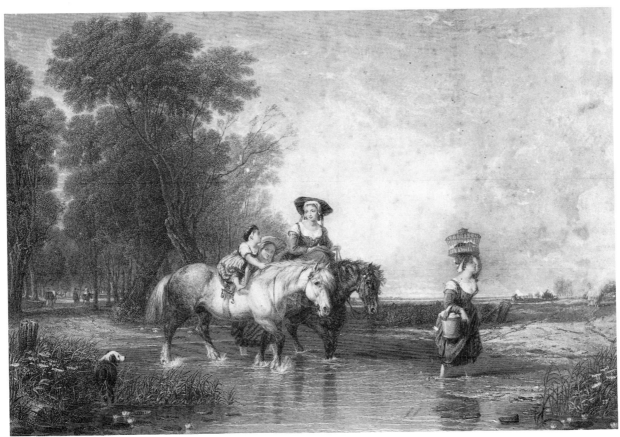

"Going to Market." *The source print from which this pattern was taken is titled "Returning from Market".*

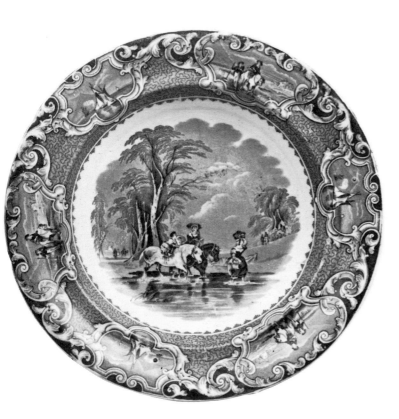

"Going to Market." *Scenic cartouche with title and maker's initials.*

"Going to Market." *J. & M.P. Bell & Co. Printed title mark with maker's initials and a scene from a border vignette. Soup plate 10¼ ins:26cm.*

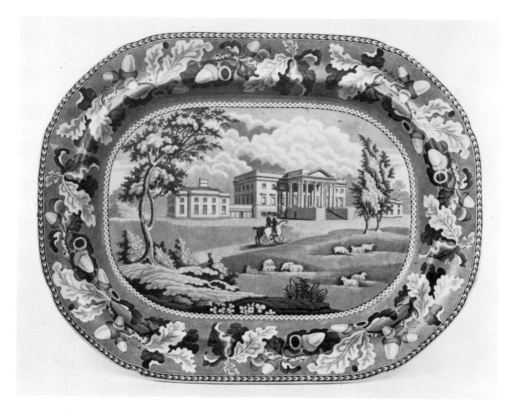

"Gondola"
Clyde Pottery Co. An open pattern with a gondola-style boat which is heavily decorated with C-scrolls and floral motifs and crewed by three men. The background is formed with pagoda-like buildings. There are sprays of flowers around the view and stringing and moulding around the edge of the rim. It is possible that this pattern was also used by other Scottish potters.

Goodfellow, Thomas fl.1828-1859
Phoenix Works, Tunstall, Staffordshire. Printed marks with pattern titles usually include the full surname.

Goodridge Castle, Kent
Laidacker lists a view entitled "Part of Goodridge Castle, Kent" by Enoch Wood & Sons in the Grapevine Border Series. It has not yet proved possible to verify this entry.

Goodwin, John
John Goodwin is believed to have been the sole survivor of the various Goodwin partnerships. In 1851 he built a pottery at Seacombe on the Mersey, where he made blue-printed wares.
 See: Seacombe Pottery.

Goodwin Partnerships fl.1827-c.1850
A series of partnerships operating potteries at Lane End, Staffordshire. Early names are believed to have been Goodwin & Co. and Goodwin & Orton, but the major firms were as follows:

Goodwin, Bridgwood & Orton	1827-1829
Goodwin, Bridgwood & Harris	1829-1831
Goodwins & Harris	1831-1838
Goodwin & Ellis	c.1839-1840
John Goodwin	1840-c.1850

The first two of the above partnerships are known to have used printed marks with the relevant initials such as G.B.O., G.B. & O. and G.B.H. Goodwins & Harris were sometimes known as Goodwin, Harris & Goodwin and used initials G. & H. or G.H. & G. although they usually used an impressed mark "GOODWINS & HARRIS". They are particularly noted for the "Metropolitan Scenery" Series which was almost always unmarked, although examples can be found with the firm's initials and a Staffordshire knot impressed. Goodwin & Ellis again used printed initials G. & E. They were still producing at least one pattern introduced by the first partnership of Goodwin, Bridgwood & Orton, i.e. "Oriental Flower Garden" (qv).

Gordon's Pottery fl.early 18th century to 1832
George Gordon, Gordon's Pottery, Prestonpans, Scotland. This firm is said to have produced blue-printed wares although marked items are rare. The impressed mark "GORDON" has been recorded and printed title marks sometimes occur with the initials G.G.

"Gorhambury, Hertfordshire"
 (i) Maker unknown. Crown Acorn and Oak Leaf Border Series. Dish 17ins:43cm.
 (ii) Maker unknown. Foliage Border Series. Soup tureen stand.
 It is also possible that this view was produced by Ralph Stevenson in his Stevenson's Acorn and Oak Leaf Border Series (qv).
 The original Gorhambury House, north of St. Albans, was built in the 16th century but was pulled down in 1787 and replaced with a large Palladian villa by Sir Robert Taylor. It has a massive stone stairway leading to a pillared portico. The first house had been owned by Francis Bacon, the statesman, essayist and philosopher, after his retirement from public life.

"Gothic"
James Jamieson & Co.

Gothic Castle

An accepted title for a Spode pattern which shows a Gothic castle in a Chinese setting, typical of the transitional period in the early years of the 19th century when the passion for chinoiserie was beginning to crumble. Pieces with this pattern, unlike most Spode wares, are often found unmarked. Ill: Coysh 1 158; Whiter 65; S.B. Williams 128-129.

Gothic Ruins

A title which has been suggested for a design printed on dinner wares by an unknown maker. The impressive Gothic ruins are under scrutiny by two mounted figures in the foreground. A waterfall on the left flows across the scene and under an arched stone bridge on the right over which a covered wagon is passing. The pattern extends on to the rim and is edged by a wide band of stringing. Ill: FOB 1.

The title was also used by Coysh for one of the patterns by Davenport in the Rustic Scenes Series (qv). Ill: Coysh 2 22.

"Gracefield, Queen's County"

John & Richard Riley. Large Scroll Border Series. Jug 8ins:20cm.

"Gracefield, Queen's County, Ireland"

William Adams. Flowers and Leaves Border Series. Plate 10¼ins:26cm. Ill: FOB 19.

Gracefield House was designed by John Nash in 1817 for the Grace family, descendants of Raymond de Gros who accompanied Strongbow to Ireland in the 12th century. Queen's County was named after Queen Mary I. Since 1922 it has been known by various names including Laois, Laoghis, Laoighise, Loighus, and the current name Leix.

"Granada"

Middlesbrough Pottery.

Granada, a town in southern Spain, was the last stronghold of the Moors. It is a cultural centre, famous for its palaces.

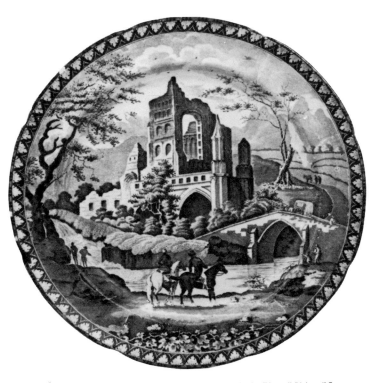

Gothic Ruins. *Maker unknown. Unmarked. Plate 9¾ ins:25cm.*

"Grand United Order of Oddfellows"

This title has been noted near the rim of a mug by an unknown maker. The decoration consists of two women standing on either side of a cartouche onto which one is shining a light while the other is holding a balance. There is a motto: "Amicitia, Amor et Veritas". The pattern is very similar to a plate illustrated in Coysh 2 118, made by Joseph Twigg for the "Independent Order of Oddfellows" (qv).

"Granite China"

A trade name frequently used in the period between 1830 and 1880 as an alternative to ironstone china. It has been noted on blue-printed wares by Brameld, Clementson, Ferrybridge and William Ridgway. It was also used by Thomas Hughes, C.J. Mason & Co., Pountney & Co. of Bristol, Ridgway & Morley and Swillington Bridge, any of whom may have used it on blue-printed wares.

Grapevine Border Series

This series of landscape views by Enoch Wood & Sons is by far the most extensive set of patterns made by any potter within one series border. The list of known views currently totals fifty-eight. Most of the scenes were copied from prints by John Preston Neale in his *Views of the Seats of Noblemen and Gentlemen in England and Wales, Scotland and Ireland,* issued in two series and eleven volumes between 1818 and 1829. The distinctive border includes vine leaves and tendrils and bunches of grapes on a cellular ground. Items are found both with and without an impressed maker's mark, although there appears to be little reason to doubt the maker of any unmarked pieces with the same grapevine border inspected to date. The standard printed mark gives the title on a flower encrusted ribbon very similar to the mark on Stevenson's Acorn and Oak Leaf Border Series (qv). The list of recorded views is:

"Armitage Park, Staffordshire"
"Barlborough Hall, Derbyshire"*
"Bedfords, Essex"
"Belsay Castle, Northumberland"
"Belvoir Castle"
"Bickley, Kent"
"Brancepeth Castle, Durham"
"Cashiobury, Hertfordshire"*
"Castle Forbes, Aberdeenshire"
"Castle Huntley, Perthshire" (sic)
"Cathedral at York"
"Cave Castle, Yorkshire"
"City of Canterbury"

continued

Grapevine Border Series. *Enoch Wood & Sons. Typical printed mark.*

"Claremont, Surrey"
"Cokethorpe Park, Oxfordshire"
"Compton Verney, Warwickshire"*
"Culzean Castle, Ayrshire"*
"Dalguise, Perthshire"
"Dorney Court, Buckinghamshire"
"Dunraven, Glamorgan"
"Esholt House, Yorkshire"*
"Fonthill Abbey, Wiltshire"* (two views, near and distant)
"Gubbins, Hertfordshire"
"Gunton Hall, Norfolk"
"Guy's Cliff, Warwickshire" (sic)*
"Hagley, Worcestershire"*
"Harewood House, Yorkshire"
"Hollywell Cottage, Cavan"
"Holyrood House, Edinburgh"
"Kenilworth Castle, Warwickshire"
"Kenmount, Dumfriesshire"
"Lambton Hall, Durham"*
"Luscombe, Devon"
"Maxstoke Castle, Warwickshire"
"Orielton, Pembrokeshire"
"Oxburgh Hall, Norfolk"
"Part of Goodridge Castle, Kent"
"Rochester Castle"
"The Rookery, Surrey"
"Ross Castle, Monmouthshire"*
"Saltwood Castle"
"Sharon Castle" (sic)
"Sherbourn Castle" (sic)
"Shirley House, Surrey"
"Spring Vale, Staffordshire"
"Sproughton Chantry, Suffolk"
"Sufton Court, Herefordshire"*
"Taymouth Castle, Perthshire"
"Thornton Castle, Staffordshire"*
"Thrybergh, Yorkshire"*
"View of Greenwich"
"View of Richmond"*
"View of Worcester"
"Wardour Castle, Wiltshire" (two slight variants)
"Warwick Castle"
"Wellcombe, Warwickshire" (sic)
"Windsor Castle"

Moore also lists a view of Durham Cathedral.

Grasshopper
A Spode pattern introduced in 1812 and invariably printed on "Stone China" or "New Stone". It has also been called the Bird and Grasshopper Pattern. The design was used again by Copeland & Sons in Victorian times. Ill: Coysh 1 110; Whiter 22; S.B. Williams 126.

Grazing Rabbits
A widely accepted title for a pattern by an unknown maker showing three rabbits grazing beneath a tree with cottages in the background. It was used on dinner wares and has also been noted on a mug and a toilet box. The pattern is frequently attributed to Rogers although no marked specimens have yet been recorded. Ill: Coysh 1 153.

The Great Wall of China
A chinoiserie-style pattern by the Leeds Pottery showing the Great Wall of China running through mountainous scenery with two pagodas joined by a bridge in the foreground. Two Chinamen and a dog are on the bank of the river on which there is a small sailing junk. The whole scene is within a typical chinoiserie border. Ill: Coysh 2 49; Lawrence p.52.

"Grecian"
(i) Andrew Muir & Co.
(ii) George Patterson.
(iii) William Ridgway. A romantic pattern with a prominent bridge and pillared buildings. A printed beehive mark bears the title with the initials W.R. The pattern was also printed in purple. Ill: P. Williams p.281.
(iv) John Thomson. A romantic pattern similar to the William Ridgway design.

"Grecian Gardens"
Job & John Jackson. A pattern showing a woman seated in a garden within a border of drapes which connect groups of flowers. It was also printed in purple. Ill: P. Williams p.284.

"Grecian Scenery"
(i) James Jamieson & Co. A design marked J.J. & Co.
(ii) Enoch Wood & Sons. A pattern printed in light blue on dinner wares with a gadrooned edge on "Celtic China". It shows a large mansion surrounded by trees. A couple in the foreground face towards the house. Ill: P. Williams p.288.

"Grecian Scroll"
T.J. & J. Mayer. A pattern noted on plates in both dark blue and light blue.

"Grecian Statue"
(i) J.T. Hudden.
(ii) Attributed to Wood & Brownfield. A romantic scene with a prominent equestrian statue in the foreground. The printed mark of the pre-1837 Royal Arms includes the title, "Stone Ware", and the initials W. & B.

"Greek"
Robert Cochran & Co. A pattern title noted on a jug which has a large medallion with a warrior on horseback.

Greek Patterns
At the end of the 18th century there was considerable interest in Greek culture. This led to the use of Greek designs of classical figures on blue-printed wares. There were three notable series produced:
(i) Herculaneum Pottery. A series of Greek patterns which are commonly called the Etruscan design. The central designs are contained within a wide border which is composed of oval figure medallions on a Greek key background. Items usually have an ochre edge and, although unmarked, are generally accepted to be of Herculaneum manufacture. Ill: Coysh 1 152; Smith 160-161; S.B. Williams 185.
(ii) Spode. The Greek patterns were probably introduced in 1805. The central designs include a variety of figures and animals, all within a border of vases and figure medallions on a background of small leaves. Examples are known in which the white bands outlining the central design, the vases and the medallions have been enamelled in red (Colour Plate III). Ill: Coysh 1 115; Whiter 74, 91-92; S.B. Williams 143-146.
(iii) Wedgwood & Co. and the Ferrybridge Pottery. A series of Greek figure designs introduced before either the Spode or Herculaneum wares. The central designs are separated from the border by a white, unprinted area, the border being composed of acanthus scrolls, the imperial eagle, and repeated pairs of figures. The series was introduced by Ralph Wedgwood at the Knottingley Pottery, and continued after his departure and also after the change of name in 1804 to the Ferrybridge Pottery. Examples are known in sepia as well as blue, and marks may be either "WEDGWOOD & CO." or "FERRYBRIDGE", both impressed. A shape and pattern book containing these designs remains in the Wedgwood

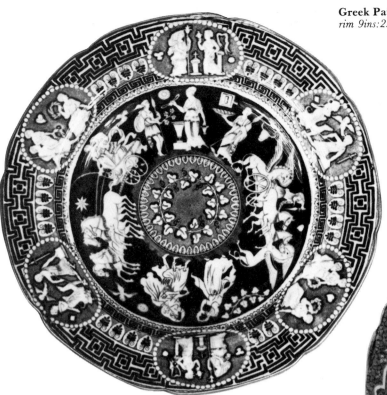

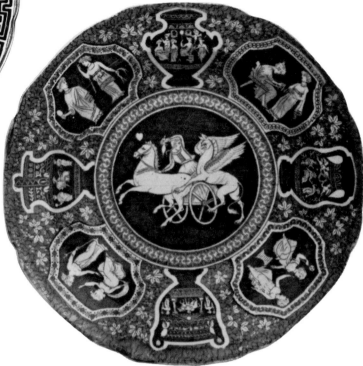

Greek Patterns. *Attributed to Spode. Unmarked. Dished plate 6¼ins:16cm.*

archives. See: Lawrence p.106. Ill: Coysh 2 35; FOB 4, 8.

The Spode designs were based on illustrations of the Greek vases in the collection of Sir William Hamilton. They were published in 1804 in a book entitled: *Outlines from the Figures and Compositions upon the Greek, Roman and Etruscan Vases of the late Sir William Hamilton, with engraved borders. Drawn and Engraved by the late Mr. Kirk.*

Green, Joseph (& Co. or & Sons) fl.c.1809-c.1842

Joseph Green was a china and glass retailer. His name first appears in a London directory for 1809 at the Wholesale Glass & Staffordshire Warehouse, Rutland Place, Upper Thames Street. This entry continues for some years before J. Green & Co. make their first entry at 10 & 11 St. Paul's Church Yard in 1834. The firm continued until 1842, with a change of style to J. Green & Sons in 1841.

Blue-printed wares are known with a printed mark "Joseph Green/ & Co./London" in a wreath of leaves. Another mark seen on ironstone wares has the full name and address:

JOSEPH GREEN & Co.
10 & 11
ST. PAULS CHURCH YARD
LONDON

A third mark, "J. Green & Sons" impressed, has been recorded on a plate. Ill: Coysh 2 131.

Green, Thomas fl.1847-1859

Minerva Works, Fenton, Staffordshire. This firm produced printed wares in many colours; green, pink, brown and black were used in addition to blue. They exported a series entitled "W. Penn's Treaty" to America. Some printed marks include the name in full although the initials T.G. were used. Care must be taken in attributing such marks as some could refer to Thomas Godwin of Burslem. One of the initial marks used by Green includes the name "Fenton" within a Staffordshire knot surmounted by a crown.

Greenfield, John

An American importer based at 77 Pearl Street, New York. A printed mark with the name and address has been recorded on export wares produced by James & Ralph Clews. A similar circular impressed mark has also been noted.

"Greenwich"

Harvey. Cities and Towns Series. Plate 9¾ins:25cm, soup plate 10ins:25cm, hot water plate and pierced dessert plate 8½ins:22cm.

Two other untitled views have been identified, one on a shell dish and dessert plate in the Foliage and Scroll Border Series by James & Ralph Clews, and the other on a mug by an unknown maker (see overleaf). Two further titled views were made by Enoch Wood & Sons in their Grapevine Border Series and by Goodwins & Harris in their "Metropolitan Scenery" Series, both titled "View of Greenwich".

Greenwich lies on the south bank of the River Thames, some six miles downstream from the City of London. It is dominated by the Royal Naval College which was built originally as a palace, but it is also the home of the National Maritime Museum.

"Greenwich." *Harvey. Cities and Towns Series. Printed title mark. Soup plate 10ins:25cm.*

"Greenwich." *Maker unknown. Untitled distant view. Unmarked. Mug 5¼ins:13cm.*

"Groom Leading Out"

Spode. Indian Sporting Series. Plates 6 and 6½ins:15 and 16cm, and a sauceboat. See Colour Plates VIII and IX. Ill: S.B. Williams 10-11.

The full title of the source print in Williamson's *Oriental Field Sports, Wild Sports of the East* was "Syces or Grooms Leading Out Horses".

"Grotto"

Robert Cochran & Co. A typical romantic scene.

Grotto Border

When a central pattern, usually a view, is of a lighter colour than the border, and the border descends into the well of the plate, the impression given is that one is looking at the view from a grotto. In such designs the border is often referred to as a grotto border. Probably the best example is the Shell Border Series by Enoch Wood & Sons, although several of the foliage borders give a similar effect.

"Grotto of St. Rosalie near Palermo"

Don Pottery and Joseph Twigg, Newhill Pottery. Named Italian Views Series. Tureen stand 15½ins:39cm.

St. Rosalie is the most saintly patron of Palermo. At a very early age she disclaimed all human contacts and disappeared. Five hundred years later, when the plague was rife in Palermo, her bones were discovered in a grotto. They were carried three times around the city walls and Palermo was at once delivered from the pestilence.

Group Pattern

An accepted name for a Spode floral pattern which has a spray of flowers in the centre and a border composed of several smaller sprays between two bands of geometrical motifs. The pattern was used on dinner wares and a cusped dish. Ill: Coysh 2 99; Whiter 43.

"Gubbins Hall"

Maker unknown. Passion Flower Border Series. Plate 6¾ins:17cm.

This title has also been noted on a small stand which actually bears a view of The Rookery in Surrey.

"Gubbins, Hertfordshire"

Enoch Wood & Sons. Grapevine Border Series. Sauce tureen stand.

This view shows a country mansion set amongst trees with a fenced formal garden and two ladies in the foreground. The actual locality is Gobions (Brookman's Park). The house belonged to the More family, including Sir Thomas More. It was pulled down in 1836 but the Folly Arch, a sham medieval entrance gate designed by James Gibb, still exists.

"The Guildhall, London"

Maker unknown. Laidacker lists this title on a plate (9ins:23cm) with a foliage border which has roses and thistles at the base.

Another design which is thought to represent the Guildhall shows an idealised building with the arms and motto of the City of London at the base. The border is identical to that used on the Eastern Port pattern (Coysh 1 166), with a crown between a rose and a thistle repeated within a string of rose leaves. The design is known only on a comport and dessert dishes.

See: "Domine Dirige Nos".

"Guitar"

Edward & George Phillips. A title recorded on an impressive coffee pot. The design consists of flowers, leaves and scrolls in bands, and a small group of musical instruments repeated several times. Ill: Coysh 2 67.

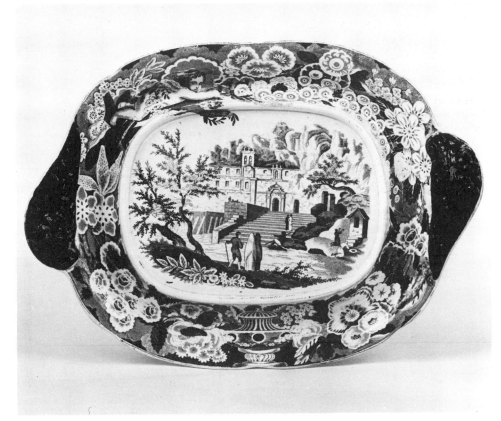

"Grotto of St. Rosalie near Palermo." *Don Pottery. Named Italian Views Series. Printed title below view, otherwise unmarked. Tureen stand 15½ ins:39cm.*

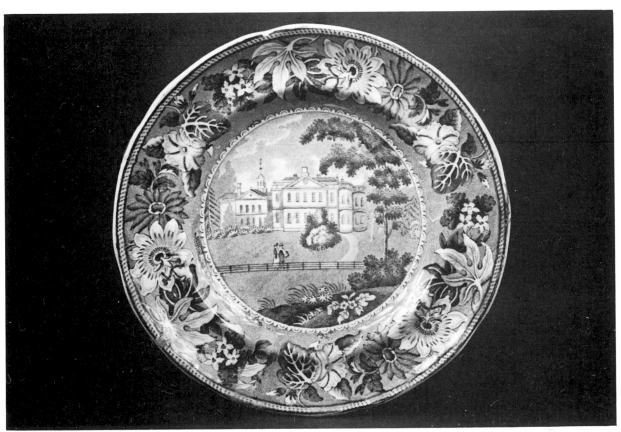

"Gubbins Hall." *Maker unknown. Passion Flower Border Series. Printed title mark. Plate 6¾ ins:17cm.*

Gunnersbury House, Middlesex

John & William Ridgway. Angus Seats Series. Dish 10¾ ins:27cm.

In common with all items from this series the view is not titled and marked pieces are very rare.

The house was built by John Webb who was a pupil of Inigo Jones. It no longer exists.

"Gunton Hall"

Maker unknown. Light Blue Rose Border Series. Deep dish 11ins:28cm.

"Gunton Hall, Norfolk"

(i) Enoch Wood & Sons. Grapevine Border Series. Plate 7½ ins:19cm.

(ii) Maker unknown. Foliage Border Series. Plate 7¾ ins:20cm.

This house by Matthew Brettingham was destroyed by fire in 1882. Only some additions made by Wyatt in about 1785 now remain.

"Guy Mannering"

Davenport. "Scott's Illustrations" Series. Dish 14½ ins:37cm.

Sir Walter Scott's *Guy Mannering* was first published in 1815. The pattern shows Meg Merrilies with arm raised as the Laird of Ellangowan and a companion pass by on horseback.

"Gunton Hall, Norfolk." *Maker unknown. Foliage Border Series. Printed title mark. Plate 7¾ ins:20cm.*

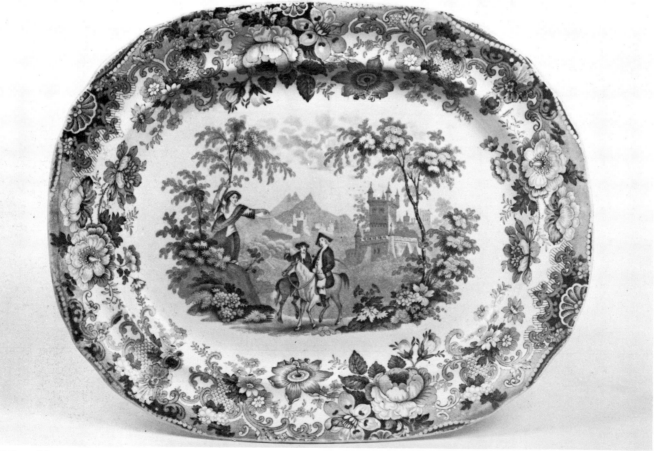

"Guy Mannering." *Davenport. "Scott's Illustrations" Series. Printed titles mark and impressed maker's anchor mark for 1852. Dish 14½ ins:37cm.*

"Guy's Cliff, Warwickshire" (sic)

Enoch Wood & Sons. Grapevine Border Series. Plate and soup plate, both 10ins:25cm. Ill: Little 78.

Another view of the house by an unknown maker is illustrated within a border of medallions, each containing a building. This view does not bear a title.

The house at Guy's Cliffe was built in 1751 in the Palladian style and additions were made for Mr. Bertie Greatheed, the dramatist, the latest in 1818. The Enoch Wood view shows the Tudor-style additions facing the river. It is now in ruins.

"Guy's Cliffe"

Elkin, Knight & Co. Rock Cartouche Series. Plate 7ins:18cm.

"Gypsies Pastime"

Maker unknown. A small bowl in the Bristol Museum has a printed mark bearing only this title. The scene shows three girls grouped around a fire over which hangs a cauldron. Facing them, on the opposite side of the fire, stands a man with a woman seated on the ground beside him.

"Gypsy"

Maker unknown. A romantic scene used on dinner wares and found also in pink and purple.

"Gyrn, Flintshire, Wales"

Ralph Hall. "Select Views" Series. Dishes 17ins:43cm and 18ins:46cm.

This seat is about two and a half miles west of Mostyn station.

Guy's Cliffe, Warwickshire. *Maker unknown. Untitled view. Unmarked. Plate 8½ins:22cm.*

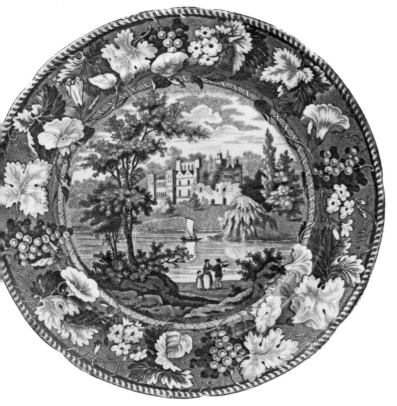

"Guy's Cliff, Warwickshire." *Enoch Wood & Sons. Grapevine Border Series. Printed title mark and impressed maker's mark. Plate 10ins:25cm.*

"Guy's Cliffe." *Elkin, Knight & Co. Rock Cartouche Series. Printed title mark. Plate 7ins:18cm.*

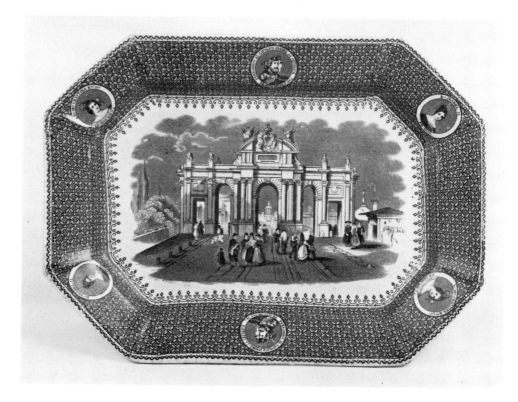

"Habana." *William Adams &*
Sons. Printed registration mark for
1845 with "IRONSTONE"
above and "HABANA/
W.ADAMS" below. Eight-sided
dish 12ins:30cm.

"Habana"

William Adams & Sons. A design registered on 26th July, 1845
with a series of medallions in the border. The inscriptions on
the medallions read "Fernandov El Catolico, Isabel La
Catolica" at the top and bottom centre, "Dª Isabel II" at the
top right and bottom left, and "Dª Mª Cristina Rna Gra" at
the top left and bottom right. They also include various
numbers, the significance of which is not known although the
dates 1474 and 1833 appear.

Habana, or La Habana, is an abbreviated form of San
Cristobal de la Habana, the name given by the Spaniards to
Havana, the capital of the island of Cuba.

Hackwood Partnerships fl.1807-1855

Several potters with the name Hackwood operated in Hanley
and Shelton between 1807 and the 1850s. The following have
been recorded:

Hackwood & Co., Eastwood, Hanley. Initial mark H. &
Co. 1807-1827

William Hackwood, Eastwood, Hanley. Initial mark W.H.
1827-1843

Hackwood & Keeling, Market St., Hanley. Initial mark
H. & K. 1835-1836

Josiah Hackwood, Upper High St., Hanley. 1842-1843

William & Thomas Hackwood, New Hall Pottery, Shelton.
1844-1846

William Hackwood & Son, New Hall Pottery, Shelton.
1846-1849

Thomas Hackwood, New Hall Pottery, Shelton. 1850-1855
Since several of the above may have used the surname
"HACKWOOD" or the initial H, it is not always easy to
attribute wares with certainty.

The most prolific maker of blue-printed wares was probably
William Hackwood between 1827 and 1843. Miniature dinner
services with the Willow pattern and floral patterns can be

found with the impressed surname. Another similarly marked
miniature pattern shows a large building on a hill. One well
known dealer refers to this as the Institution pattern and in
America it has been called Monastery Hill.

"Hagley, Worcestershire"

Enoch Wood & Sons. Grapevine Border Series. Plate
6½ins:16cm.

Hagley Hall is a Palladian building near Stourbridge owned
by Lord Cobham. It was designed by Sanderson Miller, who
also laid out the extensive grounds, and completed in 1760.

"The Hague"

Copeland & Garrett. Byron Views Series.

The Hague is the capital of the Netherlands and the
province of South Holland. In Dutch it is called either
's Gravenhage or Den Haag. Since 1922 it has been the home
of the International Court of Justice.

Hales, William fl.c.1790-1832

An engraver who is known to have worked in the first decade of
the 19th century on several of the early patterns used by
Wedgwood, including the Peony pattern.

Hall, John & Ralph fl.c.1802-1822

Sytch Pottery, Burslem and Swan Bank, Tunstall,
Staffordshire.

John & Ralph Hall operated these two potteries in
partnership until 1822 when they separated, though it is
possible that the first factory was operated by John Hall alone
after 1814. The impressed or printed mark "HALL" may
relate to the partnership.

Hall, John (& Sons) fl.c.1814-1832

Sytch Pottery, Burslem, Staffordshire. When the partnership with Ralph Hall was dissolved in 1822 this pottery was continued by John alone and the style became John Hall & Sons. Printed marks including the names "I. HALL" or "I. HALL & SONS" were used. Series of patterns included "Oriental Scenery" and "Quadrupeds".

Hall, Ralph (& Co. or & Son) fl.1822-1849

Swan Bank, Tunstall, Staffordshire. This pottery was continued by Ralph Hall following the partnership with John. The style became Ralph Hall & Co. in 1841, although another style, Ralph Hall & Son, was used in about 1836. The firm was largely engaged in producing blue-printed wares for export to America. Several series were made, including "Select Views", "Picturesque Scenery" and "Italian Buildings".

"Hallow Park, Worcestershire"

Maker unknown. Flower Medallion Border Series. Plate 7½ ins:19cm.

Hallow Park is about three miles north west of Worcester, close to the River Severn.

"Halstead, Essex"

Henshall & Co. Fruit and Flower Border Series. Plate 7½ ins:19cm.

It has not yet proved possible to locate the particular view used on this plate. There are several old houses in the parish including Baythorne Park, Bluebridge House and Oaklands.

"Hamden Mortally Wounded" (sic)

Jones & Son. "British History" Series. Plate 6½ ins:16cm.

John Hampden (1594-1643) was one of the five members who avoided arrest by Charles I on 4th January, 1642. During the Civil War which followed he was mortally wounded at Chalgrove Field on 18th June, 1643 while commanding a Buckinghamshire regiment. He died at Thame and was buried at Great Hampden.

Hamilton, Robert fl.1811-1826

Stoke, Staffordshire. Blue-printed wares are known with the impressed mark "HAMILTON/STOKE". See: Coysh 1 47, 48.

Hamilton, Sir William 1730-1803

A diplomat and archaeologist who was plenipotentiary at Naples from 1764 to 1800. He was elected a Fellow of the Royal Society in 1766. He studied the discoveries at Pompeii, sold Greek vases and antiquities to the British Museum, and purchased both the Portland Vase and the Warwick Vase. After his death Baron Pierre D'Hancarville published details of Hamilton's collection of *Etruscan, Greek and Roman Antiquities* in four volumes. These aroused great interest and became a source of designs for blue-printed patterns.

Hammersley, Ralph fl.1860-1883

Church Bank Pottery, Tunstall, Staffordshire. Printed marks were used including the initials R.H. The firm was continued as Ralph Hammersley & Son until 1905 at both Tunstall and Burslem. The initials R.H. & S. refer to this later period.

Hampson & Broadhurst fl.1847-1856

Green Dock Works, Longton, Staffordshire. Printed title marks have been recorded with the initials H. & B.

"Hampton House"

Goodwins & Harris. "Metropolitan Scenery" Series. Sauce tureen and stand.

Hampton House, known today as Garrick's Villa, lies on the north bank of the Thames about one mile upstream from Hampton Court. As its modern name implies, it was the residence of the actor David Garrick (1717-79) from the year 1754 until his death. The riverside pavilion shown in the left foreground of the ceramic view can still be seen and has been extensively restored. It is called either Garrick's Temple or Shakespeare's Temple.

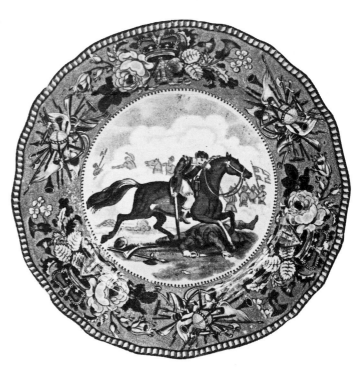

"**Hagley, Worcestershire.**" *Enoch Wood & Sons. Grapevine Border Series. Printed title mark. Plate 6½ ins:16cm.*

"**Hamden Mortally Wounded.**" *Jones & Son. "British History" Series. Printed titles and maker's mark. Plate 6½ ins:16cm.*

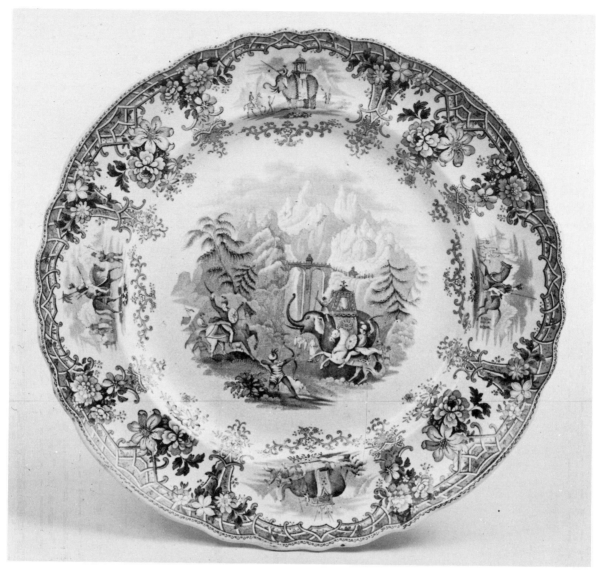

"Hannibal Passing the Alps." *Knight, Elkin & Co. Impressed eagle mark and printed coat-of-arms with the motto "LABOR OMNIA VINCIT" and the pattern title on a ribbon. Wavy edge plate 10¼ ins:26cm.*

Hancock, Sampson **fl.c.1858-1891**
Tunstall until 1870, then at the Bridge Works, Stoke, Staffordshire. Printed marks, often with a title, include either the initials S.H. or the name "S. HANCOCK". The firm continued well into the 20th century as Sampson Hancock & Sons.

Hancock, Whittingham & Co. **fl.1863-1872**
Swan Bank Pottery, Burslem, Staffordshire. Printed marks, often with a pattern title, bear the initials H.W. & Co. A new partnership, Hancock & Whittingham, was established at the Bridge Works, Stoke, in about 1872 and continued until 1879.

Handley, J. & W. **fl.c.1820-1830**
Albion Works, Hanley, Staffordshire. A little known company which produced blue-printed wares. An impressed name mark has been reported on wares bearing the Village Fishermen pattern (Ill: Coysh 1 170).

Hanley
A town one and a half miles north of Stoke-on-Trent, into which it is now incorporated. It grew rapidly in late Victorian times and became the most important of the pottery towns. It had the advantage of being near the Cauldon branch of the Trent and Mersey Canal, and steam railways linked it with Burslem, Stoke and Longton.

"Hannibal Passing the Alps"
Knight, Elkin & Co. A light blue pattern including a procession of elephants and horses within a medallion border. The ornate printed mark is armorial in form and includes both the title and the motto "Labor Omnia Vincit". Examples often bear an impressed mark in the form of an eagle with outstretched wings perched on a branch. The mark is often found on marked wares from this factory. Ill: FOB 22.

Hannibal (247-183 B.C.) swore eternal enmity to Rome as a small boy. In 218 B.C. as a Carthaginian general he crossed the Pyrenees with 90,000 troops, 12,000 horses and thirty-seven elephants in the face of almost insuperable obstacles, then crossed the Alps, forcing back the Romans under Scipio. The following year he destroyed two Roman armies but his advance was eventually halted due to lack of support, and peace had to be made.

"Hanover Lodge, Regent's Park"
Enoch Wood & Sons. "London Views" Series. Plate 9ins:23cm.

"Hanover Lodge, Regent's Park, London"
Maker unknown. Flower Medallion Border Series. Dish 11ins:28cm. Ill: Laidacker p.114.

Hanover Lodge was a small mansion in Regent's Park, next door to Albany Cottage, and adjacent to Regent's Canal in the north west corner of the park. It was the residence of Colonel Sir Robert Arbuthnot.

"Hanover Place"
Henshall & Co. Fruit and Flower Border Series. Round soup tureen stand.

It has not yet proved possible to trace this view.

"Hanover Terrace, Regent's Park"
Enoch Wood & Sons. "London Views" Series.

"Hanover Terrace, Regent's Park, London"
William Adams. Regent's Park Series. Dish 10ins:25cm, and vegetable dishes.

Designed by John Nash, Hanover Terrace is in the Palladian style. Both the centre and two wings have pediments with Doric columns. It lies on the west side of Regent's Park.

The Harbour at Macri
Spode. Caramanian Series. Dish 10ins:25cm. Ill: S.B. Williams 66-67.

Macri or Makri was the name given in the 19th century to the ancient town of Telmessos with one of the best natural harbours in the Ottoman Empire. It has many sarcophagi and rock-cut tombs and a noted necropolis east of the town covered with the signatures of travellers dating back to the late 18th century. Today the port is known as Fethiye. It exports chrome ore from local mines.

"The Harbour of Messina"
Henshall & Co. Fruit and Flower Border Series. Plate 6¾ins:17cm, and dished plate 7¼ins:18cm.

The Messina depicted in this view no longer exists. A disastrous earthquake destroyed the city on 28th December, 1908. Most of the early buildings, including the cathedral, had to be rebuilt. It lies in the extreme north east of Sicily, overlooking the narrow Strait of Messina which separates Sicily from the Italian mainland.

Harding & Cockson fl.1834-1860
Globe Pottery, Cobridge, Staffordshire. Printed marks include either the initials H. & C. or the names in full, often with the addition of the word "COBRIDGE". The company is sometimes confused with Cockson & Harding of Shelton (qv).

Harding, Joseph fl.1850-1851
Navigation Road, Burslem, Staffordshire. A blue-printed pattern has been recorded marked with the title "Asiatic Scenery" in a C-scroll cartouche with the maker's name "J. HARDING" below.

Harding, W. & J. fl.1862-1872
New Hall Works, Shelton, Staffordshire. This company succeeded Cockson & Harding and continued some of the earlier wares which can be traced further back to the Hackwood period. A miniature plate is known with the impressed name "HARDING" and printed title marks have the initials W. & J.H.

"Hare Hall, Yorkshire"
Maker unknown. Passion Flower Border Series. Dishes 10½ins:27cm and 14ins:36cm. Ill: FOB 27.

This view actually shows Harewood House (qv).

"The Hare and the Tortoise"
Spode/Copeland & Garrett. "Aesop's Fables" Series. Soup tureen cover. Ill: Whiter 90.

A hare boasted of his great speed in running. "I will run with you five miles for five pounds," said the tortoise. The hare agreed but outran the tortoise to such a degree that she stopped and took a nap. Meanwhile, the tortoise steadily jogged on, passed the sleeping hare and arrived first.

Industry and application to business makes amends for the want of a quick and ready wit.

"Harebell"
Charles Meigh & Son. This pattern is marked with a printed cartouche bearing the title and the initials C.M. & S. See: Godden M 2620.

"Harewood House"
Ralph Stevenson. Stevenson's Acorn and Oak Leaf Border Series. Dish 15ins:38cm, pierced comport, vegetable dish and soup tureen. Ill: Moore 53.

"Harewood House, Yorkshire"
Enoch Wood & Sons. Grapevine Border Series. Dishes 14¼ins:36cm and 15ins:38cm.

Harewood House was built by John Carr between 1759 and 1771 in collaboration with Robert Adam. The south facade was removed in 1843 when Sir Charles Barry was called in. The garden was laid out by Capability Brown in about 1772. Harewood lies between Leeds and Harrogate and is open to the public except in December and January.

Harley, Thomas fl.1802-1808
Lane End, Staffordshire. Blue-printed teawares are known with the mark "HARLEY" including a teapot in the Norwich Museum. Godden and Little state that printed wares are known with the name "T. Harley" within the decoration.

"Harp"
Ralph Stevenson. This pattern shows a sailor playing a lyre to a woman on board a ship, and was used on tea and coffee wares. Ill: Laidacker p.79.

Harrison, George (& Co.) fl.c.1790-1804
Lane Delph and Fenton, Staffordshire. The history and dates of this firm are obscure. George Harrison is dated as c.1790-95 in Godden M 1958, whereas a plate with a chinoiserie floral pattern, illustrated in Godden BP 305, is marked "G. HARRISON" but described as being c.1800-4. It is thought that the style became George Harrison & Co. in about 1795 and Harrison & Hyatt in about 1802. It is possible that the same mark was used throughout, although marked examples are by no means common.

Hartley, Greens & Co. fl.c.1781-1820
See: Leeds Pottery.

"Harvest"
J. & M.P. Bell & Co. A harvest scene with workers handling sheaves of corn with a windmill in the distance. The printed cartouche has two sheaves of corn above the makers' initials.

"The Harvest Home"
James & Ralph Clews. Doctor Syntax Series. Dish 21ins:53cm, a drainer and large bowl. Ill: Arman 59; P. Williams p.497.

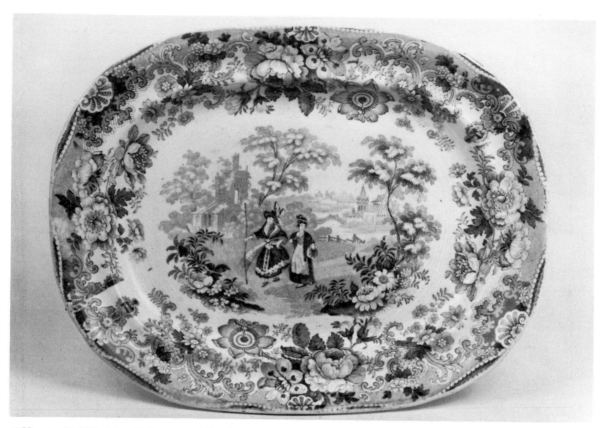

"Heart of Midlothian." *Davenport. "Scott's Illustrations" Series. Printed titles mark and impressed maker's anchor mark for 1852. Dish 10½ins:27cm.*

Harvey, Charles (& Sons)　　　　**fl.1799-1835**

Lane End, Longton, Staffordshire. Charles Harvey is said to have owned two potteries, in Stafford Street and Great Charles Street. In 1818 his sons were taken into partnership and the firm became Charles Harvey & Sons. The impressed mark "HARVEY" almost certainly relates to this period rather than the later C. & W.K. Harvey (qv). The most notable blue-printed wares were the views of English and Scottish cities and towns, listed herein as the Cities and Towns Series.

Harvey, C. & W.K.　　　　**fl.1835-1853**

Stafford Street, Lane End, Longton, Staffordshire. It is not clear exactly when Charles Harvey left the partnership with his sons, but it is known that they were in full charge of the firm by 1835 and expanded rapidly. An initial mark was used — C. & W.K.H. — and sometimes the name in full appears beneath a royal arms mark.

"Haughton Hall, Norfolk" (sic)

Andrew Stevenson. Rose Border Series. Soup tureens.

Houghton Hall was designed by Colin Campbell and Thomas Ripley for Sir Robert Walpole. It was built in the 18th century and is one of the finest examples of Palladian architecture in England, although some stone domes have been added. It lies thirteen miles east of King's Lynn.

"Hawking"

(i) J. & M.P. Bell & Co. A pattern which shows a lady on horseback with a man standing close by, each with a hawk in hand. The horse is held by a third figure and there is a Gothic castle in the background. The border consists of medallions, each with a building and two swans on a lake.

(ii) Robert Heron & Son.

"Hawking in Olden Time"

J. & M.P. Bell & Co. A pattern noted on a jug 7½ins:19cm.

"Hawthorn"

Dillwyn. An all-over or sheet pattern used at the Cambrian Pottery during the L. Ll. Dillwyn period between 1836 and 1850. Ill: Nance LXXa.

"Hawthorn Blossom"

(i) J. & M.P. Bell & Co.

(ii) James Jamieson & Co.

"Hawthornden, Edinburghshire"

William Adams. Bluebell Border Series. Plate 9ins:23cm. Ill: Laidacker p.1; Nicholls, *Ten Generations of a Potting Family,* Plate XLII.

This was an old house associated with the poet William Drummond, which he inherited in 1610. Since then a modern residence has been built on the site.

"The Haymaker"

Baker, Bevans & Irwin. This pattern title appears in a printed cartouche with the initials B.B. & I.

"Haymarket Theatre, London"

Tams & Co. Tams' Foliage Border Series. Plate 6ins:15cm.

Although founded in 1720, the Theatre Royal, Haymarket, has a frontage built by John Nash in 1821. It has a portico of six Corinthian columns with a pediment.

"Heart of Midlothian"

Davenport. "Scott's Illustrations" Series. Dish 10½ins:27cm.

Sir Walter Scott's novel *Heart of Midlothian* was first published in 1818.

Heath, John fl.1809-1823
Sytch Pottery, Burslem, Staffordshire. This potter used the
impressed mark "HEATH". Among other patterns known
with this mark are an exact copy of Spode's Girl at the Well
design, usually printed in a darker blue, and an early example
of the common "Wild Rose" design. One characteristic of
John Heath's wares seems to be an unusual form of footrim,
basically the standard double type but with the addition of a
further rounded ring.

Heath, John fl.c.1830-1877
A Hanley engraver who is known to have worked for
Wedgwood from 1840 onwards.

Heath, Joseph fl.1845-1853
High Street, Tunstall, Staffordshire. Printed marks with the
name "J. HEATH" are usually associated with this potter.
One example bearing the title "Geneva" is known with the
additional impressed mark "HEATH", but the obviously
later characteristics of such wares should preclude confusion
with the products of John Heath of the Sytch Pottery, Burslem
(qv).

Heath, Joseph,& Co. fl.1828-1841
Newfield Pottery, Tunstall, Staffordshire. Printed marks
include "& Co." in various forms such as I.H. & Co., J.H. &
Co., and "J. HEATH & Co." The wares tend to be in lighter
blue with the later shaped edges. Romantic designs were
produced such as "Italian Villas".

Heath, Joshua fl.c.1770-c.1800
Hanley, Staffordshire. Joshua Heath was one of the earliest
producers of blue-printed wares, nearly all based on Chinese
designs but sometimes including European features (see
illustrations overleaf). He used a distinctive impressed mark
consisting of his initials I.H., although Godden BP 302
attributes one such marked piece to a potter called John Heath.
See also Coysh 1 3-5, 8; Little 31-32. Another plate has been
noted with a chinoiserie border containing the words "Long
Live the King". This was possibly made to mark the twenty-
fifth year of the reign of George III.

Heath, Thomas fl.1812-1835
Hadderidge, Burslem, Staffordshire. Printed and impressed
marks include the name "T. HEATH".

Heathcote, Charles,& Co. fl.1818-1824
Lane End, Staffordshire. The name "HEATHCOTE &
Co.", sometimes with an additional numeral, can be found
both impressed and printed. One particularly notable design,
usually called the Cattle and River pattern (qv), shows an
unidentified country house. Bevis Hillier in *The Turners of Lane
End* reports that a marked Heathcote plate and a marked
Turner plate are to be found with identical underglaze
printing, suggesting that Heathcote may have acquired some
of Turner's copper plates.

"Helmsley Castle, Yorkshire"
Maker unknown. Pineapple Border Series. Sauce tureen.
 Helmsley Castle, not far from Rievaulx Abbey, stands at the
edge of the plain of Pickering. As seen today it dates mainly
from the 13th century although some buildings to the north of
the tower were remodelled in the 16th century. It is a fine
example of the type of castle owned by a local lord.

Henderson & Gaines
An American importer of Davenport wares at 45, Canal
Street, New Orleans. A printed mark can be found on
examples of the "Scott's Illustrations" Series. American
sources report similar marks with the names Hill &
Henderson, and Henderson, Lawton & Co.

"Henry IV, Act 5, Scene 4"
John Rogers & Son and Pountney & Goldney. "The Drama"
Series.
 This play by Shakespeare was written in 1597 and printed in
1598 as *The History of Henrie the Fourth; With the battell at
Shrewsbury, betweene the King and Lord Henry Percy, surnamed Henrie
Hotspur of the North. With humorous conceits of Sir John Falstaffe.*

"Henry VI, Act 2, Scene 2"
John Rogers & Son and Pountney & Goldney. "The Drama",
Series.
 This Shakespeare play was written in 1592 and printed in
1623.

Henshall & Co. fl.c.1790-1828
Longport, Staffordshire. This firm consisted of several
different partnerships. The style was Henshall & Clowes in the
last decade of the 18th century but Clowes appears to have left
soon after 1800 and the firm became Henshall, Williamson &
Co. for a period. However, since the only recorded mark is
Henshall & Co., which in any case is rare, it is virtually
impossible to attribute pieces to a particular partnership.
There is no doubt that the output of blue-printed wares was
considerable. Examples of marked pieces include the Castle
and Bridge pattern (Ill: Coysh 1 154; Little 35) and the Flowers
and Leaves pattern (Ill: Coysh 2 41). The former gives every
indication of dating from about 1810-15, whereas a
Herculaneum marked example of the latter is thought to date
from 1804 (Ill: Smith 151). The most interesting patterns are a
series of views which are titled in a union wreath style
cartouche, and contained within a border of fruit and flowers.
The series includes views in England and Europe and is listed
under the title Fruit and Flower Border Series. The same
border, but with a different form of printed cartouche mark, is
known on a series of American views. A very small number of
the English views are known with the impressed
"HENSHALL & Co." mark. The quality of Henshall pieces
is consistently high.

Herculaneum Pottery fl.c.1793-1841
Liverpool, Lancashire. There were at least twenty potteries
operating at Liverpool in the 18th century. The Herculaneum
Pottery came late on the scene but its owner, Samuel
Worthington, was the first to give a trade name to his works.
He chose Herculaneum, as Wedgwood had chosen Etruria,
because of its classical associations. It paid a handsome
dividend and is now one of the few Liverpool potteries widely
remembered. It had close links with Staffordshire, and at least
twenty-two Staffordshire potters sold wares through the
Herculaneum warehouse, including such major factories as
Adams, Ridgway, Rogers and Spode.
 Herculaneum produced a wide range of earthenwares, and
as with most potteries of the period, blue-printing was widely
used. Although the range of patterns was extensive, three
series are worth special mention — the Cherub Medallion
Border Series, the India Series, and the Liverpool Series.
Marks included the name Herculaneum, printed or impressed
in various forms, and some of the later wares were marked
with the symbol of Liverpool — the Liver Bird. For an
extensive history of the firm see Smith's *Liverpool Herculaneum
Pottery.*

"Hereford"
Enoch Wood & Sons. "English Cities" Series. Plates
9ins:23cm and 10ins:25cm, soup tureen and jug.
 The city of Hereford stands on the River Wye, and until the
recent boundary changes was the county town of Hereford-
shire. It is famous for its cathedral and the cathedral school,
founded in 1384.

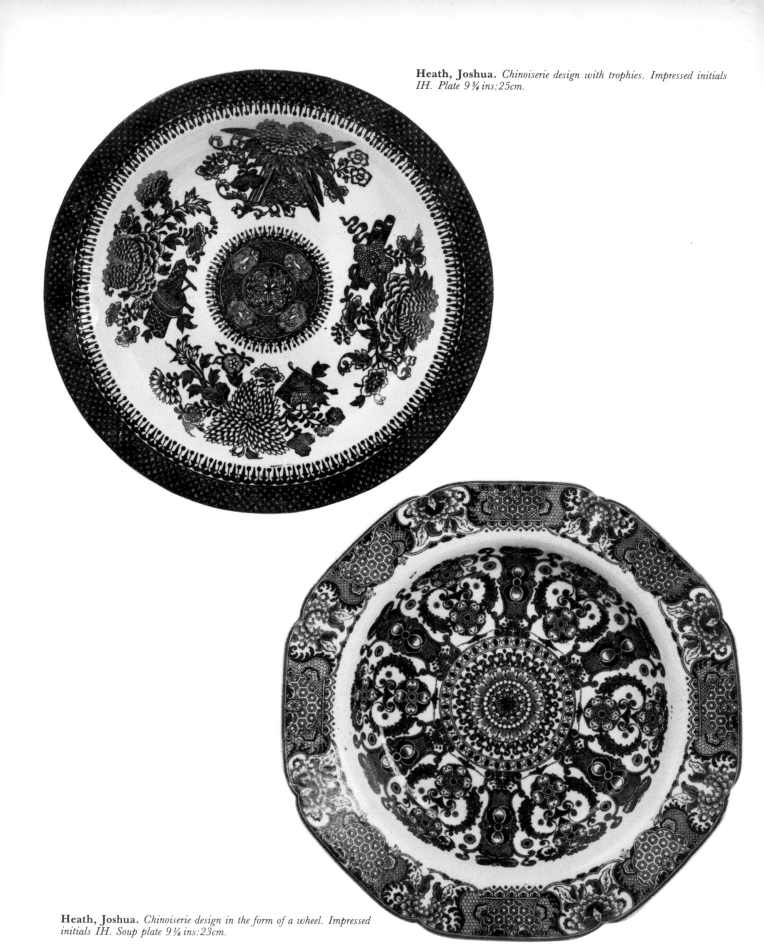

Heath, Joshua. *Chinoiserie design with trophies. Impressed initials IH. Plate 9¾ ins:25cm.*

Heath, Joshua. *Chinoiserie design in the form of a wheel. Impressed initials IH. Soup plate 9¼ ins:23cm.*

"Hermitage en Dauphine"
Enoch Wood & Sons. French Series. Dish 14¾ ins:37cm. Ill: Arman S 196.

Dauphine was an ancient province of France with Grenoble as its capital.

"Hexham Abbey"
Maker unknown. "Antique Scenery" Series. Plates 8¼ ins:21cm and 10ins:25cm. Ill: Coysh 2 134.

This view is very similar to the "Metropolitan Scenery" Series pattern titled "View near Colnebrook" and the Swansea pattern called Cows Crossing Stream (qv).

Hexham Abbey, a Priory Church, was founded in the 7th century, sacked by the Danes in the 9th century, and re-founded in the 12th and 13th centuries. The abbey as shown in the view has since been altered twice, in 1850 and 1910.

Hibiscus
A Wedgwood floral pattern introduced in 1806-7 and engraved by William Hales. The design shows hibiscus flowers and leaves radiating from a central reserve with a geometrical border which includes four panels containing Oriental towers. It was the third pattern introduced at the Wedgwood factory. Ill: Coysh 1 132.

Hicks & Meigh fl.1806-1822
High Street, Shelton, Staffordshire. This firm operated two potteries and produced blue-printed wares in "Stone China", words which appear on their mark, usually with the addition of a number, beneath a royal coat-of-arms with an inner escutcheon. They made mainly floral patterns, many of which were printed on wares with gadrooned edges. One interesting feature was a double footrim painted a buff colour underglaze. This seems to have been exclusive to this firm and their successors Hicks, Meigh & Johnson.

Hicks, Meigh & Johnson fl.1822-1835
High Street, Shelton, Staffordshire. This partnership continued to make the same type of Stone China wares as their predecessors, Hicks & Meigh. They used a similar mark with a royal coat-of-arms but with the words "Stone China" beneath in old English lettering. Another printed mark was a crown with the words "Stone China" above and below, all within a double-lined octagon. Printed title marks with the initials H.M.J. or H.M. & J. are also found.

Higginbotham
The name of a Dublin "china and delf seller" who retailed wares for C.J. Mason & Co. amongst others. The words "Higginbotham's Semi-China Warranted" have been recorded on a plate with a view of Trentham Hall now known to have been made by Mason (Ill: Coysh 1 146). Other partnerships with this name have also been reported. They include Higginbotham & Co., Grafton Street, Dublin on a blue-printed earthenware bowl; Thomas Higginbotham, 11-12 Wellington Quay, Dublin on an ironstone plate; and Higginbotham & Son, Sackville Street, Dublin on another ironstone plate.

With the help of the National Museum of Ireland it has been possible to establish the following sequence of names and addresses:

Thomas Higginbotham c.1793-1796

Thomas Higginbotham, Pill Lane, Dublin c.1796-1830

Thomas Higginbotham & Son, 11-12 Wellington Quay, Dublin c.1830-1840

Higginbotham, Grafton Street, Dublin c.1840-1870

"Highbury College, London"
William Adams. Regent's Park Series. Dish 11½ ins:29cm, and vegetable dish.

In his description of this building in *Metropolitan Improvements* (1827), James Elmes wrote: "It reflects much credit on the architect for the selection of his materials from the choice storehouse of Ionian antiquities".

Hilcock
This name appears impressed in large capital letters on a chinoiserie plate with two men on a three-arch bridge. Ill: Coysh 2 132. No potter or retailer with this name, note the single 'l', can be traced. It is possibly a mis-spelling for Hillcock and could thus relate to the retailer Robert Hillcock (qv).

Hill, Lord
A portrait of Lord Hill on horseback, printed on an unattributed mug, is illustrated in May 176.

Lord Hill (1772-1842) served in the Peninsular War and captured the forts of Almarez. He distinguished himself at Waterloo, was promoted to General in 1825, and succeeded Wellington in 1828 as Commander-in-Chief.

Hillcock, Robert (& Son) fl. 18th century to 1817
Robert Hillcock became established as a China and Glassman at 57 Cheapside, London, in the 18th century. There is some confusion in the London directories over the use of the style '& Son', but this appears only to have been used before 1810. Entries between 1811 and 1817 list simply Rob. Hillcock. The firm became Hillcock & Walton in 1817.

The impressed mark "HILCOCK", despite the single letter L, may relate to this retailer.

Hillcock and Walton fl.1817-1823
Robert Hillcock's retail business at 57 Cheapside became Hillcock and Walton in 1817 and continued under the same style until 1823. The firm then became John Whitehead Walton, a style which continued until 1842.

A plate has been noted with a rural scene, including a countryman with a crutch, which bears a neatly printed mark "Hillcock and Walton" in red. Note that the "and" is printed in full.

Higginbotham. *Mark of this Dublin chinaman on a plate made by C.J. Mason & Co.*

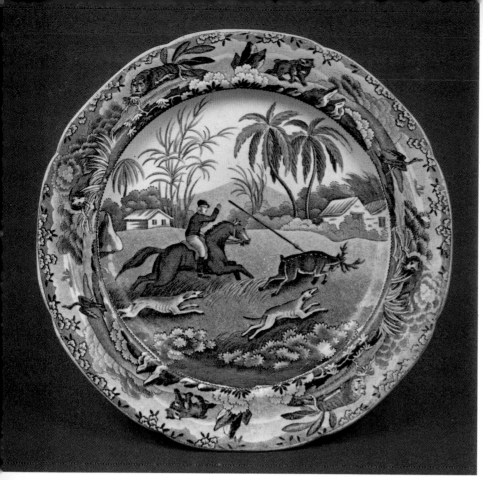

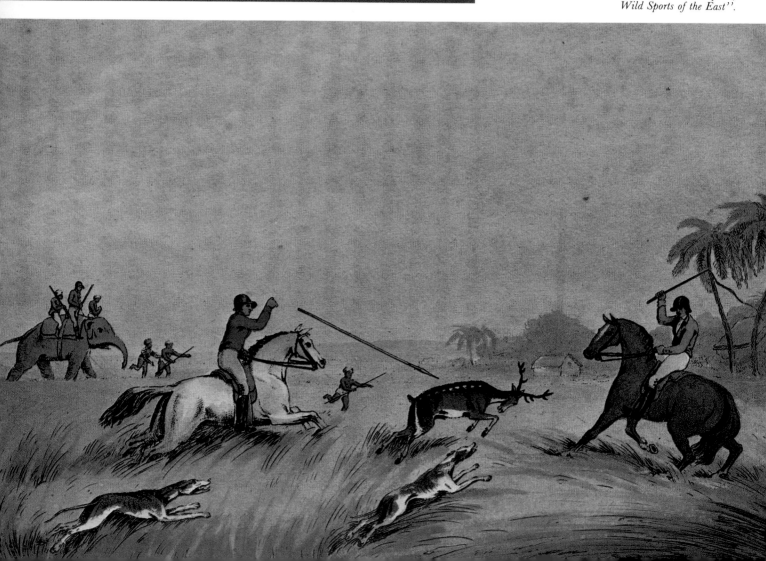

"Hinchingbrooke, Huntingdon"

Belle Vue Pottery. Belle Vue Views Series. Plate 7ins:18cm.

Hinchingbrooke House, the seat of the Earls of Sandwich, is an Elizabethan mansion dating mainly from the 16th century, but built around the walls of an early 13th century nunnery. It was originally the residence of the Cromwell family, from whom it was purchased by Sir Sidney Montagu in 1627. There was a great fire in 1830 and the house is now part of a school.

"Hindoo Ghaut"

John Hall & Sons. "Oriental Scenery" Series. Plate 5½ ins:14cm.

"Hindoo Ghaut on the Ganges"

Maker unknown. "Oriental Scenery" Series.

Ghaut is an Indian name to describe a riverside landing place, often with a stairway. With such a general title it is not possible to locate the scene.

"Hindoo Pagoda"

John Hall & Sons. "Oriental Scenery" Series. Various dishes and sauce tureen stand.

It is possible that this is the same scene as "Pagoda Below Patna Azimabad" which was used by the unknown maker of the other "Oriental Scenery" Series.

"Hindoo Temple"

John Hall & Sons. "Oriental Scenery" Series. Soup tureen stand.

"Hindoo Village"

John Hall & Sons. "Oriental Scenery" Series. Sauce tureen.

"Hindoo Village on the Ganges"

Maker unknown. "Oriental Scenery" Series.

This is possibly the same view that was used by John Hall & Sons. With such a general title it is not possible to locate the scene.

The Hog at Bay

Spode. Indian Sporting Series. Soup tureen, vegetable dish and jug. Ill: Whiter 94; S.B. Williams 27-29.

This is one of the designs from the series which is not titled on the wares.

Hog-hunting, or pig-sticking as the sport was more familiarly called, was practised all over India. In Bengal, the paradise of pig stickers, the spear, a bamboo of some eight or nine feet in length, weighted with lead at the butt, was carried by the rider close to his knee, the point being depressed and driven into the pig as he came up to it.

"The Hog Deer at Bay"

Spode. Indian Sporting Series. Plate 7¼ ins:18cm (Colour Plates XII and XIII). Ill: S.B. Williams 8-9.

Hog deer were hunted with dogs and horsemen with spears. "One very ugly trick the animal has," writes Williamson, "is that of suddenly stopping short, letting the horseman pass, and then making an impetuous rush at the horse's hindquarters". Hence the second huntsman following close behind.

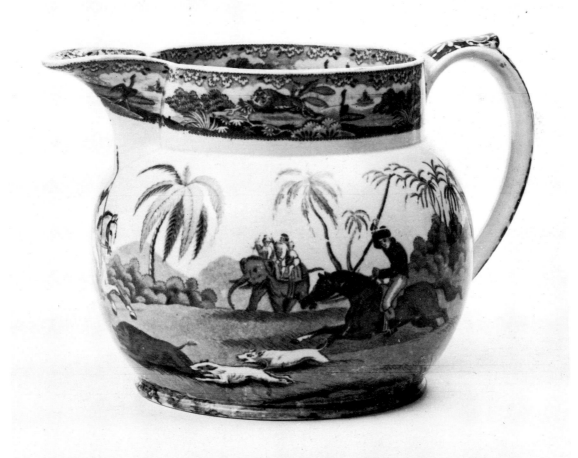

The Hog at Bay. *Spode. Indian Sporting Series. Untitled. Printed maker's mark. Jug 5½ ins:14cm.*

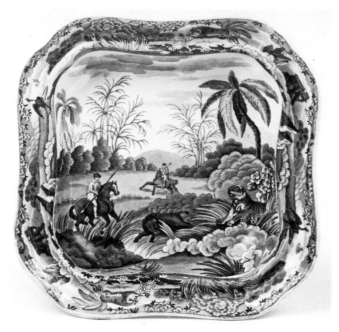

"Hog Hunters Meeting by Surprise a Tigress & Her Cubs." *Spode. Indian Sporting Series. Printed title and printed and impressed maker's marks. Vegetable dish 9¼ ins:23cm.*

"Hog Hunters Meeting by Surprise a Tigress & Her Cubs"

Spode. Indian Sporting Series. Vegetable dish. Ill: S.B. Williams 30-32.

The words "& Her Cubs" are sometimes omitted from the printed title.

The scene shows the officers of a detachment of troops marching from Berhampore to Cawnpore hunting a hog. They come across a tigress and her cubs behind a wild plum bush and their horses stampede in terror.

"Holkham Hall"

Maker unknown. Passion Flower Border Series. Dish and deep dish, both approximately 10ins:25cm.

Holkham Hall is two miles west of Wells in Norfolk. It is a fine Palladian mansion, built between 1734 and 1759. Lord Burlington, Lord Leicester and William Kent were all involved in planning the house which was inherited by Coke of Norfolk in 1775.

Holland & Green fl.1853-1882

Stafford Street Works, Longton, Staffordshire. This firm usually used their full name in printed marks but the initials H. & G. have been recorded.

Hollins, Thomas & John fl.c.1795-1818

Shelton, Hanley, Staffordshire. These brothers started potting in the 18th century and early productions were of Wedgwood-type, including creamwares and jasper. They made blue-printed wares in the 19th century. The impressed mark "T. & J. HOLLINS" has been recorded.

Hollins, Thomas, John & Richard fl.1818-c.1822

Shelton, Hanley, Staffordshire. Thomas and John were joined by their younger brother Richard in about 1818 and the mark "T.J. & R. HOLLINS" was impressed. They continued to produce general earthenwares. Godden states that the date of this partnership is open to slight doubt and Little quotes evidence of their existence as late as 1829.

"Holliwell Cottage"

Ralph Stevenson. Stevenson's Acorn and Oak Leaf Border Series. Soup tureen and plate 10ins:25cm.
See: "Hollywell Cottage, Cavan".

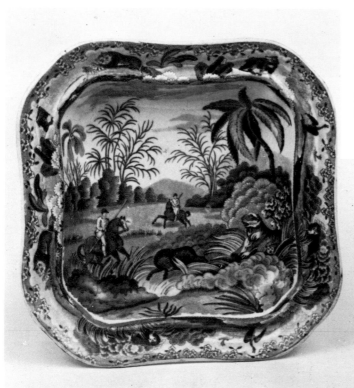

"Hog Hunters Meeting by Surprise a Tigress & Her Cubs." *James & Ralph Clews. Indian Sporting Series. Untitled. Impressed crown above "CLEWS/WARRANTED/STAFFORDSHIRE". Vegetable dish and cover 9¼ ins:23cm.*

Hollow Ware
A term used in the pottery trade for mugs, jugs and other wares designed by capacity.
See: Potters Count; Sizes.

"Holly"
Robert Cochran & Co.

"Hollywell Cottage, Cavan"
(i) John & Richard Riley. Large Scroll Border Series. Plate 10ins:25cm, and handled entree dish. Ill: P. Williams p.292.

(ii) Enoch Wood & Sons. Grapevine Border Series. Oval tureen and water jug.

Two other views are "Holliwell Cottage" (qv) and "Holywell Cottage" (qv). A further view has been noted on a small untitled jug.

Holywell is in a small Irish village known as Belcoo on the border between the counties Cavan and Fermanagh, about nine miles south west of Enniskillen. "The Cottage" is a long low shooting lodge built of bargeboards in about 1830. It was later extended to include a central yard

"Hollywood Cottage"
Henshall & Co. Fruit and Flower Border Series. Dish 20ins:51cm.

"Holme Pierrepont, Nottinghamshire"
Maker unknown. Foliage Border Series. Plates 5¾ins:15cm and 4½ins:11cm.

This is a large irregular building five miles south east of Nottingham in a small wooded park. It has a striking crenellated parapet.

"The Holme, Regent's Park"
(i) William Adams. Regent's Park Series. Plate 6ins:15cm.

(ii) Enoch Wood & Sons. "London Views" Series. Soup plate 10ins:25cm and plate 9ins:23cm.

This villa, next to the lake in Regent's Park, was the residence of the architect James Burton. It had an Ionic tetrastyle portico to the front but its most striking feature was undoubtedly the rotunda on the garden frontage, very impressive when viewed across the lake.

Holy Trinity Episcopal Church, Edinburgh
James Jamieson & Co. "Modern Athens" Series.

As with other items from the series this view is not titled. This was the Church of the Holy Trinity which survived until 1848 but was then demolished to make room for Waverley Station, the terminus of the North British Railway.

"Holyrood House, Edinburgh"
Enoch Wood & Sons. Grapevine Border Series. Plate 10ins:25cm.

The Palace of Holyrood House lies at the foot of Canongate in Edinburgh. It was largely reconstructed by Charles II and is now the official residence of Her Majesty the Queen when in Scotland.

"Holywell Cottage"
Maker unknown. Passion Flower Border Series. Round soup tureen with added gilding to knop and handles.
See: "Hollywell Cottage, Cavan".

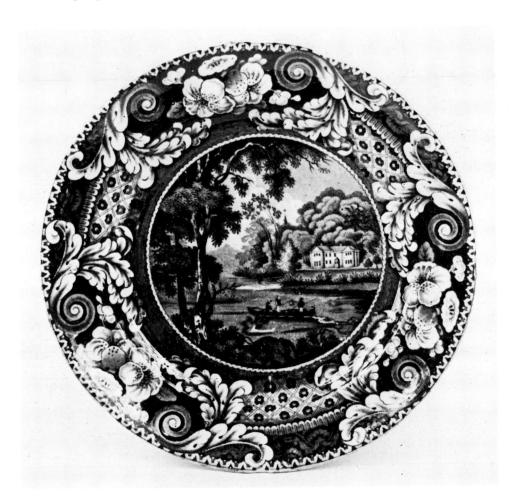

"Hollywell Cottage, Cavan."
John & Richard Riley. Large Scroll Border Series. Printed title mark with maker's name and impressed "RILEY". Plate 10ins:25cm.

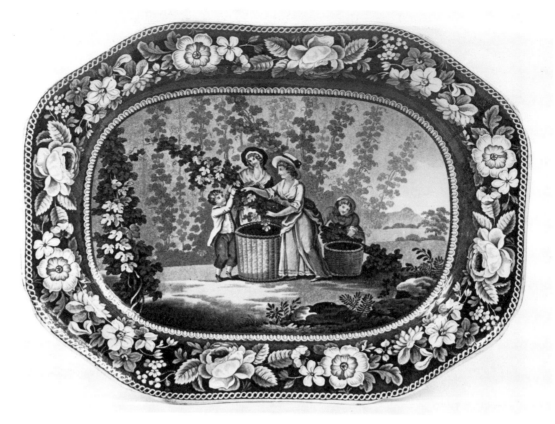

"**Hop Pickers.**" *Maker unknown. Printed title on hop sack cartouche. Dish 17ins:43cm.*

"Honi Soit Qui Mal y Pense"

Dishonoured be he who thinks ill of it. A motto which belongs to the Order of the Garter, and which forms part of the royal coat-of-arms.

See "Royal Sketches"; Royal Coat-of-Arms.

"Hop"

Davenport. A pattern of hop vines noted on mugs. The printed cartouche consists of a single hop leaf bearing the title.

"Hop Pickers"

Maker unknown. A pattern found on dinner wares showing three women and a child picking hops into two large baskets. Some examples include a cottage in the right background. The floral border includes roses and other flowers and the printed title cartouche is in the form of a hop sack. Ill: Little 91.

Hopkin & Vernon fl.c.1836

Burslem, Staffordshire. This appears to have been a very short lived partnership and was probably related to Peter Hopkin of Market Place, Burslem, and James Vernon & Co. of High Street, Burslem. An unusual impressed mark "HOPKIN & VERNON/BURSLEM" has been noted on a blue-printed plate with a romantic scene, and printed marks with the initials H. & V. have been reported.

Horse

Although not as numerous as cattle, horses appear in many of the rural and country scenes. A horse and a colt were featured on a dish (11ins:28cm) in the "Quadrupeds" Series by John Hall. A pony was used on attractive teawares by William Smith & Co. of Stockton.

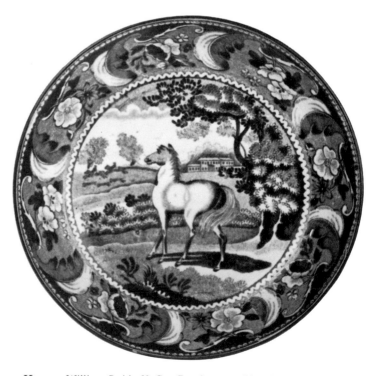

Horse. *William Smith & Co. Rural scene with a horse or pony. Impressed mark "W.S. & Co's/WEDGWOOD/WARE". Saucer 5½ ins:14cm.*

"The Horse and the Loaded Ass." *Copeland & Garrett. "Aesop's Fables" Series. Printed titles mark and impressed maker's mark. Dish 14ins:36cm.*

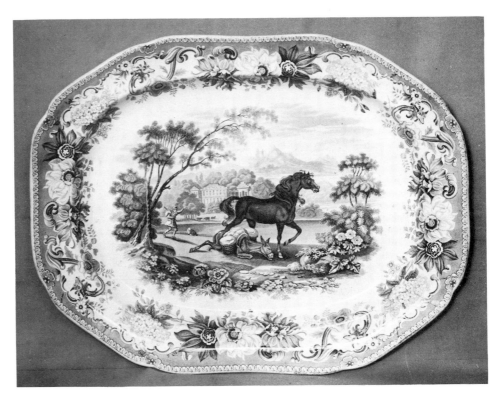

Hospitality. *Maker unknown. Unmarked. Dish 17ins:43cm.*

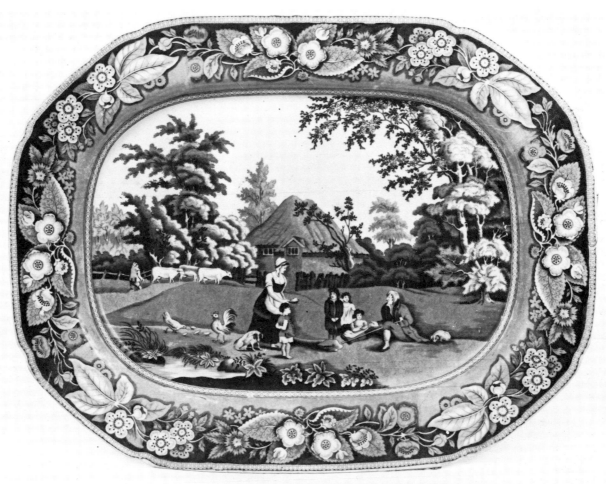

Hudson. *Maker unknown. View of the fountain at Trinity College within the border from the "British Views" Series. Printed mark "HUDSON" in an arcaded frame. Plate 9¾ ins: 25cm.*

"Humphrey's Clock." *William Ridgway, Son & Co. Printed title mark with maker's initials. Plate 7¼ ins: 18cm.*

"The Horse and the Loaded Ass"
Spode/Copeland & Garrett. "Aesop's Fables" Series. Dish 14ins:36cm.

A horse and an ass carrying a heavy burden were driven along by a countryman. The tired ass asked the horse to take some of his load but he refused. The ass fell down and died, whereupon the countryman took the whole burden and laid it upon the horse. The horse, by refusing to do a small kindness, justly brought upon himself a great inconvenience.

Behold how great a matter a little fire kindleth.

See illustration previous page.

"The Hospital near Poissy, France"
Ralph Hall. "Select Views" Series. Plate 6½ ins:16cm.

Poissy is seventeen miles north west of Paris. It stands on the banks of the River Seine and at the edge of the forest of St. Germain.

Hospitality
Maker unknown. A title adopted here for a rural scene in which a farmer's wife is offering food to a lame traveller while her children look on. The pattern is printed on dinner wares with a border of flowers and leaves. See illustration previous page.

Hot Water Plate
A hot water plate consists of a standard dinner plate fitted with a lower chamber to be filled with hot water. They are usually completely of pot and made in one piece, but some examples have the lower chamber made in pewter and fitted to a normal dinner plate. Blue-printed examples are fairly common. They are almost invariably printed with the same design as dinner plates. Sometimes fitted with a pair of handles, several different arrangements of spouts and drain holes can be found.

Houghton Conquest House, Bedfordshire
The "Diorama" Series by an unknown maker included a pattern titled "View of Houghton Conquest House, Bedfordshire". The house, which no longer exists, was two and a half miles north of Ampthill.

Hudden, John Thomas **fl.1859-1885**
Stafford Street, Longton, Staffordshire. This potter operated the British Anchor Works after 1874. Printed marks include either the initials J.T.H. or the full name "J.T. HUDDEN".

Hudson
This name is known on dinner wares decorated with the border from the "British Views" Series and a special centre showing the fountain at Trinity College, Cambridge. Beneath the central pattern is the inscription "HUDSON TRINITY COLLEGE" and a cartouche mark on the reverse repeats the name "HUDSON". These pieces are almost certainly part of a dinner service made for use within the college, and the name Hudson could relate to the College Bursar or catering contractor. Similar services are known to have been made for other colleges; examples have been recorded for King's College, Cambridge and Magdalen College, Oxford. A later Copeland plate has been reported with the inscription "H.P. HUDSON — TRINITY COLLEGE".

Hull
This city in Yorkshire, more correctly called Kingston-upon-Hull, was the home of the Belle Vue Pottery (qv) which had close links both with other Yorkshire works and with Staffordshire through Job & George Ridgway.

Hulme, John & Sons **fl.c.1828-1830**
Waterloo Works, Lane End, Staffordshire. A short lived firm which used printed marks with the name "HULME & SONS".

"Humphrey's Clock"

A generic title used for a series of patterns by William Ridgway, Son & Co. The title is usually printed within a clock cartouche which includes the initials W.R.S. & Co., but it is known printed with no embellishment (see Godden M 3309). The cartouche mark was repeated at the end of the 19th century on a toy dinner service, but the early examples, which include full-size dinner wares, bourdaloues, feeding bottles and pap boats, bear a distinctive border of scrolls and diamond shaped motifs. A feeding bottle is illustrated in Coysh 2 75, and a serving bowl in P. Williams p.501. Some of the patterns were also printed in green.

The title derives from *Master Humphrey's Clock* which Charles Dickens had intended to use for a series of stories and sketches. This initial idea, however, was abandoned and the title was used for instalments of *The Old Curiosity Shop* and *Barnaby Rudge* (1840-41). The Ridgway patterns seem to be from the former, showing scenes which include Little Nell.

"Humulus"

William & Samuel Edge. A romantic Italianate scene showing a man and a woman in the foreground with a heap of vegetation, presumably hops.

Humulus is the botanical name for the hop plant whose flowers yield a fragrant attar when distilled. The seed capsules, when dried, were often used to stuff pillows, encouraging sleep. George III is said to have used a hop pillow.

Hunter. *Hunter Shooting Fox. Enoch Wood & Sons. Sporting Series. Impressed maker's eagle mark. Plate 8½ ins:22cm.*

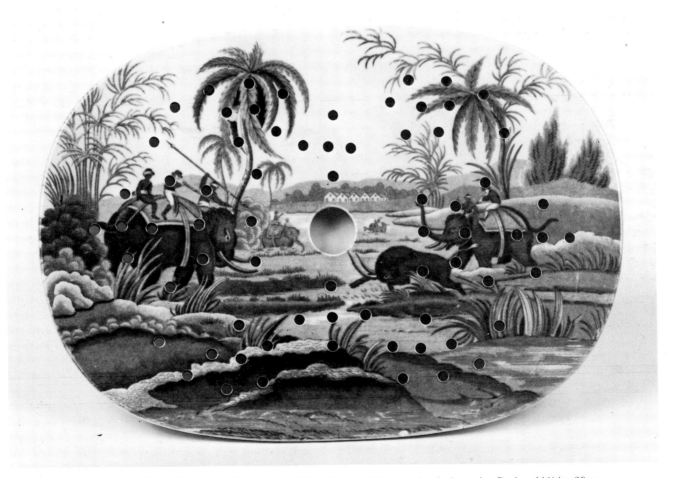

"Hunting a Buffalo." *Spode. Indian Sporting Series. Printed and impressed maker's marks. Drainer 11½ ins:29cm.*

Hundred Antiques
A name given by S.B. Williams to a Spode chinoiserie design. It is now known as Trophies-Nankin. Ill: Coysh 1 15; Whiter 28; S.B. Williams 122.

Hunt, A. fl.c.1822-c.1840
A blue-printed floral pattern has been noted with a complicated leafy cartouche mark containing the name "A. HUNT, PURVEYOR" together with addresses which on rearrangement seem to read Gt. Ryder Street, St. James', and Buckingham Palace Terrace, Pimlico.

Abraham Hunt was a London retailer who began operation in Chelsea in or before 1822 and then moved to 17 Gt. Ryder Street and 4 Church Passage, near Piccadilly. By 1834 a further address at 29 Queen's Row, Pimlico had been added, but in the following year the Church Passage address disappears, and the firm continued at Gt. Ryder Street and Queen's Row until at least 1840.

"Hunt nr. Windsor"
Maker unknown.
See: Sporting Mug.

Hunter
Hunting designs appear on several blue-printed patterns. Enoch Wood & Sons produced a Sporting Series (qv) which included at least two patterns with hunters, one described as Hunter Shooting Ducks (Ill: Coysh 1 140) and another Hunter Shooting Fox. A sporting series was also made by the Herculaneum Pottery titled "Field Sports" (qv). Several other unidentified scenes are known.
See: Coursing Scene.

"Hunting a Buffalo"
Spode. Indian Sporting Series. Soup tureen cover, soup tureen stand, drainer 11½ ins:29cm, and cover for hot water vegetable dish. Ill: Coysh 1 98; Whiter 94; S.B. Williams 25-26.

The full title of the source print in Williamson's *Oriental Field Sports, Wild Sports of the East* was "Hunting an Old Buffalo".

The water buffalo is a domestic draught animal but in the wild it is dangerous because of its bulk and enormous horns. When hunted the pursuit is usually organised, as in the case of a tiger drive, with a line of elephants. When pressed the buffalo makes for a swamp as shown in the print.

"Hunting a Civet Cat"
Spode. Indian Sporting Series. Dish 10¼ ins:26cm. Ill: S.B. Williams 21-22.

The full title of the source print in Williamson's *Oriental Field Sports, Wild Sports of the East* was "Hunting a Kuttauss or Civet Cat".

The civet cat *(Viverra zibetha)* is sought after for its perfume. The animals have a scent gland near the sexual organs from which the perfume is obtained. When made very dilute it has a pleasant and attractive fragrance.

"Hunting a Hog Deer"
Spode. Indian Sporting Series. Diamond shaped dish 11¼ ins:29cm.
See: "The Hog Deer at Bay".

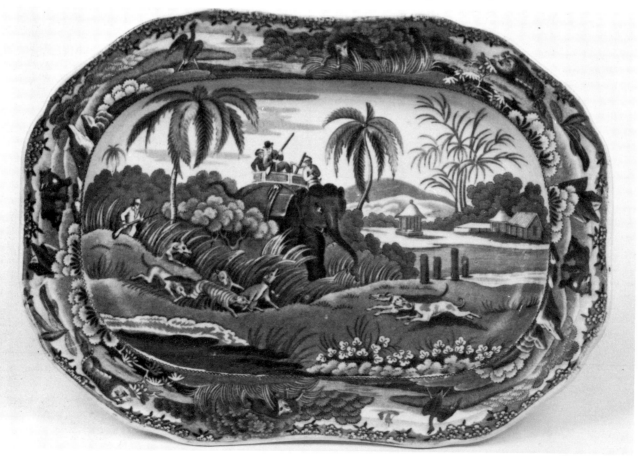

"Hunting a Civet Cat." *Spode. Indian Sporting Series. Printed title and printed and impressed maker's marks. Dish 10¼ ins:26cm.*

"Hunting a Hog Deer."
Spode. Indian Sporting Series.
Printed title and printed and
impressed maker's marks. Fitted
diamond-shaped dish
11 ¼ ins:29cm.

Hyena
The hyena was featured on patterns in two series. John Hall used the animal on small plates in his "Quadrupeds" Series (Ill: P. Williams p.661), and Enoch Wood & Sons issued one pattern on a sauce tureen stand with a hyena in their Sporting Series (qv).

"Hylands, Essex"
Maker unknown. Crown Acorn and Oak Leaf Border Series. Dish 15ins:38cm.

This house was built for Sir John Comyns in about 1728. William Atkinson added a giant four-column Ionic portico between 1819 and 1825.

"Hylands, Essex." *Maker unknown. Crown Acorn and Oak Leaf Border Series. Printed title mark. Dish 15ins:38cm.*

"Ich Dien"

A motto meaning I serve, traditionally used by the Prince of Wales.

See: Prince of Wales' Feathers.

"Illustrations of the Bible" Series

A series printed in light blue by Thomas Mayer. Examples are marked with an ornate printed cartouche of scrolls and leaves bearing the series title at the top, the name of the individual scene in the centre, and "T. MAYER" and "LONGPORT" at the base. The following subjects have been recorded:

"Flight into Egypt"
"Foot of Mount Sinai"
"Fords of the Jordan"
"Nazareth"
"Tomb of Absalom, Village of Siloan, the Brook Kedron"

The series was also printed in green and pink. Many books with biblical illustrations were published in the early 19th century, including Finden's *Landscape Illustrations of the Bible* (1830).

Impatient Child

Maker unknown. A name which has been used for an unusual pattern in which a child is tugging at his mother's hand while she is talking to a seated man. The scene appears within a grotto-style border with a simple edge of stringing and includes several very prominent flowers and an indistinct castle in the distance. Ill: FOB 3.

"Imperial"

David Methven & Sons.

"Imperial Filigree"

Reed, Taylor & Co. A pattern which is marked with the initials R.T. & Co.

Impressed Mark

A mark stamped in the soft clay body of wares before firing. It often takes the form of the maker's name, although many such marks give only the name of the body. Impressed numerals usually refer to the size of the article (See: Sizes) and other small impressed marks are probably potter's marks used for calculating piece rates for workmen's pay. Wares by Minton and Wedgwood, after 1842 and 1860 respectively, often have impressed date marks.

See: Date Marks.

"Improved Granite China"

A body used by Ridgway, Morley, Wear & Co. and also by their successors Ridgway & Morley.

"Improved Saxon Blue"

See: "Saxon Blue".

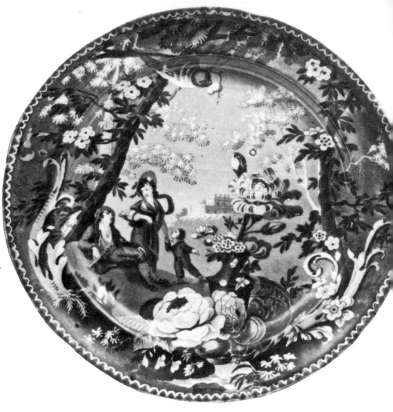

Impatient Child. *Maker unknown. Unmarked. Plate 9¾ ins:25cm.*

"Improved Stone China"

The name for a ceramic body used by Charles Meigh & Son, Minton, Pountney & Allies and probably several other potters.

An impressed mark with these words contained within an eight-sided pseudo-Chinese seal has long puzzled collectors of blue-printed wares. Godden (M 2618) attributes the mark to Charles Meigh and states that other wording can be found such as "Indian Stone China" or "French China". However, it has not been possible to trace a piece with this maker's mark. The mark has been recorded on *marked* Minton pieces and other known Minton wares, including the Minton Miniature Series.

"Improved Wild Rose"

A printed mark sometimes found on wares decorated with the "Wild Rose" pattern (qv).

"In a Full Breeze"

This title is given by Little (p.107) to a pattern in the Shell Border Series by Enoch Wood & Sons. It is not included in listings by Arman or Laidacker.

"In Tenui Labor"

Effort even in trivial things. A motto found on a ribbon below a small vignette of cherubs in a border design used with the pattern called the Precarious Chinaman (qv).

Indeo Pottery fl.1775-1841

Bovey Tracey, Devon. Marked pieces are rare. Godden illustrates a creamware plate from the collection of Dr. Bernard Watney, transfer-printed in a dark blue with a chinoiserie pattern showing five people around a table, one standing with a parasol (Godden I 322). It bears the impressed mark "Indeo".

"Independent Order of Oddfellows"

This title appears on the face of a dinner plate made by Joseph Twigg (Ill: Coysh 2 118). Beneath the inscription are two female figures, one holding a pair of scales, the other holding a mirror which reflects light on to a cartouche with a lion. Below the cartouche is the motto "Amicitia, Amor et Veritas". There is a narrow border of fruits within an edge of stringing. This plate was no doubt specially commissioned. Oddfellows lodges spread rapidly all over the world after the Manchester Unity Independent Order of Oddfellows was founded in 1810. The same basic design has also been noted on a mug by an unknown maker, titled beneath the rim "Grand United Order of Oddfellows" (qv).

Another Oddfellows plate has been noted, made for one of the lodges at Bollington in Derbyshire. It was decorated with a different central design and used the border from the standard Willow pattern.

India

A Spode pattern showing a flowering tree with exotic butterflies against a white ground. The floral border is divided into panels, each bearing one of four floral designs which are repeated twice. Ill: Coysh 1 113; Whiter 24; S.B. Williams 114-117.

Plates with this design can be found with parts of the pattern clobbered with red enamel. Some examples are known with the Wheal Sparnon Mine Inscription (qv).

India Series

The Herculaneum Pottery at Liverpool produced several dinner service designs based on prints from Thomas and William Daniell's *Oriental Scenery*. In addition to the three designs which have been recorded with the impressed "HERCULANEUM" mark, two unmarked patterns would appear to be from the same pottery. All five designs are composite views based on several of the original prints published between 1795 and 1808 by Robert Bowyer at the Historic Gallery, Pall Mall. The background in each case is based on the "View in the Fort of Tritchinopoly" (*Oriental Scenery*, Part II, 21). Each pattern has one main feature with some features taken from other prints. The five main features are:

The Chalees Satoon in the Fort of Allahabad on the River Jumna (Part I, 6). Unmarked

Gate of a Mosque built by Hafiz Ramut, Pillibeat (Part III, 10). Herculaneum

Mausoleum of Nawaub Assoph Khan, Rajemahel (Part III, 24).* Herculaneum

Mausoleum of Sultan Purveiz, near Allahabad (Part I, 22).* Unmarked

View in the Fort, Madura (Part II, 14).* Herculaneum

Details of the other subsidiary prints used for each pattern may be found under the individual entries. Each design has a different border.

"India Temple"

John & William Ridgway. This pattern was printed on stone china dinner services with gadrooned edges and shows a Chinese river or harbour scene with several junks and a large temple. The printed shield-shaped cartouche mark includes the title, the words "STONE CHINA", and the initials J.W.R. Ill: Coysh 1 71; Godden M 3264 (mark only); Godden BP 313.

This pattern has also been noted with the same printed mark, and in exactly the same style, but with an additional impressed mark: "ASHWORTH'S REAL IRONSTONE CHINA". The pattern may well have been passed on through several changes of partnership. In this case the chain would

seem to run from John & William Ridgway (1814-30), via William Ridgway to either Ridgway, Morley, Wear & Co. (1836-42) or Ridgway & Morley (1842-44), then to Francis Morley & Co. (1845-58) and their successors Morley & Ashworth (1859-62), and finally to G.L. Ashworth & Bros. (1862 *et seq.*).

"Indian Flowers"

Brameld. An open floral design in pale blue on plates with the impressed mark "BRAMELD" and the printed title "Indian Flowers" within a floral cartouche.

Indian Scenery Series

This title has been adopted here for a series of views of India which appears to have been introduced by Thomas & Benjamin Godwin and later copied by Cork, Edge & Malkin and their successors Edge, Malkin & Co. The later firms may have purchased the copper plates from the Godwins or one of their subsequent companies. The views are printed within a border which consists of two pairs of vignettes with Indian-style scenes separated by a pattern of fluting on which are superimposed bunches of grapes. The printed mark is in the form of a cartouche of scrolls and flowers, within which are the title and the maker's initials, either T. & B.G. or C.E. & M. Wares with the impressed mark "EDGE, MALKIN & Co." are known on which the initials appear to have been clipped from the mark.

Only four views have so far been recorded:
"Delhi, Hindoostan"*
"Surseya Ghaut, Khanpore"*
"Tomb of Shere Shah"*
"Tombs near Etaya on the Jumna River"*

Indian Scenery Series. *Thomas & Benjamin Godwin. Typical printed mark below one of the holes in a drainer.*

Indian Sporting Series

These Spode designs form one of the most collectable series of blue-printed patterns. They were based on coloured engravings from drawings by Samuel Howitt in Capt. Thomas Williamson's *Oriental Field Sports, Wild Sports of the East* published by Edward Orme in 1807. The original edition contained forty plates with letter press to each and was dedicated to His Majesty King George the Third. The patterns used by Spode usually have the printed title marked in capital letters together with the impressed mark "SPODE". The

actual titles marked on the wares, with the titles of the original prints in brackets where they differ, are as follows:

"Battle Between a Buffalo and a Tiger"*
"Chase after a Wolf"
"Common Wolf Trap"
"Death of the Bear"*
"Dooreahs Leading out Dogs" (Dooreahs or Dog Keepers Leading out Dogs)
"Driving a Bear out of Sugar Canes"*
"Groom Leading Out" (Syces or Grooms Leading out Horses) (Colour Plates VIII and IX)
"The Hog Deer at Bay" (Colour Plates XII and XIII)
"Hog Hunters Meeting by Surprise a Tigress & Her Cubs"* (the words "& Her Cubs" are sometimes omitted)
"Hunting a Buffalo"* (Hunting an Old Buffalo)
"Hunting a Civet Cat"* (Hunting a Kuttauss or Civet Cat)
"Hunting a Hog Deer"*
"Shooting at the Edge of a Jungle"*
"Shooting a Leopard in a Tree"* (the words "in a Tree" are often omitted)

In addition to the above, some patterns were issued without titles. Those recorded to date are based on the prints:

The Dead Hog*
Decoy Elephants Leaving the Male Fastened to a Tree*
The Hog at Bay*

The series border and some of the patterns used on smaller items are composite scenes based on more than one engraving. An example is the sauce tureen stand on which a hare has been taken from "Shooting at the Edge of a Jungle", the hounds are from "Hunting a Civet Cat", and the buildings are from "Groom Leading Out".

The popularity of the series can be judged by the fact that it was copied almost in its entirety by two other potters. James & Ralph Clews exported their copies to America and, as far as can be ascertained, they used identical patterns on each item. A vegetable dish is illustrated (See: "Hog Hunters Meeting by Surprise a Tigress & Her Cubs") and other items are shown in Atterbury p.204. Edward Challinor who also copied the series used the title "Oriental Sports".

An unidentified potter used the same engravings to produce dinner wares with a border of scrolls looping around petal motifs. A dish with a composite pattern based on the two prints

Indian Sporting Series. *Spode. Typical printed title with printed and impressed maker's marks.*

"Chasing a Tiger across a River" and "A Tiger Hunted by Wild Dogs" is illustrated in S.B. Williams 36-38.

"Indian Temple"
Elkin, Knight & Bridgwood. A large washbowl in the Castle Museum at Norwich bears this title together with the initials E.K.B.

"Indiana"
Wedgwood & Co. A pattern mentioned in Chaffer's *Marks and Monograms.*

Initial Marks
During the 1820s it became the common practice for potters to use a printed mark with a pattern title on blue-printed wares and many added the initials of the firm. Most makers can be traced from their initials by reference to the Index of Maker's Initals at the end of this dictionary, though a few firms used the same initials. C. & R., for example, may refer to Chesworth & Robinson or to Chetham & Robinson. A few are still the subject of speculation; the initials C.R. & S., for example, have been noted on wares impressed Turner or Davenport. They may relate to an as yet untraced retailer.

Inkwell. *Maker unknown. Rural scene with flowers. Unmarked. Unglazed base. Diam. 3¼ ins:8cm.*

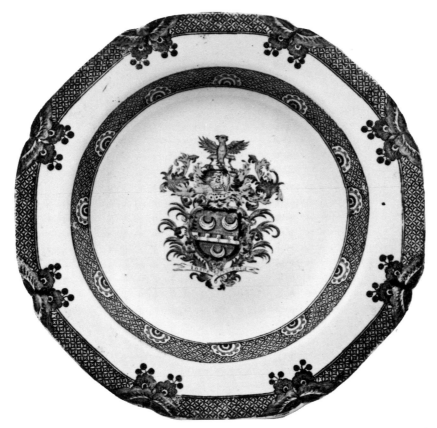

"**Inspe Crescentis.**" *Arms of the Glover family of Norfolk. Copeland & Garrett. Printed and impressed maker's marks. Soup plate 8½ ins:22cm.*

Inkwell

Blue-printed inkwells are not common. The example illustrated is made in one piece with a large central hole for the ink and four separate smaller holes for quill pens. The base is unglazed. A variety of different forms are known.

"Inspe Crescentis"

In the hope of increasing. A motto which can be found on blue-printed wares together with the arms of the Glover family of Norfolk. The example shown is marked Copeland & Garrett although earlier marked Spode specimens are known. Copeland (p.108) illustrates a tureen which is also marked Copeland & Garrett but states that wares were first made late in the Spode period with a large replacement order produced after 1833. The border is taken from the Buffalo pattern, a fact that suggests that the Spode wares may have been made somewhat earlier than thought. The later examples bear all the hallmarks of being deliberate attempts to emulate wares originally made in the early 1800s.

Institution

A pattern used on toy dinner services by one of the Hackwood potters, probably William Hackwood. The title is one used in catalogues of blue-printed wares and has been adopted here for convenience. Petra Williams (p.552) refers to this pattern as Monastery Hill.

"Interlachen" (sic)

Copeland & Garrett. Byron Views Series. Soup plate 10ins:25cm. Ill: FOB 15.

Interlaken is a resort in Switzerland which commands magnificent views of the Jungfrau and neighbouring mountains. It lies between Lakes Thun and Brienz.

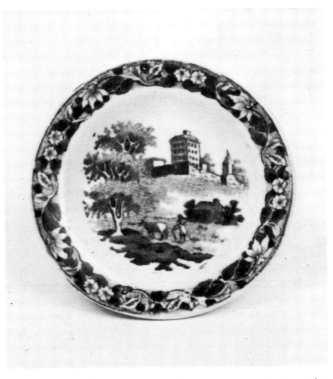

Institution. *Hackwood. Impressed maker's mark. Miniature plate 2¾ ins:7cm.*

189

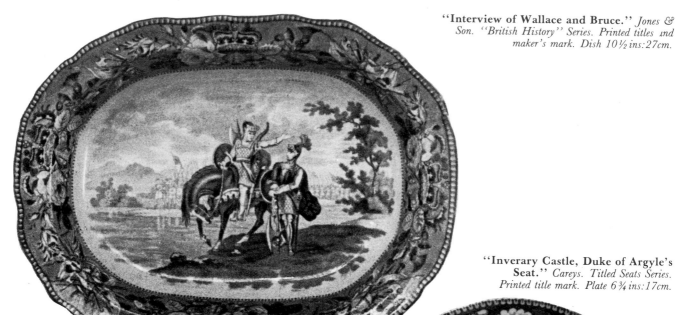

"Inverary Castle, Duke of Argyle's Seat." Careys. Titled Seats Series. Printed title mark. Plate 6¾ ins: 17cm.

"Interview of Wallace and Bruce"

Jones & Son. "British History" Series. Dish 10½ ins: 27cm.

Early in Robert Bruce's career he had sworn fealty to the English throne of Edward I who had overrun lowland Scotland. Later he became a loyal supporter of Sir William Wallace, the Scottish patriot, and he eventually claimed and re-established the Scottish throne.

"Inverary Castle, Duke of Argyle's Seat" (sic)

Careys. Titled Seats Series. Plate 6¾ ins: 17cm.

This castle lies half a mile north west of the Scottish town of Inveraray. It was originally built in the 15th century as the stronghold of the first Earl of Argyle, head of Clan Campbell. The new castle seen in this view was built between 1745 and 1777 by Archibald, the third Duke, who together with his brother helped to effect the union with England.

The view on the plate is based on a print in Jones' *Views of the Seats, Mansions, Castles, etc. of Noblemen and Gentlemen in Scotland.* See J. Macaulay, *The Gothic Revival 1745-1845* (1975), Chapter 4.

"Inverness"

John Meir & Son. "Northern Scenery" Series.

Inverness, capital of the county of the same name, stands astride the River Ness just above its entry to the Moray Firth. It is regarded as the capital of the Highlands.

"Iona"

J. & M.P. Bell & Co. A design registered in 1850.

Iona is a small island, part of the Inner Hebrides, and is also the name of a village on the island. It has had links with both Ireland and Norway and has been home to either a monastery or a cathedral since the year 563. The present cathedral was restored and reopened in 1905.

"Irish Scenery" Series. Elkins & Co. Printed series mark. Despite the title, only English and Welsh views have been recorded.

"Irish Scenery" Series

A series of views by Elkins & Co. Despite the title all of the scenes so far identified are in England or Wales. The series includes the following identified views:

Fonthill Abbey, Wiltshire
Stackpole Court, Pembrokeshire*
Warwick Castle*

An unidentified view is illustrated in Little 25.

Examples from the series have also been noted with a Carey's mark without the title "Irish Scenery".

"Irish Views" Series

An uncommon series printed in light blue by Careys. Examples bear an ornate printed mark with the view title in a shield surmounted by a bird above a panel marked "FELSPAR", beneath which is a ribbon marked "IRISH VIEWS" and "CAREY'S". Only two scenes have been recorded:

"Carrickfergus Castle & Town"*
"The Lower Lake of Killarney"*

Ironstone China

A hard, heavy earthenware, often slightly grey in colour, said to contain powdered slag from iron-smelting furnaces. The body was patented by Charles James Mason in 1813, who also introduced the name 'Patent Ironstone China', but it was soon copied by other potters. The most common alternative names were ironstone or stone china, the latter being used by several notable factories including Spode and Davenport. The full Mason's name was retained by their successors, Francis Morley (1845-58), Morley & Ashworth (1859-62), and G.L. Ashworth & Bros. (1862 *et seq.*).

"Isola"

Don Pottery and Joseph Twigg, Newhill Pottery. Named Italian Views Series.

Isola was one of the places north of Rome which were often visited by young men on the Grand Tour. Its full name is Isola del Liri.

See: "Cascade at Isola".

"Isola Bella"

William Adams & Sons. A design printed in light blue on ironstone wares. The title is printed in a mark which includes the figure of Britannia, a ship and a lion. Examples bear the impressed mark "Adams".

Isola Bella is on Lake Maggiore.

Italian

Spode's Italian pattern was introduced in about 1816 and has been produced continuously since that date with particularly large quantities made by Copeland. It appears to have been based on an ink and wash drawing attributed to the Dutch artist Frederick de Moucheron (1638-86). A seated figure and lambs on the right, together with flowers in the foreground, have been added by the Spode engraver. See illustrations overleaf. Examples are known with the Wheal Sparnon Mine Inscription (qv) and some pieces have been noted on which the border has been clobbered with red enamelling. Ill: Coysh 1 103; Godden BP 311; Godden I 536; Whiter 66 and Colour Plate III; S.B. Williams 94.

As may be expected with a popular design, the Italian pattern was copied by several other potters. Examples have been recorded with the marks of Zachariah Boyle (Ill: Little 13), Edward Challinor, John Mare (Ill: Godden I 373 on a footbath), Pountney & Allies and Pountney & Goldney of Bristol, and Wood & Challinor. The central pattern was also copied with slight differences by Joseph Stubbs, but within a floral border similar to the "Wild Rose" pattern.

"Irish Views" Series. *Carey's. Typical printed mark.*

"Italian Buildings"

Ralph Hall. A series of romantic views of various idealised Italian buildings with a common foreground showing two women beneath a giant urn. The pattern has been recorded on various size plates and a pierced basket stand. It was also printed in pink. Ill: Laidacker p.51; Little 28; P. Williams p.301.

Italian Church

A relatively uncommon Spode pattern found on teawares, often with a wavy edge and sometimes with added edge gilding. The view shows a large domed church which has not yet been identified. Ill: Coysh 1 108; Whiter 63; S.B. Williams 95.

"Italian Flower Garden"

John & William Ridgway. A romantic pattern with a rococo border of flowers and C-scrolls. It is printed on dinner wares with a moulded rim and with a J.W.R. initial mark. Ill: P. Williams p.302.

Italian Fountain

This title has been given to one of the patterns in the series by the Don Pottery listed under Landscape Series. It shows an impressive Italian building with a fountain in the foreground and a man with a bow talking to a woman with a stringed instrument. Ill: Coysh 2 30. See also illustration on page 193.

It is interesting to note that an almost identical pattern with the same figures was made by the Herculaneum Pottery. Two examples are illustrated in Little 107, one of which is dated 1809. This tends to suggest that the patterns show real places, probably based on contemporary prints.

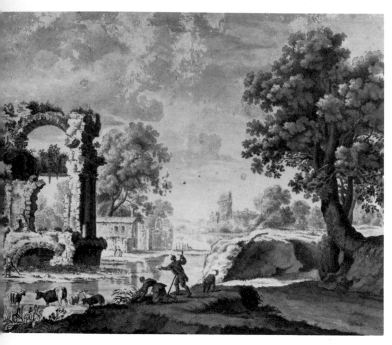

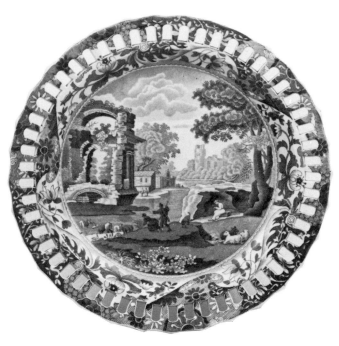

Italian. *An ink and wash drawing, attributed to Frederick de Moucheron (1638-86), which is believed to be the origin of the Spode Italian pattern.*

Italian. *Spode. Printed and impressed maker's marks. Pierced plate 9¾ ins: 25cm.*

Italian. *Joseph Stubbs. Impressed maker's mark. Note the different border and the variations in pattern when compared with the Spode version.*

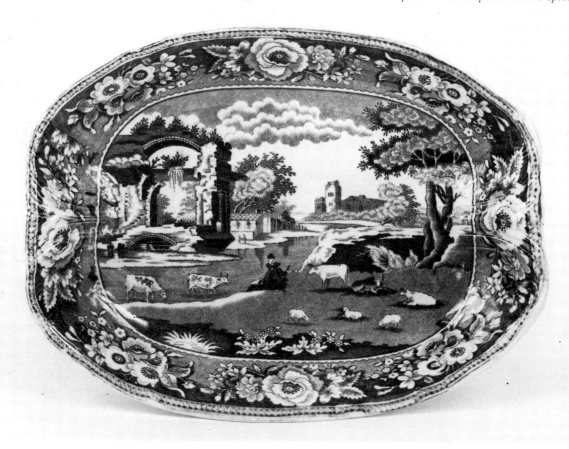

*Italian Fountain. Don Pottery.
Landscape Series. Impressed
maker's mark. Drainer
11 ¼ ins: 29cm.*

"Italian Garden"
Copeland & Garrett. Seasons Series.

This title has been noted on two different items from the series. The vegetable dish bears the month "August" on the prominent vase in the foreground of the scene, whereas the dinner plate bears the month "June".

"Italian Lakes"
J. & M.P. Bell & Co. This title covers several slightly different patterns, one of which is illustrated. The lake scene appears to be the same in each design but the figures, the dogs and the boats on the lake differ. Examples are marked with a printed title cartouche with the initials J. & M.P.B. & Co., and impressed maker's marks with either a bell or the word "IMPERIAL" are known. Ill: P. Williams p.303.

Italian Ruins
Maker unknown. This title is used for a view showing an Italianate castle standing above a river and a prominent three-arch bridge (Ill: Coysh 1 149). It is very similar in style to the Scene after Claude Lorraine (qv) which was produced by both the Leeds Pottery and John & Richard Riley. It has been suggested that it shows the same scene, but looking across the bridge from the other side. See illustration overleaf. The central pattern is contained within a border of trailing hops and barley ears, and examples seem to be invariably marked with the words "Semi-China" in two lines within a pseudo-Chinese eight-sided frame (Ill: Little, mark 105). The pattern is found on dinner wares.

"Italian Scenery"
(i) John Meir and John Meir & Son. A series of Italian views printed in light blue within a floral border which includes small landscapes in medallions. The series title appears in a flower and scroll cartouche. Seventeen different views have been recorded to date. Some examples bear the initials I.M. & S. but many are unmarked and some are known with an impressed crown. Ill: P. Williams p.305 (two examples).

(ii) Enoch Wood & Sons. Another series of Italian views

"Italian Lakes." J. & M.P. Bell & Co. Printed title cartouche with maker's initials. Impressed mark J.B. within a bell. Plate 10½ ins: 27cm.

printed in dark blue. See: "Italian Scenery" Series.

(iii) Maker unknown. A pattern illustrated by Little (98) which shows a road winding uphill towards a large building has been noted in both blue and sepia with a cartouche bearing the words "Italian Scenery". The example illustrated by Little is impressed "LEEDS POTTERY". This "Italian Scenery" pattern may be a pirated design by another maker.

See illustrations overleaf.

Italian Ruins. *Maker unknown. Printed octagonal seal with "Semi-China". Stand length 9ins:23cm, tureen height 5 ¼ ins:13cm.*

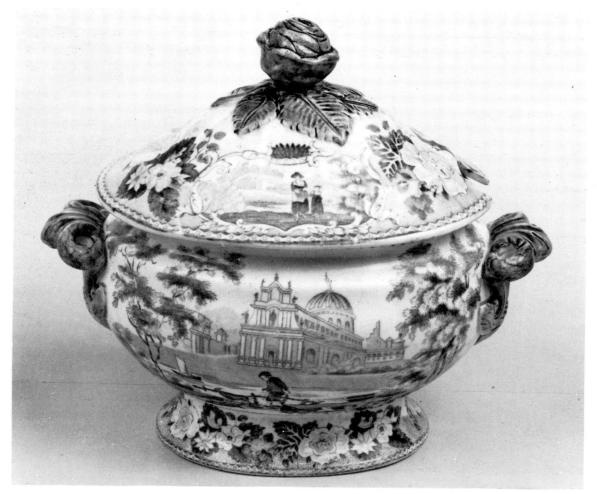

"Italian Scenery." *Attributed to John Meir & Son. Printed floral and scroll title cartouche. Sauce tureen length 7 ½ ins:19cm.*

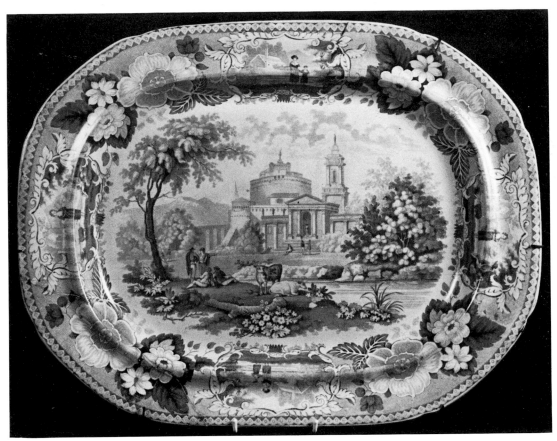

"Italian Scenery." *John Meir. Printed floral and scroll title cartouche. Impressed "J. MEIR, WARRANTED STAFFORDSHIRE" beneath a crown. Dish 21ins:53cm.*

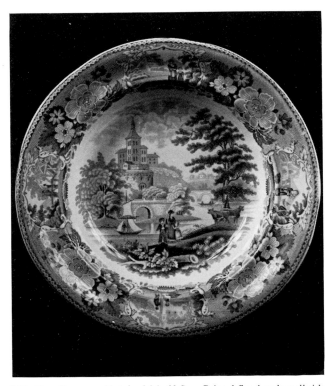

"Italian Scenery." *John Meir & Son. Printed floral and scroll title cartouche with maker's initials I.M.S. Soup plate 10ins:25cm.*

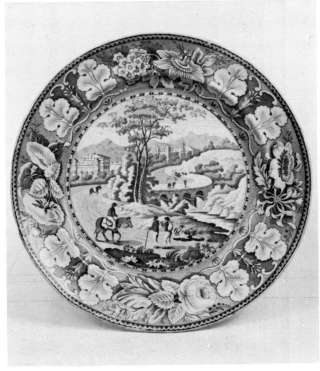

"Italian Scenery." *Maker unknown. Printed title scroll. Plate 10ins:25cm.*

"Italian Scenery" Series. *Enoch Wood & Sons. Typical printed mark.*

"Italian Scenery Series"

A series by Enoch Wood & Sons printed in dark blue with a grotto-style border of foliage which includes prominent conifer trees. As with most of the very dark blue wares, examples are not common in Britain and the set was almost certainly produced mainly for export, particularly to America. The views are titled in an ornate printed mark and the following have been recorded:

"The Arch of Janus"
"Bridge of Lucano"
"Castle of Lavenza"*
"Castle of Nepi, Italy"
"Castle of St. Angelo, Rome"
"Chateau de Chillon"
"Coliseum"
"Fisherman's Island, Lago Maggiori"
"Florence"

"Genoa"
"La Riccia"
"Lake of Albano"
"Lake Avernus
"Naples from Capo di Chino"
"Ponte del Palazzo"
"Ponte Rotto"
"St. Peter's, Rome"
"Sarento" (sic)
"Temple of Venus, Rome"
"Terni"
"Tivoli"
"Turin"
"Vesuvius"
"View near Florence"
"Villa Borghese, near Florence"
"Villa on the Coast of Posilepo"

"Italian Villas"

Joseph Heath & Co. A series of flowery romantic patterns printed in light blue on wares with a wavy edge. The title cartouche includes the initials J.H. & Co. The design was also printed in pink and purple. Ill: P. Williams p.306.

"Ivanhoe"

Joseph Twigg & Bros. Examples of this pattern have been noted with the impressed mark "TWIGG".

Sir Walter Scott's novel *Ivanhoe* was first published in 1820.

"Ivy Bridge" (sic)

James & Ralph Clews. "Select Scenery" Series. Cup plate.

This view presumably shows Ivybridge in the valley of the Erme in South Devon. It lies on the southern edge of Dartmoor about ten miles north east of Plymouth.

"Ivy Wreath"

J. & M.P. Bell & Co. A small dish (10ins:25cm) in the Glasgow Museum is marked with this title which presumably refers to the border design. The rest of the dish is plain except for a printed belt or garter in the centre which encloses the words "City Saw Mills/Glasgow/1870".

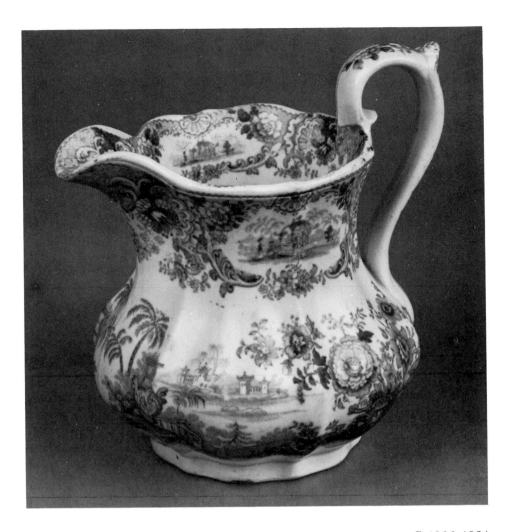

"**Japan Flowers.**" *Ridgway, Morley, Wear & Co. Printed mark with shield and anchor, title, and maker's initials. Jug 5¼ ins:13cm.*

Jackson, J. & Co. **fl.1870-1887**

Holmes Pottery, Rotherham, Yorkshire. Printed title marks include the initials J.J. & Co. or simply J. & Co.

Jackson, Job & John **fl.1831-1835**

Church Yard Works, Burslem, Staffordshire. This firm produced printed wares typical of the period with open flowery borders. They used many different colours including light blue, pink, black, purple and sepia. They marked their wares with the full name "JACKSON", either impressed or printed, sometimes with the addition of the initials. The output appears to have been largely exported to America, including a lengthy series of American views, although a few rural and romantic scenes found their way onto the home market.

Jackson & Patterson **fl.c.1826-1840**

Sheriff Hill Pottery, Gateshead, Northumberland. This firm appears to have specialised in printed tea wares. They used their initials J. & P. in the printed marks, often with a pattern title.

"Jacob and the Angel"

Enoch Wood & Sons. Scriptural Series. Plate.

"And the angel of God spake unto me in a dream, saying, Jacob: And I said, Here am I. And he said, Lift up now thine eyes, and see, all the rams which leap upon the cattle are ringstraked, speckled, and grisled: for I have seen all that Labour doeth unto thee." Genesis 31, 11-12.

Jamieson, James & Co. **fl.1836-1854**

Bo'ness (Borrowstounness) Pottery on the Firth of Forth, Scotland. This firm produced an interesting series of views of Edinburgh under the title "Modern Athens" (qv). A romantic design with a floral border and the title "Bosphorus" was also made in quantity. The usual mark was "J. JAMIESON & Co/BO'NESS" impressed.

"Japan"

(i) J. & M.P. Bell & Co. A pattern mainly of flowers but with an arch of beaded scrolls containing a scene with river and pagoda. Ill: P. Williams p.130.

(ii) Thomas Furnival & Co. A pattern in flown-blue, marked with the initials T.F. & Co.

This title has also been used for a Spode pattern of typical Japan style, with a central panel of flowers and birds surrounded by four others. It has a simple narrow band for a border. Ill: Whiter 26.

"Japan Beauty"

Read & Clementson. This pattern is marked with a shield-shaped cartouche with the title, the initials R. & C., and the words "STONE WARE" (See: Godden M 3212a).

"Japan Flowers"

A generic title which embraces several different floral patterns by John & William Ridgway; Ridgway, Morley, Wear & Co.; or Ridgway & Morley.

The typical design consists mainly of flowers with a

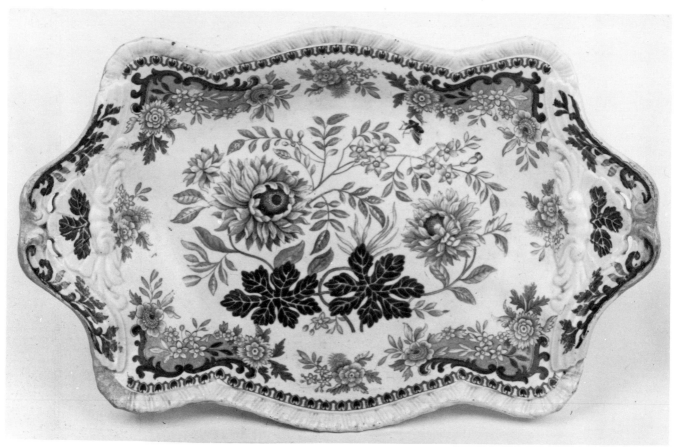

Jasmine. Spode. Printed and impressed maker's marks. Gadrooned dish 12½ ins:32cm.

prominent vase in the foreground, all within a border of flowers with scenic reserves. The printed cartouche mark shows a ship within a shield superimposed on an anchor. The title and relevant makers' initials appear on a ribbon below (See: Godden M 3274). Ill: P. Williams p.131.

"Japanese"
Samuel Alcock & Co. A pot with flowers within a border of flowering thorn. The printed mark gives the title together with the word "STONEWARE" and the maker's initials S.A. & Co. Ill: P. Williams p.638.

The border was also used for a commemorative pattern depicting William III on horseback, illustrated in Coysh 1 18; Godden I 13.

Jasmine
A Spode design of flowers within a floral scroll border. It was made on gadrooned dinner wares and has also been called the Chrysanthemum pattern. Ill: Whiter 50; S.B. Williams 155.

The border has also been recorded on a stand with a beehive replacing the central floral design. This may have been a stand for a honey pot. Ill: Coysh 1 122; S.B. Williams 156.

"Java"
(i) Charles Meigh, Son & Pankhurst, and their successors Charles Meigh & Son.
(ii) Maker unknown. A flown-blue floral pattern.
Java is an island in the Malay Archipelago, formerly belonging to the Netherlands. It is now known as Djawa and is part of Indonesia. Originally the seat of powerful Hindu princes, it was colonised by the Portuguese in the 16th century and then taken over by the Dutch. The area is highly volcanic.

"Jedburgh Abbey"
(i) Elkin, Knight & Co. Rock Cartouche Series. Dish 14¾ ins:37cm, and deep oval dish 11ins:28cm.
(ii) Joseph Stubbs. A pattern on a dark blue cup and saucer. The title may also include the county name "Roxburghshire". Ill: Laidacker p.118.
(iii) Maker unknown. "Antique Scenery" Series. Plate 6½ ins:16cm.

"Jedburgh Abbey, Roxburghshire"
William Adams. Bluebell Border Series. Dishes 14ins:36cm and 17ins:43cm, and a bowl 11ins:28cm.

Jedburgh Abbey, at Jedburgh, some fifty-six miles from Edinburgh, is one of the finest ruins in Scotland. It suffered during the English invasions, especially in the reign of Henry VIII. The remains include a Norman church with a decorated transept.

"Jeddo"
(i) J. & M.P. Bell & Co.
(ii) William Adams & Sons.
Jeddo or Jedo was the old name for Tokyo in Japan which was first opened to foreigners in 1869.

Johnson, Joseph fl.1789-c.1820
An engraver or printer who was working in Liverpool in the 1790s and continued into the 19th century. His name appears on several early printed Liverpool wares but it is not clear whether he was an engraver or only a printer. See: Smith, pp.34-38.

Jones & Son fl.c.1826-c.1828

Hanley, Staffordshire. No details are available of this partnership which existed for a very short time. It did, however, produce a fine series of blue-printed patterns on a dinner service entitled "British History". The very high quality of these wares suggests considerable expertise in all aspects of production.

Jones, Elijah

Godden gives the addresses of four potters with this name in Staffordshire:

Elijah Jones, Hall Lane, Hanley	1828-1831
Elijah Jones, Phoenix Works, Shelton	1831-1832
Elijah Jones, Villa Pottery, Cobridge	1831-1839
Elijah Jones, Mill Street, Shelton	1847-1848

Blue-printed wares can be found with the initials E.J. or with the single name Jones. It is generally felt that these belong to Elijah Jones of the Villa Pottery, Cobridge, mainly because this was notably the larger firm, becoming Jones & Walley and eventually Edward Walley.

Jumping Boy

An alternative name for the Spode pattern usually referred to as Lanje Lijsen (qv) or Long Eliza. Ill: Coysh 1 111; Whiter 23, 101; S.B. Williams 108-113.

"**Jedburgh Abbey.**" *Elkin, Knight & Co. Rock Cartouche Series. Printed title mark. This item may be incorrectly titled. Deep oval dish 11ins:28cm.*

"**Jedburgh Abbey.**" *Elkin, Knight & Co. Rock Cartouche Series. Printed title mark and impressed eagle mark. Dish 14¾ins:37cm.*

Kaolin
A name for china clay. It results from decomposition by weathering of the felspar in granite rock. It is a very white clay, generally used for porcelain, but also added to some bodies in earthenware production. In England, it is found in Devon and Cornwall.

"Kaolin Ware"
A body used by Thomas Dimmock & Co. The name can be found as part of printed cartouche marks.

Keeling, Charles fl.1822-1825
Broad Street, Shelton, Staffordshire. This firm used the initials C.K. added to printed title marks.

Keeling, James fl.c.1790-1832
New Street, Hanley, Staffordshire. James Keeling is reported to have been a pioneer of blue-printing. According to Little (p.76) he was involved in various developments including decoration and glazing of pottery, and also production improvements to the kilns and firing processes. Shards of the Long Bridge Pattern (qv) have been found during excavations at this site. See: Hugh Stretton, *The Earthenwares of James Keeling, New Street, Hanley,* Bulletin of the Morley College Ceramic Circle (1978).

In common with John Hall he is said to have used views from Buckingham's *Travels in Mesopotamia* (1828).

Keeling, Samuel & Co fl.1840-1850
Market Street, Hanley, Staffordshire. Printed marks include either the name in full or the initials S.K. & Co.

"Kenelworth Priory" (sic)
Minton. Minton Miniature Series. Plate and soup plate, both 3¾ins:9cm.

Kenilworth was an Augustinian priory founded by Geoffrey de Clinton and destroyed by Henry VIII. This pattern actually depicts the ruined gateway.

"Kenilworth"
Ralph Stevenson. "Lace Border" Series. Plate 10ins:25cm.

Kenilworth lies some four miles north of Warwick. It is particularly noted for its castle.

"Kenilworth Castle, Warwickshire"
(i) Enoch Wood & Sons. Grapevine Border Series. Plate 5½ins:14cm.
(ii) Maker unknown. Flower Medallion Border Series. Plate 10ins:25cm.

Kenilworth Castle was originally built by Geoffrey de Clinton. It was later granted to Simon de Montfort whose son held out within its walls after the battle of Evesham (1265), but a siege of six months ended in its surrender. The oldest part of the castle is the Norman keep or Caesar's Tower. John of Gaunt built the Strong Tower (known as Mervyn's Tower in Sir Walter Scott's *Kenilworth*), the banqueting hall and the White Hall. It was conferred on Robert Dudley, Earl of Leicester, by Elizabeth I in 1562, and he made further additions.

"Kenmount, Dumfriesshire"
Enoch Wood & Sons. Grapevine Border Series. Dish 16½ins:42cm, vegetable dish, pierced basket and stand.

"Kenmount House"
Ralph Stevenson. Stevenson's Acorn and Oak Leaf Border Series. Dish.

According to Laidacker, this is one of the items known with American portrait medallions in the border but no such item is listed by Arman.

Kenmount (or Kinmount) House in Dumfriesshire is about three and a half miles west of Annan, just south of the main A75.

Kennedy, James fl.c.1818-1834
An independent engraver of Commercial Street, Burslem, Staffordshire. He worked as a freelance for several potteries and his signature has been noted on blue-printed wares.

"Kenelworth Priory." *Minton Miniature Series. Printed title mark. Miniature plate 3¾ins:9cm.*

"Kent"
David Methven & Sons.

"The Kent, East Indiaman"
Enoch Wood & Sons. Shell Border Series. Plate 9¼ins:23cm. Ill: Arman S 143.

As with most items in the series, this pattern shows a marine scene, this time with two ships in stormy seas. The *Kent* first sailed in February 1825.

"Kidbrook, Sussex"
Andrew Stevenson. Rose Border Series. Dish 10ins:25cm, sauce tureen stand and vegetable dish.

This early 18th century house was rebuilt by Robert Mylne in 1805 and further changes were made by George Dance the Younger in 1814-15.

Kidston, R.A., & Co. fl.1838-1846
Verreville Pottery, Glasgow, Scotland. Wares from this pottery are known with the initials R.A.K. & Co. as part of printed marks. A large water jug is illustrated in Godden BP 326. The firm produced an interesting series of named views in Ireland and Scotland under the title "United Kingdom" (qv).

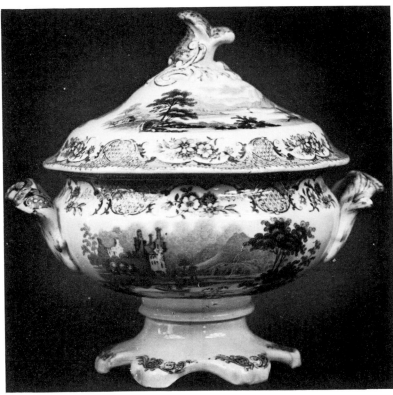

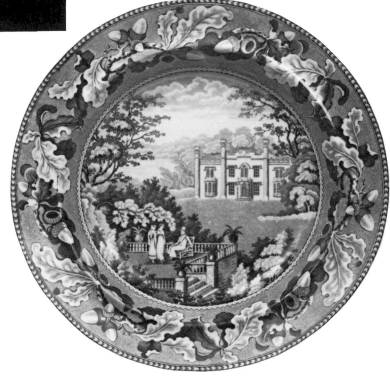

"Kilchurn Castle, Loch Awe"

John Meir & Son. "Northern Scenery" Series. Soup plate 10ins:25cm, and sauce tureen.

The castle stands on a small islet in the mouth of the Orchy and is connected to land at low tide. It dates from 1440 with later additions and was a MacGregor stronghold. It was given up as a residence in 1740 and in 1745 was garrisoned with royal troops.

"Kilcolman Castle"

James & Ralph Clews. "Select Scenery" Series. Soup plate 10ins:25cm.

This castle, three miles north east of Buttevant in County Cork, was granted to Edmund Spenser in 1587 and it was here that he wrote the *Faerie Queene*. In 1598 the rebellion of Tyrone broke out and the castle was burned with the loss of Spenser's youngest child. The original Irish spelling is Cill Colmáin. Only ruins now remain.

"Killin, Head of Loch Tay"

James & Ralph Clews. "Select Scenery" Series. Dish 9ins:23cm.

Killin is a village in Perthshire to the south west of Aberfeldy. It is situated at the meeting of the rivers Dochart and Lochay, near the head of Loch Tay.

"Kimberley Hall"

Henshall & Co. Fruit and Flower Border Series. Dishes 18ins:46cm and 16½ins:42cm.

Kimberley Hall in Norfolk was built in 1712 by William Talman. The view on these dishes shows the building before the 1850s when four corner towers were added by Thomas Prowse.

"Kincardine Castle, Perthshire"

Maker unknown. Crown Acorn and Oak Leaf Border Series. Soup plate 9¾ins:25cm.

There were numerous houses, castles and palaces named Kincardine in Scotland since the name means merely 'at the head of the rowan wood'. The old castle at this site, dismantled by the Marquis of Argyll in 1645, is in ruins. The present castle, which was built in 1806, is thought to be the work of the architect Gillespie Graham. See: James Macaulay. *The Gothic Revival, 1745-1845* (1975).

King's College Chapel, Cambridge. *C.J. Mason & Co. Untitled view. Printed maker's mark with "MASON'S PATENT IRONSTONE CHINA" and added name "JAMES LAWRANCE" below. Plate 9¾ ins:25cm.*

"The King's Cottage, Windsor Park." *John & Richard Riley. Large Scroll Border Series. Printed title mark with maker's name. Plate 6¾ ins:17cm.*

"Kingsweston, Gloucestershire." *John & Richard Riley. Large Scroll Border Series. Printed title mark with maker's name. Plate 8¾ ins:22cm.*

202

"**Kirkstall Abbey, Yorkshire.**" *Maker unknown. "Antique Scenery" Series. Printed titles mark. Dish 17¼ ins: 44cm.*

"King's College, Cambridge"
John & William Ridgway. Oxford and Cambridge College Series.

King's College was founded in 1441. The chapel was completed by 1551 but after that expansion was in stages. In 1723 James Gibb followed with what has come to be known as Gibb's Building. An elegant bridge was built across the river in 1819 and further additions were made by William Wilkins the Younger between 1824 and 1828.

King's College Chapel, Cambridge
Mason's Patent Ironstone China. An untitled view of the chapel was produced by Masons using the border from the Blue Pheasants pattern.

The design was printed only on dinner services for use in the college refectories. Most items have the printed name "JAMES LAWRANCE" in addition to the potter's mark. Two generations of the Lawrance family were catering contractors for the college, and since they were responsible for supplying the crockery, the purchase does not appear in the college records. It seems that the ware was used over a lengthy period; items can be found with the early impressed mark (generally thought to predate 1825), with the later printed mark with an angular crown (probably about 1835), and with the mark of Mason's successors Ashworths (after 1862). The Ashworths wares have only "LAWRANCE", with no christian name.

See: Lawrance, James.

"The King's Cottage, Windsor Park"
John & Richard Riley. Large Scroll Border Series. Plate 6¾ ins: 17cm.

This view probably shows the original Royal Lodge built by Nash for the Prince Regent shortly before he became George IV. It was rebuilt as Adelaide Lodge in 1831.

See: "Royal Cottage".

"King's Warehouse, Dundee"
James King is recorded as a china merchant at 9 Overgate, Dundee, in directories for 1824 and 1829. The above name has been noted on a soup plate decorated with a view of "Surseya Ghaut, Khanpore".

The Kingfisher
A title introduced by Coysh for a pattern on a dish (15ins:38cm) in Andrew Stevenson's Ornithological Series (qv). The title was adopted since the Kingfisher is the most easily identified bird in the design. Ill: Coysh 2 108. The bird was also used on other items from the series with different groups of birds.

"Kingston on Thames"
Goodwins & Harris. "Metropolitan Scenery" Series. Soup tureen stand.

Kingston-upon-Thames is the county town of Surrey, twelve miles south west of London. Some of the Saxon kings were crowned in Kingston and the coronation stone is preserved in the market place.

"Kingsweston, Gloucestershire"
John & Richard Riley. Large Scroll Border Series. Plate 8¾ ins: 22cm.

King's Weston, near Bristol, was designed by Sir John Vanbrugh and was completed in 1725. The Riley view shows the mansion surrounded by trees, with cows, sheep and a woman and child in the foreground.

"Kin-Shan"
A flown-blue pattern recorded with the printed initials E.C. & C., which probably relate to Edward Challinor & Co.

"Kirkham Abbey"
Maker unknown. Beaded Frame Mark Series.

This is an alternative name for Kirkham Priory in Yorkshire.

"Kirkham Priory Gateway, Yorkshire"
Maker unknown. Pineapple Border Series.

This title has been recorded on a plate with the view "Dalberton Tower, Wales". Note the addition of the word "Gateway" to the other view in the same series titled "Kirkham Priory, Yorkshire". The gatehouse is a fine example of the decorated style, with a great deal of interesting sculpture and moulding.

"Kirkham Priory, Yorkshire"
Maker unknown. Pineapple Border Series. Plate 9½ ins:24cm, and oval dish with handles. Ill: Little 103.

This Augustinian priory was founded by the Lord of Helmsley in about 1125. The chancel and chapter house were rebuilt on a much greater scale in about 1230, and there was much further rebuilding in the late 13th and 14th centuries.

"Kirkstall Abbey"
Maker unknown. "Antique Scenery" Series. Plate and soup plate, both 10ins:25cm.

This view has also been noted, printed in reverse, on a dish in the Wedgwood Blue Rose Border Series.

"Kirkstall Abbey, Yorkshire"
Maker unknown. "Antique Scenery" Series. Dish 17¼ins:44cm. Note that this is not the same view as "Kirkstall Abbey" in the same series.

The abbey lies on the River Aire, near Leeds, and is a 12th century building in the Norman transitional style. It was a Cistercian foundation, branching from Fountains Abbey.

Kite Flying
Maker unknown. An interesting design, sometimes referred to as the Gravestone pattern, which is found only on miniature dinner services. It shows a boy trundling a hoop, another flying a kite, and a man standing by a gravestone. There is a large church in the background on the right and a mansion on the left. The pattern is partly based on a tail-piece wood engraving by Thomas Bewick in his *History of British Birds* (1797 and 1804), which provided the man, the tombstone, and the boy with the hoop. The design has for some time been considered by American collectors to depict Benjamin Franklin flying his kite but this appears to be a somewhat doubtful attribution. It is interesting to note that Bewick had a close association with St. Anthony's Pottery at Newcastle. This firm is said to have transfer-printed on pottery from wood engravings. Ill: FOB 6.

Kite Flying. *Tail-piece wood engraving from Thomas Bewick's "History of British Birds".*

"Klostenburg, Germany"
Ralph Hall. "Picturesque Scenery" Series. Soup plates 8½ins:22cm and 9¾ins:25cm.

This view may depict Klosterneuburg, a town in Austria on the Danube, not far from Vienna, which has a magnificent monastery.

"Knaresborough Castle, Yorkshire"
Maker unknown. Pineapple Border Series. Plate 10ins:25cm.

This castle stands on a rocky pinnacle at Knaresborough, on the River Nidd, just to the north east of Harrogate. It dates from the early 14th century but is now in ruins, having been dismantled in 1648.

Knife Rests
A pair of knife rests for the carving knife and fork was included in many dinner services. They are small rectangular blocks, usually triangular in cross-section, with a central depression and were made in many materials, including glass and silver, and in various designs. Blue-printed pottery examples are usually decorated with a part of the border used for the rest of the dinner service.

Knight, Elkin Partnerships
There were at least two partnerships at the Foley Potteries, Fenton, Staffordshire, which traded under the names Knight and Elkin. They were Knight, Elkin & Bridgwood and Knight, Elkin & Co. and the two main partners were presumably the J.K. Knight and G. Elkin who registered a design titled "Baronial Halls" in 1844.

There was also a firm called Knight, Elkin & Knight at King Street, Fenton, between about 1841 and 1844. They used printed marks with their initials K.E. & K. but are believed also to have traded as Knight, Elkin & Co.

See: Elkin, Knight & Bridgwood.

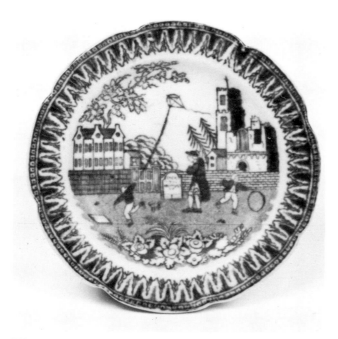

Kite Flying. *Maker unknown. Unmarked. Miniature plate 3½ ins:9cm.*

Knight, John King fl.1846-1853

The Foley Potteries, Fenton, Staffordshire. Marks are known with the name "I.K. KNIGHT" followed by the word "FOLEY".

"Knight of the Wood Conquered"

James & Ralph Clews. Don Quixote Series. Dish 16½ins:42cm. Ill: Arman 80.

The title marked on the wares may have the prefix "The".

"Knighthood Conferred on Don Quixote"

James & Ralph Clews. Don Quixote Series. Plate 10ins:25cm. Ill: Arman 66.

The title printed on the wares may have the abbreviation "confer'd".

"Knole, Kent"

Ralph Hall. "Select Views" Series.

Knole is one of the largest private houses in England and was built by Thomas Bourchier, Archbishop of Canterbury, between 1456 and 1486. It was greatly enlarged between 1603 and 1608 by Thomas Sackville to whom it was granted by Elizabeth I. It has a long west front with Jacobean gables and a central gatehouse with four battlemented corner turrets. The house lies on the southern edge of Sevenoaks and is now owned by the National Trust. It is open to the public except during the winter.

Knottingley Pottery

See: Ferrybridge Pottery.

"Korea"

(i) John Maddock.

(ii) John Meir & Son. This title was used for a series of romantic scenes, some of which include a fashionable large vase in the foreground. The border is composed of flowers and floral baskets. The patterns are known on toilet wares.

Korea, or Corea according to an early 19th century description, was occupied by people who were "civil and courteous, fond of learning, music and dancing and greatly resemble the Chinese in customs and religion".

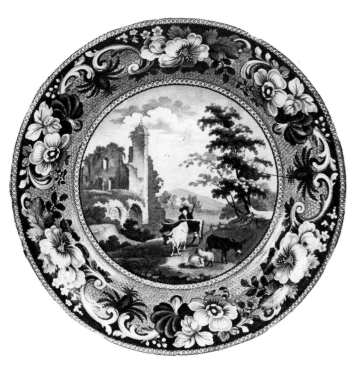

"Knaresborough Castle, Yorkshire." *Maker unknown. Pineapple Border Series. Printed title mark. Plate 10ins:25cm.*

"Kyber"

John Meir & Son. A flown-blue pattern.

The narrow Kyber Pass is flanked by mountains which rise above it to 3,000ft. It came into the news during the Afghan War between 1839 and 1842.

Knife Rests. *Pair of knife rests from a dinner service, decorated with a border design of wild roses. Unmarked. Length 3ins:8cm.*

205

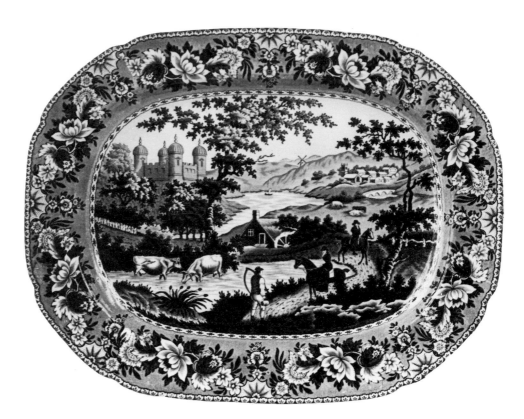

The Ladies of Llangollen.
Dillwyn & Co. Impressed maker's mark. Dish 16ins:41cm.

"La Grange, the Residence of the Marquis Lafayette"

Enoch Wood & Sons. French Series. Deep dish 11½ ins:29cm, plate 10ins:25cm, and soup plate 9½ins:24cm. Ill: Arman 197.

This series included two further views of the building, a "N.W. View" and a "S.W. View".

La Grange was a feudal château of stone near Paris. It is flanked by five round towers and originally was entered by a drawbridge over a deep moat. It stood in an estate of ancient woodlands, ponds and gardens, with avenues of apple and chestnut trees.

La Pique

See: Shipping Series.

"La Riccia"

Enoch Wood & Sons. "Italian Scenery" Series. Plate 6½ins:16cm.

Riccia lies about forty-four miles to the north east of Naples in central Italy.

"Labor Omnia Vincit"

Perseverance overcomes all difficulties.
See: "Hannibal Passing the Alps".

"Lace Border"

(i) Minton. A floral pattern printed in light blue. The title cartouche includes the cursive initial M. One example noted was marked with the impressed octagonal seal containing the words "Improved Stone China" (qv).

(ii) Ralph Stevenson. A series title for views in England, India and America.

"Lace Border" Series

A light blue series of views by Ralph Stevenson. It includes scenes in England, India and America, but is not commonly found in Britain. Items are also known in black, pink, purple and sepia. The English views are:
"Eaton Hall"
"Kenilworth"
"Virginia Water"
"Windsor Castle"

The only Indian view recorded is titled "View on the Ganges".

The same border has been noted on plates with the title "British Palaces". Since the cartouche mark is completely different, this is probably a separate series. It is, of course, by no means certain that such pieces were made by Stevenson. The border may have been copied by another potter.

The printed cartouche mark for this series is circular in form and contains both the series title and the name of the individual pattern in script. It also includes the potter's initials R.S. See: Arman p.143.

"Lachin y Gair"

Copeland & Garrett. Byron Views Series. Ill: FOB 15.

"Laconia"

Barker & Till. A design printed in light blue on ironstone dinner wares. It was registered on 1st January, 1848.

Laconia is the name of a city in New Hampshire and also a gulf into the southern tip of Morea in Greece.

The Ladies of Llangollen

Cambrian and Glamorgan Potteries, Swansea, Wales.

This pattern shows two mounted ladies in riding habits, one talking to a man with a scythe. The rural setting includes a large building on a hill with four domed towers. The prints on the wares from these two potteries are so alike that Nance stated his belief that the same copper plates were used to print them. Ill: Coysh 1 128; Little 95; Nance LIXc.

The ladies of the title were the Rt. Hon. Lady Eleanor Butler, daughter of the Marquis of Ormonde, and Miss Sarah Ponsonby, daughter of Viscount Duncannon. Following some

years' unhappiness in society, and one attempted escape when they ran away together, they were given a small allowance, and in May 1778 they left Ireland and set up home together at a cottage at Llangollen in North Wales. They converted and extended the cottage in the Gothic taste, and renamed it Plas Newydd, the New Place. They were noted for their eccentricity. Lady Eleanor died in 1829, followed by Sarah just two years later. See: Elizabeth Mavor, *The Ladies of Llangollen* (1971).

Although the pattern is supposed to show the ladies out riding in Llangollen Vale, the large house in the distance has not been identified. Another design by an unknown maker is reputed to show the same ladies (Little 119).

Ladles
Earthenware cup bowls with long handles for serving liquids or sauces. Tureens of all sizes in blue-printed dinner services were supplied with appropriately sized ladles, the lids having semi-circular apertures, usually at one end, for the ladle handle. There are some notable variations in the designs of ladles, the handle, for example is usually vertical but sometimes nearly horizontal. The smaller sauce ladles can be found with the bowl pierced by strainer holes.

Lady with Parasol
Maker unknown. An untitled early chinoiserie pattern which has a large pagoda on the left and two figures in front of a fence on the right. One of the figures is a lady holding a parasol. The alternative name of La Dame au Parasol has also been suggested.

Lady with Parasol. *Maker unknown. Printed open crescent mark. Line engraved octagonal plate 8¾ ins:22cm.*

Ladles. *Flower from the Zebra pattern. Unmarked. 6¾ ins:17cm; Forest Landscape pattern. Printed C. 6½ ins:16cm; Chinoiserie Ruins pattern. Unmarked. 6½ ins:16cm.*

"Lady of the Lake." *Two prints after Richard Westall, R.A., on which this pattern was based.*

"Lady of the Lake." *Careys. Printed title mark with maker's name. Dish 21ins:53cm.*

"Lady of the Lake"

A composite pattern used by Careys on dinner and dessert services. The design shows the Lady on the lake in her skiff on the left, and the Lady seated with a harpist on the right. It was based on engravings by F. Engleheart and Charles Heath of drawings by Richard Westall R.A. which were illustrations to the first edition of Sir Walter Scott's *Lady of the Lake,* published by John Sharpe of Piccadilly, London, in 1810.

The original prints bear extracts from the poem. For example, where she stands in her skiff:

> In listening mood she seemed to stand
> The guardian naiad of the strand.

and by the side of the harpist:

> But when he turned him to the glade
> One courteous parting sign she made.

These source prints, compared with the Careys' pattern, show clearly how the engravers built up a scene, adding many features to create an attractive final result.

The printed mark on these wares bears the title "LADY OF THE LAKE" above the Prince of Wales' feathers. Below is the maker's name "CAREYS" on a ribbon.

Lafayette

The Marquis de La Fayette (1757-1834) was a French General and politician. He left France in 1777 for America in order to help the colonists. He distinguished himself at the defence of Virginia in 1781 and at the battle of Yorktown in 1782. He returned to America amidst great acclaim on 16th August, 1824, for an extensive tour of each of the twenty-four states. This visit aroused great interest and many blue-printed wares were made at about this time for export to America. The visit was probably the inspiration for Enoch Wood & Sons' French Series (qv).

"Lake"

Maker unknown. A series of light blue views printed on ironstone. According to Laidacker the views are from paintings by W.H. Bartlett of American scenes. He also states that the same views can be found titled "Ontario Lake Scenery" and marked J. Heath. Obviously some, if not all, the views are Canadian. See: Laidacker pp.130-131.

"Lake of Albano"

Enoch Wood & Sons. "Italian Scenery" Series. Plate 7½ins:19cm.

This lake at Albano lies about fifteen miles south east of Rome. There are many ancient buildings in the area, including the villas of the emperors Caligula, Nero and Tiberius.

"Lake Avernus"

Enoch Wood & Sons. "Italian Scenery" Series. Plate 4½ins:11cm.

Lake Averno, as it is now known, fills an old volcanic crater some ten miles west of Naples. It is referred to by Virgil and was regarded by the ancients as the entrance to the infernal regions.

Lake Como

Copeland & Garrett included a view titled "Bellagio, Lago di Como" in their Byron Views Series (qv).

Lake Pattern

A Spode pattern more commonly known as Dagger-Landscape Second. Ill: Whiter 6. It has been renamed Lake by Copeland (p.99) on the grounds that a pattern is best named by the central scene rather than by its border. It was originally known only from a copper plate but stone china examples have now been recorded, made either by Spode or their successors Copeland & Garrett.

"The Lake, Regent's Park"

Enoch Wood & Sons. "London Views" Series. Plate 9ins:23cm.

Shepherd was responsible for two views showing the lake in Regent's Park. One was titled "The Coliseum and Part of the Lake, Regent's Park", and the other was "An Island on the Lake & Part of Cornwall & Clarence Terrace, Regent's Park". It is not clear which was the basis for this pattern.

"Lake Scenery"

F. & R. Pratt & Co.
See: "Lake".

Lakeside Meeting

Maker unknown. This title is introduced here for an early and rather naive pattern which was previously named Italian Lakeside in FOB 2. It shows two very crudely drawn figures, one with a pitchfork, and a dog in the foreground of a scene with a lake, buildings, trees and hills. The new title has been adopted since the view has no obvious Italian features and to avoid confusion with other similar titles.

Lakin & Poole fl.c.1791-1795

Hadderidge, Burslem, Staffordshire. This firm produced at least one early line-engraved chinoiserie design although the main output was of creamware and figures. The only pattern so far recorded with their impressed mark is a design with a willow tree and an eight-storey Chinese pagoda (see page 211). This could well have been inspired by the 163ft. high pagoda erected in Kew Gardens in 1761.

Lakin, Thomas (& Son) fl.1810-1817

Stoke, Staffordshire. This firm traded as Thomas Lakin & Son until 1812 and thereafter simply as Thomas Lakin. The impressed mark "Lakin" may relate to either of these periods. Blue-printed wares were made, particularly the Classical Ruins pattern (qv). The firm also produced wares with blue-printed outlines enamelled in various colours.

Lakeside Meeting. *Maker unknown. Unmarked. Drainer 13ins:33cm.*

Colour Plate XIV. Supper Set. *Attributed to Spode. Complete supper set in its original wooden tray. Unmarked. Overall length 22 ¾ ins: 58cm.*

Colour Plate XV. Blue Claude. *Wedgwood. Impressed maker's mark. Vegetable dish and cover. Overall length 11 ¼ ins: 29cm.*

Lakin & Poole. *A chinoiserie design which has much in common with Joshua Heath's Reindeer and Seal pattern. Impressed "LAKIN & POOLE". Soup plate 9¾ ins:25cm.*

"Lambton Hall, Durham." *Maker unknown. Crown Acorn and Oak Leaf Border Series. This example is not titled. Impressed crown mark. Soup plate 9¾ ins:25cm.*

"Lambton Hall, Durham." *Enoch Wood & Sons. Grapevine Border Series. Printed title mark. Dish 21¼ ins:54cm.*

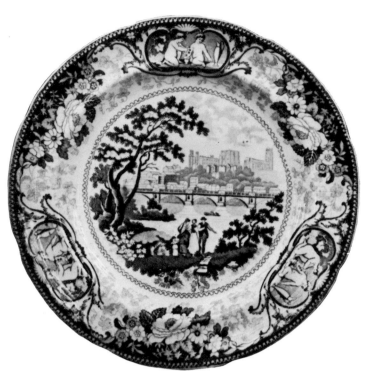

"Landing of Wm. of Orange." Jones & Son. *"British History"* Series. Printed titles and maker's mark. Plate 8½ins:22cm.

"Lancaster." Herculaneum. Cherub Medallion Border Series. Printed title mark and impressed Liver Bird. Plate 10ins:25cm.

"Lambton Hall, Durham"

(i) Enoch Wood & Sons. Grapevine Border Series. Dish 21¼ins:54cm, and various mugs. Ill: FOB 28.

(ii) Maker unknown. Crown Acorn and Oak Leaf Border Series. Plate and soup plate both 9¾ins:25cm, and cake stand.

These two potters used the same view of the Hall, or Lambton Castle as it is generally known. An Elizabethan house called Old Harraton Hall was demolished in 1787 and a two-storey classical house was designed to be built in its stead. There were delays and the work was not completed until 1830. In 1854 the foundations subsided into a coal mine and little of the original building remains. This castellated Gothic building was probably the first mansion to be lit by gas.

Illustrations on previous page.

"Lancaster"

(i) Elkin, Knight & Co. Rock Cartouche Series. Dish 19ins:48cm, and jug 12ins:30cm.

(ii) Herculaneum. Cherub Medallion Border Series. Plate 10ins:25cm.

These two views are very similar, and two more are also known, one untitled in the Rogers Views Series (qv) and the other titled "North East View of Lancaster" (qv) by an unknown maker in the "Antique Scenery" Series.

Lancaster is the county town of Lancashire and stands on the south side of the River Lune. The two main features are the castle, built in the 11th century and strengthened by John of Gaunt, and St. Mary's Church in the Perpendicular style.

"Landing of Wm. of Orange"

Jones & Son. "British History" Series. Plate 8½ins:22cm. Ill: FOB 23.

This scene shows a welcoming ceremony with flags, trumpets and pikes in evidence in the background. William of Orange landed with a small force at Torbay on 5th November, 1688, in opposition to James II.

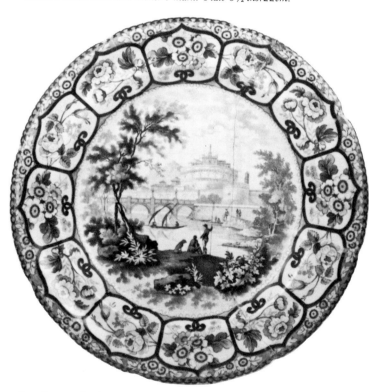

Landscape Series. Castello St. Angelo. Don Pottery. Printed and impressed maker's marks. Plate 10ins:25cm.

Landscape Series

A series of Italianate views by the Don Pottery. They are enclosed within a border of arcaded floral medallions, each containing one of three floral sprays, repeated to form a continuous band. The views are not titled but one has been

"Lanercost Priory." Source print for the Minton Miniature Series taken from Britton & Brayley's "The Beauties of England and Wales".

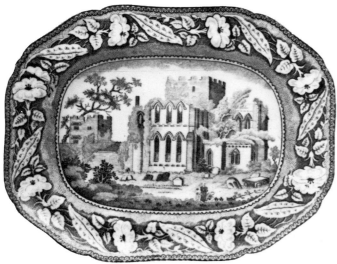

"Lanercost Priory." Minton Miniature Series. Printed title mark and impressed "MINTONS". Miniature dish 6ins:15cm.

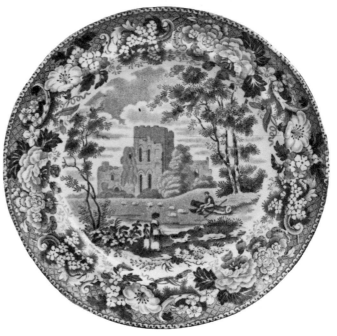

"Lanercost Priory." Maker unknown. "Antique Scenery" Series. Printed titles mark. Plate 7¼ins:18cm.

identified and the others may also be real places, probably in Italy. The three scenes recorded to date have been given preliminary titles:

Castello St. Angelo
Italian Fountain
Reading Woman

The Italian Fountain pattern with several variations of detail was also used by the Herculaneum Pottery (Ill: Little 107). The design is, however, clearly intended to be the same place and even two figures in the foreground are repeated. Either Don copied the earlier Herculaneum design or both potteries used the same unidentified source print.

Lane Delph

Part of the pottery town of Fenton in Staffordshire. It is well known as the site of the Mason factories. Together with Lane End, it lies between Fenton and Longton.

Lane End

Part of the pottery town of Longton in Staffordshire, about three miles south east of Stoke-on-Trent. It was home for many well-known potters including the Careys, Elkins & Co., the Goodwin partnerships, Charles Harvey, Charles Heathcote, F. & R. Pratt and John Turner.

"Lanercost Priory"

(i) Minton. Minton Miniature Series. Dish 6ins:15cm, and oval dish 6½ins:16cm

(ii) Maker unknown. "Antique Scenery" Series. Plate 7¼ins:18cm.

Lanercost Priory, Cumberland
John & William Ridgway. Angus Seats Series. Mug.

In common with all items from this series the view is not titled and marked pieces are very rare.

This priory was founded in about 1166 for Augustinian canons. It is in Cumberland (now Cumbria) on the Irthing river, eleven miles north east of Carlisle. At the dissolution in 1536 it passed to Sir Thomas Dacre who made the west range of the monastic quarters into his home and this is well preserved. The church, c.1220-75, is nearly complete and the nave is still in use as the parish church. The priory was built mainly of stones from Hadrian's Wall.

"Langley Park"
Henshall & Co. Fruit and Flower Border Series. Dish 11ins:28cm.

Langley Park is in the hamlet of Langley, one and a half miles south of Beckenham in Kent.

Lanje Lijsen
A Spode chinoiserie pattern copied from a Chinese K'ang Hsi original. The slight differences may be compared in Copeland p.143 and in S.B. Williams 108-113. The Chinese name for the lady was *mei yen*, or pretty lady. Lanje Lijsen is a Dutch name which can be translated to pretty damsel. Some collectors call the pattern Long Eliza or, alternatively, the Jumping Boy. It can be found on dinner wares and also on less common items such as an impressive and possibly unique footbath illustrated by Whiter, and a small chamberstick. Ill: Coysh 1 111; Whiter 23, 101; S.B. Williams 108-113.

"Lanthony Abbey, Monmouthshire" (sic)
Maker unknown. Pineapple Border Series. Dish 20¾ins:53cm, and drainer 12¾ins:32cm.

Llanthony Priory, eight and a half miles north of Abergavenny, now in Gwent, was founded in the first decade of the 12th century for Augustinian canons. Much of the ruined church still remains. A new Benedictine abbey was erected in 1870 by the Rev. Joseph Leycester Lyne, copied in style from the old priory.

Large Scroll Border Series
A series of British and Irish views by John & Richard Riley. The border consists of large leaf scrolls alternating with flowers, and with panels of geometrical motifs. Many of the views are taken from John Preston Neale's *Views of the Seats of Noblemen and Gentlemen in England and Wales, Scotland and Ireland* (1813-29). Views recorded to date include:

"Balloch Castle, Dumbartonshire" (sic)
"Bickley, Kent"
"Bretton Hall, Yorkshire"*
"Cannon Hall, Yorkshire"*
"Denton Park, Yorkshire"
"Esholt Hall, Yorkshire"
"Ettington Hall, Warwickshire"
"Goggerddan, Cardiganshire"*
"Gracefield, Queen's County"
"Hollywell Cottage, Cavan"*
"The King's Cottage, Windsor Park"*
"Kingsweston, Gloucestershire"*
"Orielton, Pembrokeshire"
"Orwell Park, Suffolk"*
"The Rookery, Surrey"*
"Taymouth Castle, Perthshire"*
"Wistow Hall, Leicestershire"*

The printed cartouche mark for this series consists of a ribbon, wrapped round a sprig of leaves with the title in capitals and the name "RILEY". Some examples can be found printed in a lighter blue with the potters' name replaced by the word "WARRANTED". It is possible that these were made by another potter who took over the copper plates and re-engraved the printed mark when the Riley firm closed in 1828.

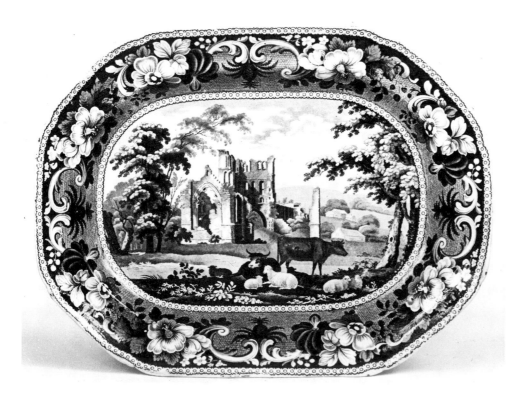

"**Lanthony Abbey, Monmouthshire.**"*Maker unknown. Pineapple Border Series. Printed title mark. Dish 20¾ins:53cm.*

Large Scroll Border Series. *John & Richard Riley. Typical printed mark.*

Large Scroll Border Series. *Mark in which "RILEY" has been replaced by "WARRANTED". Examples with this mark may not be from the Riley factory.*

Latachia

The Ottoman Empire Series by an unknown maker includes the three views "Monumental Arch in Latachia", "Mosque in Latachia" and "Port of Latachia".

The ancient seaport of Latakia on the Mediterranean coast of Syria was once known as Laodicea but is now called Al Ladhiqiya. A gazetteer of 1810 refers to it as an "ancient town built by Selencas Nicamor, who called it Laodicea, from the name of his mother. It carries a considerable commerce, chiefly in tobacco, up to 20 cargoes of which are annually sent to Damietta in exchange for rice. The remains of antiquity show it to have been a place of considerable extent".

Lattice Scroll

A Spode pattern with a central spray of flowers and a lattice-scroll border with flowers. Ill: Copeland p.138; Coysh 1 102; Whiter 33.

The border was used on special order armorial wares (See: Whiter 79) and the pattern is also known in combination with the Gothic Castle pattern on a garden seat (See: Whiter 100).

"Lausanne"

Copeland & Garrett. Byron Views Series. Plate 8½ ins: 22cm.

Lausanne, in Switzerland, stands near the northern shore of Lake Geneva, thirty-eight miles north east of Geneva itself. Lausanne was an ancient ecclesiastical and educational centre and has a noted cathedral and university. Young men on the Grand Tour visited Lausanne to study French. It had a coffee house, a playhouse and frequent assemblies. It was in Lausanne that Edward Gibbon wrote the last three volumes of his *Decline and Fall of the Roman Empire*.

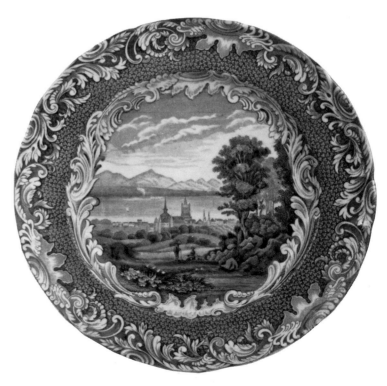

"Lausanne." *Copeland & Garrett. Byron Views Series. Printed title and maker's mark and impressed maker's mark. Plate 8½ ins: 22cm.*

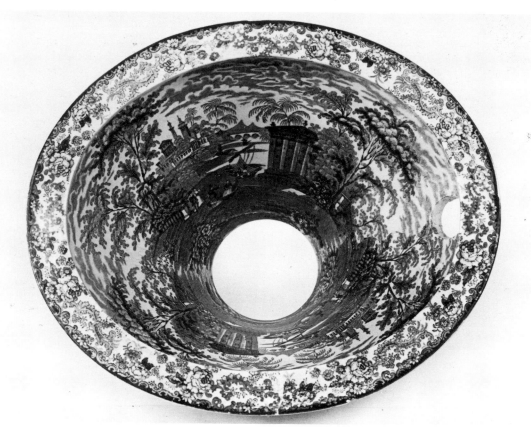

Lavatory Pan. *Maker unknown. A typical lavatory pan decorated with a romantic pattern. 17 x 15ins:43 x 38cm, tapering to 4ins:10cm.*

Lavatory Pan

Earthenware lavatory pans, then known as closet pans, were first commonly used in the 1840s and 1850s although primitive water closets existed in the 18th century. They were usually boxed in, partly to hide the pipes and partly to support the wooden seat. Many blue-printed lavatory pans were certainly made but examples seldom bear a maker's mark. A fair number have survived, typically decorated with romantic scenes.

"Lavinia"

Yale & Barker. A romantic scene marked with printed initials Y. & B.

The view was possibly intended to represent the old Roman town of Lavinium, sixteen miles south east of Rome.

Lawrance, James

The Lawrence family were catering contractors at King's College, Cambridge and the name appears on pieces from a College dinner service.

See: King's College Chapel, Cambridge and illustration on page 202.

Lawrence

This name has been noted printed in capitals on the base of a Willow pattern dish with the initials I and P in reserves on either side of the border. It appeared to date from the 1820s. No potter of this name can be traced around this period and the mark may relate to a retailer. The fact that it was a special order piece tends to support this supposition although with such a common name it would be difficult to prove.

"Laxton Hall, Northamptonshire"

Ralph Hall. "Select Views" Series. Soup tureen.

Laxton Hall was built in 1811 by John Adey Repton. Its appearance has since changed as a result of alterations carried out in 1867-68.

"Lazuli"

Dillwyn, Swansea. A sheet pattern with veining in flown-blue used on toilet wares during the period 1836-50. The printed mark consists simply of the title in capitals in a scroll. The word is short for lapis lazuli which is a chemical from which a bright blue pigment of the same name is derived.

Lawrance, James. *Printed mark on a Mason's Ironstone plate with a view of King's College Chapel, Cambridge (qv).*

Leach, B.

The name "B. LEACH" painted in large letters has been recorded on a Spode plate decorated with the Temple Landscape First pattern (qv). Whiter (p.146) considers it to be the mark of a retailer who was a customer of the factory.

Leach, B. *Underglaze freehand painted mark found on some of Spode's dinner wares bearing the Temple Landscape First pattern.*

Leaf

A Spode sheet pattern with stylised leaves on a ground of tendrils. Ill: Whiter 36.

Leaf Dish

A small dish moulded in the shape of a leaf, often in great detail both front and back. Sometimes called a pickle dish (qv).

Leamington Baths

A view by an unknown maker in the Passion Flower Border Series is marked with the mis-spelt title "Leomington Baths" (qv).

"Lechlade Bridge"

Minton. Minton Miniature Series. Vegetable dish.

Lechlade is a market town on the River Thames in Gloucestershire. St. John's Bridge is an ancient structure rebuilt in 1831 and again in 1884.

"Lee House on the Clyde"

Belle Vue Pottery. Belle Vue Views Series. Sauce tureen stand. Ill: FOB 17.

Lee House, or Lee Castle, was renovated by James Gillespie Graham in 1822 when the central courtyard was roofed in. It is a castellated mansion.

Lee, Kent

John & William Ridgway. Angus Seats Series. Dish 19ins:48cm. Ill: Coysh 2 137.

In common with all items from this series the view is not titled and marked pieces are very rare.

Lee Priory, as it was called, was built for Thomas Barrett by James Wyatt in 1783. It was altered and encased by Sir George G. Scott in 1865, and demolished in 1953.

"Leeds"

Enoch Wood & Sons. "English Cities" Series.

The city of Leeds stands on the River Aire in Yorkshire, twenty-five miles south west of York.

Leeds Pottery fl.1758-1820

Situated in Jack Lane, Hunslett, Leeds in Yorkshire, this factory is sometimes called the Leeds Old Pottery. From 1771 it was operated by Hartley, Greens & Co. It became noted for overglaze transfer-printing in red and black on creamwares from about 1775. By 1790 pearlware had been introduced and soon after the turn of the century underglaze printing in blue was flourishing.

Chinoiserie patterns included:

(i) Two men on a bridge, of which there are reported to be two versions. Ill: Coysh 1 12.

(ii) The Great Wall of China. Ill: Coysh 2 49; Lawrence p.52.

(iii) Chinese Junk pattern.

(iv) Two Figures pattern. This is characterised by a single span bridge in the shape of an inverted V, illustrated on next page.

The pottery does not appear to have produced any definite series of patterns with common borders. However, the following patterns may be recognised from the brief descriptions:

(v) Scene after Claude Lorraine. Ill: Coysh 1 55; Lawrence p.52.

(vi) The Wanderer. Ill: Coysh 2 48, 48a.

(vii) Cottage and Vase. Ill: Lawrence p.52.

(viii) Floral Sprays. Ill: Lawrence p.52.

(ix) Swans on a pond surrounded by foliage, with a distant landscape.

(x) Two cows in a ruined abbey or castle, with a distant landscape.

(xi) Cow standing in a distant landscape.

(xii) Flowers and butterflies.

(xiii) An all-over shell design.

(xiv) Man on horseback, two men on foot and a road winding towards distant mountains. Ill: Little 98. This design has been noted with a printed cartouche with the title "Italian Scenery" (qv).

Leeds marks are usually impressed, either "LEEDS POTTERY" or "HARTLEY, GREENS & Co". The firm is known to have had a large export trade to European countries, including Russia.

"Legend of Montrose"

Davenport. "Scott's Illustrations" Series. Plate 9¾ ins:25cm. Ill: Coysh 2 23; P. Williams p.519.

Sir Walter Scott's *The Legend of Montrose* was first published in 1819. This pattern depicts the rescue of Annot Lyle.

"Leighton Bussard Cross" (sic)

Maker unknown but with dealer's mark "N. NEALE". Plate 10¼ ins:26cm, and pierced chestnut basket.

Leighton Buzzard

Views of Leighton Buzzard with a border of wild roses are known with titles "Leighton Bussard Cross" (sic) and "A North-West View of Leighton Buzzard Church" (Ill: Coysh 2 133), the titles appearing on the face of most pieces. Items are marked with a printed name "N. NEALE". Directories of 1823 and 1830 list Nathaniel Neal(e) as a glass and china dealer in the High Street of the town, the earlier entry giving the name without the final e.

"Leipsig" (sic)

Joseph Clementson.

Leipzig is a town in East Germany with many ancient buildings. It was here that Napoleon was defeated by an allied army of Russians, Prussians and Austrians in October 1813.

"Leomington Baths" (sic)

Maker unknown. Passion Flower Border Series. Dish.

This title has also been noted on another item from the same series with the view of "Rippon" (sic).

In this view the baths are seen from across the river which is spanned by the Victoria Bridge of three stone arches built by H. Couchman Jr. in 1808-9. The Pump Room was built by C.S. Smith in 1813-14 but today all that remains is a Tuscan colonnade.

Leopard

A leopard was featured by Enoch Wood & Sons on a plate 8ins:20cm in their Sporting Series. Another design with an animal from the leopard family is called the Cheetah Pattern (qv).

217

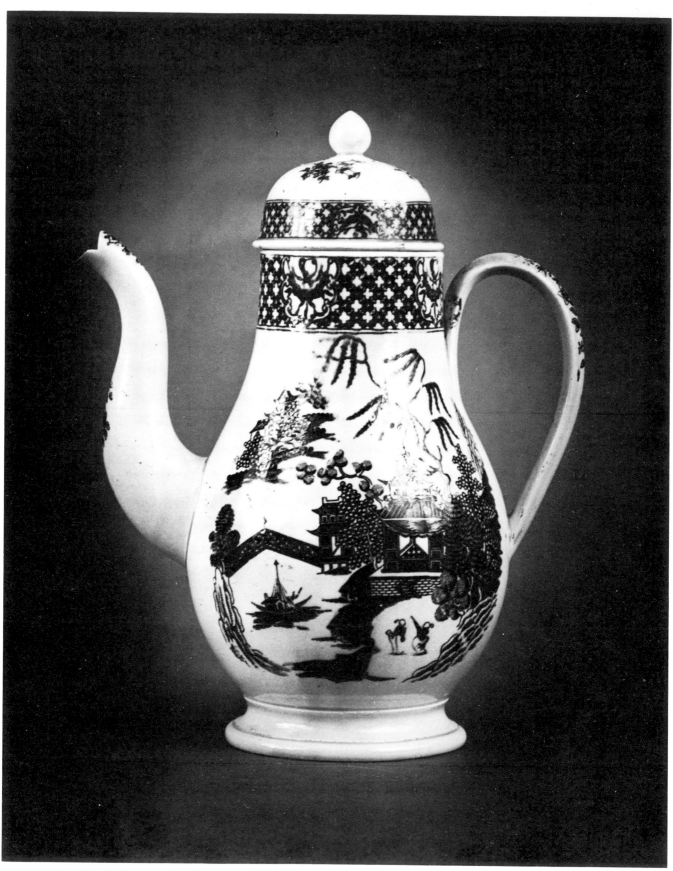

Leeds Pottery. *Two Figures pattern. Impressed mark: "LEEDS POTTERY". Coffee pot 10½ ins:27cm.*

"The Letter of Introduction"
James & Ralph Clews. "Wilkie's Designs" Series. Dish 12½ins:32cm, cup plate, and various vegetable dishes. Ill: Arman 91; Arman S 91.

"The Letter of Introduction" was painted by David Wilkie in 1813. It was a personal reminiscence, recalling the time when he first went to London in 1805. The older man probably represents Caleb Whiteefoord, a Scottish collector of works of art, who held an influential position in London.

"Library of Trinity College, Cambridge"
John and William Ridgway. Oxford and Cambridge College Series. Meat and vegetable dishes.

Trinity College, Cambridge was founded in 1546 using older buildings including King's Hall and Michaelhouse. When Dr. Thomas Nevile became Master in 1593 he rebuilt and extended these around a large court — the largest in the older universities.

Lichfield
Views of this Staffordshire city can be found under the entries "Litchfield" (sic), "Litchfield Cathedral" (sic) and "View of Lichfield".

Light Blue Rose Border Series
An uncommon series of views printed in light blue within a copy of Wedgwood's Blue Rose border. Items usually have a wavy edge and the title is printed in a floral scroll mark. Views recorded to date include:
"Denton Park"
"Gunton Hall"
"Tedesley Hall" (sic)
"Wolseley Hall"*

No pieces noted have any form of maker's mark.

"Lily"
Thomas Dimmock. A pattern used on a body called "Kaolin Ware". See: Godden M 1298. The design was registered in 1844.

The same pattern title was used on cups and saucers by Wood & Challinor but pieces have so far only been reported in pink. Ill: P. Williams p.641.

"Lily and Rose"
A pattern title used by Lockhart & Arthur of the Victoria Pottery, Glasgow, and by their successors David Lockhart & Co.

"The Limehouse Dock, Regent's Canal"
Enoch Wood & Sons. "London Views" Series. Dish 14½ins:37cm. Ill: Laidacker p.100; Moore 20.

This pattern is a very close copy of Shepherd's original drawing in *Metropolitan Improvements*. It shows five sailing ships in the dock with many smaller boats.

Limisso
See: Antique Fragments at Limisso.

"Lincoln"
Enoch Wood & Sons. "English Cities" Series. Plate 6¾ins:17cm.

City and county town of Lincolnshire, noted for its magnificent cathedral. Built mainly in the 13th century, it has been thoroughly restored since 1920.

Lind, Jenny. *J. & M.P. Bell & Co. Bowl with vine border. Diam. 13ins:33cm.*

Lind, Jenny 1820-1887
Jugs and bowls with a portrait of the Swedish singer Jenny Lind were made by J. & M.P. Bell & Co. of Glasgow. Items are marked with a printed cartouche which includes a bird, presumably a nightingale.

Jenny Lind, the Swedish Nightingale, first appeared before a British audience in London in 1847. She was adored in Britain and became a popular figure. With her composer-conductor husband, Otto Goldschmidt, she helped to found the Bach Choir (1875-76) and she became one of the earliest professors at the Royal College of Music (1883-86). She died at Malvern Wells, having become a naturalised British subject in 1859.

See: "Maddle Jenny Lind".

"Lindertis, Forfarshire"
(i) Maker unknown. Crown Acorn and Oak Leaf Border Series. Supper set segments.

(ii) Maker unknown. Foliage Border Series. Dish 11½ins:29cm, and soup tureen.

Lindertis, a castellated Gothic mansion with turrets, was built for Sir Thomas Munro by Archibald Elliot in 1813. It was demolished in 1955. Forfarshire became known as Angus in 1928 and now forms part of Tayside.

Line Engraving
A technique by which a picture is made up of many small engraved lines. It involves the use of a tool called a graver or burin to carve the lines in the copper plate. The thickness of the desired line is controlled by hand pressure on the graver and great skill is required to produce a satisfactory picture. All 18th century blue-printed patterns appear to be line engraved and the lines can easily be seen through a magnifying glass. The technique was later combined with stipple engraving in which parts of the picture are built up of many small dots, enabling a much finer control over depth and contrast.

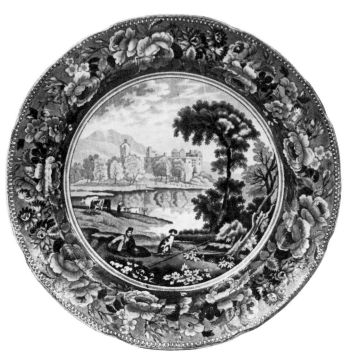

"Linlithgow Palace." *Maker unknown. Beaded Frame Mark Series. Printed title mark. Border clobbered with red, green and yellow enamels. Plate 9½ ins:24cm.*

"Linlithgow Palace"

Maker unknown. Beaded Frame Mark Series. Plate 9½ ins:24cm, and soup plate. Ill: FOB 12.

Another view of the palace was used by James & Ralph Clews in their Bluebell Border Series with the title "Palace of Linlithgow, West Lothian" (qv).

Linlithgow Palace was the birthplace of James V and Mary Queen of Scots. It overlooks Linlithgow Loch and was taken over by the Office of Works in 1928.

Lion

The lion was featured by John Hall on a plate (10ins:25cm) in his "Quadrupeds" Series. Ill: FOB 14. Other patterns showing the animal are noted under The Angry Lion (qv) and the entries below.

"Lion Antique"

William Smith & Co. This title has been recorded on a saucer with a pattern very similar to that illustrated in Little 106. The example noted bore a very clear maker's mark. It is possible that Little's example is the same pattern but with the printed title mark missing.

Another example illustrated on a cup and saucer is marked with an oval printed cartouche which reads:

<div align="center">

LION

J.B. CAPPELLEMANS

AÌNÉ

W. SMITH & C^{ie}

BRUXELLES

</div>

The word "Antique" from the full title has been omitted to make room for the name of Smith's Belgian agents.

Lion Hunter

Maker unknown with initials T.H. & Co. This untitled pattern shows a lion as the central feature with a marksman taking aim from some bushes to the right. The floral border consists of a continuous string of flowers against a stippled ground. It has not yet proved possible to attribute the design to any maker despite an example with impressed initials T.H. & Co. The only firm with these initials listed by Godden is Taylor, Harrison & Co. of Castleford, 1835-41, but examples of this design would appear to be of earlier date. The pattern is found on dinner wares and a shaped dish is illustrated. Ill: FOB 22.

"The Lion in Love"

Spode/Copeland & Garrett. "Aesop's Fables" Series. Soup plate 10ins:25cm. Ill: P. Williams p.597.

The lion fell in love with the forester's daughter. So violent was his passion that he saw her father and demanded her for his wife. Realising that a refusal would provoke the lion's rage, the forester made conditions: the lion must agree to have his teeth plucked out and his claws cut off lest he hurt her. The lion agreed, but as soon as he was deprived of teeth and claws the forester beat him to death with a club.

Some cupids kill with arrows, some with traps.

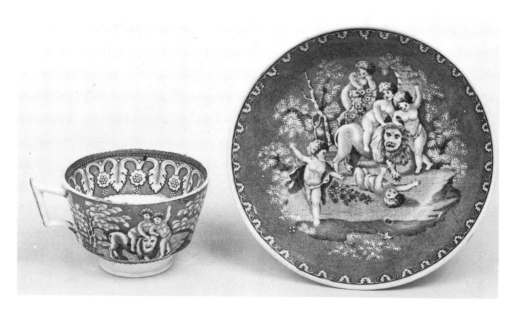

"Lion Antique." *William Smith & Co. Printed oval cartouche with title and retailer's name "J.B. CAPPELLEMANS AÌNÉ, W. SMITH & Cie., BRUXELLES". Cup and saucer. Diam. of saucer 5½ ins:14cm.*

Lion Hunter. *Maker unknown. Unmarked. Decorative square dish 8¼ ins:21cm.*

Lions Pattern

William Adams. This pattern depicts a lion watching over a lioness with two cubs in the wild. There is a border of flowers on a background of very small blooms in a regular pattern. Ill: Coysh 2 6; Little 10.

The pattern is based on a print in *The Cyclopaedia of Arts, Sciences and Literature* published by Longman, Hurst, Rees and Orme of Paternoster Row, London, in 1807. The print was engraved by J. Scott after an original by S. Edwards and was entitled "Felix Leo, Lion, Lioness and Young".

"Litchfield" (sic)

Enoch Wood & Sons. "English Cities" Series. Plate 9ins:23cm. Ill: Laidacker p.87.

Lichfield is a city and market town in Staffordshire, noted for its fine cathedral.

"Litchfield Cathedral" (sic)

Careys. Cathedral Series. Plate 10¼ins:26cm, and soup plate 9ins:23cm.

The Careys view is illustrated overleaf.

Another view by an unknown maker in the "Diorama" Series is titled "View of Lichfield Cathedral" (qv).

Lichfield Cathedral has three distinctive spires and was built mainly in the 13th and 14th centuries. Other notable features are the West front, the Chapter House, the Lady Chapel, some fine glass, and Chantrey's Sleeping Children.

Liver Bird

A symbolic cormorant with a piece of "Liverwort" in its beak, used on the Liverpool coat-of-arms. It was used as an impressed mark by the city's Herculaneum Pottery after about 1825.

Lions Pattern. *William Adams. Impressed mark "ADAMS". Dish 15½ ins:39cm.*

"Liverpool"

Enoch Wood & Sons. "English Cities" Series.

Two items from the series were printed with views titled "Liverpool". The soup plate (10ins:25cm) shows a view of the city from the river, whereas a smaller plate (9ins:23cm) shows a different view of buildings. Ill: P. Williams p.255.

Liverpool is now the capital city of Merseyside but was formerly in Lancashire. It has two 20th century cathedrals and a famous frontage to the River Mersey. It was an important seaport for the potters' export trade and is remembered for its Herculaneum Pottery.

Liverpool Views Series

Views of Liverpool were produced at the Herculaneum Pottery in the 1830s, based on engravings in *Lancashire Illustrated* published in London in 1832. They were mainly printed in black and sepia. Smith states that they were "occasionally in blue, though...less successfully since the cobalt print lacked definition as the oxide spread into the glaze." When marked the title is printed in an octagonal frame and the maker's mark is in the form of an impressed Liver Bird. The views used are listed below and those that have been recorded in blue are marked B and have individual entries:

 "Castle Street & St. George's Crescent, Liverpool" (B)
 Duke of Bridgewater's Warehouse, Liverpool
 "Exchange Buildings & Nelson's Monument, Liverpool"
 Ferry over the River Mersey at Birkenhead (B)
 Fort and Lighthouse, Liverpool
 "The House of Correction, Kirkdale, Liverpool"
 "Liverpool from the Mersey"
 Lord Street, Liverpool.
 "Royal Institution, Liverpool"
 St. Paul's Church
 Seacombe Slip

Where the titles are known to have been marked, they are indicated by quotes. The series border is open in form, with scattered floral sprays.

Livesley, Powell & Co. fl.1851-1866

Old Hall Lane and Miles Bank, Hanley, Staffordshire. This firm marked their wares either in full or with initials, printed or impressed.

"Llanarth Court, Monmouthshire"

Ralph Hall. "Picturesque Scenery" Series. Bowl 10 1/2 ins:27cm, and plate 10ins:25cm.

Llanarth lies five and a half miles south east of Abergavenny. Llanarth Court has been described as an "Italian mansion with a Roman Catholic chapel" (1896).

Llandig's Blackberry

Brameld. This name is used for a floral design within a border which has been attributed to Llandig. It is known on plates in blue but was also printed on teawares in green. Ill: Lawrence p.52.

"Llangothlen" (sic)

Maker unknown. Beaded Frame Mark Series. Small plate.

Llangollen is a market town on the River Dee in Denbighshire, now Clwyd. It is noted particularly as the home town of the Ladies of Llangollen (qv).

Llanthony Abbey, Monmouthshire

This abbey is depicted in one view in the Pineapple Border Series by an unknown maker with the incorrectly spelt title "Lanthony Abbey, Monmouthshire" (qv). It has also been reported on a very large baluster vase in the same series but with the correctly spelt title.

Lloyd

A printed mark has been reported with the wording "From Lloyd's, No. 26 Union Parade, Late of Bath Street, Leamington". William Lloyd is listed at 13 Bath Street in a directory for 1842. The same name is given as a China & Glass Dealer at 26 Lower Parade in both 1854 and 1866. There is no entry in 1876.

"**Loch Awe.**" *John Meir & Son. "Northern Scenery" Series. Printed titles mark with maker's initials. Dish 15½ ins:39cm.*

"**Loch Creran with Barcaldine Castle.**" *John Meir & Son. "Northern Scenery" Series. Printed titles mark with maker's initials. Lidded jug. Height 6½ ins:16cm.*

"Lobelia"
George Phillips. As the name suggests this is a floral pattern, printed in flow blue. The lobelia is a herbaceous plant.

"Loch Achray"
John Meir & Son. "Northern Scenery" Series.

This loch, in Perthshire, is halfway between Loch Katrine and Loch Vennachar.

"Loch Awe"
John Meir & Son. "Northern Scenery" Series. Dish 15½ ins:39cm. Ill: Coysh 2 60.

This loch is eighteen miles north of Inveraray and is over twenty-two miles long. It is noted for its fishing.

"Loch Creran with Barcaldine Castle"
John Meir & Son. "Northern Scenery" Series. Covered jug. Ill: Coysh 2 58.

Loch Creran is a sea loch in north west Argyllshire. Barcaldine Castle was built in the 15th century by Sir Duncan Campbell and became the seat of the Campbells of Barcaldine, a branch of the noble house of Breadalbane.

"Loch Katrine Looking Towards Ellen's Isle"
John Meir & Son. "Northern Scenery" Series.

Loch Katrine spans the border between Perthshire and Stirlingshire, some eight and a half miles west of Callander. Both the loch and Ellen's Isle are associated with many of the incidents in Sir Walter Scott's *Lady of the Lake* (1810).

"Loch Leven Looking Towards Ballachulish Ferry"
John Meir & Son. "Northern Scenery" Series.

The village of Ballachulish lies on Loch Leven in Perthshire. The ferry crosses the loch and connects the roads from Fort William and Glencoe. They join to form the road south to Oban.

"Loch Oich and Invergarry Castle"
John Meir & Son. "Northern Scenery" Series.

Loch Oich, in Inverness-shire, is the summit level of the Caledonian Canal and drains into Loch Ness. Invergarry is a village at the mouth of the River Garry

Loch Tay
James & Ralph Clews included a view entitled "Killin, Head of Loch Tay" in their "Select Scenery" Series.

"Loch Winnock"
(i) Robert Cochran & Co.
(ii) James Jamieson & Co.

Lochwinnock is a small town in West Renfrewshire, six miles south west of Johnstone. A low-lying valley is partly occupied by Castle Semple Loch and the town lies on the River Calder where it enters the loch. Castle Semple Loch was no doubt once named Loch Winnock.

Lockett
A number of potters with this name, all with the initial J, operated in Lane End and Longton, Staffordshire. They included:

J. & G. Lockett of Lane End	c.1802-1805
J. Lockett & Co. of King Street, Lane End	c.1812-1889
John Lockett of Chancery Lane, Lane End	c.1821-1858
John Lockett & Sons of King Street, Longton	1828-1835

Fortunately the various recorded marks seem to give the relevant name in sufficient detail to enable identification.

Two other firms with the name were George Lockett (& Co.) who appear to have linked J. & G. Lockett to John Lockett, and John & Thomas Lockett who succeeded John Lockett & Sons. According to Little (p.78), the latter became John Lockett who had factories in both King Street and Market Street in Lane End. It seems that there was considerable interchange between the various partnerships. They may have been a family firm.

Lockett & Hulme fl.1822-1826
King Street, Lane End, Staffordshire. Little illustrates a printed mark used by this firm with the initials L. & H. and L.E. together with the name of the body "Opaque China" within an oval frame (Little, mark 35).

Lockhart & Arthur fl.1855-1866
Victoria Pottery, Pollokshaws, Glasgow, Scotland. Impressed and printed marks are known with either the name in full or the initials L. & A. They were succeeded by David Lockhart & Co.

Lockhart, David & Co. fl.1866-1876
Victoria Pottery, Pollokshaws, Glasgow, Scotland. This firm seems only to have used printed marks with the initials D.L. & Co.

"Lombardy"
Joseph Heath & Co. A romantic view printed in light blue on ironstone wares. It shows tall Lombardy poplar trees and two gondolas on a lake, all within a floral border. Ill: P. Williams p.316.

Lombardy was originally an Austrian possession but it became a territory in northern Italy in 1861.

"London"
(i) John Carr & Co.
(ii) Enoch Wood & Sons. "English Cities" Series. Plate 10ins:25cm.
(iii) Enoch Wood & Sons. "London Views" Series. Dish 11½ ins:29cm.

Another view of the city by Thomas & Benjamin Godwin is titled "View of London" (qv).

"London and Edinburgh Steam Packet Company"
Maker unknown. This title appears on the back of a large well-and-tree dish in a wreath of roses and thistles with an intertwined ribbon. The pattern shows a packet ship with three masts and sails furled, steaming along in a choppy sea. The border consists of parallel bands on which are superimposed the arms of the cities of London (with the motto "Domine Dirige Nos") and Edinburgh (with the motto "Nisi Dominus Frustra"). The coats-of-arms are separated by four groups of roses, thistles and scrolls.

The first steam packet between London and Edinburgh was introduced when the London and Edinburgh Steam Packet Company placed the *City of Edinburgh* on the route in 1821. In 1836 the company was absorbed by the General Steam Navigation Company. It is probable that the ship seen on the dish is the *City of Edinburgh*.

"The London Institution"
William Adams. Regent's Park Series. Plate 7ins:18cm.

The London Institution was in Finsbury Circus. In the text to *Metropolitan Improvements* (1827), James Elmes comments on the tetrastyle portico "of that species of the Corinthian Order which Mr. Soane first used at the Bank of England, copied from the beautiful circular temple, called the Sybils, at Tivoli".

"London and Edinburgh Steam Packet Company." *Maker unknown. Printed title mark. Dish 18ins:46cm.*

"London and Edinburgh Steam Packet Company." *Printed title mark (enlarged).*

"London Views" Series

A series in dark blue by Enoch Wood & Sons which duplicates some of the views in the Adams Regent's Park Series. They both based their patterns on drawings by Thomas H. Shepherd which appeared as prints in *Metropolitan Improvements* (1827). The views in the Wood series are contained within a square or rectangular frame bordered with scallop shell, acanthus scroll, and leaf motifs. The wide border is of vine leaves and bunches of grapes. Some examples have a gadrooned edge. They are marked with a leafy scroll bearing the series title "London Views" and the name of each individual view. Known titles include:

"Bank of England"
"Clarence Terrace, Regent's Park"
"The Coliseum, Regent's Park"
"Cumberland Terrace, Regent's Park"
"Doric Villa in Regent's Park"
"East Gate, Regent's Park"
"Finsbury Chapel"
"Hanover Lodge, Regent's Park"
"Hanover Terrace, Regent's Park"
"The Holme, Regent's Park"
"The Lake, Regent's Park"
"The Limehouse Dock, Regent's Canal"
"London"
"Macclesfield Bridge, Regent's Park"
"St. George's Chapel, Regent Street"
"St. Philip's Chapel, Regent Street"
"Sussex Place, Regent's Park"
"Ulster Terrace, Regent's Park"
"Villa in the Regent's Park" (two views: the residence of John Maberly; the residence of the Marquis of Hertford)

As with most of the series of views printed in very dark blue, items from this series are not commonly found in Britain.

Long Bridge Patterns. *Swansea. Two man/scroll chinoiserie pattern with ochre edge to the rim. Printed mark two blue dots, impressed mark small open cross. Plate 9¼ ins:23cm.*

Long Bridge Patterns

One of the early chinoiserie patterns is characterised by a long bridge with three arches of equal size. Two figures, leaning slightly forward, are crossing the bridge from right to left, and the landscape features two large pagodas, boats and an island. This pattern, with variations, was used by a number of potters.

(i) Castleford Pottery. The figures on the left side of the bridge carry poles with bundles. There is a slanting fence and a boat without a mast. The border includes manuscript scrolls and the mark is D.D. & Co. impressed. Ill: Copeland p.117.

(ii) Hilcock. This version has a similar scroll border, two figures to the right on the bridge, a boat with a mast, but no fence. The name Hilcock (qv) has not been traced and may belong to a retailer. Ill: Coysh 2 132.

(iii) James Keeling. Shards of a Long Bridge pattern were found during excavations at the site of this potter's works in Hanley.

(iv) Leeds Pottery. A pattern almost identical to the Hilcock example, very crisply printed and with a fine clear glaze. Impressed mark "LEEDS POTTERY". Ill: Copeland p.118; Coysh 1 12 (where it is called the two-man/scroll pattern).

(v) Swansea. A landscape with similar features to (ii) and (iv) but with smaller figures on the bridge and a manuscript scroll border. The rim is decorated with ochre enamel. Impressed mark "SWANSEA". Ill: Copeland p.118; Coysh 1 10 (where it is called the two-man/scroll pattern); Nance XIIIf.

(vi) Swansea. A landscape, once again with similar features, but with an insect border and enamelled rim. Impressed mark "SWANSEA". Ill: Coysh 1 11 (where it is called the two-man/insect pattern).

Versions of the design were undoubtedly also made by other potters who did not mark their wares. Copeland devotes a complete chapter to this pattern and discusses it in considerable detail (Chapter 9).

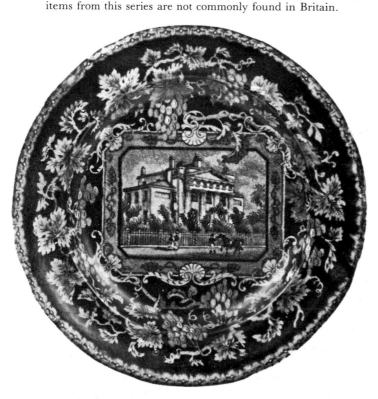

"London Views" Series. *"Doric Villa in Regent's Park." Enoch Wood & Sons. Printed mark with incorrect title "Macclesfield Bridge, Regent's Park". Plate 7½ ins:19cm.*

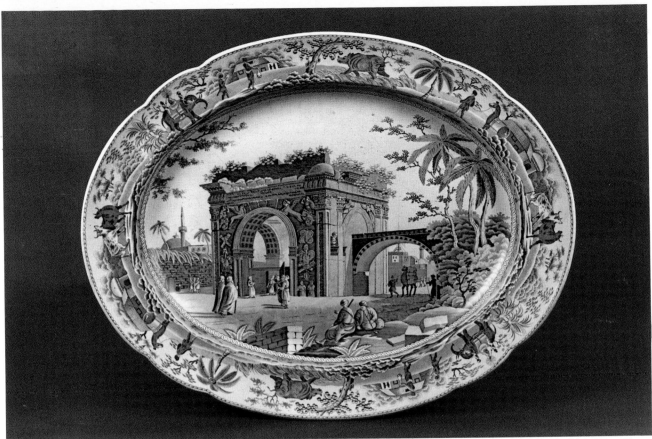

Colour Plate XVI. Triumphal Arch at Tripoli in Barbary. *Spode. Caramanian Series. Impressed maker's mark. Dish 21ins:53cm.*

Colour Plate XVII. Triumphal Arch at Tripoli in Barbary. *Source print for the Caramanian Series taken from Mayer's "Views in the Ottoman Empire, Chiefly in Caramania".*

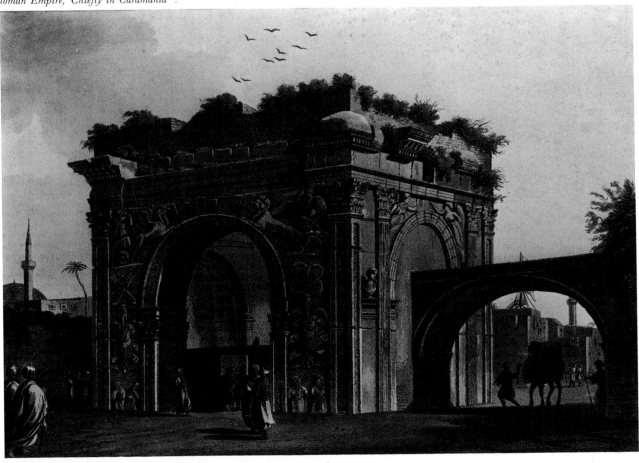

Longport

A pottery district in Staffordshire about a mile to the south and west of Tunstall and Burslem. It was home to some important potters including Davenport, Henshall & Co., Edward & George Phillips, Rogers, and Joseph Stubbs.

Longton

A pottery town three miles to the south east of Stoke-on-Trent, into which it is now merged. It originally included Lane End, an area in which most of the potteries were sited.

"Lorne"

(i) Robert Cochran & Co.
(ii) David Methven & Sons.

Lorne is a district in North Argyllshire. It takes its name from Loarn, one of the three sons of Erc, who at the close of the 5th century sailed here from Dalriada in Ireland and founded the kingdom of the Scots.

Lorraine

See: Claude Lorraine.

Lotus

An alternative name for Wedgwood's Water Lily pattern (qv).

Louis Quatorze

A border design registered by Copeland & Garrett in 1844.

"Louise"

J. & M.P. Bell & Co.

It is possible that this pattern was named after Princess Louise, Duchess of Argyll, who married Lord Lorne in 1871.

The Love Chase

A Spode pattern recorded on a marked slop basin and other unmarked tewares. It has also been noted printed in brown on later marked Copeland wares.

It tells the story of Atlanta, daughter of Zeus. When she sought a husband she expected every suitor to compete with her in a race. If he won he was to have her hand; if he lost he was to be put to death. Many died before Milanion decided to compete. Aphrodite had given him three golden apples which he dropped at various stages during the race and Atlanta was so charmed by their beauty that she could not resist picking them up. In this way Milanion won the race and Atlanta became his wife.

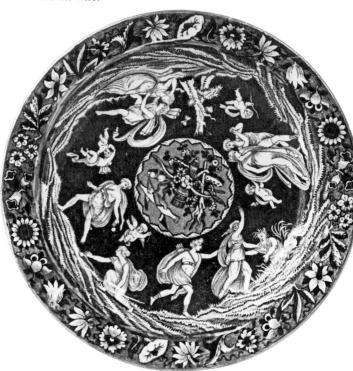

The Love Chase. *Attributed to Spode. Unmarked. Plate 7½ ins:19cm.*

The Love Chase. *Spode. Printed maker's mark. Basin.*

"Love in a Village, Act 1, Scene 4"

John Rogers & Son and Pountney & Goldney. "The Drama" Series. Plate 10ins:25cm. Ill: Little 59.

This play was written by Isaac Bickerstaffe in 1762, one of his many successful plays produced between 1756 and 1771. In 1772 he was suspected of a capital crime and fled abroad where he died in degraded circumstances.

"Love's Labour's Lost, Act 4, Scene 1"

John Rogers & Son and Pountney & Goldney. "The Drama" Series.

Shakespeare wrote this play in about 1590 but it was not printed until 1598 when it appeared as *A Pleasant Conceited Comedie called, Loves labors lost.*

Lovick

A marked plate by Ralph Stevenson & Son decorated with a pattern titled "Cologne" has been noted with an additional printed legend for "Lovick's China & Glass Emporium, Norwich". The same mark has also been noted on a small unattributed plate with a floral pattern.

In the Norwich directories of 1810 and 1822, Samuel Lovick is recorded as a House-broker and an Auctioneer at Bridge Street, St. Andrew's. By 1830 the business had expanded and diversified with entries under Auctioneers, China Glass and Earthenware Dealers, and Tea and Coffee Dealers, in new premises at Bridewell Alley and Broad Street, St. Andrew's. The china, glass and earthenware entry includes the word "Emporium". The three entries remain in 1836 but by 1839 there is only the single entry of Ann Lovick at the Glass Emporium. In later directories she is recorded as Mrs. Ann Lovick so it may be that she was Samuel's widow, carrying on with the china shop. The entries continue until 1846, but in 1850 there is a new entry under Lovick & Co. which continues

at the same addresses until at least 1879. At one stage the firm is entered as William Lovick & Co., possibly Ann Lovick's son taking over after her death.

The term emporium was used only in the entries for 1830 and 1839. This corresponds well with the marked Stevenson plate, since the dates of the relevant partnership were c.1832 to 1835.

Loving Cup

A large mug with two handles. Many loving cups have a prominent foot. Blue-printed examples are found but very few are marked. See illustration overleaf.

Lovick. *"Lovick's China and Glass Emporium, Norwich." Typical printed mark.*

"Love in a Village, Act 1, Scene 4." John Rogers & Son. "The Drama" Series. Title beneath design. Printed series title mark and impressed "ROGERS". Plate 10ins:25cm.

Lovick. *Maker unknown. A floral design c.1830-40. Printed retailer's mark "LOVICK'S China and Glass Emporium, NORWICH". Plate 6¾ins:17cm.*

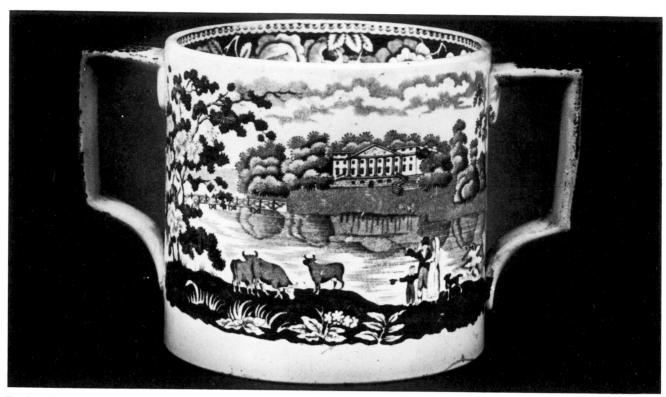

Loving Cup. *Maker unknown. Country scene which is the same as the Palladian Mansion view in the "British Scenery" Series (qv). Unmarked. Two-handled mug. Diam. 4¾ ins:12cm.*

Loving Cup. *Maker unknown. Unmarked. Two-handled mug height 5¼ ins:13cm. The two birds are the hen-harrier (left) and the red-backed shrike, copied from wood engravings by Thomas Bewick in his "History of British Birds". The reverse is similar with the fieldfare and the wren.*

"The Lower Lake of Killarney"

Careys. "Irish Views" Series. Plate 10¾ins:27cm.

The lakes of Killarney have always been a tourist attraction. To the west rise the highest mountains in Ireland, the Macgillicuddy's Reeks. To the east is the town of Killarney and the main east-west road. The Lower Lake, with an area of 5,000 acres, has thirty islands and is drained by the River Laune to the Atlantic.

"Loweswater"

C.J. Mason & Co. "British Lakes" Series. Plate 9ins:23cm.

Loweswater is one of the most north westerly lakes in Cumbria (originally Cumberland). It is about nine miles from Workington. The name is also that of a village in the same area.

Lowndes & Beech fl.c.1821-1834

Lion Works, Sandyford, Tunstall, Staffordshire. This firm was a partnership between James Beech and Abraham Lowndes, sometimes spelt Lownds. The firm has also been known as Beech & Lowndes. Initial marks with L. & B. have been noted.

"Lowther Castle, Westmorland"

Maker unknown. Crown Acorn and Oak Leaf Border Series. Dish 19¼ins:49cm and well-and-tree dish 21ins:53cm. Ill: FOB 16.

It is also possible that this view was produced by Ralph Stevenson in his Stevenson's Acorn and Oak Leaf Border Series (qv).

Lowther Castle was built by Viscount Lonsdale in 1694 but was burnt down in 1720. A later mansion dates from between 1806 and 1811 and was built by Robert Smirke. It was gutted in 1957 and is now in ruins. They are to be found by the River Lowther in the village of the same name, four miles south of Penrith.

"Lozere"

Edward Challinor. Romantic patterns printed in light blue on ironstone dinner wares. Ill: P. Williams p.319 (two examples).

Lozere is the old French province of Languedoc, a mountainous area that slopes down to the Rhône valley.

"The Lower Lake of Killarney." Careys. "Irish Views" Series. Printed titles mark with maker's name. Plate 10¾ins:27cm.

Lucano

See: Bridge of Lucano.

Lucas, Thomas

An engraver engaged by Josiah Spode in 1783 to work on patterns for blue-printed wares. He had previously been working at Caughley in Shropshire.

"Lowther Castle, Westmorland." Maker unknown. Crown Acorn and Oak Leaf Border Series. Printed title mark. Dish 19¼ins:49cm.

"Lucern" (sic)

Maker unknown. This title has been noted in upper case letters within a simple cartouche on a large mid-19th century washbowl.

"Lucerne"

Maker unknown. This appears to be a direct copy of the Minton "Genevese" design. The title is contained in a scroll cartouche very similar to that used by Minton.

Lucerne is the capital of the Swiss canton of the same name. It lies on the River Reuss where it flows out of Lake Lucerne.

"Lucknow"

John Hall & Sons. "Oriental Scenery" Series. Sauce tureen stand.

Lucknow is a city in northern India, not far from the border with Nepal. It contains many ancient buildings including palaces, mosques, and a notable mausoleum. It was here that Sir Henry Lawrence was besieged during the Indian Mutiny in 1857, being relieved by Sir Colin Campbell after several months.

"Ludlow Castle, Salop"

William Adams. Bluebell Border Series. Plate 7½ins:19cm.

Ludlow Castle was built at the end of the 11th century. In the late 15th century it became the seat of the Lords President of Wales and their Court of the Marches. It was ruined in the 18th century by the removal of lead from the roof.

Lumley Castle, Durham

John & William Ridgway. Angus Seats Series. Plate 7¼ins:18cm.

In common with all items from this series the view is not titled and marked pieces are very rare.

"Lumley Castle, Durham"

(i) James & Ralph Clews. Bluebell Border Series. Dish 15ins:38cm. Ill: Moore 34.

(ii) Maker unknown. Pineapple Border Series. Sauceboat.

Lumley Castle, originally built as a mansion in the reign of Edward I, was converted to a fortress in the reign of Richard II. In the 17th century it was subjected to a complete renovation in the Italian style.

"Luscombe, Devon"

(i) Enoch Wood & Sons. Grapevine Border Series. Plate 7ins:18cm.

(ii) Maker unknown. Crown Acorn and Oak Leaf Border Series. This title has been found printed in error on a drainer with the view of "Wakefield Lodge, Northamptonshire". No item in this series with the view of Luscombe has yet been noted.

"Luscombe, Devonshire"

Ralph Hall. "Select Views" Series. Sauce tureen stand and pierced basket stand.

Luscombe Castle was built by John Nash in 1800 for Charles Hoare, the banker. It is a castellated mansion with a large Gothic porch and a central tower. The grounds were designed by Humphrey Repton.

"Luton Hoo, Bedfordshire, Marquis of Bute's Seat"

Careys. Titled Seats Series. Dish 11½ins:29cm, and pierced basket.

This view shows the original house designed by Robert Adam in the 18th century for the third Marquis of Bute (1713-92). He was a leading politician closely associated with George III. Since then the house has been remodelled twice, first by Sir Robert Smirke in about 1827 and again in 1903 for Sir Julius Werhner, the diamond magnate. It is still owned by the Werhner family and is open to the public in summer.

"Lyme Castle, Kent" (sic)

William Adams. Bluebell Border Series. Dish 21ins:53cm.

Lympne Castle has a Roman, Saxon and Norman history. It was rebuilt about 1360 and is in a commanding position on the coast, some four miles from the ancient Cinque Port of Hythe.

"Lymouth, North Devon" (sic)

Maker unknown. Beaded Frame Mark Series. Shallow moulded dish.

Lynmouth is a resort on the north Devon coast, about eighteen miles north east of Barnstaple. It has a small harbour and the River Lyn descends through a wooded gorge to the coast.

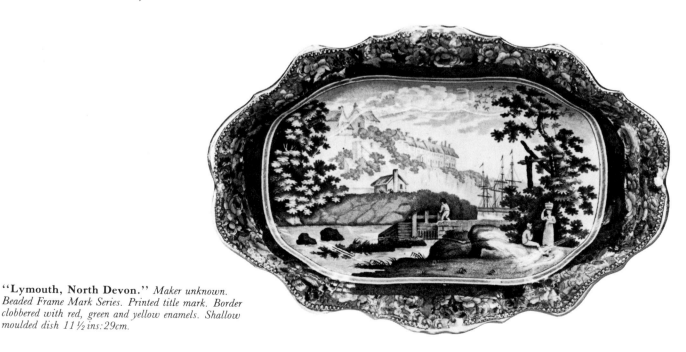

"Lymouth, North Devon." *Maker unknown. Beaded Frame Mark Series. Printed title mark. Border clobbered with red, green and yellow enamels. Shallow moulded dish 11½ins:29cm.*

"Macclesfield Bridge, Regent's Park"

Enoch Wood & Sons. "London Views" Series. Plate 7½ ins:19cm.

Macclesfield Bridge crossed the Regent's Canal on the north side of the park to give access to Primrose Hill via Macclesfield Gate. It was designed by James Morgan and noted for its piers which were cast iron columns of Grecian Doric design. The print shows the bridge from the bank of the canal on which is a horse-drawn barge marked Pickford.

Machin & Potts fl.1833-c.1842

Waterloo Pottery, Burslem, Staffordshire. W.W. Potts started his career as a calico printer at the New Mills Works near Derby. When he joined William Machin he used his experience to devise new methods for transfer-printing on ceramics. Ward writes that Machin & Potts "have... introduced a new process for printing china and earthenware by machinery, the paper impressions being thrown off from steel cylinders, each engraved with the required pattern in rapid and almost endless succession, ready for the transferrer's hands".

The original patent was taken out in 1831 and followed in 1835 by a second which covered multi-colour printing. The firm marked their wares with the full printed name, sometimes with the addition of the word "PATENT". A mark is illustrated by Chaffers which consists of a crest with the inscription "W.W. POTTS'S PATENT Printed Ware" above, and the address "St. George's Potteries, New Mills, Derbyshire" below. Little (p.79) suggests that it may be an early piece made while experiments were still being made at the calico works in Derbyshire.

Macri

See: The Harbour at Macri.

"Maddle Jenny Lind"

William Adams & Sons and also J.T. Close (Close & Co. appear to have taken over the Church Street works in 1855). This design has been noted on small plates. The word Maddle is an equivalent of the English Madam.

See: Lind, Jenny.

Maddock, John (& Sons) fl.1842 to present

Newcastle Street, Burslem, Staffordshire. This firm was a continuation of the Maddock & Seddon business. The style became John Maddock & Sons in 1855 and the firm added a further pottery at Dale Hall, Burslem.

Some of the designs used by Maddock & Seddon were continued by the new firm including the pattern titled "Fairy Villas". The original initials M. & S. were altered to read simply M. The name "MADDOCK" was also used. Marks introduced after 1855 include "& Sons".

Maddock & Seddon fl.c.1839-1842

Newcastle Street, Burslem, Staffordshire. Wares from this firm bear marks which include the initials M. & S., often with a title and the name of the body "Stone China". A good example is the pattern called "Fairy Villas" (qv).

"Mahomedan Mosque & Tomb" (sic)

John Hall & Sons. "Oriental Scenery" Series. Plate 9¾ ins:25cm. Ill: FOB 11; P. Williams p.154.

"The Maid at the Mill, Act 1, Scene 1"

John Rogers & Son and Pountney & Goldney. "The Drama" Series.

This pattern probably represents a scene from *The Maid of the Mill*, a comic opera by Isaac Bickerstaffe (c.1735-1812) which was written in 1765 when he was a page to Lord Chesterfield, Lord Lieutenant of Ireland. It was based on Samuel Richardson's *Pamela*, which exploded the prevalent notion that dukes and princesses were the only possible heroes and heroines. The play won immediate popularity.

"Maison de Raphael"

Enoch Wood & Sons. French Series. Plate 6½ ins:16cm, and custard cup. Ill: Arman S 198.

Makers' Initial Marks

Sometime during the 1820s it became common practice to use a printed mark with a pattern title, and for some reason many factories chose to add their initials to the mark. It is not clear why the use of impressed name marks fell from fashion or why marks carried initials rather than a full name, although it may be that the powerful London retailers were reluctant to market marked examples due, it is said, to their concern that customers might approach the potters direct.

Most initial marks can be traced by reference to the Index of Makers' Initials at the end of the dictionary.

Maling, Christopher Thompson fl.1853-1890

Ouseburn Bridge Pottery, Ford (A) and Ford (B) Potteries, Newcastle-upon-Tyne, Northumberland.

C.T. Maling succeeded his father Robert at the Ouseburn Bridge Pottery in 1853. It was only a small factory and in 1859 the Ford (A) works were added, covering some two acres of land. The Ford (B) works were built in 1878. The output of the firm was considerable, a vast number of jam pots, jars, bottles, and official measuring mugs and jugs were made. Blue-printed wares were made but there appears to be little of interest to the specialist collector. A wide variety of marks were used, either with the name in full or the initials C.T.M.

A full account of the development of this firm and its successors is given by Bell in *Tyneside Pottery*.

Maling, Robert fl.1817-1853

Ouseburn Bridge Pottery, Newcastle-upon-Tyne, Northumberland. Robert Maling (1781-1853) was previously involved in the family business at the North Hylton Pottery, Sunderland, and was responsible for the move to Ouseburn which began in 1815. Blue-printed wares typical of the period were made, including common patterns such as Willow and "Albion". The usual mark was "MALING" impressed or simply the initial M. Printed marks are known with the name or initials R.M.

Malkin, Walker & Hulse fl.1858-1864

British Anchor Pottery, Longton, Staffordshire. Printed title marks were used with the initials M.W. & H.

"**Malmsbury Abbey, Wiltshire.**" *Maker unknown. Pineapple Border Series. Printed title mark. Dish 11½ ins:29cm.*

"**Malmsbury Abbey, Wiltshire.**" *Maker unknown. Pineapple Border Series. Printed title mark. This view may be incorrectly titled since it does not appear to be Malmesbury Abbey. Tray 11½ x 8¾ ins:29 x 22cm.*

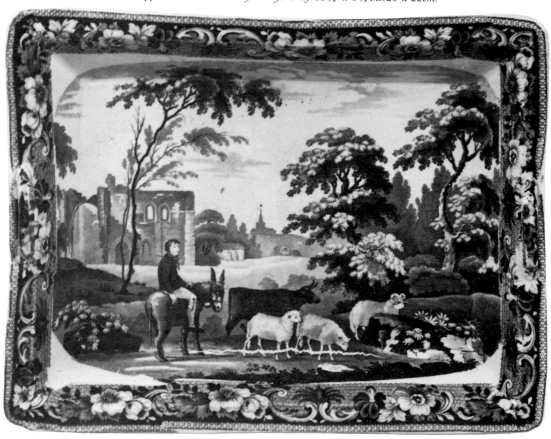

"Malmsbury Abbey, Wiltshire" (sic)
Maker unknown. Pineapple Border Series. Dishes 11½ ins:29cm and 12¾ ins:32cm.

This view is taken from a source print which is reproduced in Marshall's *Select Views in Great Britain*, Vol. 2, p.81. The same title has also been recorded on a tray (11½ ins:29cm) with a different view, possibly incorrectly titled.

Malmesbury Abbey was a Benedictine foundation. The second Abbot, St. Aldhelm, added several churches in the 8th century. The present church was part of the abbey. It is mainly 12th century and is noted for its beautiful Norman porch.

"Mandarin Opaque China."
Printed title mark.

"Mambrino's Helmet"
James & Ralph Clews. Don Quixote Series. Plate and soup plate, both 10ins:25cm. Ill: Arman 74.

Mandarin
A Spode pattern which may well have been the origin of the standard Willow pattern. Copeland describes it as characterised by a "central willow tree growing at the edge of a river and leaning out to the left over the water". There is a tea-house to the right, a small pavilion to the left, two birds in the sky, and an island. There are several versions, mainly on bone china, but a version which Copeland calls Mandarin I is found on pearlware (Ill: Copeland pp.35, 47).

"Mandarin"
Pountney & Co. A gilt edged titled pattern in flow blue.

"Mandarin Opaque China"
Maker unknown. This series title is printed in a cartouche on wares bearing scenes with Chinese figures. Four different designs have been noted to date:

(i) Two Chinese figures in a stylised floral surround which includes a classical urn.

(ii) Three Chinese figures, one seated.

(iii) A Chinese gardener carrying a triangular spade and a bucket.

(iv) Three Chinese figures and a dog, two of the figures holding birds.

These designs appear to be part of a multi-pattern service. One example has been noted with the impressed seal mark "Improved Stone China" (qv) which suggests that the wares may have been made by Minton.

"Mandarin Opaque China."
Maker unknown. Printed mark with title. Soup plate 9¾ ins:25cm.

Marine Archaeology. *Rhyl Sub-Aqua Club divers, John Pavah, John Spiller and Steven Cryer, bring up some Podmore, Walker & Co. blue-printed "COREAN" pattern plates from the wreck of the "Ocean Monarch" lost off Colwyn Bay on 24 August, 1848. (By kind permission of North Wales News Pictures.)*

Marine Archaeology. *Podmore, Walker & Co. plate brought up from the wreck of the "Ocean Monarch". Apart from chips and an attached barnacle it has survived its long submersion remarkably well.*

"Manilla" (sic)
Podmore, Walker & Co. A flow-blue chinoiserie pattern with a central willow tree and pagoda, printed on ironstone. Ill: Laidacker p.62.

The name probably derives from the capital of the Philippines, Manila. It is unusual to find a chinoiserie design with a romantic-style pattern name.

Mann & Co. fl.1858-1860
Cannon Street, Hanley, Staffordshire. This short-lived partnership between Arthur and Edward Mann produced blue-printed wares, one pattern showing an elephant between two palm trees. The impressed mark of a rectangular frame containing the name "MANN & Co/HANLEY" has been recorded. Godden states that similar wording can be found on printed marks with pattern titles (Godden M 2498).

"Mantua"
Read & Clementson. A romantic pattern within a border with scenic medallions. It was printed in light blue on ironstone. Ill: P. Williams p.325.

Mantua is a city in northern Italy. It is best known as the birthplace of Virgil, and in the 18th century was in the possession of Austria. The Italian name is Mantova.

"Many a Little Makes a Mickle"
Davenport. "Franklin's Morals" Series. Plate. Ill: Camehl, *The Blue China Book.*

A rural scene with a woman and child in the foreground. The maxim was used by Benjamin Franklin in the introduction to *Poor Richard's Almanack* for 1758. The Franklin version is unusual. The Cervantes original: "Muchos pocos hacen un macho" is translated in *The Oxford Dictionary of Quotations* as: many a pickle makes a mickle.

Marble
A Spode sheet pattern introduced c.1821. It was used for teawares on both earthenware and New Stone, and was later revived by Copelands. Two alternative names are Mosaic, and Cracked Ice and Prunus. Ill: Coysh 2 101; Whiter 37.

Mare and Foal
Davenport. A country scene under this title was illustrated in Coysh 1 34. Since then, other patterns with the same border have come to light and there was clearly a series of rural scenes. The designs noted to date are:

(i) A mare and foal at the side of a river with a country house in the background. Ill: Coysh 1 34.

(ii) A fisherman on an island, again with a country house in the background. Ill: FOB 25.

(iii) Two men on horseback talking to a woman, a central house, and two cows in the foreground.

(iv) Traveller with a bundle on a stick approaching two female figures by a cottage. Three-arched bridge and further cottages in the distance.

Mare, John fl.c.1802-1825
Shelton, Hanley, Staffordshire. The impressed mark "MARE" is generally accepted to have been used by this potter. The main blue-printed pattern found with this mark is a good quality copy of the Spode Italian design. In addition to the usual dinner wares, two major pieces with the pattern are known, a footbath illustrated in Godden I 373, and a cheese coaster in the Castle Museum, Norwich.

"Marine"
(i) J. & M.P. Bell & Co.
(ii) Job & John Jackson. A pattern printed in dark blue.
(iii) George Phillips. A pattern printed in light blue on ironstone dinner wares.

Marine Archaeology
Blue-printed wares were exported to North America in large quantities in the first half of the 19th century, often carried as cargo on emigrant ships. A number of such ships are known to have foundered, leaving their cargoes on the sea bed. A striking example has recently come to light. In 1848 the *Ocean Monarch* left Liverpool for Canada but caught fire off the north Wales coast and was lost with 178 lives.

In 1979 a fishing trawler's nets were fouled in the area and when a diver went down to free them he discovered that they were caught in a wreck. Three divers from the local sub-aqua club examined the ship and found the *Ocean Monarch,* complete with its ceramic cargo in storage racks. They brought up several pieces in slightly flow blue bearing the title "Corean" and marked Podmore, Walker & Co., together with some plain white wares marked R. Hall & Co.

Podmore, Walker & Co. had a flourishing trade with Canada and as a result produced some wares with Canadian views. See: E. Collard, *Nineteenth Century Pottery and Porcelain in Canada* (1967).

Ralph Hall is known to have exported dark blue wares to America including British views such as the "Picturesque Scenery" and "Select Views" Series. By a fortunate quirk of marine archaeology we can now suggest that Podmore, Walker & Co. must have been negotiating the transfer of the Swan Bank Works at Tunstall from Ralph Hall before the latter firm finally closed in 1849. It seems that they may have acquired some of Hall's stock at this period, or alternatively were assisting him in its sale in North America.

"Mariner's Arms"
This title has been noted on a presentation mug by an unknown maker (see overleaf). On one side an ornate coat-of-arms with a prominent anchor has two sailors with flags as supporters and a three-masted sailing ship as a crest. The arms are titled as above and also bear the motto "Deus Dabit Vela" — God Will Fill the Sails. On the other side are tools of many occupations and Masonic emblems including dividers, key, quills, ladder, three candles and a book, trowel, mallets, a coffin and a prominent eye. The mug is inscribed "R. & E. YOUNG, 1826".

Presentation mugs were usually personal gifts but it is possible that this particular example was made for a public house called the Mariner's Arms.

Marks
In the 18th century most potters produced wares without any marks but in the early years of the 19th century marked wares became more common. As the century progressed the use of marks steadily became the rule rather than the exception.

Early marks were impressed and simple in form, consisting of only the name of the maker or his pottery. These tended to become more complex in the first quarter of the 19th century, often including some trade device such as a crown or an eagle, together with more extensive wording. The introduction of printed marks gave much more scope and from about 1820 the use of pattern titles became widespread. Many such marks were used to contain the place name for views, but the form remained relatively simple until the romantic style patterns became common in the 1830s, the associated marks often being quite ornate. Later marks tend to be complex but more functional and less artistic.

See: Anchor Mark; Backstamp; Cartouche; Crown Mark; Date Marks; Eagle; Impressed Mark; Initial Marks; Plus Marks; Potters Count; Printed Mark; Registration Mark; Retailers' Marks; Rock Cartouche; Sizes; Stilt Marks; and Workman's Marks.

"Mariner's Arms." *An inn mug with a shield and naval symbols on one side with the motto "DEUS DABIT VELA" and many symbols of trades on the other. The names of "R. & E. YOUNG 1826" are painted in black underglaze. Height 4¾ ins:12cm.*

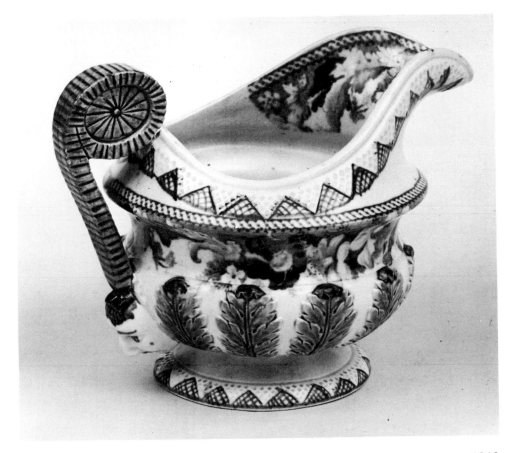

Marsh, Jacob. *Circular sauceboat. Impressed "MARSH". Printed royal arms with the words "OPAQUE CHINA WARRANTED". Height 5¼ ins:13cm. Note the moulded face at the base of the handle.*

"Marmora"

William Ridgway & Co. A river scene with Eastern buildings within a floral border containing medallions, each with the same small view. The pattern is titled on a ribbon printed below an anchor superimposed on an urn (very similar to Godden M 3303a). Ill: FOB 10.

Marmora, also known as Marmara, is an island in the Sea of Marmora which lies between the Black Sea and the Aegean. It is famous for its marble quarries.

Marsh, Jacob fl.c.1804-1818

Burslem, Staffordshire. There were several potters with this surname in Staffordshire before 1828, one of whom was Samuel Marsh, possibly Jacob's son. The impressed mark "MARSH" has been recorded but it is not possible to attribute it to a particular potter. This impressed mark has also been found in association with a large printed royal arms mark with the words "OPAQUE CHINA WARRANTED". An ornate moulded sauceboat with this mark is illustrated and it is also known on a version of the Villager pattern usually associated with Turner.

Marsh & Willet fl.c.1835

Burslem, Staffordshire. This firm appears in a directory of 1835 but no other record appears to exist. They are believed to have been responsible for a blue-printed pattern titled "Tom Piper" which is marked with initials M. & W. No other firm of appropriate date has the same initials.

Marshall, John (& Co.) fl.1854-1899

Bo'ness Pottery, Borrowstounness, Scotland. This firm succeeded James Jamieson & Co. in 1854, the style becoming John Marshall & Co. in 1866. Printed marks are known which include the name in full or the initials J.M. & Co.

Martin, John c.1810

The name of a Shelton engraver sometimes found on underglaze blue-printed patterns. The date of around 1810 is given by Little (p.80).

Mason, Charles James fl.1845-1854

Fenton Works, Lane Delph (1845-48) and Daisy Bank, Lane End (1849-54), Staffordshire. This firm succeeded C.J. Mason & Co. The change of address in 1848-49 is explained by Mason's bankruptcy. The standard Mason's Patent Ironstone China mark was continued and it is not usually possible to differentiate such wares from those made by the earlier firm.

Mason, Charles James, & Co. fl.1826-1845

Fenton Works, Lane Delph, Staffordshire. These works were sometimes known as the Fenton Stone Works or as the Patent Ironstone China Manufactory. This firm continued many of the wares and marks introduced by their predecessors, G.M. & C.J. Mason. Printed marks can also be found with the initials C.J.M. & Co., and the legend "GRANITE CHINA" was occasionally used. The firm was continued after 1845 by Charles Mason alone.

Mason, G.M. & C.J. fl.1813-1826

Fenton Works, Lane Delph, Staffordshire. The patent for ironstone china was taken out by C.J. Mason in 1813 and the firm concentrated largely on the production of the new durable body. The earlier wares bear an impressed mark "MASON'S PATENT IRONSTONE CHINA" in one or two lines, with a circular version omitting the name Mason's used on smaller pieces. Later, the famous printed mark with the same legend above a crown and on a scroll beneath, became widespread

239

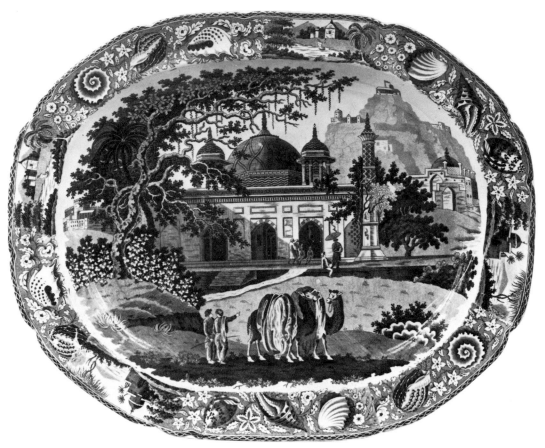

Mausoleum of Nawaub Assoph Khan, Rajemahel. *Herculaneum. India Series. Impressed maker's mark. Dish 20ins:51cm.*

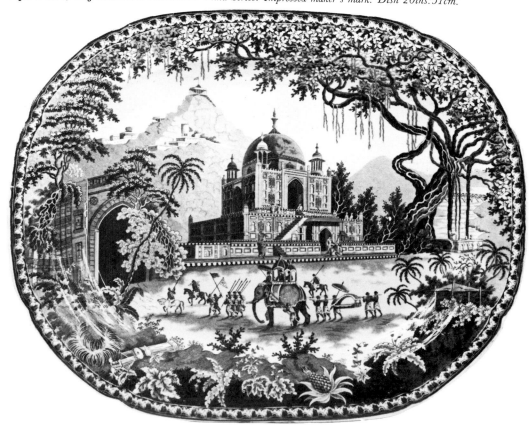

Mausoleum of Sultan Purveiz, near Allahabad. *Attributed to Herculaneum. India Series. Unmarked. Dish 15¼ins:39cm.*

and superseded the impressed mark. This mark was continued by the firm's successors.

Although the production of ironstone was of prime importance, the firm did not entirely neglect other earthenwares. The impressed mark "MASON'S CAMBRIAN ARGIL" can be found on blue-printed wares, and another mark was "SEMI-CHINA WARRANTED" printed in two lines, rarely with the addition of the name "MASON'S". See: G.A. Godden, *Mason's Patent Ironstone China* (1971); *Godden's Guide to Mason's China and the Ironstone Wares* (1980); Haggar and Adams, *Mason Porcelain and Ironstone, 1796-1853* (1977).

Mason, John
This name appears in the form "JOHN MASON, MEMEL" with a ship inside an oval frame, on the standard Willow pattern, replacing the doves in the sky.

Memel is now known as Klaipeda, a seaport on the Baltic coast of Lithuania. It was part of Prussia and the German Empire until 1919 and was ceded to Lithuania in 1923. John Mason was a shipping agent who kept a Captain's Hotel.

Mason, Miles fl.1800-1813
Victoria Pottery (1800-6) and Minerva Pottery (1806-13), both in Lane Delph, Fenton, Staffordshire. Miles Mason was a London retailer who started in the pottery trade in Liverpool when the tax on imported Chinese porcelains became excessive. He moved to Staffordshire in about 1800 and his firm tended to concentrate on the manufacture of porcelain. He did, however, produce some printed wares using an early version of stone china. He took his sons William, George and Charles into the business and when he retired in 1813 the firm was continued by the last two. It is possible that Miles Mason invented the famous Ironstone China although it was his son, Charles, who applied for the patent and who usually gets the credit.

Although Miles Mason marked his porcelains with both impressed and printed marks using his full name, few marked earthenwares appear to have been recorded although early stone china must have been made before 1813.

Mason, William fl.c.1811-1824
Lane Delph, Staffordshire. Blue-printed wares marked by this potter are rare. He produced a series of views within a border of flowers and small medallions, a few of which have been recorded with the printed name "W. MASON". Examples are illustrated in Coysh 2 50; Godden I 389. In 1824 he left the potting industry and opened a retail establishment in Manchester.

"Mausoleum of Kausim Solemanee at Chunar Gur"
Maker unknown. Parrot Border Series. Plate 10ins:25cm.

Mausoleum of Nawaub Assoph Khan, Rajemahel
An aquatint published in June 1803 in T. and W. Daniell's *Oriental Scenery* (Part III, 24). This provided the main feature for a pattern by the Herculaneum Pottery in the India Series, printed on a dish with a border of sea shells and small Indian scenes. The decoration on the dome was taken from "The Mausoleum of Mucdoom Shah Dowlut, at Moneah, on the River Soane" (Part I, 12); the building on the extreme right from "View at Delhi, near the Mausoleum of Humaioon" (Part III, 19); and the background from a "View in the Fort of Tritchinopoly" (Part II, 21). Ill. Coysh 2 42; Smith Colour Plate IV.

Mausoleum of Sultan Purveiz, near Allahabad
An aquatint published in November 1796 in Thomas Daniell's *Oriental Scenery* (Part I, 22). This provided the main feature for a pattern attributed to the Herculaneum Pottery in the India Series, within a foliage border.

The procession in the foreground is simplified from the "Eastern Gate of the Jummah Musjid at Delhi" (Part I, 1); the tree on the right is printed in reverse from "The Sacred Tree of the Hindoos at Gyah, Bahar" (Part I, 15); the ruin on the left is from "Ruins at the Antient City of Gour formerly on the Banks of the River Ganges" (Part I, 4); and the usual India Series background based on a "View in the Fort of Tritchinopoly" (Part II, 21). Ill. Coysh 2 140.

It appears that the pattern depicts the Governor General's suwarree, or procession.

"Maxstoke Castle, Warwickshire"
(i) Enoch Wood & Sons. Grapevine Border Series. Plate 8¼ins:21cm.
(ii) Maker unknown. Foliage Border Series. Dish 15ins:38cm.

Maxstoke Castle dates from 1346 and was remodelled in the 15th century. It is surrounded by a perfect moat.

"May Morn"
J. & M.P. Bell & Co. A pattern with a wide border of hawthorn noted on a bowl 13½ins:34cm.

May, Robert fl.c.1829-1830
Hanley, Staffordshire. When the partnership of Toft & May ceased in about 1829, Robert May continued for a brief period on his own. His impressed mark, simply "MAY", has been recorded on the "Fountain" pattern, illustrated as the Bird Fountain pattern in Coysh 2 56.

"*May Morn.*" *J. & M.P. Bell & Co. Printed title mark with maker's initials. Bowl 13½ins:34cm.*

Mayer Partnerships

Mayer was a common name in the Staffordshire Potteries in the early 19th century. A number of works were operated by potters of this name, many of whom were probably members of a large family. They are listed below in chronological order with a note of the marks they used:

Elijah Mayer of the Cobden Works, Hanley. Impressed mark "E. MAYER". c.1790-1804

Elijah Mayer & Son, also of the Cobden Works, Hanley. Impressed or printed name in full: "E. MAYER & SON". 1805-1834

Mayer & Newbold of Market Place, Lane End. Printed mark with initials M. & N. or the name in full. c.1817-1833

Joseph Mayer & Co. of High Street and Church Works, Hanley. Marks are "MAYER & Co." or the name in full. c.1822-1833

Thomas Mayer of the Cliff Bank Works, Stoke and Brook Street, Longport. Printed marks with the name "T. MAYER". c.1826-1838

John Mayer of Foley. Printed marks with the initials J.M. over the initial F. 1833-1841

Mayer & Maudesley of Tunstall. Printed marks with the initials M. & M. 1837-1838

Thomas, John & Joseph Mayer of the Furlong Works and Dale Hall Pottery, Burslem. Printed marks with the name in full or Mayer Bros. 1843-1855

Mayer & Elliott of Fountain Place and Dale Hall, Longport. Printed marks with the initials M. & E. in cursive script. 1858-1861.

Thomas Mayer and the partnership of Thomas, John & Joseph Mayer are known to have exported wares to America between 1830 and 1860, including some flow-blue patterns. Thomas Mayer used an American eagle in his mark on such export wares.

"Mayflower"
J. & M.P. Bell & Co.

"Maypole"
Little mentions this title as if it were part of "The Drama" Series by John Rogers & Son. No confirmation of this fact has yet become known. If it does exist, it was possibly also copied by Pountney & Goldney of Bristol. See: Little p.94.

"Mecca"
Maker unknown. A typical romantic pattern marked with a printed cartouche very similar to one used by John Ridgway (Godden M 3257), but with the unidentified initials C.R. & S. The plate noted also bore a prominent impressed anchor.

Mecca is in Saudi Arabia. It was the birthplace of Mohammed and is the chief Holy City of the Moslems.

Medallion
A term used for a panel enclosed by lines, scrolls, or other decorative edging. Medallions were frequently used in borders to contain small scenes of the same type as the central pattern, or to frame floral sprays.

"Medici"
Mellor, Venables & Co. A romantic pattern with a large urn decorated with figures in relief in the foreground. There is a statue behind a sloping balustrade to the left, and in the distance is a very tall classical building seen above a dark archway. The border has a scroll pattern with reserves, each containing an urn with two scrolled handles. Ill: P. Williams p.333.

"Medici" *Mellor, Venables & Co. Printed title and maker's mark. Dish.*

"Medina"

A pattern title used by:

(i) Dixon, Austin & Co. and their successors Dixon, Phillips & Co. of Sunderland.

(ii) Jacob Furnival & Co. A light blue design on ironstone.

(iii) Thomas Godwin. A series of romantic views with tents, minarets, and people in Arab costume. Examples are illustrated in Godden I 275; P. Williams p.141. The mark is shown in Godden M 1731.

(iv) Charles Meigh, Son & Pankhurst.

Medina is in Saudi Arabia, about two hundred miles north of Mecca. It is the second Holy City of the Moslems and contains the tomb of Mohammed in the main mosque. It became a centre of religious learning and now attracts large numbers of pilgrims.

"Meeting of Don Quixote and Sancho Panza"

James & Ralph Clews. Don Quixote Series. Plate 6¾ins:17cm, and sauce tureen stand. Ill: Arman 73.

There is disagreement over the title of this design, some writers omitting the words "Meeting of". The confusion is probably caused by another scene in the same series which is titled simply "Don Quixote and Sancho Panza".

"The Meeting of Sancho and Dapple"

James & Ralph Clews. Don Quixote Series. Plate 9ins:23cm. Ill: Arman 76.

Meigh, Charles fl.1835-1849

Old Hall Pottery, Hanley, Staffordshire. Although Job Meigh died in 1817 the style of the firm did not become Charles Meigh until 1835. At this period printed wares were produced largely in colours other than blue. Printed marks generally include the initials C.M. whereas impressed marks tend to have the name in full. The firm is particularly noted for its moulded stoneware jugs.

Meigh, Charles, & Son fl.1851-1861

Old Hall Pottery, Hanley, Staffordshire. Following another brief partnership (see below) the style became Charles Meigh & Son in 1851. Printed marks include the initials C.M. & S. and Godden also quotes M. & S. although these are known to have been used by Maddock & Seddon some years earlier.

Meigh, Charles, Son & Pankhurst fl.1850-1851

Old Hall Pottery, Hanley, Staffordshire. A brief partnership which existed long enough to issue some designs with printed marks including the initials C.M.S. & P.

Meigh, Job (& Son) fl.1805-1834

Old Hall Pottery, Hanley, Staffordshire. This firm became established in 1805 and became Job Meigh & Son in about 1812, a style which continued, despite the death of the father in 1817, until 1834. Early impressed marks were the name "MEIGH" or sometimes "OLD HALL". Later printed marks include the initials J.M. & S., although these were extensively used by John Meir & Son at a later date and style must be considered when attributing such marks. They made blue-printed wares but not many marked examples are found. An attractive series showing animals is titled "Zoological Sketches" (qv).

Meir, John fl.c.1812-1836

Tunstall (Greengates Pottery from about 1820), Staffordshire. The earlier mark of this potter was the simple impressed name "MEIR". This is most commonly found on the River Fishing pattern (qv) but is also recorded on a child's plate in Little 43. Later printed marks include the initials J.M. or I.M.

"Medina." *Thomas Godwin. Printed title mark with maker's initials. Dish.*

Melville Castle, Midlothian. *John & William Ridgway. Angus Seats Series. Unmarked. Dish 17ins:43cm.*

Meir, John & Son fl.1836-1897
Greengates Pottery, Tunstall, Staffordshire. This firm made large quantities of blue-printed ware, often with title marks. Such marks include the initials J.M. & S. or I.M. & S., both of which may have been used at an earlier date by Job Meigh & Son (qv). Later marks tend to have the name in full.

Amongst the patterns made were the common "Wild Rose" design and many romantic style patterns. One particularly notable series was titled "Northern Scenery", although the printed title mark is known with two sets of initials, J.M. & S. or J.M. & Co. Godden states that no firm used both sets of initials although the attribution to Meir is commonly accepted (See: Godden M 4461-4462).

Mellor, Venables & Co. fl.1834-1851
Hole House Pottery, Burslem, Staffordshire. This firm has been recorded as producing printed wares for the American market, although Little states that much of this output was in colours other than blue. Romantic patterns such as "Burmese" were made as were several American scenes. Printed and impressed marks are known with either the name in full or the initials M.V. & Co.

"Melrose"
Clyde Pottery Co.

Melrose is a historic regional centre on the River Tweed, noted particularly for its abbey.

"Melrose Abbey, Roxburghshire"
William Adams. Bluebell Border Series. Plate 7ins:18cm.

According to earlier writers, this view is always mismarked "Branxholm Castle, Roxburghshire" and vice versa, presumably due to an engraver's error. Untitled views of the abbey by William Adams and James & Ralph Clews have been identified on plates in the Foliage and Scroll Border Series.

Melrose Abbey was founded in 1136 by David I, and was once the most magnificent building in Scotland. It is now a splendid ruin which was presented to the nation in 1918 by the Duke of Buccleuch.

Melville Castle, Midlothian
John & William Ridgway. Angus Seats Series. Dish 17ins:43cm.

In common with all items from this series the view is not titled and marked pieces are very rare.

The original building on this site was said to have been the hunting lodge of Mary Queen of Scots. James Playfair replaced it with a new building in the style of Inveraray Castle for Henry Dundas (1742-1811), the first Viscount Melville. It lies one mile north east of Lasswade on the North Esk.

"Menai Bridge"
Thomas Dimmock & Co. "Select Sketches" Series. Vegetable dish base and soup plate 10½ins:27cm. Ill: Coysh 2 27.

This view is based on a steel engraving after a drawing by Henry Gastineau which was used on the title page of *Wales Illustrated in a Series of Views comprising the Picturesque Scenery, Towns, Castles, Seats of the Nobility and Gentry, Antiquities etc.*, published by Jones & Co., Temple of the Muses, Finsbury Square, London in 1830.

The Menai Suspension Bridge was built by Thomas Telford and opened in 1826. It carries the London to Holyhead road over the Menai Strait. In the background of the pattern is the Marquis of Anglesey's Column, built to commemorate the achievement of Henry William Paget, second-in-command at the Battle of Waterloo in 1815. The Menai Bridge was reconstructed to the original design between 1938 and 1940 after which it was freed of tolls.

"**Menai Bridge.**" *Title page engraving from Henry Gastineau's "Wales Illustrated" (1830) on which the Dimmock "Menai Bridge" view was based.*

"**Menai Bridge.**" *Thomas Dimmock & Co. "Select Sketches" Series. Printed titles mark with initial D. Soup plate 10½ ins:27cm.*

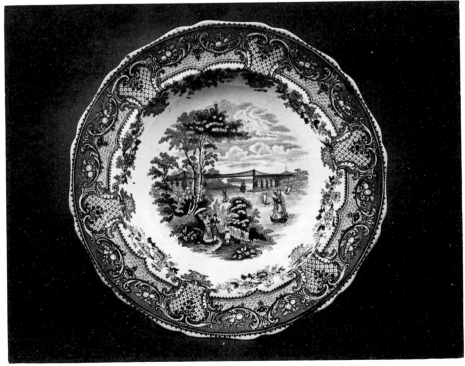

"Merchant of Venice, Act 4, Scene 1"
John Rogers & Son and Pountney & Goldney. "The Drama" Series.

"Merchant of Venice, Act 5, Scene 4"
John Rogers & Son and Pountney & Goldney. "The Drama" Series.

Shakespeare wrote this play in 1595 and it was printed in 1600 as *The most excellent Historie of the Merchant of Venice. With the extreame crueltie of Shylocke the Jewe towards the sayd Merchant, in cutting a iust pound of his flesh: and the obtayning of Portia by the choice of three chests.* The story was derived from three sources — Il Pecorone, Gesta Romanorum and Masuccio.

"Mereworth House"
Andrew Stevenson. Rose Border Series. Dish 22ins:56cm, and a footbath.

Mereworth House in Kent, sometimes called a castle, is an 18th century building by Colen Campbell based on Palladio's Villa Rotunda at Vicenza.

"Merio"
Clyde Pottery Co.

"Merry Wives of Windsor, Act 5, Scene 5"
John Rogers & Son and Pountney & Goldney. "The Drama" Series. Moulded dish or comport.

The pattern, which depicts Falstaff with the Merry Wives under the oak in Windsor Great Park, was copied from a painting by Robert Smirke R.A. (although the painting actually depicts Act 4), for the Boydell Shakespeare Gallery. The play was written c.1599 and printed in 1602 as *A most pleasant and excellent conceited comedie, of Syr John Falstaffe, and the merrie Wives of Windsor.*

Mess Plates
Plates were often specially commissioned for use in mess rooms on board naval ships, usually with the number of the mess printed on the face.

Examples are known with a variety of different designs and borders. Some were made by the Bovey Pottery Co. in Devon, and possibly also by their predecessors the Bovey Tracey Pottery Co. Others are known with the marks of Copeland, Pountney & Co., and of the Cardiff and Swansea retailers F. Primavesi & Son.

One unmarked but particularly attractive example, probably dating from the 1840s, has been noted with a border composed of small rural scenes depicting the four seasons. The scenes were a maypole (spring), haymaking (summer), harvesting (autumn), and ice skating (winter).

"Messina"
Wood & Challinor. A pattern printed in light blue on ironstone.

Messina is a seaport in north east Sicily which lies on the strait separating the island from mainland Italy. It was damaged in 1848 when it was taken by Neapolitan troops after a five-day siege. It was practically destroyed by an earthquake on 28th December, 1908.

Methven, David & Sons fl.c.1840-1930
Kirkcaldy Pottery, Fife, Scotland. David Methven died in 1861 and his works were taken over by Andrew R. Young who later became the proprietor, retaining the name of Methven & Sons. Later wares are marked with the initials D.M. & S. or with the name in full.

Mess Plates. *Bovey Pottery Co. Ltd. Printed maker's initials. Plate 9½ins:24cm.*

"Metropolitan Scenery" Series
A series of views around London were produced by Goodwins & Harris, the maker being identified by an impressed mark on one piece. All other examples recorded to date are unmarked. The border is composed of passion flowers and leaves and other smaller floral sprays. The printed cartouche bears both the series title and the name of each individual scene. The known titled views are:
 "Bow Bridge"*
 "Hampton House"
 "Kingston on Thames"
 "North End, Hampstead"
 "St. Albans Abbey"*
 "View from Blackheath"
 "View near Colnebrook" (sic)*
 "View of Eton Chapel"*
 "View of Greenwich"*
 "View of Richmond"
 "View near Twickenham"
 "Waltham Cross"*
 "Windsor Castle"
 "Woolwich"

In addition, one unmarked view has been positively identified as Osterley Park.

"North End, Hampstead" (Ill: Little 83) has the impressed initials G.C. and it has been suggested that these refer to Goodwin & Co., one of the forerunners of Goodwins & Harris. Other examples are known with an impressed Staffordshire Knot (qv).

An almost identical border was used by an unknown maker for a series of English views listed as the Passion Flower Border Series. The major difference is the lack of inner stringing on these "Metropolitan Scenery" views which have a small irregular unprinted area between the border and the central scene. The printed cartouche marks are completely different.

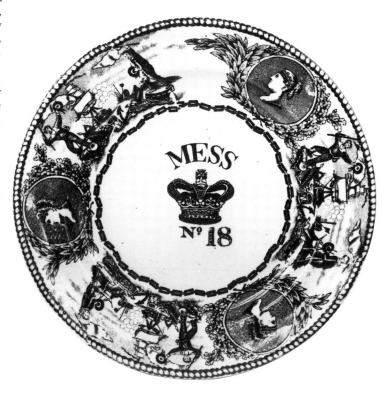

246

"Midas, Act 1, Scene 3"

John Rogers & Son and Pountney & Goldney. "The Drama" Series. Plate. Ill: Little 93.

Midas was a comedy written by John Lyly in 1592 for child actors in the royal service. However, this scene is almost certainly from a later English burletta, or comic opera, of the same title by Kane O'Hara (c.1714-82) which was first produced in Dublin in 1762 and later in London in 1766. It may well have been inspired by Lyly's earlier work.

Middlesbrough Pottery fl.1831-1852

Middlesbrough-on-Tees, Yorkshire (now Cleveland). This firm traded as the Middlesbrough Pottery until 1844 when it became the Middlesbrough Earthenware Company. Blue-printed wares were made on a large scale, especially the "Wild Rose" pattern. Marks include either the initials M.P. Co. or the name "MIDDLESBRO' POTTERY", often with an anchor. The most common mark consists of the name impressed in horseshoe form around an anchor.

"Milford Green"

Henshall & Co. Fruit and Flower Border Series.

It has not proved possible to trace this scene. There are some twenty villages called Milford in Great Britain. None is followed by the word "Green".

"Military Sketches"

Maker unknown with initials S.H. & Co. A design found on dinner wares in either light blue or sepia. The initials could relate to at least three potters of the 1830s.

Milking Time

William Adams. A scene printed in very dark blue showing a thatched cottage in a rural setting. In the foreground a woman with a child on her back is handing a bowl to a kneeling girl who is milking a cow. The view is within a grotto border of leaves and flowers. Laidacker calls the design Thatched Cottage. Ill: Coysh 2 1.

Milkmaid

A Spode pattern introduced c.1814 which shows a woman milking a cow in a field with sheep. It has a floral border which was also used by Spode on the Tower pattern. Ill: Coysh 2 100; Whiter 60.

The same pattern was adapted by Davenport for use on teawares (See: Godden BP 318), and was also used by the Belle Vue Pottery, Hull (See: Lawrence p.160).

A different pattern known by this title was included by Bathwell & Goodfellow in their "Rural Scenery" Series. The design features a milkmaid carrying pails with a yoke.

Mill Scene

This title is given by Laidacker to a pattern by William Adams. He describes it as "people in boat fishing with a seine in the foreground. Shell and foliage border".

The same title could well be used for at least three other designs which feature watermills. Davenport made one scene with a watermill and two figures with a horse and cart in the foreground. This design is part of the Rustic Scenes Series (qv). The same firm also made the Cornucopia Flower Border Series (qv) and Laidacker describes one design as "mill with low falls in foreground" (p.38). The third pattern with a watermill is in the ?Monk's Rock Series (qv). This shows a mill with the millpond in the foreground and the miller carrying a sack up wooden steps into the mill from a loaded donkey at their foot (Ill: FOB 2).

"Millennium"

Ralph Stevenson & Son. An unusual design which shows a girl surrounded by various animals. In the sky above her head are the words "Peace on Earth", and beneath the group is a line from the Lord's Prayer, "Give us this day our daily bread". The border has a selection of fruit and is separated from the centre by a zig-zag line. At the top of the border a prominent eye is reading two pages of print. The printed title mark includes the initials R.S. & S. Examples are also known in black, pink, purple and sepia. Ill: Laidacker p.80; P. Williams p.645.

"The Miller"

Maker unknown. This title appears on the face of a child's plate in the Victoria and Albert Museum, marked with the series title "The Progress of a Quartern Loaf". It has a moulded border and the pattern shows a watermill with the miller carrying sacks of flour. Also on the face is a small verse:

It is now the Miller's turn we find,
Who into Flour the Corn must grind.
The Husk, or shell, is used as Bran,
The Flower as general Food for Man.

"Millennium." *Ralph Stevenson & Son. Printed scroll tablet with title. Plate 10¼ ins:26cm.*

Miniature Wares. *Spode. Four examples, each with a printed maker's mark. Tiber pattern, plate 4¼ ins:11cm; Tower pattern, deep dish 3¾ ins:9cm; Tower pattern, sauceboat 2½ ins:6cm; Filigree border, toilet tray 2¼ ins:6cm.*

Miller, James, & Co fl.1869-1875

North British Pottery, Dobbies Loan, Glasgow, Scotland. This pottery is known to have used printed marks with three different sets of initials; I.M. & CO., J.M. & Co., and J.M. Co.

"Milnes Bridge House, Yorkshire"

Maker unknown. Foliage Border Series. Dish 8ins:20cm, pierced dish, and sauce tureen stand.

Milnsbridge House, on the south side of Huddersfield, is a mid-18th century stone building with a five-bay central block under a large pediment.

"Milnes House, Yorkshire" (sic)

Maker unknown. Morning Glory Border Series. Cup.

This title presumably refers to Milnsbridge House, near Huddersfield, described above.

Miniature Wares

The makers of pottery and porcelain have produced miniature versions of their wares since the 18th century. Many of the major potteries made miniature blue-printed wares and many marked and unmarked patterns are known. Most of these pieces are from miniature or toy dinner services, although it has been suggested that some may be traveller's samples (qv).

Several small tea services are known. Although these are often described as miniatures, they were probably made as children's play things and should more properly be called toys.

See: Cockle Plates; Cup Plates; Eel Plates; Trade Card; Traveller's Samples.

Minton fl.1793 to present

Stoke, Staffordshire. This firm was founded by Thomas Minton (1766-1836) who had served as an apprentice engraver at the Caughley works in Shropshire. He moved to London, working in Josiah Spode's warehouse in Portugal Street, and in the late 1780s set up as an engraver in Stoke-on-Trent. In 1793 he started his own pottery.

The firm expanded and in 1817 he took his sons into partnership but Herbert Minton (1793-1858) was the only one to stay with the business. When his father died in 1836 he acquired his first partner. The sequence was as follows:

Thomas Minton	1793
Thomas Minton & Sons	1817
Minton & Boyle	1836
Minton & Co.	1841
(sometimes Minton & Hollins 1845-1868)	
Mintons	1873

Most of the blue-printed wares are either floral patterns or romantic scenes. Typical examples of the latter are titled "Chinese Marine", "Devon", "Genevese" and "Swiss Cottage". Many of these Minton patterns were copied by other potters and attributions must be treated with caution. Floral patterns include "Floweret", "Lace Border" and "Dresden Flowers".

Until the 1820s wares were not marked for fear that retailers might disapprove. The earliest marks on blue-printed wares consisted of a scroll cartouche bearing a serial number or the name of the pattern above a cursive initial M. The same mark was later repeated with other relevant initials M. & B.,

M. & Co., or occasionally M. & H. These initials can also be found on a variety of ornate cartouche marks. Many such marks were continued long after the relevant partnership had ceased. Some of the patterns were even used again in late Victorian times.

From 1842 a year cypher was impressed on most wares. They may be dated by reference to the following key:

1842	1843	1844	1845	1846	1847	1848
1849	1850	1851	1852	1853	1854	1855
1856	1857	1858	1859	1860	1861	1862
1863	1864	1865	1866	1867	1868	1869
1870	1871	1872	1873	1874	1875	1876
1877	1878	1879	1880	1881	1882	1883

Minton may have been responsible for several well-known patterns that are impressed with a small seal mark containing the words "Improved Stone China" (qv). The firm did use this mark, but it may also have been used by other potters.

Minton Miniature Series

A series of named English views printed within a border of leaves and convolvulus flowers on miniature dinner services. The scenes are titled on a printed flower-decorated drape and the list of known views is as follows:

"Abbey Mill"
"Bysham Monastery"*
"Corf Castle" (sic)
"De Gaunt Castle"
"Donington Park"*
"Embdon Castle"
"Entr. to Blaize Castle"
"Kenelworth Priory" (sic)*
"Lanercost Priory"*
"Lechlade Bridge"
"St. Mary's, Dover"
"Tewkesbury Church"

The source prints for several of these views have been reported by M. and E. Milbourn in an article on "Observations on Miniature China", *Antique Collecting*, March 1980. "Bysham Monastery" is taken from Grose's *The Antiquities of England and Wales* (1773-87); "Donington Park" and "Lanercost Priory" are from Britton & Brayley's *The Beauties of England and Wales* (1800-10); "Kenelworth Priory" and "Tewkesbury Church" are from Storer & Greig's *The Antiquarian and Topographical Cabinet* (1807-11); and "Lechlade Bridge" is from Cooke's *The Thames* (1822). They have since discovered that the view of "St. Mary's, Dover" is based on an engraving by George Cook published by J. Murray in 1814 although the source of the print remains unidentified. They also report that some of the subsidiary untitled scenes on the wares seem to be taken from the last named book.

There is some doubt about the date of this series. Most are

unmarked but several "Lanercost Priory" dishes are known with the later impressed mark "MINTONS" (after 1873) and early 20th century date marks as late as 1915. Some examples are known printed in grey with the impressed name "MINTON" (pre-1873) and corresponding date marks of the early 1870s.

Minton Miniature Series. *Minton. Typical printed mark.*

"Missouri"

(i) Barker & Son. A romantic scene with two figures and two dogs in the foreground printed on ironstone in light blue. It was registered on 5th June, 1850. Ill: P. Williams p.340.

(ii) Cork, Edge & Malkin. The same romantic scene.

The scene has no connection with either the American river or state.

Mist, James Underhill fl.c.1809-c.1815

Following a partnership with Andrew Abbott between about 1806 and 1809, Mist took over the retail business at 82 Fleet Street, London, and continued until about 1815. He sold wares for John Turner and examples are known with the impressed mark "TURNER/MIST SOLE AGENT". See: Coysh 1 p.14.

Mitchell & Freeman

China and glass wholesalers of Chatham Street, Boston, Massachusetts. Their warehouse distributed wares by William Adams from 1828-32 and this potter produced a pattern showing the building. The printed mark reads "Mitchell & Freeman's China and Glass Warehouse, Chatham Street, Boston".

"Modern Athens" Series

This series of views of Edinburgh was produced between 1836 and 1854 by James Jamieson & Co. of the Bo'ness Pottery. The views are not individually named but each piece bears the above series title. The border consists of four medallions separated by motifs with a scroll, a lyre and a palette, together representing literature, music and the arts. The four medallions in clockwise order contain views of the Dugald Stewart Monument, the Burns' Monument, the Parthenon-style National Monument with the nearby Nelson Monument, and an equestrian statue — all Edinburgh landmarks. Views identifed to date are:

Burns' Monument
Dean Bridge*
Donaldson's Hospital
Dugald Stewart's Monument and Princes Street
 from Calton Hill
George Heriot's Hospital
Holy Trinity Episcopal Church
Royal High School
Royal Scottish Academy*
St. John's Church
Scott Monument*

These views are not taken from Shepherd's *Athens of the North* (1829) although this work may well have been the inspiration

"**Modern Athens**" Series. *James Jamieson & Co. Printed series mark with impressed maker's mark.*

for the series. Copying such prints had been prohibited by the Copyright Act of 1842 which was passed before these views were made. The term 'Modern Athens' was first applied to Edinburgh in about 1815.

The series was also printed in other colours, particularly black and green.

"Moditonham House, Cornwall"
Maker unknown. Foliage Border Series. Soup tureen lid.

Moditonham House, north west of Saltash, is a Georgian building of seven bays and three storeys with a parapet.

"Mogul"
Robert Cochran.

Mollart, J. fl.1806-1811
An engraver who worked for Wedgwood and was involved in the plates for the Willow and Blue Bamboo patterns.

Monastery Hill
See: Institution.

"Monastery at Tre Castagne"
Don Pottery and Joseph Twigg, Newhill Pottery. Named Italian Views Series. Plate 8½ ins:22cm.

Tre castagne means three chestnuts. It is a town in the east of Sicily, north west of Catania. The monastery is a fine Renaissance building, probably the work of Antonello Gagini.

Monk's Rock Series
A view by an unknown maker printed on a dish (16¼ ins:41cm) within a border composed largely of four mixed bunches of flowers on a stippled ground has been called Monk's Rock, Tenby, after the title on the source print from Middiman's *Select Views of Great Britain* (1813), Plate LIII, engraved after a painting by Julius Caesar Ibbotson (1759-1817). The rock depicted is usually called by the Norse name of Giltar. No doubt there was, at some time, an association with the monk's priory on Caldy Island (Norse for Cold Island), a Benedictine monastery founded in 1113 and re-established in 1929.

Tenby was described in the early 19th century as "a neat agreeable seaport with a commodious quay, a good harbour or road for shipping, a large fishing for herrings and a considerable coasting trade to Ireland and Bristol. It is a place of some resort for sea bathing and is situated on the declivity of a hill". The view clearly shows the early bathing boxes which were drawn into the water by horses, and were provided with canopies which could be rolled down to water level to protect the bathers from prying eyes.

This design is one of a series, mostly of rural scenes, all

printed within the same border of floral sprays. None of the other views are taken from Middiman and it has not been possible to trace the source prints. However, as this was the first view to be identified it gives its name to the series. The following scenes have been recorded:

(i) A watermill with the miller unloading a donkey at the foot of a wooden flight of steps.

(ii) A thatched cottage amongst trees with two figures in the central doorway and children playing on the lawn. Ill: FOB 22.

(iii) A three-storey cottage on the far side of a river, with a line of washing in the garden. Ferry boat on the river and steep hills in the background.

(iv) A view with a castle and a thatched cottage, a man with a saddled horse in the doorway. Animals feeding from a trough.

(v) A rural scene with houses and a large barn. There are several cows, some drinking from a pond.

(vi) Three cottages, one with three beehives in front. Figures, a cart and a horse, and farm buildings.

(vii) A classical ruin with three pillars and a shepherd with a stick. Slopes lead up to the walls of a town.

(viii) A large farmhouse on the left with a man seated in the porch and a woman in the doorway. Trees on the right and hills in the background. Ill: FOB 28.

(ix) A river with a bridge, many large high buildings on the left, and three figures in the foreground.

(x) A view lately identified as Carreg Cennen Castle, Carmarthenshire which shows a watermill below a rocky hill. See: FOB 33 and 34.

The patterns used on tureens are framed in scrolls, leaves and flowers, sometimes surmounted by a scallop shell. The remaining surface is covered with large and prominent flowers, in the same style as the series border but using different blooms.

"Monmouth"
Maker unknown. Beaded Frame Mark Series. Soup tureen stand, dish, and open bowl. Ill: Coysh 2 136.

Monmouth was the county town of Monmouthshire but is now in Gwent. It stands at the junction of the rivers Wye and Monnow.

Monnow Bridge, Monmouth
Maker unknown. "Beauties of England & Wales" Series. Dish.

An untitled view which clearly depicts the famous fortified bridge across the River Monnow. It was built in 1272 and although mainly original, it has been widened and strengthened.

Monopteros
A monopteros is the architectural term for a temple consisting of a circle of pillars supporting a roof. The name Monopteros was first given by Morton Nance to the well-known blue-printed pattern of such a building and has become so widely accepted that it is retained here.

The pattern is now known to be a view entitled "Remains of an Ancient Building near Firoz Shah's Cotilla, Delhi". It is based on an aquatint in Thomas Daniell's *Oriental Scenery* (Part I, 5). See Colour Plate XI. The following potters used the scene:

(i) John Rogers & Son. This design keeps very closely to the Daniell print. It was used on dinner wares and is also found on a miniature dinner set which is generally accepted to be of Rogers manufacture. Colour Plate X. Ill: Coysh 1 86-87.

(ii) Bevington & Co. of Swansea. This version has two beasts of burden in the foreground, a background of high mountains,

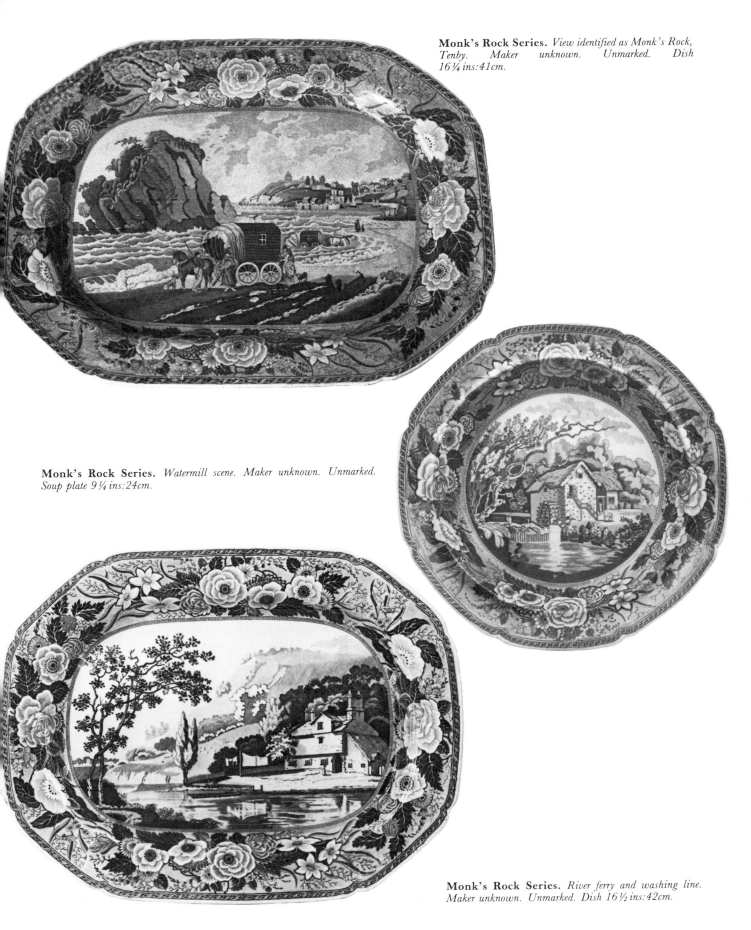

Monk's Rock Series. *View identified as Monk's Rock, Tenby. Maker unknown. Unmarked. Dish 16¼ ins: 41cm.*

Monk's Rock Series. *Watermill scene. Maker unknown. Unmarked. Soup plate 9¼ ins: 24cm.*

Monk's Rock Series. *River ferry and washing line. Maker unknown. Unmarked. Dish 16½ ins: 42cm.*

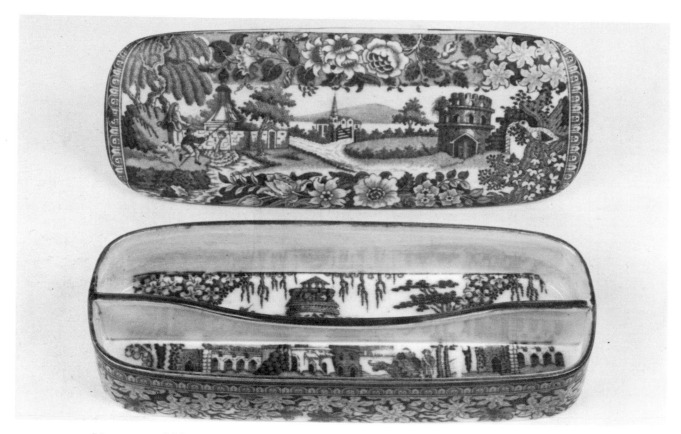

Monopteros. Maker unknown. Toilet box with an unrecorded country scene on the cover. Length 7¾ins:20cm.

and a tree on the left with large melon-like fruits.

(iii) Maker unknown. A version which appears to be the same as the Rogers design is illustrated in the base of a toilet box (see above). The lid is printed with an unrecorded country scene. The major features are a boy fishing near a monumental fountain, a church, a folly, and a plump bird perched on the trunk of a tree.

"Monterey"
Joseph Heath & Co. A light blue pattern recorded on a large octagonal ewer.

Monterey was the capital of the Mexican province of Lower California but was taken by the United States in 1846. It is now a seaside resort.

"Montilla"
Davenport. A romantic scene with a lake and a pseudo-Gothic temple with a woman in its doorway. A plate dated 1865 printed in grey is illustrated in Lockett 34, but examples are known in blue. Ill: P. Williams p.344.

Montilla is a Spanish town in the province of Cordoba. It gives its name to Amontillado sherry and is also known for its pottery.

"Monumental Arch in Latachia"
Maker unknown. Ottoman Empire Series. Dish 21ins:53cm.

The town of Latakia, on the Mediterranean coast of Syria, is now known as Al Ladhiqiya.

See: Latachia.

Moore, Samuel, & Co. fl.1803-1882
Wear Pottery, Southwick, Sunderland, Durham. This pottery traded under the same name despite several changes of management. It was finally demolished in 1883. Blue-printed wares were made in addition to other types of earthenware.

Printed and impressed marks are known both with and without the initial, and some printed marks include the initials only — S.M. & Co.

Moose
The moose was featured on at least two patterns. John Hall's "Quadrupeds" Series included a moose with hunters on a dish (16ins:41cm), and Enoch Wood & Sons used the animal on a dish (10½ins:27cm) in their Sporting Series.

"Morea"
(i) J. Goodwin of the Seacombe Pottery, Liverpool. A view which shows a central palladian building, a river and a four-arch bridge. The design was registered on 30th June, 1846. The printed mark is illustrated by G.A. Godden in *Mason's Patent Ironstone China* (1971), p.91.

(ii) Maker unknown. A series of romantic scenes of classical ruins noted on dinner wares.

Morea is a peninsula forming the southern part of Greece, so-named because it is said to resemble a mulberry leaf. It is separated from the mainland by the Gulf of Corinth and its modern name is Peloponnisos.

Morley & Ashworth fl.1859-1862
Broad Street, Shelton, Hanley, Staffordshire. A relatively short-lived partnership which linked Francis Morley & Co. to G.L. Ashworth & Bros. They used printed and impressed marks with either the name in full or the initials M. & A.

Morley, Francis, & Co fl.1845-1858
Broad Street, Shelton, Hanley, Staffordshire. This firm took over from earlier partnerships with William Ridgway. They acquired the equipment of C.J. Mason & Co., the services of their engraver, and the right to use the name Mason's Patent Ironstone China. Many of the earlier Mason marks were used,

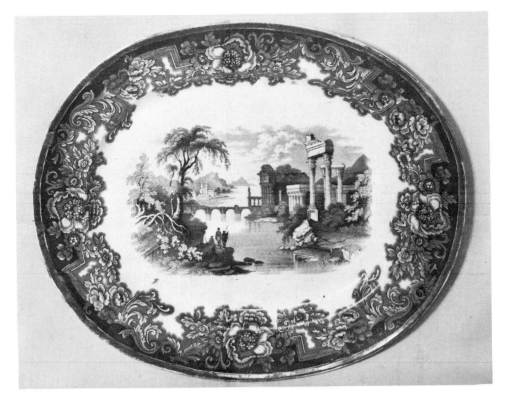

"Morea." John Goodwin, Seacombe Pottery. Printed title and maker's mark. Oval dish.

sometimes with the addition of the new name, but other marks were also used with either the name in full or the initials F.M. or F.M. & Co. The firm is known to have exported extensively to Canada.

Morning Glory Border Series
A series of English and Irish named views by an unknown maker. In each case the view is contained within a scrolled panel and printed in dark blue on teawares. Laidacker suggests that the maker may be Ralph Hall and lists the following views:

"Barlborough Hall, Derbyshire"
"Bear Forest, Ireland"
"Crognall Priory, Hamstead" (sic)
"Denton Park, Yorkshire"
"Finborough Hall, Suffolk"
"Gilrad House, Lancashire"
"Milnes House, Yorkshire" (sic)

Items are not common in Britain.

"Morpeth Castle, Northumberland"
William Adams. Bluebell Border Series. Dish 15ins:38cm.
Morpeth is seventeen miles north of Newcastle. The gatehouse of this castle, built by John Dobson in 1822 to contain prisons and a courthouse, still stands.

Morshall, W.
A name recorded on the base of an early chinoiserie pattern blue-printed mug. It forms part of the legend: "W. MORSHALL, SEDBERGH, 1790." Its significance is not yet known. Ill: FOB 17.
Sedbergh is in Yorkshire, nine miles east of Kendal in the old county of Westmorland (now Cumbria).

Mortlock, John fl.c.1746-1933
An important London retailer with a variety of addresses at different periods in Oxford Street, Orchard Street and Portman Square. Established in about 1746, the firm was active throughout the 19th century under various titles and a wide range of marks can be found. The firm held an agency for Coalport, Brameld, and Minton. Several other manufacturer's wares can be found with Mortlock marks. Ill: Coysh 1 145; Little 84-85.
See: "Quails"; Trade Card.

Mosaic
See: Marble.

"Mosaic Tracery"
James & Ralph Clews. An unusual floral pattern showing a vase of flowers rising out of acanthus-like scrolls. It is an all-over design with no distinct border and was also printed in pink. Ill: FOB 13.

Moses in the Bulrushes
A scene clearly intended to depict this biblical story has been noted on an unmarked teabowl. It shows two women bending over a cradle amongst some rushes within a border of large diamond-shaped medallions, each with four fleur-de-lis arranged in the form of a star.
The story tells how Pharaoh was worried by rumours that a new prince was born and decreed that every male child of the Hebrews born in Egypt should be killed. The mother of Moses heard of the decree and placed him in an ark near the bank of the Nile where he was found and adopted by Pharaoh's daughter.

Mosque and Fishermen
Davenport. A scene showing three Eastern figures in a boat in front of an impressive mosque. There is a border of roses superimposed on latticework framing. Ill: Coysh 1 32.

"Mosque in Latachia"
Maker unknown. Ottoman Empire Series. Dish 16ins:41cm.
The ancient seaport of Latakia, on the Mediterranean coast of Syria, is now known as Al Ladhiqiya.
See: Latachia.

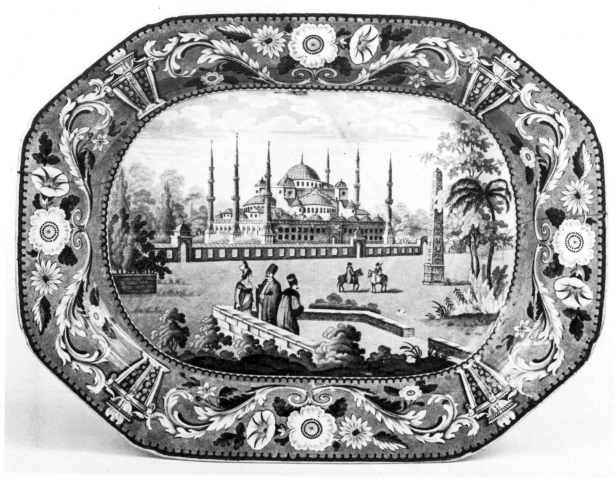

"Mosque of Sultan Achmet." *Maker unknown. Ottoman Empire Series. Printed title mark. Well-and-tree dish 18½ ins:47cm.*

"Mosque of Sultan Achmet"

Maker unknown. Ottoman Empire Series. Dish 18ins:46cm, and well-and-tree dish 18½ ins:47cm. Ill: FOB 27.

This is the famous Blue Mosque in Istanbul (formerly Constantinople). It is planned as a perfect square with a great dome supported by four half domes, in turn supported by four massive columns. There are six minarets. The mosque was built between 1609 and 1617 by Sedefkar Mehmet Aga.

"Moss-Rose"

Knight, Elkin & Bridgwood. A floral pattern in light blue with moss roses on a stippled ground. The printed cartouche mark includes "No. 35" and the makers' initials K.E. & B. Ill: Coysh 1 41.

Mottoes

Mottoes are almost invariably associated with armorial wares, although they are sometimes found in printed marks. They provide a useful clue to the original owner of the relevant coat-of-arms since they are relatively easy to trace by reference to books on heraldry. A useful reference is C.N. Elvin, *A Handbook of Mottoes,* republished by Heraldry Today, 1963.

Moulds

When clay has to be formed into special shapes such as tureens, ladles, handles for cups, etc., it is usually moulded. This is done by making a model of the required part and then casting a plaster negative. This can, in turn, be used to mould the necessary shape in clay. One big advantage is that such moulds can be used to produce items both in quantity and to a constant quality. Mould lines can often be detected on items made by this method.

Similar moulds were used by different potters and shapes were copied in the same way as patterns. Moulded knops and handles are no sure guide to attributions.

"Moulin pres de Royat, Dept. du Puy de Dome"

Enoch Wood & Sons. French Series. Dish 12ins:30cm, and vegetable dish. Ill: Arman S 199.

Royat is a resort near Clermont-Ferrand known for its thermal springs. Puy de Dome is an administrative region in central France of which Clermont-Ferrand is the capital.

"Moulin sur la Marne a Charenton"

Enoch Wood & Sons. French Series. Two different views on a plate 9¼ ins:23cm, and a sauce tureen. Ill: Arman S 200, 201.

Charenton lies at the junction of the rivers Marne and Seine and is now a suburb of Paris. The mill depicted on this pattern is a large, impressive building. Another view "Charenton, near Paris" was included by an unknown maker in the Pineapple Border Series (qv).

"Mount Etna"

Copeland & Garrett. Byron Views Series. Plate 7ins:18cm, and sauce tureen stand. Ill: Coysh 2 20; FOB 15.

Etna is a volcano near the east coast of Sicily. Its eruption in 1669 destroyed Catania and there were other serious eruptions in 1923 and 1928. The original drawing for this pattern was by W. Purser.

See: "Aetna from the Augustines".

"Mount Olympus"

Copeland & Garrett. Byron Views Series. Water jug 10¾ins:27cm.

Mount Olympus (9,754 ft.), now called Elymbo, is in north east Greece near the Aegean coast. It was regarded by the ancient Greeks as the abode of the gods and as having the palace of Zeus at its summit.

"The Mountains in Labour"

Spode/Copeland & Garrett. "Aesop's Fables" Series. Dish 10ins:25cm, and ewer with "The Dog and the Shadow" on reverse side 10¾ins:27cm. Ill: Coysh 2 103; Whiter 89.

The mountains were said to be in labour, and uttered most dreadful groans. People came from far and near to see what birth would result and, after they waited a considerable time in expectation, out crept a mouse.

Great cry and little wool.

"Much Ado about Nothing"

John Rogers & Son and Pountney & Goldney. "The Drama" Series.

This romantic comedy by Shakespeare was written c.1599. It is noted for the 'skirmishes of wit' between Beatrice and Benedick, and for its comic characters Dogberry and Verges, the policemen.

Muffineer

A small castor for sprinkling salt or sugar on muffins.

Muffins

A pottery term encountered on many invoices where dinner services are itemised. It derives quite simply from an abbreviation of 'plates for muffins' and applies to a plate some 6ins-8ins in diameter.

Muffle Oven

The muffle oven, or kiln, was fired at a relatively low temperature and used to dry wares and fix the transfer prints. It was also used for an additional firing process to fix overglaze enamels on clobbered or other decorated wares.

Muir, Andrew & Co. fl.1816-c.1840

Clyde Pottery, Greenock, Scotland. The works were established by James & Andrew Muir who appointed an experienced potter, James Stevenson, as their works manager. The firm produced blue-printed wares from the start, some of which were exported to Canada. The initials A.M. were used towards the end of the period and the firm was succeeded by Thomas Shirley & Co. and then the Clyde Pottery Co.

"Muleteer"

Davenport. This title appears on landscape patterns of a rather romantic type within a border of C-scrolls and flowers. There seem to be several different scenes, all including a man mounted on a mule. They were used on a wide variety of items including dinner wares, mugs, feeding cups, and toilet wares. Ill: Coysh 1 35; Locket 28; P. Williams p.347.

Multi-Pattern Dinner Services

Dinner services can be broadly divided into two types, those in which the same pattern appears on every piece and those in which a number of different patterns were used with a common border. These are usually called multi-pattern services and a different pattern was used on each size and shape of plate and dish. Typical examples are the Indian Sporting, "Metropolitan Scenery", Byron Views, and "The Drama" Series. Many floral and romantic designs were also used for multi-pattern services.

"Murthly, Perthshire"

William Adams. Flowers and Leaves Border Series. Plate 9ins:23cm.

Murthly Castle was begun in 1829 by James Gillespie Graham for his friend Sir John Stewart of Grantully. It was never completed but the frontage seen in a photograph of 1875 shows that the main structure was already well defined (See: James Macaulay, *The Gothic Revival, 1745-1845*, p.248). The castle was demolished in 1949.

Mushroom Picker

Herculaneum Pottery. An attributed title for a pattern which shows a girl with a basket stooping to pick mushrooms. It was used on tea wares with a rare mark consisting of the name "Herculaneum Pottery" within a circular wreath of laurel leaves.

Musketeer

John Rogers & Son. An attributed title for a scene now known to be a composite of several prints by Thomas Daniell from *Oriental Scenery* (Parts I and II).

The main building is taken from a "View in the Fort, Madura" (Part II, 14) printed in reverse, but with the addition of a dome from "The Mausoleum of Mucdoom Shah Dowlut, at Moneah, on the River Soane" (Part I, 12). The figures in the foreground, once again in reverse, are from the "Eastern Gate of the Jummah Musjid at Delhi" (Part I, 1). The background, as with several of the Herculaneum Pottery patterns, is based on the "View in the Fort of Tritchinopoly" (Part II, 21).

The pattern is illustrated on a plate in Coysh 1 85. It has also been recorded printed in dark blue on gadrooned plates with wavy edges. A version on an unmarked jug with designs from several Daniell prints is illustrated by Archer, *Early Views of India*, p.228.

Named Italian Views Series

The Don Pottery produced a series of views of the area known as the Two Sicilies, the island of Sicily itself and the area around Naples and Vesuvius on the Italian mainland. The views are mainly of ancient buildings and monuments and the series title derives from the presence of a title in script, often difficult to read, beneath most of the scenes. An ornate floral border includes two prominent putti and slight variations of the border are known.

The scenes all depict places which could have been included in the Grand Tour and, although they are almost certainly copied from some contemporary travel book, the source has not yet been discovered. Sicily was not an integral part of Italy when this series was produced. It was the property of the House of Austria and the Spanish Bourbons after a brief period of French rule from 1806 to 1815. Its most prominent landmark is the volcano, Mount Etna.

The plates used to print this series were almost certainly acquired by Joseph Twigg of the Newhill Pottery. Dinner services with the same patterns indifferently printed can be found marked "TWIGG/NEWHILL". Such items are of poor quality compared to the Don Pottery examples, and the view titles are often missing or difficult to read.

The list of views known by the Don Pottery is given below. Items marked T are also known by Twigg:

"Aetna from the Augustines"*
"Ancient Cistern near Catania"
"Brundisium"*
"Cascade at Isola" T
"The Church of Resina at the Foot of Vesuvius"
"Grotto of St. Rosalie near Palermo"*
"Isola"
"Monastery at Tre Castagne"
"Obelisk at Catania" T
"On the Heights of Corigliano"
"Port of Ansetta"
"Port of Turenium"
"Residence of Solimenes near Vesuvius" (two different views) T
"Ruins near Agrigenti"
"Ruins of the Castle of Canna"
"Temple of Serapis at Pouzzuoli" T
"Terrace of the Naval Amphitheatre at Taorminum"
"Tomb of Theron at Aggrigentum" (sic)
"View in Alicata"
"View of Corigliano" (Colour Plate XVIII)
"View in Palma"*
"View near Taormina"
"View in the Valley of Oretho near Palermo"

In addition to the above, there are two other views about which some doubt exists. These are "...On the Poe" and "Port of Alicata".

The place names found on these wares are shown on a map at the end of this dictionary.

Named Views

A collectors' term referring to patterns which depict real places and are marked with the name of the view. Many examples are known which are marked with the wrong title due to a transferrer's error, typical of which are a view of The Rookery, Surrey, marked Gubbins Hall; a view of Wakefield Lodge, Northamptonshire, marked Luscombe, Devon; and a view of Ripon marked Leomington Baths (sic). In the case of "Branxholm Castle, Roxburghshire" and "Melrose Abbey, Roxburghshire" by William Adams in his Bluebell Border Series, the titles are always transposed. Collectors should not be too certain, therefore, that their views represent the places named in the marks.

In addition, many of the titles are mis-spelt or contain other inaccuracies such as the wrong county name. All titles with such errors are clearly marked "sic" in the text.

"Nankeen Semi-China"
See: "Semi-Nankeen China".

"Nanking"
(i) Edward Challinor. A series of light blue romantic patterns printed on ironstone. They depict Chinese-style buildings with trees and boats or figures within a border of wavy lines. Ill: P. Williams p.147 (two examples).
(ii) John & Richard Riley. A dark blue pattern.

Nanking is a major seaport and city in China. The name means 'southern capital' and the city was the capital of China for many years before 1403, and also from 1928 in Nationalist China. The name was in common use for Chinese porcelain in the 18th and 19th centuries.

"Nant Mill"
Elkin, Knight & Co. Rock Cartouche Series. Plate 8½ins:22cm.

Nant Mill is on the River Gorfai, Caernarvonshire, one mile south east of Bettws Garmon in north Wales. It has always been a favourite resort of artists.

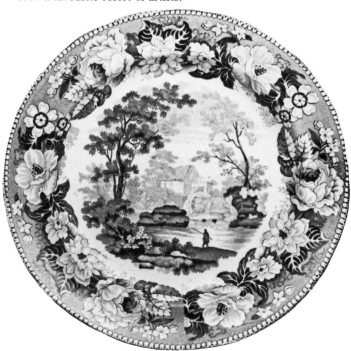

"Nant Mill." *Elkin, Knight & Co. Rock Cartouche Series. Printed title mark and impressed crown above "ELKIN, KNIGHT & CO." Plate 8½ins:22cm.*

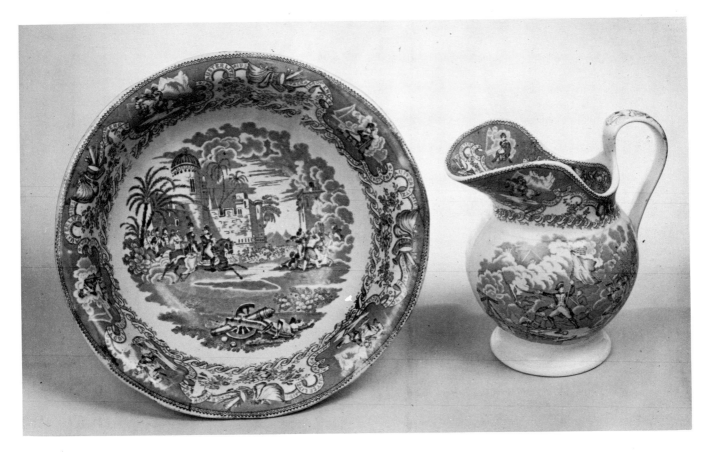

"Napoleon's Victories." *William Smith & Co. Titled ribbon mark. Ewer height 10ins:25cm, washbowl diam. 14ins:36cm.*

"Napier"

John Ridgway. A scene with figures, a boat and a background of temples and trees. The border has Oriental buildings alternating with groups of flowers on a trellis background. The printed mark includes the title "Imperial Stone", and the initials J.R.

"Naples from Capo di Chino"

Enoch Wood & Sons. "Italian Scenery" Series. Plate 6½ins:16cm.

Another view of Naples was included by Copeland & Garrett in their Byron Views Series under the title "Bay of Naples" (qv).

Naples is a city and seaport on the south west coast of Italy. It lies near the foot of Vesuvius, and not far away are the ruins of Pompeii.

"Napoleon" Series

A series by C.J. Mason & Co. depicting events in the military career of Napoleon. The scenes are printed within a border of flowers and scrolls with classical figures and ewers, and examples are known in light blue and green. The following titles are recorded:

"Napoleon" (several different scenes)
"Napoleon at the Battle of Austerlitz"
"Napoleon at the Battle of Marengo"
"Napoleon's Battles — Return from Elba"
"Napoleon's Battles — Revolt of Cairo"

Additional patterns are illustrated in Laidacker p.57; P. Williams p.510.

"Napoleon's Victories"

William Smith & Co. A title printed on ribbon marks on a ewer and washbowl.

The bowl shows Napoleon on horseback together with another mounted soldier in a village street. The border has four medallions, two with Napoleon on horseback and the other two with Napoleon seated with arms folded. A ribbon twines around the medallions and bears the names of Napoleon's victories: Arcola, Austerlitz, Jena, Lodi, Marengo, Montebello, Rivoli, Toulon, Ulm and Wagram.

Native Pattern

This title is commonly used for a rural scene printed by William Adams. It shows two dismounted women talking to a kneeling fisherman beside two horses on the bank of a river. There are cottages and a bridge in the background. Ill: Coysh 1 17.

The pattern was copied by F. & R. Pratt & Co. as "Native Scenery" (qv) and has also been noted on unmarked porcelain.

"Native Scenery"

F. & R. Pratt & Co.. A copy of the Adams Native pattern noted on vases with this title printed in a beaded frame mark.

"The Nativity"

Enoch Wood & Sons. Scriptural Series.

"Then Joseph being raised from sleep did as the angel of the Lord had bidden him, and took unto him his wife: And knew her not till she had brought forth her first born son; and he called his name JESUS". Matthew 1, 24-25.

"Nautilus"

Maker unknown. This pattern title is found with the initial B on printed marks, virtually impossible to attribute.

A nautilus is a small sea creature of the mollusc family.

"Nazareth"

Thomas Mayer. "Illustrations of the Bible" Series. Dish 17½ ins:44cm.

Nazareth (the modern al-Nasira) is a town in Galilee, Palestine, where Christ spent his early years in the house of Joseph and Mary. "(Joseph) came and dwelt in a city called Nazareth: that it might be fulfilled which was spoken by the prophets, He shall be called a Nazarene". Matthew 2, 23.

"Ne Plus Ultra"

Dillwyn & Co., Swansea. A pattern printed on teawares in blue, green, mauve and pink. It shows a girl with a harp seated amongst flowers. The border is of flowers and ornaments alternating with a small scene of a woman by the side of a lake. The printed mark has the title over a leafy scroll. Ill: Nance LXIIb.

The motto means: No farther.

Neale & Bailey fl. 1790-1814

Church Street, Hanley, Staffordshire. This firm appears to have acted mainly as agents for other potters although they may have potted on their own account.

A retail business was also operated at 8 St. Paul's Church Yard, London, under several different styles. The London directories list:

Bailey & Neale, Glass manuf. to His Majesty (pre-1817)
Bailey, Thomas, China, Glass and Earthenware for Exporta- tion at the original Staffordshire Wareho. (1817 and later)
Neale, Bailey & Neale (concurrent with Thomas Bailey)
Bailey & Neales (1826 and later)

The date at which the London business commenced is not clear but it continued after the end of the Staffordshire establishment until at least 1826. It had closed by 1834.

Neale, John Preston

John Preston Neale was an artist who specialised in drawing country houses in Britain and Ireland. These were published in two sets under the title *Views of the Seats of Noblemen and Gentlemen in England and Wales, Scotland and Ireland*. The first series was published in six volumes between 1818 and 1823. The second series followed almost immediately in five further volumes between 1824 and 1829. Many of the drawings were later copied by another publisher, Jones & Co. of Finsbury Square, London, and issued in two volumes.

The importance of Neale to collectors of blue-printed wares lies in the fact that his drawings were copied for many of the earlier named views by several of the major potters. Enoch Wood & Sons used them for their Grapevine Border Series, and other firms known to have used them include William Adams, James & Ralph Clews, Elkins & Co., John & Richard Riley, and Ralph Stevenson.

Neale, N.

This name is found marked on two views titled "Leighton Bussard Cross" (sic) and "A North-West View of Leighton Buzzard Church". It refers to a local retailer named Nathaniel Neale.

See: Leighton Buzzard.

"Near Bucharest"

Maker unknown. Ottoman Empire Series. Plate 6¼ ins:16cm.

Bucharest was the residence of the rulers of Wallachia from the 14th century until 1698, after which it was part of the Ottoman Empire. It became the capital of Romania in 1861.

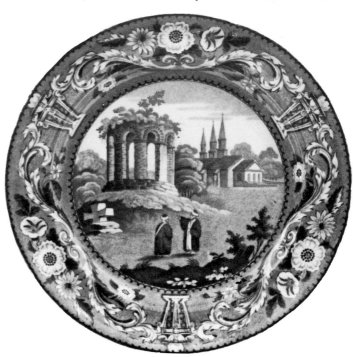

"Near Bucharest." *Maker unknown. Ottoman Empire Series. Printed title mark. Plate 6¼ ins:16cm.*

"Near Newark." *Elkin, Knight & Co. Rock Cartouche Series. Printed title mark. Plate 7ins:18cm.*

"Near Caernarvon"

Maker unknown. Beaded Frame Mark Series. Vegetable dish and sauce tureen.

The county town of Caernarvonshire, now Gwynedd, on the north Wales coast near the southern entrance to the Menai Strait. It has a famous castle built by Edward I.

"Near Calcutta"

Enoch Wood & Sons. Shell Border Series. Plates 6ins:15cm and 6½ins:16cm, and sauce dish. Ill: Arman S 138.

As with other items from the series, this view shows a shipping scene. Figures in the foreground are looking out over several sailing ships and a rowing boat in the bay.

"Near Newark"

Elkin, Knight & Co. Rock Cartouche Series. Plate 7ins:18cm.

Newark is nineteen miles north east of Nottingham. It had a ruined castle which was the scene of King John's death in 1216. This view shows a cottage and a lake with figures.

Necropolis or Cemetry of Cacamo

Spode. Caramanian Series. Plate 8½ins:22cm, and oval dish 7½ins:19cm. Ill: Coysh 2 89; S.B. Williams 53-55.

See: Cacamo.

Nelson

When Lord Nelson died at Trafalgar in 1805 his body was brought home and buried in St. Paul's Cathedral on 6th January, 1806. A number of blue-printed wares were made to commemorate his death, mainly mugs and jugs. One such pattern shows a bust of Nelson in an oval medallion with his famous words "England Expects Every Man to do his Duty".

A scene showing the "Death of Lord Nelson" (qv) was used by Jones & Son in their "British History" Series on a meat dish and a comport. Ill: Coysh 1 53. Another pattern often associated with Nelson is included here as the Neptune pattern

Net Pattern. *Job Ridgway. Impressed "J. RIDGWAY" in curve over a beehive. Pierced plate 8¼ins:21cm.*

(qv), sometimes known as The Apotheosis of Nelson. Ill: Coysh 2 151; S.B. Williams 184.

Nelson blue-printed commemorative wares may be seen in the Nelson Museum, Monmouth, Gwent which is open from April to October.

"Neptune"

John & George Alcock. A light blue pattern with a ship, lighthouse and a feathery lined border.

Laidacker also uses the name for an untitled pattern in dark blue by James & Ralph Clews, showing Neptune with his trident within a border of sea shells. Ill: Atterbury p.205; Laidacker p.79.

Neptune Pattern

Maker unknown. This name is used for a pattern which shows Neptune with his trident, riding across the waves with Britannia in his chariot. The border contains four heads in medallions, each with female supporters, alternating with groups of military accoutrements. S.B. Williams expresses the opinion that the heads may represent various famous seamen such as Nelson, Howe, Hood, Collingwood or Jervis. He calls it the Victory pattern but it has also frequently been called The Apotheosis of Nelson, a title implying the deification or release from earthly life of the famous Admiral. Ill: Coysh 2 151; S.B. Williams 184.

"Nestor's Sacrifice"

Joseph Clementson. "Classical Antiquities" Series. Eight-sided dish 17¾ins:45cm. Ill: Godden I 154.

Along with other patterns from the series, this design was registered on 13th March, 1849.

Nestor was a mythical king of Pylos who lived to be a very old man. He took part in the Trojan war with his son Antilochus but returned home without his friend Odysseus. Odysseus' son went to Nestor to ask for news of his father and arrived at Pylos just as ninety bulls were being sacrificed by a gathering of Nestor's men. The stranger was welcomed and given the banquet which is depicted on the dish.

Net Pattern

A pattern in the Chinese style named from the net background to a central medallion which contains a flower cross. This is surrounded by four further medallions consisting of small pagoda landscapes, inset on a background of flowers. The border is of typical chinoiserie type but contains similar smaller scenes.

The pattern was used by at least four factories:

(i) Herculaneum. Ill: Copeland p.91; Smith 152 (also 149-150).

(ii) Job Ridgway.

(iii) Spode. Ill: Copeland p.90; Coysh 1 114; Whiter 21; S.B. Williams 123-125.

(iv) A potter with the initials C.T., possibly Charles Tittensor of Shelton.

"Netley Abbey"

Maker unknown. Beaded Frame Mark Series.

In addition to this named view, two untitled views of the abbey have been identified:

(i) William Mason. A view with a border of scrolls and convolvulus. Ill: Haggar and Adams, *Mason Porcelain and Ironstone, 1796-1853,* 90.

(ii) Andrew Stevenson. This pattern was previously called the Gothic Ruins pattern. See overleaf and Colour Plate XX.

Both these untitled versions are based on a print by W. Westall entitled "The Chapel and South Transept". The figure and sheep in the foreground of the Stevenson view are

Netley Abbey. *Andrew Stevenson. Untitled view. Impressed maker's circular crown mark. Dish 13ins:33cm.*

from another print of Kirkstall Abbey, Yorkshire entitled "The Tower and Part of the Cloisters", drawn by W. Craig and engraved by J. Pye. Both prints were published in *The Beauties of England and Wales* (1805).

This Cistercian abbey at Netley, near Fareham in Hampshire, was founded in 1239 by the Bishop of Winchester, Peter des Roches, and dissolved in 1536. The ruins attracted early visitors such as Horace Walpole and Thomas Gray.

"Neuilly"
J. & M.P. Bell & Co. A pattern with urns and a fountain, noted on a bowl 10ins:25cm.

Neuilly-sur-Seine is a suburb of Paris, not far from the Bois de Boulogne.

"New Blanche"
A trade name used for an earthenware body and named in printed marks by Copeland & Garrett.

"New Fayence"
A trade name for a body introduced at the end of the Spode period and continued by their successors Copeland & Garrett. It has a slightly creamy appearance and a very clear glaze. The name can be found as part of printed marks.

"New Post Office, London"
Tams & Co. Tams' Foliage Border Series. Dish 10¼ins:26cm.

"New Stone"
An ironstone body introduced by Spode early in the 1820s. It was a replacement for the earlier body called simply Stone China. Items in the new material bear an impressed mark

"SPODE'S NEW STONE" in two lines and examples are known with a printed Copeland & Garrett mark, presumably made at the time of the change-over in 1833.

Newbigging Pottery fl.c.1800-1843
This pottery at Musselburgh in Scotland is known to have produced blue-printed wares. It operated under the following names:

William Reid	c.1800-1837
William Reid & Son	1837-1839
Reid & Forster	1839-1843

Newcastle-upon-Tyne
Although by no means as extensive as the Staffordshire Potteries, the area around Newcastle was heavily involved in the pottery trade in the late 18th and 19th centuries. There were many small firms with continuous changes of name and style, in addition to some major companies. See: Bell *Tyneside Pottery.*

Newnham Court, Oxfordshire
John & William Ridgway. Angus Seats Series. Dish 15½ins:39cm. Ill: FOB 7.

In common with all items from this series the view is not titled and marked pieces are very rare.

This view shows the former seat of Earl Harcourt, normally called Nuneham Courtenay. A comment by Angus in the text alongside the source print is that "Every floor is arched to prevent the dreadful ravages of fire".

See: "Wild Rose".

Newnham Court, Oxfordshire. *Source print for the Angus Seats Series taken from Angus' "Seats of the Nobility and Gentry in Great Britain and Wales. . . . "*

 Newnham Court, Oxfordshire. *John & William Ridgway. Angus Seats Series. Unmarked. Dish: 15½ ins: 39cm.*

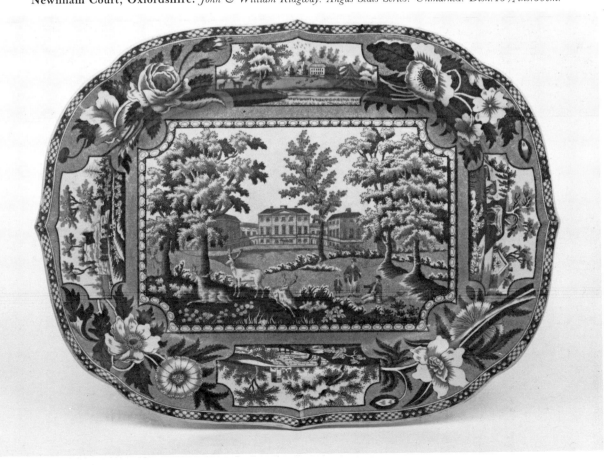

Colour Plate XVIII. "View of Corigliano." *Don Pottery. Named Italian Views Series. Printed maker's mark. Dish 21ins:53cm.*

Colour Plate XIX. "View of London." *Thomas & Benjamin Godwin. Unmarked. Tureen. Overall length 15¼ins:39cm.*

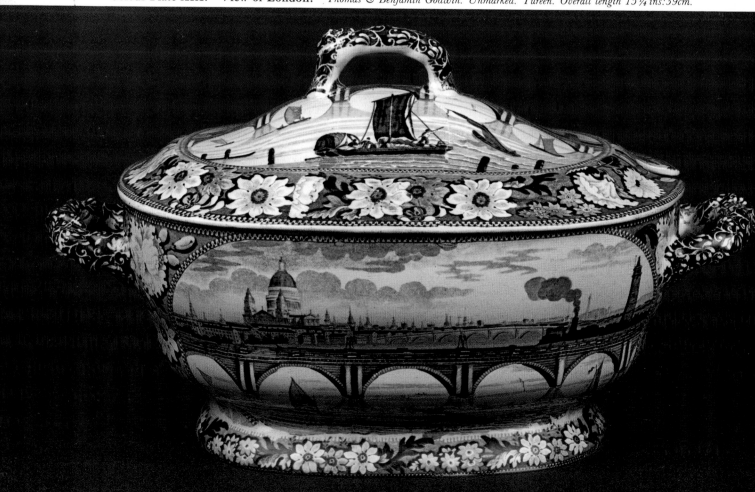

"Newstead Abbey"
Baker, Bevans & Irwin. This view is illustrated on a ewer which bears a printed title mark with the initials G.P. for Glamorgan Pottery.

Newstead Abbey was founded in 1170 and was purchased in 1539 by Sir John Byron who converted it into a mansion. The poet Byron lived in the abbey for a few years from 1808. It lies eleven miles north of Nottingham and is now owned by the Nottingham City Council. It is open to the public daily during the summer.

Nicholson & Wood fl.1837-1855
Mere Pottery, Castleford, Yorkshire. This partnership is referred to by Jewitt and also by Heather Lawrence as Wood & Nicholson. A plate with the "Eton College" pattern has, however, been noted with the printed mark Nicholson & Wood.

"Nisi Dominus Frustra"
It is vain without the Lord. A motto associated with the coat-of-arms of the City of Edinburgh which was registered in 1732. A design on the central shield represents Edinburgh Castle.

The coat-of-arms is found on a pattern showing a steamship titled "London and Edinburgh Steam Packet Company" (qv). The arms are printed in the border, alternating with those of the City of London.

"Newstead Abbey." Baker, Bevans & Irwin. Printed title mark and G.P. (Glamorgan Pottery). Ewer height 8½ ins:22cm.

"North East View of Lancaster." Maker unknown. "Antique Scenery" Series. Printed titles mark. Dish 21½ ins:55cm.

"Normanton Park, South View, Rutlandshire." William Adams. Flowers and Leaves Border Series. Printed title mark and impressed maker's eagle mark. Dish 21ins:53cm.

"No Gains Without Pains"

Davenport. "Franklin's Morals" Series. Plate 10ins:25cm. Ill: Camehl, *The Blue China Book*.

A scene which shows a gardener planting a tree in the foreground and fishermen working in sailing boats behind to the right. The maxim was used by Benjamin Franklin in *Poor Richard's Almanack* for 1745.

"Noble Hunting Party"

James & Ralph Clews. Doctor Syntax Series. Dish 17ins:43cm. Ill: Arman 65.

The title printed on the wares may have a prefix, either "The" or "A".

"Non Pareil"

Dixon, Austin & Co.

"Normanton Park, South View, Rutlandshire"

William Adams. Flowers and Leaves Border Series. Dish 21ins:53cm. Ill: Laidacker p.3.

The same potter printed another, untitled view of this house on a dish (19ins:48cm) in the Rocks and Foliage Border Series.

Normanton Park was an 18th century Palladian house, five miles south east of Oakham. It was the seat of the Earl of Ancaster but was pulled down in 1924.

"North East View of Lancaster"

Maker unknown. "Antique Scenery" Series. Dish 21½ins:55cm.

This scene is similar to other views listed in the entry "Lancaster".

"North End, Hampstead"

Goodwins & Harris. "Metropolitan Scenery" Series. Dish 16½ins:42cm, and insert for hot-water dish. Ill: Little 83.

North End runs north from the inn called Jack Straw's Castle on the western edge of Hampstead Heath.

"Northern Scenery" Series.

This series of Scottish views bears a printed mark which is known with two different sets of initials, J.M. & S. or J.M. &

"Northern Scenery" Series. *John Meir & Son. Typical printed mark.*

Co. According to Godden (M 4461-4462) no firm can be traced which used both, but these views are commonly attributed to John Meir & Son. They are based on engravings in William Beattie's *Scotland: Illustrated in a Series of Views Taken Expressly for this Work by Messrs Allom, W.H. Bartlett and H. McCullock*, published in two volumes by George Virtue, 26 Ivy Lane, Paternoster Row, London in 1838. The "Northern Scenery" views appear to be taken from the second volume. The printed mark consists of an oval strap with lion and unicorn supporters. The series title is within the strap, the initials are on a ribbon beneath, and the view title is written in script below.

The recorded views include:
"Bothwell Castle"
"Dunolly Castle, near Oban"
"Inverness"
"Kilchurn Castle, Loch Awe"*
"Loch Achray"
"Loch Awe"*
"Loch Creran with Barcaldine Castle"*
"Loch Katrine Looking Towards Ellen's Isle"
"Loch Leven Looking Towards Ballachulish Ferry"
"Loch Oich and Invergarry Castle"
"Pass of the Trossachs, Loch Katrine"

"Northumberland Castle"

William Adams. Bluebell Border Series.

This title is listed by Laidacker with the comment that it is a mistake and should be "possibly Morpeth Castle".

"A North-West View of Leighton Buzzard Church"

Maker unknown but with dealer's mark "N. NEALE". Plate 10¼ins:26cm, mug and pierced chestnut basket. Ill. Coysh 2 133.

See: Leighton Buzzard.

"Norwich"

(i) James & Ralph Clews. "Select Scenery" Series. Ewer and bowl, and tray.
(ii) Enoch Wood & Sons. "English Cities" Series. Dishes 13ins:33cm and 15ins:38cm.

Norwich is a city and the county town of Norfolk. It is particularly noted for its outstanding cathedral. The castle with a Norman keep stands on a mound in the city centre and is now used as a museum.

"Norwich Cathedral, Norfolk"

Ralph Hall. "Picturesque Scenery" Series. Dish 10ins:25cm, and pierced basket stand.

The cathedral is a fine example of Norman architecture although it was not finished until about 1500, despite being established in 1096.

Nottingham

James & Ralph Clews produced an untitled view of Nottingham on a dish (19ins:48cm) in the Foliage and Scroll Border Series.

Nottingham did not become a city until 1897. The famous castle was completely rebuilt after 1831.

Nuneham Courtenay, Oxfordshire

The grounds of this house near Oxford are depicted on the pattern usually known as "Wild Rose" (qv).

"N.W. View of La Grange, the Residence of the Marquis Lafayette"

Enoch Wood & Sons. French Series. Soup tureen. Ill: Arman 202.

See: Lafayette; "La Grange".

"The Oak and the Reed"
Spode/Copeland & Garrett. "Aesop's Fables" Series.

An oak on the bank of a river was blown down in a violent storm and some of its branches brushed against a reed. The oak asked the reed how he withstood the storm. The reed replied: "Instead of being stubborn and stiff, I yield and bend to the blast, and let it go over me; knowing how vain and fruitless it would be to resist".

Bend or break.

"Oatlands, Surrey"
(i) Ralph Hall. "Select Views" Series. Plate 5ins:13cm.
(ii) Andrew Stevenson. Rose Border Series. Dishes 16½ins:42cm and 14½ins:37cm. Ill: Arman 420.

The house, known as Oatlands Park, one mile east of Weybridge, was built for the Duke of York by Henry Holland in 1794. It was bought in 1827 by a very wealthy man — Edward Bale Hughes, who was known as 'The Golden Bull'. He carried out an extensive reconstruction and little remains of Holland's original building.

"Obelisk at Catania"
Don Pottery and Joseph Twigg, Newhill Pottery. Named Italian Views Series. Plate 10ins:25cm. Ill: Lawrence p.88.

Catania is a seaport in eastern Sicily. The obelisk is the fountain in the centre of the piazza. It was built in 1736 using what appears to be an old turning post from a Roman circus in the form of an antique elephant carrying an Egyptian obelisk.

"Oberwessel on the Rhine"
Enoch Wood & Sons. A romantic view of the Rhine with a central large round castellated tower, all within a floral border. Ill: P. Williams p.351.

Oberwessel was a town in the electorate of Treres or Triers in Germany. It lies on the Lower Rhine to the north west of Essen and Duisburg and is now known as Wesel. It was part of Prussia but is only some fifteen miles from the border with the Netherlands.

"Observatory, Oxford"
John & William Ridgway. Oxford and Cambridge College Series. Square dish 9½ins:24cm.

This building in Woodstock Road is better known as the Radcliffe Observatory. It was begun by Henry Keene in 1772 and completed by James Wyatt in 1794. No longer used as an observatory, it is now a medical department of the University.

Ochre
A natural earthy hydrated oxide of iron which is used as a pigment producing shades between light yellow and brown. The colour was applied to the rims of some blue-printed wares, including wares by Swansea and Herculaneum, and possibly by other potters.

Oddfellows
See: "Grand United Order of Oddfellows"; "Independent Order of Oddfellows".

"The Offering"
Chetham & Robinson or Chesworth & Robinson. A romantic scene within a floral border on a plate with a wavy rim. The printed mark includes the initials C. & R. together with both the above title and the place name "TERNI" as part of a landscape cartouche. Another scene is known, also titled "TERNI", but with a different sub-title "A Romantic District of Italy". Ill: Little 16.

Terni is a city with ancient buildings to the north of Rome in Italy.

"Old Castle of Martigny"
Henshall & Co. Fruit and Flower Border Series. Dish 10ins:25cm.

Martigny is a town on the River Drance to the south east of Lausanne in Switzerland. The fort was built to defend the southern frontier.

Old Hall Earthenware Co. Ltd. fl.1861-1886
Old Hall Pottery, Hanley, Staffordshire. This pottery had been owned and operated by various members of the Meigh family from 1790 until 1861. Various printed marks include the initials O.H.E.C.

Old Peacock
A name given by S.B. Williams to a relatively late Spode pattern and now generally accepted. The design shows flowers and peacocks among foliage around a circular central geometric panel. There is no separate border. Ill: Coysh 2 87; Whiter 25; S.B. Williams 130.

"Olympic Games" Series
A light blue series by Thomas Mayer recorded with printed marks including the series title and the names of each individual scene. The following have been recorded by Laidacker and P. Williams:
 "Animal Prize Fight"
 "Darting"
 "The Discuss" (sic)
 "Spanish Bull Fight"
 "Victors Crowned"
The title "Bull Fight" listed by Laidacker is probably a mistake for "Spanish Bull Fight". Examples are also reported in sepia and black.

"On the Heights of Corigliano"
Don Pottery and Joseph Twigg, Newhill Pottery. Named Italian Views Series. Square dish 6ins:15cm.

Corigliano is a town in Calabria near the Gulf of Otranto. It is noted for a fine castle.

"One & All"
The motto of the county of Cornwall. Nowadays it is found with the coat-of-arms of the County Council which was granted on 5th April, 1939, but it has been in use for very many years.

The motto is found on mugs and jugs made at the Cambrian Pottery, Swansea, usually along with the Cornish toast "Fish, Tin & Copper" and the quote "Success to the Trade in the County of Cornwall". One rare example is a mug with a very crude picture entitled "St. Michael's Mount" above the print.

On-Glaze
A term used when a print or colour is applied to a ceramic surface after the glaze has been fired. On-glaze decoration is usually heated in a muffle oven at a low temperature so that it will adhere to the glaze, but its major disadvantage is that it tends to rub off in use.

"Ontario Lake Scenery"
See: "Lake".

"Opaque China"
A trade name used by many potters to suggest that their supposedly fine white earthenwares compared favourably with china or porcelain. Amongst many others it was used by Elkin, Knight & Bridgwood; Thomas Godwin; Mayer & Newbold; Charles Meigh; Minton; and John & William Ridgway.

"Opaque Porcelain"
A trade name used as part of printed and impressed marks on earthenwares by Charles Meigh & Son of Hanley. It may also have been used by other potters.

Open Pattern
A name used to describe a type of pattern in which the engraved print covers only part of the surface of the wares. In general this means that there are white areas between the central pattern and the border. Borders in later wares may be similarly described. They have flowers and scrolls on a white ground in contrast to the earlier styles in which the designs stand out against a stippled blue ground, sometimes very dark in colour.

"Opera House, London"
Tams & Co. Tams' Foliage Border Series. Bowl.

Operative Union Pottery
See: "Society of Operative Potters".

Opium Smokers
C.J. Mason & Co. An untitled Chinese scene with a bridge, a pagoda, two figures in the foreground, and three figures on the balcony of an ornate pavilion. It is illustrated on an unmarked mug but is also known on dinner wares, sometimes with the printed mark "MASON'S SEMI-CHINA WARRANTED". Ill: FOB 14.

"Oregon"
T.J. & J. Mayer. A flow-blue pattern including a pagoda, used on dinner wares. Oregon is a state on the west coast of America, settled in 1838 and admitted to the Union in 1859.

"Orielton, Pembrokeshire"
(i) John & Richard Riley. Large Scroll Border Series. Dish 11ins:28cm, and jug 7½ins:19cm.
(ii) Enoch Wood & Sons. Grapevine Border Series. Bulbous jug 6¾ins:17cm.

Orielton is a Welsh manor house about three miles south west of Pembroke. It was originally Norman but was rebuilt in the 17th century. Some years ago it became empty and was acquired by the naturalist Ronald Lockley. It has now been restored as a centre for field studies. The full history is told by R.M. Lockley in *Orielton* (1977).

"Oriental"
(i) Robert Cochran & Co.
(ii) William Ridgway. A series of romantic scenes within a medallion border marked with a typical Ridgway urn and beehive cartouche. Ill: P. Williams pp.150-151 (four examples).
(iii) William Ridgway, Son & Co. Possibly a copy from the above series.

"Oriental Beauties"
Jones. A pattern title on dinner wares with a printed mark which includes the name "Jones". There is no indication which of several potters named Jones made the wares.

Opium Smokers. *Attributed to C.J. Mason & Co. Mug height 4½ins:11cm. Note unusual C-scroll handle.*

"Oriental Birds"
John & William Ridgway. Open patterns in which birds perch on the branches of a tree. They are printed on wares with a moulded edge and the border consists of small sprays of roses and forget-me-nots. The mark includes initials J.W.R. and the words "Opaque China". Ill: P. Williams pp.650, 689.

"Oriental Birds." *John & William Ridgway. Printed floral title cartouche with "Opaque China" and "JWR". Plate with moulded edge 10¼ins:26cm.*

"Oriental Flower Garden"

Goodwin, Bridgwood & Orton. A scene with pagodas and Chinese figures dominated by a giant spray of flowers to the left and an urn to the right. It was printed on gadrooned edge wares bearing a printed scroll cartouche with the title and the initials G.B.O. Ill: Coysh 2 37; P. Williams p.153 (two examples).

Examples have also been noted with the initials G. & E. for Goodwin & Ellis, one of the succeeding partnerships. The design may well also have been used during the intervening period when the factory was run by Goodwins & Harris.

Oriental Panel Pattern

A name given by Coysh to a pattern found on Mason's Patent Ironstone China. The design includes three circular panels containing geometrical and floral fan-shaped motifs and three comma-shaped panels with trees, animals, birds and bamboo. Ill: Coysh 2 54.

"Oriental Scenery" Series

Two different potters produced series under the title "Oriental Scenery" although they are sufficiently distinct not to cause confusion. Neither series was based on the Daniell *Oriental Scenery* prints.

The first and almost certainly earlier series was made by John Hall & Sons in a dark blue. These patterns are clearly titled with the series name, the name of the individual view, and the potter's name "I. HALL & SONS". They are contained within a border of fruit and flowers which includes a pineapple.

The list of recorded views includes:
"City of Benares"
"Fakeer's Rock"
"Ghaut of Cutwa"
"Hindoo Ghaut"
"Hindoo Pagoda"
"Hindoo Temple"
"Hindoo Village"
"Lucknow"
"Mahomedan Mosque & Tomb" (sic)
"Palace of the King of Delhi"
"Sicre Gully Pass"

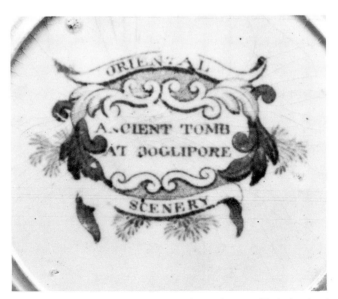

"Oriental Scenery" Series. *Maker unknown. Typical printed mark.*

"Surseya Ghaut, Khanpore"
"Tomb of the Emperor Shah Jehan"
"Tomb at Jeswunthnagure"
"Tombs of Etaya"

The second series, by an unknown maker, appears to be later and is light blue. The views are titled in an ornate cartouche of scrolls and leaves; the words "Oriental" and "Scenery" are printed on ribbons above and below. The series border is basically floral but with small medallions containing an Eastern Mosque scene. The views so far recorded are:
"Ancient Tomb at Boglipore"*
"City of Benwares" (sic)
"Fort of Allahabad"
"Hindoo Ghaut on the Ganges"
"Hindoo Village on the Ganges"
"Pagoda below Patna Azimabad"*
"Part of the City of Moorshedabad"
"Surseya Ghaut, Khanpore"
"Tomb of the Emperor Acber"
"Tomb of the Emperor Shah Jehan"
"Tomb of Jeswuntnagurth"

The similarity of many of these titles to those of the John Hall & Sons series suggests that both potters may have used the same source book.

"Oriental Sports"

Edward Challinor. This is a series of scenes which are copies of Spode's Indian Sporting Series (qv). They are marked with a printed cartouche which includes a crown and the above title on a ribbon, some versions including the initials G.R. The maker has been identified by a single example bearing the impressed mark: "EDWARD CHALLINOR, WARRANTED, BURSLEM, STAFFORDSHIRE" between concentric circles.

The example illustrated overleaf is a copy of Spode's "Groom Leading Out", and it appears that each item in the series is decorated with the same view as the corresponding Spode piece.

"Oriental Stone"

A trade name for an ironstone body made by John & George Alcock. It forms part of an impressed mark, but in common with other such trade names it may have been used by other potters.

"Oriental Vases"

Thomas Dimmock & Co. A pattern marked with the initial D.

Ornate Pagodas

Attributed to Richard Woolley. A transitional design with three pagodas highly decorated with C-scrolls and other western motifs. The example illustrated overleaf is from the collection of the late W.L. Little and bears a label which states "One of a pair, impressed mark WOOLLEY, 1809-1814".

Ornithological Series

A name given to a series of patterns, usually unmarked, which depict a variety of birds within a border of floral panels. An impressed mark "Stevenson" above a three-masted ship has been noted on one example. The patterns are not titled but the following names have been used by Coysh:
Birds of Prey
Birds and Willow*
The Kingfisher
The Peacock
Pheasant
A sixth example in the form of a supper set segment and lid is illustrated overleaf. It is a composite design with some new species together with the Kingfisher listed above.

"Oriental Sports." *Edward Challinor. Printed mark with two leaf sprays around a crown, G.R. beneath and a ribbon with title. The subject is "Groom Leading Out". Plate 6½ ins:16cm.*

Ornate Pagodas. *Attributed to Richard Woolley. Unmarked. Plate 8¼ ins:21cm.*

Ornithological Series. *Andrew Stevenson. A composite design which includes the Kingfisher. Unmarked. Supper set segment and lid with lion knop, length 16¼ ins:41cm.*

"Orwell Park, Suffolk." John & Richard Riley. Large Scroll Border Series. Printed title mark with maker's name. Plate 7¾ ins:20cm.

"Orwell Park, Suffolk"

John & Richard Riley. Large Scroll Border Series. Plate 7¾ ins:20cm.

Orwell Park was built in about 1770. The view on the plate can no longer be seen since the house was altered in 1854 and again in 1873.

"Osborne"

Robert Cochran & Co. A pattern composed of light blue key-pattern motifs.

The title was probably inspired by Osborne House on the Isle of Wight, the favourite residence of Queen Victoria.

"Ostend Gate at Bruges"

Henshall & Co. Fruit and Flower Border Series. Dish. Ill: Atterbury p.168.

Bruges, in Belgium, is particularly noted for its city gates and many canals.

Osterley Park

Three untitled views of this house have been identified:

(i) Goodwins & Harris. "Metropolitan Scenery" Series. Sauce tureen stand 7¼ ins:18cm. This view is identical to the titled view in the Passion Flower Border Series.

(ii) John & William Ridgway. A view with a distinctive single-span bridge and a group of fallow deer in the foreground. Examples are recorded with the rare impressed lower case mark "Ridgway". The pattern is illustrated on a spirit barrel (qv). Ill: Coysh 1 73.

(iii) John Rogers & Son. Rogers Views Series. Sauce tureen stand (illustrated overleaf). This is also identical to the view in the Passion Flower Border Series.

"Osterley Park"

Maker unknown. Passion Flower Border Series. Sauce tureen stand. Ill: FOB 27.

This view shows the house with its Adam portico in the background behind the river. There are two men in a boat and on the near bank a woman and child talk to a seated man.

Osterley Park House was built in 1577 by Sir Thomas Gresham but later extensively remodelled by Robert Adam. It is readily recognised by both Gresham's towers and by Adam's portico. Situated just outside Hounslow in Middlesex, Osterley was the seat of the Earl of Jersey but is now owned by the National Trust.

Ostriches

Ostriches were featured together with a zebra and other animals by James & Ralph Clews on plates (5½ ins:14cm and 9ins:23cm) in their "Zoological Gardens" Series. The birds can also be seen on at least one of the patterns used by Enoch Wood & Sons under the generic title "Belzoni" in which they are being hunted by mounted horsemen using bows and arrows.

Otter

The otter is featured on a plate (8½ ins:22cm) in the "Quarupeds" Series by John Hall.

Osterley Park. *Goodwins & Harris. "Metropolitan Scenery" Series. Untitled and unmarked. Sauce tureen stand 7¼ ins:18cm.*

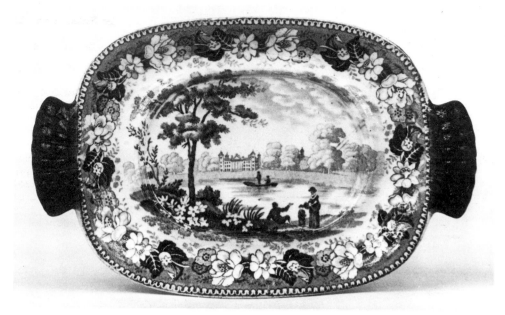

Osterley Park. *John Rogers &*
Son. Rogers Views Series.
Untitled. Impressed maker's mark.
Sauce tureen stand 8ins:20cm.

"Ottoman"

Dillwyn & Co. A pattern found on Swansea mugs, often with a frog inside. It consists of a reserve with two figures dressed in Turkish style, one mounted on a horse. They are in a romantic landscape enclosed within a scrolled floral frame. The border within the mugs is composed of linked medallions containing animals. The pattern is titled in a printed mark in the form of an eastern footed bowl or vase. This design is typical of the period between about 1840 and the late 1850s.

Ottoman Empire Series

All the views in this series by an unknown maker are of places in the Ottoman Empire as it existed in the early 19th century — hence the title. It has also been called the Torch Border Series or the Incense Burner Series after a distinctive incense burner in the floral scroll border. The titles are named in a simple architectural cartouche and are as follows:

"Cialka Kavak"
"Eski Estamboul"
"Monumental Arch in Latachia"
"Mosque in Latachia"
"Mosque of Sultan Achmet"*
"Near Bucharest"*
"Pera"
"Piccolo Bent"*

Ottoman Empire Series. *Maker unknown. Typical printed mark.*

"Pillar of Absalom"
"Port of Latachia"
"Tchiurluk"
"Tomb of Jeremiah"

With the single exception of the "Pillar of Absalom", these are all taken from Luigi Mayer's *Views in the Ottoman Dominions, in Europe, in Asia, and some of the Mediterranean Islands, from the Original Drawings, taken for Sir Robert Ainslie, by Luigi Mayer, F.A.S. with Descriptions, Historical and Illustrative* (1810), published by R. Bowyer of 80 Pall Mall, London.

It is probable that further views exist. An unidentified view on a leaf pickle dish, for example, shows a man leading a mounted mule, behind which is a wall of Coptic brickwork with an archway. Behind the wall is a mosque and minaret.

"Oxburgh Hall"

(i) Ralph Stevenson. Stevenson's Acorn and Oak Leaf Border Series. Pierced stand and dish, both 10½ins:27cm. Ill: Laidacker p.75.

(ii) Maker unknown. Passion Flower Border Series. Small deep dish, and dish 9ins:23cm. Ill: FOB 19.

"Oxburgh Hall, Norfolk"

Enoch Wood & Sons. Grapevine Border Series. Dish 10ins:25cm.

Oxburgh Hall, seven miles south west of Swaffham, was originally a square 15th century moated mansion with a courtyard and gatehouse. Many changes were made in the 18th and mid-19th centuries but the original massive gatehouse survives. It is 80ft. high with seven storeys and is flanked by projecting octagonal turrets. The home of the Bedingfield family until 1952, the hall is now owned by the National Trust. It is open to the public in summer.

"Oxford"

(i) Harvey. Cities and Towns Series. Washbowls 12ins:30cm and 13¼ins:34cm. Ill: Smith 168 (showing border only).

(ii) Herculaneum. Cherub Medallion Border Series. Dishes 20ins:51cm and 21½ins:55cm. Ill: Little 110; Smith 165. See Colour Plate XXI.

(iii) Pountney & Allies/Pountney & Goldney. "River Thames" Series. Soup tureen. Ill: Coysh 2 72.

(iv) Enoch Wood & Sons. "English Cities" Series. Plates

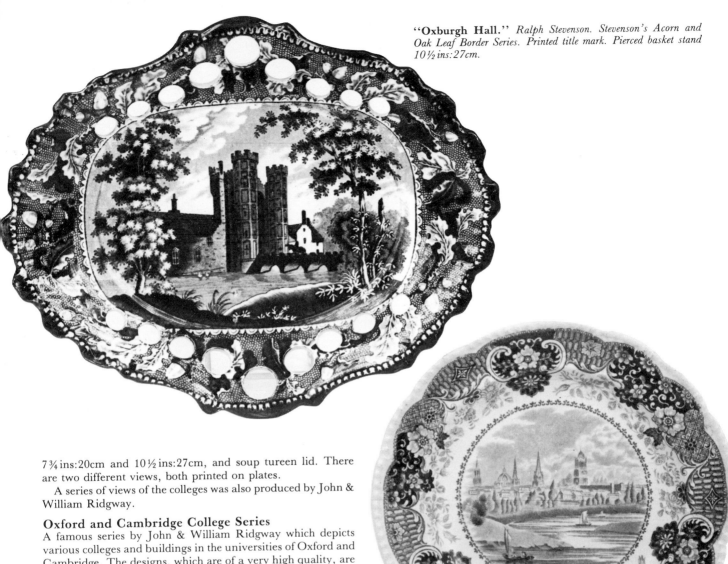

"Oxburgh Hall." *Ralph Stevenson. Stevenson's Acorn and Oak Leaf Border Series. Printed title mark. Pierced basket stand 10½ ins:27cm.*

7¾ ins:20cm and 10½ ins:27cm, and soup tureen lid. There are two different views, both printed on plates.

A series of views of the colleges was also produced by John & William Ridgway.

Oxford and Cambridge College Series

A famous series by John & William Ridgway which depicts various colleges and buildings in the universities of Oxford and Cambridge. The designs, which are of a very high quality, are printed in a dark-medium blue within a border which includes two pairs of medallions, each with a goat and cherubs, outside an octagonal frame. The title of each view is printed in a lozenge-shaped cartouche with the words "OPAQUE CHINA" and the makers' name "J. & W. RIDGWAY".

Views in Cambridge include:
"Caius College, Cambridge"
"Clare Hall, Cambridge"
"Downing College, Cambridge"*
The Fountain, Trinity College, Cambridge (untitled)
"King's College, Cambridge"
"Library of Trinity College, Cambridge"
"Pembroke Hall, Cambridge"*
"St. Peter's College, Cambridge"*
"Senate House, Cambridge"*
"Sidney Sussex College, Cambridge"*
"Trinity Hall, Cambridge"
Views in Oxford include:
"All Souls College and St. Mary's Church, Oxford"
"Christ Church, Oxford" (two views)*
"Observatory, Oxford"
"Radcliffe Library, Oxford"
"Theatre Printing House &c, Oxford"*
"Trinity College, Oxford"
"Wadham College, Oxford"

"Oxford." *Enoch Wood & Sons. "English Cities" Series. Printed titles and maker's mark. Plate with gadrooned edge 7¾ ins:20cm.*

Oxford and Cambridge College Series. *John & William Ridgway. Typical printed mark.*

271

Packhorse

A pattern name given to a Brameld rural scene. It features a man with a packhorse and has been recorded on toilet wares. Ill: Lawrence p.70.

"Pagoda in the Montpellier Gardens"

Minton. A scene printed in light blue recorded on a plate and a water jug. The border consists of feathers and wheat and the printed title mark includes a cursive initial M.

The Botanic Gardens, or Jardin des Plantes, at Montpellier in the south of France were established in 1593. They are closely associated with the faculty of botany at Montpellier University. Montpellier was renowned as a health resort to which consumptives came for a cure. There were said to be nearly two hundred apothecaries in the town.

"Pagoda below Patna Azimabad"

Maker unknown. "Oriental Scenery" Series. Dish 16½ins:42cm. This view shows a Hindu temple rather than a pagoda beside a river (presumably the Ganges) on which there is a two-masted ship with men rowing.

"Pain's Hill, Surrey"

Ralph Hall. "Select Views" Series. Plate and soup plate, both 9½ins:24cm. Ill: Coysh 1 46; Laidacker p.48.

In the 1740s the Hon. Charles Hamilton, youngest son of the Duke of Abercorn, inspired by the French landscapists, laid out fine ornamental grounds at Painshill with a nineteen acre lake. He also commissioned well-known architects to build features to enhance the views. By 1774 he was forced to sell for lack of money and the gardens suffered.

In 1975, urged on by the voluntary Friends of Pain's Hill, the local Elmbridge Borough Council started to buy back the land and began the difficult task of restoration, rebuilding and the clearing of undergrowth. The Council Minute of 14th October, 1980, states "that the Council accepts as their policy that Pain's Hill Park and the Follies be restored as nearly as possible to the Charles Hamilton original design and the concept of a landscape garden with a variety of scenery, for the benefit of the public and with the aim of making the Park a self-supporting enterprise".

Seven of the original follies remain for restoration including a Gothic Tower, a Mausoleum, a Ruined Abbey and a Grotto. See: an article by Gordon Winter in *Country Life* (12th March, 1981).

"Palace of the King of Delhi"

John Hall & Sons. "Oriental Scenery" Series. Soup tureen.

The palace at Delhi was built by Shah Jehan, fifth of the Mogul Emperors of India, early in the 17th century.

"Palace of Linlithgow, West Lothian"

James & Ralph Clews. Bluebell Border Series. Dish 9½ins:24cm.

Linlithgow Palace was the birthplace of James V and his daughter, Mary Queen of Scots. It overlooks Linlithgow Loch and is open to the public.

See: "Linlithgow Palace".

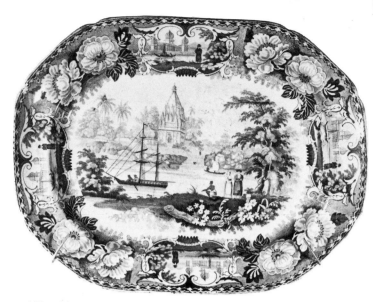

"Pagoda below Patna Azimabad." *Maker unknown. "Oriental Scenery" Series. Printed titles mark. Dish 16½ ins:42cm.*

"Palace of St. Cloud, France"

Ralph Hall. "Picturesque Scenery" Series. Dish 17ins:43cm.

St. Cloud is on the River Seine, ten miles west of central Paris. The palace was demolished in 1871.

"Palace of St. Germain, France"

Ralph Hall. "Picturesque Scenery" Series. Dish 18¾ins:48cm.

St. Germain-en-Laye became a royal residence in the time of Louis VI. It is next to a forest of the same name, only three miles further west from St. Cloud, also on the Seine.

"Palermo"

Lockhart & Arthur.

The city of Palermo is the capital of Sicily. It is a seaport on the northern coast and its history goes back to Carthaginian and Roman times.

"Palestine"

(i) William Adams & Sons. A series of romantic scenes with prominent tents or gazebos, figures and distant minarets. The border consists of smaller scenes within scroll frames separated by floral groups. Ill: Laidacker p.13; P. Williams pp.156-157 (three examples).

(ii) J. & M.P. Bell & Co. A series of romantic scenes with figures of which three different examples have been noted. The printed mark includes a classical column.

(iii) John Ridgway. A romantic scene printed in light blue on ironstone tureens and bowls. There is a central river with an imposing range of classical buildings along the bank to the left. Ill: P. Williams p.356.

(iv) Ralph Stevenson. A dark blue chinoiserie style pattern marked with a cartouche and "R. Stevenson" in script. One example has been recorded with an embossed white rim, another with a prominent impressed anchor.

Palestine, the Christian Holy Land, lies between the Mediterranean and the Dead Sea. Its history has been stormy and it has been conquered by the Egyptians, Philistines, Alexander, the Romans and the Turks before the more recent turbulent events.

Palladian Pagoda

A title given by Coysh to a chinoiserie pattern by Joshua Heath. Although in the true style of early chinoiseries, it is a transitional pattern with a single European feature in the form of a Palladian entrance to the pagoda. Ill: Coysh 1 5.

Palladian Porch

Maker unknown. An Eastern scene which features a Palladian-style porch. On the left a man is leading a camel through an archway which leads to a town. In the foreground a rowing boat is arriving at a flight of landing steps. The scene is printed within an octagonal frame which is separated by an area of vermicelli from a border of fruit, flowers, and acanthus leaves.

Palladian Temple

Maker unknown. A title adopted here for the design on a tea plate which shows a classical lakeside or riverside temple with a large portico. This plate dates to c.1820, a time when temples were fashionable additions to the grounds of country houses.

"Panama"

Edward Challinor & Co. A romantic pattern printed on ironstone, also in pink and sepia. Ill: P. Williams, p.359.

Before the construction of the Panama Canal the city was already a centre of trade. Merchandise from Chile and Peru, including gold and silver, was brought to a small island off the coast since the water was too shallow for any but the smallest craft. However, the romantic scene seems to have no connection at all with this Central American state.

Pankhurst, J.W., & Co. fl.1850-1882

Charles Street, Hanley, Staffordshire. This factory used a wide variety of name and initial marks printed on their wares.

"Panorama"

Maker unknown. This title has been noted in large upper case letters on washbasins with integral metal plug holes. The pattern is a typical romantic scene with classical ruins.

"Panoramic Scenery"

Ralph Stevenson produced a series of views marked only with this title and not individual place names. The following views have been identified:

 Canterbury Cathedral
 Chichester Cathedral
 Fonthill Abbey
 York Minster

Items are printed in dark blue with a typical grotto-style foliage border.

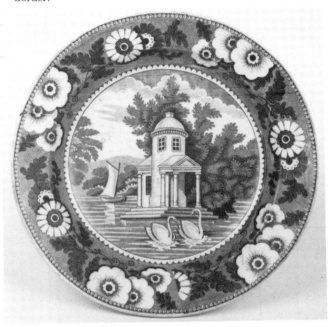

Palladian Temple. *Maker unknown. Unmarked. Plate 6¾ ins:17cm.*

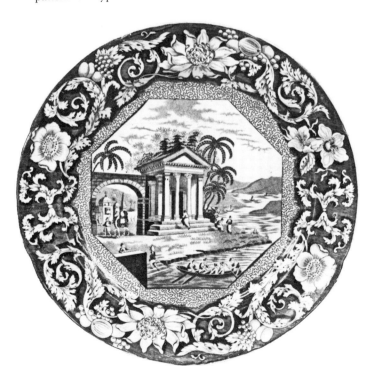

Palladian Porch. *Maker unknown. Unmarked. Plate 10ins:25cm.*

"Panorama." *Maker unknown. Basin, with plug hole, diam. 12¼ ins:31cm.*

"Panshanger, Hertfordshire"

Ralph Hall. "Picturesque Scenery" Series. Plate 5½ ins. 14cm.

Panshanger, built from 1806 onwards on the site of an earlier mansion, broke with the Georgian tradition. It was a long low building with turrets and battlements in the Romantic Gothic style. Unfortunately the house was demolished in 1953-54 but the landscape designed by Humphry Repton with a line of lakes still survives.

Pap Boat

A small shallow oval boat-shaped vessel with a tapering spout, used for feeding invalids or infants. Pap was a substance made of flour or bread boiled in water, sometimes with added sugar or butter. Occasionally an egg or some beer was included, but for some reason milk was not encouraged.

A collection of feeding bottles owned by Cow & Gate Limited includes a good selection of pap boats in various materials. Silver, glass and plain white pot are represented, in addition to several blue-printed examples. They were made by many famous potteries including Davenport, Minton, Ridgway, Spode and Wedgwood.

"Paradise"

Livesley, Powell & Co. A bird of paradise perches on a large spray of exotic flowers. Ill: P. Williams p.653.

Parasol Figure

A name given to a Spode pattern which is a variant of the Temple Landscape design. Copeland refers to it as Temple Landscape var. Parasol.

Parasol Willow Pattern

Walter Daniel. A rare chinoiserie pattern which features a lady with parasol on a path before a large temple.

"Paris Stripe"

Brameld. A pattern which has been recorded on a plate and a jug. The title is printed in script within a cartouche with trailing flowers.

"Parisian Basket"

Chesworth & Robinson or Chetham & Robinson. A design of vases and flowers noted on a bourdaloue (qv). It is marked with an ornate cartouche together with the initials C. & R. which could relate to either of the partnerships stated above.

"Parisian Basket." *Printed title mark with initials of Chesworth & Robinson or Chetham & Robinson. The pattern is shown on a bourdaloue (qv).*

"Parisan Chateau"

Ralph Hall. A series of romantic patterns of French châteaux within a border of flowers and scrolls. They were also printed in black, green, pink, purple and sepia. Ill: Laidacker p.51; P. Williams pp.363-364 (three examples).

"Parisian Sprig"

J. & M.P. Bell & Co.

"Park Place, Henley"

Pountney & Allies/Pountney & Goldney. "River Thames" Series. Plate 6½ ins: 16cm.

This design can be found in two distinct variants, one with the standard floral border from the series and the scene surrounded by the usual stringing, the other with the same border but with the scene set into a hexagonal frame. The scene itself has some features in common with a print in Tombleson's *Eighty Picturesque Views on the Thames and Medway* (1834), but the similarities are not sufficient to state with certainty that this was the source of the pattern.

The house is no longer to be seen; it was replaced in 1870. The main interest in the early 19th century centred on the grounds which slope down to the river. They were planned by General Conway, who had an interest in forestry, and included bridges, grottoes and plantations.

"Park Scenery"

George Phillips. A series of romantic scenes within a border of single detached flowers on a geometric ground. Examples were also printed in green. Ill: P. Williams p.365 (two examples).

"Park Place, Henley." *Pountney & Allies/Pountney & Goldney. "River Thames" Series. Printed titles mark and impressed P. Plate 6½ ins: 16cm.*

"Parroquet." Brameld. Printed mark "PARROQUET/FINE STONE" in frame with initial B at base. Impressed "BRAMELD + 8". Soup plate 8¾ins:22cm.

Parkland Scenery

Chetham & Robinson. This title is used for a design which shows a country mansion behind a stretch of water, all within a distinctive quatrefoil-shaped frame. There is a border of various flowers on a fine net background, and a man, woman and child can be seen in the front of the view. The printed mark consists of a Staffordshire knot (qv) containing the word "WARRANTED" and the initials C. & R. Although the mark alone could relate to Chesworth & Robinson, the attribution to Chetham & Robinson has been proved by discoveries made during a dig on the site of the old Chetham & Robinson works in Commerce Street, Lane End. Ill: Coysh 2 17; Little 15.

"Parroquet"

Brameld. An open pattern with two parroquets among flowers and foliage which was printed on dinner wares with a gadrooned edge. The title is contained in a cartouche with the words "PARROQUET/FINE STONE" within an octagonal frame, the initial B beneath, and the whole surrounded by flowers and overlooked by a bird (Lawrence mark 61). Ill: Coysh 2 13; Lawrence p.52; Rice 21.

Parrot Border Series

A series of Indian views by an unknown maker, each titled in script within a rock cartouche. The name has been adopted because the border design includes a distinctive parrot, among a group of fruit and roses. It has also been called the Pecking Parrot Border Series. The only views recorded to date are:

"Gateway & Tomb of Secundra"

"Mausoleum of Kausim Solemanee at Chunar Gur"
"Surseya Ghaut, Khanpore"
A further unidentified view is illustrated on a toilet box and cover (overleaf).

Parrot and Fruit

Leeds Pottery. A name used by Little for a pattern on a creamware mug showing a parrot on a branch reaching down to peck at some fruit. The design is based on a print by R. Hancock of Worcester. Ill: Little 96.

"Part of the City of Moorshedabad"

Maker unknown. "Oriental Scenery" Series. Dish approximately 13ins:33cm.

Murshidabad, as it is now known, lies on the River Bhagirathi, some 120 miles north of Calcutta. It was once the capital of the Nawab of Bengal but as early as 1810 it was described as "an ill-built decaying city".

"Part of Goodridge Castle, Kent"

Enoch Wood & Sons. Grapevine Border Series. Plates 8¼ins:21cm and 7½ins:19cm.

It has not yet proved possible to locate this scene.

"Part of Regent Street, London"

William Adams. Regent's Park Series. Dish 13ins:33cm, vegetable dish and soup tureen stand. Ill: Atterbury p.211.

Shepherd produced three drawings of Regent Street which were used in *Metropolitan Improvements*, two of the west side and one of the east side. It is not yet known which was used for this pattern.

Parrot Border Series. *Maker unknown. Unidentified view. Unmarked. Toilet box and cover length 7½ ins:19cm.*

Pashkov House, Moscow

Maker or makers unknown. Two views of this house are known, one of which is illustrated under the title Pashkov Palace Pattern in Coysh 1 169. They are shown here on a plate and a jug.

The house is part of a large palace estate built by Vasily Ivanovich Bazenov between 1784 and 1786, for P.E. Pashkov, a wealthy nobleman of the household cavalry. It faces the west side of the Kremlin and is approached by driveways at the rear. The design shows the transition from baroque to neo-classicism, the central block with its two Palladian wings is surmounted by a belvedere and a balustrade with decorative vases. When it ceased to be a private residence it was used as a museum to house the Rumyantsev Collection. After the revolution it became the Old Building of the Lenin Library.

An old print of the building (though not the one from which the patterns were copied) is reproduced by K. Berton in *Moscow* (1977), pp.130-131.

"Pass of the Trossachs, Loch Katrine"

John Meir & Son. "Northern Scenery" Series.

The Trossachs, in Perthshire, join Loch Achray to Loch Katrine. The Gaelic name means 'bristling country' and the area is famed for its beauty.

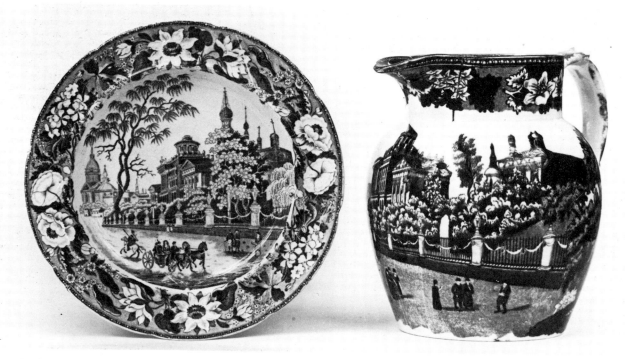

Pashkov House, Moscow. *Plate: Maker unknown. Unmarked. 8½ ins:22cm. Jug: Maker unknown. Unmarked. 7½ ins:19cm.*

Passion Flower Border Series

A series of views in England and Ireland contained within a floral border which features prominent passion flowers. Each item bears its title on a printed ribbon decorated with flowers and leaves, but no maker's mark has yet been found. The views recorded to date include:

"Alnwick Castle"*
"Ashton Hall"
"Belvoir Castle"*
"Dorney Court"*
"Endsleigh Cottage"
"Fonthill Abbey"*
"Gubbins Hall"*
"Hare Hall, Yorkshire"
"Holkham Hall"
"Holywell Cottage" (sic)
"Leomington Baths" (sic)
"Osterley Park"
"Oxburgh Hall"
"Rippon, Yorkshire" (sic)

In addition to the above titles, it is known that a view of The Rookery in Surrey exists, since one view incorrectly marked "Gubbins Hall" is identifiable as The Rookery. Other mismarked items are known.

Items from this series appear in two distinct versions. Some are found in a deep-medium blue, appearing to date from about 1825, whereas most are in a much lighter blue and would appear to be later, c.1835.

An interesting observation is that the series seems to consist of little original design. Several of the patterns are straight copies from Ralph Stevenson's Acorn and Oak Leaf Border Series, and the inner stringing which frames the view is also taken from the same source. The border is very similar to the one used by Goodwins & Harris for their "Metropolitan Scenery" Series, although the earlier versions of these passion flower border pieces would seem to predate the Goodwin partnership.

"Pastoral"

(i) Edward Challinor. A rural scene with a cottage on the left and sheep in the foreground.

(ii) Lockhart & Arthur. A pattern used on moulded plates.

(iii) Ralph Stevenson and Ralph Stevenson & Williams. A rural scene with a copy of Wedgwood's Blue Rose Border (qv). The scene shows a shepherd who has left his flock and is talking to a girl. The title and the relevant maker's initials are printed in a cartouche. Ill: P. Williams p.514.

"Pastoral Scene"

Edward & George Phillips. A rural scene showing a man, woman and child seated beneath a tree. The printed cartouche mark has an eagle with outspread wings above the title. Ill: Little 46.

Patent Ironstone China

A trade name for a heavy ironstone body introduced in 1813 by G.M. & C.J. Mason to imitate Nankin china. The use of the word Patent in such terms should be unique to the Mason firms and relates to the patent specification filed when the body was introduced. Other makers were not slow to copy the ware and many other trade names were used for similar bodies such as Granite China, Indian Stone, Opaque China, Saxon Stone, and Stone China.

Mason's Patent Ironstone China was so strong that it could be used for very large articles such as fireplaces.

Passion Flower Border Series. *Maker unknown. Typical printed mark.*

"Patent Mosaic"

A trade name for a body used by Cork & Edge.

"Patrass" (sic)

Copeland & Garrett. Byron Views Series. Oval dish 11½ ins:29cm.

Patras, or Patrai, is an ancient seaport on the south side of the Gulf of Patras in Greece. The Gulfs of Patras and Corinth separate the peninsula known as Peloponnisus from the mainland. In the early 19th century one-third of the population was Jewish and there were four synagogues. There was a flourishing trade in silk, leather, wax, cheese, tobacco and wheat.

"Pastoral Scene." *Edward & George Phillips. Untitled. Impressed maker's Staffordshire knot mark. Plate 8½ ins:22cm.*

"Patriot's Departure"
Edward & George Phillips. "Polish Views" Series. Dish 17ins:43cm.

Patterson & Co.
This name could well cover several partnerships. All that is certain is that there were two potteries south of the Tyne which were operated by members of the Patterson family and their partners. The available information recorded by Jewitt in 1883 and Bell in 1971 is conflicting. The two potteries involved were:

(i) Tyne Pottery, Heworth Shore, Gateshead. These works were operated by Thomas Patterson & Co. from 1827 until 1835, and possibly longer. Jewitt states that it was carried on by Patterson, Fordy & Co. and closed in 1835. Bell lists a partnership of Patterson, Dawson & Codling from directories of 1833 and 1838.

(ii) Sheriff Hill Pottery, Gateshead. Between 1833 and 1838, directories give the name Jackson & Patterson and Bell states that this partnership succeeded Fordy & Patterson. The next record is of Patterson & Codling in 1844. In 1851 the works appear to have been taken over by a George Patterson who used his initial with the address "Sheriff Hill" in most of his marks. The firm continued until the 1890s.

The mark Patterson & Co. could have been used by any of the partnerships which include the name Patterson. Among patterns known with George Patterson marks are "Albion" and "Grecian".

Patton, John fl. 1848-1856
Phoenix Pottery, Ouseburn, Northumberland. This potter is said to have operated this pottery on his own after the end of a partnership with John Carr as Carr & Patton.

Paul and Virginia
Laidacker uses this title for a dark blue pattern showing a boy and a girl in the woods. He states that it is "supposed to be a picture of the often repeated story". The maker is not known and items are not titled. Ill: Laidacker p.79.

The story of Paul and Virginia was a favourite with children in the late 18th and early 19th century. It was written in 1788 as *Paul et Virginie* by Jacques Henri Bernadin de Saint Pierre (1737-1814). The best known translation into English as *Paul and Virginia* was made by Helen Maria Williams in 1795.

The story tells how two fatherless children were brought up together in idyllic surroundings in a remote corner of Mauritius. They loved each other from infancy. Virginia left the island to visit an aunt in France but when she returned the ship was wrecked off the coast in sight of Paul. A sailor threw off his clothes to swim to the shore, urging Virginia to do the same, but she refused and Paul saw her die with dignity. Two months later he died himself of a broken heart.

Pavilion
See: Absalom's Pillar.

"Peace"
David Methven & Sons. A pattern printed on jugs to celebrate the end of the Crimean War in 1856. One side shows the victorious soldiers and a ribbon marked "The brave soliders and sailors of the Crimea", the other depicts a soldier's return home and includes another ribbon marked "Peace". The printed title mark is a cartouche of flags and laurel wreaths with the makers' name. Ill: May 185.

Peach and Cherry
Coysh introduced this name for a dark blue design used by Stubbs & Kent of Longport. The pattern shows the fruit in the centre and a very wide border of flowers separated into panels with C-scrolls. Laidacker calls the same pattern Fruit and Flowers. Ill: Coysh 1 126; Laidacker p.81.

The Peacock
A title used for the pattern on a 10ins:25cm plate in the Ornithological Series by Andrew Stevenson. Ill: Coysh 2 106.

"Pearl Stone Ware"
A trade name used by Podmore, Walker & Co. for an ironstone-type body. The term can be found as part of printed marks, some of which seem to be designed to cause confusion with the famous Wedgwood factory.

Pearl Ware
A white earthenware made with a high proportion of white clay and flint. It was first made by Josiah Wedgwood in 1779, as an improvement on creamware, and was widely copied by other potters who found it an ideal body for blue-printed wares. Small quantities of cobalt oxide were usually added to the glaze to help give a white appearance, but where the glaze has run thickly against a footrim it shows up very clearly as a blue or greenish tint.

"Peasant Girl Mistaken for the Lady Dulcinea"
James & Ralph Clews. Don Quixote Series. Dish 9½ins:24cm, and vegetable dish.

The title printed on the wares may not include the word "the" before "Lady Dulcinea".

Peel, Sir Robert 1788-1850
A jug by an unknown maker is known with a head and shoulders portrait of Sir Robert Peel in a floral cartouche on one side. The other side is decorated with a picture of Peel on horseback, nearing the scene of his fatal accident. An inscription on the base reads: "Sir Robert Peel, lamented by an Empire".

Both engravings are based on prints taken from the *Illustrated London News*. Peel fell from his horse when returning from a call at Buckingham Palace on 29th June, 1850. He died on 2nd July and was buried at Drayton Bassett.

"Pekin"
(i) Thomas Dimmock & Co.
(ii) Malkin, Walker & Hulse. The mark used for this pattern can be seen in Godden M 2496.
(iii) John Thomson.
(iv) Maker unknown with initials R.D. This Oriental-style floral design may have been made by either Richard Dudson of Hanley or Richard Daniel of Stoke.
The title derives from Peking, the capital of China.

"Pekin Palm"
Herculaneum Pottery. A romantic scene with figures beneath a tree and a distant pagoda. The border is of trellis and flowers with pagoda medallions, whereas the printed mark has the title in a wreath surmounted by a Liver bird. Ill: Smith 170 (pattern and mark).

"Pekin Sketches"
Joseph Clementson. A design marked with initials I.C.

Peking Japan
C.J. Mason & Co. A chinoiserie design similar in layout to the standard Willow pattern. A plate and the print in the original pattern book are illustrated by Haggar and Adams in *Mason Porcelain and Ironstone, 1796-1853*, 101-102. It is not clear whether the pattern is titled and it may have been additionally decorated with overglaze enamels.

"Pelew"
Edward Challinor. A flow-blue design printed on ironstone dinner wares.

Colour Plate XX. Netley Abbey. *Andrew Stevenson. Impressed mark "Stevenson" above a three-masted ship. Dish 21¼ ins:54cm.*

Colour Plate XXI. "Oxford." *Herculaneum. Cherub Medallion Border Series. Printed title mark. Dish 20½ ins:52cm.*

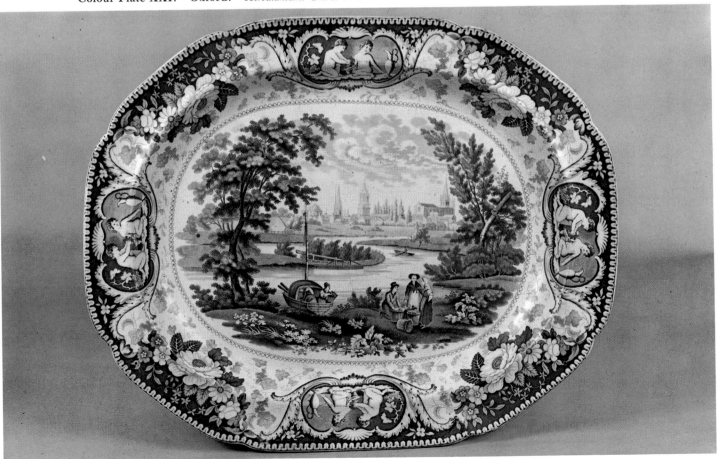

Pellatt & Green fl.c.1802-c.1830

A firm of retailers at 16 St. Paul's Church Yard, London. They appear in a directory of 1803 as: Glass & Staffordshire Warehouse, but from 1806 their entry is much more impressive as: Potters & Glass Manufacturers to the King. This style continues until 1817 when the entries change to: Manufacturers and Exporters of all Kinds of Plain, Flint and Fine Cut Glass, China and Earthenware.

A blue-printed romantic scene is sometimes found with a cartouche below which is printed in script: "Pellatt & Green/16 St. Paul's Churchyard".

"Pembroke Hall, Cambridge"

John & William Ridgway. Oxford and Cambridge College Series. Soup plate 9¾ ins:25cm.

The original hall of Pembroke College was given a doorway in 1634. This is still preserved but major repair and restoration changed the character of the hall in 1863.

"Pennsylvania"

Knight, Elkin & Co. A pattern showing a party in a punt in front of an ornate building with two towers. There is a geometric and floral border. The title appears in script within a scrolled floral cartouche with the initials K.E. & Co. Some items bear an impressed mark of an eagle on a branch, useful in identifying other products from this factory. It is also known in black, pink and purple. Ill: P. Williams p.368.

The title derives from the name of the American state, but the design is a romantic pattern, clearly not meant to be topographical.

Peonies and Birds

A pattern on Mason's Patent Ironstone China, more commonly known as Blue Pheasants (qv).

Peony

A floral pattern by Wedgwood, part of which was engraved by William Hales. The design features an arrangement of peony flowers and leaves repeated four times. There is no border as such although items are edged with a narrow band composed of small circles in groups of three on a line-engraved ground. The pattern is found on dinner wares and a service was made for the Prince of Wales in 1807. Ill: Coysh 2 122.

A dish with this pattern has been recorded with the impressed initials I.E.B. These would relate to John & Edward Baddeley of Shelton.

Peony and Willow

A Swansea pattern described by Morton Nance as "with a peony, a willow tree, a Chinese fence and rocks". He states that two varieties exist, one with a winged insect on the flower. Early pieces are impressed "SWANSEA", later pieces have the name "DILLWYN & Co. SWANSEA".

Peplow

A 20th century name for an early 19th century Spode floral pattern composed of a stylised group of flowers and a decorated vase. The border consists of similar flowers asymmetrically placed on a wide geometric ground. Ill: Whiter 41.

Pepper Pots

Blue-printed pepper pots and salts were made for dinner services but relatively few have survived. Two typical early examples with rural scenes are illustrated.

See: Salt Cellar.

"Pembroke Hall, Cambridge." *John & William Ridgway. Oxford and Cambridge College Series. Printed title and maker's mark. Soup plate 9¾ ins:25cm.*

Pepper Pots. *Makers unknown. Typical shapes 4¼ ins:11cm and 3¾ ins:9cm.*

"**Persian Sun Flower.**" *John Ridgway. Printed title mark with maker's initials. Plate 10ins:25cm.*

"**Phemius Singing to the Suitors.**" *Joseph Clementson. "Classical Antiquities" Series. Printed titles and maker's mark with registration diamond for 13th March, 1849. Plate 10ins:25cm.*

"Pera"

Maker unknown. Ottoman Empire Series. Soup plate 10ins:25cm. Ill: P. Williams p.370.

The scene shows an octagonal building with a porch, rather like an old toll house. There is a galloping horseman watched by several turbaned figures. Pera was a surburb of Constantinople, now Istanbul, in the European quarter on the north side of the Golden Horn. It is now known as Beyoğlu.

"Perseverance and Integrity"

A motto apparently adopted by the potters' unions in Staffordshire. It is found as part of the decoration on a plate marked "OPERATIVE UNION POTTERY".

See: "Society of Operative Potters".

"Persian"

William Ridgway. This design was also printed in lavender. Ill: P. Williams p.159.

"Persian Bird"

Davenport. A flow-blue pattern which shows two heron-like birds with flowers within an open scroll border. The printed title mark is in the form of a bird. The example illustrated with the entry Flow Blue shows the typical blurred effect which was deliberately produced on flow-blue wares.

Persian Lion

A pattern in the Persian style used by J. Carr & Sons (see Bell, *Tyneside Pottery*, p.52) sometimes shows a Persian lion brandishing a sword in the centre and also in the printed mark. The design would appear to have been adapted to show the lion when Queen Victoria entertained the Shah, Nasir-ud-Din, in London in 1873.

"Persian Sun Flower"

John Ridgway. A floral centre on a white ground within a floral border which has a stippled ground. The printed cartouche mark is formed of an oval string of flowers with radial daggers, containing the title "PERSIAN Sun Flower" and the initials J.R. The pattern was printed on dinner wares with a wavy edge. See illustration on previous page.

"Persiana"

Francis Morley. A pattern marked with the initials F.M.

"Peru"

David Lockhart & Co.

"Peruvian Horse Hunt"

A horse hunting scene with a border composed of equestrian vignettes, which was printed in blue and in sepia. Ill: P. Williams p.516.

The mark gives the maker's name as "Shaw's" and this pattern is almost certainly the one registered on 8th August, 1853 by Anthony Shaw of Tunstall.

"Peruvian Hunters"

Goodwin & Ellis. Several scenes were printed under this title, one of which shows four Indians looking across a lake at a group of deer. The border has medallions, each with an Indian standing or kneeling. The title is printed in a cartouche mark with shield and arrows.

"Peter in the Garden"

Enoch Wood & Sons. Scriptural Series. Plate 6¼ins:16cm.

"And Simon Peter stood and warmed himself. They said therefore unto him, Art thou not also one of the disciples? He denied it and said I am not. One of the servants of the high priest...said, Did I not see thee in the garden with him? Peter then denied again: and immediately the cock crew." John 18, 25-27.

"Peterborough"

Enoch Wood & Sons. "English Cities" Series.

The city of Peterborough stands on the River Nene in Cambridgeshire. At one time it was on the borders of Northamptonshire and Huntingdon. The cathedral, noted for its Early English west front, was mainly built between 1118 and 1193.

"Pett Lamb" (sic)

Edward & George Phillips. A pattern on children's tea services which shows a seated girl caressing a lamb. There is a country house in the background and a floral border. Many of the hollow pieces bear only the border. The printed title mark incorporates the makers' initials E. & G.P.

Petty's Pottery, Leeds.

See: Rainforth & Co.

"Pheasant"

Ridgway & Morley. A flow-blue design printed on ironstone.

The same title is known on a design printed in purple by Wood & Challinor.

The pheasant was used in designs by several potters, for instance Mason's Blue Pheasants (qv) and Andrew Stevenson's Pheasant in his Ornithological Series (qv). It also appears in some patterns with exotic birds (qv).

"Phemius Singing to the Suitors"

Joseph Clementson. "Classical Antiquities" Series. Plate 10ins:25cm.

Along with other patterns from the series, this design was registered on 13th March, 1849.

Phemius was a celebrated musician who sang to the suitors of Penelope in Ithica while they waited to try their skill in shooting with the bow of Ulysses. Penelope had promised her hand in marriage to the one who was most successful but none of them was able to draw the bow.

Phillips, Edward fl.1855-1862

Cannon Street, Shelton, Staffordshire. This potter used his full name in printed marks.

Phillips, Edward & George fl.1822-1834

Longport, Staffordshire. This firm produced several blue-printed designs, including patterns such as "Chinese Views" and "Guitar". Printed marks are usually in the form of title cartouches which include the name in full, sometimes with the addition of "Longport", although some examples bear initials E. & G.P. The impressed mark of a Staffordshire knot with the words "PHILLIPS" and "LONGPORT" is frequently attributed to George Phillips, although it has been seen on pieces which appear to predate 1834, and may thus also have been used by this earlier partnership. The letter 'N' is impressed in reverse.

Phillips, Edward and George. *Typical impressed mark of Edward & George Phillips. Note the reversed letter N.*

Phillips, George — fl.1834-1848

Longport, Staffordshire. George Phillips continued after the end of the partnership with Edward, and many blue-printed designs were produced. This firm appears to have originated the "Eton College" pattern which was later copied by several other potters. Many different designs were made including "Park Scenery", "Verona", "Marine" and "Canova". A selection of floral and romantic patterns were included, and flow-blue was also made. Many printed marks are known, usually including the name G. Phillips. Where the name is simply the surname, such marks could also relate to the earlier partnership with Edward, and it is necessary to consider the style of the piece before making an attribution. It is however, generally thought that such marks belong to this later firm, particularly where the Staffordshire knot is included.

Phillips, Jesse — fl.c.1804-1834

A dish in the Village Church pattern has been recorded with a printed cartouche of leaves and berries containing the legend:

J. PHILLIPS. Junr
POTTER
6 Gt. Queen St.
Lincolns Inn
LONDON

Jesse Phillips opened a China, Glass and Staffordshire Warehouse at 187 Drury Lane, London, in about 1804. The business moved to 6 Queen Street, Lincoln's Inn Fields, in about 1811, an address which seems to have changed to Great Queen Street from 1815. Phillips is listed as either a Potter & Glassman, or a Glass &c. Warehouse. Entries continued until 1827, but by 1834 the firm of Jesse Phillips Jr. was at 11 Great Newport Street. The firm appears to have ceased at about this time although there are two further firms at different addresses with the name Jesse Phillips before 1840. The above mark must date somewhere between 1827 and 1834, which agrees with the pattern recorded.

The Philosopher. *Maker unknown. Unmarked. Plate 8¼ ins: 21cm.*

Phillips, John — fl.c.1807-1812

Sunderland or Garrison Pottery, Sunderland, Durham. Wares from this pottery are found with impressed marks, usually in the form "J. PHILLIPS" and the name "SUNDERLAND POTTERY". If the address is simply "SUNDERLAND", the item could have been made either here or at the North Hylton Pottery (see next entry).

This pottery continued until 1865 under various partnerships including the name Dixon.

See: Dixon, Austin & Co.

Phillips, John — fl.c.1815-c.1851

North Hylton Pottery, Sunderland, Durham. John Phillips took over the North Hylton Pottery in 1815. He was already involved in the Sunderland (or Garrison) Pottery and there was apparently some considerable interchange between the two works. Marks used at North Hylton were normally printed and have the name "JOHN PHILLIPS" or "J. PHILLIPS" together with the words "HYLTON POTTERY" or "HYLTON POT WORKS".

The Philosopher

An untitled pattern by an unknown maker is frequently given this name. It shows a draped figure seated on a plinth amid ruins in a rural setting. There is a standing figure to the right and two more figures gaze up at the philosopher. It is an early (c.1820) pattern produced in good quality on dinner wares. Ill: FOB 5.

"Piccolo Bent"

Maker unknown. Ottoman Empire Series. Wavy edge dessert dish 9½ ins:24cm. Illustration overleaf.

This scene clearly shows the dam at a waterworks but the exact locality has not yet been traced.

Picking Apples

A small unmarked plate with this title is illustrated in Coysh 2 154. The design covers the whole surface, edged only by a line of beading. The scene shows two boys, one in a tree and the other on a ladder, picking apples and passing them to a girl standing beneath with a spread apron full of apples. There are two baskets on the ground and a doorway on the left.

Coysh lists his example as "maker unknown", but the same design is illustrated by Eaglestone and Lockett in *The Rockingham Pottery*, plate XIIa. Their example has a floral border added but otherwise appears to be identical. It is impressed "BRAMELD". Eaglestone and Lockett use the alternative title of Apple Gatherers.

Pickle Dish

A small dish used for serving pickles.

The term covers a variety of shapes but is particularly associated with a small dish in the form of a leaf with dentil edge. Most of these dishes are moulded in fine detail, including veins underneath the leaves. They were made by many of the major works such as Ridgway, Spode and Wedgwood but are usually unmarked. An example by John & William Ridgway is illustrated overleaf.

"Picturesque"

Maker unknown. A title found together with a set of unidentifiable initials on a small light blue plate.

"Picturesque Asiatic Beauties"

Jones. A romantic style pattern featuring Indian minarets and figures within a floral border, printed on wares with a moulded shaped edge. The printed cartouche mark has the wording "Picturesque ASIATIC Beauties" superimposed on an ornate building, with leaves and scrolls and the name "Jones" beneath. There were several potters with this name in Staffordshire when these wares were produced. Both pattern and mark are illustrated in FOB 12.

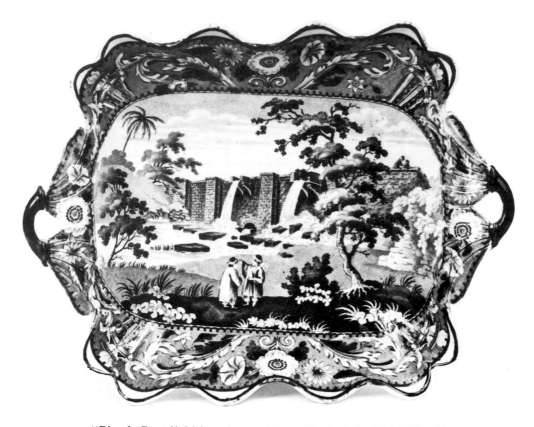

"**Piccolo Bent.**" *Maker unknown. Ottoman Empire Series. Dish 9 ½ ins:24cm.*

Pickle Dish. *John & William Ridgway. Oxford and Cambridge College Series. Unidentified view. Unmarked. Length 5 ¾ ins:15cm.*

"Picturesque Scenery" Series

A series by Ralph Hall printed in dark blue with a border of fruit and flowers. The border includes pears, nuts, blackcurrants and raspberries but appears to vary from item to item. The central views are mainly British but Irish, French and German scenes are included, suggesting that the maker may have had export to Europe in mind.

The printed cartouche mark of flowers and scrolls includes the legend "R. HALL'S, PICTURESQUE SCENERY" together with the name of the individual scene. The known titles are as follows:

"Alton Abbey, Staffordshire, England"
"Broadlands, Hampshire"
"Cashiobury, Hertfordshire"
"Croe House"
"Crome Court, Worcester" (sic)
"Culford Hall, Suffolk"
"Dreghorn House, Scotland"
"Dunsany Castle, Ireland"
"Fulham Church, Middlesex"*
"Klostenburg, Germany"
"Llanarth Court, Monmouthshire"
"Norwich Cathedral, Norfolk"
"Palace of St. Cloud, France"
"Palace of St. Germain, France"
"Panshanger, Hertfordshire"
"St. Woolston's, Kildare, Ireland" (sic)
"Terwin Water, Hertfordshire" (sic)
"Trematon Castle"
"Worcester Cathedral"

"Picturesque Scenery" Series. *Ralph Hall. Typical printed mark.*

Piercing

A lattice-work produced near the rims of plates and dishes, or in the walls of baskets and comports. The holes are cut from the leather hard clay by hand, although the cutter would be guided by a moulded design. The result is usually a geometric pattern of holes.

Pilgrim Flask

See: Flasks.

"Pillar of Absalom"

Maker unknown. Ottoman Empire Series. Vegetable dish.
See: Absalom's Pillar.

Pillement, Jean 1728-1803

A French artist who produced a series of engravings under the title *The Ladies Amusement* which was published by Robert Sayer of London in 1759. It contains over 1,500 designs, many of which were copied for patterns on pottery and porcelain, including blue-printed wares.

Pineapple Border Series. *Maker unknown. Typical printed mark.*

Pineapple Border Series

A series of views by an unknown maker, mainly depicting ruined castles and abbeys. Each piece bears a title printed in a cartouche consisting of a paper scroll festooned with flowers. The name has been chosen because of the distinctive pineapple in the border of flowers and scrolls on a geometric ground. Views noted to date include:

"Barnard Castle, Durham"
"Caerfilly Castle, Glamorganshire" (sic)
"Charenton, near Paris"*
"Dalberton Tower, Wales"*
"Furness Abbey, Lancashire"
"Helmsley Castle, Yorkshire"
"Kirkham Priory Gateway, Yorkshire"
"Kirkham Priory, Yorkshire"
"Knaresborough Castle, Yorkshire"*
"Lanthony Abbey, Monmouthshire" (sic)*
"Lumley Castle, Durham"
"Malmsbury Abbey, Wiltshire" (sic)*
"Roche Abbey, Yorkshire"
"St. Alban's Abbey, Hertfordshire"*
"St. Joseph's Chapel, Glastonbury, Somersetshire"
"Slingsby Castle, Yorkshire"
"Valle Crucis Abbey, Wales"
"Windsor Castle, Berkshire"*

Items are frequently mis-marked; the presence of "Kirkham Priory Gateway, Yorkshire" is known only by a mark on a piece with the view of Dalberton Tower. The quality can only be described as variable, some pieces are crisply printed and well potted, others are so indistinctly printed that details of the background have almost disappeared.

Piping Shepherd

An untitled pattern showing a shepherd playing his pipe to a lady seated amongst sheep. Two figures are crossing a bridge in the middle distance right, and there is a large house on the hill in the background. The border is of flowers and ivy leaves. A large dish has been reported with a Phillips impressed mark but all other known examples are unmarked. The pattern is found mainly on dinner wares. Ill: FOB 2.

"Pishobury, Hertfordshire" (sic)

William Adams. Flowers and Leaves Border Series. Dish 13ins:33cm, and tureen stand 14ins:36cm.

Pishiobury is a Tudor mansion rebuilt by James Wyatt in 1782 with gardens laid out by Capability Brown. The view shows the garden side with its three-bay castellated pediment. There are tents erected in the garden and soldiers are on parade.

Pitcher

The American name for a jug or ewer, especially for the large water jug found in jug and washbowl sets.

"Plasnewydd, Anglesey"

William Adams. Flowers and Leaves Border Series. Plate 8½ ins:22cm.

Plas Newydd, meaning the new place, is an 18th century house built by James Wyatt on the bank of the Menai Strait. It is the home of the Paget family and is now owned and opened by the National Trust. A particularly notable feature is the largest mural painted by Rex Whistler.

Platter

A name used in America for a meat dish, also known as a charger or, in Scotland, an ashet. In Britain a platter is strictly a circular plate. Samuel Pepys, for example, "dined on an earthen platter".

"Playing at Draughts"

James and Ralph Clews. "Wilkie's Designs" Series. Plates and soup plates between 7¾ ins:20cm and 10ins:25cm. Ill: Arman 88.

"Plover"

Charles Meigh.

Plus Marks

Brameld impressed marks are often followed by a plus sign and a number, for example "BRAMELD + 4". The most common number is 1; the highest so far recorded is 16. The application of the numbers seems to bear no relation to the items involved and their significance is not yet known.

Plymouth Pottery

Jewitt states that printed Queen's Ware was made at Plymouth from 1810 by three manufacturers. One of these may well have been the Plymouth Pottery since an early blue-printed teapot has been noted with the rare impressed mark "PLYMOUTH POTTERY" in circular form.

Podmore, Walker & Co. fl.1834-1859

Tunstall, Staffordshire. This firm operated three potteries in Tunstall at different periods and is one of the firms that tried to sell their wares as Wedgwood. This was strictly legitimate since the third partner was Enoch Wedgwood, but it still leads to confusion. A typical design marked Wedgwood which originated here is titled "California". They did, however, produce wares with printed initials P.W. & Co., and later items are marked P.W. & W. for Podmore, Walker & Wedgwood (after 1856).

The firm closed down in 1859 but one of the potteries, in Amicable Street, was continued by Wedgwood & Co. who made use of several patterns introduced by this earlier partnership. Podmore, Walker & Co. were the original manufacturers of the then popular "Asiatic Pheasants" pattern.

Pointer and Quail

A pointer and quail appear on one design printed on a plate (8½ ins:22cm) in Enoch Wood & Sons' Sporting Series. Ill: Laidacker p.105.

"Pishobury, Hertfordshire." *William Adams. Flowers and Leaves Border Series. Printed title mark and impressed maker's eagle mark. Tureen stand 14ins:36cm.*

Polar Bear

The polar bear is featured on two patterns, one by John Hall on a vegetable dish in the "Quadrupeds" Series, and the other by Enoch Wood & Sons on a dish (16½ ins:42cm) and a pierced basket in their Sporting Series. Ill: FOB 4.

"Polish Views"

Edward & George Phillips. Laidacker states that this series is known in light blue and pink. The only views recorded are:
- "Patriot's Departure"
- "A Tear for Poland"
- "Wearied Poles"

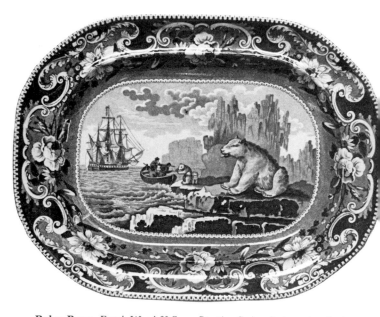

Polar Bear. *Enoch Wood & Sons. Sporting Series. Impressed maker's eagle mark. Dish 16½ ins:42cm.*

"Pomerania"
John Ridgway. A series of romantic scenes used on dinner wares, each with a different view of buildings. They were also printed in pink, purple and sepia. Ill: P. Williams p.378 (two examples).

Pomerania lies on the Baltic coast and is an area noted for its lakes. It was ruled by Dukes in the Middle Ages but split between Brandenburg and Sweden in 1643. The Swedish part was ceded to Prussia in 1815 but the area is now divided between Germany and Poland.

"Pomona"
Elijah Jones. A pattern showing a basket of fruit within a border of fruit and C-scrolls. The title is printed in a floral cartouche with the initials E.J. The title was also used by other potters.

Pomona, sometimes called Mainland, is the largest of the Orkney Islands.

"Pompeii"
John Rogers & Son. This design features an egret surrounded by acanthus-type scrolled foliage, all within a border of classical antiquities and motifs. It is found on dinner and dessert wares with a wavy edge. The title is printed in an oval cartouche. Ill: Coysh 2 81.

Pompeii, close to the shore of the Bay of Naples, was a town which was buried by ashes after an eruption of Vesuvius in A.D. 79. Great interest was shown during the 18th century in the systematic excavations which began in 1763 and continued for many years.

Ponte Molle
Maker unknown. A view of the bridge near Rome which was copied from an engraving by Thomas Major dated 1753 after a pastoral landscape by Claude Lorraine which is now in the Birmingham Art Gallery. The pattern is illustrated overleaf on a drainer, but can also be found on other dinner wares with a border of flowers and cornucopia-shaped floral scrolls. Ill: Coysh 1 171.

The Ponte Molle, or Pons Melvius, crosses the Tiber about two miles from Rome. It was built in 109 B.C., remodelled in the 15th century, and restored in 1805 by Pope Pius VII. The bridge was blown up by Garibaldi in 1849 to delay the French but was restored again in 1850.

When Constantine the Great marched on Rome in A.D. 312 against the Roman Emperor Maxentius, the Roman attempted to escape into the city over the Pons Melvius but was drowned in the river.

"Ponte del Palazzo"
Enoch Wood & Sons. "Italian Scenery" Series. Dish 17ins:43cm.

"Ponte Rotto"
(i) Enoch Wood & Sons. "Italian Scenery" Series. Dishes 16ins:41cm and 18ins:46cm.

(ii) Maker unknown. A view of the ruined bridge printed on dinner wares. It shows a city with a prominent monastery in the background. It is framed by six segments of trellis-work and a border of flowers and leaves. See illustrations overleaf.

The printed title mark is identical in form to that used by Rogers for the "Tivoli" pattern (Little mark 101). It has long been suggested that this is a Rogers production and one example with an indistinct impressed mark has been reported. Ill: FOB 29.

The Ponte Rotto or broken bridge was given this name after the Pons Aemilius collapsed in 1598. This was the first stone bridge to cross the Tiber and was built between 179 and 142 B.C.

Poonah, J.
A name which has been recorded on a dish made for the Gateshead Railway. It has not yet been traced but may be either a retailer or a company official.

"Poor Richard's Maxims"
See: Doctor Franklin's Maxims.

"Port of Ansetta"
Don Pottery and Joseph Twigg, Newhill Pottery. Named Italian Views Series.

"Port of Latachia"
Maker unknown. Ottoman Empire Series.

The ancient seaport of Latakia, on the Mediterranean coast of Syria, is now known as Al Ladhiqiya.

See: Latachia.

"Port of Turenium"
Don Pottery and Joseph Twigg, Newhill Pottery. Named Italian Views Series. Footbath.

Turenium, the modern Trani, is on the Adriatic coast some thirty miles west of Bari. It was formerly also called Tarenum or Tarentum. There are many ancient monuments including Roman ruins with the Mausoleum of Marcus Aurelius, a cathedral, a castle and an old Benedictine Abbey.

"Portland Basket"
John & William Ridgway. A floral design recorded on stone china moulded dessert wares with a prominent basket of flowers. The printed cartouche includes the title, "Opaque China", and the makers' initials J.W.R.

Portland Vase
A pattern showing this famous vase in a border of acanthus scrolls was made by Spode and Copeland & Garrett. Ill: Whiter 76.

The Portland Vase is a remarkable example of Roman art, made of dark blue glass and decorated with figures in relief in white glass. It was purchased from Byres, the architect, by Sir William Hamilton in 1770, and then sold to the Duchess of Portland. In 1810 it was lent to the British Museum where it was broken by a maniac in 1845. It was repaired and finally acquired by the museum in 1946.

Posset Pot
A two-handled bowl, usually with lid and stand, which was used to serve posset. This was a gruel made from hot milk, curdled with ale or wine, and flavoured with spices. It was regarded as a remedy for colds.

See: Caudle Cup.

"Post Office, Dublin"
Tams, Anderson & Tams. Tams' Foliage Border Series. Dishes 17ins:43cm and 18ins:46cm, and vegetable dish. Ill: Little 70. See illustration on page 289.

The General Post Office lies on the west side of O'Connell Street, Dublin's chief commercial district. Built by Francis Johnston in 1818, it was the site of the declaration of an Irish Republic during the Easter Rising in 1916. The view also shows the 100 feet high Nelson Pillar, erected in 1808. It was for long a notable landmark in the city, but was blown up in 1966.

The Potteries
The district known as The Potteries is in north Staffordshire, centred on Stoke-on-Trent. It covers an area some ten miles long and, as its name implies, was devoted to the production of pottery, for which it became world famous. The area includes the towns and hamlets called Burslem, Cobridge, Etruria, Fenton, Hanley, Lane Delph, Lane End, Longport, Longton, Shelton, Stoke-on-Trent and Tunstall.

Ponte Molle. *Scene after Claude Lorraine. Maker unknown. Unmarked. Drainer 13 ¼ ins:34cm.*

"Ponte Rotto." *Maker unknown. Printed title mark. Pierced plate or stand 8 ½ ins:22cm.*

"Ponte Rotto." *Printed title mark.*

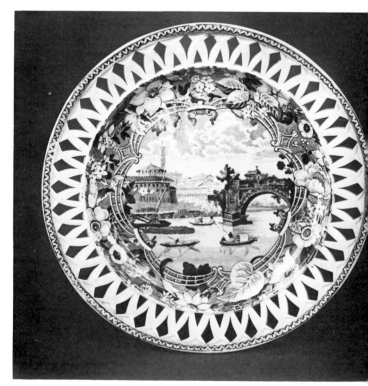

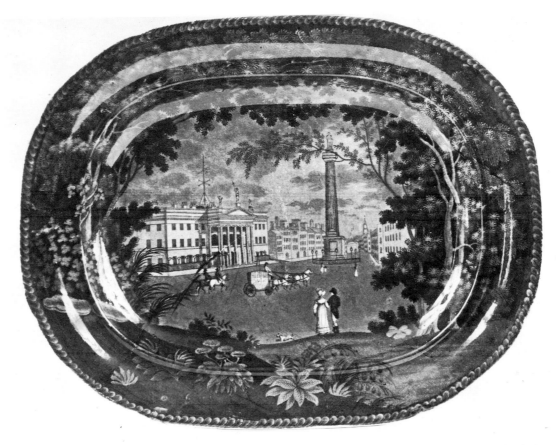

"**Post Office, Dublin.**" *Tams, Anderson & Tams. Tams' Foliage Border Series. Printed title mark and impressed maker's mark. Dish 17ins:43cm.*

Potters' Count
The potters' count is a novel and historical way in which the size of hollow items is defined. An interesting definition is contained in a leaflet entitled *The Ruin of Potters and the Way to Avoid it — by a Manufacturer* (1804), preserved in the Birmingham Reference Library:

And here, gentlemen, the rule of our forefathers presents itself to our view in the original standard of count, dominated by the size of a pint mug, by which we are to understand, that all articles that may be deemed *hollow* ware, of whatever shape, containing one pint, are counted 12 to the dozen. If they contain less, the quantity is increased; if more, the quantity is diminished. As when we reckon a vessel holding 6 pints, at 2 to the dozen, to a coffee-can containing only one-third of a pint, at 36 to the dozen. These things are so well known, that they require no further explanation.

The system was used to establish a standard for selling wares, a price being quoted 'per dozen'. The significance to present-day collectors of blue-printed wares lies in the fact that it explains many of the numbers impressed on the wares. A number 12 on a jug, for example, means that it holds a nominal one pint; a number 6 signifying two pints; and so on. It is emphasised that the numbers define a *nominal* size; the potters used to compete on the *actual* sizes of their wares and many one-pint jugs can hold very nearly two pints.

Pottery Tissue
The name used in the trade to describe the paper used in the transfer-printing process.

Poultry Dish
An alternative name for a well-and-tree dish (qv).

Pountney & Allies fl. 1816-1835
Bristol Pottery, Temple Backs, Bristol. This pottery probably started blue-printing rather late. It is said to have employed an engraver from Staffordshire by the name of Wildblood to help with the development. Certainly, some of the patterns used were pirated from Staffordshire designs. The pottery did, however, produce a very fine Bristol Views Series (qv) and another "River Thames" Series (qv), although these may all have been views printed on the same multi-pattern dinner service.

Wares are usually marked with the name "POUNTNEY & ALLIES" in the form of a horseshoe around a cross although many examples seem to have only an impressed initial P. Printed marks were common with titles, often with the addition of initials P. & A. or P.A. The single initial P is also often attributed to this firm. A Willow pattern plate has been noted with a printed mark of three bottle kilns, and the words "IMPROVED STONE CHINA".

The firm was succeeded by Pountney & Goldney, who continued many of the patterns.

Pountney & Co. fl. 1849-1889
Bristol Victoria Pottery, Temple Backs, Bristol. When Goldney withdrew in 1849, the firm was continued under the title Pountney & Co., a style which continued until 1889 when the firm became a limited company. When marked, wares have either the full name or the initials P. & Co. Some of the Bristol Views Series (qv) were revived after World War II using the old copper plates. These later prints can easily mislead the inexperienced collector.

Pountney & Goldney fl. 1836-1849

Bristol Pottery, Temple Backs, Bristol. This partnership continued to produce many of the patterns introduced by Pountney & Allies. There is little evidence that many new patterns were introduced but "The Drama" Series was copied from designs used by John Rogers & Son of Longport. This series may also have been produced by the earlier partnership but all marked examples so far recorded bear Pountney & Goldney marks.

The major mark used during this period was "POUNTNEY & GOLDNEY" in the form of a horseshoe around a cross, a similar design to that used earlier.

Pouzzuoli

A volcanic region near Naples in Italy, known today as Pozzuoli. The Don Pottery and Joseph Twigg of the Newhill Pottery used a view entitled "Temple of Serapis, Pouzzuoli" in the Named Italian Views Series (qv).

"Powder Mill, Hastings"

Maker unknown. Beaded Frame Mark Series. Soup plate 9¾ ins:25cm. Ill: Coysh 2 135.

This scene is thought to depict the windmill which was at Fairlight in East Sussex, three miles north east of Hastings. A powder mill was used to grind the consituents for gunpowder.

See: Colour Plate IV.

Powell & Bishop fl. 1876-1878

Stafford Street Works, Hanley, Staffordshire. This short-lived partnership is known to have used the "Abbey" pattern on toilet wares. Marks included either the full name or the initials P. & B. They were succeeded by Powell, Bishop & Stonier.

"Powder Mill, Hastings." *Maker unknown. Beaded Frame Mark Series. Printed title mark. Border clobbered with pink, orange, green and yellow enamels. Soup plate 9¾ ins:25cm.*

Pratt, F. & R. (& Co.) fl. c.1818 to present

High Street, Fenton, Staffordshire. This company is best known for its multicolour printed wares, particularly pot lids, but single colour printing was used. Marked examples are distinguished by either the name in full or the initials F. & R.P. (with & Co. added from 1840). Marked examples in blue are not common, but since the multicolour printing would require considerable experience, this tends to suggest that earlier wares were possibly unmarked. One pattern commonly found on marked vases is titled "Native Scenery", a copy of the Native pattern by William Adams.

Precarious Chinaman

A title attributed to a pattern used at the Cambrian Pottery, Swansea. It shows a chinaman with a pointed hat descending a slope while other figures with feathered hats, one holding a parasol over him, appear to follow. It is based on Plate 50 in Jean Pillement's *The Ladies Amusement* (1759). One example has been recorded dated 1805 and another version has been found with a border which includes vignettes with cherubs on a geometric ground, one vignette bearing the inscription "In Tenui Labor" on a scroll. It was a widely used design which was printed on plates, mugs, bowls, and at least one puzzle jug. Ill: Coysh 2 110; FOB 19.

Primavesi, F. (& Son) fl. c.1850-1915

A firm of china retailers based in Cardiff and Swansea. A printed mark in the form of the royal arms with the words "F. PRIMAVESI & SON/CARDIFF & SWANSEA" has been recorded on mess plates (qv). According to Godden M 3167, the style "& Son" appears to date from c.1860.

Prince of Wales

Robert Cochran & Co. A jug printed in dark blackish-blue has been noted with portraits of the Prince and Princess of Wales (later Edward VII and Queen Alexandra), one on either side.

Prince of Wales' Feathers

The device known as the Prince of Wales' Feathers consists of three large feathers rising out of a coronet, sometimes with the addition of a ribbon bearing the motto Ich Dien. The device can be found as part of printed or impressed marks on blue-printed wares. Potters known to have used it are:

(i) John Denton Bagster. Printed in association with a Staffordshire knot.

(ii) Baker, Bevans & Irwin. Impressed alone and also within the maker's mark shaped like a horseshoe.

(iii) Thomas & John Carey. Printed on examples with the "Lady of the Lake" pattern.

(iv) D.J. Evans & Co. Printed with the firm's name on a pattern titled "Floral".

(v) John Rogers & Son. Impressed above the name "ROGERS", not a common mark.

(vi) John Turner. Impressed or printed above the name "TURNER" and used after 1784 when Turner & Abbott were appointed potters to the Prince of Wales.

The device was also used in the 1870s by Hammersley & Asbury (1872-75) and their successors Edward Asbury & Co. (1875-1925) of the Prince of Wales' Works, Sutherland Road, Longton, Staffordshire. The works were named in honour of the marriage of the Prince on 10th March, 1863. The printed marks include either the initials H. & A. or the name Asbury with the place name Longton.

Princess Charlotte

See: Charlotte.

Principal Entrance of the Harbour of Cacamo. *Spode. Caramanian Series. Impressed and printed maker's marks. Drainer 11½ ins:29cm.*

Principal Entrance of the Harbour of Cacamo

Spode. Caramanian Series. Oval dish 14½ ins:37cm, and drainer 11½ ins:29cm. Ill: S.B. Williams 44-45.

See: Cacamo.

Printed Mark

As the technique of transfer printing became widely accepted so its benefits were increasingly appreciated. Early impressed marks were supplemented by printed marks soon after 1800 and by about 1820 printed marks with titles and other information became common. The use of such marks is easy since it is necessary only to engrave the mark on the same copper plate as the pattern itself; the transferrer then simply cuts off the mark from the tissue transfer paper and applies it to the back of the ware.

The style of printed marks can be of assistance in dating wares. The earliest consisted simply of the maker's name in imitation of the currently used impressed marks, but decorative cartouche marks were in use by about 1820 and widespread in the 1830s and 1840s. Later printed marks tend to be more informative but less artistic.

See: Initial Marks; Named Views.

"Priory"

(i) John Alcock. A series of romantic scenes with ecclesiastical buildings within a border of vine leaves and grapes on a stippled ground. The title appears in a floral cartouche with "JOHN ALCOCK" above and "COBRIDGE" below. Ill: P. Williams pp.380-381 (two examples).

(ii) Edward Challinor & Co. A romantic scene within a border of scrolled medallions.

(iii) Hicks, Meigh & Johnson. A pattern marked with the initials H.M.J.

"The Progress of a Quartern Loaf"

Maker unknown. This title is known printed on a child's plate with a moulded border of flowers. It would appear to be a series title although only one pattern has so far been recorded with a design named "The Miller" (qv).

A quartern loaf was one weighing four pounds.

Pull

The name used for a piece of transfer paper after it has been printed with the design ready for transferring to the ware. Tissue paper pulls were used for keeping records in pattern books and can occasionally be found by the collector. Such pulls were sometimes illegally smuggled out of potteries by rival concerns, an early form of industrial espionage. The design is in reverse on the pull, and this explains why some pirated designs are found printed in reverse.

Pulteney Bridge, Bath

A view which appears to represent the famous Pulteney Bridge in Bath has been recorded on a puzzle jug with an attractively pierced rim and on a smaller jug, 5ins:13cm high. This design has been attributed by Pryce and Williams, *Swansea Blue and White Pottery,* to Dillwyn & Co. of Swansea.

The bridge over the River Avon was built in 1770 by Sir William Pulteney to a design by Robert Adam. It has three arches and a row of buildings, now shops, on each side.

Putti

The plural of the Italian word *putto,* meaning the figure of young boy. The term is used for a chubby, naked infant like a cherub, particularly in the field of decorative painting and sculpture of the Renaissance period, and in baroque art. Putti are found in the border of the Named Italian Views Series (qv). Similar words occasionally used are *amoretti* and *amorini.*

Puzzle Jug

A jug with a pierced neck around which there is a hollow tube with three or more spouts. This tube is connected to the interior of the jug by a hollow handle, often with a concealed hole. The drinker is challenged to empty the jug without spilling any liquid. This can only be done by suction through one spout when all the others, together with the hole in the handle, have been covered.

See Colour Plate XXVII.

Pulteney Bridge, Bath. *Attributed to Dillwyn & Co. Unmarked. Jug 5ins:13cm.*

Putti. *Two putti on the end of a tureen by the Don Pottery in the Named Italian Views Series. The same figures were used in the border printed on the other pieces.*

"Quadrupeds" Series

Animal studies by John Hall which are marked with the series title "Quadrupeds" in an angular cartouche but do not have individual titles. The designs have the featured animal in a central circular panel, with four further animals in scrolled medallions in the very wide border. These border medallions are separated by vase and flower motifs. Laidacker lists the following central designs:

Antelope
Camel and other animals
Deer
Dog
Dog and rabbit
Fox
Horse and colt
Hyena
Lion
Moose and Hunters
Otter
Polar Bear
Rabbit and Hunters
Rhinoceros
Wolverine

Some of these designs have been noted with the same printed title "Quadrupeds" in a cartouche over the initials D. & S. It is possible that Dimmock & Smith of Hanley acquired the copper plates when the Hall firm ceased to trade in 1832. It would have been simple to re-engrave the mark with the new initials rather than the old name.

"Quails"

This title appears on a shaped dessert dish with a mainly floral pattern and an impressed mark "CHILD". The printed cartouche with the title is in the form of a leafy oval with a ribbon at the bottom and the inscription "Mortlock's, Oxford Street" around the top. The firm of Smith Child potted at Tunstall between 1763 and 1790. The impressed mark "CHILD" is usually considered to have been used during the last decade of the period. Printed title cartouche marks did not come into general use until the 1820s and these dates are clearly inconsistent. The only satisfactory explanation seems to be that the successors of Smith Child who potted under the style Child & Clive between 1811 and 1828, may have utilised old biscuit ware which was still in stock.

This pattern was later copied under the same title by Furnivals Ltd. The printed mark is dated "1913".

"The Quaker, Act 2, Scene 2"

John Rogers & Son and Pountney & Goldney. "The Drama" Series.

This was a play by Charles Dibdin (1745-1814) who started his career as a dramatist at the age of sixteen. His main claim to fame, however, was as a prolific song-writer. He is credited with having written in excess of 1,200 songs, among them *Tom Bowling* and *Blow High, Blow Low*.

"Quails." *Attributed to Child & Clive. Printed title mark with inscription "Mortlock's, Oxford Street". Impressed "CHILD". Diamond shaped dish with moulded 'veins' 9¼ ins:23cm.*

Queen Caroline. *Jug made to commemorate Queen Caroline's defence by Henry Brougham, M.P., in 1820 when a Bill was introduced for her deposition and for the dissolution of her marriage to George IV. Maker unknown. Height 4¼ ins: 11cm.*

Queen Caroline 1768-1821

Caroline Amelia Elizabeth of Brunswick came to England in 1795 to marry the Prince of Wales. The marriage was an unhappy one. Caroline was persecuted by her husband, there was a formal separation and eventually she went abroad in 1814. When George III died in 1820 and his son became George IV, Caroline returned to England as Queen. A Bill was quickly brought before Parliament to deprive her of her rights and prerogatives. She was ably defended by Henry Brougham. Popular feeling was on Caroline's side and the Bill was dropped. A number of commemorative pieces reflect the support for Caroline at the time. The jug above, for example, shows ''Her Majesty Caroline Queen of England'' on one side and ''H. Brougham Esq. M.P.'' on the other.

Queen Charlotte Pattern

A Spode Chinese landscape pattern. The name derives from the suggestion that it was used on a service made for Queen Charlotte when she paid a visit to the Spode works in 1817, but there is no evidence to support this. However, after long usage the title Queen Charlotte Pattern is used here in preference to the title New Bridge, a name given to it when it was re-engraved in Victorian times.

Two figures stand to the left of a bridge which joins a small island to the mainland, both with pagodas. The distinguishing feature is a long well-trodden pathway leading to a gap between two trees to the left of the pagoda on the mainland. There are several versions, discussed in Copeland, chapter 10. Whiter (p.170) states that all pieces he has seen are on china, not earthenware, but Coysh illustrates an earthenware well-and-tree dish. Ill: Coysh 2 84; Whiter 17.

The Chinese original was also copied by Enoch Wood & Sons though the Wood version does not define the pathway. Moreover it has a double border — an outer one of the Fitzhugh type and an inner honeycomb border.

Queen of Sheba

A name gaining wide acceptance for a pattern found both on miniature and full-size dinner wares. It is similar in style to Spode's Gothic Castle design with Gothic ruins in a Chinese landscape and a typical chinoiserie border. The name derives from the foreground of the pattern where the Queen is escorted on a walk by a blackamoor holding a parasol and two children holding her train. There is another child at her side.

This design has also been known as the Chinese Procession pattern.

Queen of Sheba. *Maker unknown. Unmarked. Miniature soup plate 3¼ ins: 8cm.*

Queen Victoria 1819-1901

The Princess Alexandrina Victoria was born on 24th May, 1819 and acceded to the throne on the death of William IV on 20th June, 1837. Following the longest reign in British history she was succeeded by Edward VII on 22nd January, 1901. Blue-printed wares were made to commemorate her coronation and her marriage.

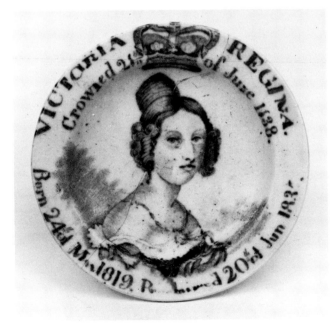

Queen Victoria's Coronation. *Child's toy plate made to commemorate the Coronation of Queen Victoria. Unmarked. Diam. 3¼ ins:8cm.*

Queen Victoria and Prince Albert

A blue-printed jug by an unknown maker, possibly made to commemorate the marriage. It shows a portrait of Victoria on one side, surrounded by ensigns, symbols of war and flowers. The other side has a portrait of Prince Albert. The base is marked with a crown and the word "UNION". It may be that this mark relates to the Southwick Union Pottery at Sunderland, or alternatively to the Operative Union Pottery, Burslem. It may also refer to the couple's union in marriage.

Queen Victoria's Coronation

The following four blue-printed commemoratives have been noted for Victoria's accession and/or coronation:

(i) A loving cup by an unknown maker with an elaborate cartouche on both sides surrounding an unusual portrait of the young Victoria inscribed "Her Gracious Majesty Queen Victoria".

(ii) A jug by an unknown maker with a portrait of the young Queen. Beneath the lips is the royal crown and the inscription "Victoria Regina. Born 25th of May 1819. Proclaimed 20th of June 1837" (sic). Note the incorrect date of birth.

(iii) A mug with a portrait of the young Queen in front of Windsor Castle. A drape above bears the wording "Victoria Regina". Ill: May 91.

(iv) A toy plate by an unknown maker with similar inscriptions to the jug (ii) above but with the correct date of birth and the addition of "Crowned 28th of June 1838".

Queen's Ware

Queen's Ware was a name used by Wedgwood for an improved form of creamware following patronage by Queen Charlotte, consort of King George III, in 1765. The importance of this early body in the development of transfer printing cannot be overemphasised. It was the first body which lent itself to sophisticated forms of decoration and was essential for the unblemished surface on which transferring depended. All the early printing was carried out on creamware, even though most was overglaze in black.

It was a development of creamware into the white pearlware, again by Wedgwood, which provided the ideal body for underglaze blue-printing. This development was copied by all the major potters, and was particularly perfected by Spode. Virtually all the early line-engraved patterns are printed on forms of pearlware.

Rabbit

Apart from the many hunting scenes which include rabbits or hares, the rabbit features in one of John Hall's "Quadrupeds" Series on a soup tureen stand. Laidacker lists it under the title Rabbit and Hunters.

Amongst the hunting scenes is one listed by Laidacker as part of a hunting series by an unknown maker (p.116). He describes one plate as "Rabbit Hunting — two hunters, one holding a rabbit — three dogs."

See: Grazing Rabbits.

"The Rabbit on the Wall"

James & Ralph Clews. "Wilkie's Designs" Series. Dish 10ins:25cm, sauce tureen stand, sauce boat, and vegetable dish. Ill: Arman 92.

Raby Castle, Durham

John & William Ridgway. Angus Seats Series. Dish and well-and-tree dish, both 19¼ins:49cm. See Colour Plate XXII.

In common with all items from this series the view is not titled and marked pieces are very rare.

Raby Castle, at Staindrop between Barnard Castle and Bishop Auckland, is one of the largest 14th century castles in Britain. It was built by the Nevilles, although one of the towers probably dates back to the 11th century, and changes were made by James Paine in the second half of the 18th century to bring it up to date. Further changes were made in Victorian times. The castle is open to the public on certain days during the summer.

"Radcliffe Library, Oxford"

John & William Ridgway. Oxford and Cambridge College Series. Plate 8¼ins:21cm. Ill: Little 51.

The Radcliffe Library, or Radcliffe Camera, was built by James Gibbs between 1737 and 1749 in the form of a rotunda. The ground floor is rusticated, the upper floor has the windows between pairs of Corinthian columns, and the whole is surmounted by a dome. It is one of the reading rooms of the Bodleian Library.

Radford, Thomas fl.c.1760-c.1802

Shelton, Staffordshire. A Derby engraver who joined John and Edward Baddeley of Shelton in the 1780s to help with the development of transfer printing. Little (p.90) states that his name appears in 1802 as an independent engraver, still in Shelton.

Railway Commemoratives

Many pieces of pottery were produced to commemorate the opening of various railway lines. A wide selection of cheap printed wares was made, mostly in colours other than blue, the majority of which are unmarked. Such prints are usually found on mugs and jugs, and three blue-printed examples are:

(i) A bulbous jug with a view of John Blenkinsop's locomotive and a train of coal wagons on the viaduct at Leeds. It would seem likely that this was made at one of the Yorkshire potteries. It is probably the earliest railway commemorative for the engine was given its test at Hunslet, Leeds on 24th June,

1812. Ill: Griselda Lewis, *A Collector's History of English Pottery* (1969), 278.

(ii) A mug to commemorate the partial opening of the main lines from London to Manchester and Liverpool in 1837. Maker unknown. Ill: ibid., 282.

(iii) A jug showing the "Entrance to the Liverpool & Manchester Railway" on one side with an early locomotive and carriage on the other. The view of the famous Moorish Arch is based on a print in Henry Booth's *Account of the Liverpool and Manchester Railway* (1830). Ill: FOB 33.

Rainforth & Co. fl.1800-c.1814

Hunslet Hall Pottery, Holbeck, Leeds, Yorkshire. This pottery was built by Samuel Rainforth who had previously worked at Swillington Bridge. Blue-printed wares are known with the impressed mark "RAINFORTH & Co". Two examples, one chinoiserie and one floral, are illustrated in Lawrence p.51.

"Rajah"

James Jamieson & Co. A pattern showing a carriage drawn by an elephant.

Ratcliffe, William fl.c.1831-1840

New Hall Works, Shelton, Hanley, Staffordshire. This firm used a distinctive printed mark consisting of the letter R within a circular sunburst cartouche (See: Godden M 3200; Little mark 42). They are also known to have used another mark which has the letter R printed or impressed above the name "HACKWOOD". The works were taken over by William and Thomas Hackwood.

Rathbone, Thomas, & Co. fl.c.1810-1845

Portobello, near Edinburgh, Scotland. Marks used by this firm include either the full name or the initials T.R. & Co. Amongst patterns in use was a Girl at the Well design titled "The Font". The site of the pottery was redeveloped in 1980 and a great many blue-printed shards were recovered during excavations. A jug has already been attributed to Rathbone after comparison with glazed shards.

"Reach of the River Avon, Roman Encampments"

Pountney & Allies/Pountney & Goldney. Bristol Views Series.

A view looking down the Avon Gorge from Rownham towards Sea Mills, the site of Roman remains.

Read & Clementson fl.1833-1835

High Street, Shelton, Hanley, Staffordshire. This firm introduced several printed designs, not all in blue, using the initials R. & C. as part of the title marks.

Read, Clementson & Anderson fl.c.1836

High Street, Shelton, Hanley, Staffordshire. The successors to Read & Clementson who survived for only a very short period. Printed marks are known with the initials R.C. & A.

Reading Woman

This title has been given to the pattern used on a sauceboat in the Don Pottery Landscape Series (qv). The foreground shows a woman reading to a boy at the side of a lake. Ill: Coysh 2 29.

"Real Ironstone China"

A trade name noted on blue-printed wares by Francis Morley & Co. and their eventual successors G.L. Ashworth & Bros. It was also used by other potters including Davenport, Meakin and John Ridgway.

Regent's Park Series. *William Adams. Typical printed mark.*

Reaper
A pattern which has been given this title is found on a plate (9¾ ins:25cm) in Bathwell & Goodfellow's "Rural Scenery" Series. The design shows a reaper, with his sickle, greeting his wife and child. Ill: Coysh 2 8.

"Reapers"
William Smith & Co. A pattern noted on teawares marked with the title and the maker's name in a printed cartouche. One example has been recorded with the impressed mark "WEDGEWOOD", a name often found on wares from this factory.

Reed & Taylor fl.c.1830-c.1843
Rock Pottery, Mexborough (c.1830-c.1843); Ferrybridge Pottery (1832-c.1843); and Swillington Bridge (1833-c.1843), all in Yorkshire. The detailed history of this partnership is obscure. The dates given are taken from Lawrence, but other reference books differ. The partnership was strictly Reed, Taylor & Co. after c.1838. The initials R. & T. or R.T. & Co. are found in printed title marks of several designs, and could relate to any of the three potteries. Such marks often include a trade name — "Opaque China" or "Stone China".

Reeves, James fl.1870-1948
Victoria Works, Fenton, Staffordshire. A potter who marked his wares with either the name "J. REEVES" or the initials J.R.

Reform Jug
A blue-printed jug has been noted with the words "Reform and Success to the National Union" on one side. The reverse features a design of standards carrying the names of the four main protagonists of reform, all surmounted by the word "VICTORY".

The movement for parliamentary reform had its roots in the 18th century but developed mainly after the Napoleonic wars. There were many political unions created, hence the reference to the "National Union" on the above jug, and the four main heroes were Althorp, Brougham, Grey and Russell. The movement gave rise to considerable feeling throughout the country and, after much difficulty, culminated in the Great Reform Bill of 1832.

Many commemorative wares were produced during the years of the movement. Blue-printed jugs are not so common as those printed in black or purple. See: May for further details.

Regent's Park Series
This series was printed in dark blue by William Adams. The designs were based mainly on drawings by Thomas Shepherd which appeared in *Metropolitan Improvements* (1827), but a few of the patterns were copied from engravings by J. Shury after drawings by West. The views are contained within a foliage border and the titles are printed on a ribbon beneath an American eagle with outstretched wings. A similar set of views was made by Enoch Wood & Sons under the title "London Views" but within a totally different border of grapevines and a rectangular frame.

The views recorded in this series by William Adams include:
"Bank of England, London"
"Church of England Missionary College, London"
"Clarence House"
"Clarence Terrace, Regent's Park, London"
"The Coliseum"
"Cornwall Terrace, Regent's Park, London"
"Hanover Terrace, Regent's Park, London"
"Highbury College, London"
"The Holme, Regent's Park"
"The London Institution"
"Part of Regent Street, London"
"The Regent's Quadrant, London"
"Royal Hospital, Regent's Park, London"
"St. George's Chapel, Regent Street, London"
"St. Paul's School, London"
"Sussex Place, Regent's Park"
"Villa in the Regent's Park, London" (three views: the residence of G.B. Greenough*; the residence of John Maberly*; the residence of the Marquis of Hertford)
"York Gate, Regent's Park, London"
The series was made primarily for export to America, and the above list is partly based on American records.

"The Regent's Quadrant, London"
William Adams. Regent's Park Series. Dish 17ins:43cm.

Regent's Quadrant, at the southern end of Regent's Street, was Nash's great display piece. Unfortunately, the original design has been ruined in this century; Norman Shaw built the Piccadilly Hotel (1905-8), and Sir Reginald Blomfield rebuilt the rest (1920-23). Thus, Nash's work can no longer be seen and only old prints and the Adams dish remind us of its former glory.

"Regina"
(i) Enoch Wood & Sons. A very open floral design used on plates and toilet wares. A printed title cartouche includes the initials E.W. & S. Ill: P. Williams p.48.

(ii) Maker unknown with initials C. & P. A romantic pattern showing a young lady with parasol standing next to an urn. Trellis border. See illustration overleaf.

It is possible that the patterns were titled after the Queen, Victoria Regina.

Registered Designs
Following the Copyright Act of 1842 it was possible for designs or shapes to be registered at the Patent Office in London, thus giving them protection from copying for a period of three years. The protection could be continued for a further period by re-registration. The procedure gained wide acceptance and was used by retailers and designers in addition to the manufacturers. Protected designs were often indicated by a diamond-shaped registration mark (qv).

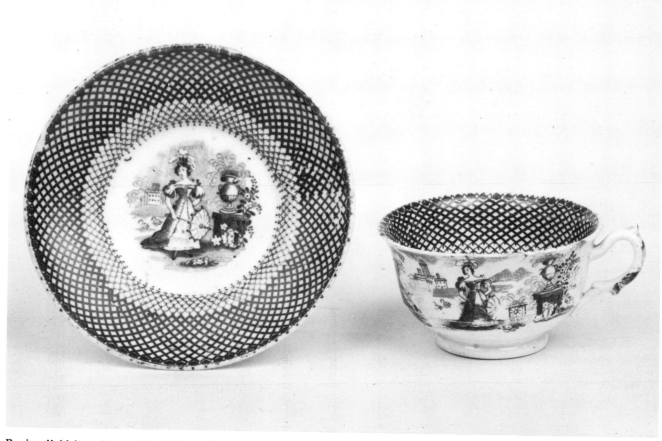

Regina." *Maker unknown. Printed title mark with unidentified initials C. & P. Impressed "WEDGWOOD". Cup and saucer. Diam. of saucer 5¼ ins:13cm.*

Regout, Petrus. *Two of many marks in English found on wares made by the Dutch potter Petrus Regout of Maastricht. Such wares are often mistaken for those of British origin.*

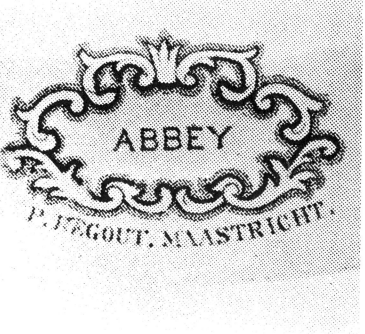

Registration Mark

Designs which had been registered at the Patent Office in London were usually marked with a diamond-shaped registration mark. This mark makes it possible to determine the date on which a design was registered; it does not show the date of manufacture. Such marks were often used over a long period, sometimes beyond the time for which protection was provided by the act. Manufactured items were divided into several classes, of which ceramics are Class IV. The same basic mark was used from 1842 to 1883 although there are two variants:

1842-1867 **1868-1883**

These marks can be interpreted by using the following keys:

Month letters (for both periods):

A — December	E — May	K — November
B — October	G — February	M — June
C — January	H — April	R — August
D — September	I — July	W — March

Year letters (1842-1867):

A — 1845	H — 1843	O — 1862	U — 1848
B — 1858	I — 1846	P — 1851	V — 1850
C — 1844	J — 1854	Q — 1866	W — 1865
D — 1852	K — 1857	R — 1861	X — 1842
E — 1855	L — 1856	S — 1849	Y — 1853
F — 1847	M — 1859	T — 1867	Z — 1860
G — 1863	N — 1864		

Year letters (1868-1883):

A — 1871	H — 1869	L — 1882	V — 1876
C — 1870	I — 1872	P — 1877	W — 1878
D — 1878	J — 1880	S — 1875	X — 1868
E — 1881	K — 1883	U — 1874	Y — 1879
F — 1873			

The parcel number was used to differentiate between designs registered on the same day. There were three variations from the above scheme, probably caused by errors at the Patent Office. The month letter R was continued from August 1857 until 19th September (instead of D). The month letter K was continued from November 1860 throughout December (instead of A). Between 1st and 6th March, 1878, the year letter appeared as W instead of D and the month letter G was continued (instead of W). Godden states that the letter O was also used for January.

The examples given above decode to 21st June, 1850 (left), and 18th February, 1868. Collectors wishing to trace the maker of any design bearing the registration mark are recommended to refer to Cushion, *Pocket Book of British Ceramic Marks,* where designs registered under Class IV are listed.

Regout, Petrus fl. 1836-1899

Maastricht, Holland. Although not a British manufacturer Regout produced many blue-printed designs which are often mistaken for British productions. Copper plates were provided by Staffordshire engravers in the 1850s and many designs are marked with a printed title cartouche and the cursive initials P.R. The titles are usually in English, e.g. "Aurorea", "The Dancers", "Pilgrim", "Wild Rose" and "Willow". Quite often the maker's initials are missing and it is easy to be misled by such titles.

Reid, William. *Typical printed mark used at the Newbigging Pottery.*

Reid, William (& Son) fl. c. 1800-1839

Newbigging Pottery, Musselburgh, Scotland. William Reid began potting alone at the turn of the century and continued until he took his son into partnership in 1837. This partnership only lasted for two years although the pottery was continued until 1843 under the style of Reid & Forster. Blue-printed wares were made including the standard Willow pattern, one example of which bears a printed maker's mark.

"Reindeer"
J. & M.P. Bell & Co.

Reindeer Pattern. *Unmarked but possibly Joshua Heath. Leaf pickle dish 5ins:13cm.*

Reindeer Pattern
The reindeer appears on a pattern by the Don Pottery (Ill: Lawrence p.52). It also features with a seal in a transitional chinoiserie-style pattern on a fish dish by Joshua Heath (Ill: Coysh 1 4) and on a pickle dish, see previous page. This design has several components including some temples, a willow tree, a pagoda, the seal, a man with a bundle on a stick, two birds, and a man with a conical hat leading the reindeer. It is a good example of the transitional period when pure chinoiserie designs began to show the influence of Western ideas.

Remains of an Ancient Building near Firoz Shah's Cotilla, Delhi
An aquatint published in September 1795 based on a drawing and engraving by Thomas Daniell, in *Oriental Scenery* (Part I, 5). Colour Plate XI.

It was used in its entirety by John Rogers & Son for a design normally called the Monopteros pattern (Colour Plate X). It was also copied by Bevington & Co. of Swansea, although their design has some differences including two beasts of burden in the foreground, a background of high mountains, and a tree on the left with large melon-like fruits.

"Remains of the Church, Thornton Abbey"
James & Ralph Clews. Bluebell Border Series. Plate 6¼ins:16cm.

Thornton Abbey, four miles south east of New Holland in Lincolnshire (now Humberside), was founded in 1139 by Augustinian canons from Kirkham Priory. The original buildings are gone, but there are substantial ruins from the 13th and 14th centuries, mainly of the chapter house and the south transept, all in the Gothic style. There is a spectacular gatehouse.

"Remains of Covenham"
Andrew Stevenson. Rose Border Series. Plate 6½ins:16cm, and cup plate 4½ins:11cm.

The view depicted is probably within one of the two parishes of Covenham St. Bartholomew or Covenham St. Mary, five miles north east of Louth in Lincolnshire.

"Repose in the Wood"
James & Ralph Clews. Don Quixote Series. Plate 6ins:15cm, cup plate and sauce tureen.

"Residence of Solimenes near Vesuvius"
Don Pottery and Joseph Twigg, Newhill Pottery. Named Italian Views Series. Dish 18ins:46cm, drainer 12½ins:32cm, footbath and basin. Ill: Coysh 1 36; FOB 21; Godden I 243.

There are two different views, one from each side of the residence. One has three figures and two horsemen in the foreground; the other a loaded cart drawn by four oxen, and a river with boys fishing.

The name Solimenes probably refers to Francesco Solimena (1657-1747), a Neapolitan painter.

Retailers' Marks
Many of the early retailers of pottery and porcelain ordered their stock to be marked with their own name rather than that of the pottery. There is known to have been considerable distrust between the powerful London retailers and the Staffordshire potters. The retailers wanted to sell unmarked goods, being concerned that marked wares would lead their customers to buy direct from the makers. This lead fairly naturally to orders for pieces to be marked with the retailer's name, a practice which the potters were reluctant to encourage. The problem arose when sub-standard wares were produced: if they were marked with a retailer's name it was not possible to sell them as seconds through other retailers who would traditionally buy the cheaper seconds. This was an important source of income for some firms.

Retailers' marks tend to be fairly distinctive. The early versions were impressed like the earlier potters' marks, although the retailers tended to order much more prominent marks with their names in large letters. As printed marks became common the retailers started to include an address. The majority of such marks bear London addresses, although provincial examples are known from Dundee, Leamington, Norwich and Swansea. Overseas marks are also found, particularly for America, but several others are known covering Belgium, Cuba, Jamaica, and even Russia.

Retailers' marks, although not common, are helpful in determining the date of wares, since most retailers can be readily traced by reference to old directories. The London retailers can be traced particularly easily since annual directories have survived from the late 18th century.

"The Return"
Enoch Wood & Sons. Scriptural Series.

This scene may represent the return of the prodigal son but this has not yet been confirmed.

"Return from Elba"
C.J. Mason & Co.

In 1814, when Napoleon was driven back by advancing Austrian, Russian and Prussian armies, he surrendered, abdicated and retired to the island of Elba. In 1815 he left Elba and returned to France, ready to defeat the British and Prussians but failed and was soundly defeated by Wellington and Blucher at Waterloo.

See: "Napoleon" Series.

Returning Woodman
An accepted name for a pattern by Brameld which shows a woodman returning to his cottage and being greeted by his daughter. Outside the cottage door, his wife is working at a spinning wheel. The design is found printed in dark blue on dinner wares, the plates and dishes being eight-sided. Ill: Coysh 2 10; Little 99; Rice 16, which shows all the major components of a dinner service.

"Revelation"
Enoch Wood & Sons. Scriptural Series. Plate.

In theology the word Revelation denotes the unveiling of some truth by God to man.

"The Revenge"
John Rogers & Son and Pountney & Goldney. "The Drama" Series. Tea plate.

Plays with revenge as their theme were very popular in the 17th century. They included Henry Chettle's *Revenge for a Father* (1631), George Chapman's *The Revenge of Bussy D'Ambois* (1613), and *The Revenge: or a Match at Newgate* by Mrs. Aphra Behn (1640-89) which was first produced in 1680.

"Revolt of Cairo"
C.J. Mason & Co.

See: "Napoleon" Series.

Rhenish Views
Davenport. This title refers to a series of blue-printed patterns which are mentioned in a letter from John Davenport in London to his son Henry in Longport on 19th July, 1834 (See: Lockett p.52). The letter makes it clear that these patterns are distinct from another series called Swiss Scenery, and it has not yet proved possible to identify them.

"Rhine"
This name was given to romantic patterns which were widely used in Victorian times. They were usually printed in grey but blue examples have been recorded by Thomas Fell & Co., J.T. Hudden, David Lockhart & Co., and the Middlesbrough

Pottery Co. The title is usually printed in a C-scroll cartouche but the Middlesbrough designs are marked with a bridge (Lawrence, mark 207a). A similar pattern was also used by Dillwyn of Swansea on teawares. It is titled "The Rhine" and is a fairly typical design showing travellers in a landscape of buildings and trees.

Rhinoceros
The rhinoceros is not common on blue-printed wares. It was featured with a ship in the background on a dish (17ins:43cm) in the "Quadrupeds" Series by John Hall.

"Rhodes"
Copeland & Garrett. Byron Views Series. Ill: FOB 15.

The island of Rhodes lies about ten miles off the south west coast of Turkey. At the time this pattern was made it was part of the Ottoman Empire but it was ceded to Italy following the Italo-Turkish War of 1912. It now belongs to Greece and has a growing tourist trade. The island's capital, also called Rhodes, was the headquarters of the Knights of St. John between 1329 and 1522.

Richards, James
A printer who worked for Thomas Turner at the Caughley works and joined Spode in about 1783.

"Richmond"
(i) Harvey. Cities and Towns Series. Tureen stand. Ill: Little 87.

(ii) Maker unknown. Beaded Frame Mark Series. Various dishes. Ill: Little 86.

Both of these views show the River Thames and the famous bridge rather than the Surrey town itself.

See: "View of Richmond".

"Richmond Bridge"
Pountney & Allies/Pountney & Goldney. "River Thames" Series. Dish 10¾ins:27cm. Ill: FOB 16.

This beautiful stone bridge of five semi-circular arches crosses the River Thames at the bottom of Richmond Hill. It was designed by Kenton Couse and James Paine, built between 1774 and 1777, and widened in 1937.

"Richmond Hill"
Copeland & Garrett. Seasons Series. Dish 21ins:53cm. Ill: Coysh 2 19.

This pattern shows a view over the River Thames with a group of figures dancing round a maypole. In the foreground is a massive vase of flowers. This is the pattern which illustrates Spring, and the vase bears the inscription "SPRING" just above female supporters.

Ridgway
The Ridgway family was of great importance in Hanley throughout the 19th century. The various partnerships operated a variety of works in the area. See: G.A. Godden *Ridgway Porcelains* (1972), for further details.

The early history revolved around two brothers, Job and George, and Job's two sons, John and William. At this period the history is relatively straightforward, the dates and establishments being as follows:

Job & George Ridgway, Bell Works, Shelton, Hanley
c.1792-1802

Job Ridgway, Cauldon Place, Shelton, Hanley
c.1802-1808

Job Ridgway & Sons, Cauldon Place, Shelton, Hanley
c.1808-1814

John & William Ridgway, Cauldon Place and Bell Works, Shelton, Hanley c.1814-1830

In 1830 John and William separated. John continued at Cauldon Place whereas William took over the Bell Works and opened other potteries.

As with most potters, the early wares were usually unmarked. Blue-printed wares are known with an impressed mark "J. RIDGWAY" over a beehive and these relate to Job Ridgway. This mark is known on at least three patterns, Chinoiserie Ruins (qv), Curling Palm (qv) and Net (qv). The lower case mark "Ridgway & Sons" is known (though not on blue-printed wares) and this suggests that the similar mark "Ridgway" may have been used by John & William, a supposition that is supported by the style of wares with the mark. It is, however, a rare mark, so far only recorded on three patterns; the Angus Seats Series (qv), the Osterley Park pattern (qv), and the Blind Boy pattern (qv).

"Richmond Bridge." Pountney & Allies/Pountney & Goldney. "River Thames" Series. Printed titles mark. Dish 10¾ins:27cm.

Ridgway, John

When John and William Ridgway separated in 1830, John continued at the Cauldon Place Works, Shelton, Hanley. The history of this side of the family can be summarised by the following details of the firms, all operating at Cauldon Place:

John Ridgway c.1830-1840
John Ridgway & Co. c.1840-1855
John Ridgway, Bates & Co. 1856-1858

The firm continued, but without the Ridgway name, after 1858.

The various partnerships used a variety of printed and impressed marks, many of which have the relevant name in full, although the initials J.R., J.R. & Co., and J.R.B. & Co. are all fairly common. A printed mark in the form of an oval garter above a ribbon, sometimes surmounted by a crown, is typical (See: Godden M 3257, 3269). A good selection of blue-printed ware was made, mostly the floral and romantic patterns typical of the period.

Ridgway, John & William fl.c.1814-1830

Cauldon Place and Bell Works, Shelton, Hanley, Staffordshire. When Job Ridgway died in 1813, his firm was carried on by his two sons who also acquired the Bell Works from their uncle, George Ridgway. Blue-printed wares were of great importance during this period. The earliest identifiable designs are thought to be those impressed ''Ridgway'', a rare mark which has been found on only three patterns, the Angus Seats Series, the Osterley Park pattern, and the Blind Boy pattern. The firm had an export trade to America and a particularly fine set of American views was made, though it did not reach the high standard of the noted Oxford and Cambridge College Series (qv).

The later wares comprised mainly floral patterns printed on a good quality stone china. Examples are titled ''Windsor Festoon'' and ''India Temple''. One series made on standard earthenware is titled ''Rural Scenery''.

Many different marks were used, mainly printed title marks, which include either the full name or the initials J.W.R. or J. & W.R.

Ridgway & Morley fl.1842-1844

Broad Street, Shelton, Hanley, Staffordshire. This partnership succeeded Ridgway, Morley, Wear & Co. and later became Francis Morley & Co. Printed marks include either the full name or the initials R. & M.

Ridgway, Morley, Wear & Co. fl.1836-1842

Broad Street, Shelton, Hanley, Staffordshire. This firm took over the works of Hicks, Meigh & Johnson, and was a partnership between William Ridgway and his son-in-law Francis Morley. Although it was theoretically separate from the other William Ridgway partnerships, the fact that there was interchange between them is confirmed by pieces marked with different printed and impressed names on the same item. Marks appear to be restricted to printed title cartouches with initials R.M.W. & Co.

Ridgway, William

When John and William Ridgway separated in 1830, William continued at the Bell Works, Shelton, Hanley. The operation soon expanded considerably, other works being added and a variety of trading firms being set up. It is not easy to separate the various partnerships with any certainty and there was clearly interchange of patterns and even wares between them. The major trading names, with approximate dates, can be summarised as follows:

William Ridgway, Bell Works, Shelton and Church
 Works, Hanley c.1830-1834
William Ridgway & Co., Bell Works, Shelton and
 Church Works, Hanley c.1834-1854
William Ridgway, Son & Co., Church Works, Hanley
 and Cobden Works, Hanley (c.1841-1846) c.1836-1848
Ridgway & Abington, Church Works, Hanley c.1836-1860
E.J. Ridgway (& Son), Church Works, Hanley and
 Bedford Works, Shelton c.1860-1873
Ridgway, Sparks & Ridgway, Bedford Works, Shelton
 c.1873-1879

It can be seen from the addresses and dates that more than one partnership worked the Church Works at any given date. William Ridgway was also concerned with separate firms under the names Ridgway, Morley, Wear & Co. (qv), and Ridgway & Morley (qv).

A very wide range of wares was made including many printed designs of a generally consistent good standard. The marks used by the different partnerships include either the relevant name in full or initials, of which W.R., W.R. & Co., W.R.S. & Co., and R.S.R. have so far been recorded.

Rievaulx Abbey, Yorkshire

A view of this abbey from the ''Select Scenery'' Series by James & Ralph Clews is incorrectly titled ''Rivax Abbey'' (sic) (qv).

Riley, John & Richard fl.c.1802-1828

Nile Street (c.1802-14) and Hill Works (1814-28), Burslem, Staffordshire. The Rileys produced some good quality printed wares, mostly dinner services decorated with single patterns, typical of which are the Eastern Street Scene, Scene after Claude Lorraine, Europa, and Girl Musician patterns. These were not titled. It appears that they only produced one series of titled views with the scenes printed within a striking border of large leaf-like scrolls and flowers (See: Large Scroll Border Series).

All the blue-printed wares appear to have printed marks which include the name Riley, although it is clear that not all examples are marked. The three most common marks are shown by Little (marks 44-46); an oval garter inscribed ''RILEY'S Semi China'', a flower spray and ribbon inscribed ''RILEY'', and a scroll cartouche with ''OPAQUE CHINA'' and ''RILEY'' which is less commonly found. The Large Scroll Border Series has its own printed cartouche of a ribbon wrapped round a sprig of leaves, once again with the name ''RILEY'' and the addition of the name of the individual view.

Rim Colouring

A few potters coloured the rims of their dinner and tea wares with overglaze enamel. Herculaneum and Swansea are known to have used an ochre colour and Shorthose used orange on tea wares. A dark red may also be found on wares by an unknown maker. One such example bears a painted mark ''DONOVAN'' on the base in the same red colour which indicates that his workshop in Dublin probably added the enamel decoration. It is more than likely that other potters used the technique on unmarked wares and it does not provide a sound basis for attribution.

''Rimini''

Wood & Challinor.

The Italian town of Rimini, near the Adriatic coast to the south east of Bologna, is the ancient city of Ariminum. There are Roman ruins and a monument on the site where Caesar addressed his troops after crossing the Rubicon.

River Fishing. *John Meir. Unmarked. Shaped dish 9¾ ins:25cm.*

"Rio"

W. Williams of the Ynysmedw Pottery near Swansea, south Wales. A flow-blue chinoiserie pattern with a pagoda and a palm tree. Ill: Godden, *Mason's Patent Ironstone China*, 141.

"Ripon, Yorkshire"

James & Ralph Clews. "Select Scenery" Series. Dish 17ins:43cm.

"Rippon" (sic)

Maker unknown. Beaded Frame Mark Series. Dish and drainer.

"Rippon, Yorkshire" (sic)

Maker unknown. Passion Flower Border Series. Dish 16½ ins:42cm.

An identical but untitled view was produced by an unknown maker in the "English Scenery" Series (qv).

A directory of 1810 lists Ripon as a "well-built populous town in the W. Riding of Yorkshire, with a market place, reckoned by some the finest square of the kind in England, and adorned with a curious obelisk". The cathedral took three centuries to build.

"Rivax Abbey" (sic)

James & Ralph Clews. "Select Scenery" Series. Laidacker records this view on a jug.

Rievaulx was the first Cistercian abbey in the north of England, founded by Walter L'Espel in 1132. The entire site was energetically developed, even including the moving of a river to the opposite side of the valley. The abbey was suppressed in 1539 and the estate was granted to Thomas, Earl of Rutland. The ruins can be seen some three miles west of Helmsley.

River Avon

See: "View near Bristol, River Avon".

River Fishing

John Meir. A country scene showing two boys fishing in a river and cows standing in the water. There is a mill, a wooden bridge, some cottages, and a church spire and a country house in the distance. The border consists of wild roses against a stippled ground. Several examples of the design are known with the impressed mark "MEIR" although many are unmarked and a few have only an impressed crown. Ill: Coysh 1 61.

"River Thames" Series

This series of views on the River Thames by Pountney & Allies and their successors Pountney & Goldney uses the same border as the Bristol Views Series (qv). Both series of views may have been included in the same dinner service but they have been separated until more definite evidence is available. The printed mark is the same as for the Bristol Views Series with flowery scrolls decorated with leaves and an arched ribbon, but all the Thames views seem to include the series title "River Thames", with the single exception of "Temple House". A Temple House was known in Bristol as well as near Marlow. The view is included here pending certain identification. The list of known views is as follows:

"Oxford"
"Park Place, Henley"*
"Richmond Bridge"*
"Temple House"

The view of "Park Place, Henley" is known in two versions, one of which shows the view within a hexagonal frame.

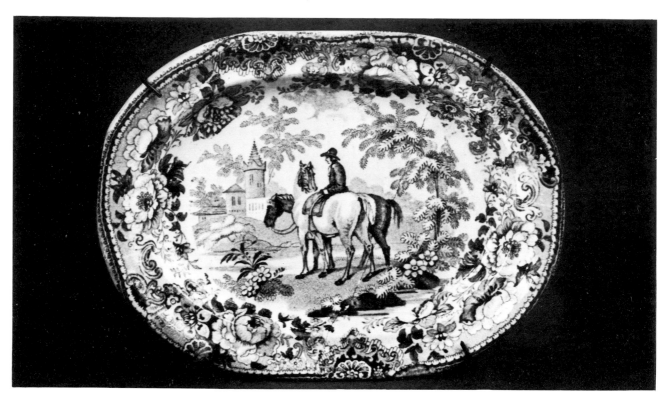

"Rob Roy." Davenport. "Scott's Illustrations" Series. Printed titles mark and impressed maker's anchor mark for 1848. Sauce tureen stand 6½ ins:16cm.

"Rob Roy"

Davenport. "Scott's Illustrations" Series. Sauce tureen stand 6½ ins:16cm. The example illustrated bears an impressed anchor mark with the date 1848.

Sir Walter Scott's *Rob Roy* was first published in 1817.

"The Robert Bruce"

Maker unknown. This title appears on the face of a dinner plate above a scene which shows a steamboat with passengers leaving a quay. The border is of roses, thistles and shamrocks. This may well be a plate from a service used by a shipping line.

Robert the Bruce, Earl of Carrick, was a famous Scots lord who claimed and re-established the Scots throne following the suppression of the Lowlands by Edward Longshanks.

"Robinson Crusoe"

Maker unknown. This title appears on the face of a child's plate with a rim of moulded daisies. The design shows a kneeling man in front of a jungle. Ill: Coysh 2 152.

The subject is the castaway Robinson Crusoe from Daniel Defoe's famous children's book.

Robinson, John fl.1793-1819

A London engraver, printer and print seller. He is known to have supplied Wedgwood with several engravings, including those for the Water Lily pattern with cut reed border.

Robinson & Wood fl.1832-1836

Broad Street, Shelton, Hanley, Staffordshire. This short-lived partnership made printed wares in blue and other colours. Designs are marked with printed initials R. & W.

Robinson, Wood & Brownfield fl.1836-1841

Cobridge Works, Staffordshire. When William Brownfield joined Robinson and Wood, the new partnership moved into different premises but opinions differ as to the site. Little (p.93) reports that they took over the works of James & Ralph Clews whereas Jewitt opts for the works previously run by Andrew Stevenson. Printed wares were produced, title marks including the initials R.W. & B. The firm continued after Robinson's death in 1841 under the style of Wood & Brownfield (qv).

"The Roby Day and Sunday Schools"

James Edwards. This inscription has been noted on the face of tea wares above and below the picture of school buildings. The wares bear an impressed mark "JAS. EDWARDS/PORCELAIN", despite the fact that they are clearly made of earthenware. James Edwards operated in Burslem between about 1842 and 1851.

The Roby Schools at Manchester were erected in 1844 as a memorial to William Roby (1766-1830), a congregational divine. He was born near Wigan and started his professional life teaching classics. Following his ordination in London on 20th September, 1789, he became a notable preacher and attracted large congregations. Between 1807 and his death in 1830 he worked at a chapel in Grosvenor Street, Manchester. "To no man more than to Mr. Roby was nonconformity indebted for its revival and rapid growth in Lancashire" (Halley, 1869).

"Roche Abbey, Yorkshire"

Maker unknown. Pineapple Border Series. Plate 10ins:25cm, vegetable dish, and square dish with moulded and pierced corners.

This abbey was founded by Cistercians in 1147. The name derives from a steep rocky face next to which it is built. The ruins are largely reduced to the foundations although some of the church walls still stand. The stone was quarried nearby and a description in 1810 stated that it was "so white and so beautiful, that masons prize it above all others".

"Rochester"
Enoch Wood & Sons. "English Cities" Series. Plate 9¼ins:23cm, and tray 10ins:25cm.

Rochester is an old Roman town where Watling Street (the Dover road) crosses the River Medway. A cathedral city, it has close associations with Charles Dickens who lived at Gad's Hill Place close by.

"Rochester Castle"
Enoch Wood & Sons. Grapevine Border Series. Dish 17ins:43cm.

Another untitled view of the castle has been identified on a 9¾ins:25cm dish, and a sauce tureen stand in the Foliage and Scroll Border Series by James & Ralph Clews.

Although there were earlier castles at Rochester, the present building was started in about 1127. It was neglected from the 15th century and the major remaining part is the massive Norman keep, one of the finest in England.

Rock
This is an authentic name for an early Spode line-engraved chinoiserie pattern showing a central willow tree and a pagoda built on a fenced platform. There are two varieties which Copeland distinguishes with the names Rock I (on pearlware) and Rock II (on bone china). Ill: Copeland pp.51-52; Whiter 9.

Rock Cartouche
A term used for a printed mark in the shape of a rock or boulder backed by plants or foliage. It was used by the Daniells for the title pages in *Oriental Scenery* and the style was later adapted by some potters for printed title marks. Examples can be found on the Parrot Border Series, the Rock Cartouche Series, and on wares by Phillips of Longport. The latter firm used it to contain the name of the body "Opaque China". See: Coysh 2 69.

Rock Cartouche Series
A series of views in England and Wales by Elkin, Knight & Co. The title has been adopted to reflect the rock cartouche used to contain the view names. The border of roses and other flowers on a stippled ground is very similar to that used by John Rogers & Son on the Rogers Views Series, and another used at Swansea on the Cows Crossing Stream pattern. There has been some confusion in the past caused by this similarity. Most examples do not bear a maker's mark but several are known with the impressed name "ELKIN/KNIGHT & Co" beneath a crown. The list of views recorded to date is as follows:

"Byland Abbey, Yorkshire"*
"Craig Castle"
"Guy's Cliffe"*
"Jedburgh Abbey"*
"Lancaster"
"Nant Mill"*
"Near Newark"*
"Sweetheart Abbey"

Another untitled view on a diamond-shaped dish bears a watermill scene with a weir, and it is likely that further views were made. In addition, the same firm produced a view titled "Fountain's Abbey, Yorkshire" (qv) in a very similar border but with a completely different title cartouche.

Rocking Horse
A name used by Lawrence (p.89) for a Brameld pattern.

Rockingham
See: Brameld & Co.

Rocks and Foliage Border Series
A series title used by Laidacker for a set of untitled views which he lists under William Adams. They are printed in dark blue and the border, as with other foliage designs, gives a grotto effect. In common with some other series printed in dark blue, it appears that this set was made mainly for export to America and the authors have not found any examples in Britain. Two views have so far been identified:
Denton Park, Yorkshire
Normanton Park, Rutlandshire

Rococo
A decorative style of European art dating from between 1730 and 1780, marked by a profusion of C-scrolls, flowers, rockwork, etc. It was revived in Victorian times.

"Rode Hall, Cheshire"
(i) William Adams. Flowers and Leaves Border Series. Plate 6¾ins:17cm.
(ii) Maker unknown. Foliage Border Series. Dishes 12ins:30cm and 15ins:38cm.

Rode Hall is near Sandbach. It started life as a humble house completed in 1708, but a new house was built to the north west in 1752. In 1818 it was enlarged, reorganised, and covered with stucco which was removed in 1927 when further changes were made.

Rock Cartouche Series. *Elkin, Knight & Co. Typical printed mark. Note the impressed eagle mark, often found on wares from this factory.*

Rogers, John & George fl.c.1784-1815
Dale Hall, Longport, Burslem, Staffordshire. The Rogers brothers started a firm which became a prolific producer of quality blue-printed wares. Although they used the impressed name "ROGERS", most items with this mark were made by John Rogers & Son (qv). The only patterns which can be stated with some confidence to have been made during this period are early chinoiserie patterns similar to one design illustrated in Little 49, made for the Dublin retailer James Donovan.

George Rogers died in 1815 and the firm was continued for the remainder of its existence as John Rogers & Son.

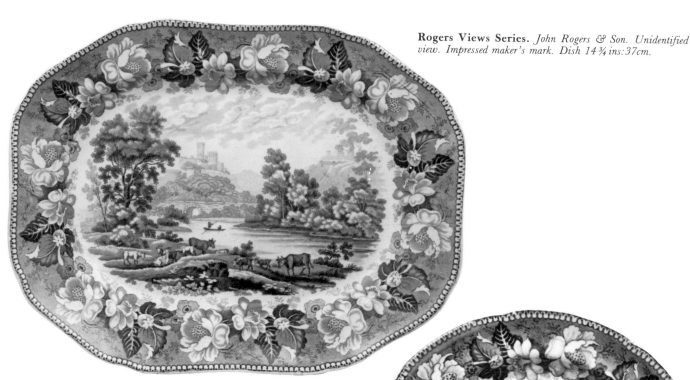

Rogers, John, & Son fl.1815-1842
Dale Hall, Longport, Burslem, Staffordshire. Following the death of George Rogers, his brother John took his own son Spencer into partnership, trading as John Rogers & Son. This style was continued for the firm until its demise in 1842 (not 1836 as sometimes stated). The simple impressed mark "ROGERS" was continued throughout, although the fashionable printed cartouche marks were added in the later years. An uncommon mark has the name "ROGERS" beneath the Prince of Wales' feathers.

By far the majority of the patterns used are untitled. The firm produced three patterns based on Daniell prints (the Camel, Monopteros, and Musketeer patterns), two animal designs (the Zebra and Elephant patterns), a single American view of the Boston State House, and many others. They produced two notable series, one titled "The Drama", and the other a set of untitled views (see below). Some later designs were titled, e.g. "Athens", "Florence", "Pompeii", "Tivoli", "Vase" and "Vine".

Rogers Views Series
A series of landscape views by John Rogers & Son which are not titled on the wares. The views are contained in a border of roses and other flowers on a stippled ground, very similar to borders used by Elkin, Knight & Co. for their Rock Cartouche Series, and at Swansea for the Cows Crossing Stream pattern. Although not individually titled, the following views have been identified:
 Byland Abbey, Yorkshire*
 Durham
 Lancaster
 Osterley Park*
Unidentified views are found on:
 Dish with unusual gadrooned edge. Ill: P. Williams p.256
 Dish (illustrated above)
 Tea plate (illustrated)
 Soup tureen and cover (different views). Ill: Godden I 502
 Fruit comport. Ill: Coysh 1 90 (as the Gothic pattern)
 Plate. Ill: FOB 19
It seems likely that a different view was used on each shape in a

Rogers Views Series. *John Rogers & Son. Unidentified view. Impressed maker's mark. Plate 6½ ins:16cm.*

dinner service. Several other pieces with unidentified views are known and the discovery of the source prints would solve many problems. Most wares are marked with the impressed name "ROGERS", usually together with a size number. A few unmarked dinner plates have been noted.

"Romania"
Middlesbrough Pottery Co. A typical romantic scene marked with the initials M.P. Co. Ill: FOB 22.

In the early 19th century Romania was a European province of Turkey.

"Romantic"
Dawson, Sunderland. A typical romantic pattern printed in a light blue but also known in green. The title is unconfirmed since it has also been called the "Romantic Landscape" pattern. Ill: Little 115. Samuel Alcock also used the "Romantic" title. See P. Williams p.391.

"**The Rookery, Surry.**" *Source print used by several potters from John Preston Neale's "Views of the Seats of Noblemen and Gentlemen in England and Wales, Scotland and Ireland".*

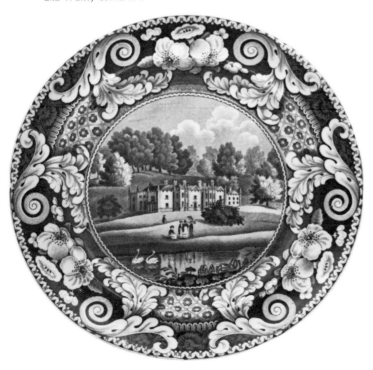

"**The Rookery, Surrey.**" *John & Richard Riley. Large Scroll Border Series. Printed title mark with maker's name and impressed "RILEY". Plate 9¾ ins:25cm.*

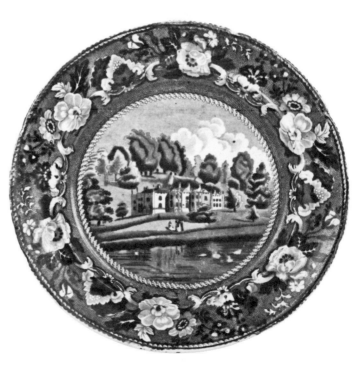

"**The Rookery, Surry.**" *William Adams. Flowers and Leaves Border Series. Printed title mark and impressed maker's eagle mark. Plate 8¾ ins:22cm.*

"A Romantic District of Italy"

Chetham & Robinson or Chesworth & Robinson. A romantic scene within a floral border on a plate with a wavy rim. The printed mark includes the initials C. & R. together with the above title and the place name "TERNI" as part of a landscape cartouche. Another scene is known, also titled "TERNI", but with a different sub-title "The Offering". Ill: P. Williams p.431.

Terni is a city with ancient buildings to the north of Rome in Italy.

Romantic Ruins

An accepted name for an untitled pattern by James & Ralph Clews. It shows a ruined archway in front of which a woman on a donkey with panniers is led by a man with a staff. The central scene merges into a border of flowers and leaves. The pattern is known on dinner and dessert wares. Ill: Little 17.

Rome

Rome is an authentic factory name for a Spode design which is more commonly known as the Tiber pattern (qv). A similar view was produced by the Don Pottery in their Landscape Series (qv), listed as the Castello St. Angelo pattern. A third pattern by an unknown maker is titled "Ancient Rome".

The city of Rome was founded in 753 B.C. by Romulus and Remus. Known as the Eternal City, it was the capital of the ancient Roman Empire and has many historic buildings.

"The Rookery, Surrey"

(i) John & Richard Riley. Large Scroll Border Series. Plate 9¾ins:25cm. Illustration on previous page.

(ii) Enoch Wood & Sons. Grapevine Border Series. Plate 7¾ins:20cm, and dished plate 6½ins:16cm.

(iii) Maker unknown. Passion Flower Border Series. Small dish. This view is known on a piece mismarked "Gubbins Hall". No piece with the printed title "The Rookery" has yet been recorded.

In addition to these titled views, there are two unmarked views which have been identified. One is by Wedgwood in the Blue Rose Border Series, the other in a rather light blue by an unknown maker.

"The Rookery, Surry" (sic)

William Adams. Flowers and Leaves Border Series. Plate 8¾ins:22cm. Illustration on previous page.

The early spelling of Surrey was copied from the caption on the source print (see previous page).

The Rookery no longer exists; it was demolished as recently as 1968. Located just two miles to the west of Dorking, the house was the birthplace of Malthus (1766-1834), the political economist.

"Rose"

James Jamieson & Co.

Rose Border Series

A series of English landscape views by Andrew Stevenson which contains a single American view "Niagara". The border consists of wild roses superimposed on a background pattern which is rather reminiscent of banks of organ pipes. Some very rare examples are known in which the border is broken by medallions of Clinton, Jefferson, Lafayette and Washington, together with vignettes of the Erie Canal. The printed mark has the title on a cloth draped before a lidded urn with a background of leaves and shrubs. Known views include:

"Ampton Hall, Suffolk"
"Audley End, Essex"
"Barrington Hall"

Rose Border Series. *Andrew Stevenson. Typical printed mark with impressed maker's crown mark.*

"Boreham House, Essex"
"The Chantry, Suffolk"
"Culford Hall, Suffolk"
"Dulwich College, Essex" (sic)*
"Duston Hall"
"Enville Hall, Staffordshire"
"Faulkbourn Hall"*
"Felix Hall"
"Haughton Hall, Norfolk" (sic)
"Kidbrook, Sussex"
"Mereworth House"
"Niagara"
"Oatlands, Surrey"
"Remains of Covenham"
"Summer Hall, Kent"
"Tunbridge Castle, Surrey" (sic)
"Walsingham Priory, Norfolk"
"Wanstead House, Essex"
"Wolvesey Castle"
"Writtle Lodge, Essex"*

The fact that so many of these views are in the neighbouring counties of Essex, Suffolk and Norfolk suggests that they may have been based on prints in a book on East Anglia.

"Rose and Lily"

Davenport.

"Rose and Violet Wreath"

Minton.

"Ross Castle, Monmouthshire." *Enoch Wood & Sons. Grapevine Border Series. Printed title mark. Plate 6ins:15cm.*

Roses. *G.M. & C.J. Mason. Printed Mason's crown mark and single line impressed mark: "MASON'S PATENT IRONSTONE CHINA". Plate 9¼ ins:23cm.*

Rosedale

Rosedale is an area just to the north of Pickering and Helmsley in the old North Riding of Yorkshire. A pattern titled "View of Rosedale" was included by an unknown maker in the "Diorama" Series. On some examples the title is incorrectly printed as "View of Rosedoe".

"Roselle"

A pattern used on teawares by John Meir & Son. It was registered in August 1848, and examples are printed in light blue. They are characterised by a border with hanging baskets of flowers in cartouche reserves. Ill: P. Williams p.393.

Roses

G.M. & C.J. Mason, and possibly also C.J. Mason & Co. Although not titled this pattern is very distinctive with a spray of roses in full bloom within a border of flowers and leafy scrolls. It was printed on Patent Ironstone China and also on the less common earthenware marked "Mason's Cambrian Argil". Two versions are found, one printed simply in blue and the other enamelled overglaze in a variety of colours. Ill: Haggar and Adams, *Mason Porcelain and Ironstone 1796-1853,* 104, Colour Plate G.

"Ross Castle, Monmouthshire"

Enoch Wood & Sons. Grapevine Border Series. Plate 6ins:15cm.

It has not yet proved possible to locate this view.

"Rothesay Castle, Buteshire"

James & Ralph Clews. Bluebell Border Series.

Rothesay Castle is first mentioned in 1228 when it was besieged and taken by Hushac, the Norwegian and Olave, King of Man. It was later retaken by the Scots, seized by the English, and in 1311 it surrendered to Robert Bruce. The Marquis of Bute is the hereditary keeper of the castle.

Rothwell, Thomas 1740-1807

An independent engraver and copper plate printer who moved from Staffordshire to Swansea between 1780 and 1790. He was responsible for most, if not all, of the early transfer-printed designs of the Cambrian Pottery, and it is thought that he took some Staffordshire designs with him. He is known to have lived in both London and Birmingham.

See Norman Stretton, *Thomas Rothwell, Engraver and Copper-Plate Printer, 1740-1807,* Transactions of the English Ceramic Circle, Vol. 6, Part 3 (1967).

Rowley

A Staffordshire potter named Josiah Rowley took over as manager of the Caledonian Pottery in Glasgow in 1807. It is possible that he was also responsible for acting as an agent for Staffordshire potters, possibly with a warehouse run in collaboration with the Caledonian Pottery. Examples of the Castle and Lucano patterns, unmarked but possibly Spode, have been recorded with a printed mark "Rowley, Wilson Street, Glasgow. Stone China".

Rowley. *Printed retailer's mark, possibly related to Josiah Rowley who moved from Staffordshire to manage the Caledonian Pottery in Glasgow.*

Royal Coat-of-Arms. *The arms used on official Government documents from 1814 to 1837. Note the inner escutcheon surmounted by a crown.*

Royal Coat-of-Arms

The illustration shows the royal coat-of-arms as used on official documents between 1814 and 1837. Note the inner escutcheon or small shield, surmounted by a crown, in the centre of the arms. After 1837, this second inner shield was omitted.

Many potters used a modified version of the royal arms as part of their printed marks. A crown is often added above the shield and the motto ribbon sometimes carries the maker's name or the title of the pattern. Occasionally the entire shield is replaced by a pattern name as in John Meir & Son's "Northern Scenery" Series, and there are many other variations of the theme.

One of the earliest known royal arms marks was that of Hicks & Meigh on ironstone wares. Other pre-Victorian versions were used by Elkins & Co; Stephen Folch; Hicks, Meigh & Johnson; and John Ridgway. The Victorian version is much more common and can be found on wares from Samuel Alcock & Co; G.L. Ashworth & Bros; Jonathan Lowe Chetham; Robert Cochran & Co; Cork & Edge; Elsmore & Forster; Ford, Challinor & Co; C. & W.K. Harvey; T.J. & J. Mayer; Charles Meigh & Son; Francis Morley & Co; Morley & Ashworth; William Ridgway; and Ridgway & Morley.

"Royal Conservatory"

J. & M.P. Bell & Co.

"Royal Cottage"

(i) Barker & Till. A romantic scene with a large 'cottage' behind a fence, an elaborately decorated bridge over a weir, and two swans in the foreground. Ill: FOB 19.

(ii) W. Barker & Son.

(iii) Cork, Edge and Malkin.

(iv) Dixon, Austin & Co.

These patterns, which vary in detail, are romantic views of the Royal Lodge, built for the Prince Regent by Nash. The Adelaide Lodge in the Home Park at Windsor is the only surviving part; it was re-erected in 1831.

"Royal Cottage." Barker & Till. Printed title in cartouche. Impressed mark "STONE WARE" in semi-circle above the initials B. & T. Soup plate 10¼ ins:26cm.

"Royal Exchange"
John Goodwin. "Views of London" Series. Plate.

The view shows the third Royal Exchange built by William Tite and opened by Queen Victoria in 1844. The equestrian statue of the Duke of Wellington by Sir Francis Chantrey stands in front of the building.

"Royal Exchange, London"
S. Tams & Co. Tams' Foliage Border Series. Dishes 15ins:38cm and 16ins:41cm.

This building would be the second Royal Exchange, opened by Charles II in 1667, which had a large tower in the Italian style. In 1779 it became the headquarters of the Royal Exchange Assurance Company. It was destroyed by fire in 1838.

"Royal Flora"
John Ridgway. A central floral spray framed in a wreath of floral rosettes, all within a stippled border bounded by a band of C-scrolls. Maker's initial mark J.R. Ill: P. Williams p.50.

"Royal George"
An early blue-printed bowl bears the inscription: "May the next Royal George save the People." The bowl is unmarked but is similar in style to a bowl dated 1796 attributed by Little to the Herculaneum Pottery. It was made following the sinking of Admiral Kempenfelt's flagship the *Royal George* in Portsmouth harbour on 29 August, 1782, an event immortalised in Cowper's *Loss of the Royal George*:

> Toll for the brave —
> Brave Kempenfelt is gone,
> His last sea-fight is fought,
> His work of glory done...
> His sword is in its sheath,
> His fingers held the pen,
> When Kempenfelt went down
> With twice four hundred men.

It is worth noting that at this period King George III was suffering from mental instability and the regency question was very much to the fore. The inscription "May the next Royal George save the People" may well have been intended as political comment.

Royal High School, Edinburgh
James Jamieson & Co. "Modern Athens" Series. As with other items from the series this view is not titled.

The Royal High School was founded in about 1518. The present building was constructed in the Doric style between 1825 and 1829 with a central portico, colonnaded wings, and a pilastered pavilion at each end. Former pupils of the school included Robert Adam, Alexander Graham Bell, James Boswell and Sir Walter Scott.

"Royal Hospital, Regent's Park, London"
William Adams. Regent's Park Series. Sauce tureen stand.

The Royal Hospital of St. Katherine was moved to Regent's Park in 1826 in order to make way for the building of St. Katherine's Dock on its old site. The new buildings were designed by Ambrose Poynter, a pupil of John Nash, and were erected to the north of Cumberland Terrace.

"Royal Palace"
J. & M.P. Bell & Co.

"Royal Persian"
Maker unknown. A floral design with two large sunflowers and a fence in the foreground. The printed mark is a floral and scroll cartouche which includes the title together with the words "STONE CHINA". The pattern is found on dinner wares with a gadrooned edge. The presence on some examples of an impressed seal with the wording "Improved Stone China" (qv) suggests a possible attribution to Minton.

Royal Scottish Academy, Edinburgh
James Jamieson & Co. "Modern Athens" Series. Dish 15¼ins:39cm. As with other items from the series this view is not titled. See illustration overleaf.

The Academy stands on the south side of Princes Street and was originally built by William Playfair to house the museum of the Society of Antiquaries, the Royal Society, and the Society for the encouragement of the Fine Arts in Scotland. It was enlarged by Playfair in 1835 and became the Royal Scottish Academy. A statue of Queen Victoria was erected on the portico in 1844 but this does not appear on the printed pattern.

"Royal George." Bowl with deep footrim inscribed "May the next Royal George save the People". No maker's mark. Diam. 6½ins:16cm. Height 2½ins:6cm.

Royal Scottish Academy, Edinburgh. *James Jamieson & Co. "Modern Athens" Series. Printed series title and maker's mark. Dish 15¼ins:39cm.*

Ruined Castle. *Robert Hamilton. Unmarked. Dish 21ins:53cm.*

"Royal Sketches"

A series by an unknown maker of untitled views of places with Royal associations. Items are marked "Royal Sketches" in script within a ribbon with flowers surmounted by a crown. On flatware the central pattern appears within a garter bearing the inscription "Honi Soit Qui Mal y Pense". The border has groups of roses, thistles and other flowers. Views so far identified are:

Royal Pavilion, Brighton
Windsor Castle. Ill: P. Williams p.395

Another example is illustrated in P. Williams p.395. The view of the Royal Pavilion, Brighton is known on an ornate covered jug.

The wares appear to date from the 1830s and the same title has been recorded on a plate printed in pink.

"Royal Vase"

James Jamieson & Co.

Ruined Castle

This name has been used for a pattern by Robert Hamilton. It shows a ruined castle standing above an overgrown bridge. There are figures on the far bank of the river and cows in the water in the foreground. When marked, examples bear the impressed legend "HAMILTON/STOKE". Ill: Coysh 1 47; P. Williams p.396.

The same basic pattern but with an additional tree on the left has been noted with the printed mark "TAMS" on a dish (14ins:36cm) and with the printed mark "S. TAMS & CO." on a dessert plate. Both these marks are in prominent capital letters.

Ruined Castle and Bridge

Maker unknown. A title adopted here for an unmarked design found on dinner wares. It shows an impressive castle, partly in ruins, approached by a multi-arched bridge with a statue at one end. A man on a horse crosses the bridge, a man and three cows stand in the water, and two men stand in conversation on the far bank. The plate illustrated is impressed $\frac{9}{20}$, almost certainly a date mark for September 1820.

"Ruins near Agrigenti"

Don Pottery and Joseph Twigg, Newhill Pottery. Named Italian Views Series. Vegetable dish.

Agrigento is a small town close to the south west coast of Sicily. It was an ancient Greek centre near which is the famous Valley of the Temples, possibly the ruins named by this pattern.

"Ruins of the Castle of Canna"

Don Pottery and Joseph Twigg, Newhill Pottery. Named Italian Views Series. Pierced oval basket and stand.

"Cannae, in ancient geography, a town of Apulia, rendered famous by a terrible overthrow which the Romans received from the Carthaginians, under Hannibal. The modern name of Cannae, if this place exists at all and is not entirely abandoned, is Canne, situated in the country of Bari. Many writers have mistaken it for Canasium, now Canosa" — John Walker's *Universal Gazetteer* (1810).

"The Rukery"

Griffiths, Beardmore & Birks. A pattern with a Blue Rose border. There have been as many as ten different seats in England known as "The Rookery", but this is likely to be The Rookery near Dorking, Surrey which was featured by several other potters.

"Rural"

(i) James Jamieson & Co.
(ii) James Miller & Co. A pattern noted on a jug showing a horse and cart, two elderly figures and a cow. The title is printed in a scroll cartouche.

Rural Homes

A name given by Laidacker (p.107) to a group of patterns by Enoch Wood & Sons, each depicting a different cottage. They are printed in dark blue on plates varying in size between 6ins:15cm and 10¼ins:26cm, each with a wide scroll and flower border.

Ruined Castle and Bridge. *Maker unknown. Unmarked. Plate 9¾ins:25cm.*

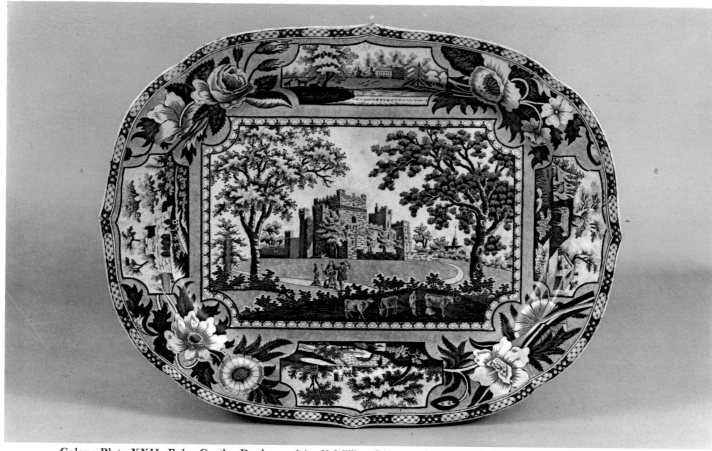

Colour Plate XXII. Raby Castle, Durham. *John & William Ridgway. Angus Seats Series. Unmarked. Dish 19¼ ins:49cm.*

Colour Plate XXIII. **"Thun."** *Copeland & Garrett. Byron Views Series. Printed title and maker's mark and impressed maker's mark. Dish 21ins:53cm.*

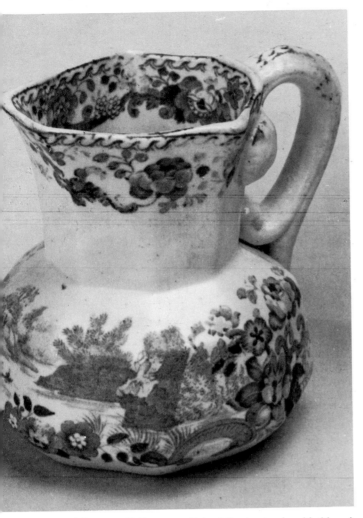

"**Rural Scenery.**" *Davenport. Printed floral cartouche with title and maker's name below. Impressed maker's anchor mark. Octagonal jug height 3½ ins:9cm.*

"**Rural Scenery**" **Series (Bathwell & Goodfellow).** *Printed series mark.*

"Rural Scenery"

At least four potters produced patterns with this title:

(i) Bathwell & Goodfellow. A series of country scenes known as "Rural Scenery" Series (Bathwell and Goodfellow) (qv).

(ii) Davenport. A romantic river scene framed with flowers and rococo scrolls, illustrated on a dish (Colour Plate XXIX) and a small octagonal jug.

(iii) John & William Ridgway. A series of country scenes with prominent animals known as "Rural Scenery" Series (John and William Ridgway) (qv).

(iv) James Wallace & Co. of Newcastle. This rural scene is known with two different marks. The first has the title printed in an oval cartouche with initials J.W. & Co. whereas the second has the same printed mark without the initials but an additional impressed mark "WALLACE & CO." The change is explained by the style of the firm which was James Wallace & Co. from 1838 to 1857 but simply Wallace & Co. between 1858 and 1893. The design is very similar to the Bathwell & Goodfellow patterns.

"Rural Scenery" Series (Bathwell & Goodfellow)

A series of country scenes within a border of roses, other small flowers and prominent acanthus-type scrolls. Examples are marked with the series title in a printed rock cartouche and sometimes with the impressed makers' name "BATHWELL & GOODFELLOW" arranged in the form of an oval. The central designs all feature a group of figures in the foreground with a much lighter background, usually of rural thatched buildings. The following scenes have so far been noted:

(i) Firewood pattern. A man carrying wooden poles approaches a woman standing over a seated child who is leaning against a basket. Ill: Coysh 2 7.

(ii) Milkmaid pattern. A milkmaid carrying two buckets slung on a yoke across her shoulders.

(iii) Reaper pattern. A man with a reaping hook and a pack on his back talks to a woman and a girl. Ill: Coysh 2 8.

(iv) Shepherd pattern. A shepherd with a crook is seated talking to a girl.

(v) Unnamed. A man with a cane talks to a woman while a girl clings to him.

"Rural Scenery" Series (John & William Ridgway)

A series of country scenes within a border of hops, barley and wild roses. Examples are marked with a vine leaf and grape cartouche which contains the title in script above the initials J. & W.R. The central designs feature prominent animals but only two have so far been recorded:

A drover with his dog and two cows
Three deer, one of which is standing
They are illustrated overleaf.

"Rural Village"

This title has been recorded on an example of the design commonly known as the Village Church pattern (qv). The printed mark is in the form of a ribbon bearing the title, surmounted by a crown and framed by two leafy branches.

Russian Palace

Maker unknown. A title adopted here for an unmarked design found on dinner wares. It appears to show a Russian palace in a country setting with a four-arch bridge, two figures in a boat, deer in the foreground, and two Russian figures crossing another bridge under a weeping willow tree on the right. The scene is printed within a floral border which includes convolvulus, roses and other flowers. See illustration overleaf.

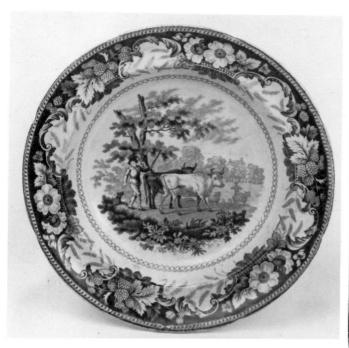

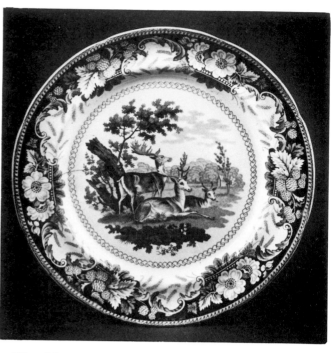

"Rural Scenery" Series (John & William Ridgway). *Printed mark with series title and maker's initials. Soup plate 9¾ ins:25cm.*

"Rural Scenery" Series (John & William Ridgway). *Printed mark with series title and maker's initials. Plate 9¾ ins:25cm.*

Russian Palace. *Maker unknown. Unmarked. Drainer 13¼ ins:34cm.*

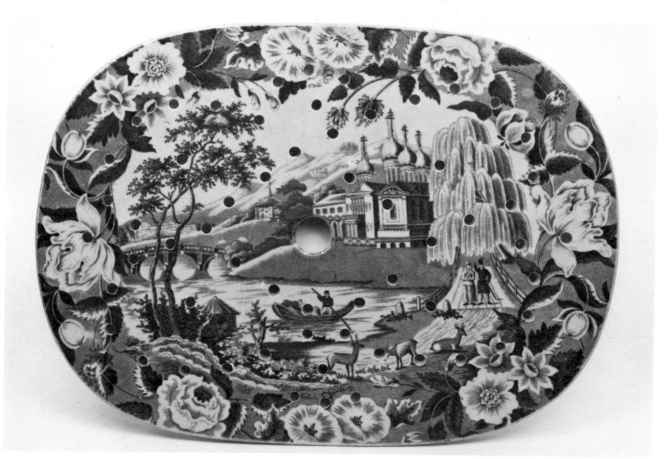

"Rustic Figures." *Maker unknown. Printed mark with title and "OPAQUE CHINA". Posset pot diam. 5½ ins:14cm.*

"Rustic Figures"

Maker unknown. A pattern noted on a two-handled posset pot. The title appears together with the words "OPAQUE CHINA" on a printed ribbon cartouche. On one side a rural scene shows a miller taking corn from a horse to the mill. On the reverse a woman with a mule or donkey is carrying a child in a basket, with two other figures and a windmill in the distance.

Rustic Scenes Series

This title has been adopted here for an untitled series of patterns by Davenport. They are marked with the earlier impressed anchor surmounted by "Davenport" in lower case letters and bear a series border of flowers with no distinctive features. Scenes include:

(i) Watermill scene. Two men stand talking by a horse and cart in the right foreground; on the left is a watermill with the wheel turning. Lockett (p.50) refers to this pattern as "quite rare". Ill: Little 23.

(ii) Farm and cattle shed. A thatched cottage with very tall chimneys and an attached cattle shed. One cow is in the doorway and another outside. There is a seated man with a dog in the foreground. Ill: FOB 12.

(iii) Gothic ruins. A large tree on the left and a tall ruined Gothic tower on the right. There are three figures, one seated, in the foreground. Ill: Coysh 2 22.

(iv) Thatched cottage. A cottage with a central dormer window. There is a four-barred gate, two cows with their calves, and two men, one seated, are seen talking in the left foreground.

Rustic Scenes Series. *Farm and cattle shed. Davenport. Impressed "Davenport". Plate 8¼ ins:21cm.*

Rustic Scenes Series. *Watermill scene. Davenport. Impressed maker's anchor mark. Plate 9¾ ins:25cm.*

"St. Alban's Abbey." *Goodwins & Harris. "Metropolitan Scenery" Series. Printed titles mark. Washbowl 12½ ins:32cm.*

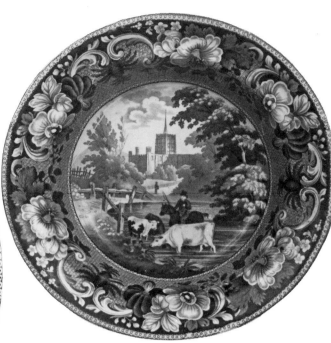

"St. Alban's Abbey, Hertfordshire." *Maker unknown. Pineapple Border Series. Printed title mark. Soup plate 10ins:25cm.*

"St. Alban's Abbey"
Goodwins & Harris. "Metropolitan Scenery" Series. Washbowl 12½ ins:32cm.

"St. Alban's Abbey, Hertfordshire"
(i) Maker unknown. "Antique Scenery" Series. Dish and deep dish, both 11ins:28cm.

(ii) Maker unknown. Pineapple Border Series. Soup plate 10ins:25cm.

The view by Henshall & Co., commonly called the Castle and Bridge pattern (qv), is also said to be a view of St. Albans.

St. Alban's Abbey overlooks the fields of Roman Verulaneum where Britain's first Christian martyr died. He was Alban, a Roman soldier, and the first abbey was built to his memory by Paul of Caen in the 11th century. Little of this original building remains though there is much 13th and 15th century work around the Norman tower. In 1875 it became the Cathedral of a new diocese.

"St. Catherine's Hill, near Guildford"
James & Ralph Clews. "Select Scenery" Series. Dish 15½ ins:39cm, and soup tureen stand.

Untitled views were also made by both William Adams and James & Ralph Clews in the Foliage and Scroll Border Series.

St. Catherine's Hill is about one mile to the south west of Guildford, overlooking the River Wey. On the summit are the ruins of the ancient chapel of St. Catherine of the early decorated period. Nearby is the course of the Pilgrim's Way.

"St. Cloud"
Henshall & Co. Fruit and Flower Border Series.

St. Cloud is a seat four miles south of Worcester but also a resort on the River Seine, ten miles west of Paris. Since this series includes both British country houses and Continental views, this pattern may show either.

St. Catherine's Hill, near Guildford. *William Adams. Foliage and Scroll Border Series. Untitled. Impressed maker's crown mark. Plate 8¾ ins:22cm.*

"St. George's Chapel, Regent Street"
Enoch Wood & Sons. "London Views" Series. Dish 16¾ins:43cm.

"St. George's Chapel, Regent Street, London"
William Adams. Regent's Park Series. Dish 15ins:38cm. Ill: Moore 62.

In the source book *Metropolitan Improvements,* James Elmes describes this chapel as "a tasteful production of Mr. C.R. Cockerell, whose travels and researches in Greece have added much to our knowledge of the sublime architecture of the ancient Greeks".

St. John's Church, Edinburgh
James Jamieson & Co. "Modern Athens" Series.

As with other items from the series, this view is not titled. St. John's Church is a Gothic building in style but mainly 19th century. The distinctive nave was added by William Burn in 1817 and further additions were made in 1882 and 1935, after this view was produced.

"St. Joseph's Chapel, Glastonbury, Somersetshire"
Maker unknown. Pineapple Border Series. Dish 10½ins:27cm.

St. Joseph's Chapel, traditionally ascribed to Joseph of Arimathea, is a beautiful example of late Norman work with a vaulted crypt dating from the 15th century. It is now called St. Mary's Chapel.

"St. Mary's Abbey, York"
(i) William Adams. Bluebell Border Series. Bowl 10ins:25cm.
(ii) James & Ralph Clews. Bluebell Border Series. Plate 7½ins:19cm.

This is the only case in which these two potters used the same title in this series, although on different items.

St. Mary's Abbey was founded by William Rufus for Benedictine monks in 1088. The ruins are now in the grounds of the Yorkshire Museum.

"St. Mary's, Dover"
Minton. Minton Miniature Series. Square bowl, height 2ins:5cm.

The church of St. Mary the Virgin is an old flint building, mainly Norman and Early English. It was restored and enlarged in 1843.

"St. Michael's Mount"
A very crude picture of the mount is known on a mug from the Cambrian Pottery, Swansea, on which the title appears above the print. The decoration also includes a toper proposing the Cornish toast "Fish, Tin & Copper", and a shield with the fifteen besants of the Duchy of Cornwall surmounted by the Cornish motto "One & All".

St. Michael's Mount lies in Mounts Bay, just to the east of Penzance. It is over two hundred feet high and on the summit is a 6th century castle. At low tide it is possible to reach the mount by means of a causeway from the mainland.

"St. Paul's Cathedral"
Careys. Cathedral Series. Drainer 16ins:41cm, and dish. Ill: Little 14.

The early cathedrals on this site were destroyed by fire and restoration work was begun in 1620 under Inigo Jones. The great fire of London which started on 2nd September, 1666, put an end to these efforts, despite some attempts to rebuild the west end which finally collapsed in 1668. The first stone of the new cathedral by Christopher Wren was laid in 1675, and the building was completed in 1711. For over two centuries it

dominated the London skyline as an outstanding landmark. Today it is overshadowed by high-rise buildings including the flats in the Barbican and the latest, and tallest, addition, the NatWest Tower.

"St. Paul's School, London"
William Adams. Regent's Park Series. Plate 7¾ins:20cm. Ill: Nicholls, *Ten Generations of a Potting Family,* Plate LII (incorrectly captioned).

This school was built by George Smith in 1825. It has since been demolished.

"St. Peter's College, Cambridge"
John & William Ridgway. Oxford and Cambridge College Series. Oval tureen stand.

The central feature of this view is Peterhouse Chapel, consecrated in 1632. Pevsner describes it as "the most remarkable building of its age in Cambridge".

"St. Peter's College, Cambridge." *John & William Ridgway. Oxford and Cambridge College Series. Printed title and maker's mark. Tureen stand 15½ins:39cm.*

"St. Peter's, Rome"
Enoch Wood & Sons. "Italian Scenery" Series. Bowl 12ins:30cm, plate 10¼ins:26cm, and soup plate 10ins:25cm.

"The church of St. Peter, in the opinion of many, surpasses, in size and magnificence the finest monuments of ancient architecture. In length it is exactly 730 feet; the breadth 520; and the height from the pavement to the top of the cross, which crowns the cupola, 450" (1810).

"St. Philip's Chapel, Regent Street"
Enoch Wood & Sons. "London Views" Series. Plate 10ins:25cm. Ill: FOB 5.

According to Elmes in *Metropolitan Improvements,* the tower of this chapel was copied from "the beautiful little circular temple at Athens...known to travellers as the lantern of Demosthenes". The chapel no longer exists.

"St. Vincent's Rocks"
Pountney & Allies/Pountney & Goldney. Bristol Views Series. Plate 10ins:25cm. Ill: Coysh 1 66.

This pattern shows a view of the River Avon looking towards Bristol which was the port for ships from the Severn estuary. St. Vincent's Rocks rise on the left above the Hotwells spa.

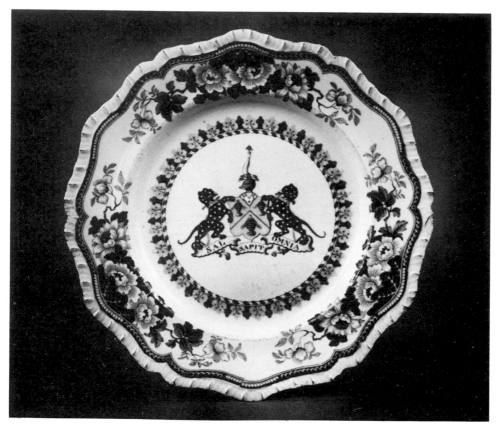

"Sal Sapit Omnia." *Arms of the Salters' Company. Hicks, Meigh & Johnson. Printed royal arms mark with "Stone China" beneath and "Du Croz, Skinner Street, London" above. Plate 10¼ ins:26cm.*

"St. Woolston's, Kildare, Ireland" (sic)

Ralph Hall. "Picturesque Scenery" Series. Dish 14½ ins:37cm. Ill: Laidacker p.46.

An identical central view was used by an unknown maker in the series titled "British Views", none of which bear individual titles.

St. Wolston's is one mile north east of Celbridge. It is a seat with some decorated gateways which are the remains of a 13th century priory.

It is near the Curragh which, even in the early 19th century, was already the headquarters of racing in Ireland.

The Sacred Tree of the Hindoos at Gyah, Bahar

An aquatint published in May 1796 based on a drawing and engraving by Thomas Daniell, in his *Oriental Scenery* (Part I, 15).

It was used to provide one half of a design usually called the Eastern Street Scene by John & Richard Riley. The remainder of the pattern comes from another Daniell print entitled "View on the Chitpore Road, Calcutta" (Part II, 2). The pattern was also used by Samuel Alcock who took over the Riley pottery in 1829 and presumably inherited some of the copper plates. Ill: Coysh 1 74; Little 54.

The same print was used for a detail on a design in the India Series, commonly called the Indian Procession pattern. The main feature is from another Daniell print entitled "Mausoleum of Sultan Purveiz, near Allahabad" (Part I, 22), the tree being printed in reverse on the right hand side. The pattern is normally attributed to Herculaneum. Ill: Coysh 2 140.

The tree is the Akshai Vata, or the undying banyan tree. The significance of the pedestal built around the base lies in the custom of collecting heads of idols from statues mutilated by Mohammedans. These fragments were venerated by the Hindus.

"Sal Sapit Omnia"

Salt savours everything. A motto associated with the coat-of-arms of the Worshipful Company of Salters of the City of London. Their arms were granted in 1530, with the crest and supporters following in 1591.

A blue-printed service decorated with their coat-of-arms was made for the Salters' Company in 1827 by Hicks, Meigh & Johnson. It was supplied through the London retailer John Du Croz of 7 Skinner Street, London, whose name and address were added to the potter's printed royal arms mark. Examples are of stone china with gadrooned edges and the armorial centre is printed within a floral border.

See: Armorial Wares; Du Croz, John C.

Salad Bowl

Two distinct forms of bowl may be found. If the bowl has a rim which is nearly vertical, it is called a salad bowl; where the rim is curved over, it is almost certainly a washbowl. Salad bowls can be found in several shapes but most are either round or square, the latter sometimes having shaped corners. The majority of salad bowls are earlier than washbowls, dating from before about 1840. Some very early chinoiserie bowls are called punchbowls.

"Salamis"

Copeland & Garrett. Byron Views Series.

Salamis is an island in the Saronic Gulf of Greece, to the west of both Athens and Piraeus. It was the site of a famous naval battle in which the Greeks routed the Persians in 480 B.C.

"Salisbury"

Enoch Wood & Sons. "English Cities" Series. Dish 11¾ ins:30cm, and vegetable dish.

Virtually all pictures of the city of Salisbury in Wiltshire give an uninterrupted view of the 13th century cathedral with its superb 404 feet high spire.

Salt Cellar. *Maker unknown. Urn-shaped salt cellar with gadrooned edge. Height 2¼ ins:6cm, diam. 3ins:8cm.*

Salt Cellar

Blue-printed salt cellars and pepper pots were made for dinner services although relatively few have survived. It appears that they were individual pieces and not produced as sets. The example illustrated is a typical shape with the distinct foot but the gadrooned edge is not common.

See: Pepper Pot.

"Saltwood Castle"

Enoch Wood & Sons. Grapevine Border Series. Plate 6½ ins:16cm.

This castle was practically rebuilt by Archbishop Courtenay at the end of the 14th century and was used as his chief residence. It is about two miles north west of Hythe in Kent and was completely restored with a new block added in 1882.

Sancho Panza

Sancho Panza was the companion of Don Quixote and appears on several of the patterns by James & Ralph Clews in their Don Quixote Series. The designs include:

"Sancho Panza at the Boarhunt." Soup plate 9¾ ins:25cm. Ill: Arman S 83

"Sancho Panza's Debate with Teresa." Plate 9ins:23cm. Ill Arman 78

"Sancho Panza and the Duchess." Dish 18½ ins:47cm. Ill: Arman 82; Laidacker p.24

"Sancho Panza Hoisted in the Blanket." Plate and soup plate, both 10ins:25cm. Ill: Arman 72

"Sancho and the Priest and the Barber." Plate 7½ ins:19cm. Ill: Arman 75

See: Don Quixote Series.

Sander

A box with a pierced top, not unlike a large pepper pot. Sanders were used for sprinkling fine sand over wet ink to speed drying. They became unfashionable and were no longer made shortly after the introduction of blotting paper in the 1820s. Blue-printed examples are often mistaken for pepper pots.

"Sandon Hall, Earl of Harrowby's Seat"

Careys. Titled Seats Series. Oval sauce tureen stand.

Sandon is on the River Trent about five miles north of Stafford. The house seen in this view was destroyed by fire in 1848 and a new house was built for the second Earl of Harrowby in 1852.

Sarcophagi at Cacamo

Spode. Caramanian Series. Square dish 8ins:20cm, and pierced chestnut basket and stand. Ill: S.B. Williams 61.

See: Cacamo.

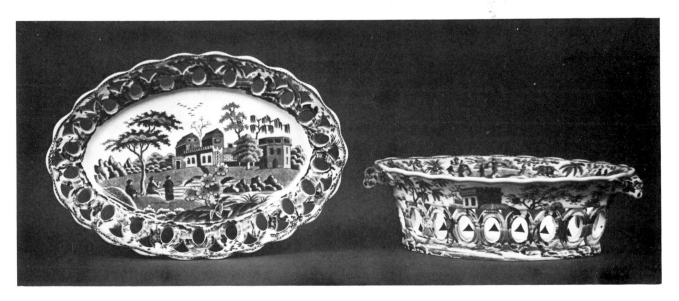

Sarcophagi at Cacamo. *Spode. Caramanian Series. Impressed maker's mark. Chestnut basket and stand length 9ins:23cm.*

Sarcophagi and Sepulchres at the Head of the Harbour at Cacamo. *Spode. Caramanian Series. Impressed maker's mark. Plate 10ins:25cm.*

Sarcophagi and Sepulchres at the Head of the Harbour at Cacamo

Spode. Caramanian Series. Plate 10ins:25cm. Ill: Coysh 1 102; Whiter 73; S.B. Williams 56-57.

See: Cacamo.

"Sardinia"

J. & M.P. Bell & Co. A romantic rural scene with cattle and a church. The medallion border alternates between roses and scenes of cattle and a herdsman.

The same title was used by Ralph Hall & Co. for a different pattern printed in pink.

This mountainous island in the Mediterranean passed to the Duke of Savoy in 1718 and he took the title of King of Sardinia. When Victor Emmanuel II became King of Italy in 1861 the separate kingdom of Sardinia ceased to exist and it became an administrative district of Italy.

"Sarento"

Enoch Wood & Sons. "Italian Scenery" Series. Soup tureen.

Sarento, known today as Sorrento, is seventeen miles south south east of Naples on the peninsula that separates the Bay of Naples from the Gulf of Salerno. It was a seaport but has now also became a resort.

"Satsuma"

A Japanese-style pattern with a fan, some birds, etc., marked with the initials F.J.E. This is the mark of Francis J. Emery of Burslem who was potting between about 1878 and 1893. It may well have been introduced after 1880.

Satsuma is an island group of Japan.

Sauceboat

Sauceboats were included in some dinner services but by no means all. Sauces were usually served with a small ladle from a sauce tureen. Where sauceboats exist, they are similar in shape to modern gravyboats.

Saucer Dish

The name given to the early shape of saucer with a turned-up rim and no central depression for the cup or teabowl. The term is more often used for the larger examples which may be up to 8ins:20cm.

Sauceboat. *Maker unknown. Unmarked. Length 7¼ ins:18cm.*

"Saxham Hall"
Henshall & Co. Fruit and Flower Border Series. Plate 8ins:20cm.

The Hall at Great Saxham in Suffolk is an 18th century building. It was originally built in red brick which has now been plastered over.

"Saxon"
A trade name used by Thomas Shirley & Co. and the Clyde Pottery Co. of Greenock, often on its own but sometimes with the word "Warranted".

"Saxon Blue"
A name found on wares from Dillwyn & Co. of Swansea, often in the expanded form "Improved Saxon Blue". It was probably intended as a trade name for the body since it is found on at least three designs. Nance describes two patterns on teawares "one diapered and with a lace border; the other of rows of overlapping shield-like forms, shaded and bearing wavy vertical lines and broken at intervals by four-lobed floral vignettes" (Ill: Nance LXXXIc). Another pattern shows white figures in Oriental style against a vivid blue ground.

"Saxon Stone China"
A trade name used by Careys for the body of their Cathedral Series. It is a type of ironstone and may well have been used for other patterns without being named on the wares.

"Scaleby Castle, Cumberland"
William Adams. Bluebell Border Series. Plate 7½ins:19cm.

The south range of this 14th and 15th century castle was rebuilt between 1835 and 1840, after the Adams view was produced.

"A Scene in Campania, Rome"
Henshall & Co. Fruit and Flower Border Series.

Campania was the ancient name for the country around a town or city. This area, known as Campagna di Roma, extended from the coast to the Apennines.

Scene after Claude Lorraine
A romantic scene after Claude Lorraine was used by the Leeds Pottery and by John & Richard Riley. The Leeds version has a fisherman beneath the tree to the left of the bridge; Riley examples have two ladies, one seated and one standing. There are several other minor differences. Lawrence (p.53) states that "there are two versions known from Leeds and four different border patterns". She illustrates an example (p.52) bearing the inscription "J. & S. Gott, 1819". See also: Coysh 1 55, 2 77; Little 52.

See: Claude Lorraine; Ponte Molle.

"Scinde"
A flow-blue pattern by John & George Alcock which was continued by their successors John & Samuel Alcock, Junior. It is often found on a body with the trade name "Oriental Stone".

Scinde, perhaps better known as Sind, was once an autonomous province of the lower Indus valley in what is now Pakistan. After a campaign in 1843 under Sir Charles Napier, the Sind was annexed by Britain and Napier made Karachi the capital and reorganised the province. The first Indian postage stamp was issued in Scinde in 1852.

"Scotch View"
Maker unknown. A river scene with two fishermen and a man on horseback. In the distance is a ruined castle with a gateway and four towers. The border includes roses, birds and leaves, broken by large C-scrolls which enclose a thistle and two roses.

"Scotia"
David Lockhart & Co.

Scene after Claude Lorraine. *Leeds Pottery. Impressed maker's mark. Dish 17¾ins:45cm.*

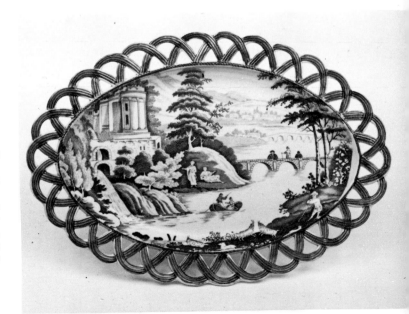

Scene after Claude Lorraine. *Riley. Printed floral spray with maker's name. Pierced basket stand 10¾ins:27cm.*

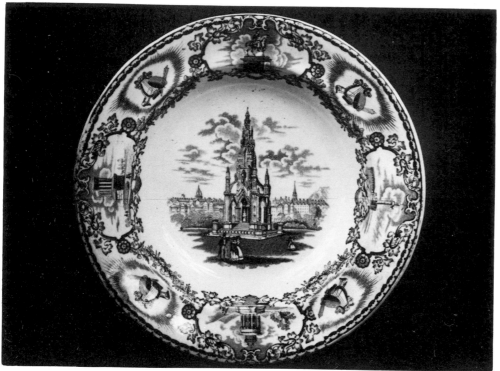

Scott Monument, Edinburgh.
*James Jamieson & Co. "Modern
Athens" Series. Printed series title
mark with maker's initials. Soup
plate 10½ ins:27cm.*

Scott Monument, Edinburgh

James Jamieson & Co. "Modern Athens" Series. Soup plate 10½ ins:27cm.

As with other items from the series this view is not titled. This monument to Sir Walter Scott, on the south side of Princes Street, was designed by G.M. Kemp and erected between 1840 and 1846.

"Scottish Arts"

Maker unknown. A pattern showing a group of classical figures, one of whom is holding a scroll bearing the names of Abercrombie, Bruce, Douglas, Duncan, Graham, Hamilton, Murray and Wallace. There is a border of thistles. Ill: FOB 8.

"Scott's Illustrations" Series

A series by Davenport of Longport illustrating scenes from the works of Sir Walter Scott. Examples are known with date marks ranging from the mid-1830s right through to the 1860s, and pieces can also be found in black, green and pink. Combinations of these colours were also used, one for the border and another for the central design.

The titles are printed within a floral scroll cartouche with the series title at the top together with the name "DAVENPORT". Several instances are recorded with the added mark of Henderson & Gaines, a firm of importers at 45 Canal Street, New Orleans. Another mark has a version of the royal arms with added initials D.W., the significance of which is not known.

The patterns are taken from the Magnum Opus collected edition of Scott's works published by Robert Cadell between 1829 and 1833. Titles include:

"Bride of Lammermoor"*
"Guy Mannering"*
"Heart of Midlothian"*
"Legend of Montrose"
"Rob Roy"*
"Waverley"*

In addition, an example illustrated has an unidentified scene titled "Guy Mannering", possibly in error.

Scott's Pottery

See: Southwick Pottery.

Scriptural Series

A series of biblical scenes printed in dark blue by Enoch Wood & Sons. The border consists of four vignettes within acanthus scroll frames separated by small flowers, each vignette containing a chalice, an open book, a cross, a lamb and a casket. Examples do not appear to exist in Britain and the output was probably all exported to America. The form of the marks used is not known. The following scenes have been recorded:

"Christ and the Woman of Samaria"
"The Coming of the Wise Men"
"Death of Abel"
"The Flight into Egypt"
"Jacob and the Angel"
"The Nativity"
"Peter in the Garden"
"The Return"
"Revelation"

A scene depicting "The Flight into Egypt" was also made by the Herculaneum Pottery (See: Smith 166A). This item bears a very clear factory mark and appears to have the same border as the scenes listed above by Enoch Wood & Sons.

"Scroll"

A pattern title used by Francis Morley. It has also been noted on designs by an unknown maker showing romantic river scenes within a light blue textured border. Ill: P. Williams pp.409-410 (three examples).

Seacombe Pottery fl.1852-1871

John Goodwin, a Staffordshire potter, moved to Liverpool in 1851 and built Seacombe Pottery on the Wirral Peninsula. He took equipment with him, including copper plates, and made blue-printed wares including "Views of London". Printed marks include the name J. Goodwin, or Goodwin & Co., together with the name of the pottery.

"Scott's Illustrations" Series. *Typical printed mark together with impressed maker's anchor mark dated 1836 and an additional printed mark for the American importer Henderson & Gaines of New Orleans.*

"Scott's Illustrations" Series. *Unattributed printed royal arms mark from a "Waverley" pattern soup plate c.1860. The initials probably relate to a retailer.*

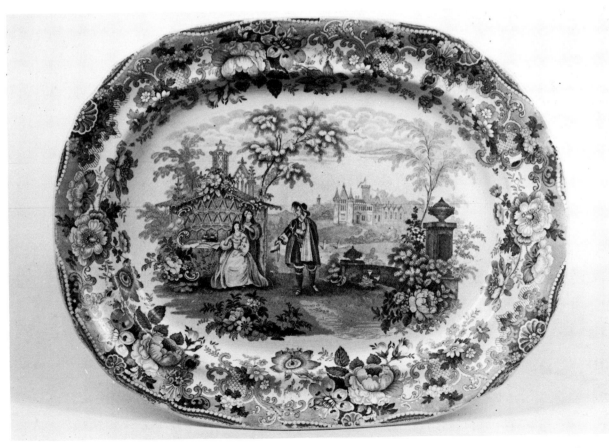

"Scott's Illustrations" Series. *Davenport. Unidentified scene with the titles mark for "Guy Mannering", possibly an error. Impressed maker's anchor mark for 1852. Dish 16½ ins:42cm.*

Seasons Series

A series of patterns which were introduced by Copeland & Garrett and continued by their successors Copeland. The patterns are characterised by a large central vase or urn containing flowers and marked with either the season or the month. Behind the vase is a landscape which is often titled on the printed mark, several different versions of which are known. The earliest would appear to be an ornate shield within a drape marked with the words "Copeland & Garrett, Stoke upon Trent & London". The scene title appears, if marked, on a suspended ribbon, beneath which is the name of the body used — "China Glaze". The title "Seasons" can be found on later Copeland examples with different printed marks but it does not appear on the earlier productions. Examples are also known in brown and green.

Views recorded to date include:
"The Alps" (with "February")*
"Italian Garden" (with "June" or "August")
"Richmond Hill" (with "Spring")
Untitled (with "April")
"Vintage of Sorrento" (with "Autumn")

The border consists of four small vignettes, each with a cherub, representing the four seasons. These are separated by longer panels with a geometric lattice ground, the whole border being ornamented with a profusion of scrolls. The designs are thought to have been introduced immediately after the end of the Spode period in 1833.

"Seine"

John Wedg Wood. A romantic scene printed in light blue on ironstone dinner wares. The title was probably taken from the French river which rises to the north west of Dijon and flows via Paris and Rouen into the English Channel.

"Select Scenery" Series

A series of British views by James & Ralph Clews. The scenes are printed within a fine border of large lily- and camellia-type flowers and they are titled in a printed leaf and ribbon cartouche together with the series title. The series appears to have been made mainly for export and examples are rare in Britain. Views recorded are:
"Aysgill Force in Wensleydale"
"Cheddar, Somersetshire"
"Donemark Mill"
"Fountains Abbey"
"Ivy Bridge" (sic)
"Kilcolman Castle"
"Killin, Head of Loch Tay"
"Norwich"
"Ripon, Yorkshire"
"Rivax Abbey" (sic)
"St. Catherine's Hill, near Guildford"
"View in Glengyle"
"Windsor"*

"Select Sketches" Series

A light blue series of views attributed to Thomas Dimmock & Co. Examples are also known in pink and purple. The printed series mark is an ornate scroll cartouche containing the name of the view in script. The series title appears above, and below are the words "Stone Ware" and the initial D. This initial is the basis of the attribution to Dimmock although Laidacker credits the Jacksons, stating that "there are reasons" but without further comment.

Three views have been recorded to date:
"Cowes"
"Menai Bridge"*
"New York"

Seasons Series. *Copeland & Garrett. Typical printed mark with impressed maker's mark.*

"Select Scenery" Series. *James & Ralph Clews. Typical printed mark.*

"Select Sketches" Series. *Thomas Dimmock & Co. Typical printed mark.*

"Select Views." *William Smith & Co. Printed building mark with "W. SMITH & CO." above and "SELECT VIEWS" below. Impressed mark "W.S. & CO'S./QUEEN'S WARE/STOCKTON." Plate 8¾ ins:22cm.*

"Select Views"

William Smith & Co. Dinner wares with typical romantic scenes within a border of scrolls and scenic medallions. One example is shown above; another in P. Williams p.412.

"Select Views" Series

A series of views from England, Wales and the Continent printed in dark blue by Ralph Hall, mainly for export. The central views appear in a small scroll vignette within a very wide border of fruit and flowers. Items bear a printed oval cartouche headed "R. Hall's Select Views" and containing the name of the view above the body name "Stone China". Views include:

"Biddulph Castle, Staffordshire"
"Boughton House, Northamptonshire"
"Bramber Church, Sussex"
"Castle Prison, St. Albans, Hertfordshire"
"Church of St. Charles and Polytechnic School, Vienna, Germany" (sic)
"Conway Castle, Caernarvonshire, Wales"
"Eashing Park, Surrey"
"Gyrn, Flintshire, Wales"
"The Hospital near Poissy, France"
"Knole, Kent"
"Laxton Hall, Northamptonshire"
"Luscombe, Devonshire"
"Oatlands, Surrey"
"Pains Hill, Surrey"
"Thoresby Park, Nottinghamshire"
"Valle Crusis Abbey, Wales" (sic)

"Warleigh House, Somersetshire"
"Wilderness, Kent"

Laidacker also mentions an untitled view which he identifies as Worcester Cathedral.

"Semi-China"

A trade name used by many potters for earthenware bodies, some of which resemble ironstone. The term can be found as part of printed marks by Thomas & Benjamin Godwin, John & Richard Riley, Tams & Co., and Enoch Wood & Sons. It may well have been used by other makers.

For some reason the term is relatively common on wares with no maker's name. A good example is the "English Scenery" Series which has "Semi-China" with the series title on a crowned drape. The term is often found on its own with

"Semi-China." *Common mark by an unknown maker.*

"Semi-China." *Maker unknown. Unidentified view from a series of country scenes. Printed mark "SEMI/CHINA" in octagonal frame. Drainer 13ins:33cm.*

no other wording, e.g. "SEMI CHINA" in two lines in a double-line octagonal frame, and "Semi China", also in two lines but in lower case letters within a double line diamond. The former is found on an untitled series of English country scenes. The latter is known on a miniature plate with an impressed mark "ROGERS".

A mark worthy of mention consists of "Semi-China" in two lines in lower case letters within an octagonal frame rather like a Chinese seal. This is known on three patterns, Italian Ruins (Ill: Coysh 1 149), an all-over floral design in light blue, and a design of bamboo and flowers (Ill: Coysh 1 167). Little (p.73) records a dish with this mark which also bears the printed name of the retailers Hillcock & Walton (qv).

"Semi-China Warranted"

A printed mark which consists of the words "SEMI-CHINA WARRANTED" in two lines with no ornamentation is known to have been used by C.J. Mason & Co. A few examples have been found with the addition of the name "MASON'S" in an arc above. The mark is commonly found on an untitled view of a country house which is thought may be Trentham Hall in Staffordshire. Ill: Coysh 1 146, 2 51; Godden BP 312. Examples are recorded with the addition of the name of the retailer Higginbotham (qv).

The same wording can be found in an elaborate ribbon cartouche printed on a series of attractive rural scenes within a floral border. An example has been noted on which the initials R.S. had been added at the base of the mark and the name "STEVENSON" was also impressed. This leads to an attribution to Ralph Stevenson for the series. One example is illustrated and further scenes can be seen in FOB 6, 29.

"Semi-Nankeen China"

This trade name is found on a printed mark which has a small scene with a three-masted ship beneath a ribbon bearing the wording. Above is a crown with a rose on one side and a thistle on the other. The wording could possibly be read as Nankeen Semi-China. This mark has only been found on wares printed with a Filigree pattern and has always been attributed to Andrew Stevenson on the basis of the three-masted ship. Several examples are known with the impressed seal mark "Improved Stone China" (qv) which is known to have been used by Minton, and one plate has now been found with the clear impressed mark "MINTON" and a date mark for 1862. It is, of course, possible that the design or the copper plates were used by more than one potter.

"Senate House, Cambridge"

John & William Ridgway. Oxford and Cambridge College Series. Plate 7¼ ins:18cm. Ill: P. Williams p.413.

The Senate House was built by James Gibbs in the years 1722 to 1730. The facade has giant Corinthian pilasters.

"Semi-China Warranted."
*Attributed to Ralph Stevenson.
Rural scene with printed ribbon
cartouche titled "SEMI-CHINA
WARRANTED". Dish
18½ ins:47cm.*

"**Semi-Nankeen China.**" *Printed mark on a Filigree pattern plate impressed "MINTON".*

"**Semi-Nankeen China.**" *Maker unknown. Filigree pattern. Printed crown and ship cartouche with words "SEMI-NANKEEN CHINA". Handled dish 8½ ins:22cm.*

"**Senate House, Cambridge.**" *John & William Ridgway. Oxford and Cambridge College Series. Printed title and maker's mark. Plate 7¼ ins:18cm.*

"The Seven Bishops Conveyed to the Tower"

Jones & Son. "British History" Series. Soup tureen stand 15ins:38cm, dish 12½ins:32cm, and vegetable dish. Ill: Coysh 2 47.

The seven bishops whom James II committed to the Tower in June 1688 were William Sancroft, Archbishop of Canterbury; Thomas Ken, Bishop of Bath and Wells; Francis Turner, Bishop of Ely; Thomas White, Bishop of Peterborough; John Lake, Bishop of Chichester; William Lloyd, Bishop of St. Asaph; and Sir Jonathan Trelawny Bishop of Bristol. They were fondly styled the Seven Lamps of the Church, and popular feeling invested them with the attributes of patriots and martyrs. This is symbolised on the print by the woman with arm outstretched and the two men standing in the water. See: A. Strickland, *The Lives of the Seven Bishops committed to the Tower in 1688* (1866).

Sewell fl.c.1804-1878

Three different Sewell partnerships operated the St. Anthony's Pottery at Newcastle-upon-Tyne in Northumberland. They were:

Joseph Sewell	c.1804-c.1819
Sewell(s) & Donkin	c.1819-1852
Sewell(s) & Co.	1852-1878

A blue-printed plate with a transfer showing a castle by Joseph Sewell is illustrated by Bell in *Tyneside Pottery*, p.106. All three partnerships used simple impressed marks with the relevant name, known varieties being "SEWELL", "SEWELL & DONKIN", "SEWELLS & DONKIN", "SEWELL & Co.", and "SEWELLS & Co."

"Shanghai"

Jacob Furnival & Co. A flow-blue pattern used on dinner wares.

"Shannon"

Maker unknown. A romantic scene in light blue with a border of scenic vignettes which bears no relation to the name of the river in Ireland. Ill: P. Williams p.415.

Details of the ship pattern often referred to as the Shannon can be found under Shipping Series (qv).

"Shapoo"

T. & R. Boote. A title noted on flow-blue wares.

The name is probably an anglicised version of Chapu, a town near Nanking in China.

Shard (Sherd)

A fragment of broken pottery or porcelain. Shards found on the sites of old potteries have been of vital importance to ceramic archaeologists in tracing the history of certain makers' wares. Some blue-printed patterns have been traced to their makers by shards recovered during excavations.

"Sharon Castle" (sic)

Enoch Wood & Sons. Grapevine Border Series. Sauce tureen and stand.

Sharow Castle, in Yorkshire, is one mile to the east of Ripon. It is, in fact, the church of St. John which has a large west tower with angle buttresses and battlements, built by George Knowles in 1825.

Sharpe, Thomas fl.1821-1838

Swadlincote Potteries, Burton-on-Trent, Derbyshire. According to Little (p.115) this firm produced blue-printed wares.

Sharpus fl.c.1800-1893

Earthenwares of the 1830s period are known with the printed retailer's legend "Sharpus, 13 Cockspur Street, London". This has been noted on marked wares from the Mason and John Ridgway factories.

It would seem that Sharpus was a family firm. It started in about 1800 at Cockspur Street, Charing Cross, under the style Sharpus & Co. An early variant was R. & E. Sharpus, a partnership which lasted a very short time, the Cockspur Street premises being run by Edward Sharpus from about 1805. Richard Sharpus ran a similar firm at 33 Berkeley Square, and later at 27 Davies Street (after about 1820), but no marked pieces with these addresses have been noted.

The Cockspur Street address was run by a succession of Sharpus partnerships which became Sharpus & Cullum in 1842, and Cullum & Sharpus in 1872. The illustrated advertisement for Sharpus & Co. appeared in a London directory for 1842. An identical advertisement appeared in 1843 under the new name of Sharpus & Cullum. It is interesting to note the specific entry for "Table Services" in both blue and green which were the popular colours at the time. As can be seen from the comparative prices, the printed wares were cheaper than ironstone, and both were considerably less expensive than china.

MISCELLANEOUS. [1842.

SHARPUS & CO,
CHINA, GLASS, AND EARTHENWARE MANUFACTURERS,
13, COCKSPUR STREET, CHARING CROSS, LONDON,

Beg most respectfully to solicit the attention of the Nobility and Gentry to view their modern and extensive assortment of China, Glass, and Earthenware, at the following very moderate prices:—

Table Services.

	£. s. d.	£. s. d.
Green and Blue Patterns	2 15 0 to	5 5 0
Ditto, Gilt	5 15 0 to	6 6 6
Rich Japan & Ironstone pattern, Gilt	8 18 6 to 20 0 0	
Ditto, China	18 18 0 to 40 0 0	

Dessert Services.

	£. s. d.	£. s. d.
Earthenware, China patterns	1 5 0 to	2 10 0
China, with Flowers and Gold	2 18 0 to	4 14 6
Ditto, very superb	5 5 0 to 34 0 0	

Breakfast Services.

	£. s. d.	£. s. d.
China, with Flowers or Japan	0 14 6 to	1 12 6
Ditto, with Gold	1 4 0 to	2 12 6
Ditto, very elegantly gilt	2 18 0 to	6 6 0

Tea Services.

	£. s. d.	£. s. d.
China, with Flowers or Japan	1 2 0 to	1 10 0
Ditto, Gilt	1 12 0 to	2 12 6
Ditto, very rich patterns	2 18 0 to 10 10 0	

Cut Quart Decanters, per pair, 10s. 6d. to £1 6s.; Ditto, very handsome, per pair, £1 8s. to £2 2s.

Cut Wine Glasses, best flint glass, per dozen, 7s. 6d.; 8s.; 10s. 6d.; 11s.; 12s.; 13s.; 14s. and upwards.

Cut Tumblers, per dozen, 10s. 6d.; 12s.; 14s.; 16s.; 18s.; 21s.; 24s. and upwards.

Sharpus. A typical London retailer's advertisement from a directory dated 1842.

Colour Plate XXIV. Smoker's Sets. *Two examples, both unmarked and by unknown makers. On the left a compact version with tray, tobacco jar, and combined lid/candlestick, decorated with a sheet pattern of shells and seaweed. On the right a taller but incomplete set (see below) bearing two country scenes, one of which shows Inveraray Castle. Overall heights 7¾ ins:20cm and 14½ ins:37cm.*

Colour Plate XXV. Smoker's Set. *Component parts of the larger set illustrated above: candlestick, tobacco jar, goblet, combined weight/snuff box with screw top, reversible lid/ashtray. A lower spittoon is missing and the rim at the top of the candlestick suggests the loss of some other part. Tobacco jar height 5ins:13cm.*

The Sheep Shearer. *Maker unknown. Unmarked. Washbowl 13ins:33cm.*

Tunstall (1851-c.1856) and Burslem (c.1858-1882), Staffordshire. Anthony Shaw is known to have made blue-printed wares. A pattern titled "Peruvian Horse Hunt" was registered in 1853. The name Shaw appears, sometimes with the initial A or the name Anthony in full, in a variety of printed and impressed marks. .

The Sheep Shearer
Maker unknown. A title adopted here for a pattern illustrated on an unmarked washbowl. It shows the sheep shearer at work in a rural setting within a wide floral border.

Sheet Pattern
A pattern which repeats the same motifs all over so that it can be used on any shape without engraving several different copper plates. These designs are sometimes referred to as all-over patterns. For reasons of simplicity and economy the technique was very commonly used for toy dinner services.

The Daisy and Leaf patterns produced by Spode are typical examples (Ill: Whiter 35-36).

Sheffield Place, Sussex
John & William Ridgway. Angus Seats Series. Dish 12¾ins:32cm, and drainer.

In common with all items from this series the view is not titled and marked pieces are very rare.

Sheffield Place, known today as Sheffield Park, is a large house based on a Tudor building. It was rebuilt by James Wyatt between 1775 and 1778 for John Holroyd, who became the first Lord Sheffield, and was Wyatt's first Gothic country house. It is open to the public on certain days in the summer, but the gardens are now owned by the National Trust and are famous for their beautiful layout based on five lakes.

Sheet Pattern. *Thomas Fell & Co. Impressed maker's anchor mark. Shallow dish 5¼ins:13cm.*

Sheet Pattern. *Andrew Stevenson. Acorn and oak leaf design. Impressed ship mark. Plate 6¼ins:16cm.*

Sheet Patterns. *Miniature wares. Left: Hackwood. Impressed maker's mark. Plate 3¼ ins: 8cm. Right: Copeland. Printed maker's mark. Dish 4¼ ins: 11cm. Below: Harding. Impressed maker's mark. Plate 2ins: 5cm.*

Shell Border Series

A series of maritime subjects printed in dark blue by Enoch Wood & Sons. The views are titled on the front and appear within a wide, irregular grotto-type border with large sea shells set against a background of star-like flowers. Items are virtually unknown in Britain but the list of recorded views is as follows:

"The Beach at Brighton"
"Cape Coast Castle on the Gold Coast, Africa"
"Chiswick on the Thames"
"Christianburg, Danish Settlement on the Gold Coast, Africa"
"Cowes Harbour"
"Dartmouth"
"Dix Cove on the Gold Coast, Africa"
"East Cowes, Isle of Wight"
"The Eddistone Lighthouse" (sic)
"Erith on the Thames"
"The Kent, East Indiaman"
"Near Calcutta"
"A Ship of the Line in the Downs"
"Southampton, Hampshire"
"View of Dublin"
"View of Liverpool"
"Whitby"
"Yarmouth, Isle of Wight"

There are several more scenes without titles, two with steamers named *Union Line* and *Chief Justice Marshall, Troy,* and three American subjects.

"Shelter'd Peasants"

Ralph Hall. A rustic scene showing a shepherd, woman and child sheltering beneath a tree, within a fruit and flower border. The pattern has a printed mark in the form of a leafy branch bearing the title. Some marks have an added ribbon with the name "R. HALL". Examples are found on dinner wares, but the pattern is also known on an unmarked miniature plate. Ill: FOB 6.

"Shelter'd Peasants." *Ralph Hall. Printed mark with title on a branch, from which "R. HALL" hangs on a ribbon. Plate 8½ ins: 22cm.*

Shelton

A Staffordshire pottery town adjacent to Hanley about a mile north of Stoke-on-Trent. Shelton and Hanley formed an urban district prior to 1910 when, together with other pottery towns, they were federated into the city and county borough of Stoke. Amongst Shelton potters were Joseph Clementson, Hicks & Meigh, William Ratcliffe, the Ridgway family, and many smaller firms. The town was popular with engravers, the names of Bentley, Wear & Bourne, James Cutts, Thomas Fletcher and John Martin, are all associated with Shelton.

"The Shepherd Boy Rescued"

James & Ralph Clews. Don Quixote Series. Dish 12½ins:32cm, and pierced basket stand.

The title printed on the wares may not include the prefix "The".

"Sherborne Castle, Dorsetshire"

Maker unknown. Flower Medallion Border Series. Soup plate 10ins:25cm.

"Sherbourn Castle" (sic)

Enoch Wood & Sons. Grapevine Border Series. Sauce tureen stand.

Sherborne Old Castle was built in the 12th century by the Bishop of Salisbury. It was converted in part by Sir Walter Raleigh into a private mansion in the 1590s, but this scheme was abandoned in favour of a new castle. The old castle was held by Royalists during the Civil War, but it was stormed and dismantled. After Raleigh's downfall his estates were confiscated, and in 1817 the new castle was granted to Sir John Digby who made changes and additions. The most striking features are the angle towers with chimney stacks. The grounds were laid out by Capability Brown, mainly between 1776 and 1779.

"Sherborne Castle, Dorsetshire." *Maker unknown. Flower Medallion Border Series. Printed title mark. Soup plate 10ins:25cm.*

Sherd

See: Shard.

Ship

Several patterns with full-rigged ships were produced at Swansea. One design of a brig within a chinoiserie border is known with an added inscription "The Betsy" together with the name of the ship's Master, Michael George. A similar pattern is illustrated in Nance XLVIa. One particularly popular design has the ship with a group of nautical implements in the foreground and a simple lined border. An example printed in black is illustrated in Godden I 567, but similar blue-printed items are known. The mark may be "DILLWYN & Co.", "BEVINGTON & Co.", or simply "DILLWYN".

"A Ship of the Line in the Downs"

Enoch Wood & Sons. Shell Border Series. Various bowls and a vegetable dish. Ill: Arman 139.

"The Downs" are an open roadstead in the English Channel where ships may lie in the westerly winds.

Shipping Series

Hayden in his book *Chats on English Earthenware* (p.341) illustrated a dish with a view of a naval engagement between two frigates. He attributed the dish to Rogers and described the scene as "the Naval Fight between the *Chesapeake* and *Shannon*". Since then over seventy years have passed and no definite evidence has been produced to support the attribution to Rogers. Moreover, despite the fact that later authors have repeated his description of the scene, the battle was *not* between the *Chesapeake* and *Shannon*.

The scene is based on a print (see opposite) of the moonlight battle between the *Blanche* and *La Pique* which took place on 4th January, 1795. The dish corresponds in almost every detail with the print which bears the caption: "The situation of *La Pique* of 40 guns, 400 men, a French Frigate and His Mjs Ship *Blanche* of 32 guns and having on board only 180 men about 2 o'clock in the morning after the *Blanche* had lost her Main and Mizen masts. The action began about half past 12 and continued to half past five in the Morning. Captain Faulkner fell when the ships were in the above situation". Eventually, however, *La Pique* surrendered.

The error over this battle throws doubt on other titles in the series. Some of the scenes may be of merchant vessels rather than naval ships. The series has therefore been named the Shipping Series.

The various scenes are printed in frames within a border of shells and seaweed and the following have been recorded:

(i) Frigate I (previously called the Shannon). The waves are breaking against the bow and a pennant at the masthead is flying upwards in a wavy line. Plate and soup plate, both 10ins:25cm, and dessert dish 9½ins:24cm.

(ii) Frigate II (previously called the Chesapeake). The sea is calmer and the pennant flies horizontally. Plate 8½ins:22cm.

(iii) Night Sea Battle: *Blanche* and *La Pique* (see opposite). Dishes 19½ins:50cm, 20¾ins:53cm and 22½ins:57cm. Also reported on jugs.

(iv) Day Sea Battle. A large fully rigged ship firing amongst several others. Dish 17½ins:44cm.

(v) Shipwreck Scene. A ship with sails furled, heeling over in a rough sea. A small boat with survivors is seen in the foreground. Soup plate 9¾ins:25cm.

(vi) Fleet Scene I. A number of ships, the largest with sails furled and pennant flying horizontally. Sauceboat 6½ins:16cm.

(vii) Fleet Scene II. A number of ships, the largest with

Shipping Series. *Battle between "Blanche" and "La Pique". Source print from J. Jenkins "The Naval Achievements of Great Britain" (1817).*

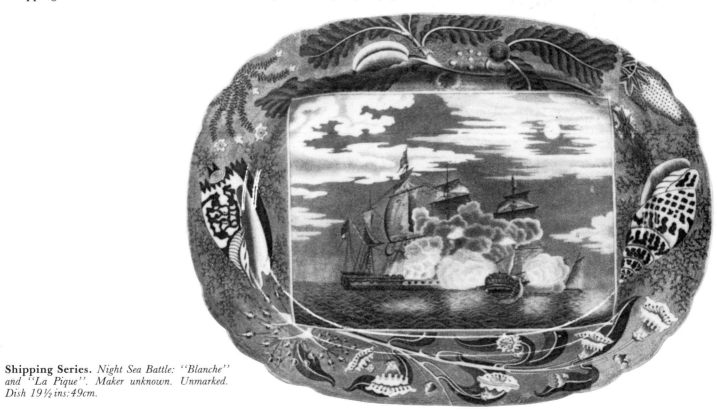

Shipping Series. *Night Sea Battle: "Blanche" and "La Pique". Maker unknown. Unmarked. Dish 19½ ins:49cm.*

Shipping Series. *Frigate I. Maker unknown. Unmarked. Plate 10ins:25cm.*

Shipping Series. *Frigate II. Maker unknown. Unmarked. Plate 8½ins:22cm.*

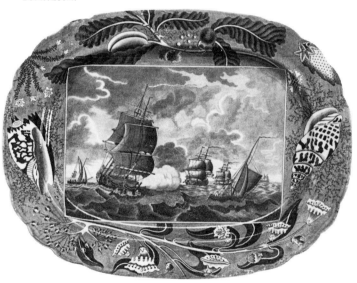

Shipping Series. *Day Sea Battle. Maker unknown. Unmarked. Dish 17½ins:44cm.*

Shipping Series. *Shipwreck Scene. Maker unknown. Unmarked. Soup plate 9¾ins:25cm.*

Shipping Series. *Fleet Scene II. Maker unknown. Pierced basket. Length 10ins:25cm.*

"Shooting at the Edge of a Jungle." *Spode. Indian Sporting Series. Printed title and printed and impressed maker's marks. Dish 14½ ins:37cm.*

"Shooting a Leopard." *Spode. Indian Sporting Series. Printed title and printed and impressed maker's marks. Dish 20½ ins:52cm.*

topsails furled, partly obscured by the sails of a smaller boat. Dish 9¾ ins:25cm, and pierced basket. Ill: Arman S 440B.

(viii) Approaching Port. Two ships approach a castle-like building with tower and battlements. Choppy sea. Mug 5¼ ins:13cm.

(ix) Sailing Galley. A long galley-like sailing ship flying a prominent white ensign. Soup tureen. Ill: Godden BP Colour Plate X.

(x) Landing Scene. A view listed by both Arman and Laidacker on an oblong footed comport.

(xi) Harbour Scene. A view listed by both Arman and Laidacker on a water jug 7ins:18cm.

We are indebted to Mr. B.H. Plimer of Ottawa for information regarding this series.

"Shirley House, Surrey"
Enoch Wood & Sons. Grapevine Border Series. Plate 6¾ ins:17cm.

This scene is considered to represent the 18th century building now known as Coombe House. It is a red brick building having a doorway with Tuscan columns and a broken pediment.

Shirley, Thomas, & Co. fl.c.1840-1857
Clyde Pottery, Greenock, Scotland. This firm succeeded Andrew Muir & Co. and was in turn succeeded by the Clyde Pottery Co. Marks appear to be restricted to impressed initials; T.S. & Coy., T.S. & C., and T.S. & Co. have all been recorded.

Shooting with Dogs
A title used by Coysh for a pattern showing a marksman with a top-hat out shooting with three gundogs. The scene includes a cottage and a horse with a foal, and the border is of scrolls and flowers. Ill: Coysh 2 149.

"Shooting at the Edge of a Jungle"
Spode. Indian Sporting Series. Dish 14½ ins:37cm, and oval soup tureen stand 17ins:43cm. Ill: S.B. Williams 19-20.

"Shooting a Leopard in a Tree"
Spode. Indian Sporting Series. Dish 20½ ins:52cm. Ill: S.B. Williams 12-13.

The words "in a Tree" are sometimes omitted from the printed title.

Shorthose fl.c.1795-1823
The name Shorthose appears in the title of three firms operating in Shelton and Hanley, Staffordshire, between about 1795 and 1823, although John Shorthose was mentioned

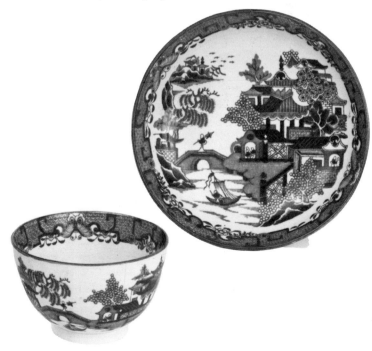

Shorthose. *A one man/insect willow pattern. Printed mark "SHORTHOSE & CO" on saucer. Tea bowl and saucer. Saucer diam. 5¼ ins:13cm.*

earlier in 1783. The correct dates are not clear but the periods are approximately:

Shorthose & Heath, Shelton	c.1795-1815
John Shorthose, Hanley	1807-1823
Shorthose & Co., Shelton	c.1817-1822

Marks appear to be restricted to the names "SHORTHOSE", "SHORTHOSE & HEATH", and "SHORTHOSE & CO.", either impressed or printed. The third of these may have been used also by the Shorthose & Heath partnership. The Shorthose & Co. mark is known on chinoiserie pattern tea wares and a printed Shorthose mark is found on a saucer commemorating Waterloo.

See: "Wellington Hotel, Waterloo".

"Shrewsbury"

Herculaneum. Cherub Medallion Border Series. Water jug 9½ ins:24cm. Ill: Smith 162.

Shrewsbury, on the River Severn, is the county town of Shropshire (Salop). This view shows the spires of St. Mary and St. Alkmund together with part of the old town wall.

"Shugborough Hall, Staffordshire, Viscount Anson's Seat"

Careys. Titled Seats Series. Soup tureen cover.

"Shugborough, Staffordshire"

Maker unknown. Foliage Border Series. Entree dish with cover.

Shugborough Hall, five miles south east of Stafford, the ancestral home of the Earls of Lichfield, was designed by James Stuart and Samuel Wyatt, built in stages, and finally completed in 1806. Part of the building now houses the Staffordshire County Museum.

"Siam"

Joseph Clementson. A light blue pattern registered in the 1850s. It is a romantic scene of buildings with minarets on either side of a stretch of water. Ill: P. Williams p.160. This service was made during the period when Siam (now Thailand) was showing interest in British trade. It was a period which led to the treaty of 1855 when Englishmen were allowed to own land in the country and new trade facilities were granted.

"Siam." *Joseph Clementson. Printed title and maker's mark with "IRONSTONE" and a registration diamond for 1850. Octagonal dish.*

"Sicilian"

Maker unknown. A series of romantic scenes marked with the title in script in a scrolled cartouche. The designs use rococo scrolls freely on buildings, among flowers and in the borders. Some examples are known with an impressed seal mark with the wording "Improved Stone China" (qv). Ill: P. Williams p.416 (three examples).

"Sicilian Beauties"

Maker unknown. A title recorded in a printed cartouche found on light blue dinner wares.

"Sicily"

Copeland & Garrett. Byron Views Series. Cup plate. Ill: P. Williams p.418.

"Sicilian." *Maker unknown. Printed title cartouche. Drainer 12ins:30cm.*

"Sidney Sussex College, Cambridge." *John & William Ridgway. Oxford and Cambridge College Series. Printed title and maker's mark. Dish 14½ ins:37cm.*

"Sicre Gully Pass"

John Hall & Sons. "Oriental Scenery" Series. Sauceboat.

Sakrigali, on the Ganges, was visited by Thomas and William Daniell in October 1788 during their Indian journeys. They issued a print titled "Siccra Gulley on the Ganges" in *Oriental Scenery* but it is not thought to be the source of this particular view.

"Sidney Sussex College, Cambridge"

John & William Ridgway. Oxford and Cambridge College Series. Dish and deep dish, both 14½ ins:37cm, and pierced stand. Ill: Coysh 1 69.

Sidney Sussex College was founded in 1596. Sir Jeffry Wyatville started to rebuild the old college in 1821 and this view would appear to predate the alterations.

"Signing of Magna Charta"

Jones & Son. "British History" Series. Plate 10¼ ins:26cm. Ill: Coysh 2 46.

This scene shows the barons presenting the charter to King John on 15th June, 1215. The King is seated on a throne and flanked by two bishops, the whole group in front of a tent. The Magna Charta was signed at Runnymede, near Egham, and was an important turning point in English history.

"The Simplon"

(i) Copeland & Garrett. Byron Views Series. Round sauce tureen (the cover showing "Cintra").

(ii) John Meir. "Byron's Illustrations" Series. Punch bowl. Ill: Coysh 2 57. Note that this design is titled simply "Simplon".

These two views are practically identical and were no doubt taken from the same source print by E. Finden after H. Gastineau. Many travellers on the Grand Tour reached Italy from Switzerland by crossing the Simplon Pass, arriving at Domodossola and Lake Maggiore after what to many was a frightening journey. The Simplon road was begun in 1800 under Napoleon.

"Singanese"

John Wedg Wood. A romantic scene printed in light blue on ironstone dinner wares. The title probably derives from the town of Singan, capital of the province of Chensi. A writer of 1810 describes it as "next to Pekin, the largest and most populous, and commercial city of China, for several ages the seat of the Chinese emperors".

"Signing of Magna Charta." *Jones & Son. "British History" Series. Printed titles and maker's mark. Plate 10¼ ins:26cm.*

Smith, William, & Co. *Printed mark of a Brussels agent on a "Lion Antique" pattern saucer.*

Single Pattern Services

A term used to describe dinner, dessert or tea services in which every piece is decorated with the same pattern. These patterns vary only in minor details which are changed to suit the various shapes. Services in which different pieces bear different patterns are correspondingly called Multi-Pattern Services (qv).

Sizes

The size of a piece of pottery was stated in two ways. For hollow ware such as mugs and jugs, the size was defined by use of the Potters' Count (qv). For flatware such as plates and dishes, the size was measured in inches. Hence an impressed number 14 on a dish almost certainly indicates a nominal size of 14ins. It is emphasised that the number represents a *nominal* size; the potters used to compete over the *actual* sizes of their wares in defiance of cartel agreements. This explains why a dish impressed 14 may measure 15ins., and a plate impressed 9 may measure 10ins.

"Slingsby Castle, Yorkshire"

Maker unknown. Pineapple Border Series. Soup tureen stand 13ins:33cm. Ill: FOB 10.

Slingsby Castle dates from the early 17th century although there were additions at the time of Charles I. It is now in ruins.

Slop Basin

Most tea services included a slop basin in to which the dregs from cups could be poured. An example printed with the Spode pattern known as The Love Chase is illustrated on page 228.

Smalt

A deep blue pigment obtained by fusing oxide of cobalt with silica and potash, and reducing the glass thus formed into powder. It was used in underglaze blue-printing.

Smith, George F. (& Co.) fl.c.1855-1860

North Shore Pottery, Stockton-on-Tees, Durham. This firm made blue-printed wares typical of the period, a "Florentine" pattern, for example. Printed and impressed marks include the name in full or the initials G.F.S. or G.F.S. & Co.

Smith, William

A Liverpool engraver who joined Ralph Baddeley at Shelton, Staffordshire to help with experiments in underglaze blue-printing, certainly before 1782.

Smith, William, & Co. fl.1825-1855

Stafford Pottery, Stockton-on-Tees, Durham. Although technically in Durham, this pottery is almost always considered with the Yorkshire potteries nearby. The firm had a vast export trade to European countries, especially Germany, Belgium and Holland. Children's plates were made with early pictures of locomotives and captions in German, and tea wares are known with printed marks including the name of the Brussels agents J.B. Cappellemans Aîné.

There was also a flourishing domestic trade. For some reason the firm seems to have concentrated on tea wares although dinner services were also produced. Pattern titles were relatively common, a few examples being "Lion Antique", "Fountain", "Napoleon" and "Pastimes", although some may have been in colours other than blue. The firm was early in the field with colour-printing which had been introduced by the Pratts in the 1840s. Services were produced with a pattern titled "Fruit Basket", in which the border was blue but the central design was in colour. Ill: Coysh 2 83.

A very large number of marks were used, mostly with the initials W.S. & Co. or the name in full. Many of these marks include the words Queen's Ware, Wedgwood, or Wedgewood. It seems quite clear that these marks were intended to deceive and the attempt to benefit from the famous Wedgwood name, even with the incorrect spelling, led to trouble. In 1848 Wedgwood successfully applied for an injunction to restrain Smith from such practices. Marks like these should therefore indicate an earlier date. It seems strange that Smith felt the need for such deception since many of his early tea wares are of a high standard in their own right.

Smoker's Set

A set of pots which fit together in the form of a pyramid and serve a variety of smoker's needs. Several varieties are known, amongst which are a few examples in blue-printed ware. A typical example would consist of a spittoon onto which fits a tobacco jar. This jar contains a weight to press the tobacco, often in the form of a small screw-top snuff box, and is fitted with a lid which, when inverted, doubles as an ashtray. A rim in the lid locates the base of a goblet, on top of which stands a candlestick. Simpler versions are known, sometimes with alternative pieces such as a tray. Complete examples are rare but constituent parts are sometimes found, their function being betrayed by the tell-tale rims and recesses necessary for the pieces to fit together. The name Bargee's Companion is sometimes used.

See Colour Plates XXIV and XXV.

Snow Scenes

Apart from the "Arctic Scenery" Series (qv), snow scenes have been noted on other blue-printed wares:

(i) An egg ring (a double-ended egg cup rather like a napkin ring) with a design showing an eskimo and sledge.

(ii) A saucer with a man in snow shoes.

Soap Dish

Part of a toilet set, usually in three parts — base, strainer and lid. Some examples are known in which the strainer section forms an integral part of the base. Soap dishes are normally part of a toilet set with matching ewer, bowl, chamber pot and toothbrush holder or toilet box.

"Society of Operative Potters"

An interesting plate with a moulded rim, printed with a design including a beehive, has as part of the decoration the inscription "Society of Operative Potters, High Street, Burslem" together with the motto "Perseverance and

Integrity'' (Ill: Little 44). This plate is impressed with the mark ''OPERATIVE UNION POTTERY'' and is believed to date from around 1830.

The first Potters' Union was organised in 1824. In the following year a strike of some branches took place but quickly collapsed, many workers returning to work on the old terms. Some strikers maintained the action and a manufactory controlled by the Union was established. The object was to give employment to the strikers, but as may be expected the business acumen was missing and the venture soon folded. The unrest continued and a National Union of Operative Potters was formed in August 1831. It consolidated its strength in the years up to 1833 and some members formed a Co-operative Pottery, apparently early in 1834. It is possible that the plate was produced by either of these two ventures, although the later date seems more likely. The subject of unionisation within the Potteries is covered in some detail by Thomas in *The Rise of the Staffordshire Potteries,* and also by Owen in *The Staffordshire Potter.*

''Somerset House, London''
Tams & Co. Tams' Foliage Border Series. Dish 11ins:28cm.

Somerset House in the Strand was built by the Surveyor General, Sir William Chambers, from 1776. It was originally intended to house the leading learned societies but it is probably better known in recent years as the home of the registers of births, marriages and deaths.

''Soracte''
Copeland & Garrett. Byron Views Series. Plate 9ins:23cm.

Soracte lies close to the River Tiber, about thirty miles north of Rome.

Source Prints
The majority of the landscape patterns on blue-printed wares were based on prints in late 18th century and early 19th century illustrated books. These are generally referred to as source prints. It is one of the main delights of the keen collector to match the ceramic pattern with the original print, although the complete books are seldom easily accessible. It is, however, well worth looking through the loose prints in print shops. When a source print is found, it is usually possible to identify the source book using the information printed below the inscription on the print.

Many of the most likely sources are listed in an appendix by Ronald Russell in *Guide to British Topographical Prints* (1979). Another extremely useful booklet by John Harris under the title *A Country House Index* (1971) lists the views of country houses in over fifty-five illustrated books published between 1715 and 1872.

Appendix II at the end of this dictionary lists source books used by makers of blue-printed ware.

South Wales Pottery fl.c.1839-1858
Llanelly, Wales. This factory was operated by Chambers & Co. up until 1854 and then by Coombs & Holland. It was continued beyond 1858 by other partnerships and survived until about 1927. That printed wares were produced is confirmed by the illustration of a pull in Godden I 528. The design is titled ''Damask Border'' and the printed mark includes the words ''South Wales Pottery''. Other marks are known with either the name of the pottery, the proprietors, or the initials S.W.P.

''Southampton, Hampshire''
Enoch Wood & Sons. Shell Border Series. Plate 7¾ins:20cm. Ill: Arman 140.

In 1810 Southampton employed about thirty ships in foreign commerce and upwards of one hundred in the coastal trade. It had a ''respectable trade in French and Port wines, and in the Newfoundland fishery''.

''**Soracte.**'' *Source print for the Byron Views Series taken from Finden's ''Landscape and Portrait Illustrations to the Life and Works of Lord Byron''.*

''**Soracte.**'' *Copeland & Garrett. Byron Views Series. Printed title and maker's mark and impressed maker's mark. Plate 9ins:23cm.*

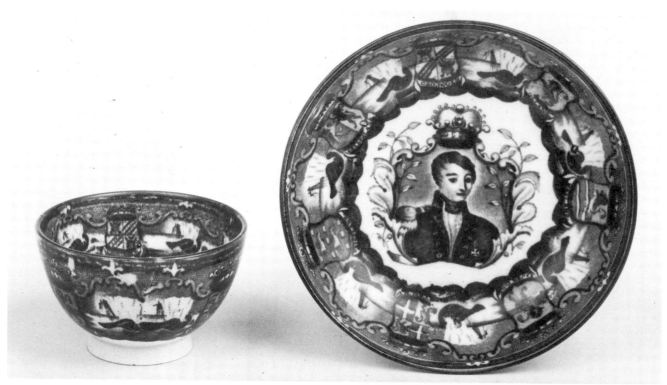

Southwick Pottery. *A pattern commemorating the Dutch United Provinces which are named below the shields: "OVERIJSSEL" "GRONINGEN" "UTRECHT" "HOLLAND" "FRIESLAND" "GELDERLAND" "ZEELAND". Printed retailer's mark "Gebr. Zwakenberg". Impressed "SCOTT". Teabowl and saucer. Saucer diam. 4½ins:11cm.*

"The Sow and the Wolf." *Spode. "Aesop's Fables" Series. Printed titles mark with maker's name. Impressed "SPODE". Dish 16½ ins:42cm.*

"Spaniard Inn." *Willow pattern. Davenport. Impressed maker's anchor mark for 1856. Plate 10¼ins:26cm.*

Southwick Pottery fl.1788-1896

Sunderland, Durham. The family of Anthony Scott (1764-1847) was involved in this pottery for over one hundred years, so much so that it came to be known as Scott's Pottery. The output consisted of lustre wares, black-printed mugs and jugs with mottoes, and some blue-printed wares. There was a considerable export to Holland, especially of tea wares. Examples have been noted with a printed mark of the Dutch retailers Gebr. Zwakenberg.

Marks nearly always included the surname Scott in various forms, although initial marks have been noted including S. & Sons (1829-38) and S.B. & Co. (1838-54). A useful account of the firm is given in Shaw's *Sunderland Ware: The Potteries of Wearside* (the 4th revised edition contains an appendix listing many printed designs used at this pottery).

"The Sow and the Wolf"

Spode/Copeland & Garrett. "Aesop's Fables" Series. Dish 16½ins:42cm. Ill: Whiter 89.

A sow lay with her litter of piglets. A wolf endeavoured to insinuate himself into her good opinion. "If you have a mind to go abroad," he said, "I will take as much care of your pigs as you could yourself." "Your humble servant," says the sow, "I had rather have your room than your company; I beg I may never see your face again."

When one who is a stranger to us makes offers of services, we have good reason to exert a shyness and coldness towards them.

Sower

A title used by Laidacker for a light blue pattern produced by William Adams on tea wares. It shows a sower casting seed with a two-horse harrow in the background, all within a border of flowers. The design was also printed in black, pink, purple and sepia. Ill: Laidacker p.16; P. Williams p.526.

"Spaniard Inn"

Davenport. The inscription "Spaniard Inn" printed in a frame within the upper border of a Willow pattern plate is illustrated. The plate is marked with the standard impressed Davenport anchor mark with date numbers for the year 1856.

Although it cannot be stated with certainty, this plate may have been made for the famous Spaniards Inn in Spaniards Road, Hampstead, London. The Inn was built in the 17th century on the sandy soil of Hampstead Heath where the old lodge entrance to the Bishop of London's rural park once stood. Some say that the first landlord was a Spaniard; others that the Spanish Ambassador to the court of James I lived in a house on the site.

In 1780 the landlord, Giles Thomas, discovered that Kenwood House in the nearby parkland was in danger from the Gordon rioters who, in an anti-popery demonstration, had just burned down Lord Mansfield's house. Thomas managed to keep the rioters occupied at the Spaniards Inn while the ostler alerted a contingent of the Horse Guards.

The Inn was used by Keats and Coleridge who lived nearby, and also by Byron, Shelley and Joshua Reynolds. Dickens knew the Spaniards well and used it in the *Pickwick Papers.*

"Spanish Beauties"

Maker unknown.

"Spanish Bull Fight"

Thomas Mayer. "Olympic Games" Series. Plate 9ins:23cm. Ill: P. Williams p.511.

"Spanish Marriages, Madrid"

William Adams & Sons. A pattern with this title is illustrated on a dish in Little 11. He suggests that it is part of a series made for the countries of Brazil, Cuba and Mexico. The design shows the ceremony taking place in a stately room attended by finely-dressed guests. The border is a simple design of leafy scrolls.

Sparks, Thomas

An engraver from Hanley who supplied copper plates to several of the major factories including Ridgway, Spode, Stevenson and Wedgwood. He is known to have engraved the Bamboo, Hibiscus and Peony patterns for Wedgwood and is believed to have been responsible for at least some of Spode's Tiber pattern by virtue of a small capital letter S to be found amongst the rocks on some examples. He was still working in Hanley in 1815 but by 1818 he was based in London. An interesting paper entitled *Letters from Thomas Sparks, Engraver, to Josiah Wedgwood, 1815-1819* by J.K. des Fontaines was published in the Proceedings of the Wedgwood Society, 1966, No. 6.

Sparrow, I.

This name has been reported printed in large underglaze blue letters on the reverse of a plate decorated with the early Buffalo pattern. It has been suggested that it relates to a John Sparrow of Staffordshire but it has not proved possible to trace any potter with the name. It may be a retailer's mark although there is no such name in the London directories after 1800.

"Spetchley, Worcestershire"

Maker unknown. Crown Acorn and Oak Leaf Border Series. Oval soup tureen stand.

The house in Spetchley Park was built by John Tasker between 1811 and 1818. It is of Bath stone and has a large portico with four Ionic columns. There are over thirty acres of gardens and the ornamental park supports a herd of deer and includes a lake. Spetchley lies some three miles east of Worcester and the gardens are open to the public during the summer months.

Spice Box
A low, circular box, fitted with a lid and divided internally into several compartments. The central compartment is round and was used to house a nutmeg grater, whereas the outer spaces would be for different spices. An example in the Net pattern is illustrated in FOB 23.

Spirit Barrel
A small barrel similar in size and shape to those said to have been carried by St. Bernard dogs with brandy for the traveller who had lost his way in the Alps. However, the attachment holes in ceramic versions are too small to take the necessary strap or small cord. It must be concluded that they were made for decorative purposes and that they were suspended by thin string or wire.

Spode, Josiah fl.c.1784-1833
Stoke-on-Trent, Staffordshire. Josiah Spode I (1733-97) was one of the pioneers of blue-printing on earthenwares and had perfected the process by about 1790. Following his sudden death in 1797, his son, Josiah Spode II (1755-1827), realised that there was a large potential market for blue-printed wares and he developed this side of the Spode output. He replaced services of single Oriental patterns by multi-pattern services with views taken from illustrated books of the period; the two classic examples are the Caramanian and Indian Sporting Series. In addition there were many floral patterns together with some country scenes.

The wares of the Spode works have been described in considerable detail by Copeland; Whiter; S.B. Williams.

"Spoleto"
Copeland & Garrett. Byron Views Series.

Spoleto stands on a hill some sixty miles to the north of Rome in Italy. It is dominated by a citadel in which Lucrezia Borgia was imprisoned in 1499.

Sporting Mug
A mug by an unknown maker, which appears to date from the 1820s, is decorated with a most interesting series of sporting scenes. A floral border contains two small scroll vignettes at the top, one showing bull baiting and the other showing cock fighting, two sports which were outlawed in 1835 and 1849 respectively. Three larger titled vignettes, also in scroll frames, are printed around the lower section. On one side is a hunting scene titled "Hunt nr. Windsor", in the centre is a boxing match titled "Fives Court", and on the other side is a racing scene titled "Cup at Doncaster".

The Fives Court was a boxing ring in Panton Street, Haymarket, London. Tom Cribb, 'Champion Boxer of all England' who had often fought there, retired in 1811 and became landlord of the Union Arms (now The Tom Cribb) in the same street. This became a rendezvous not only for those who attended fights in the Fives Court but also for actors and men of letters, among them Lord Byron who was a great friend of Tom Cribb. He wrote in his diary in 1812: "I have seen some of his best battles in my nonage. He is now a publican and, I fear, a sinner".

Spirit Barrel. *All-over printed pattern including a view of Osterley Park as used by John & William Ridgway. Unmarked. There are holes so that the barrel may be fitted with a string or wire for suspension. Length 4¼ins:11cm.*

Sporting Series
A series of hunting scenes printed in dark blue by Enoch Wood & Sons. It has been called the Zoological Series but the above title seems more appropriate and avoids confusion with Clews' "Zoological Gardens" Series. All the designs depict hunting scenes or hunted animals but the wares are not titled. Laidacker gives a list of suggested pattern titles as follows:

Antelope
Deer Hunting
Elephant*
Hunter Shooting Ducks
Hunter Shooting Fox*
Hyena
Leopard
Moose
Pointer and Quail
Polar Bear Hunting*
Tiger Hunt
Two Whippets
Wolf and Other Animals
Zebra

As with many other dark blue designs from this factory, examples are scarce in Britain and the series was probably made primarily for export.

"Sporting Subjects"
(i) J. & M.P. Bell & Co. An open pattern with horsemen and hounds within a floral border.

(ii) Plates with a printed mark including this title together with the name "T. HEATH" have been noted with the impressed mark of Davenport. This may possibly be explained by the purchase of Davenport biscuit wares by Thomas Heath of Burslem.

Sporting Mug. *Maker unknown. Three main reserves are titled "HUNT NR. WINDSOR", "FIVES COURT", and "CUP AT DONCASTER". Smaller reserves show bull baiting and cock fighting. Unmarked. Height 4¾ ins:12cm.*

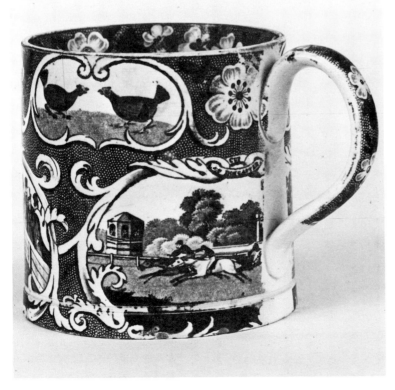

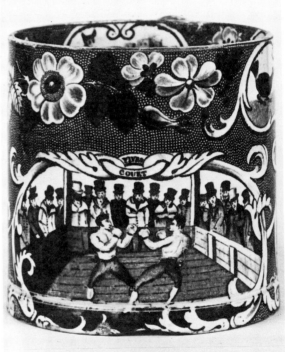

Sportsman's Inn

Maker unknown. An untitled scene which shows two hunting gentlemen seated at a tripod table beneath the bow window of an inn. A doorway bears a sign "WINES". Hunting dogs are at the men's feet and there are several dead birds on the ground and some guns leant against a wall. A large country house is in the left background. This scene is so far known only on a mug.

"Spring Hall"

Henshall & Co. Fruit and Flower Border Series. Soup plate 10ins:25cm.

It has not proved possible to pinpoint this house. It is possible that it should read Spring Hill, the name of several country seats in England, Scotland and Ireland.

"Spring Vale, Staffordshire"

Enoch Wood & Sons. Grapevine Border Series. Small plates less than 5¾ins:15cm.

It is known that Spring Vale existed since this view was copied from a John Preston Neale print. It has not, however, been possible to trace any detailed information.

Springer Spaniel

Ralph Stevenson. This attribution is based on a label by W.L. Little on the plate illustrated. It reads: This pattern is recorded with impressed mark — "STEVENSON".

The print on which this pattern is based appeared in *The Sportsman's Cabinet* of 1803.

"Sproughton Chantry, Suffolk"

Enoch Wood & Sons. Grapevine Border Series. Sauceboat.

The Chantry is on a hill just to the east of Ipswich. The house is late 18th century but was extended in 1853 and 1854.

Spur Marks

See: Stilt Marks.

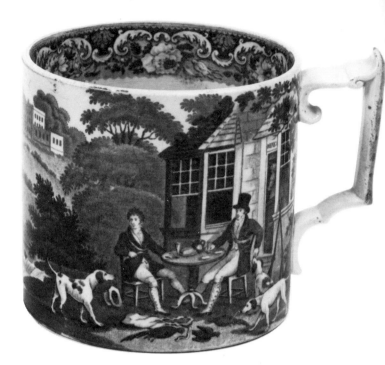

Sportsman's Inn. *Maker unknown. Unmarked. Mug 4¼ ins:11cm.*

Squire and Lackey

Dawson. An adopted title for a design which shows an unidentified building. The pattern has been noted on a teabowl and on a dessert plate, both unmarked, and also on a miniature plate with a prominent impressed mark "DAWSON". The title derives from two figures in the foreground, apparently a squire out shooting followed by his servant. Ill: FOB 30.

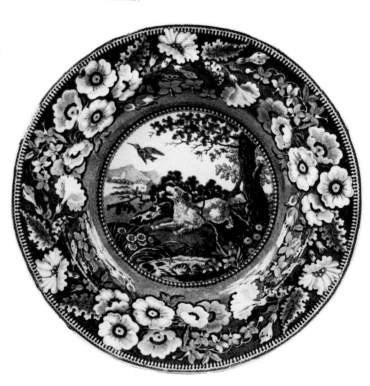

Springer Spaniel. *Attributed to Ralph Stevenson. Unmarked. Soup plate 10ins:25cm.*

Squire and Lackey. *Attributed to Dawson. Unmarked. Plate 8ins:20cm.*

"Squirrel"
David Methven & Sons.

Stackpole Court, Pembrokeshire
This house has been identified on one of the untitled views in the so-called "Irish Scenery" Series by Elkins & Co. Ill: Coysh 1 38.

Stackpole Court was an early 18th century mansion in the parish of St. Petrox, about three miles due south of Pembroke. It was the seat of the Earl of Cawdor but was demolished in about 1955.

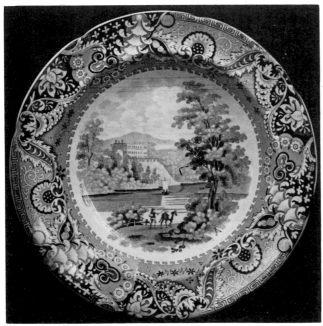

Stackpole Court, Pembrokeshire. *Elkins & Co. "Irish Scenery" Series. Printed royal arms mark with series title and maker's name. Soup plate 10ins:25cm.*

"Stafford Gallery." *Maker unknown. Printed series mark.*

"Stafford Gallery"
Maker unknown. This title appears on a series of rural scenes printed within a distinctive floral border of flowers and leafy scrolls. The printed cartouche contains only the series title and the individual scenes are not named. Only a few of the patterns have so far been allocated titles:

(i) The Signpost. A man is leading a woman mounted on a horse. They have just passed a signpost, and there are buildings in the background. Ill: FOB 9.

(ii) White Horse. A group of figures in the foreground with a

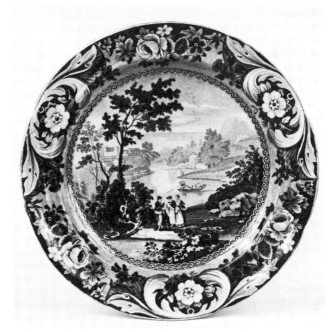

"Stafford Gallery." *The Trio. Maker unknown. Printed series title mark. Plate 9½ins:24cm.*

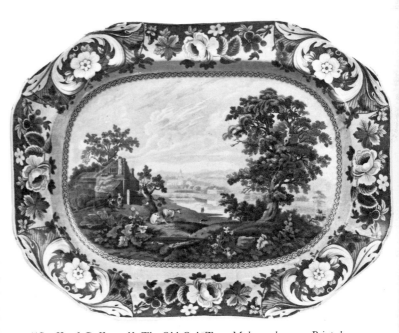

"Stafford Gallery." *The Old Oak Tree. Maker unknown. Printed series title mark. Dish 21ins:53cm.*

saddled but riderless horse. Once again there are buildings in the background. Ill: FOB 9.

(iii) The Trio. A scene with a lake and, in the foreground, a fisherman with rod talking to two women.

(iv) The Rough Sea. A scene in which a rough sea dashes onto some rocks. There are high cliffs surmounted by classical buildings. Figures in the foreground have their clothing blown by the strong wind.

(v) The Old Oak Tree. A scene with a cottage on the left and a prominent tree on the right.

Staffordshire Knot. *A typical Staffordshire knot printed mark. In this case from the Parkland Scenery pattern by Chetham & Robinson.*

Staffordshire Knot

A distinctive knot with three loops which was widely used by the Staffordshire potters as part of their marks on ceramics. It can be found both impressed and printed, the latter form often including the potter's initials within the three loops.

Originally the knot was a badge of the Earls of Stafford, but it has become closely associated with both the town of Stafford and the county of Staffordshire. A tradition has become established that it was invented to solve a penal problem, the area supposedly being so infested with criminals that it was necessary to devise a noose so that three could be hanged at the same time.

Stag

The stag appears on several blue-printed patterns. It is common in the foreground of views showing country houses but it features more prominently in three designs. An early chinoiserie pattern by John Turner (Ill: Coysh 1 6-7) is a typical line engraved Chinese scene in which a man and his dog are chasing a stag. Another pattern was included by Enoch Wood & Sons in the Sporting Series on a stand and a dinner plate. A third design, by an unknown maker is called The Bewick Stag (qv).

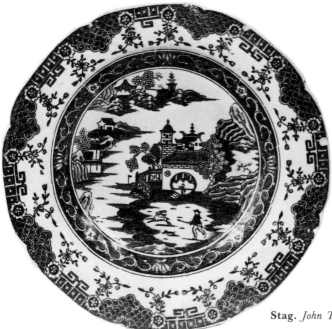

Stag. *John Turner. Impressed "TURNER". Soup plate 6¼ ins: 16cm.*

"Stag"

Thomas Shirley & Co.

"The Stag Looking into the Water"

Spode/Copeland & Garrett. "Aesop's Fables" Series.

This scene has not yet been confirmed in blue although it is known in green.

A stag saw his reflection in some water and was full of admiration. "Ah," says he, "what a gorgeous pair of branching horns are there". He then hears the noise of huntsmen and hounds and bounds away until they are a vast distance behind him. But entering a copse his horns became entangled in a thicket where he was held fast till the hounds came in and tore him down. "Unhappy creature that I am," cried the stag, "What I prided myself in has been the cause of my undoing".

Pride comes before a fall.

"Stagg" (sic)

Read, Clementson & Anderson. A pattern by a short-lived partnership which is illustrated on an ornate oval teapot. The design is titled in a printed leafy scroll cartouche with the initials R.C. & A.

Stands

Each tureen within a dinner service would be supplied with a matching stand. As a general rule such stands were made with handles, although designs vary considerably, some being rather crudely moulded whereas others are very carefully applied and ornate in form. The basic shape of the stand would follow that of the tureen; rectangular, oval, or (usually later) round.

The practice of supplying a matching stand also applied to baskets in dessert services. Once again, the style followed the basket closely, particularly for the pierced fruit or chestnut baskets.

"Stanley"

Ralph Hammersley. A pattern in the Japanese style marked with a circular garter surmounted by a crown. See: Godden M 1913.

"Statuary"

Henry & William Davenport. A garden scene showing a woman pouring water from a pitcher into a large urn. The border consists of flowers and scrolls on a geometric ground. Ill: Lockett 31.

This pattern is a rare example from the Davenport factory of a mark which includes the name of the current partnership, in this case H. & W. Davenport. By far the majority of Davenport marks, both printed and impressed, have only the surname, usually in capital letters.

Steamboat

The emergence of the steamboat and its immediate popular interest is reflected by its appearance on several blue-printed patterns. Two designs in the "Diorama" Series feature such a vessel (See: Laidacker p.110), and another appears in the view titled "York Minster" in the Fruit and Flower Border Series by Henshall & Co. Two American views with the same border are usually titled "The Dam and Water Works, Philadelphia" although they may be found unmarked. Another steamboat appears in a view titled "Montreal", made by Davenport for the Canadian market.

See: "London and Edinburgh Steam Packet Company".

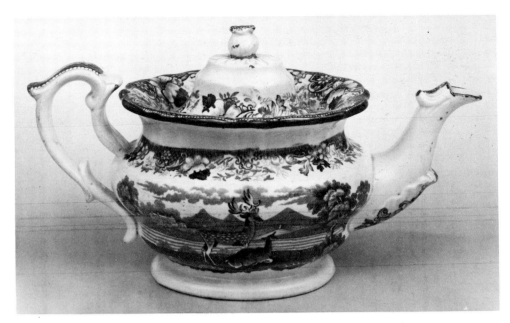

"**Stagg.**" *Read, Clementson &*
Anderson. Printed leafy scroll
cartouche with title and maker's
initials. Teapot length
11 ½ ins:29cm.

Stevenson, Andrew fl.c.1816-1830

Cobridge, Staffordshire. Before 1816 Andrew Stevenson was
in the partnership Bucknall & Stevenson. During his years on
his own he produced large quantities of blue-printed ware,
much of which was made for export to America. The only
designs which have previously been attributed to
this potter are those which are marked with an impressed
circular stamp of a crown surrounded by the legend "A.
STEVENSON, STAFFORDSHIRE WARRANTED".
Such wares include a series of English views listed herein as the
Rose Border Series.

Wares which are marked with the surname Stevenson but no
initial are less easy to attribute. It is known that the mark
"STEVENSON" in a straight line was used by Ralph
Stevenson (qv), whereas the name impressed in a curve over a
three-masted ship is now known to belong to Andrew. Two
examples of a view identified as Netley Abbey are illustrated in
this dictionary, one with the ship mark (Colour Plate XX) and
the other with the circular crown mark described above (page
260). The ship mark can also be found on examples of the
Chinese Traders pattern (Ill: Coysh 2 104), a pastoral scene
(Ill: Little 64), and the Ornithological Series (qv).

Stevenson, James, & Co. fl.c.1820-c.1835

Greenock Pottery, Scotland. This pottery was established by
Stevenson who had previously helped to manage the nearby
Clyde Pottery. After a few years he set up as a retailer, selling
Staffordshire as well as Scottish wares, and the Greenock
Pottery was sold to the Clyde Pottery.

Stevenson, Ralph fl.c.1810-1835
(& Williams or & Son)

Lower Manufactory, Cobridge, Staffordshire. Ralph
Stevenson potted alone between c.1810 and 1832 except for a
short period around 1825 when he was in partnership as Ralph
Stevenson & Williams. In 1832 he was joined by his son and
continued as Ralph Stevenson & Son until the firm closed in
1835.

Blue-printed ware was a major production and several
different patterns were used including a selection produced
especially for export to America. A series of British views was
made within a border of acorns and oak leaves, and another
series of British and Foreign views was titled "Lace Border".

There were also several single patterns including "Ancient
Greece", "Cologne", "Harp", "Millennium", and
"Palestine". Another series of rural scenes was issued with a
ribbon cartouche titled simply "Semi-China Warranted".

A variety of printed marks were used with appropriate
initials, such as R.S., R.S.W., R.S. & W., and R.S. & S. The
name sometimes appears in full. Printed marks which are
known with initials are frequently encountered without them
and it is possible that they were added as an afterthought when
their use became fashionable. The impressed mark
"STEVENSON" in a straight line has been found on several
examples also bearing printed marks with Ralph Stevenson
initials and is now normally assigned to Ralph rather than
Andrew.

Stevenson's Acorn and Oak Leaf Border Series. *Ralph*
Stevenson. Typical printed mark.

Stevenson's Acorn and Oak Leaf Border Series

Ralph Stevenson produced two series of views with a border of
acorns and oak leaves. The inner stringing used to frame the
border on the American views usually differs from that used on
the British views although the same style of printed mark was
used. The mark sometimes has added initials: R.S. for Ralph
Stevenson, or R.S.W. for Ralph Stevenson and Williams, and
it is very similar to the mark used by Enoch Wood and Sons for

their Grapevine Border Series (qv). The British views recorded include:

"Belvoir Castle"
"Cave Castle, Yorkshire"*
"Compton Verney"
"Dorney Court"
"Endsleigh Cottage"*
"Harewood House"
"Holliwell Cottage"
"Kenmount House"
"Oxburgh Hall"
"Sufton Court"
"Windsor Castle"

Two more views of "Gorhambury, Hertfordshire" and "Lowther Castle, Westmorland" are listed by Laidacker although, since their existence has been confirmed in the very similar Crown Acorn and Oak Leaf Border Series, there remains some doubt as to their attribution. Two of these English views, those of Dorney Court and Windsor Castle, were sold in America with vignettes of the Erie Canal and medallions of Clinton, Jefferson, Lafayette and Washington in the border.

Stevenson's Willow

A very early Willow pattern plate impressed "STEVENSON" in very small letters has all the characteristics of 18th century wares — very rippled glaze, no footrim, and line engraving. It would appear to have been made before either Ralph or Andrew Stevenson started potting.

Stevenson's Willow. *Early chinoiserie pattern. Impressed "STEVENSON" in small capital letters. Dished plate 6½ins:16cm.*

Stilt Marks

Stilts are pieces of refractory material used to support wares in the kiln. Several different designs exist in a variety of sizes but they are usually triangular in form with sets of three tiny conical points. When the wares were removed from the kiln after firing the stilts were broken away, leaving small marks in the glaze. These marks are called stilt marks and can usually be very easily found on flatware such as plates and dishes.

The smaller stilts have three points downwards and one upwards. They were distributed in threes around the rims of plates and careful examination can reveal which way the plates were stacked in the kiln. Smaller plates conversely used larger stilts with three points in each direction, only one stilt being used between the plates. A few very early chinoiserie patterns have been noted in which the stilt marks are in groups of four rather than three but it is not known whether these were used by one particular potter, or even in only one pottery district.

Stilt marks are also known as Spur Marks.

Stipple Engraving

A technique by which a picture is built up by the engraver with a tonal effect produced by tiny dots of graded sizes and proximity. This is done with an etching needle, several needles tied together, or a roulette, an engraving tool in the form of a toothed wheel mounted on a handle. The earliest blue-printed patterns were built up by line engraving (qv) and stipple did not appear before 1800. The new technique which increased control over depth and contrast was rapidly mastered by the best engravers and some of their work can only be described as art.

"Stirling Castle"

Maker unknown. "Antique Scenery" Series. Dish 13¼ins:34cm, and deep dish 12ins:30cm.

Stirling is the key to the Highlands and the castle was for many years an important Royal residence for the Scottish kings. It was the birthplace of both James II in 1430 and James V in 1512. Mary Queen of Scots and James VI spent some years there. It is now public property.

"Stirling Castle." *Maker unknown. "Antique Scenery" Series. Printed titles mark. Dish 13¼ins:34cm.*

Strainer. *Maker unknown. Net pattern. Unmarked. Diam. 3¼ ins:8cm.*

Stoke-on-Trent

Stoke-on-Trent has always been considered as the centre of the English pottery industry. It was originally a borough on its own, but has always been the major town of the area known as the Potteries. In 1910 the nearby boroughs of Burslem, Hanley and Longton, together with the urban districts of Easton and Tunstall, were amalgamated with Stoke, which in 1925 became a city.

Stoke was the home of three factories noted for blue-printed wares — those of William Adams, Thomas Minton and Josiah Spode. There were, of course, many other less prestigious works, amongst which were those of Zachariah Boyle, Stephen Folch, Thomas Lakin, Thomas Mayer and Thomas Wolfe, all producing blue-printed wares.

The city has some notable features. In 1856 a School of Science and Art was built as a memorial to Herbert Minton and in 1863 a bronze statue of Josiah Wedgwood was erected by public subscription. The church of St. Peter ad Vincula, rebuilt in 1839, contains memorials to many great potters. They include a medallion by Flaxman to the memory of Josiah Wedgwood, who was buried at the church in 1795, a medallion to William Adams, and a memorial to William Taylor Copeland.

The collector of ceramics is served by several museums in Stoke, including the City Museum in Broad Street, Hanley, the Spode-Copeland Museum in Church Street, and the new living and working museum of British pottery in Uttoxeter Road, Longton — the Gladstone Pottery Museum.

Stone China

The name given to a hard, dense ceramic body said to have been introduced in about 1805 by Josiah Spode II. The name is widely used for strong ironstone-type bodies today, but in the 19th century it was often printed as part of ceramic marks. It can be found on the wares of many potters including James & Ralph Clews, Davenport, Thomas Godwin, Ralph Hall, Hicks & Meigh, Francis Morley, John & William Ridgway, and Wedgwood.

The same, or similar bodies were given a variety of names by the different potters. A useful list can be found in G.A. Godden, *Mason's Patent Ironstone China* (1971), pp.108-112.

Strainer. *Maker unknown. Chinoiserie-style border. Unmarked. Diam. 3¾ ins:9cm.*

"Stone Ware" or "Stoneware"

Another trade name for a body similar to stone china. It was used by Dillwyn of Swansea and can also be found on wares by Barker & Till, Thomas Dimmock & Co., and J. Maudesley & Co.

Strainer

A small circular shallow saucer pierced with holes and fitted with a small handle. The use to which these strainers were put has been the subject of considerable debate, suggestions ranging from straining fruit to separating egg yolks. The most likely purpose seems to be the straining of tea in the days when tea leaves were large and coarse.

The name strainer is also sometimes used for the flat draining slabs made to fit in meat dishes, although these are more properly called drainers (qv).

"Stratford-on-Avon, Warwickshire"

James & Ralph Clews. Bluebell Border Series. Plate 8¾ ins:22cm.

"Stratford upon Avon, Warwickshire"

Maker unknown. "Antique Scenery" Series. Plate approximately 8½ ins:22cm.

This town was no doubt chosen for use on blue-printed wares due to its association with William Shakespeare. His reputed birthplace in Henley Street was purchased for the nation in 1847 and a memorial fountain and a statue were erected in 1887 and 1888. The first Shakespeare Memorial theatre was burned down in 1926 but it was rebuilt and reopened in 1932.

Stubbs, Joseph fl.c.1822-1836

Dale Hall, Longport, Burslem, Staffordshire. Although Joseph Stubbs produced blue-printed wares, relatively few marked patterns have been recorded. Apart from a series of American views made for export, there appear to be only four known designs:

(i) A version of the Spode Italian* pattern with a floral border.

(ii) A design of sea shells on a dark blue ground. Ill: Laidacker p.82.

(iii) Peach and Cherry pattern, a design of fruit on a dark blue ground. Ill: Coysh 1 126; and Laidacker p.81.

(iv) A view on tea wares titled "Jedburgh Abbey".

The firm traded for a short period between 1828 and 1830 as Stubbs & Kent. Marks on the above designs appear to be of two forms, either "STUBBS" impressed or a circular impressed mark which includes the address "LONGPORT" together with either "JOSEPH STUBBS" or "STUBBS & KENT".

"Suez"

Maker unknown. A flow-blue pattern featuring a long-billed bird and a butterfly.

The name may have been given to this pattern when the Suez Canal was opened in 1869.

"Sufton Court"

Ralph Stevenson. Stevenson's Acorn and Oak Leaf Border Series. Pierced comport.

"Sufton Court, Herefordshire"

Enoch Wood & Sons. Grapevine Border Series. Dish 12¼ ins:31cm.

Sufton Court, at Mordiford, was built in the second half of the 18th century in Bath stone. It has a pedimented porch with four Ionic columns.

"Sultan"

David Methven & Sons.

"Summer Hall, Kent"

Andrew Stevenson. Rose Border Series. Dish 9¾ ins:25cm, and vegetable dish.

It has not yet proved possible to trace this view.

"Summer Rose"

James & Ralph Clews. A pattern title recorded on a teapot decorated with a reserve containing two wild roses in a vase. Ill: Atterbury p.205.

Sun and Fountain

A pattern name used for a design by the Don Pottery. It shows a large fountain gushing water amongst parkland, the scene lit by a prominently shining sun. There is a simple floral border. Items are known with the Don Pottery demi-lion mark but some are recorded with the impressed retailers' mark "J. Green & Sons". Ill: Coysh 2 131; Lawrence p.88.

Sunderland

The area around Sunderland on the River Wear and a few miles to the south in Durham was already important in the manufacture of earthenware in the 18th century. It became a major pottery district in the 19th century with at least sixteen manufactories in operation. It was particularly noted for pink lustre wares but blue-printed decoration was also extensively used. The firms had a considerable export trade with north-western Europe. See: J.T. Shaw, *Sunderland Ware: The Potteries of Wearside.*

"Sunning Hill Park, Berkshire"

William Adams. Flowers and Leaves Border Series.

Sunninghill Park was a country house about five miles south west of Windsor. It was destroyed in 1947.

Supper Set

A supper set consists of a circular or elliptical tray fitted with a set of curved dishes, each with a lid, and a central dish, sometimes fitted out to hold four or six eggcups and a salt cellar. Most of these sets have long since been split up into individual segments but a few complete examples are known. They were made by several potters including William Adams, Spode, Andrew Stevenson and Wedgwood. The basic arrangement was copied from earlier Chinese porcelain.

A complete but unmarked supper set on its original wooden tray is illustrated in Colour Plate XIV. This example consists of a total of seventeen pieces. The nine constituent parts of a similar marked Spode supper set centre piece in the Castle pattern are illustrated opposite. The very close similarity between the two centre dishes and their contents suggests that the complete set may also have been made by Spode.

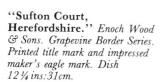

"Sufton Court, Herefordshire." *Enoch Wood & Sons. Grapevine Border Series. Printed title mark and impressed maker's eagle mark. Dish 12¼ ins:31cm.*

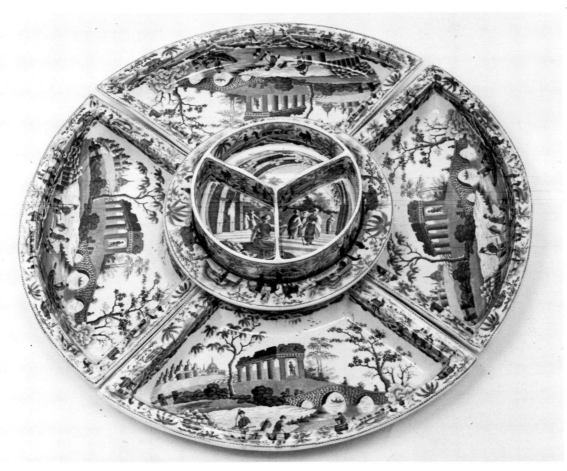

Supper Set. *Spode. Caramanian Series. The four segments are printed with the Citadel near Corinth, and the centre with An Ancient Bath at Cacamo. Impressed and printed maker's marks on various pieces. Overall diam. 18½ ins:47cm.*

Supper Set. *The central portion only of a Spode Castle pattern supper set showing the nine pieces of which it is composed. Printed and impressed maker's marks. Overall length of central piece 9½ ins:24cm.*

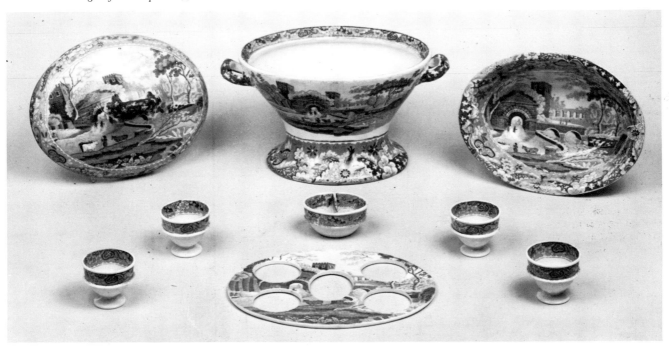

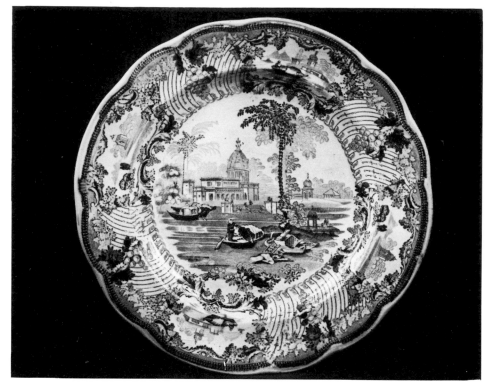

"Surseya Ghaut, Khanpore"

(i) Edge, Malkin & Co. Indian Scenery Series. Plate 10ins:25cm.

(ii) Thomas & Benjamin Godwin. Indian Scenery Series. Plate 10½ins:27cm. Ill: Coysh 1 43; Little 26.

(iii) John Hall & Sons. "Oriental Scenery" Series. Dish.

(iv) Maker unknown. "Oriental Scenery" Series. Dinner plate and hot-water plate.

(v) Maker unknown. Parrot Border Series. Soup plate.

It has not yet proved possible to locate this scene. It may, however, be on a tributary of the Indus near Khanpur in West Pakistan.

"Sussex Place, Regent's Park"

(i) William Adams. Regent's Park Series. Sauce tureen.

(ii) Enoch Wood & Sons. "London Views" Series. Sauceboat.

"Sussex Place, Regent's Park, London"

Maker unknown. Flower Medallion Border Series. Dish 18ins:46cm.

James Elmes described Sussex Place as a "whimsical row of houses... designed, I believe, by Mr. Nash". It was built between Clarence Terrace and Hanover Terrace, on the west side of the park.

Swans

Swans feature on a small plate in the "Zoological Gardens" Series by James & Ralph Clews. They are often found in the foreground of country views with rivers or lakes and have been noted as a feature on a saucer by an unknown maker.

See: Palladian Temple.

Swansea

The town of Swansea, in Wales, had two potteries. The Cambrian Pottery flourished for well over eighty years but the neighbouring Glamorgan Pottery had a shorter life of only twenty-five years. During this period of coexistence there appear to have been close links between the two concerns, possibly extending to the exchange of copper plates. Certainly they produced some identical patterns. Blue-printed wares were made at both establishments. They are discussed in detail by Nance.

See the following two entries.

Swansea's Cambrian Pottery fl.1783-1870

This pottery existed in Swansea as early as 1764 but early wares were seldom marked. It is not clear when the name Cambrian Pottery was adopted but probably before 1783 when some wares were impressed "SWANSEA". Transfer printing was introduced in the 1790s, not long after George Haynes joined the Coles brothers, sons of the founder. In 1802 a partnership was established between Haynes and Lewis Weston Dillwyn and this lasted until 1810, a period when the wares were marked "DILLWYN & CO".

For a very short time Dillwyn operated alone, but in 1811 he took Timothy Bevington and his son John into partnership. It was during this period that considerable quantities of blue-printed wares were produced, some of which were marked "DILLWYN & CO", with the occasional addition of the name "SWANSEA". In 1817 the Bevingtons took over and traded as T. & J. Bevington & Co. until 1821 when the "& Co." was dropped. Dillwyn returned in 1824 and the firm once again traded as Dillwyn & Co., a style which continued after transfer to the son, Lewis Llewelyn Dillwyn, in 1836.

The Dillwyn involvement terminated in 1850 when the works were taken over by the Evans & Glasson partnership. This name continued until 1862 when the firm was continued by Evans' son under the style D.J. Evans & Co. The pottery closed in 1870.

The patterns produced at these works were many and varied. In addition to early chinoiserie designs, later productions included some fine landscapes such as the Ladies of Llangollen pattern and copies of the Spode Castle, Lucano and Italian designs. After about 1835 the quality declined steadily.

An extensive description of the wares can be found in articles by Pryce and Williams entitled *Swansea Blue and White Pottery* (see: Bibliography).

Swansea's Glamorgan Pottery fl.1813-1838

This pottery was founded by William Baker who formed a partnership with William Bevan and Thomas Irwin under the style Baker, Bevans & Irwin. Baker died in 1819 and thereafter the name Glamorgan Pottery Co. was adopted. The works closed in 1838 and the stock and equipment were moved to Llanelly.

The marks used include the name Baker, Bevans & Irwin in full or the initials B.B. & I. or B.B. & Co. The initials G.P. Co. were adopted during the later period. An impressed Prince of Wales' Feathers mark can also be found.

Amongst the patterns used was the Ladies of Llangollen design, also produced at the Cambrian Pottery. Other patterns are known with printed titles, e.g. the "Archers" pattern.

Sweet Peas

Brameld. A widely accepted name for a pattern which shows sweet peas in white against a blue ground with a simple edge of stringing. The design is found on angular eight-sided dinner wares, a typical plate being illustrated in Coysh 2 11. That it was also used on dessert wares is confirmed by a pierced basket shown by Eaglestone and Lockett in *The Rockingham Pottery*, Plate XIb.

"Sweetheart Abbey"

Elkin, Knight & Co. Rock Cartouche Series. Dishes 16¾ins:43cm and 17¼ins:44cm. Ill: Coysh 2 138.

This view shows the ruined abbey, seven miles south of Dumfries in Kircudbrightshire, Scotland. It was founded in 1273 as a Cistercian priory by Devorgella, wife of John de Balliol who endowed Balliol College, Oxford. The name derives from the fact that when he died she had his heart embalmed and interred in her tomb.

Swinton

Swinton is about four miles north of Rotherham. The area is important in the study of blue-printed wares since it included the works of Brameld at the Swinton Pottery, the Don Pottery, and the Newhill and Kilnhurst Potteries, both operated by members of the Twigg family. The history of the area can be found in Lawrence.

"Swiss"

Ralph Stevenson. A scene with an Alpine cottage rather similar to the common "Genevese" design. It was printed in a variety of colours.

"Swiss Cottage"

Minton. An open romantic pattern, rather similar to the same factory's "Genevese" design. It features a Swiss chalet amongst trees within a border of flowers and scrolls which surround small landscape vignettes. The title is printed on a scroll mark which includes a cursive initial M and the name of the body "Opaque China". The design was possibly pirated by other makers. Ill: Coysh 2 62.

Swiss Fishing Scene

This title has been adopted by Lockett for a Davenport pattern of a romantic mountainous landscape within a textured border printed in a light blue. The design is almost certainly one of a series used for a complete dinner service. Ill: Lockett 29.

"Swiss Scenery"

James Jamieson & Co.

"Swiss Villa"

Dillwyn & Co., Swansea. A pattern with a lake, a mountain and a chalet, reminiscent of the Minton "Genevese" design. The floral border is common to the Cows Crossing Stream pattern (qv). The title is marked in a rococo scroll decorated with sprays of flowers and leaves.

"Swiss Water Mill"

J. & M.P. Bell & Co.

"S.W. View of La Grange, the Residence of the Marquis Lafayette"

Enoch Wood & Sons. French Series. Dishes 18½ins:47cm and 20ins:51cm. Ill: Arman 203; Laidacker p.91.

See: Lafayette; "La Grange".

Syces or Grooms Leading Out Horses

The title of the source print used by Spode for side plates in the Indian Sporting Series. The actual title marked on the wares is shortened to "Groom Leading Out" (qv).

Syllabub Cup

A small cup with no handle and an out-turned rim, rather like an inverted bell. These cups appear to be almost exclusive to the Spode pottery where they were made in the Caramanian Series, the Tower, the Union Wreath, and other patterns.

Syllabub, also spelt sillabub, was a dish made of cream or milk, whipped with brandy, sherry or wine, and flavoured with lemon and sugar. A typical 18th century recipe was as follows:

"Take the whites of two eggs, a pint of cream, six spoonfuls of sack, as much sugar as will sweeten it; then take a birchen rod and whip it; as it rises with froth, skim it, and put into the syllabub pot. So continue whipping and skimming till your syllabub pot be full."

From the syllabub pot it would be served into individual syllabub cups.

"Syria"

Robert Cochran & Co. A romantic design with a mansion, river and figures. The leaf border includes large medallions, also with figures. Ill: P. Williams p.429.

This is a common Cochran pattern which was continued at the Verreville Pottery by the later partnerships of Kidston & Price and R.A. Kidston & Co.

Syria is now a republic in south west Asia, bounded by Turkey, Iraq, Jordan, Israel, Lebanon and the Mediterranean. Its history includes periods as part of the Babylonian, Assyrian and Persian Empires, and of the Ottoman Empire from 1516.

Tall Door
A Spode Chinese landscape with a pagoda which has a distinctive tall door. Whiter states that it is very rare. There are variations and it is possible that some unmarked pieces may have been made by other potters. Ill: Copeland p.89; Whiter 19.

"The Taming of the Shrew, Act 4, Scene 1"
John Rogers & Son and Pountney & Goldney. "The Drama" Series.

"The Taming of the Shrew, Act 4, Scene 3"
John Rogers & Son and Pountney & Goldney. "The Drama" Series.

Shakespeare wrote this play in about 1595 and it was printed in 1623. There is little doubt that it was based directly on *The Taming of a Shrew* by Samuel Rowley, who died c.1624.

Tams
The name Tams appears as part of marks on early wares which were made for both the home market and for export to America. It has been recorded in the styles of three partnerships called S. Tams & Co.; Tams & Anderson; and Tams, Anderson & Tams. There are unfortunately no records of these firms which must date from the period around 1820 to 1830. The only known clue is the place name Staffordshire as part of some marks. The name Tams does not appear in official records until after 1860. See: Tams, John.

The wares recorded are restricted to only two series of British views, a few American subjects, and a close copy of Robert Hamilton's Ruined Castle pattern (qv). One series consists of untitled views and is referred to by Laidacker as the Floral City Series. He identifies one of the subjects as Ludlow Castle, and another untitled view on a saucer as Worcester Cathedral. Ill: Laidacker p.118. The second series, which has a foliage border, consists mainly of views of London but with some from Dublin and elsewhere. See: Tams' Foliage Border Series.

Marks include an impressed circular mark with the name "TAMS, ANDERSON & TAMS", a printed mark with "S. TAMS & CO." in very large letters, and another impressed mark with "S. TAMS & CO." together with the wording "WARRANTED STAFFORDSHIRE".

Tams' Foliage Border Series. *Tams, Anderson & Tams. Typical printed mark.*

Tams' Foliage Border Series
A series produced in very dark blue with a foliage border including two prominent trees, one growing up each side. Items are known with marks of different Tams partnerships including Tams, Anderson & Tams; and S. Tams & Co. A typical printed mark is illustrated but many views are untitled and marks are often missing even from the known views:
"Broke Hall, Suffolk"
"Covent Garden Theatre, London"
"Customs House, London"
"Drury Lane Theatre, London"
"Four Courts, Dublin"
"Haymarket Theatre, London"
"New Post Office, London"
"Opera House, London"
"Post Office, Dublin"*
"Royal Exchange, London"
"Somerset House, London"
An unidentified view is shown in Laidacker p.84.

Tams, John fl.1875-c.1903
Crown Pottery, Longton, Staffordshire. This firm is known to have made blue-printed wares. A hunting scene has been noted on an "Imperial Quart" mug.

The usual mark consists of the initials J.T. in the form of a monogram within a belt which carries the words "CROWN POTTERY", all surmounted by a crown and flanked by two sprays of leaves (Godden M 3793). Other marks were used with the initials J.T. but earlier pieces may have been made by John Thomson of Glasgow (qv).

Taormina
The small medieval town of Taormina on the east coast of Sicily is now the island's most famous holiday resort. Two scenes in the Named Italian Views Series by the Don Pottery refer to this town — "Terrace of the Naval Amphitheatre at Taorminum" and "View near Taormina".

Tams. *Printed mark of S. Tams & Co.*

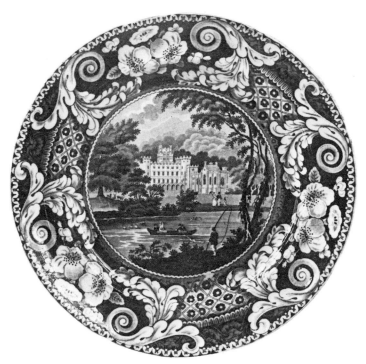

"**Taymouth Castle, Perthshire.**" *John & Richard Riley. Large Scroll Border Series. Printed title mark with maker's name. Plate 10ins:25cm.*

"Taymouth Castle, Perthshire"

(i) John & Richard Riley. Large Scroll Border Series. Plate 10ins:25cm.

(ii) Enoch Wood & Sons. Grapevine Border Series. Plate 10ins:25cm.

Two other untitled views have been noted, one illustrated below on a jug by John Geddes, and the other by Robert Heron & Son.

Taymouth Castle is a fine country house in castellated Gothic style by Archibald and James Elliot. It was built for the fourth Earl of Breadalbane between 1806 and 1810. This earlier part has four storeys and round corner towers. Wings were added by William Atkinson in 1818 and 1828.

"Tchiurluk"

Maker unknown. Ottoman Empire Series. Plate. Ill: P. Williams p.430.

The scene shows a domed building with a minaret and in the foreground is a man holding a spear and leading a heavily laden camel. Tchiurluk, or Chiourlic, was described in 1810 as "a town and river in Romania, fifty miles north west of Constantinople".

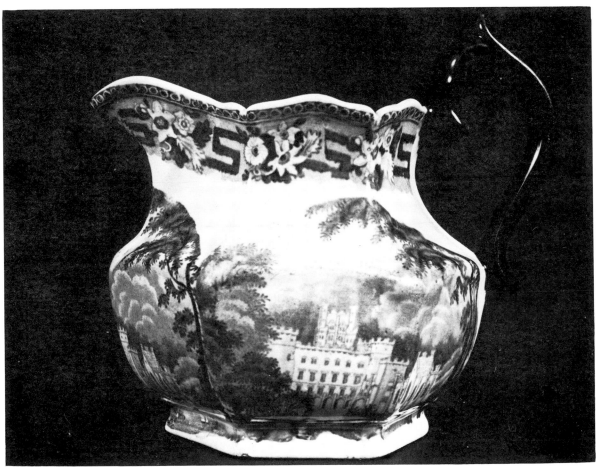

Taymouth Castle, Perthshire. *John Geddes. Impressed mark: "JOHN GEDDES, VERREVILLE, GLASGOW" in a circle round a view of the potworks. Six-sided jug 6¾ins:17cm to top of handle.*

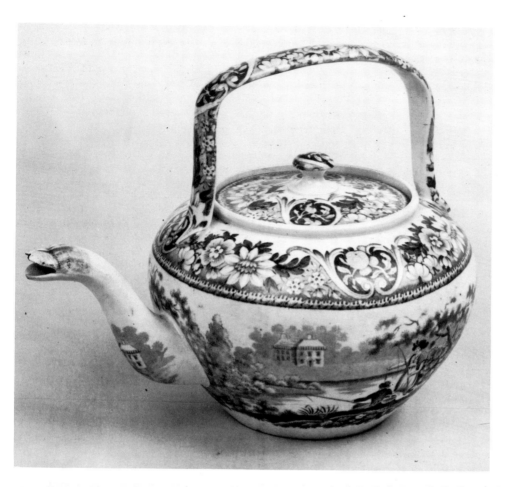

Tea Kettle. *Maker unknown. Unmarked. View with a man and woman fishing. Height 8½ins:22cm to top of handle.*

Tea Party. *Southwick Pottery. Impressed "SCOTT". Teabowl and saucer. Saucer diam. 4¾ins:12cm.*

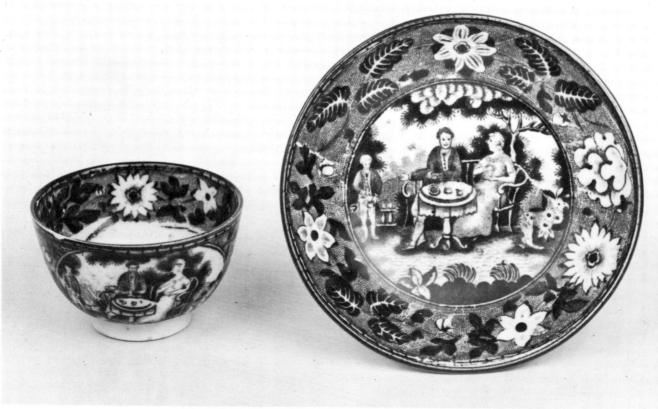

Tea Drinking

In the 18th century tea was very expensive and most tea services were made of porcelain. Earthenware services started to appear soon after 1800, closely following the style of the early porcelain wares. Tea was taken from a teabowl imitating the Chinese custom. However, cups with handles were made by the 1820s, for they are seen in Spode's Marble pattern which was introduced in about 1821. The first saucers were of the deep dish type, a style which existed for many years, even after handled cups were available. The deep saucer was used in China where tea was often taken from the saucer. It was some years before saucers developed the flatter shape with a recess to locate the cup.

Tea Kettle

Tea kettles are rare in blue-printed wares. An example by an unknown maker is illustrated. The country scene is untitled and shows a man and girl fishing on the near bank with a large house on the far side of the water. There is also a border of flowers and acanthus scrolls.

Tea Party

A pattern which was used on 18th century porcelains and copied extensively for use on earthenwares after about 1820. It usually consists of a lady and gentleman seated at a circular pedestal table beneath a tree. A dog often appears in the foreground as does a standing servant pouring water into a teapot. There are, however, several variants. Among the potters known to have used the design on tea services are:

(i) Thomas Fell & Co. This version excludes the servant. Ill: Coysh 2 33.

(ii) Scott, Southwick Pottery. In this design there is a begging dog on the right (see opposite).

(iii) William Smith & Co. A variant very similar to the Scott design. Ill: Coysh 2 82.

(iv) William Smith & Co. A completely different scene from the above with no servant and a different border. Ill: Godden I 525.

(v) Maker unknown. Very similar to (iii) above but the dog is seated.

"A Tear for Poland"

Edward & George Phillips. "Polish Views" Series. Plate. Ill: P. Williams p.377.

"Tedesley Hall" (sic)

Maker unknown. Light Blue Rose Border Series. Soup plate 10ins:25cm.

Teddesley Hall, in Staffordshire, was built by William Baker for Sir Edward Littleton in 1757. It lay seven miles north of Cannock but was destroyed in 1954.

Telford, Thomas 1757-1834

A brilliant engineer who is said to have revolutionised civil engineering and was particularly noted for his pioneering work with iron bridges. One of his most famous projects was the Menai Bridge, at the time the longest span in the world.

Telford's work is featured on at least three patterns found on blue-printed wares. The Menai Bridge (1819-25) appears in the Dimmock "Select Sketches" Series (qv) and one of the aqueducts on the Ellesmere Canal (1801-5) on a mug by an unknown maker titled "Cambrian Bridges" (qv). Dean Bridge, over the Water of Leith in Edinburgh, was opened in 1831 and appears on one of the patterns by James Jamieson & Co. in the "Modern Athens" Series (qv).

"The Tempest, Act 1, Scene 2"

John Rogers & Son and Pountney & Goldney. "The Drama" Series.

Shakespeare wrote this play in about 1610 and it was printed in 1623. This was his last play and the editors of the first Folio edition chose it to start the volume. It is regarded by many to be his finest work.

"Temple"

Robert Heron & Son.

"The Temple"

Podmore, Walker & Co. A flow-blue design printed in dark blue on ironstone wares.

"The Temple of Friendship"

Henshall & Co. Fruit and Flower Border Series. Dish 20¼ins:51cm.

The Temple of Friendship was an important feature in the grounds at Stowe, near Buckingham. It was built by James Gibbs in 1739 but has long been in ruins.

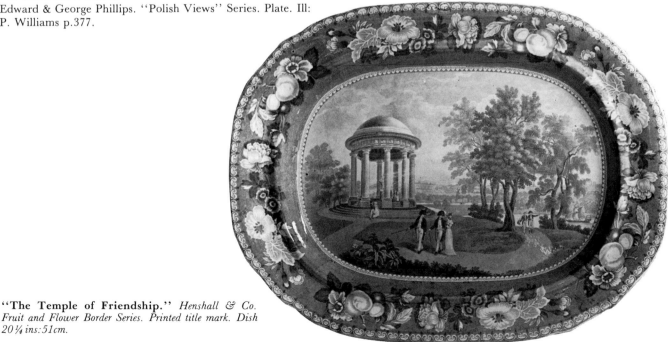

"The Temple of Friendship." *Henshall & Co. Fruit and Flower Border Series. Printed title mark. Dish 20¼ins:51cm.*

"Temple House"

Pountney & Allies/Pountney & Goldney. "River Thames" Series. Ill: FOB 17.

This view is thought to show Temple House in Berkshire, just across the Thames from Marlow. It was built by Samuel Wyatt in about 1790 but destroyed in the early 1920s.

Temple Landscape

Whiter identified two Spode chinoiserie patterns as Temple Landscape, First (Whiter 2) and Temple Landscape, Second (Whiter 14). They were renamed by Copeland who argued that it is better to name a pattern after the central view rather than similarity of border. The first became Buddleia, the second Temple Landscape. The distinguishing features on the first are a buddleia-style tree and a Chinese figure and tree in a typical early white reserve in the foreground. The second is clearly a later design with a man holding a parasol on a small bridge in the foreground. It is usually found on Stone China.

There are several versions of these patterns which are discussed in detail in Copeland, pp.80-82, 96-99.

"Temple of Serapis at Pouzzuoli"

Don Pottery and Joseph Twigg, Newhill Pottery. Named Italian Views Series. Plate 9½ ins:24cm, and soup plate 9¾ ins:25cm. Ill: Coysh 2 117; FOB 21.

The Temple of Serapis is in a volcanic area west of Naples where the land is still rising. On columns that still remain standing it is possible to see the high water marks beneath which they were once submerged. Pouzzuoli is known today as Pozzuoli.

"Temple of Venus, Rome"

Enoch Wood & Sons. "Italian Scenery" Series. Plate 6½ ins:16cm.

The Temple of Venus lies on the Via di S. Gregorio, opposite the Colosseum on Monte Palatino.

Tendril Pattern

A widely accepted name for a pattern by Benjamin Adams. It is composed of a small circular centre containing a stylised flower motif, surrounded by a mass of tendrils linking further stylised leaves and flowers. Several variants are known without marks and it seems likely that the design was used by other potters. One example has been noted with an armorial crest in the centre. See: "Cavendo Tutus". Dinner wares have been recorded with an ochre rim. Ill: Coysh 2 3.

"Teresa Panza and the Messenger"

James & Ralph Clews. Don Quixote Series. Dish 14½ ins:37cm, soup tureen stand and vegetable dish. Ill: Arman S 84.

"Terni"

(i) Chesworth & Robinson or Chetham & Robinson. This would appear to be a series title since two different designs have been noted with sub-titles:

"The Offering"

"A Romantic District of Italy"

Examples are marked with a landscape cartouche which includes the title "TERNI" in a rectangle and has the appropriate sub-title beneath together with the maker's initials C. & R. These two romantic scenes appear within a floral border on plates with wavy edges.

(ii) Enoch Wood & Sons. "Italian Scenery" Series. Sauce tureen.

Terni is an Italian town in the district of Umbria which lies on a tributary of the Tiber about forty miles north of Rome. It had many fine buildings which were destroyed by bombing during World War II in an attempt to put out of action the nearby steel works.

Temple Landscape, First. *Attributed to Spode. Painted mark "B. LEACH". Plate 9ins:23cm.*

"Terrace of the Naval Amphitheatre at Taorminum"

Don Pottery and Joseph Twigg, Newhill Pottery. Named Italian Views Series. Plate 10ins:25cm, and cakestand. Ill: Lawrence p.88.

This outdoor theatre was first built in the 3rd century B.C. but was rebuilt by the Romans in the 3rd century A.D. It overlooks magnificent views of the sea, the beaches below, and also Mount Etna. Taorminum is now known as Taormina and has become the most famous holiday resort on the east coast of Sicily.

"Terwin Water, Hertfordshire" (sic)

Ralph Hall. "Picturesque Scenery" Series. Soup tureen ladle.
See: "Tewin Water, Hertfordshire".

"Teutonic"

Brown-Westhead, Moore & Co. A pattern titled on a crown and shield mark with the initials B.W.M. & Co. (See: Godden M 679).

"Tewin Water, Hertfordshire"

Maker unknown. Crown Acorn and Oak Leaf Border Series. Pierced basket stand. Ill: FOB 33.

This country seat is in the parish of Tewin, three and a half miles north west of Hertford. The house dates from 1819 and the view shows the notable west front with its seven bays of Ionic columns, the three central bays recessed.

"Tewkesbury Church"

Minton. Minton Miniature Series. Dish 5¼ ins:13cm.

The Abbey Church of St. Mary was originally a Benedictine foundation and much of the 12th century Norman work remains. At the Dissolution it became the parish church and it was restored between 1875 and 1879.

"Theatre Printing House &c, Oxford". *John & William Ridgway. Oxford and Cambridge College Series. Unmarked. Drainer 13ins:33cm.*

"Theatre Printing House &c, Oxford"

John & William Ridgway. Oxford and Cambridge College Series. Dish 18½ins:47cm, and drainer 13ins:33cm. Ill: Coysh 1 70; Little 50.

This somewhat misleading title is used on a view which shows the Theatre *and* the Printing House which are separate buildings standing close together in Broad Street. The Printing House was built for the University Press between 1711 and 1715, largely from the profits of the Earl of Clarendon's *Historical Narrative of the Rebellion and Civil Wars in England* (1704-7). It is now known as the Clarendon Building and since 1830 it has been the University Registry.

The Sheldonian Theatre, set back from the street, was built by Sir Christopher Wren between 1664 and 1669 for the ceremonial meetings of the University. It is behind a wall with sculptured heads on piers.

Thénard's Blue

A relatively inexpensive blue colouring material prepared by Louis Jacques Thénard (1777-1857) in France. It was imported into England by the Staffordshire potters, supposedly by 1802, but the extent of its use is not clear.

"Thirlmere"

C.J. Mason & Co. "British Lakes" Series.

Thirlmere is a narrow sheet of water less than four miles long in the most mountainous part of the Lake District. It lies between Helvellyn and Whiteside on the east and Armboth Fells and Raven Crag on the west. Since 1894 the lake has provided Manchester's water supply.

Thomson, John (& Sons) fl.1816-1884

Annfield Pottery, Gallowgate, Glasgow, Scotland. John Thomson is said to have had connections in Staffordshire from where many of his workmen were recruited. The firm produced transfer-printed wares in quantity. The style became John Thomson & Sons in 1865. A variety of printed and impressed marks were used, mostly with initials J.T. or J.T. & Sons. Several such marks include the name of the pottery "ANNFIELD" or the location "GLASGOW".

"Thoresby Park, Nottinghamshire"

Ralph Hall. "Select Views" Series. Handled dish 6½ins:16cm.

This view has long since disappeared. The present Thoresby Hall at Ollerton was built in 1864 by Salvin.

Thornton Abbey

James & Ralph Clews included a view in their Bluebell Border Series under the title "Remains of the Church, Thornton Abbey" (qv).

"Thornton Castle, Staffordshire"

Enoch Wood & Sons. Grapevine Border Series. Plate 10¼ins:26cm.

It has not yet proved possible to trace this view.

"Thornton Castle, Staffordshire." *Enoch Wood & Sons. Grapevine Border Series. Printed title mark and impressed maker's eagle mark. Plate 10¼ins:26cm.*

"Thorp, Derbyshire." *Maker unknown. Beaded Frame Mark Series. Printed title mark. Border clobbered with brown, green, pink and yellow enamels. Plate 7ins:18cm.*

"Thorp, Derbyshire" (sic)
Maker unknown. Beaded Frame Mark Series. Plate 7ins:18cm.

The picturesque village of Thorpe lies on the River Dore in the west of the county, close to the Staffordshire border. The view shows the tower of St. Leonard which dates from 1150.

Three Chinamen
Ferrybridge Pottery. A name used by Lawrence for a transitional chinoiserie design with three Chinamen in front of a building. Ill: Lawrence p.52.

Three Cows
William Adams. A name used by Coysh for a scene with three cows in a wooded landscape within a grotto border of scrolls, fruit and flowers, printed in a very dark blue. Ill: Coysh 2 2.

"Thrybergh, Yorkshire"
Enoch Wood & Sons. Grapevine Border Series. Plate 10¼ins:26cm, and soup plate 10ins:25cm.

Thrybergh Park, now the headquarters of the Rotherham Golf Club, is a late Georgian castellated house with angle turrets.

"Thun"
Copeland & Garrett. Byron Views Series. Well-and-tree dish 20ins:51cm and dish 21ins:54cm. See Colour Plate XXIII.

Thun is the name of both a town and a lake in Switzerland. The lake, traversed by the River Aar, is eleven miles long. The town is dominated by a 15th century feudal castle and commands views of the Bernese Oberland.

"The Tiber"
Copeland & Garrett. Byron Views Series. Vegetable dish and cover. Ill: FOB 15.

The River Tiber rises in the Tuscan Apennines and flows past Rome to its mouth in the Tyrrhenian Sea. It is sometimes called the Yellow Tiber due to the alluvium of its flood waters.

"Thrybergh, Yorkshire." *Enoch Wood & Sons. Grapevine Border Series. Printed title mark. Plate 10¼ins:26cm.*

Tiber Pattern
Spode. This design should strictly be called after the authentic factory name which is Rome, but the above name has become so well accepted by collectors that it is retained here. The view shows the River Tiber, the Castle of St. Angelo, The Bridge of St. Angelo, and St. Peter's with its high dome. To the left of the castle is Trajan's column which is misplaced: it does not appear from the viewpoint chosen for this scene. Ill: Coysh 1 106; Whiter 69; S.B. Williams 73-78.

The view is based on two aquatints by J. Merigot and R. Edwards published in *Views and Ruins in Rome and its Vicinity* (1798). The main scene is from a print called The Castle and Bridge of St. Angelo, with the addition of a tree on the left and another in the centre. The column is inserted from another print titled Trajan's Column.

Spode introduced the pattern in 1811. A copy has been reported with the impressed mark Lakin in lower case letters. A few of the Spode examples bear a small letter 'S' engraved amongst the rocks on the right hand side. It has been suggested that this may be the monogram of the independent engraver, Thomas Sparks (qv), who is known to have worked for Spode.

Tiger
The Tiger appeared in one of the Sporting Series patterns by Enoch Wood & Sons on a dish (19ins:48cm) and was also featured in two designs based on Williamson's *Oriental Field Sports, Wild Sports of the East* (1807).

See: "Hog Hunters Meeting by Surprise a Tigress & Her Cubs''; A Tiger Hunted by Wild Dogs.

A Tiger Hunted by Wild Dogs
This engraving from Thomas Williamson's *Oriental Field Sports, Wild Sports of the East*, the source of Spode's Indian Sporting Series (qv), was used by an unknown maker for part of a scene on a dish. It was combined with part of another print titled "Chasing a Tiger across a River". Ill: S.B. Williams 36-38.

Tiles: *Wedgwood. Printed title "March" beneath pattern. Moulded mark "JOSIAH WEDGWOOD & SONS/ETRURIA/PATENT IMPRESSED TILE". 6ins:15cm square.*

Tiles

Decorative tiles were extensively made from about 1870 for use on fireplaces, washstands, window boxes and chairs but only a relatively small number are blue-printed.

Amongst the major manufacturers were Wedgwood, and Minton, Hollins & Co. The Wedgwood example illustrated is one of an attractive series representing the months of the year. Minton, Hollins & Co. should not be confused with the main Minton firm. They operated at the Patent Tile Works in Stoke from 1868. A marked blue-printed example from this factory is illustrated with a pattern in the Dutch Delft style.

Till, Thomas, & Son(s) fl.c.1850-1928

Sytch Pottery, Burslem, Staffordshire. Thomas Till continued at these works following his partnership as Barker, Sutton & Till. The style became Thomas Till & Sons when a second son became a partner in about 1861. The firm used a variety of printed marks, all including the name Till in full.

"Tintern Abbey, Monmouthshire"

James & Ralph Clews. Bluebell Border Series. Soup plate 10ins:25cm.

This ruined Cistercian abbey, situated on a bend of the River Wye, was founded in 1113 by Walter de Clare, Lord of Chepstow. It was extensively rebuilt on a grand scale between 1270 and 1301 by the Earl of Norfolk. The ruins were acquired by the crown in 1900.

Titled Seats Series

This series of views of country seats is listed by Laidacker under the maker Carey & Sons and is described as having a border of morning glory and roses. The title of each seat together with the name of its owner is printed in a drape cartouche but the maker's mark is rare. Known views include:

"Alton Abbey, Earl of Shrewsbury's Seat"
"Belvoir Castle, Leicestershire, Duke of Rutland's Seat"
"Castle Freke, Cork, Ireland, Lord Carbery's Seat"*
"Dunraven Castle, Honorable Wm. Wyndham Quin's Seat"
"Eaton Hall, Cheshire, Earl Grosvenor's Seat"
"Inverary Castle, Duke of Argyle's Seat" (sic)*
"Luton Hoo, Bedfordshire, Marquis of Bute's Seat"
"Sandon Hall, Earl of Harrowby's Seat"
"Shugborough Hall, Staffordshire, Viscount Anson's Seat"
"Woburn Abbey, Duke of Bedford's Seat"

Tiles: *Minton, Hollins & Co. Decorated in the style of a Delft tile. Moulded mark with "MINTON HOLLINS & CO. PATENT TILEWORKS, STOKE-ON-TRENT". 5ins:13cm square.*

Titled Seats Series. *Careys. Typical printed mark.*

Toast Rack. *Minton. Printed scroll cartouche with ''Claremont/Stone China'' above a cursive M. Length 8ins:20cm.*

Toast Rack. *Spode. Trophies-Etruscan Pattern. Printed and impressed maker's mark. Length 9¾ins:25cm.*

Tittensor, Charles fl.c.1815-1823

Shelton, Staffordshire. The name Tittensor has been recorded on printed marks found on transfer-printed wares but such marks are rare.

"Tivoli"

(i) Copeland & Garrett. Byron Views Series. Tall comport.

(ii) John Rogers & Son. A scene of pillars from ruined temples printed in dark blue on dinner and dessert wares. Ill: Coysh 1 92; Little 57.

(iii) Enoch Wood & Sons. "Italian Scenery" Series. Plate 5¾ins:15cm.

Tivoli, some seventeen miles north east of Rome, was a favourite country residence of the ancient Romans. It is famed for its ruins which include a great villa built by the Emperor Hadrian, the Temple of Tiburtus and the beautiful circular Temple of the Sibyl.

"Tixall, Staffordshire"

(i) William Adams. Flowers and Leaves Border Series. Dish 19ins:48cm.

(ii) Maker unknown. Foliage Border Series. Sauce tureen.

Tixall as a house no longer exists. It was destroyed in 1927.

"To God Only Be All Glory"

A motto which is used by the Worshipful Company of Skinners of the City of London. Their arms were confirmed in 1550.

A blue-printed divided serving dish by Spode decorated with the coat-of-arms of the Skinners' Company is known with the border from the Geranium pattern. This item is marked with the initials "TG" surrounded by the legend "Master 1821, 22". Ill: Whiter 81.

See: Armorial Wares.

Toast Rack

Earthenware toast racks are usually in the form of a long dish with an added row of vertical dividers. They are by no means common with blue-printed decoration although several marked Spode examples have been noted. As may be expected the shape does not lend itself to pictorial patterns and most examples seem to have either sheet or floral patterns. Examples are illustrated with the Minton "Claremont" design and the Spode Trophies-Etruscan pattern.

Todd & Shortridge & Co.

This firm of calico printers in Glasgow insured premises in 1792 which were described as their "china blue-printing house and old copper plate print house, all communicating". It seems likely that the words 'china blue' should be read as the name of a colour rather than the process of printing on china. However, it is clear that there were skilled commercial engravers working in Glasgow at this period.

Toft & May fl.c.1825-1829

Hanley, Staffordshire. A relatively short-lived partnership which is known to have produced blue-printed wares. A version of the Rogers Zebra pattern is known with the impressed mark "TOFT & MAY" (Ill: Little 67). The firm was continued for a very short time by Robert May (qv).

Toilet Box

A long narrow lidded box, often part of a toilet set. These boxes are believed to have been used to hold early implements for cleaning teeth. The lids are sometimes pierced by two or three ventilation holes. They can be found divided into two sections or with two small cross-pieces which appear to be rests.

See: Toothstick Box.

Toilet Sets

Blue-printed toilet sets are now seldom found complete. A set would consist of a ewer or water jug, a washbowl, soap dish, toothstick box and chamber pot. Sets of this type became standard bedroom equipment in late Victorian times.

"Tom Piper"

Marsh & Willet. A pattern which is marked with the initials M. & W. as part of a printed cartouche.

"Tom Tit"

David Methven & Sons.

"Tomb of Absalom, Village of Siloan, the Brook Kedron"

Thomas Mayer. "Illustrations of the Bible" Series. Plate. Ill: P. Williams p.296.

See: Absalom's Pillar.

Toilet Box. *William Adams. A typical toilet box with longitudinal divider. This pattern is sometimes called a Bird and Basket Chinoiserie.*

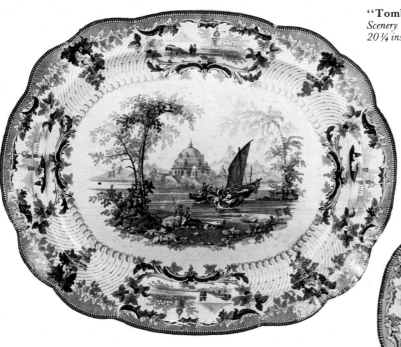

"Tomb of Cecilia Metella"

Copeland & Garrett. Byron Views Series. Circular soup tureen.

The tomb of a member of the plebeian Roman family Caecilia Metellus which flourished between about 250 and 60 B.C.. It is on the Appian Way, near Rome.

"Tomb of the Emperor Acber"

Maker unknown. "Oriental Scenery" Series.

"Tomb of the Emperor Shah Jehan"

(i) John Hall & Sons. "Oriental Scenery" Series. Dish 19ins:48cm.

(ii) Maker unknown. "Oriental Scenery" Series. Dish 20ins:51cm.

Shah Jehan was the fifth of the Mogul Emperors of India. He was active between 1627 and 1658.

"Tomb of Jeremiah"

Maker unknown. Ottoman Empire Series. Plate.

The great prophet Jeremiah suffered frequent imprisonment for his writings and was eventually forced to retire to Egypt. Tradition says that he met his death by stoning.

"Tomb at Jeswunthnagure"

John Hall & Sons. "Oriental Scenery" Series. Plate 7ins:18cm.

See: "Tomb of Jeswuntnagurth".

"Tomb of Jeswuntnagurth"

Maker unknown. "Oriental Scenery" Series.

A similar view in the other "Oriental Scenery" Series by John Hall & Sons bears the slightly different title "Tomb at Jeswunthnagure" (qv).

Tomb Pattern

Thomas Fell. This title was used by Coysh for a design on tea wares which shows a lady and child weeping at a tomb. It may have been made to commemorate the death of Princess Charlotte in 1817. Ill: Coysh 1 42.

"Tomb of Shere Shah"

Thomas & Benjamin Godwin. Indian Scenery Series. Dish 20¼ ins:51cm.

The best known Moslem tombs in Bihar are at Sasaram, south of Patna. The most impressive is the tomb of Sher Shah, a five-tiered hexagonal structure with a great dome some 150 feet high.

"Tomb of Theron at Aggrigentum" (sic)

Don Pottery and Joseph Twigg, Newhill Pottery. Named Italian Views Series. Soup plate 9¾ ins:25cm. Ill: Little 101.

Theron ruled in Sicily from 488 to 472 B.C. The scene shows a funerary monument built in the Greek style in the last years of the Roman Republic. Agrigento is a city on the south coast of Sicily, sometimes known as Girgenti. Its Roman name was Agrigentum.

"Tombs of Etaya"

John Hall & Sons. "Oriental Scenery" Series. Soup plate 10ins:25cm.

"Tombs near Etaya on the Jumna River"

Thomas & Benjamin Godwin, and Cork, Edge & Malkin. Indian Scenery Series. Plate 9¼ ins:23cm.

The town of Etaya, some fifty-two miles south of Agra in India, is built on the banks of the Jumna River. The banks are about sixty feet above water level.

367

Tong Castle, Shropshire

John & William Ridgway. Angus Seats Series. Plate 8¼ ins:21cm, and arcaded plate 7¾ ins:20cm.

In common with all items from this series the view is not titled and marked pieces are very rare.

Tong Castle, built for George Durant in 1765, was dismantled in 1913. The shell was finally demolished in 1954. See: D. Stroud, *Capability Brown* (1950), for details of the castle and grounds.

"Tonquin"

John Carr & Co. An open design with a ship, pagodas and trees.

Tonquin is the name given to the beans from an evergreen tree *(Dipteryx odorator)* which grows in tropical America. They are used in perfumery, snuff and tobacco. There seems to be no connection with the pattern name.

"Tonquin China"

A trade name for an ironstone body. It is found as part of a printed mark with the wording on a ribbon crossed by a band of flowers and superimposed on a lined panel. The whole is surmounted by a crown. The mark appears on good quality wares, some with blue-printed patterns, apparently dating from the 1820s. The maker is unknown.

Toothstick Box

A long narrow lidded box, often called a toilet box (qv), believed to have been intended for holding toothsticks. In Georgian times a toothstick was made by wrapping a clean piece of cloth around one end of a stick. This was then used to clean the teeth using lemon juice mixed with salt to whiten them. It was also possible to buy these implements ready-made. See: E. Burton, *The Georgians at Home* (1967), p.335.

Examples are illustrated by Turner with The Villager pattern, by an unknown maker with the Monopteros pattern, and by an unknown maker with an unidentified view from the Parrot Border Series.

See: Toilet Box.

Tower

Probably the most common design made during the Spode period, the Tower pattern is based on an engraving of the Bridge of Salaro, near Porta Salara, from Merigot's *Views of Rome and its Vicinity* (1798). The floral border was also used on Spode's Milkmaid pattern. There are two slight variants of the pattern, one with an additional pair of buildings on the extreme left of the scene in the background. Both forms can be found on plates so it is not just a case of engravers extending or cropping the scene to fit different shapes.

The Tower pattern was used on a vast number of different shapes. In addition to complete dinner services it has been noted on a bidet, a giant teapot, dessert wares, a footbath and miniature dinner services. Ill: Coysh 1 107; Whiter 70, 97-99; S.B. Williams 84-89.

Townsend, George fl.c.1850-1864

St. Gregory's Pottery, Longton, Staffordshire. The name of this potter is found as part of printed title marks, sometimes with the royal arms.

Toys

There can be little doubt that most miniature dinner and tea services, especially in Victorian times, were made as toys. The toy tea services usually consist of three cups, saucers and plates, a small teapot, a creamer, and sometimes a sugar basin.

Trade Card

A miniature plate made as a trade card for the London retailer John Mortlock is illustrated in Little 84-85. On the front the standard Willow pattern design is overwritten by a scroll with the inscription:

ESTD. 1746
JOHN MORTLOCK
THE POTTERY GALLERIES
OXFORD ST. & ORCHARD ST.
PORTMAN SQUARE. W.

On the reverse is the name of the representative "Mr. Narracott". It is believed that the piece was made at the Cambrian Pottery, Swansea. It was not made before 1856 since the address includes the letter W for West, one of the original London postal districts introduced in that year.

"Trafalgar." *Maker unknown. Unmarked. The title is incorporated on the face of the saucer in a ribbon surmounted by a Union Jack. The rim is enamelled a reddish-brown. Diam. 5¼ ins:13cm.*

"Trafalgar"

Maker unknown. The name of this famous battle of 1805 is found as part of the decoration on tea wares. The main design is of mermen blowing horns and the border includes Union Jacks and anchors. The word "TRAFALGAR" is printed on a ribbon inside a cusped medallion containing also a Union Jack and a cannon. The rims are enamelled a dark reddish-brown and both teabowls and saucers have an impressed circle. The same pattern has been noted on a teapot.

Trafalgar is a headland in south west Spain at the western end of the strait of Gibraltar. It is famous as the scene of the sea battle between the British fleet, under Nelson, and the French and Spanish fleets on 21st October, 1805. The battle lasted four and a half hours and was a decisive victory for the British, marred by the tragic death of Nelson.

Traveller's Samples

Some miniature blue-printed wares may have been made as samples for travelling salesmen. It would not have been practical for them to carry around heavy dinner services in the days when the coach was the chief means of transport. Two miniature plates thought to have been samples have been noted made by Spode with the Tiber and Forest-Landscape patterns. Such miniatures often have sparkling clear engravings and are of high quality. Moreover they are rare.

However, Rogers' Monopteros pattern and the Spode Tower pattern miniatures are relatively common and were almost certainly made as toys. Toy services were very common in Victorian times and are often poorly printed and heavily potted.

It is impossible to decide with certainty whether a miniature service was made for travellers or children and this may well remain an open question.

Trial Plate. *Maker unknown. Impressed crown over G. Plate 10ins:25cm.*

"Trematon Castle"

Ralph Hall. "Picturesque Scenery" Series. Sauce tureen and cover.

Trematon Castle is about a mile from Saltash in Cornwall. It was built in the 13th century and later became part of the Duchy of Cornwall, although it is now in ruins. In 1808 a castellated house was built within the bailey for the Surveyor-General of the Duchy, Benjamin Tucker, and part of the bailey wall was demolished to provide a view of the sea.

Trentham Hall, Staffordshire

C.J. Mason & Co. An untitled view of a country house is believed to represent Trentham Hall before it was enlarged in the 1830s. The pattern is found on dinner and dessert wares, usually marked with the printed words "SEMI-CHINA WARRANTED" in two lines, although a few items also have the name "MASON'S" as part of the mark. Examples with the name of Mason's Dublin retailer Higginbotham are also known. Other examples have been reported with a different border and a gadrooned edge. Petra Williams refers to it as the Hercules Fountain pattern. Ill: Coysh 1 146; Coysh 2 51; Godden BP 312; P. Williams p.290.

Trentham Hall was enlarged by Sir Charles Barry for the second Duke of Sutherland between 1833 and 1842. The fountain to be seen on the blue-printed pattern is of particular interest since Hercules with his club attacking the Lernian hydra is also to be found as one of the supporters in the Duke of Sutherland's coat-of-arms. The house was dismantled in 1911 but seven hundred acres of formal gardens, woodland and parkland are open to the public in summer.

Trial Plate

An interesting trial plate is illustrated with three similar printed scenes, each identified by a number. This may have been for testing different types of ink. The plate bears an impressed crown over the initial G, a mark which has been attributed to Neale & Co. See: Godden M 2846.

"Trinity College, Oxford"

John & William Ridgway. Oxford and Cambridge College Series. Dish 9½ ins:24cm.

Trinity College was founded in 1555 on the site of the former Durham College, a dissolved priory. It is noted for its fine chapel rebuilt between 1691 and 1694.

"Trinity Hall, Cambridge"

John & William Ridgway. Oxford and Cambridge College Series. Sauce tureen and pierced dish.

Trinity Hall was founded in 1350 by William Bateman for the study of canon and civil law. The buildings were greatly changed in the 18th century.

Triumphal Arch at Tripoli in Barbary

Spode. Caramanian Series. Oval dish 21½ ins:55cm, and matching drainer 16½ ins:42cm. Ill: Coysh 1 101; Whiter 93; S.B. Williams 62-63. See Colour Plates XVI, XVII.

Tripoli, in North Africa, is now the joint capital of Libya (not to be confused with Tripoli in Lebanon). It is a typical Moorish city built on a spit of land running out into the sea. The 'Triumphal Arch', which is built of marble, is the arch of the Roman Emperor Marcus Aurelius (A.D. 161-180).

"Triumphal Car"

(i) J. & M.P. Bell & Co.
(ii) James Jamieson & Co.
(iii) John Thomson.

At least eleven variations of this pattern have been recorded, some makers producing several versions. The car, or chariot, is sometimes drawn by three horses driven by a Roman or Greek warrior. Another version shows the car drawn by two leopards with a seated goddess holding aloft a crescent, and dancing maidens in attendance. One of the versions by J. & M.P. Bell & Co., still under the same title, shows swans drawing a boat. The design is said to be based on a drawing by Sir David Roberts R.A.

Trophies

The Spode factory used three patterns with a centre of Chinese trophies around a medallion with a stylised motif. They are called:

(i) Trophies-Dagger, or more completely the authentic factory name of Dagger Border and Trophy Centre. A relatively late version is still produced under the name Fitzhugh. Ill: Copeland p.132; Whiter 30.

(ii) Trophies-Etruscan, or more completely the authentic factory name of Etruscan Border and Trophy Centre. This is also a relatively late version, introduced about 1825. The border consists of pear-shaped medallions with stylised flowers. Ill: Copeland p.131; Coysh 2 95; Whiter 29; S.B. Williams 122 (known as the Hundred Antiques pattern).

(iii) Trophies-Nankin, or more completely the authentic factory name of Nankin Border and Trophy Centre. This is the earliest design with a typical chinoiserie border of geometrical motifs similar to the common Willow pattern. Ill: Copeland p.131; Coysh 1 15; Whiter 28.

"Tudor"

David Methven & Sons.

Tudor Mansion

Davenport.
See: Bisham Abbey, Berkshire.

"Tunbridge Castle, Surrey" (sic)

Andrew Stevenson. Rose Border Series. Dishes 15ins:38cm and 16ins:41cm, and pierced dish and stand.

This puzzling title is given by both Laidacker and Moore. It may be Tonbridge Castle in Kent, built in the reign of Henry I and dismantled during the civil war. The ruins, mainly the gateway, overlook the River Medway and are open to the public in summer.

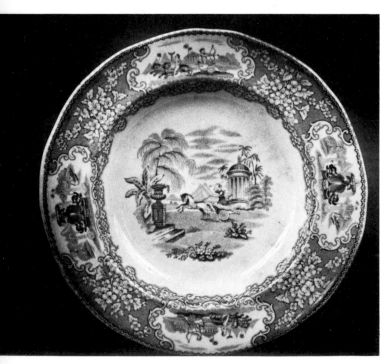

"Triumphal Car." *J. & M.P. Bell & Co. Printed title mark with maker's initials surmounted by an eagle with outstretched wings. Impressed mark J.B. within a bell. Soup plate 9½ ins:24cm.*

"Triumphal Car." *Swan version. J. & M.P. Bell & Co. Printed title mark with maker's initials surmounted by an eagle with outstretched wings. Bowl diam. 13½ ins:34cm.*

Tunstall

A Staffordshire pottery town some four miles north of Stoke-on-Trent. It had coal and iron works and also works for raising and calcining ironstone. Amongst the makers of blue-printed wares who worked in the town were Joseph Heath & Co.; John Meir; Podmore, Walker & Co.; Wedgwood & Co.; Wood & Challinor; and John Wedg Wood. There is a clock tower in Victoria Park erected in memory of William Adams (1746-1805) and a 20th century namesake who was also a potter. The urban district of Tunstall was amalgamated with Stoke-on-Trent in 1910.

Tureen

Blue-printed dinner services were supplied complete with matching tureens. A typical service would include one, or maybe two, large soup tureens, together with up to four small sauce tureens, both sizes being of the same shape. Three basic shapes are found — rectangular, oval and round. As a general rule the rectangular forms are earlier and the circular ones later. Styles did, however, change and some patterns are found on more than one shape. Each tureen was supplied with a matching stand and most dishes with handles are actually tureen stands rather than meat dishes.

"Turin"

Enoch Wood & Sons. "Italian Scenery" Series. Dish 19ins:48cm.

The Italian city of Torino is in the north, not far from the border with France. Until 1860 it was the capital of the kings of Sardinia and at the time this pattern was made was an accepted stop on the Grand Tour.

"The Turk"

David Methven & Sons.

Turnbull, G.R. fl.c.1863-1875

Stepney Street, Ouseburn, Newcastle-upon-Tyne, Northumberland. This pottery is known to have made blue-printed wares, including the common "Albion" pattern popular in the north east. The only recorded mark is the impressed name "TURNBULL" curving above "STEPNEY".

The Turner Family fl.1759-1829

Lane End, Longton, Staffordshire. John Turner (1738-87) and his two sons William (1762-1835) and John (1766-1824) operated in Lane End for a total of seventy years. The styles of their various partnerships appear as follows:

John Turner	1759-c.1781
Turner & Abbott	c.1781-1792
William & John Turner	1792-1803
Turner & Co.	1803-1806
William Turner	1806-1829

As a general rule the mark throughout the life of the firm was simply the impressed name "TURNER", although "TURNER & CO." was used between 1803 and 1806. Several marks after 1784 include the Prince of Wales' Feathers, reflecting the firm's appointment as potters to the Prince.

The Turners produced many early blue-printed designs, mostly in the fashionable chinoiserie style. They were clearly amongst the first potters to perfect the technique and this is reflected in the very high standard of the marked wares. Later patterns tended to follow popular taste and both floral and rustic designs were used.

A very full description of their lives and work can be found in Hillier, *The Turners of Lane End.*

The Turner Family. *Elephant Pattern. Impressed "TURNER". Plate 7¾ins:20cm.*

The Turner Family. *Moulded vase with printed chinoiserie design. Impressed "TURNER". Printed open crescent. Height 7¼ins:18cm.*

"Tuscan Rose"
John & William Ridgway. A typical Ridgway floral pattern with a profusion of roses within a matching border. The printed cartouche mark bears both the title and the initials J.W.R.

"Tweekenham, Surrey" (sic)
Henshall & Co. Fruit and Flower Border Series. Plate 6ins:15cm.

Twickenham is only twelve miles from central London, not far from Richmond on the other bank of the River Thames. Another view of the town was made by Goodwins & Harris in their "Metropolitan Scenery" Series under the title "View near Twickenham" (qv).

Twiffler
The name twiffler, or twifler, was used in the pottery trade for a size of plate. In *The Staffordshire Potter* Harold Owen states: "In the trade the different sizes of plates are distinguished by separate names. The largest size is called a plate, the next a twiffler, the smallest a muffin". This is confirmed by proportional prices to be found on several surviving contemporary invoices. Tea sets were also sold with 'cup, saucer and twiffler'. In modern parlance we would call the muffin a tea plate and the twiffler a dessert plate.

Twigg, Joseph (& Bros.) **fl.c.1809-1884**
This firm operated at two potteries near Swinton in Yorkshire:

Newhill Pottery	c.1809-1866
Kilnhurst Pottery	1839-1884

Joseph Twigg had been manager of the Don Pottery before he built the pottery at Newhill. He operated with his three sons Joseph, Benjamin and John who traded after the father's death in 1843 as Joseph Twigg & Bros. The two potteries clearly operated very closely together and it is not possible to distinguish between most of the wares. The marks found are mostly impressed with the name either "TWIGG" or "TWIGGS". Some examples made at the Newhill works are impressed "TWIGG/NEWHILL" and others from Kilnhurst include the initials K.P.

Blue-printed wares were made although the quality is not very high. The most notable series are the Named Italian Views which were also made at the Don Pottery. The Twigg examples are poorly printed from apparently worn copper plates which were probably acquired from the Don Pottery when it closed in 1835, before its eventual takeover by Samuel Barker.

Twisted Tree
Brameld. An open pattern, which includes a twisted tree with flowers and an exotic bird. It is found on dinner wares, toilet articles and decorative vases, the latter with lids, often clobbered overglaze and gilded. It was also printed in green. Ill: Coysh 2 12; Rice 22.

Two Figures
Spode. This is thought to be the earliest of all Spode blue-printed patterns on earthenware. It is sometimes called the Caughley Willow due to its similarity to a pattern made on porcelain at Caughley. It is a chinoiserie landscape which takes its name from the two figures which appear in conversation within a white reserve in the foreground. The pattern is line-engraved and printed in a dark, harsh blue. It was also used by Joshua Heath and by the Leeds Pottery. Ill: Copeland pp.67-74; Coysh 1 3; Whiter 3.

"Two Gentlemen of Verona, Act 5, Scene 4"
John Rogers & Son and Pountney & Goldney. "The Drama" Series. Dish 10¾ins:27cm.

The *Two Gentlemen of Verona*, one of Shakespeare's romantic comedies, was written in about 1591 and first printed in 1623. It was one of his earlier plays and is said to reflect the lack of development in the writer's art.

Two-Man Chinoiserie
A title introduced by Coysh for a design by G.M. & C.J. Mason printed on Patent Ironstone China. It is open in form with two Chinese figures and two exotic birds in a garden. There is an open border of Chinese motifs. Ill: Coysh 2 53.

Two Temples
This pattern has two temples, one in front of the other so that at first glance there appears to be only one. Two men are crossing a single arch bridge. The pattern was widely used on porcelain but the following makers used it on earthenware:

(i) Davenport. A late version registered in 1879. Ill: Copeland, Chap. 7, Fig. 14.

(ii) Don Pottery. Ill: Copeland, Chap. 7, Fig. 35.

(iii) William Mason. Ill: Copeland, Chap. 7, Fig. 36. This attribution is confirmed by a marked example in Haggar and Adams, *Mason Porcelain & Ironstone*, 92.

(iv) Spode. An early version before 1825. Ill: Copeland, Chap. 7, Fig. 20; Whiter 16 (as the Temple pattern).

(v) Wedgwood. Another early version c.1817. Ill: Copeland, Chap. 7, Fig. 38.

"Tyburn Turnpike"
Maker unknown. Beaded Frame Mark Series. Plate 8ins:20cm.

The Tyburn Turnpike was close to the west end of Oxford Street in London. The name was well known as the site of a permanent gallows from 1571 to 1759. It was named after a small stream which nowadays runs underground from Hampstead, through Regent's Park, to the Thames at Westminster.

"Tyrol Hunters"
Davenport. A pattern which shows two hunters holding guns and a third taking aim. They are wearing belted jerkins and Tyrolean hats and appear in an Alpine setting. The scene is separated from the floral border by a wide unprinted area. Ill: P. Williams p.438.

"Tyrolean"
William Ridgway & Co. A series of Alpine scenes with mountains, buildings and figures, used on a wide variety of wares. They have been reported on toilet wares and are known in other colours. Ill: P. Williams p.437 (two examples).

"Tyrolese"
An Alpine scene with chalets, rather similar to the Minton "Genevese" design. As a result of excavations on the site, it has been attributed to the Clyde Pottery Co., probably from the Andrew Muir period between 1836 and 1840. An example on a jug is in the Glen Coe Folk Museum. Ill: FOB 28.

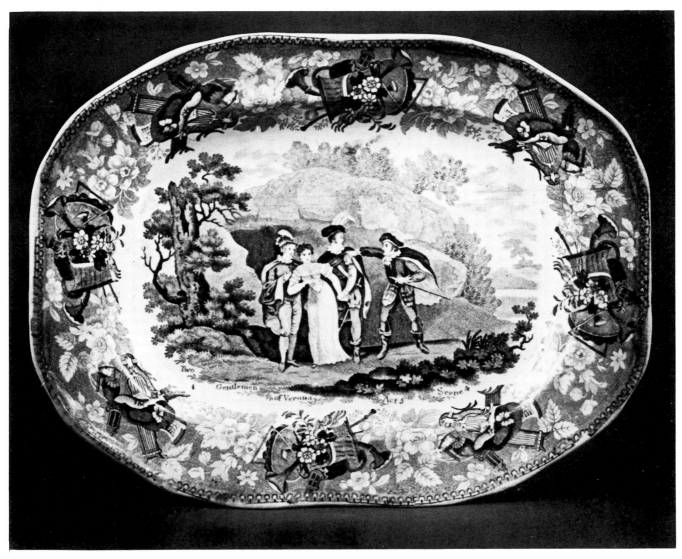

"Two Gentlemen of Verona, Act 5, Scene 4." *Pountney & Goldney. "The Drama" Series. Title beneath design. Printed series title mark. Dish 10 ¾ ins:27cm.*

"Ullswater"

C.J. Mason & Co. "British Lakes" Series. Dishes 19ins:48cm and 21½ins:55cm. Ill: FOB 23.

Ullswater, to the south of Penrith was originally in both Cumberland and Westmorland (now in Cumbria). It is the second largest lake in England, being some eight miles long and half a mile wide, and is divided into three reaches. Much of the shoreline belongs to the National Trust.

"Ulster Terrace, Regent's Park"

Enoch Wood & Sons. "London Views" Series. Dish 10ins:25cm.

Ulster Terrace was on the south side of the Park. Elmes described it, adjoining Park Square, as "four bow-windowed houses" and stated that it had "nothing particularly architecturally striking in its composition".

"Ulysses at the Table of Circe"

Joseph Clementson. "Classical Antiquities" Series. Dessert plate.

Along with other patterns from the series, this design was registered on 13th March, 1849.

Underglaze

A term used to describe decoration or printing carried out before application of the glaze. Printed designs were applied to the biscuit ware which was then dipped into the glaze and fired. The advantage compared to overglaze processes is that the decoration is protected by the glaze and is effectively permanent, whereas overglaze decoration is subject to wear. Until the 1830s cobalt blue was usually the only colour which withstood the heat of the glost furnace. Hence the vast output of blue-printed wares.

"Union"

(i) William Ridgway, Son & Co. Printed in light blue on tea wares.

(ii) J. Venables & Co. and also Venables & Baines. A design registered in 1852 printed in light blue on tea wares. It features a man ploughing.

See: Queen Victoria and Prince Albert.

Union of Britain and Ireland

The Union of Great Britain and Ireland was effected on 1st January, 1801. From that date the shamrock began to appear in decoration along with the English rose and the Scottish thistle.

"Union Club"

Copeland & Garrett. A few examples of Spode's Union Wreath: Third pattern have been noted with the addition of the words "Union Club" to the small ribbon which ties the stems of the spray. Examples are known with different marks, one with a standard Copeland & Garrett mark and others with a printed mark "Imperial" in the same Gothic letters as used by Spode in the "Spode's Imperial" mark but surmounted by a crown.

The Union Club owes its name to the Union of Britain and Ireland. It was started at Cumberland House by 1805 under the chairmanship of the Marquis of Hertford. At that time many of the members were newly created Irish Peers following the dissolution of the Irish Parliament. Familiarly known as the "Onion", it was principally a gaming club, occupying various temporary addresses in Pall Mall, St. James's Square, Regent Street and Cockspur Street. Amongst early members were Byron and the Dukes of Sussex and York. In 1821 it was established as a non-political members club by Colonel William Mayne and a new club house was built by Sir Robert Smirke in New Square (now Trafalgar Square) and opened in 1824. This is the building now known as Canada House which was sold to the Canadian Government in 1924 for £225,000. The club moved to premises in Carlton House Terrace which were in turn taken over by the Foreign Office after the Second World War. In 1952 the Union Club took over from the Thatched House Club in St. James's Street where it remained until 1964 when the Constitutional Club moved in, and the Union Club ceased to exist.

Union Wreath

Three Spode floral patterns are covered by this general title. Whiter identifies them as:

(i) Union Wreath: First. An open pattern with a small spray of rose, shamrock and thistle within a continuous border of similar flowers. It is found only on china teawares, not earthenware. Ill: Whiter 56.

(ii) Union Wreath: Second. The border from Union Wreath: First above, but with a centre spray of various flowers taken from Spode's Blue Rose design. It dates from about 1825. Ill: Whiter 57.

(iii) Union Wreath: Third. A completely new design with a large spray of rose, shamrock and thistle tied together by a ribbon. The border consists of groups of stylised flowers of other species and was also used by Spode on the Girl at the Well pattern. This version is the commonest of the three and is often called simply Union Wreath or Union Spray. Ill: Coysh 1 117-118; Whiter 58.

See: "Union Club".

"United Kingdom" Series

A series printed in light blue by R.A. Kidston & Co. The views are contained within a geometrical border with floral sprays. The printed series mark consists of an oval garter with a crown above and flanked by roses and thistles. Inside are the makers' initials R.A.K. & Co. and beneath are the series and view titles. The prints are of rather poor quality.

The following views have been recorded:
"Dublin from Phoenix Park"
"Dunkeld"*
"Edinburgh"
"Edingburgh" (sic)*

"Unity"

The name of a Newquay pilchard-fishing company, sometimes found beneath a fish in an oval medallion on Swansea wares. These are decorated with early chinoiserie designs, one of which features a palm tree.

"University"

John Ridgway & Co. A light blue design so far recorded only on dinner and toilet wares. It shows a building with a long façade and a central domed tower with students in the foreground. A trelliswork border includes medallions, each showing the same building. Ill: P. Williams p.442.

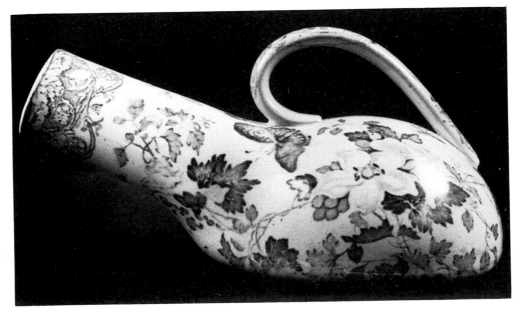

"Unto God Only Be Honour and Glory"

A motto which is used by the Worshipful Company of Drapers of the City of London. They were the recipients of the first known grant of arms to a livery company in 1439, followed by subsequent grants in 1561 and 1613.

A blue-printed plate decorated with the coat-of-arms of the Drapers' Company is illustrated. It was made by John & Richard Riley for use in 'Hall feasts' and was supplied through the London retailers J. Huson & Son of 120 Great Portland Street in 1813. The design utilises a border which the firm produced on a floral pattern. Ill: Little 53.

See: Armorial Wares.

"Unto God Only Be Honour and Glory." *Arms of the Drapers' Company. John & Richard Riley. Printed garter mark with "RILEY'S/Semi China". Impressed maker's mark. Plate 8½ ins:22cm.*

Urine Bottle

Urine bottles for gentlemen were made for use in the sickroom. They differ little from those in use today.

Urine Bottle. *Maker unknown. Unmarked. Length 10¼ ins:26cm.*

"Vale House"
Henshall & Co. Fruit and Flower Border Series. Soup plate 10ins:25cm.

This may be a view of Vale Lodge, a seat one mile south of Leatherhead in Surrey.

"The Valentine"
James & Ralph Clews. "Wilkie's Designs" Series. Dinner wares. Ill: Arman 93; Arman S 93; Moore 33.

"Valle Crucis Abbey, Wales"
Maker unknown. Pineapple Border Series. Dish 14½ins:37cm.

"Valle Crusis Abbey, Wales" (sic)
Ralph Hall. "Select Views" Series. Vegetable dish and cover.

Valle Crucis, the Valley of the Cross, is a small ruined Cistercian abbey one and a half miles north west of Llangollen. It was founded in 1201 by Madoc ap Gryffydd Maelor. Most of the 14th century church survives but with many later changes.

Van Huysum's Fruit and Flowers
John Rogers and Son. A design of fruit and flowers draped around an almost hidden vase. It is based on a painting by Van Huysum which was also used to decorate a painted porcelain tray by Spode (See: Whiter 209). Ill: Coysh 2 79.

"Variety"
Ralph Hall. A pattern so far only recorded on tea wares.

"Vase"
(i) Edward Challinor. A pattern with a romantic scene within a border featuring several vases. Marked with the title and the initials E.C.

(ii) John Rogers & Son. A later Rogers design with a romantic scene of ruins and cows within a border of vases, flowers, scrolls and small vignettes.

"Vauxhall Gardens"
Maker unknown. A title which is printed beneath a picture of an orchestral stand within a border of trailing ivy. The design has been found on dessert plates and a shallow square dish 9½ins:24cm wide.

Vauxhall Gardens were opened in 1660 and soon became a fashionable centre of entertainment. They were extensively used for masques and balls and later for other spectacles such as balloon ascents. In the 19th century the gardens no longer attracted the wealthier patrons and they gradually declined to a rather seedy level. They were closed in 1859 "in consequence of scenes of riot and dissipation for which they became notorious". The print shows the orchestral stand which also appears in a well-known Rowlandson aquatint.

"Vedgwood"
A mark used by William Smith & Co. of Stockton-on-Tees and also by Carr & Patton of North Shields. It was clearly intended to mislead buyers into thinking that such wares were made by Josiah Wedgwood. In 1848 Wedgwood obtained an injunction against Smith to prevent the use of these marks.

Vegetable Dish
A deep dish supplied with a high domed cover. They are usually square but a few examples of rectangular form are known. A dinner service would have four such dishes, sometimes found with an inner liner or water pan.

Veilleuse
See: Food Warmer..

"Venetian Scenery"
Robinson & Wood. A series of romantic Italianate patterns on wavy edged dinner wares. The mark is an ornate printed drape surmounted by a crown and containing the title together with the name of the body "STONE CHINA". The makers' name appears on a ribbon beneath.

"Venice"
Copeland & Garrett. Byron Views Series. Dish 19ins:48cm.

This pattern shows a general view of the city with a gondola in the foreground. Venice is built largely on piles. It is based on a small group of islands and is famous for its system of canals. It was an essential stop on the Grand Tour.

"Venus"
Podmore, Walker & Co. and their successors Wedgwood & Co. This title was used on both blue-printed and polychrome patterns.

"Vermicelli"
(i) William Ridgway & Co.
(ii) William Ridgway, Son & Co.

These partnerships appear to have shared the Church Works, Hanley for some years. It is not surprising, therefore, that they shared the same design. One example noted had an impressed mark for the former and a printed mark for the latter. The title derives from the Latin *vermis* (worm) and is a good description of the designs which are like a mass of threads.

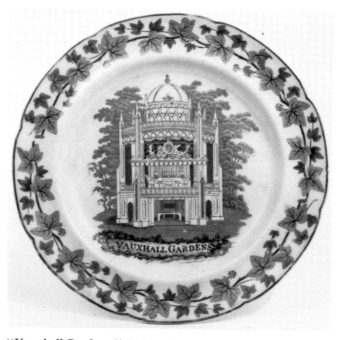

"Vauxhall Gardens." *Maker unknown. Unmarked. Title on face of plate. Plate 8½ins:22cm.*

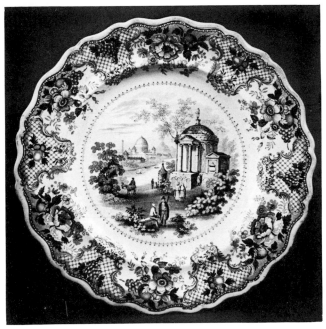

"Venetian Scenery." Robinson & Wood. Printed draped cartouche with title and "STONE CHINA". Maker's name in full on ribbon below. Plate 10½ ins: 27cm.

"Venetian Scenery." Robinson & Wood. Ornate printed mark.

Vernon, James (& Son) fl. 1860-1880

Waterloo Pottery, Burslem, Staffordshire. There were various partnerships with the name Vernon in Burslem in the mid-19th century. The above dates are quoted by Godden M 3934; the style "& Son" was used from 1875. Other firms which are probably related include:

Hopkin & Vernon	c.1836
James Vernon & Co., Waterloo Pottery	c.1846-1860
James Vernon, Scotia Works	c.1857-1862

Initial marks J.V. and J.V. & S. are known and almost certainly were used by these firms.

"Verona." Maker unknown. Printed title mark. Soup plate 10¼ ins: 26cm.

"Verona"

(i) Cork & Edge and their successors Cork, Edge & Malkin. A romantic scene with buildings, a lake, and ladies in the foreground. Titled with a printed oval strap supported by a lion and a unicorn and with initials below. See: Godden M 1102.

(ii) Lockhart & Arthur. A view of classical ruins with a grapevine and medallion border.

(iii) David Methven & Sons. Believed to be the same design as used by Lockhart & Arthur above.

(iv) George Phillips. A romantic scene printed in light blue on dinner wares.

(v) Maker unknown. A romantic scene of Gothic ruins marked with a printed scroll cartouche. Examples are known with an impressed seal mark including the words "Improved Stone China" (qv).

Verona is an Italian city, capital of a province of the same name. It lies in the north of the country, midway between Venice and Milan.

"Veronese"

Charles Meigh. A view of Gothic ruins with distant lakes and mountains, all within a flower and scroll border.

Verreville Pottery, Glasgow

This pottery operated over a long period under various partnerships, most of whom made blue-printed wares. The dates were approximately as follows:

John Geddes	1806-1824
John Geddes & Son	1824-1827
Geddes, Kidston & Co.	1827-1834
Kidston, Cochran & Co.	
Kidston & Price	1834-1846, sequence unclear
R.A. Kidston & Co.	
Robert Cochran	1846-1867
Robert Cochran & Co.	1867-1918

The partnerships are listed individually where marked wares have been recorded.

"Versailles"

(i) Batkin, Walker & Broadhurst. A romantic view with a river, bridge, buildings, a statue, and two figures with a dog in the foreground. Printed initial mark. Ill: Godden I 36.

(ii) Robinson, Wood & Brownfield. Although this maker has been reported, the similarity of initials with the above leads to some doubt.

(iii) Maker unknown with initials J.G. A light blue design of vases which could have been made by any of at least five firms with these initials between 1824 and 1853. Ill: P. Williams p.81.

Versailles is ten miles west of Paris and is famous for its palace and park. The palace was started in 1661 and became the main royal residence of France. The park is famous for its ornamental fountains and waters, and also for an orangery.

"Vesuvius"

Enoch Wood & Sons. "Italian Scenery" Series. Plate 8ins:20cm.

Vesuvius is an intermittently active volcano near Naples in Italy. Tourists on the Grand Tour made a point of visiting the excavations at nearby Pompeii and Herculaneum, and afterwards it became a matter of honour to make the difficult ascent of the mountain.

"Vevay"

Henshall & Co. Fruit and Flower Border Series. Plates 6ins:15cm and 6¾ins:17cm. Ill: Arman 344.

This title has long puzzled collectors. The same border was used for both American and European views. Some think the view may show Vevay in Indiana, others that it may be Vevey at the head of Lake Geneva in Switzerland, some ten miles south east of Lausanne, which was noted for the manufacture of hats and had a large trade in cheese. The regicide General Edmund Ludlow who escaped to Switzerland after the restoration in 1660 died at Vevey in 1692.

"Victoria"

Clyde Pottery Co. A pattern which shows a horseman in top hat prancing in front of a country house before which are standing ladies in Regency-style costume. This attribution is the result of excavations on the site. The reason for the title is obscure.

"Victors Crowned"

Thomas Mayer. "Olympic Games" Series. Soup tureen stand. Ill: P. Williams p.512.

"View in Alicata"

Don Pottery and Joseph Twigg, Newhill Pottery. Named Italian Views Series. Plate 10ins:25cm. Ill: Lawrence p.88.

A description of 1810 states that Alicata "the Leocata of the Ancients, a town of Noto in Sicily, is remarkable for corn and good wine". It is now known as Licata, a seaport on the south coast at the mouth of the Salso River. American troops landed at Licata during the invasion of 1943.

"View from Blackheath"

Goodwins & Harris. "Metropolitan Scenery" Series. Dish 13½ins:34cm.

A contemporary description (1810) refers to Blackheath as "a fine elevated plain, adorned with several fine seats, an hospital for decayed merchants etc., and commanding rich and beautiful prospects".

"View of Brecknock"

Maker unknown. "Diorama" Series. Dish 12½ins:32cm.

Brecknock was the old Welsh county of Breconshire. Together with Montgomeryshire it now forms part of Powys. The main towns were Brecon and Hay-on-Wye.

"View near Bristol, River Avon"

Pountney & Allies/Pountney & Goldney. Bristol Views Series. Dish 16ins:41cm. Ill: Coysh 2 71.

This view shows the limestone cliffs of the Avon Gorge rising steeply from the river, up which ships sailed to Bristol harbour. Two men can be seen tending the lime kilns in the foreground. The source print, called "St. Vincent's Rock", appears in *The Beauties of England and Wales* (1800).

"**View near Bristol, River Avon.**" *Print entitled "St. Vincent's Rock" from "The Beauties of England and Wales", probably the source for the view in the Bristol Views Series.*

"**View near Bristol, River Avon.**" *Pountney & Allies/Pountney & Goldney. Bristol Views Series. Printed title mark. Dish 16ins:41cm.*

"View near Colnebrook." *Goodwins & Harris. "Metropolitan Scenery" Series. Printed titles mark. Hot water plate 9¾ ins:25cm.*

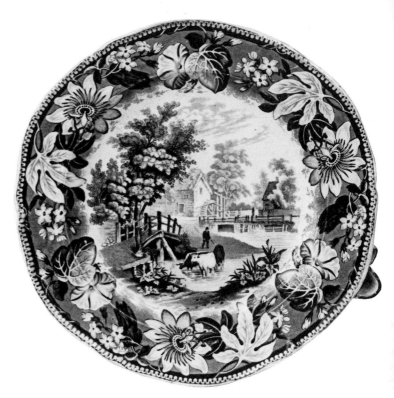

View on the Chitpore Road, Calcutta

An aquatint published in August 1797 based on a drawing and engraving by Thomas Daniell in *Oriental Scenery* (Part II, 2).

It was used to provide the right hand side and background of a design usually called the Eastern Street Scene, by John & Richard Riley. The remainder of the pattern comes from another Daniell print entitled "The Sacred Tree of the Hindoos at Gyah, Bahar" (Part I, 15). The pattern was also used by Samuel Alcock who took over the Riley pottery in 1829 and presumably inherited some of the copper plates. Ill: Coysh 1 74; Little 54.

"View near Colnebrook" (sic)

Goodwins & Harris. "Metropolitan Scenery" Series. Plate and hot water plate, both 9¾ ins:25cm.

Colnbrook is a village in Buckinghamshire, four miles to the north of Staines. It is noted for the Ostrich Inn which was originally a hospice in trust to the Abbey of Abingdon. The inn has had a long and eventful history. King John is said to have stopped here on his way to Runnymede and it was also involved in the Civil War.

"View of Corigliano"

Don Pottery and Joseph Twigg, Newhill Pottery. Named Italian Views Series. Dish 21ins:53cm. Colour Plate XVIII.

Corigliano is a town in Calabria near the Gulf of Otranto. It is noted for a fine castle.

"View of Dublin"

Enoch Wood & Sons. Shell Border Series. Dish 14½ ins:37cm, soup tureen stand and vegetable dish. Ill: Arman 145.

As with other items from the series, this view is a shipping scene. It shows the quays and docks at the mouth of the River Liffey.

"View of Eton Chapel"

Goodwins & Harris. "Metropolitan Scenery" Series. Dish 9¾ ins:25cm.

Eton College was founded by Henry VI in 1440. The famous chapel in the Perpendicular style dates from 1441 and together with the ante-chapel totals some 190 feet in length. The east front has polygonal turrets and the 15th century wall paintings are the most important of their kind in England.

"View of Eton Chapel." *Goodwins & Harris. "Metropolitan Scenery" Series. Printed titles mark and impressed Staffordshire knot. Dish 9¾ ins:25cm.*

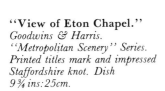

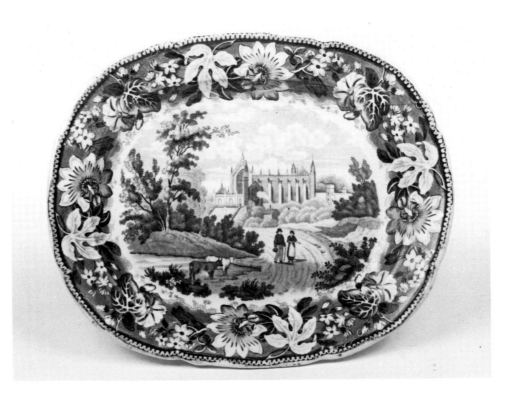

"View near Florence"

Enoch Wood & Sons. "Italian Scenery" Series. Plate 8½ ins:22cm.

Florence (Firenze) is one of the great art centres of the world. It is in central Italy, midway between the coasts. It was described in 1810 as "bounded on every side by an amphitheatre of fertile hills, adorned with villages, country-houses, and gardens".

View in the Fort, Madura

An aquatint published in November 1797 based on a drawing and engraving by Thomas Daniell in *Oriental Scenery* (Part II, 14).

It was used to provide the main building for a pattern in the India Series (qv), by the Herculaneum Pottery. The scene is framed in a border of various flowers and is composed from several prints. The main building is as above but with the addition of ruins from "Ruins at the Antient City of Gour formerly on the Banks of the River Ganges" (Part I, 4). An

elephant with howdah in the foreground is from "The Punj Mahalla Gate, Lucnow" (Part III, 5), and as with all these Herculaneum views the background is based on a "View in the Fort of Tritchinopoly" (Part II, 21). Ill: Coysh 2 43; Smith 158-159.

See: Musketeer.

"View in Glengyle"

James & Ralph Clews. "Select Scenery" Series. Plate 6½ ins:16cm.

The valley of Glengyle leads to the western end of Loch Katrine. The district is described in Sir Walter Scott's *Lady of the Lake*. The Glen was formerly a possession of the MacGregors.

"View of Greenwich"

(i) Goodwins & Harris. "Metropolitan Scenery" Series. Dish 21¼ ins:54cm.

(ii) Enoch Wood & Sons. Grapevine Border Series. Dish 15ins:38cm.

See: "Greenwich".

View in the Fort, Madura. *Herculaneum. India Series. Impressed maker's mark. Dish 13ins:33cm.*

"View of Greenwich." *Goodwins & Harris. "Metropolitan Scenery" Series. Printed titles mark and impressed Staffordshire knot. Dish 21¼ ins:54cm.*

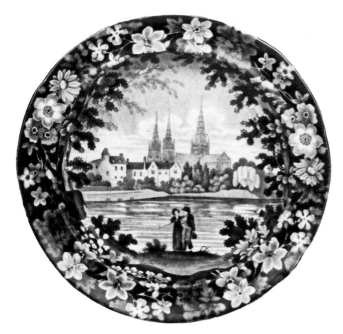

"View of Lichfield Cathedral." *Maker unknown. "Diorama" Series. Printed titles mark. Plate 7½ ins:19cm.*

"View of Houghton Conquest House, Bedfordshire"
Maker unknown. "Diorama" Series. Dish 21½ ins:55cm.

Houghton Conquest House was two and a half miles north of Ampthill but no longer exists.

View of the Imperial Park at Gehol
A Davenport pattern, previously called the Chinese River Scene, has now been identified as this view. It shows a junk sailing on a river with Chinese figures and buildings on the bank in the background. The scene is copied from John Barrow's *Travels in China,* published by T. Cadell and W. Davies in 1806. It is a relatively early topographical pattern, probably introduced around 1820. Ill: Coysh 1 28; Lockett 22.

"View of Lichfield Cathedral"
Maker unknown. "Diorama" Series. Plates 7½ ins:19cm, 8½ ins:22cm, 9ins:23cm, and soup plate 9ins:23cm. An example has been noted incorrectly titled "View of York".

Lichfield Cathedral was built mainly in the 13th and 14th centuries. It has three spires and is famous for its striking west front.

See: "Litchfield Cathedral" (sic).

"View of Liverpool"
Enoch Wood & Sons. Shell Border Series. Plate and soup plate, both 10ins:25cm. Ill: Arman 146.

As with other items from the series, this view shows a shipping scene. A sailing ship and a large rowing boat are seen on the River Mersey in the foreground with the city skyline including several churches in the background.

"View of London"
Thomas & Benjamin Godwin. This view is found on dinner wares and the maker has been identified by a single plate with an impressed mark "T. & B. GODWIN/NEW WHARFE".

The scene shows the 19th century London skyline with its elegant steeples and the majesty of St. Paul's Cathedral. Wider items such as tureens and dishes also show the Shot Tower on the south bank of the Thames which has long since disappeared. Colour Plate XIX. Ill: FOB 10.

"View in Palma." *Don Pottery. Named Italian Views Series. Printed title below view. Printed maker's mark. Plate 10ins:25cm.*

"View in Palma"
Don Pottery and Joseph Twigg, Newhill Pottery. Named Italian Views Series. Plate 10ins:25cm. Ill: Coysh 1 37; FOB 21; Lawrence p.88.

Palma di Montechiaro is a town on the south coast of Sicily, twelve miles south east of Agrigento.

"View of Richmond." *Enoch Wood & Sons. Grapevine Border Series. Printed title mark and impressed maker's eagle mark. Dish 12¾ ins:32cm.*

"View of Richmond"
(i) Goodwins & Harris. "Metropolitan Scenery" Series. Hot-water plate 9ins:23cm.

(ii) Enoch Wood & Sons. Grapevine Border Series. Dish 12¾ ins:32cm. See illustration on previous page.

See: "Richmond"; "Richmond Bridge"; "Richmond Hill".

"View of Rosedale"
Maker unknown. "Diorama" Series. Dish 9ins:23cm. One example has been noted with an engraver's error as "View of Rosedoe".

Rosedale is an area just to the north of Pickering and Helmsley in the old North Riding of Yorkshire.

"View of Southampton, Hants"
Maker unknown. "Diorama" Series. Dish 14ins:36cm.

See: "Southampton, Hampshire".

"View near Taormina"
Don Pottery and Joseph Twigg, Newhill Pottery. Named Italian Views Series. Plate 8½ ins:22cm.

The small medieval town of Taormina lies on the east coast of Sicily. It is now the island's major tourist resort.

"View of the Town and Harbour of Liverpool from Seacombe"
Maker unknown. This title has been recorded on a dish (19ins:48cm) with a shipping scene. The river in the foreground has a mixture of boats including a fine sailing ship and a paddle steamer. In the background can be seen the river front with churches and other buildings. The border is very similar to that found on another view by an unknown maker entitled "Foremark, Derbyshire, the Seat of Sir Franˢ Burdett, Bart" (qv). The printed title mark is also of similar style but is not identical.

"View near Twickenham"
Goodwins & Harris. "Metropolitan Scenery" Series.
See: "Tweekenham, Surrey" (sic).

"View in the Valley of Oretho near Palermo"
Don Pottery and Joseph Twigg, Newhill Pottery. Named Italian Views Series. Dish 12½ ins:32cm, and deep dish 11½ ins:29cm.

Palermo is the capital of Sicily, on the north coast of the island. The best view of the Oretho valley is said to be from the garden of the Benedictine Monastery, not far from the city.

View of Whitby
See: Whitby Harbour.

"View of Worcester"
Enoch Wood & Sons. Grapevine Border Series. Dish 12ins:30cm.

See: "Worcester"; "Worcester Cathedral".

"View of the Town and Harbour of Liverpool from Seacombe." *Maker unknown. Printed title mark.*

"View of the Town and Harbour of Liverpool from Seacombe." *Maker unknown. Printed title cartouche. Dish 19ins:48cm.*

Colour Plate XXVIII. Chinoiserie Ruins. *Attributed to Ralph Stevenson. Impressed mark "STEVENSON". Soup plate 9½ ins:24cm.*

Colour Plate XXIX. "Rural Scenery." *Davenport. Printed floral cartouche with title and maker's name below. Impressed maker's anchor mark. Dish 16¾ ins:42cm.*

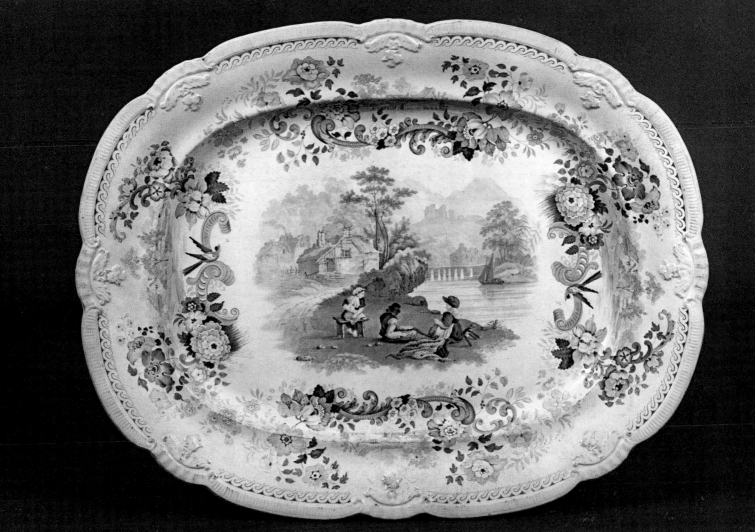

"View of York." Maker unknown. "Diorama" Series. Printed titles mark. Plate 9¾ ins:25cm.

"Vignette" Series. Reaping scene. John Denton Bagster. Printed series title mark with the maker's initials I.D.B. Plate 9¾ ins:25cm.

"View of York"

Maker unknown. "Diorama" Series. Plate 9¾ ins:25cm, and soup plate 8¾ ins:22cm.

This view shows the skyline of York with its churches in the background. In front is the river with a fishing boat and figures on the nearside bank. The famous Minster does not appear.

"Views of London" Series.

A series of views by John Goodwin of the Seacombe Pottery, Liverpool, in borders of architectural medallions. Examples are titled beneath the view. The printed mark is in the form of a garter surmounted by a bird with "J. Goodwin" and "Views of London" within and the inscription "Seacombe Pottery, Liverpool" below. Only one example, "Royal Exchange", has been recorded to date.

"Views of Mesopotamia"

James Keeling.

Mesopotamia, a Greek word meaning the land between two rivers, was the name given to the country between the upper reaches of the Tigris and the Euphrates. The Tigris is now called Nahr Dijlah and the Euphrates Nahr al Furat. Mesopotamia, now Al Jazirah, is mainly in Iraq but extends into Syria. Little states that James Keeling used illustrations from Buckingham's *Travels in Mesopotamia* (1828) and this could well be the source of these views. Ill: P. Williams p.169.

"Vignette"

(i) John Denton Bagster. A series of rural scenes marked with the initials I.D.B. See below.

(ii) Thomas Dimmock.

"Vignette" Series

A series of rural scenes which were made by John Denton Bagster, sometimes called Baxter, under the general title "Vignette". The title refers to the design in which the scene occupies a small vignette within a broad border of flowers and floral scrolls. Items bear a cartouche mark with the title, initials I.D.B., and a Staffordshire knot. An impressed Staffordshire

"Vignette" Series. John Denton Bagster. Printed series mark with impressed Staffordshire knot.

knot was also used. Three scenes have been noted to date:

(i) Horses trotting across a field in front of a cottage. Dish 21¼ ins:53cm illustrated by J.K. des Fontaines in *Underglaze Blue-Printed Earthenware* (See: Bibliography).

(ii) Woman with basket out walking with a small boy; cottages and a church in the background. Ill: Godden I 21.

(iii) Reaping scene (illustrated above).

"Villa"

(i) William Ridgway & Co.
(ii) William Ridgway, Son & Co.

A romantic view with a bridge and classical buildings within a medallion border of architectural scenes. Printed urn and anchor cartouche similar to Godden M 3303a and 3308. There was considerable interchange between the various William Ridgway partnerships and many designs are common to more than one of the factories.

"Villa Borghese, near Florence"

Enoch Wood & Sons. "Italian Scenery" Series. Plate 7½ins:19cm.

The Villa Borghese, built by Cardinal Scipione Caffarelli-Borghese is, in fact, in Rome. Its grand collection of works of art was sold to Napoleon in 1806 and the villa now belongs to the Italian state.

"Villa on the Coast of Posilepo"

Enoch Wood & Sons. "Italian Scenery" Series. Vegetable dish and cover.

Posilepo is the long promontory which separates the Bay of Pozzuoli from the Bay of Naples. It has always been a fashionable residential area.

"Villa D'Este"

Moore & Co. This view shows Queen Caroline's house on Lake Como in Italy, titled on a rock in the foreground. The Queen and Count Bartolommeo Bergami are sitting in a royal barge beneath an awning, being rowed across the lake. There is a very narrow border of scrolls. The design is also known in black. Ill: May 58.

The villa played a leading role in a scandal in which there were moves to deny Queen Caroline her title. A Bill to deprive her of her rights was introduced to Parliament in 1820 when it was alleged that she had committed adultery with the Count. However, she was extremely popular with the people and the Bill was eventually withdrawn.

See: Queen Caroline.

"Villa in the Regent's Park"

Enoch Wood & Sons. "London Views" Series. Two different views were produced under this title, both identifiable from the source prints in *Metropolitan Improvements*:

(i) The Residence of John Maberly Esq. Cup plate 4¾ins:12cm. This view was also used by William Adams (see overleaf).

(ii) The Residence of the Marquis of Hertford. Vegetable dish and cover. Once again, this view was also used by William Adams.

"Villa in the Regent's Park, London." *The residence of G.B. Greenough, Esq. William Adams. Regent's Park Series.* **Printed title mark and impressed maker's eagle mark. Plate 9ins:23cm.**

"Villa in the Regent's Park, London." *The residence of G.B. Greenough, Esq. Source print for the Adams view above from the Regent's Park Series taken from Shepherd's "Metropolitan Improvements".*

"Villa in the Regent's Park, London"

William Adams. Regent's Park Series. Three different views were produced under this title, each identifiable from the source prints in *Metropolitan Improvements*:

(i) The Residence of G.B. Greenough, Esq. Plate and soup plate, both 10ins:25cm and plate 9ins:23cm. The source print is accurately copied except for the addition of a man and

"**Villa in the Regent's Park, London.**" *The residence of John Maberly, Esq. William Adams. Regent's Park Series. Printed title mark and impressed maker's eagle mark. Plate 8¾ ins:22cm.*

woman walking in the foreground (see illustrations on previous page). Greenough was a geographer and geologist who founded the Geological Society of London and was its first president. The villa was designed by Decimus Burton. Ill: Laidacker p.7; Little 5.

(ii) The Residence of the Marquis of Hertford. Plate 9ins:23cm. This Italian villa was also designed by Decimus Burton and was on a larger scale than any other in the park. Francis Seymour, second Marquis of Hertford, as Lord Chamberlain of the Household from 1812 to 1821. The pattern has a group of three people and two dogs in the foreground.

(iii) The Residence of John Maberly, Esq. Plate 8¾ ins:22cm. This villa was named St. John's Lodge and its owner, John Maberly, was a Member of Parliament. There are two people in the foreground of the pattern and a groom with horse and chaise in front of the villa.

Village Church

Maker unknown. A widely accepted name for a rural scene which shows a central church with a square tower, a thatched cottage to the right, two men standing talking by a gate on the left, and three sheep in the foreground. The scene appears within a floral border, similar in appearance to the "Wild Rose" border. The pattern is found on a wide variety of wares and is relatively common. At least two marks are known, one a printed cartouche with the title "Rural Village", the other a printed name and address mark for the London retailer Jesse Phillips (qv). No examples with a maker's mark have so far been reported despite the fact that the pattern is frequently encountered. It appears likely that it was used by several different potters, none of whom marked their wares. Ill: Coysh 1 150; Little 72.

"**Villa in the Regent's Park, London.**" *The residence of John Maberly, Esq. Source print for the Adams view above from the Regent's Park Series taken from Shepherd's "Metropolitan Improvements".*

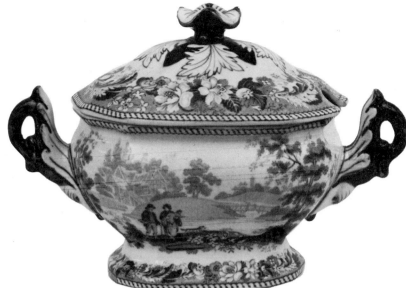

Village Fishermen. *Attributed to J. & W. Handley. Unmarked. Soup plate 9¾ ins:25cm.*

The Villager. *Attributed to Turner. Unmarked. Sauce tureen and cover. Length 8¾ ins:22cm.*

Village Fishermen

J. & W. Handley. A scene used on dinner wares showing two fishermen with cows in the foreground, in front of an arched bridge with a village behind on the far bank. The maker has been identified by one marked item reported from America. Ill: Coysh 1 170.

A slight variant of this design has been noted within the border from the "British Scenery" Series (qv).

Village Scene

A very rare Spode design known only on a small circular toilet box and the lid from a toilet tray. The lids show a man and woman dancing beneath a tree while another man plays a serpent, whereas the box base has a scene of villagers grouped around a decorated pole. There is a narrow edging of continuous scrolls against a blue ground. Ill: Coysh 2 86; Whiter 64.

The Villager

This name is widely accepted for a rural scene which shows a villager with his wife and child, standing in front of a river with a cottage and footbridge in the background. At least four variants exist, by three different potters:

(i) Turner. The central scene is printed on dinner wares with a moulded rim, the rim also printed with separate sprays of flowers. Examples are marked "TURNER". Ill: Coysh 1 131.

(ii) Turner. The same central scene but printed within a floral border of the type fashionable in the 1820s. Examples are known on a variety of shapes including dinner and dessert services, toilet wares, and jugs. The marks noted include "TURNER", either impressed or printed.

(iii) Marsh. A version similar to (ii) with the same floral border, but bearing an impressed mark "MARSH".

(iv) Heathcote & Co. Once again similar to (ii) with the floral border, but impressed "HEATHCOTE & CO."

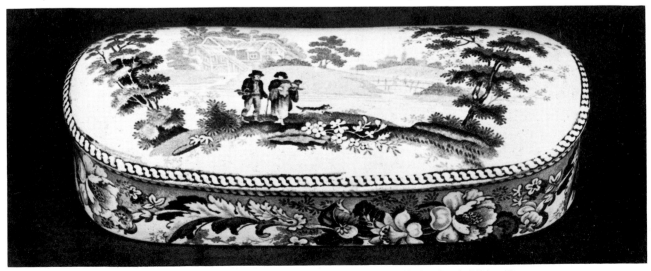

The Villager. *Turner. Prominent printed maker's mark. Toilet box length 7½ ins:19cm.*

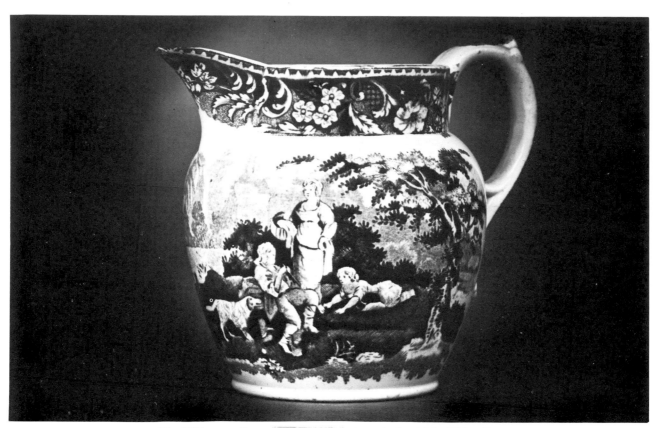

The Villagers. *Davenport. Printed maker's mark. Jug height 4¾ ins:12cm.*

"Vintage." *Maker unknown. Printed title mark. Jug height 6¼ ins:16cm.*

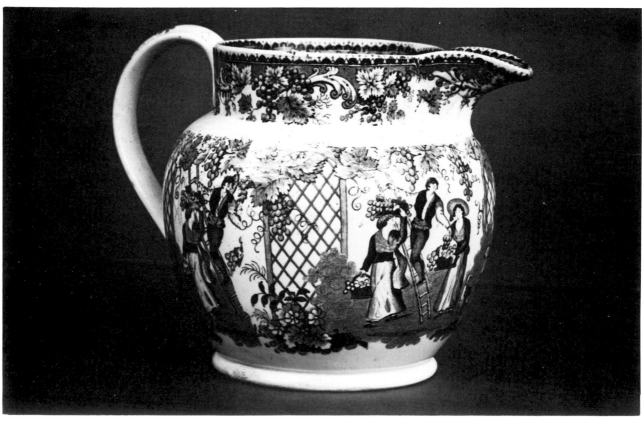

The Villagers
Davenport. This name is widely accepted for a rural scene with
a village in the background. A group of figures feature a boy
blowing bubbles from a pipe, a standing woman, a sprawling
child, and a watching dog. The border consists of flowers and
scrolls against a stippled ground. The design is printed in a
fairly dark blue on dinner wares which appear to date from the
1820s. Ill: Coysh 1 33.

"Vine"
(i) Baker, Bevans & Irwin, Swansea. A pattern of vine leaves
and grapes. Ill: Nance XC (I).
(ii) John Rogers & Son. A small central scene with classical
ruins, figures and sheep, all within a wide border of grape-
bearing vines and stylised flowers.

"Vintage"
(i) John Meir & Son.
(ii) Maker unknown. A design showing a man up a ladder
picking grapes and passing them down to a girl, illustrated
opposite on a jug. The title appears in a simple vine cartouche.

"Vintage of Sorrento"
Copeland & Garrett. Seasons Series.
The usual vase included in the foreground of this design
bears the inscription "AUTUMN". The seaport of Sorrento
lies about sixteen miles south of Naples in Italy. It is celebrated
for its fine wine.

"Virginia"
(i) James & Ralph Clews. A light blue design recorded on
both dinner and tea wares, also known in black, purple and
sepia.
(ii) Lockhart & Arthur.
Virginia is a state on the east coast of the United States but
these patterns are probably not topographical. It is quite likely
that the makers chose the girl's name simply for a decorative
title.

"Virginia Water"
Ralph Stevenson. "Lace Border" Series. Plate 7½ ins:19cm.
This Surrey lake is one and a half miles long and lies in the
south of Windsor Great Park. It was formed by the Duke of
Cumberland, the victor of Culloden. Notable features are the
cascade, cavern, and a colonnade brought by George IV from
the ruins of Leptis Magna in Tripoli.

"Virtute et Industria"
By virtue and industry. A motto associated with the coat-of-
arms of the City of Bristol which were recorded and confirmed
in 1569.
A blue-printed plate decorated with the coat-of-arms of the
city was part of a service made by Pountney & Allies of Bristol
in 1828 for use in the Mansion House. The design utilises a
border which is a close copy of one used by John Rogers & Son
for their Elephant pattern. Ill: Coysh 1 82; Little 58. It is
believed that this dinner service was engraved by a recruit from
Staffordshire named Wildblood (qv).
See: Armorial Wares.

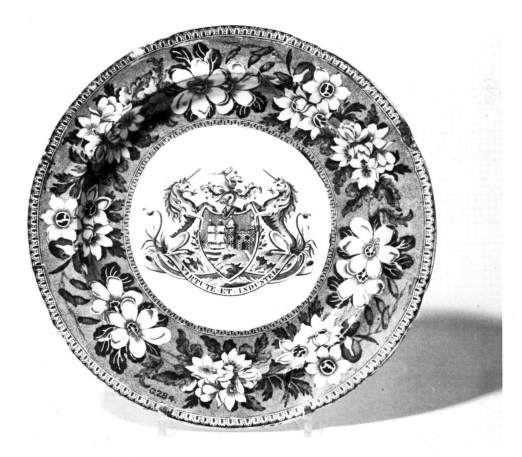

"Virtute et Industria." *Arms of the City of Bristol. Attributed to Pountney & Allies. Unmarked. Plate 9½ ins:24cm.*

"Vista"
Francis Morley & Co. A romantic scene with a vista between two trees which form an arch. In the foreground are steps, a typical urn on a pedestal, and figures. In the distance is a lake and a castle. The border is of flowers and prominent vine leaves. Ill: P. Williams p.463.

"Vista de la Habana"
This title has been noted on a shaped-edge dessert plate with a scene within a lacy border made up with alternate flower groups with and without vases. The title is printed in script within a drape and scroll cartouche.
 See: "Habana".

"Vue d'une Ancienne Abbaye"
Enoch Wood & Sons. French Series. Plate 9¼ ins:23cm. Ill: Arman S 204.
 With such a general title it has not yet proved possible to locate this view.

"Vue du Chateau de Coucy"
Enoch Wood & Sons. French Series. Plate 10¼ ins:26cm, and soup plate 10ins:25cm.
 Coucy-le-Chateau lies on the River Oise, ten miles north of Soissons. The castle was a perfect example of a feudal stronghold but was blown up by the Germans during their retreat from the Somme in March 1917.

"Vue du Chateau Ermenonville"
Enoch Wood & Sons. French Series. Plates 9ins:23cm and 10ins:25cm, dish 14ins:36cm, soup tureen stand and cover. Ill: Arman S 206.
 See: "Vue du Temple de Philosophie, Ermenonville".

"Vue de la Porte Romaine a Andernach"
Enoch Wood & Sons. French Series. Plates 4½ ins:11cm, 6½ ins:16cm and 9¼ ins:23cm. Ill: Atterbury p.211.
 Andernach is a port on the west bank of the Rhine, ten miles north west of Coblenz. It was ruled by the electors of Cologne but became Prussian in 1815. It is now in Germany.

"Vue Prise aux Environs de Francfort"
Enoch Wood & Sons. French Series. Plate 6½ ins:16cm. Ill: Atterbury p.211.
 This view probably depicts Frankfurt-am-Main which was part of Prussia but is now in Germany. In the early 19th century it was noted for its two great annual fairs.

"Vue Prise en Savoie"
Enoch Wood & Sons. French Series. Plate 7¾ ins:20cm, and bowl 6½ ins:16cm. Ill: Arman 208.
 Savoy was an old province of Italy until it became part of the Duchy of Savoy. In 1792 it was annexed by France but this lasted only until 1815, although it was eventually ceded to France in 1860. It became part of the Department of Savoie and is one of the most beautiful districts with part of the shores of Lake Geneva and the high Alps culminating in Mont Blanc (15,781ft.).

"Vue du Temple de Philosophie, Ermenonville"
Enoch Wood & Sons. French Series. Dish 17ins:43cm.
 Ermenonville is a French village in the Department of Oise, seven miles from Senlis. It is associated with the philosopher Jean Jacques Rousseau. The Marquis of Girarden offered him a permanent home at the Chateau d'Ermenonville and it was there that he died in 1778.

"Vue d'une Ancienne Abbaye." Enoch Wood & Sons. French Series. Printed title mark and impressed maker's eagle mark. Plate 9¼ ins:23cm.

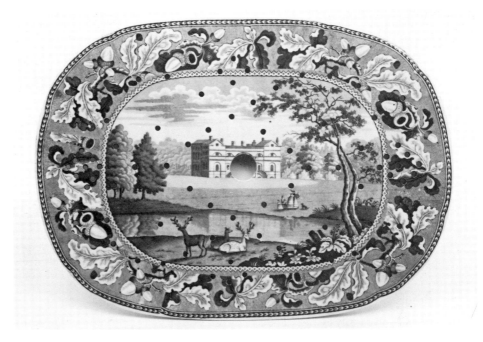

"Wakefield Lodge,
Northamptonshire." Maker
unknown. Crown Acorn and Oak
Leaf Border Series. Printed mark
with incorrect title "Luscombe,
Devon". Drainer 13¼ ins:34cm.

"W"

This impressed initial has been noted on several relatively early blue-printed items. If intended as a potter's mark it may have been used by several contemporary firms, notably John Warburton, Thomas Wolfe and Enoch Wood.

"Wadham College, Oxford"

John & William Ridgway. Oxford and Cambridge College Series. Dish 17ins:43cm, and pierced basket.

Wadham College was built between 1610 and 1613 and has remained virtually unchanged. It was here that the Royal Society was founded.

"Wakefield Lodge, Northamptonshire"

Maker unknown. Crown Acorn and Oak Leaf Border Series. Dish 14ins:36cm, tall comport and drainer 13¼ins:34cm (drainer mismarked "Luscombe, Devon").

Wakefield Lodge, in Whittlewood Forest near Pottersbury, was built in about 1745 by Kent for the second Duke of Grafton. It was intended as a hunting lodge and has extensive stables.

Walker & Carter fl.1866-1889

British Anchor Pottery, Longton (until 1872) and then Stoke, Staffordshire. This firm used the initials W. & C. as part of printed marks although the same initials were used earlier by Wood & Challinor (qv).

Walker, Thomas fl.c.1845-c.1853

Lion Works, Tunstall, Staffordshire. This potter marked his wares with either "T. WALKER" or "THOS. WALKER". The initials T.W. may also have been used but they could equally apply to other firms of the same period.

Wall, W.G.

An Irish artist who went to America in 1818 to sketch scenes which could be reproduced as engraved prints on blue-printed wares. He worked for both James & Ralph Clews and Andrew Stevenson and his name is printed on the marks of some items. As far as is known, he was associated only with American scenes.

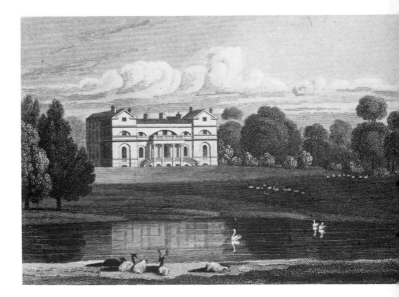

"Wakefield Lodge, Northamptonshire." Source print for the Crown Acorn and Oak Leaf Border Series taken from Neale's "Views of the Seats of Noblemen and Gentlemen in England and Wales, Scotland and Ireland".

Wallace, James, & Co. fl.1838-1892

Newcastle Pottery, Forth Banks, Newcastle-upon-Tyne, Northumberland. This firm traded as J. Wallace & Co. between 1838 and 1857 and then became simply Wallace & Co. Blue-printed wares were produced including some designs titled "Rural Scenery". Examples have been noted with an impressed mark "WALLACE & CO.", presumably made after 1857, and also with initials J.W. & Co. added to the printed cartouche. These would refer to the period before 1857 but were also used by J. Wileman & Co.

See: Wileman Family.

Walley, Edward fl.1845-1856

Villa Pottery, Cobridge, Staffordshire. The major product at this pottery appears to have been moulded jugs although ironstone china with printed decoration was also made. A variety of printed and impressed marks were used with the surname in full and either the initial E or the full christian name. The printed initial W has also been attributed to this potter.

Walsh

A dish printed with the India Series pattern identified as View in the Fort, Madura (qv) has been noted with the printed mark "WALSH" which may be a printer's or retailer's mark. A firm called Walsh & Eardley did exist in Liverpool in the early 19th century. Their name has been recorded as part of the printed design on a creamware jug with prints of the Farmers' Arms and Charity (See: Godden M 3997).

"Walsingham Priory, Norfolk"

Andrew Stevenson. Rose Border Series. Dish 19ins:48cm.

Walsingham Priory is a ruined Augustinian house in the valley of the River Stiffkey about five miles south east of Wells. It was founded as the Shrine of Our Lady in the 11th century and became a priory between the 12th and 16th centuries.

"Waltham Cross"

Goodwins & Harris. "Metropolitan Scenery" Series. Plate 6½ins:16cm.

Waltham Cross is a district in Cheshunt, Hertfordshire. It has one of the crosses erected by Edward I to commemorate the resting places of the body of Queen Eleanor on its way to Westminster Abbey in 1290.

The Wanderer

A name used for a design produced at the Leeds Pottery. It shows a man with a bundle over his shoulder accompanied by his dog, standing in front of some cottages. It has an interesting border composed of a folded ribbon on a vermicelli background. Some examples are marked "HARTLEY GREENS & CO./LEEDS POTTERY" impressed in a semi-circle. The pattern is known on coffee and tea wares.

"Waltham Cross." *Goodwins & Harris. "Metropolitan Scenery" Series. Printed titles mark. Plate 6½ins:16cm.*

"Wanstead House, Essex"

Andrew Stevenson. Rose Border Series. Vegetable dish.

This large classical mansion was built by Colen Campbell for Sir Richard Child who had inherited a fortune from his father Sir Josiah Child, chairman of the East India Company. It was started in 1715 and the building was some 260 feet in length. The house no longer exists.

The Wanderer. *Leeds Pottery. Impressed mark on plate "HARTLEY, GREENS & CO." Plate 7½ins:19cm. Lidded box height 3½ins:9cm.*

"Wardour Castle, Wiltshire"

Enoch Wood & Sons. Grapevine Border Series. Plate 10ins:25cm.

Wardour Castle, fifteen miles west of Salisbury near Tisbury, was designed by James Paine in 1768 for the eighth Lord Arundel. It is a magnificent Palladian house which was restored in 1960 for Cranborne Chase School. It is open to the public on certain days in the summer.

"Warkworth Castle, Northumberland"

James & Ralph Clews. Bluebell Border Series. Plate 8ins:20cm.

The castle at Warkworth dates back to the 12th century. It came into the possession of Henry, second Lord Percy of Alnwick, in 1302 and was extensively remodelled and extended in the 14th and 15th centuries. It lies near the mouth of the River Coquet, seven miles south east of Alnwick, and was presented to the nation by the Duke of Northumberland.

"Warleigh House, Somersetshire"

Ralph Hall. "Select Views" Series. Plate 9ins:23cm.

Warleigh is a picturesque Tudor-style villa near Bathford built in about 1814 with castellated towers.

"Warranted Ironstone China"

The trade name for a stone china body found on blue-printed wares by Baggerley & Ball, and by Batkin, Walker & Broadhurst.

"Warren"

This name has been recorded printed within a laurel wreath on examples of the "Irish Scenery" Series by Elkins & Co. Its significance is not yet known but it may relate to a retailer.

"Warwick Castle"

Enoch Wood & Sons. Grapevine Border Series. Plate 10ins:25cm. Ill: Moore 21.

Untitled views of the castle have been seen on unmarked blue-printed wares and a view was also produced by Elkins & Co. in their so-called "Irish Scenery" Series.

Warwick is a medieval castle on a steep cliff above the River Avon, eight miles from Stratford. The fortifications, towers

"Warren." Typical printed mark on a soup plate by Elkins & Co. in their *"Irish Scenery"* Series together with the possible retailer's mark *"WARREN".*

and dungeons are 14th century while the grounds were landscaped by Capability Brown. It is open to the public throughout the year.

Warwick Castle. *Elkins & Co. "Irish Scenery" Series. Printed royal arms mark with series title and maker's name. Dish 17ins:43cm.*

"Warwick Vase." *Maker unknown (possibly an Elkin partnership). Printed title cartouche with initials E. & Co. Plate 7ins:18cm.*

"Warwick Vase"

(i) J. & M.P. Bell & Co.

(ii) Copeland & Garrett. A design with the Warwick Vase within a wide border of acanthus scrolls. Ill: Whiter 77.

(iii) Elkin & Newbon.

(iv) Enoch Wood & Sons. A pattern with a castle in the background, a lake with a boat, and a prominent "Warwick Vase" on a rectangular platform. The border is of scrolled vignettes, each with a vase. Ill: P. Williams p.82.

(v) Maker unknown with initials E. & Co. A pattern almost identical to (iv) above. This appears to date from about 1840. The initials may relate to an Elkin partnership.

The Warwick Vase is thought to have been made by Greeks employed by Hadrian in Rome in the 2nd century A.D. Fragments of the marble vase were found in 1770 by the Scottish painter Gavin Hamilton (1723-98) in the lake of Pantanello near Tivoli. The fragments were acquired by the famous collector Sir William Hamilton (qv) who arranged for its restoration and attempted to sell it to the British Museum. However, it was eventually acquired by his nephew, George Greville, Earl of Warwick, and it was transferred to Warwick Castle in 1774 where it remained for over two hundred years. In 1977 it was acquired for the Burrell Collection and is now in the possession of the City of Glasgow Museums and Art Galleries. A booklet by Richard Marks and Brian J.R. Bleuch, *The Warwick Vase,* is available from Glasgow Museums.

Washbasin

A heavy earthenware basin with a metal plug hole, made to fit into a wooden washstand.

Washbowl

Many washstands were fitted with washbowls rather than basins. The difference is slight but bowls were made without a metal plug hole and hence without any easy way of disposing of the dirty water. There is also often a deep footrim made to fit into a Sheraton-style corner washstand. Washbowls have an outward flaring rim and, of necessity, tend to be larger than other types of bowl. In Victorian times most bedrooms had a ewer and washbowl on a marble-topped washstand and the dirty water was carried away in a slop pail, sometimes made of earthenware, with a cane handle.

"Washington"

Clyde Pottery Co.

"Washington Vase"

(i) Podmore, Walker & Co. and their successors Wedgwood & Co. A design which is usually found in mulberry but is also known in light blue. The main feature is a large covered vase set against a background of buildings and mountains. The body is "Pearl Stone Ware". Ill: P. Williams p.84.

(ii) Enoch Wood & Sons. This design is mentioned by Moore (p.22) and he describes the mark with the title, the name of the body "Pearl Stoneware", and the initials E.W. & S.

Waster

A spoiled fragment of pottery which has been discarded at the works during manufacture, usually on or near the site of a kiln. Wasters play an important part in the work of industrial archaeologists by helping to identify the types of ware made at the pottery, which may have been closed for many years.

Water Girl

A title used by Laidacker for a pattern by James & Ralph Clews. It shows a girl at a well accompanied by her dog, all within a border of flowers and large scrolls, and was printed in dark blue on tea and toilet wares. Ill: Laidacker p.36.

Water Lily

This Wedgwood design is also known as the Lotus pattern. It was introduced in 1808 when it was printed in brown within the border of interlacing rings used on other botanical patterns. In 1811 it was issued in blue but the border was changed to a cut-reed design.

It is a composite pattern based on four different prints which were listed by Una des Fontaines in the *Proceedings of the Wedgwood Society,* No. 6, pp.83-88. Three flowers are used:

(i) *Nelumbium speciosum,* or the Sacred Lotus of Buddha. This

Water Lily. *Wedgwood. Impressed maker's mark. Plate 9¾ins:25cm.*

forms the central part with the large open flower and is based on a print in *The Botanical Magazine* for February 1806, Plate 903.

(ii) *Nymphaea stellata,* or the Starry Water Lily. This provides the open flowers on either side which are based on a print in the *The Botanist's Repository* for October 1803, Plate 330.

(iii) *Nymphaea lotus,* or the Lotus of Egypt. This forms the rest of the design including the smaller flower on the right. It is taken from two prints, one in *The Botanical Magazine* for December 1804, Plate 797, and the other in *The Botanist's Repository* for September 1804, Plate 391.

Watermill
A watermill is a relatively common feature on patterns showing rural scenery.

See: Mill Scene; Monk's Rock Series; Rustic Scenes Series.

Watson, William fl.c.1750-1820·
Watson's Pottery, Prestonpans, Scotland. This firm traded under the family name of Watson until about 1800 when it became Watson & Co. According to Fleming there were financial problems which culminated in a change to Fowler, Thompson & Co. from about 1820, although the name Watson's Pottery continued to be used, at least locally. The early years of the 19th century saw the introduction of blue transfer-printing and some very good quality wares were made with views of Edinburgh. A Watson & Co. jug is illustrated in Godden BP 320. The marks used were restricted to the names "WATSON" impressed, "WATSON & CO." printed, or "FOWLER, THOMPSON & CO.", either printed or impressed. Some rectangular marks bear a title only.

"Watteau"
(i) Francis Morley & Co. A flow-blue pattern used on dinner wares and marked with the initials F.M. & Co.

(ii) John Thomson. An Italianate scene with a man, woman, and two children, and a background of mountains. There is a medallion border.

The title is puzzling. It is possible that the potteries were simply using the name of the brilliant French artist Jean Watteau (1684-1721).

"Waverley"
Davenport. "Scott's Illustrations" Series. Plate 9¾ ins:25cm, and soup plate 10¼ ins:26cm. Ill: Lockett 36.

Sir Walter Scott's *Waverley* was first published in 1814. The pattern is based on a print after F.P. Stephanoff's "Flora Playing to Waverley in the Glen of Glennaquoich". It was engraved by R. Graves and was published in the Magnum Opus edition of Scott's works by Robert Cadell between 1829 and 1833.

"Flora introduced a few irregular strains which harmonised well with the distant waterfall, and the soft sigh of the evening breeze in the rustling leaves of an aspen which overhung the seat of the fair harpist."

F. P. Stephanoff. R . Graves.

WAVERLEY.

Flora introduced a few irregular strains which harmonized well with the distant waterfall, and the soft sigh of the evening breeze in the rustling leaves of an aspen, which overhung the seat of the fair harpress.

"Waverley." *Above: Davenport. "Scott's Illustrations" Series. Printed royal arms mark with "IRONSTONE" below and initials D and W on either side. Impressed maker's anchor mark with indistinct date, possibly 1860. Soup plate 10¼ ins:26cm.*

"Waverley." *Left: Source print for the "Scott's Illustrations" Series taken from the Magnum Opus collected edition of Scott's works, 1829-33.*

"Wear Sc."

This signature has been recorded within the design on examples of Andrew Stevenson's Chinese Traders pattern (See: Coysh 2 104) and has also been noted on the Chinese Market Stall pattern (qv). It is the signature of the engraver and is almost certainly related to the firm of Bentley, Wear & Bourne (qv) of Vine Street, Shelton. Current knowledge suggests that this partnership started in 1815 and since both these designs appear to have been engraved prior to this date, it is possible that Wear was previously trading alone.

"Wearied Poles"

Edward & George Phillips. "Polish Views" Series. Dish 9½ins:24cm.

Wedg Wood, John

This potter's surname was Wood and the christian name Wedg, a fact which leads to some confusion.

See: Wood, John Wedg.

"Wedgewood"

A mark used by William Smith & Co. at the Stafford Pottery, Stockton-on-Tees. Despite the spelling, it was clearly intended to mislead buyers into thinking that such wares were made by Josiah Wedgwood. In 1848 Wedgwood obtained an injunction against Smith to prevent the use of these marks.

Wedgwood

The name Wedgwood is one of the most famous in the pottery trade. Apart from the prestigious firm founded by Josiah Wedgwood, it can be found in the marks of several other potteries. These include Wedgwood & Co. of Ferrybridge, run by Josiah's nephew Ralph Wedgwood, and the later firms of Podmore, Walker & Wedgwood and their successors Wedgwood & Co. The name was also used deceptively by John Wedg Wood, whose surname was actually Wood, and by William Smith & Co. of the Stafford Pottery, Stockton-on-Tees.

Wedgwood. *A late chinoiserie-style pattern c.1830. Impressed maker's mark. Plate 8½ ins:22cm.*

The Wedgwood Factory fl.1759 to present

The firm founded by Josiah Wedgwood I has always been known by the single surname despite several partnerships which included one or more sons. The firm operated at Brick House, Burslem until the famous Etruria works were opened in 1769.

The first blue-printed design, introduced in 1806, was the Chinese Vase pattern, sometimes called simply Blue Chinese (Ill: Coysh 1 133). This was followed before 1810 by several other designs including the Blue Bamboo (or Chinese Garden), Hibiscus, Peony and Water Lily patterns (Ill: Coysh 1 134, 1 132, 2 122, 2 119). These were in turn followed by a whole series of botanical patterns based on prints in journals such as *The Botanical Magazine,* which reflected the personal interests of John Wedgwood. A range of single-pattern dinner services followed — Absolom's Pillar (Ill: Coysh 1 137), Blue Claude (Ill: Coysh 2 124; Little 73), and the Crane pattern (Ill: Coysh 2 123). A slightly later series with views, some British and some Continental, was printed within a border of roses which was widely copied by other firms. These views are listed as the Blue Rose Border Series although they are sometimes simply called Landscape.

Throughout the period under consideration here the standard mark was the impressed name "WEDGWOOD". The size and positioning of the name varies and early wares usually have a pair of impressed letters, figures or other devices. Wares made after 1860 also bear impresssed coded date marks which consist of a group of three letters, e.g. CRB. The *last* letter in the group indicates the year of potting (which may be slightly earlier than the date of decoration and sale). The following key may be used to obtain the appropriate date:

O — 1860	V — 1867	C — 1874	I — 1880
P — 1861	W — 1868	D — 1875	J — 1881
Q — 1862	X — 1869	E — 1876	K — 1882
R — 1863	Y — 1870	F — 1877	L — 1883
S — 1864	Z — 1871	G — 1878	M — 1884
T — 1865	A — 1872	H — 1879	N — 1885
U — 1866	B — 1873		

After 1885 the year letters were repeated in sequence. Hence the letter P, for example, could refer to either 1861 or 1887 and it is necessary to use personal judgement to date pieces. It can be helpful to remember that the word "ENGLAND" should appear in the mark after 1891.

The Wedgwood Family

Josiah Wedgwood I (1730-95) established his own pottery at Burslem in Staffordshire in 1759 and by 1769 opened a new works at Etruria. It was here that he produced some of the finest of all 18th century pottery. He concentrated on black basalt, creamware, and jasper ware in the Greek style. When other potters were beginning to turn out blue-printed dinner and tea sets his modellers and decorators became concerned about their security and waited on him in a deputation. Shaw reports that Josiah I reassured them: "I will give you my word as a man," he said, "that I have not made, neither will I make, any Blue Printed Earthenwares". He kept his promise.

When he died in 1795 the firm was left in the hands of his son, Josiah Wedgwood II (1769-1843), and his nephew Thomas Byerley, both of whom had been his partners. His other two sons, John and Tom, had left the firm sometime before his death.

Josiah II was an absentee partner, visiting the factory only occasionally, so that the responsibilities of management fell mostly on Byerley. However, John Wedgwood (1766-1844), who had been working at Bristol in a banking firm, rejoined the factory as a partner in 1800 and took a keen interest in the

management. By this time he had developed an enthusiasm for botany and horticulture, and in 1801 he arranged a meeting in London with several botanist friends which led to the formation of the Royal Horticultural Society.

John soon realised that he needed to take an even more active part in the firm, and in 1804 he moved back to Staffordshire. Meanwhile the manufacture of blue-printed wares in other potteries had proved a great success and the Wedgwood firm could no longer hold back. Their first blue-printed dinner service was produced in 1806, the year in which Josiah II moved back to Etruria and devoted himself full time to the management of the firm. John Wedgwood spent more and more time following his horticultural interests and eventually left Staffordshire and retired to the Cotswolds.

Full biographical details of the various members of the famous family firm are given by Reilly and Savage in *The Dictionary of Wedgwood*.

Two other Wedgwoods are worthy of mention here. Ralph Wedgwood was the nephew of Josiah I and potted at both Burslem and Ferrybridge in firms unconnected with the main family concern. (See: Ferrybridge Pottery). An Enoch Wedgwood was a partner in the firm of Podmore, Walker & Co. of Tunstall which later became simply Wedgwood & Co. (qv). It is not clear what relationship he bore to the rest of the family.

Wedgwood & Co. of Ferrybridge fl.c.1798-1801
The mark "WEDGWOOD & CO" was used at the Knottingley Pottery at Ferrybridge in Yorkshire for a short period at the end of the 18th century. The full name of the partnership was Tomlinson, Wedgwood, Foster & Co. but the shortened form was used in marks, presumably to profit from the association with the famous Wedgwood name. The connection arose through Ralph Wedgwood, nephew of Josiah Wedgwood I, who joined the firm from Burslem. Although he left in 1801, several of the patterns he introduced were continued and the mark is also thought to have been used after his departure. The name of the pottery was changed to Ferrybridge in 1804.

See: Ferrybridge Pottery.

Wedgwood & Co. of Tunstall fl.1860 to present
Unicorn Pottery, Amicable Street and Pinnox Works, Great Woodland Street, Tunstall, Staffordshire. The firm of Podmore, Walker & Co. (qv) traded as Podmore, Walker & Wedgwood between 1856 and 1859. This was to make use of the famous Wedgwood name which was brought to the partnership by Enoch Wedgwood. The firm became Wedgwood & Co. in 1860. Many blue-printed patterns from the earlier days were continued and a few new designs were introduced. The most famous pattern was the "Asiatic Pheasants" design which had been introduced by their predecessors. Very many printed and impressed marks were used, all of which include the full name. The suffix Ltd. indicates a date after 1900.

Well-and-Tree Dish
There are two distinct types of meat dish, one flat and the other moulded with a gravy well. The latter has the well at one end and a series of channels moulded into its surface to drain the gravy into the well. In order to maintain the necessary slope, an extra high rim is fitted underneath at the other end. These pieces are referred to as well-and-tree dishes for obvious reasons. There are very many different designs used for the pattern of gravy channels, some of which are very distinctive.

Well-and-tree dishes are sometimes called poultry dishes.

"Wellcombe, Warwickshire." *William Adams. Flowers and Leaves Border Series. Printed title mark and impressed maker's eagle mark. Plate 6¾ins:17cm.*

"Wellcombe, Warwickshire" (sic)
(i) William Adams. Flowers and Leaves Border Series. Plate 6¾ins:17cm.
(ii) Enoch Wood & Sons. Grapevine Border Series. Plate 10ins:25cm, and soup tureen stand.

The house at Welcombe, two miles north of Stratford-on-Avon can no longer be seen as depicted on these views. It was dismantled and a Jacobean-style mansion was built on the site by Henry Clutton in 1867. The original Welcombe Lodge was the home of the Combes who were friends of Shakespeare.

Wellington
There are several designs which relate to the Duke of Wellington:
(i) Copeland & Garrett. A series which depicts battles and other events in the life of the Duke. Several of the scenes were copied from illustrations in a three volume biography by W.H. Maxwell which was published between 1839 and 1841.
(ii) Maker unknown. Two different mugs which bear on one side a titled portrait of "The Duke of Wellington". On one mug the reverse has a similar portrait titled "Lord Combermere", whereas the other has "Lord Hill". Ill: May 176-178.
(iii) Maker unknown. Designs found on dark blue tea wares commemorating the Battle of Waterloo. One has medallions of Wellington and Blucher in the border with the date 1815. A building bears the words "Le France de la Touronne de Holland. WATERLOO". See illustration overleaf.

"Wellington Hotel, Waterloo"
Shorthose. This title can be found printed as part of the design on tea wares. It appears on a building which is said to have been Napoleon's headquarters during the Battle of Waterloo. In the foreground there are some soldiers wearing shakos or Belgic caps.

In the Glasgow Art Gallery and Museum there is a saucer by

"Wellington Hotel, Waterloo." John Shorthose. *This legend appears on the gable end of a building on the face of a saucer. Printed maker's mark: "SHORTHOSE". Diam. 4¾ins:12cm.*

Wellington Hotel, Waterloo. ("Le France de la Touronne de Holland, Waterloo"). *Maker unknown. The legend appears on the gable end of a building on the face of a saucer, otherwise unmarked. Diam. 5ins:13cm.*

an unknown maker with a very similar view. The building is in the same place but the notice on its gable end reads "Le France de la Touronne de Holland. WATERLOO".

"Wells"
Enoch Wood & Sons. "English Cities" Series. Plate 10ins:25cm. Ill: P. Williams p.255.

Wells is a small city in Somerset, some twenty miles south of Bristol at the foot of the Mendips. It has many well preserved historic buildings including Wells Cathedral.

"Wells Cathedral"
(i) William Adams. Flowers and Leaves Border Series. Plate 10ins:25cm.

(ii) James & Ralph Clews. Bluebell Border Series. Plate 10ins:25cm.

"Wells Cathedral, Somersetshire"
Probably Ralph Hall. This item is reported by Laidacker on a dark blue bowl (11ins:28cm) with a leaf and heart border. It bears an impressed mark "HALL" with no initial. It does not appear to be part of a series.

The Cathedral of the diocese of Bath and Wells was started in about 1180 and is largely Transitional Norman in style. The east end and central tower are 14th century. It possesses a remarkable clock but the most notable feature must be the beautifully decorated west front with its 350 statues.

Wensleydale
Wensleydale is the upper valley of the River Ure in the North Riding of Yorkshire. James & Ralph Clews included a view in their "Select Scenery" Series under the title "Aysgill Force in Wensleydale" (qv).

"West Acre House, Norfolk"
Maker unknown. Foliage Border Series. Dish 10ins:25cm.

This house was built prior to 1756 but a castellated yellow-brick façade was added in 1829. This view was probably taken from a print engraved before the alteration. It is now known as

Westacre High House. Westacre is a village five miles north west of Swaffham.

"Whampoa"
Dillwyn & Co. and also Evans & Glasson of the Cambrian Pottery, Swansea. A flow-blue chinoiserie pattern with a pagoda and fence within a C-scroll border. It was used on dinner wares, toilet wares and mugs. Examples sometimes have the design outlined with gilding. During the Dillwyn & Co. period the printed mark included the name of the body "Improved Stone Ware".

Whampoa is a seaport on an island of the same name off the coast of China. It was here that ships which had loaded cargoes of tea, silks, porcelain and ivories lay at anchor in preparation for their long voyage back to Britain.

Wharf
The word wharf was sometimes included in marks by Thomas Godwin, one example reading simply "T. GODWIN WHARF". It relates to the address of the pottery at New Wharf, Burslem, but it has sometimes been confused with a potter's name.

Wheal Sparnon Mine Inscription
Examples of the Spode India and Italian patterns have been recorded with a printed inscription concerning the use of cobalt from the Wheal Sparnon Mine. The wording reads:

This BLUE-WARE is printed
from the CALX of British COBALT.
produced from Wheal Sparnon Mine
in the County of Cornwall.
August 1816

A corrected version was also used in which the third line has been re-engraved to remove the word "Wheal".

The mine referred to was discovered to yield cobalt in 1807. The ore was used by Staffordshire potters during the

Wheal Sparnon Mine Inscription. *An inscription recorded on Indian and Italian pattern Spode plates.*

Napoleonic Wars when imported materials were difficult to obtain.

"Wheat"
Elsmore & Forster. This design was registered on 2nd November, 1859 and was printed on ironstone with moulded decoration.

Whippets
Enoch Wood & Sons produced a scene on plates (6ins:15cm) in their Sporting Series which shows a pair of whippets.

"Whitby"
Enoch Wood & Sons. Shell Border Series. Plate 9ins:23cm. Ill: Arman 148.

This view, in common with the rest of the series, is a shipping scene. It shows a rowing boat in the foreground and a sailing ship together with a smaller vessel off the Yorkshire coast.

Whitby Harbour
A view of the harbour at Whitby in the East Riding of Yorkshire was made by William Adams. It was printed in dark blue within a grotto-type border of fruit and flowers which was apparently not used for other patterns. This title was used by Laidacker, who states that it is very scarce. Coysh called it View of Whitby. It shows shipping in the harbour with a prominent shipbuilder's slip on the left. There is a church tower on a hill in the background. Ill: Coysh 1 16.

Whitby stands at the mouth of the River Esk, some twenty miles to the north of Scarborough. It is now a fishing port. Throughout the 19th century it was noted for its jet industry. The jet was taken from the laminated shales of the cliffs, fashioned into brooches and necklaces, and sold to satisfy the fashion for mourning jewellery.

White Horse
See: Wild Horse.

Whitehaven Pottery fl.1819-c.1877
This pottery at Whitehaven, on the coast of Cumberland, had close associations with Staffordshire throughout its life. The pottery advertised blue-printed wares. The owners were:

Woodnorth, Harrison, Hall & Co.	1819-1829
John Wilkinson	1829-1868
John Wilkinson's widow	1868 *et seq*

The Hall in the earlier partnership is believed to have been Ralph Hall of Burslem. His daughter was married to John Wilkinson who came from Tunstall.

"Whitney, Oxfordshire" (sic)
Maker unknown. Flower Medallion Border Series. Dish 13ins:33cm.

Witney, on the River Windrush ten miles west of Oxford, has long been celebrated for the manufacture of blankets. Six almshouses were built close to the church for the widows of the weavers. It had five major fairs each year for the sale of cattle and cheese.

Wild Horse
Don Pottery. This title is used by Lawrence for a pattern which shows a white horse galloping in the foreground of a mountainous scene which features a road climbing up to a village. The scene is printed in an octagonal frame within a border of heraldic items and leaves. It has also been called the White Horse pattern. Marked examples bear the printed Don Pottery demi-lion mark. Ill: Lawrence p.89; Little 102.

"Wild Rose"
The Wild Rose pattern was extremely popular from the 1830s to the 1850s. It is a rustic scene with a cottage by a bridge and two punts in the foreground. The name describes the floral border and examples often bear the title "Wild Rose" or "Improved Wild Rose". The design is found on a very wide variety of wares ranging from dinner services to supper sets, jugs to toilet wares.

The design has been the subject of considerable speculation. Widely accepted to depict a real place, it was for many years called a Staffordshire canal scene. More recently the name Payne's Ferry was mooted. It is, in fact, a view of Nuneham Courtenay, about five miles south east of Oxford. The print illustrated overleaf gives clear confirmation. It shows an engraving by W. Cooke after a drawing by S. Owen published on 1st February, 1811 jointly by Vernon, Hood & Sharpe of Poultry and W. Cooke of 12 York Place, Pentonville.

The print shows the Nuneham Park house on the left, the seat of Earl Harcourt. This building was constantly modified, a major extension being made in 1832 by Robert Smirke. The main feature of the pattern is, however, the rustic bridge with the lock-keeper's thatched cottage. These were part of a riverside walk planned by Capability Brown when he landscaped the grounds to the south and west of the house between 1779 and 1782. The central building in the ceramic design does not appear in the print and it is thought to represent a Gothic tower which was designed to be built on the hill but never materialised. The punts in the foreground may represent a ferry across the river and appear in both the print and the pattern.

Nuneham Courtenay was one of the most famous of all 18th century gardens. The landscape was described by Horace Walpole as "the most beautiful in the world" and it was praised in many guidebooks. Small wonder, therefore, that the view was popular with artists, many of whom made drawings and paintings of the scene, including the famous watercolourist Paul Sandby.

This "Wild Rose" pattern was used by many potters. The following have been noted:

Samuel Barker & Son, Don Pottery, Swinton, Yorkshire
J. & M.P. Bell & Co. Ltd., Glasgow Pottery, Scotland
Bell, Cook & Co., Phoenix Pottery, Ouseburn, Northumberland
Bourne, Baker & Bourne, Fenton, Staffordshire
Bovey Tracey Pottery Co., Devon
Joseph Burn & Co., Stepney Bank Pottery, Ouseburn, Northumberland
Robert Cochran & Co., Verreville Pottery, Glasgow, Scotland

continued

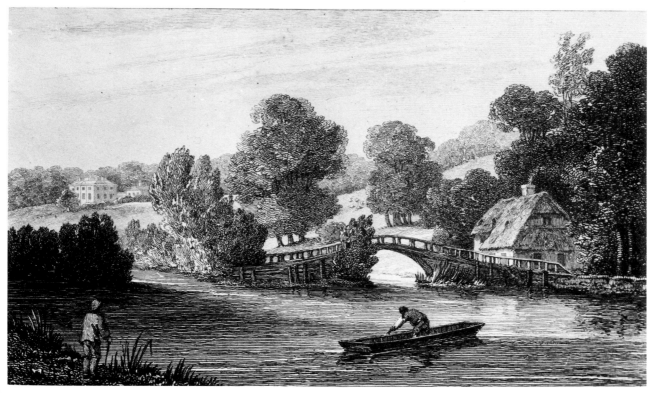

"Wild Rose." *Print entitled "Nuneham Courtenay, Bridge & Cottage", almost certainly the source for the "Wild Rose" pattern.*

Thomas Fell & Co., Newcastle-upon-Tyne, Northumberland
William Hackwood & Son, Shelton, Staffordshire
John Heath, Burslem, Staffordshire
John Meir & Son, Tunstall, Staffordshire
Middlesbrough Pottery Co., Yorkshire
Samuel Moore & Co., Sunderland, Durham
Plymouth Pottery Co., Coxside, Plymouth, Devon
Podmore, Walker & Co., Tunstall, Staffordshire
Read, Clementson & Anderson, Shelton, Staffordshire
George Townsend, Longton, Staffordshire
Joseph Twigg & Co., Kilnhurst Old Pottery, Yorkshire
Edward Walley, Villa Pottery, Cobridge, Staffordshire
John Wood & Co., Stepney Pottery, Ouseburn, Yorkshire

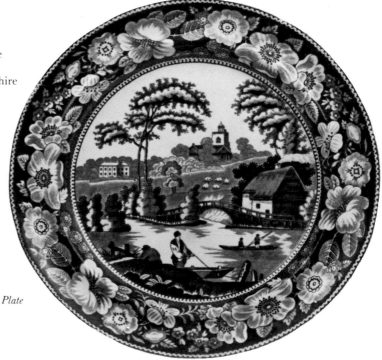

"Wild Rose." *John Heath. Impressed "HEATH". Plate 8¼ ins: 21cm.*

400

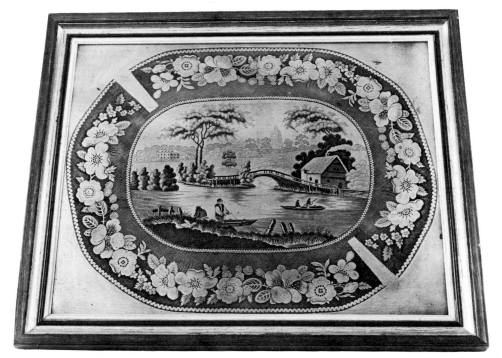

Wildblood

W.J. Pountney in *Old Bristol Potteries* (1920) states that "Mr. Wildblood of Burslem, was the designer and engraver of nearly all the printed patterns made for Pountney & Allies and Pountney & Goldney". He also states that he engraved "the *Bristol* dinner service" (See: "Virtute et Industria"). It is quite possible that Wildblood worked as an engraver for several firms in Staffordshire before his move to Bristol and he could have taken the patterns for "The Drama" Series with him.

Wildblood, John, & Co. fl.1817-1833

Swillington Bridge Pottery, Methley, Yorkshire. In 1805 William and Thomas Wildblood operated this pottery. (See: Hurst, *Catalogue of the Boynton Collection*). Lawrence states that the pottery was let in 1817 to William Wildblood, trading as "Wildblood & Co." but the only recorded marked piece gives John Wildblood and a date in 1831. It is known that blue-printed wares were made but it appears that few name marks were used.

"Wilderness, Kent"

Ralph Hall. "Select Views" Series. Plate 5ins:13cm.

Wilderness is a country seat about one and a half miles to the north east of Sevenoaks.

Wilding & Allen fl.1834-1851

Engravers and printers of Vine Street, Shelton, Staffordshire.

Wileman Family fl.1860-1892

Foley China Works, Longton, Staffordshire. This family concern traded as three different partnerships:

Henry Wileman	1860-1864
James & Charles Wileman	1864-1869
James F. Wileman	1869-1892

It was continued until 1925 as Wileman & Co.

A wide variety of printed marks were used by the partnerships including J. & C.W., J.F.W., J.F. & C.W., C.J.W. (Charles J. Wileman, c.1869), and J.W. & Co. (James Wileman & Co., c.1864-1869). The full name "J.F. WILEMAN" has also been recorded.

A blue-printed "Etruscan" pattern was produced during the James F. Wileman period.

"Wilkie's Designs" Series

This series was printed on dinner, dessert and tea wares by James & Ralph Clews. It is based on the paintings of Sir David Wilkie R.A. which mainly depicted contemporary cottage life. Examples are printed in dark blue and marked with an oval scroll with flowers at the base, with both the series title "Wilkie's Designs" and the name of each individual scene:

"Christmas Eve"
"The Errand Boy"
"The Escape of the Mouse"
"The Letter of Introduction"
"Playing at Draughts"
"The Rabbit on the Wall"
"The Valentine"

Examples are very scarce in Britain.

Sir David Wilkie (1785-1841) was the son of a minister of Cults in Fifeshire, Scotland. He studied in Edinburgh and in 1805 he went to London to study at the Royal Academy Schools. He was elected R.A. in 1811, became painter to the King in 1830, and was knighted in 1836. In 1841 he died at Gibraltar on his way home from a visit to Jerusalem.

"William III"

Samuel Alcock & Co. A design that uses the border and mark from the "Japanese" pattern. The centre has an equestrian figure standing on a plinth with the name "William III". The figure is surmounted by a ribbon bearing the inscription "The Glorious and Immortal Memory". Ill: Coysh 1 18; Godden I 13.

It is likely that this design was made on dinner wares for the Orange Society. William III was honoured by the Orangemen as the man who rescued England from popery when he defeated James II in the Battle of the Boyne in 1690.

Williamson

See: Henshall & Co.

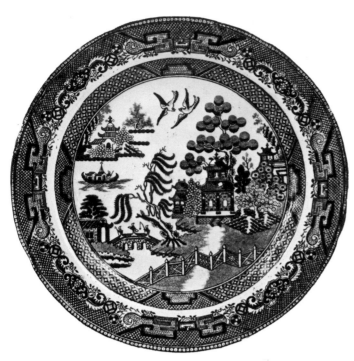

Willow Pattern. *A standard design by Baker, Bevans & Irwin, Glamorgan Pottery, Swansea. Impressed mark: "BAKER, BEVANS & IRWIN" in a semi-circle around a figure 5. Plate 10ins:25cm.*

Willow Pattern

The Willow pattern was originally derived from the Chinese. Early versions vary a good deal but unless they are marked it is virtually impossible to attribute them to any particular maker. By the first decade of the 19th century a standard pattern emerged which has been used ever since.

It is generally accepted that Thomas Minton engraved the earliest pattern with a willow tree when he was apprenticed to Thomas Turner at the Caughley porcelain factory. He later moved to London where he is said to have engraved copper plates for Josiah Spode. In 1789 he set up in Stoke-on-Trent as a freelance designer and engraver. There can be little doubt that many of the line-engraved designs in the Chinese style which were used by the early Staffordshire makers of blue-printed wares were supplied by Minton. Indeed, several of these early prints are very like designs on Caughley porcelain.

Almost all of the very early versions are either unmarked or marked only with small blue-printed symbols which do not help with attribution. The commonest of these are a small eight-pointed star and a little leaf spray. One early design, despite the fact that it includes a willow tree, is normally called the Two Figures pattern.

The name Willow pattern is now generally applied to a standard design which emerged in the first decade of the 19th century and became very popular in Victorian times. Indeed, it is still produced today. It shows a pagoda with pavilion or tea house on the right, backed by an apple tree. In the centre a willow tree leans over a three-arched bridge across which three figures are crossing to the left. In the top left a covered boat crewed by one man floats in front of a small island, and two doves fly in the sky. In the foreground of the design there is a zig-zag fence. There are very many variations on the basic theme. This is not a direct copy of a Chinese design but a composite picture drawn from Chinese sources.

The design gained immense popularity, probably because various legends grew up around it. It is certainly the only design which should be described as Willow. Three distinct types can be recognised:

(i) Willow I. An early line-engraved version. Ill: Copeland, Chap. 5, 5; Whiter 10.·

(ii) Willow II. A similar version but more finely engraved and softer in appearance. Ill: Copeland, Chap. 5, 6; Whiter 11.

(iii) Willow III. The standard pattern with clear cut engraving and stippled areas. Ill: Copeland, Chap. 5, 7; Whiter 12.

There were many minor variations. Copeland illustrates more than twenty.

See: "Spaniard Inn"; Stevenson's Willow.

Willow Pattern Legends

The standard Willow pattern was extremely popular and legends grew up around the design. These differ considerably in detail but essentially the story concerns a Chinese mandarin, Li-Chi, who lived in a pagoda beneath an apple tree. He had a beautiful daughter, Koong-Shee, who was to marry an elderly merchant named Ta Jin. However, she fell in love with her father's secretary, Chang, who was dismissed when it was discovered that they had been having clandestine meetings. Koong-Shee and Chang then eloped and, helped by the mandarin's gardener, they are seen crossing the bridge which spans the river. The boat is used to approach Chang's house but the furious mandarin discovers their retreat. They are pursued and about to be beaten to death when the Gods take pity on them and turn them into a pair of doves.

A different version of the tale states that the three figures on the bridge are Koong-Shee carrying a distaff, a symbol of virginity, Chang carrying a box of jewels, and Li-Chi, the mandarin, in pursuit with his whip.

Willow Pattern Makers

The following list records many of the pre-1880 potters who marked their Willow pattern wares:

Allerton, Brough & Green, Lane End, Staffordshire
G.L. Ashworth & Bros., Hanley, Staffordshire
Baker, Bevans & Irwin, Swansea, Wales
Samuel Barker & Son, Swinton, Yorkshire
J. & M.P. Bell & Co., Glasgow, Scotland
Belle Vue Pottery, Hull, Yorkshire
Brameld, Swinton, Yorkshire
Joseph Burn & Co., Newcastle-upon-Tyne, Northumberland
Clyde Pottery Co., Glasgow, Scotland
Robert Cochran & Co., Glasgow, Scotland
Copeland, Stoke-on-Trent, Staffordshire
Davenport, Longport, Staffordshire
Richard Davies & Co., Gateshead, Durham
Dillwyn & Co., Swansea, Wales
Thomas Dimmock & Co., Shelton and Hanley, Staffordshire
Elkin & Newbon, Longton, Staffordshire
D.J. Evans & Co., Swansea, Wales
Evans & Glasson, Swansea, Wales
Thomas Fell & Co., Newcastle-upon-Tyne, Northumberland
Garrison Pottery, Sunderland, Durham
Thomas Godwin, Burslem, Staffordshire
Thomas & Benjamin Godwin, Burslem, Staffordshire
George Gordon, Prestonpans, Scotland
William Hackwood, Hanley, Staffordshire
Herculaneum Pottery, Liverpool, Lancashire
Robert Heron & Son, Kirkcaldy, Scotland
J.T. Hudden, Longton, Staffordshire

James Jamieson & Co., Bo'ness, Scotland
R.A. Kidston & Co., Glasgow, Scotland
J.K. Knight, Fenton, Staffordshire
C.T. Maling, Newcastle-upon-Tyne, Northumberland
John Meir & Son, Tunstall, Staffordshire
David Methven & Son, Kirkcaldy, Scotland
Andrew Muir & Co., Greenock, Scotland
Patterson & Co., Gateshead, Durham
Thomas Phillips & Son, Burslem, Staffordshire
Podmore, Walker & Co., Tunstall, Staffordshire
Phoenix Pottery Co., Ouseburn, Northumberland
Pountney & Allies, Bristol, Somerset
Thomas Rathbone & Co., Portobello, Scotland
Read & Clementson, Shelton, Staffordshire
William Reid, Musselburgh, Scotland
John & Richard Riley, Burslem, Staffordshire
John Rogers & Son, Longport, Staffordshire
Sewell & Donkin, Newcastle-upon-Tyne, Northumberland
John Tams, Longton, Staffordshire
John Thomson, Glasgow, Scotland
James Vernon, Burslem, Staffordshire
Wallace & Co., Newcastle-upon-Tyne, Northumberland
Watson's Pottery, Prestonpans, Scotland
Wedgwood, Etruria, Staffordshire
Isaac Wilson & Co., Middlesbrough, Yorkshire
John Wood, Newcastle-upon-Tyne, Northumberland
Thomas Wood & Co., Burslem, Staffordshire

Willow Pattern Rhyme

An old Staffordshire rhyme which serves merely as a description of the standard Willow pattern:

> Two pigeons flying high,
> Chinese vessels sailing by,
> Weeping willows hanging o'er,
> Bridge with three men, if not four.
> Chinese temple, there it stands,
> Seems to take up all the land.
> Apple tree with apples on,
> A pretty fence to end my song.

Wilson, David fl.c.1802-1818
Church Works, Hanley, Staffordshire. Early blue-printed wares have been noted with the impressed name "WILSON". One piece has been noted with a printed mark "David Wilson, Bordeaux, Importation Anglais" which may have been made by this potter although such address marks are usually of later date. There may have been a British china retailer of the same name trading in Bordeaux.

Wilson, Isaac, & Co. fl.1852-1887
Middlesbrough Pottery, Middlesbrough, Yorkshire. Isaac Wilson was the manager of the Middlesbrough Earthenware Co. and took over the works in 1852. He traded as Isaac Wilson & Co. and the firm was in occupation until the eventual closure of the pottery in 1887. Various marks were used, all with the initials I.W. & Co., either impressed or printed. The name Middlesbrough also appears, sometimes abbreviated to Middlesbro'.

"Wilton House, Wiltshire"
William Adams. Flowers and Leaves Border Series. Dish 9¾ins:25cm.

The original Wilton House was built for the first Earl of Pembroke in the 16th century. The south front was reconstructed in 1649 by John Webb who was advised by Inigo Jones, and James Wyatt made further changes for the eleventh Earl in 1801. Wilton House, two and a half miles west of Salisbury, is open to the public during the summer.

"Windermere"
C.J. Mason & Co. "British Lakes" Series. Dish 15ins:38cm.

Windermere, in the old county of Westmorland, is the largest lake in the Lake District. It is some ten and a half miles long and up to one and a quarter miles wide. Its waters flow south via the Leven to Morecambe Bay.

"The Windmill"
Thomas & Benjamin Godwin.

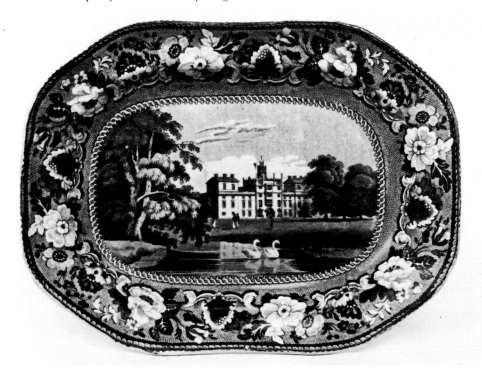

"Wilton House, Wiltshire."
William Adams. Flowers and Leaves Border Series. Printed title mark and impressed maker's eagle mark. Dish 9¾ins:25cm.

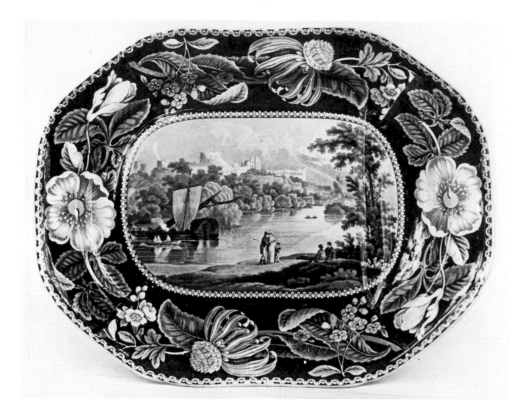

"Windsor." James & Ralph Clews. "Select Scenery" Series. Printed title mark. Well-and-tree dish 21 ¼ ins:54cm.

"Windsor"

(i) James & Ralph Clews. "Select Scenery" Series. Dish 18ins:46cm, and well-and-tree dish 21¼ins:54cm. Ill: Little 18.

(ii) David Methven & Sons.

(iii) Andrew Muir & Co.

(iv) Maker unknown. Beaded Frame Mark Series. Soup tureen.

The town of Windsor, in Berkshire, is overshadowed by its famous castle. It consists of an old village and a newer market town, some twenty-two miles to the west of London.

"Windsor Castle"

(i) Goodwins & Harris. "Metropolitan Scenery" Series. Dish 19¾ins:50cm. This pattern shows a game of cricket in progress in front of the castle.

(ii) Ralph Stevenson. "Lace Border" Series. Plates 8½ins:22cm and 10½ins:27cm.

(iii) Ralph Stevenson. Stevenson's Acorn and Oak Leaf Border Series. Dish 18½ins:47cm, and bowl 12½ins:32cm. Ill: Moore 79.

(iv) Enoch Wood & Sons. Grapevine Border Series. Dishes with and without gravy well, both 18½ins:47cm.

In addition to these four patterns another untitled view by James & Ralph Clews is known within a border of parrots amidst apple blossom; this was used by the firm for some of their American views (Ill: Arman p.1; P. Williams p.375). A further untitled view, also by Clews, was included in their Foliage and Scroll Border Series on a variety of plates and dishes.

"Windsor Castle, Berkshire"

(i) William Adams. Bluebell Border Series. Dish 19¼ins:49cm.

(ii) Maker unknown. Pineapple Border Series. Sauce tureen stand.

Windsor Castle was begun by William, the Norman, and was first used by Henry I in 1110. It was enlarged by Henry II between 1167 and 1171 and further extended by Henry III. The castle was largely rebuilt by Edward III between 1350 and 1377 and St. Georges's Chapel was rebuilt by Edward IV in the 1470s. It covers about twelve acres and is the largest inhabited castle in the world. It is open to visitors throughout the year although not all parts can be visited due to requirements of state.

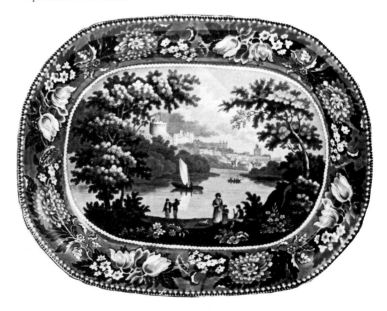

"Windsor Castle, Berkshire." William Adams. Bluebell Border Series. Printed title mark and impressed maker's eagle mark. Dish 19¼ins:49cm.

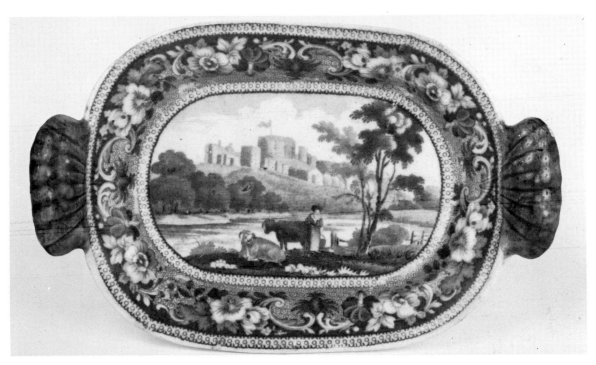

"**Windsor Castle, Berkshire.**" *Maker unknown. Pineapple Border Series. Printed title mark. Sauce tureen stand 8ins:20cm.*

The Winemakers. *Maker unknown. Unmarked. Wine cooler height 9½ ins:24cm.*

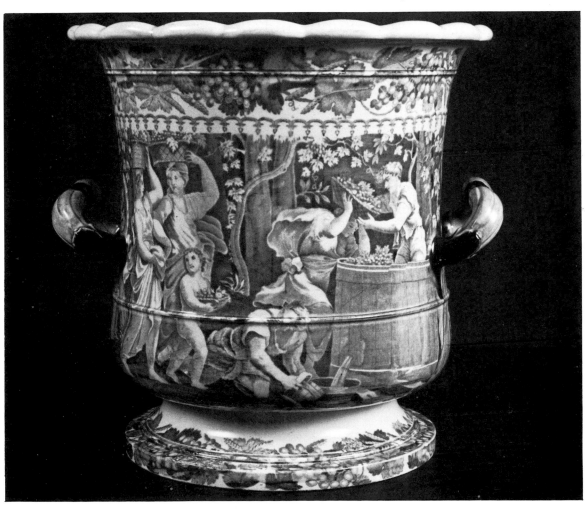

"Windsor Festoon"

John & William Ridgway. A floral pattern found on dinner wares with gadrooned edges. It is marked with a shield-shaped cartouche which bears the title, the name of the body "OPAQUE CHINA", and the initials J. & W.R. (See: Godden M 3265). Slight variants of this mark have been noted.

"Windsor Group"

Maker unknown. A flow-blue pattern with a butterfly hovering over a spray of flowers.

The Winemakers

Maker unknown. This title is used for a pattern which shows two women carrying baskets of grapes on their heads to the treading tub where other women are busy. There is also a child helping out and a man collecting the juice. It has so far been recorded on a plate, and a wine cooler with a splayed foot and two handles (illustrated on previous page).

"Wingfield Castle, Suffolk"

Maker unknown. "Antique Scenery" Series. Sauce tureen stand.

This 14th century castle in east Suffolk has a central three-storey gatehouse. A 16th century house has been added at right angles to the gatehouse.

"Winter's Tale, Act 4, Scene 3"

John Rogers & Son and Pountney & Goldney. "The Drama" Series. Dish 14½:37cm. Ill: Coysh 1 68.

The Winter's Tale was written in about 1610 and was first printed in 1623. Perdita, the daughter of Leontes and Hermione, who opens this scene with Florizel at the shepherd's cottage, is one of Shakespeare's most colourful characters. The design is copied from a painting executed by William Hamilton and engraved by J. Collyer for an edition of Shakespeare's plays published in 1802 by John & Josiah Boydell. The painting was commissioned for the Boydell Shakespeare Gallery.

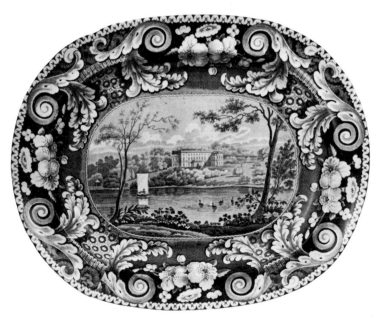

"Wistow Hall, Leicestershire." *Attributed to John & Richard Riley. Large Scroll Border Series. Printed title mark with "WARRANTED". Dish 17¼ins:44cm.*

"Wistow Hall, Leicestershire"

(i) John & Richard Riley. Large Scroll Border Series. Dishes 17¼ins:44cm and 18ins:46cm.

(ii) Maker unknown. Foliage Border Series. Plate 9ins:23cm, and soup plate 8½ins:22cm.

Wistow Hall was a Jacobean house with five steep gables. In 1810 it was stuccoed and given turret pinnacles. Nikolaus Pevsner writes: "It looks now a little sadly romantic, stuccoed and with the main angles stressed by polygonal turret pinnacles". Wistow is seven miles south east of Leicester.

Witney

See: "Whitney, Oxfordshire" (sic).

"Woburn Abbey, Duke of Bedford's Seat"

Careys. Titled Seats Series. Plate 8½ins:22cm.

Woburn Abbey, eight miles north west of Dunstable, was rebuilt in the mid-18th century by Henry Flitcroft and Inigo Jones. There were additions by Henry Holland in the early 1800s. It is located in a deer park of some three thousand acres and is open to the public.

Wolf

The wolf was used by James & Ralph Clews for the design on an 8ins:20cm plate in their "Zoological Gardens" Series. It can also be found with other animals on a vegetable dish by Enoch Wood & Sons in their Sporting Series and in some of the patterns in the "Aesop's Fables" Series by Spode and Copeland & Garrett.

"The Wolf and the Crane"

Spode/Copeland & Garrett. "Aesop's Fables" Series. Vegetable dish. Ill: Whiter 89.

A wolf had a bone stuck in his throat. A crane, tempted by a reward, ventured his long neck into the wolf's throat and plucked out the bone. "I could have bit off your head whenever I pleased," said the wolf, "and yet you are not content with your life as a reward".

Fools stand in slippery places.

"The Wolf and the Lamb"

Spode/Copeland & Garrett. "Aesop's Fables" Series. Cover for vegetable dish. Ill: Whiter 90.

A wolf and a lamb came to quench their thirst at a stream. The wolf stood on higher ground with the lamb beneath. The wolf asked the lamb what she meant by disturbing the water and making it muddy. The lamb replied in a mild tone that she could not see how this could possibly happen. The wolf, finding it to no purpose to argue with the truth, fell into a great passion and seized the poor, innocent lamb, tore it to pieces and made a meal of it.

'Tis an easy matter to find a staff to beat a dog.

"The Wolf, the Lamb and the Goat"

Spode/Copeland & Garrett. "Aesop's Fables" Series. Soup tureen. Ill: Whiter 90.

As a lamb was following a goat, up came a wolf wheedling to get the lamb aside. "You're mistaken," says the wolf, "this is not your mother, she is yonder". "Well," says the lamb, "but my mother has placed me here for security, and now you would fain get me into a corner to worry me. Prithee, which of the two am I to trust now?"

Train up a child in the way he should go.

Wolfe (& Hamilton) fl.1784-1818

Church Street, Stoke-on-Trent, Staffordshire. This factory was originally run by Thomas Wolfe, one of the pioneers of underglaze blue-printing on earthenwares. In 1800 the firm became a partnership as Wolfe & Hamilton, but in about 1811

Hamilton left and it was continued by Thomas Wolfe junior. The Hamilton concerned was Robert Hamilton, Wolfe's son-in-law, who later set up on his own.

The early pioneering designs were line-engraved and printed in dark blue in the form of chinoiserie patterns. These are sometimes impressed with the name ''Wolfe'' in lower case letters, a typical example is illustrated in Little 75. John Davenport worked with Wolfe for a period before leaving to set up his own works in 1794. Some later wares are known with the impressed mark ''WOLFE & HAMILTON'', occasionally with the addition of the word ''STOKE''.

''Wolseley Hall''
Maker unknown. Light Blue Rose Border Series. Plate 6½ins:16cm. Ill: FOB 19.

Wolseley Hall was near Wolseley Bridge in the parish of Colwich in Staffordshire, approximately six and and a half miles south east of Stafford. It was destroyed in 1965.

Wolverine
This animal has been identified on an 8¾ins:22cm plate in the ''Quadrupeds'' Series by John Hall.

''Wolvesey Castle''
Andrew Stevenson. Rose Border Series. Sauceboat.

''Wolvesey Castle, Hampshire''
William Adams. Bluebell Border Series. Plate 8ins:20cm.

This 12th century building is now in ruins. It lies adjacent to Wolvesey Palace, the residence of the Bishop of Winchester, within the city walls and close to the cathedral.

Women with Baskets
Dillwyn & Co. An attributed title for a scene which shows two women with baskets standing beside a man seated on the bank of a stream. He has his trousers rolled up and his feet are in the water. There is a mill in the background and a church spire in the distance. Ill: Nance LIXa, LIXb.

''Wolseley Hall.'' *Maker unknown. Light Blue Rose Border Series. Printed title mark. Plate 6½ins:16cm.*

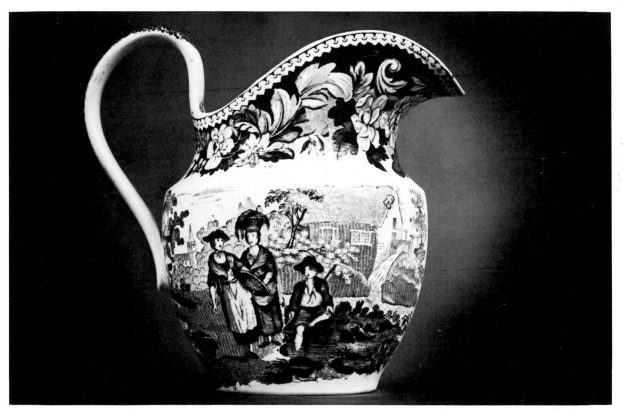

Women with Baskets. *Dillwyn & Co. Unmarked. Ewer height 8¼ins:21cm.*

Wood & Brettell fl.c.1818-1823

Brownhills Pottery, Tunstall, Staffordshire. This partnership existed for a short period with uncertain dates at the pottery run by John Wood who eventually joined Edward Challinor to trade as Wood & Challinor (qv). Blue-printed wares are known with the impressed initials W. & B. which appear to be consistent in date with this partnership. One transitional chinoiserie design is illustrated in FOB 6 under the name Chinese Gardener and a later pattern showing a bird feeding its young in their nest within a border of fruit and flowers is illustrated in FOB 18. Both patterns are too early to have been made by Wood & Brownfield, another partnership known to have used the initials W. & B.

Wood & Brownfield fl.c.1838-1850

Cobridge Works, Cobridge, Staffordshire. This partnership succeeded Robinson, Wood & Brownfield when the first named partner died. They used a variety of printed and impressed marks with their initials W. & B. The firm was in turn succeeded by William Brownfield.

Wood & Caldwell fl.c.1790-1818

Fountain Place, Burslem, Staffordshire. This firm was a partnership between Enoch Wood and James Caldwell. Although marked wares are not common it is clear that blue-printed wares were of great importance to the firm. Marked pieces are impressed "WOOD & CALDWELL", a mark recorded on a view of the Boston State House in Little 76. They were succeeded by the important firm of Enoch Wood & Sons (qv).

Wood & Challinor fl.1828-1843

Brownhills Pottery (until 1841) and Woodland Pottery (from 1834), Tunstall, Staffordshire. Blue-printed wares were produced by this partnership with printed marks including the initials W. & C., often within the loops of a Staffordshire knot. A typical romantic design titled "Corsica" is shown in Coysh 1 139.

Wood, Enoch 1759-1840

Enoch Wood has sometimes been called the "Father of the Potteries". He came from an important potting family, his father being Aaron Wood, his cousin Ralph Wood, and his elder brother William Wood, all important figures in the industry. In 1784 he began a partnership with his first cousin Ralph Wood but between 1790 and 1818 this was superseded by a new partnership with James Caldwell. When Caldwell retired in 1818 Enoch Wood was joined by his three sons, Enoch, Joseph and Edward under the style Enoch Wood & Sons, a style which continued until the end of the firm in 1846, despite the father's death in 1840. This firm developed a flourishing business exporting large quantities of blue-printed ware to America.

Enoch Wood was the first great collector of British pottery. His collection was eventually dispersed but many pieces are now in the Victoria and Albert Museum.

Wood, Enoch, & Sons fl.1818-1846

Fountain Place, Burslem, Staffordshire. This firm must rank as one of the most important producers of blue-printed ware. The output was vast. A single shipment to America is recorded in a document sent to a Philadelphia dealer in 1834 as having 262,000 pieces. The early productions were in blue and many of the export pieces were printed in a very dark shade which was fashionable in the overseas market. The general style of wares followed popular trends and later designs were more open, often romantic scenes, many of which were also printed in pink, purple, black, sepia, green or mulberry.

The most notable wares are undoubtedly the series of views,

each piece in a dinner service being printed with a different scene. The American market naturally demanded American scenes but many others were made and it is clear that the bulk of the output was exported. Amongst the British views were the "English Cities" Series, the "London Views" Series, the Shell Border Series and the Grapevine Border Series, the last of which is by far the largest made by any potter. There was also a French Series and an "Italian Scenery" Series. Although views were clearly most popular other designs were used including a Scriptural Series of biblical scenes, a Sporting Series of hunting scenes, and a Cupid Series showing a variety of cherubs. Many single-pattern services were also made.

Most of the printed designs bear appropriate title marks. By far the majority of pieces also bear an impressed maker's mark although the later items tend to include initials E.W. & S. within the printed mark. The standard impressed mark consists of the wording "ENOCH WOOD & SONS" around an American eagle with the word "BURSLEM" beneath, but this mark is also common without the central eagle. An alternative mark is circular in form, once again with the American eagle, but with the wording "E. WOOD & SONS, BURSLEM, WARRANTED" together with the body name "SEMI CHINA". The single impressed surname "WOOD" is also known but this may relate to the earlier period when the partnership was Wood & Caldwell (qv).

Wood, John, & Co. fl.1877-1912

New Stepney Pottery, Ouseburn, Newcastle-upon-Tyne, Northumberland. This firm made blue-printed wares for both the home market and for export. Wares bear printed marks with the full name and address, often in association with the impressed mark "J. WOOD/NEWCASTLE". The common "Albion" pattern has been noted.

Wood, John Wedg fl.1841-1860

Hadderidge, Burslem (until 1844) then at Tunstall, Staffordshire. The second christian name "Wedg" (sometimes printed as Wedge) may well have been adopted deliberately. Certainly many printed marks include the name "J. WEDGWOOD", not always with a space between Wedg and Wood, and these are often confused with the prestigious firm of Josiah Wedgwood, although the latter never used the initial J. Godden records the impressed initials W.W.

Woodman

A Spode design believed to have been introduced in 1814. It shows a woodman with his axe standing beneath a tree and talking to a seated woman who is holding a baby. The scene is enclosed within a border of idealised flowers and leaves. It is not clear whether the design was used for complete dinner services although several less common items have been recorded such as a toilet box and a very large jug. Ill: Whiter 61, 98; S.B. Williams 136-137.

The pattern was also used by Thomas Fell of Newcastle but printed in reverse. The border in the Fell version is often separated from the central scene by an unprinted white band. Ill: Coysh 1 43.

Tea wares by an unknown maker have been noted with the Woodman pattern but with the rims overpainted with ochre enamel. There is another version with a completely different border of fruit and flowers.

Another Woodman pattern, by Brameld, is known as the Returning Woodman (qv).

Woodnorth, Harrison, Hall & Co. fl.1819-1829

See: Whitehaven Pottery.

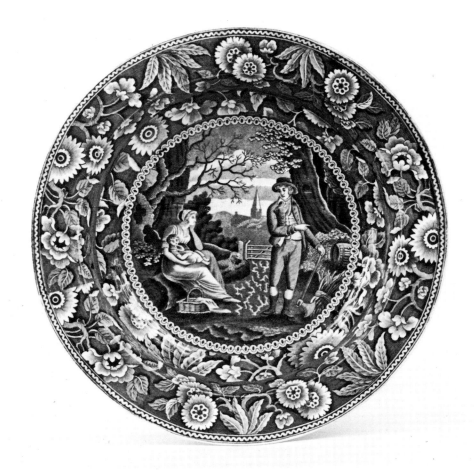

Woodman. *Spode. Printed and impressed maker's marks. Note that the transfer paper used for the border was badly cut. Soup plate 9 ¾ ins: 25cm.*

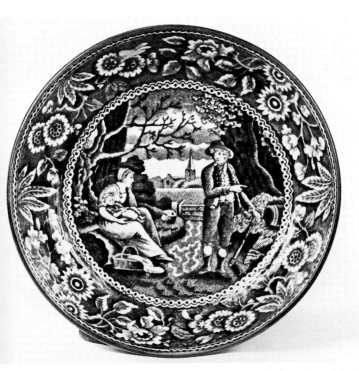

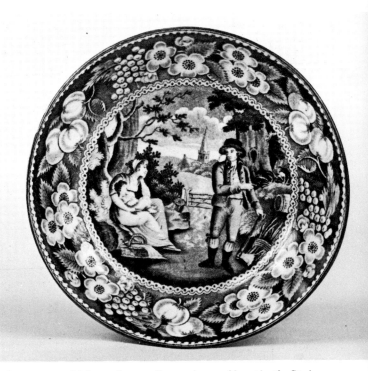

Woodman. *Two unmarked saucers with different versions of the Spode Woodman pattern. Makers unknown. One version roughly copies the Spode border: the other has a fruit and flower border. Diam. of saucers both 5 ¼ ins: 13cm.*

Woolley, Richard fl.1809-1814

Turner's Pottery, Lane End, Longton, Staffordshire. Richard Woolley, who had previously been in partnership with Anne Chetham, rented the potworks of Turner & Co. not long after the lease was offered in 1806. Chinoiserie patterns with the impressed mark "WOOLLEY" have been recorded. The firm closed on its founder's bankruptcy in 1814.

See: Ornate Pagodas.

"Woolwich"

Goodwins & Harris. "Metropolitan Scenery" Series. Vegetable dish.

Woolwich lies on the south bank of the Thames, ten miles downstream of the City of London. It is particularly noted for the Royal Arsenal established by Queen Elizabeth in 1585. It is part of the headquarters of the Royal Artillery.

"Worcester"

(i) Herculaneum. Cherub Medallion Border Series. Soup plate 9¾ ins:25cm.

(ii) Enoch Wood & Sons. "English Cities" Series. Plates 10ins:25cm and 10¾ins:27cm, and bowl 12ins:30cm.

The city of Worcester lies on the River Severn, some twenty-two miles south west of Birmingham. It is particularly noted for its cathedral.

"Worcester Cathedral"

Ralph Hall. "Picturesque Scenery" Series. Vegetable dish and cover.

Other untitled views have been identified on tea wares by one of the Tams partnerships (Ill: Laidacker p.118), and on a cup plate and sauce ladle by Ralph Hall in his "Select Views" Series.

Worcester Cathedral dates from the early part of the 13th century although it was greatly damaged during the Civil War. The main restoration was carried out in 1857 and 1874, some time after these views were printed.

Workmen's Marks

Many blue-printed wares bear small printed or impressed marks in the form of numbers, letters or other symbols or devices. These were used to record the output of a particular worker or group of workers who were usually paid on a piece-work basis. Although it is often suggested that they can be used to help in attributing wares, many of the symbols were clearly used at more than one factory. A typical example is the small arrow-like symbol for iron, or Mars, which has been found on marked wares by both Spode and Rogers.

"Writtle Lodge, Essex"

Andrew Stevenson. Rose Border Series. Soup plate 10¼ ins:26cm.

Writtle is a parish and village two and a half miles west of Chelmsford. In Marshall's *Select Views in Great Britain* (1825) Writtle Lodge is described as "lately the residence of C. Nightingale, Esq. The house is extensive, and commands delightful views; the lawn and slope to the water with the opposite acclivity are much to be admired, and the timber on the estate increases its beauty".

"Writtle Lodge, Essex." *Andrew Stevenson. Rose Border Series. Printed title mark and impressed maker's circular crown mark. Soup plate 10¼ ins:26cm.*

Yale & Barker fl.1841-1853
Longton, Staffordshire. Printed marks have been noted with the initials Y. & B.

"Yanguesian Conflict"
James & Ralph Clews. Don Quixote Series. Sauceboat and cup plate 3¾ins:9cm. Ill: Arman S 70.
 This title is recorded by Arman and Laidacker.

"Yanina"
Copeland & Garrett. Byron Views Series. Sauceboat and dish 14ins:36cm with different views.
 Yanina, Yannina, Janina or Jannina — the earlier names vary — is now the Greek town of Ioannina. It is in the north of the country near the frontier with Albania; there is a lake of the same name. In 1430 it was captured by the Ottoman Sultan Murad II and it remained under Turkish rule until the first Balkan War (1913). It is best known for the barbaric rule of Ali Pasha, The Tiger of Jannina, from 1788 until 1822.

"Yarmouth, Isle of Wight"
Enoch Wood & Sons. Shell Border Series. Dish 12ins:30cm, vegetable dish and soup tureen stand. Ill: Arman S 149.
 A harbour scene with a sailing ship at anchor and the town in the background. Yarmouth is on the west end of the island and is famous as a yachting centre.

Yates, John fl.c.1784-1835
Shelton, Hanley, Staffordshire. John Yates must have been one of the pioneers of blue-printing. In his *History of the Staffordshire Potteries* Shaw tells us that he engaged John Ainsworth, an engraver and printer from Caughley, to work for him in about 1783. John Yates, the son, took over the business from his father but since the names were the same it is not possible to date the changeover with any accuracy, although it must have been before 1802 when another son, William, seems to have been briefly involved. It is interesting to note that Joseph Ring (Senior), of the Bristol Pottery visited several Staffordshire firms between 1784 and 1787 and is said to have bought blue-printed wares from John Yates.
 The impressed mark "YATES" is thought to have been used by John Yates. Printed and impressed marks with the initials J.Y. have been recorded.

Yates, William fl.c.1840-1880
William Yates was a china retailer at Leeds in Yorkshire. His mark appears occasionally on printed wares, usually with just the surname and town.

"Yeddo"
Ridgway, Sparks & Ridgway. A design registered in 1873. The printed title mark includes the initials R.S.R.

Ynysmedw Pottery fl.1854-1859
Nr. Neath, South Wales. This pottery in the Swansea Valley made bricks, tiles and chimney pots between about 1840 and 1870. For a few years in the 1850s it was operated by William Williams and made transfer-printed earthenwares. At the end of this short period in 1859, Jewitt states that the copper plates were sold to the South Wales Pottery (qv). The exact name of the pottery is not clear since printed works refer to "Ynysmedw", Ynismedw" and "Ynysmeudwy". Impressed initial marks with either Y.P. or Y.M.P. have been recorded and a complete name and address mark has been found. Some printed title marks include only the name of the proprietor "Williams".

"York"
 (i) Harvey. Cities and Towns Series. Dish 15ins:38cm.
 (ii) Herculaneum. Cherub Medallion Border Series. Dish approximately 14ins:36cm.
 (iii) Enoch Wood & Sons. "English Cities" Series. Dish 16ins:41cm, and plate 7¾ins:20cm.
 York was an early British settlement which became the Roman city of Eboracum. It is noted for its fine cathedral, or Minster, but has many other historic buildings.
 See: "St. Mary's Abbey, York"; "View of York".

"York Cathedral"
Careys. Cathedral Series. Hexagonal tureen stand 14¾ins:37cm. Ill: Godden, *Mason's Patent Ironstone China*, 106.
 See: "Cathedral at York"; "York Minster".

"York Cathedral." *Careys. Cathedral Series. Impressed maker's anchor mark. Hexagonal tureen stand with gilding on handles 14¾ins:37cm.*

411

"York Gate, Regent's Park, London"

William Adams. Regent's Park Series. Plate 7ins:18cm.

York Gate, on the south side of the park, was not a gateway in the accepted sense. It was formed by an entrance between the two halves of York Terrace which were designed to give the appearance of entrance lodges. It made a most effective frame for the church of St. Mary-le-Bone, just to the south of the gate.

"York Minster"

Henshall & Co. Fruit and Flower Border Series. Plate and soup plate, both 10ins:25cm. Ill: Arman 345; Little 33.

This Henshall view shows the Minster, as seen from the south side of the River Ouse, with a steamboat in the foreground.

There are several other untitled views of the Minster which have been identified:

(i) John Geddes of Glasgow. This view is listed by Laidacker on a soup plate (10ins:25cm) with an acorn and oak leaf border.

(ii) John Rogers & Son. Rogers Views Series. Dish 19ins:48cm.

(iii) Ralph Stevenson. "Panoramic Scenery" Series. Dish 21ins:53cm.

York Minster, or the Cathedral Church of St. Peter, was built on the site of a 7th century church between 1220 and 1470. It is a mixture of several styles including Early English, Decorated and both early and late Perpendicular. There are two towers on the west end, one of which has the famous bell Great Peter, and the central tower stands 198 feet high.

The Young Philosopher

Enoch Wood & Sons. Cupid Series. This title has been accepted for the design on a plate (10ins:25cm) which shows a child in glasses reading a book. Ill: Atterbury p.213.

Another design by an unknown maker has also sometimes been associated with this title but it is listed under its more widely accepted name of the Philosopher.

"**York Minster.**" *Henshall & Co. Fruit and Flower Border Series. Printed title mark. Plate 10ins:25cm.*

Zaffre

An oxide of cobalt fused with sand to make a pigment in the ink used for blue transfer-printing.

Zebra

This animal is featured particularly on a pattern made by John Rogers & Son. It shows pagoda-style buildings in an Oriental garden with a group of figures and a mounted zebra in the foreground. There is a wide border of flowers and dark leaves against an all-blue background. Very high quality examples of this pattern have been noted with gilt rims. Ill: Coysh 1 80; P. Williams p.665.

The same design was made by Toft & May but with several differences. The end of the pagoda has a lattice pattern, the zebra and figures stand on a prominent path, there are distant mountains and the border, although similar, has prominent white five-petalled flowers. Ill: Little 67.

The zebra also appears on patterns by Enoch Wood & Sons in their Sporting Series and by Job Meigh & Son in the "Zoological Sketches" Series. It was also used along with other animals by James & Ralph Clews in their "Zoological Gardens" Series.

"Zoological Gardens" Series

A multi-pattern dinner service by James & Ralph Clews based on views in the London Zoological Gardens which were first opened to the public in 1829. It was probably introduced shortly before the firm went bankrupt in 1834 or 1835 since it is also known in pink, sepia and black. The printed mark includes the American eagle and the series title but the individual scenes are not named.

The series was almost certainly made mainly for export to America, since examples are very rare in Britain. Laidacker lists the following:

Aviary
Bear Cages
Bird Cages
Camel, Cow and Gnu
Deer
Foxes
Goats
Ostriches, Zebra and Other Animals
Swans
Wolf

Three illustrated contemporary books tell us what the zoo looked like at the period: *The Zoological Keepsake* (1830), G. Scharf's *Six Views of the Zoological Gardens, Regent's Park* (1835), and the two volume work *The Gardens and Menagerie of the Zoological Society Delineated* (1830, 1831).

"Zoological Sketches" Series

A series of patterns attributed to Job Meigh & Son. The animals appear within an open border of flowers, scrolls and birds, edged by a continuous scroll design. The individual patterns are not titled but each item bears a printed mark with the series title on a rectangular panel backed by a lion and including a bird in a tree. This mark includes the maker's

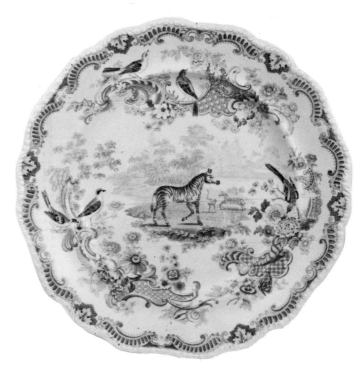

"Zoological Sketches" Series. *Zebra. Job Meigh & Son. Printed series title mark with maker's initials J.M. & S. Plate with moulded rim 10¼ ins:26cm.*

"Zoological Sketches" Series. *Job Meigh & Son. Printed series mark.*

initials J.M. & S. in script which could apply to either Job Meigh & Son or John Meir & Son. The attribution to Meigh is based on the fact that John Meir & Son operated from 1837 and these patterns appear to be of earlier date. Only two designs have been recorded:

Badger Ill: Coysh 1 60.
Zebra*

Zwakenberg, Gebr.

The name of this Dutch retailer has been recorded in printed marks on blue-printed wares made by the Scotts of the Southwick Pottery, Sunderland. An example illustrated (See: Southwick Pottery) is decorated with a pattern showing a Dutch king surrounded by shields of various provinces of the Netherlands. The name "Gebr. Zwakenberg" appears in a figure-of-eight ribbon and there is also an impressed mark "SCOTT".

Appendix I

Index of Potters' Initial Marks
Printed or Impressed on Wares

A.B. & Co.	Alexander Balfour & Co.
	Allman, Broughton & Co.
A.B. & G.	Allerton, Brough & Green
A. Bros.	G.L. Ashworth & Bros.
A.M.	Andrew Muir & Co.
B.	Brameld & Co.
	John & Edward Baddeley
B. & B.	Baggerley & Ball
B.B. & Co.	Baker, Bevans & Irwin
B.B. & I.	Baker, Bevans & Irwin
B. & Co.	Joseph Burn & Co.
B. & E.	Beardmore & Edwards
B.E. & Co.	Bates, Elliott & Co.
B.G.	Benjamin Godwin
B. & M.	Bagshaw & Meir
	Brougham & Mayer
B. & S.	Barker & Son
B.S. & T.	Barker, Sutton & Till
B. & T.	Barker & Till
B.T.P. Co.	Bovey Tracey Pottery Co.
B.W. & B.	Batkin, Walker & Broadhurst
B.W. & Co.	Bates, Walker & Co.
C.A. & Sons	Charles Allerton & Sons
C. & B.	Cotton & Barlow
C. & E.	Cartwright & Edwards
	Cork & Edge
C.E. & M.	Cork, Edge & Malkin
C. & H.	Cockson & Harding
C.J.M. & Co.	C.J. Mason & Co.
C.J.W.	Charles J. Wileman
C.K.	Charles Keeling
C.M.	Charles Meigh
C.M. & S.	Charles Meigh & Son
C.M.S. & P.	Charles Meigh, Son & Pankhurst
C.P.	Charles Purves (Elgin Pottery)
C.P. Co.	Clyde Pottery Co.
C. & R.	Chesworth & Robinson
	Chetham & Robinson
C.R. & S.	Maker unknown (See: Initial Marks)
C.T.M.	C.T. Maling
C. & W.K.H.	C. & W.K. Harvey

D.	Thomas Dimmock & Co.
D. & B.	Deakin & Bailey
D.D. & Co.	David Dunderdale & Co.
D.L. & Co.	David Lockhart & Co.
D.M. & S.	David Methven & Sons
D. & S.	Dimmock & Smith
E.B. & B.	Edge, Barker & Barker
E.B. & Co.	Edge, Barker & Co.
E.C.	Edward Challinor
E. & C.C.	E. & C. Challinor
E. & G.P.	Edward & George Phillips
E.J.	Elijah Jones
E.K.B.	Elkin, Knight & Bridgwood
E.K. & Co.	Elkin, Knight & Co.
E.M. & Co.	Edge, Malkin & Co.
E. & N.	Elkin & Newbon
E.P.	Elgin Pottery
E.W. & S.	Enoch Wood & Sons
F. & C.	Ford & Challinor
F.C. & Co.	Ford, Challinor & Co.
F. & Co.	Thomas Fell & Co.
F.D.	Francis Dillon
F.M.	Francis Morley
F.M. & Co.	Francis Morley & Co.
F. & R.P.	F. & R. Pratt
F. & R.P. & Co.	F. & R. Pratt & Co.
F.T. & R.	Flackett, Toft & Robinson
G.B.H.	Godwin, Bridgwood & Harris
G.B.O.	Goodwin, Bridgwood & Orton
G.B. & O.	Goodwin, Bridgwood & Orton
G.C.P. Co.	Clyde Pottery Co., Greenock
G. & E.	Goodwin & Ellis
G.F.	George Forrester
G.F.S.	George F. Smith
G.F.S. & Co.	George F. Smith & Co.
G.G.	George Gordon (Gordon's Pottery)
G. & H.	Goodwins & Harris
G.H. & G.	Goodwin, Harris & Goodwin
G.L.A. & Bros.	G.L. Ashworth & Bros.
G.P. Co.	Glamorgan Pottery Company (Baker, Bevans & Irwin)
	Greenock Pottery Co.
G.R. & Co.	Godwin, Rowley & Co.

| | | | | |
|---|---|---|---|
| H. & B. | Hampson & Broadhurst | J.W. & Co. | James Wallace & Co. |
| H. & C. | Harding & Cockson | | James Wileman & Co. |
| H. & Co. | Hackwood & Co. | J.W.P. | J.W. Pankhurst & Co. |
| H. & G. | Holland & Green | J.W.R. | John & William Ridgway |
| H. & K. | Hackwood & Keeling | J. & W.R. | John & William Ridgway |
| H.M.J. | Hicks, Meigh & Johnson | J.Y. | John Yates |
| H.M. & J. | Hicks, Meigh & Johnson | | |
| H. & V. | Hopkin & Vernon | K. & E. | Knight & Elkin |
| H. & W. | Hancock & Whittingham | K.E.B. | Knight, Elkin & Bridgwood |
| H.W. & Co. | Hancock, Whittingham & Co. | K.E. & B. | Knight, Elkin & Bridgwood |
| | | K.E. & Co. | Knight, Elkin & Co. |
| I.C. | Joseph Clementson | K.P. | Kilnhurst Pottery (Joseph Twigg) |
| I.D.B. | John Denton Bagster | | |
| I.E.B. | John & Edward Baddeley | L. & A. | Lockhart & Arthur |
| I.H. | Joshua Heath | L. & B. | Lowndes & Beech |
| I.H. & Co. | Joseph Heath & Co. | L. & H. | Lockett & Hulme |
| I.M. | John Meir | L.P. & Co. | Livesley, Powell & Co. |
| I.M. & Co. | James Miller & Co. | | |
| I.M. & S. | Job Meigh & Son | M. | John Maddock |
| | John Meir & Son | | Robert Maling |
| I.W. & Co. | Isaac Wilson & Co. | | Minton |
| | | M. & A. | Morley & Ashworth |
| J.B. | J. & M.P. Bell & Co. | M. & B. | Minton & Boyle |
| J.C. | Joseph Clementson | M. & Co. | Minton & Co. |
| J.C. & Co. | John Carr & Co. | M. & E. | Mayer & Elliott |
| J.C. & S. | John Carr & Son | M. & H. | Minton & Hollins |
| J.C. & Son | John Carr & Son | M. & M. | Mayer & Maudesley |
| J. & C.W. | James & Charles Wileman | M. & N. | Mayer & Newbold |
| J.D.B. | John Denton Bagster | M.P. Co. | Middlesbrough Pottery |
| J.E. & S. | James Edwards & Son | M. & S. | Maddock & Seddon |
| J.F. & Co. | Jacob Furnival & Co. | M.V. & Co. | Mellor, Venables & Co. |
| J.F. & C.W. | James F. & Charles Wileman | M. & W. | Marsh & Willet |
| J.F.W. | James F. Wileman | M.W. & H. | Malkin, Walker & Hulse |
| J. & G.A. | John & George Alcock | | |
| J.H. & Co. | Joseph Heath & Co. | O.H.E.C. | Old Hall Earthenware Co. |
| J.J. & Co. | John Jackson & Co. | | |
| J.M. | John Mayer | P. | Pountney & Allies |
| | John Meir | P.A. | Pountney & Allies |
| J.M. Co. | James Miller & Co. | P. & A. | Pountney & Allies |
| J.M. & Co. | John Marshall & Co. | P.A./B.P. | Pountney & Allies, Bristol Pottery |
| | James Miller & Co. | | |
| J. & M.P.B. & Co. | J. & M.P. Bell & Co. | P. & B. | Powell & Bishop |
| J.M. & S. | Job Meigh & Son | P. & Co. | Pountney & Co. |
| | John Meir & Son | P.R. | Petrus Regout (of Maastricht, Holland) |
| J. & P. | Jackson & Patterson | | |
| J.R. | James Reeves | P.W. & Co. | Podmore, Walker & Co. |
| | Job Ridgway | P.W. & W. | Podmore, Walker & Wedgwood |
| | John Ridgway | | |
| J.R.B. & Co. | John Ridgway, Bates & Co. | R. | William Ratcliffe |
| J.R. & Co. | John Ridgway & Co. | R.A.K. & Co. | R.A. Kidston & Co. |
| J. & R.G. | John & Robert Godwin | R. & C | Read & Clementson |
| J.T. | John Tams | R.C. & A. | Read, Clementson & Anderson |
| | John Thomson | R.C. & Co. | Robert Cochran & Co. |
| | Joseph Twigg | R.G. | Robert Garner |
| J.T.H. | John Thomas Hudden | R.H. | Ralph Hammersley |
| J.T. & Sons | John Thomson & Sons | R.H. & Co. | Ralph Hall & Co. |
| J.V. | James Vernon | R.M. | Robert Maling |
| J.V. & S. | James Vernon & Son | | |

R. & M.	Ridgway & Morley	T. & R.B.	T. & R. Boote
R.M.W. & Co.	Ridgway, Morley, Wear & Co.	T.R. & Co.	Thomas Rathbone & Co.
		T.S. & C.	Thomas Shirley & Co.
R.S.	Ralph Stevenson	T.S. & Co.	Thomas Shirley & Co.
R.S.R.	Ridgway, Sparks & Ridgway	T.S. & Coy.	Thomas Shirley & Co.
R.S. & S.	Ralph Stevenson & Son		
R.S.W.	Ralph Stevenson & Williams	W.	John Warburton
R.S. & W.	Ralph Stevenson & Williams		Thomas Wolfe
R. & T.	Reed & Taylor (Ferrybridge)		Enoch Wood
R.T. & Co.	Reed, Taylor & Co. (Ferrybridge)	W.A. & S.	William Adams & Sons
		W.B.	William Brownfield
R. & W.	Robinson & Wood	W. & B.	Wood & Brettel
R.W. & B.	Robinson, Wood & Brownfield		Wood & Brownfield
		W.B. & S.	William Brownfield & Son
S.A. & Co.	Samuel Alcock & Co.	W.B. & Sons	William Brownfield & Sons
S.B. & Co.	Scott Bros. & Co. (Southwick Pottery)	W. & C.	Walker & Carter
			Wood & Challinor
S.B. & S.	Samuel Barker & Son	W.H.	William Hackwood
S.H.	Sampson Hancock	W.H. & S.	William Hackwood & Son
S. & I.B.	Samuel & John Burton	W. & J.H.	W. & J. Harding
S.K. & Co.	Samuel Keeling & Co.	W.R.	William Ridgway
S.M. & Co.	Samuel Moore & Co.	W.R. & Co.	William Ridgway & Co.
S. & Sons	Scott & Sons (Southwick Pottery)	W.R.S. & Co.	William Ridgway, Son & Co.
		W.S. & Co.	William Smith & Co.
S.W.P.	South Wales Pottery	W. & S.E.	William & Samuel Edge
T. & B.G.	Thomas & Benjamin Godwin	Y. & B.	Yale & Barker
T.B. & S.	T. & R. Boote	Y.M.P.	Ynysmedw Pottery
T.F. & Co.	Thomas Fell & Co.	Y.P.	Ynysmedw Pottery
	Thomas Furnival & Co.		
T.G.	Thomas Godwin	Z.B.	Zachariah Boyle
	Thomas Green	Z.B. & S.	Zachariah Boyle & Sons

Appendix II

Source books known to have been used by makers of blue and white printed earthenwares

Angus, W., *The Seats of the Nobility and Gentry in Great Britain and Wales in a collection of Select Views engraved by W. Angus from Pictures and Drawings by the most Eminent Artists with descriptions of each view,* London, 1787. There was a second edition in 1815.

Barrow, John, *Travels in China,* London, 1806.

Baynes, T.H., *Twenty Views of the City and Environs of Edinburgh,* London, 1823.

Beattie, William, *Scotland: Illustrated in a Series of Views Taken Expressly for this Work by Messrs Allom, W.H. Bartlett and H. McCullock,* London, 1835; second edition in two volumes 1838.

Bewick, T., *A General History of Quadrupeds,* Newcastle and London, 1790.

Bewick, T., *A History of British Birds,* Newcastle and London, 1797 and 1804. Both this and the previous work were printed in many later editions.

Britton, J., *Picturesque Views of the English Cities,* London, 1828.

Britton, J., and Brayley, E.W., *The Beauties of England and Wales,* London 1801-8, twenty-six volumes.

Buckingham, J.S., *Travels in Mesopotamia including a Journey to Aleppo,* London, 1827.

Byrne, W., *The Antiquities of Great Britain, illustrated in views of Monasteries, Castles and Churches now existing. Engraved by W. Byrne from drawings by Thomas Hearne,* London, 1807.

Croxall, S., *Aesop's Fables,* London, 1793. There were many later editions.

Daniell, T. and W., *Oriental Scenery,* London, 1795-1808, six parts; a later edition published 1812-16.

D'Hancarville, Baron P. (publisher), *A Collection of Etruscan, Greek and Roman Antiquities from the cabinet of the Hon. William Hamilton,* Naples, 1766-67, four volumes.

Elmes, J., *Metropolitan Improvements: or London in the Nineteenth Century being a series of Views of the new and most interesting objects in the British Metropolis, with engravings after drawings by Thomas H. Shepherd,* London, 1827.

Finden, E. and W., *Landscape and Portrait Illustrations to the Life and Works of Lord Byron,* London, 1832-34, three volumes.

Gastineau, H., *Wales Illustrated in a Series of Views comprising the Picturesque Scenery, Towns, Castles, Seats of the Nobility and Gentry, Antiquities etc.,* London, 1830.

Jenkins, J., *The Naval Achievements of Great Britain from the Year 1793 to 1817,* London, 1817.

Jones & Co. (publishers), *Views of the Seats, Mansions, Castles etc. of the Noblemen and Gentlemen in England, Wales, Scotland and Ireland,* London, 1827.

Marshall, W., *Select Views in Great Britain,* two parts, London, 1825.

Mayer, L., *Views in Egypt, Views in the Ottoman Empire,* and *Views in Palestine,* London 1801-4, three volumes.

Merigot, J., *Views and Ruins in Rome and its Vicinity,* London, 1797-98.

Middiman, S., *Select Views in Great Britain,* London, 1784.

Neale, J.P., *Views of the Seats of the Noblemen and Gentlemen in England and Wales, Scotland and Ireland,* London, 1818-29, eleven volumes.

Parry, W.E., *Journal of a Voyage for the Discovery of a North-West Passage to the Pacific in His Majesty's Ships Hecla and Griper,* London, 1821.

Parry, W.E., *Journal of a Second Voyage for the Discovery of a North-West Passage,* London 1824.

Scott, Sir W., Magnum Opus, collected edition of Scott's works, London, 1829-33.

Williamson, T., *Oriental Field Sports, Wild Sports of the East, with aquatints by Samuel Howitt,* London, 1805.

Appendix III

Maps of the Ganges and Jumna Valleys
and the Two Sicilies

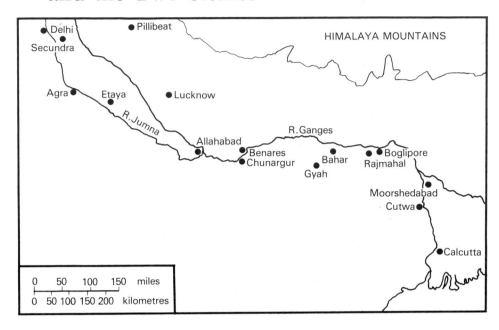

Places in the Ganges and Jumna valleys illustrated on blue-printed earthenwares between 1820 and 1840.

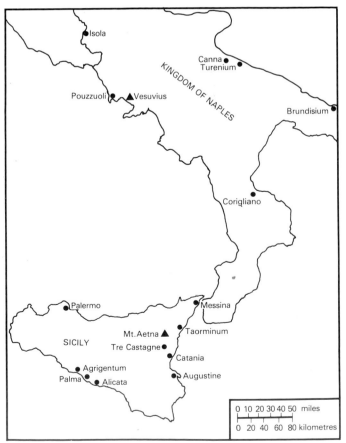

Places in Southern Italy and Sicily, known in the early nineteenth century as 'The Two Sicilies', illustrated on blue-printed earthenwares in the Named Italian Views Series of the Don Pottery and the Newhill Pottery in Yorkshire.

Bibliography

Adams, P.W.L., *A History of the Adams Family of North Staffordshire and their Connection with the Development of the Potteries,* London 1914.

Archer, M., *Early Views of India: The Picturesque Journeys of Thomas and William Daniell, 1786-1794,* London 1980.

Arman, D. and L., *Historical Staffordshire: An Illustrated Check-List,* Danville, Virginia 1974.

Arman, D. and L., *Historical Staffordshire: An Illustrated Check-List, First Supplement,* Danville, Virginia 1977.

Atterbury, P., (Ed.), *English Pottery and Porcelain,* London 1980.

Bartlett, J., and Brooks, D., *Hull Pottery,* Kingston-upon-Hull Museums Bulletin, Hull 1972.

Battie, D., and Turner, M., *The Price Guide to 19th and 20th Century British Pottery,* Woodbridge 1979.

Bell, R.C., *Tyneside Pottery,* London 1971.

Camehl, A.W., *The Blue China Book,* New York 1916; reprinted 1948, 1971.

Copeland, R., *Spode's Willow Pattern,* London 1980.

Coysh, A.W., *Blue and White Transfer Ware, 1780-1840,* Newton Abbot 1970; second edition 1974.

Coysh, A.W., *Blue-Printed Earthenware, 1800-1850,* Newton Abbot 1972; reprinted 1980.

Coysh, A.W., and Stefano, F., *Collecting Ceramic Landscapes,* London 1981.

Cushion, J.P., *Pocket Book of British Ceramic Marks,* London 1959; third edition 1976.

Eaglestone, A.A., and Lockett, T.A., *The Rockingham Pottery,* Newton Abbot 1964; revised edition 1973.

Faulkner, F., *The Wood Family of Burslem,* London 1912.

Fleming, J.A., *Scottish Pottery,* Glasgow 1923.

Fontaines, J.K. des, *Staffordshire Underglaze Blue-Printed Earthenware of the Early Nineteenth Century,* Proceedings of the Wedgwood Society, London 1961, No.4.

Fontaines, J.K. des, *Underglaze Blue-Printed Earthenware with Particular Reference to Spode,* Transactions of the English Ceramic Circle, 1969, No.7 Part 2.

Fontaines, U. des, *The Darwin Service and the First Printed Floral Patterns at Etruria,* Proceedings of the Wedgwood Society, London 1966, No.6.

Fontaines, U. des, *Early Printed Patterns at Etruria,* Proceedings of the Wedgwood Society, London 1975, No.9.

Godden, G.A., *British Pottery: An Illustrated Guide,* London 1974.

Godden, G.A., *Encyclopaedia of British Pottery and Porcelain Marks,* London 1964; reprinted 1979.

Godden, G.A., *Godden's Guide to Mason's China and the Ironstone Wares,* Woodbridge 1980.

Godden, G.A., *An Illustrated Encyclopaedia of British Pottery and Porcelain,* London 1966.

Godden, G.A., *The Illustrated Guide to Mason's Patent Ironstone China,* London 1971.

Grabham, O., *Yorkshire Potteries, Pots and Potters,* York 1916.

Haggar, R.G., *The Masons of Lane Delph,* London 1951.

Haggar, R.G., and Adams E., *Mason Porcelain and Ironstone, 1796-1853,* London 1977.

Hayden, A., *Chats on English Earthenware,* London 1922.

Hayden, A., *Spode and his Successors,* London 1925.

Hibbert, C., *The Grand Tour,* London 1969.

Hillier, B., *Pottery and Porcelain, 1700-1914,* London 1968.

Hillier, B., *The Turners of Lane End: Master Potters of the Industrial Revolution,* London 1965.

Hughes, G.B., *English and Scottish Earthenware, 1660-1860,* London n.d.

Hughes, G.B., *Victorian Pottery and Porcelain,* London 1965.

Hurst, A., *A Catalogue of the Boynton Collection of Yorkshire Pottery,* Yorkshire Philosophical Society, York 1922.

Jewitt, L., *The Ceramic Art of Great Britain,* London 1878.

Kidson, J.R. and F., *Historic Notices of the Leeds Old Pottery with a Description of its Wares,* Leeds 1892; reprinted Wakefield 1970.

Laidacker, S., *Anglo-American China, Part II,* Bristol, Pennsylvania 1951.

Lawrence, H., *Yorkshire Pots and Potteries,* Newton Abbot 1974.

Little, W.L., *Staffordshire Blue,* London 1969.

Lockett, T.A., *Davenport Pottery and Porcelain, 1794-1887,* Newton Abbot 1972.

Macaulay, J., *The Gothic Revival, 1745-1845,* Glasgow and London 1975.

Mankowitz, W., and Haggar, R.G., *The Concise Encyclopaedia of English Pottery and Porcelain,* London 1957.

May, J. and J., *Commemorative Pottery, 1780-1900,* London 1972.

Moore, N.H., *The Old China Book,* New York 1903; reprinted 1936.

Nance, E.M., *The Pottery and Porcelain of Swansea and Nantgarw,* London 1942.

Nicholls, R., *Ten Generations of a Potting Family,* London 1931.

Owen, H., *The Staffordshire Potter,* London 1901; reprinted Bath 1970.

Pountney, W.J., *Old Bristol Potteries,* Bristol 1920; reprinted Wakefield 1972.

Pryce, P.D., and Williams, S.H., *Swansea Blue and White Pottery,* Antique Collecting 1972, Vol. 7, Nos. 1, 2, 3.

Reilly, R., and Savage G., *The Dictionary of Wedgwood,* Woodbridge 1980.

Rhead, G.W., and F.A., *Staffordshire Pots and Potters*, London 1906.

Rice, D.G., *The Illustrated Guide to Rockingham Pottery and Porcelain*, London 1971.

Shaw, J.T. (ed.), *Sunderland Ware: The Potteries of Wearside*, fourth revised edition Sunderland 1973.

Shaw, S., *History of the Staffordshire Potteries*, Hanley, 1829; reprinted Newton Abbot 1970.

Smith, A., *The Illustrated Guide to Liverpool Herculaneum Pottery*, London 1970.

Thomas, J., *The Rise of the Staffordshire Potteries*, Bath 1971.

Towner, D., *The Leeds Pottery*, London 1963.

Turner, W., *Transfer Printing on Enamels, Porcelain and Pottery*, London 1907.

Turner, W., *William Adams, an Old English Potter*, London 1923.

Wakefield, H., *Victorian Pottery*, London 1962; reprinted 1970.

Whiter, L., *Spode: A History of the Family, Factory and Wares from 1733 to 1833*, London 1970.

Williams, P., *Staffordshire Romantic Transfer Patterns*, Jeffersontown, Kentucky 1978.

Williams, S.B., *Antique Blue and White Spode*, London 1943; third edition 1949.

Books on Art Reference published by
Antique Collectors' Club

5 Church Street, Woodbridge, Suffolk, England

The Dictionary of British 18th Century Painters
by Ellis Waterhouse

The Dictionary of British Book Illustrators and Caricaturists 1800-1914
by Simon Houfe

The Dictionary of Victorian Painters — 2nd Edition *by C. Wood.*

The Dictionary of British Artists 1880-1940. *A.C.C. research project.*

Dictionary of Watercolour Artists up to 1920 Volume I — The Text *by H. Mallalieu.*

Dictionary of Watercolour Artists up to 1920 Volume II — The Plates *by H. Mallalieu.*

Dutch Painters of the 19th Century *by Marius.*

19th British Century Marine Painting *by D. Brook-Hart.*

20th Century British Marine Painting *by D. Brook-Hart.*

A Dictionary of Contemporary British Artists, 1929 *edited by B. Dolman.*

The Williams Family of Painters *by J. Reynolds.*

Dictionary of Sea Painters *by E. Archibald.*

Collecting Miniatures *by D. Foskett.*

BOOKS ON ARCHITECTURE AND GARDENS

Houses and Gardens by E.L. Lutyens *by L. Weaver.*

Suffolk Houses *by E. Sandon.*

Wood and Garden *by Gertrude Jekyll.*

Gardens for Small Country Houses *by Gertrude Jekyll and Sir Lawrence Weaver.*

Books on Furniture and Ceramics
Antique Collectors' Club

5 Church Street, Woodbridge, Suffolk, England

The Dictionary of Wedgwood
by R. Reilly and G. Savage

Pictorial Dictionary of British 19th Century Furniture Design
An A.C.C. Research Project

CERAMICS

18th Century English Porcelain Figures 1745-1795 *by P. Bradshaw.*

Flight and Barr Worcester Porcelain 1783-1840 *by H. Sandon.*

Godden's Guide to Mason's China and the Ironstone Wares *by G. Godden.*

Caughley and Worcester Porcelains 1775-1800 *by G. Godden.* Limited edition reprint of 1,500 copies.

Coalport and Coalbrookdale Porcelains *by G. Godden.* Limited edition reprint of 1,500 copies.

Collecting Victorian Tiles *by T. Lockett.*

The Price Guide to the Models of W.H. Goss *by R. Ward.*

The Price Guide to 18th Century English Pottery *by S. Mount.*

The Price Guide to 19th and 20th Century British Porcelain *by D. Battie and M. Turner.*

The Price Guide to 19th and 20th Century British Pottery *by D. Battie and M. Turner.*

The Price Guide to Pot-lids *by A. Ball.*

FURNITURE

The Price Guide to Antique Furniture *by J. Andrews.*

The Price Guide to Victorian, Edwardian and 1920s Furniture *by J. Andrews.*

English Furniture from Charles II to George II *by R.W. Symonds.* A limited edition reprint.

The Price Guide to 19th Century European Furniture *by Christopher Payne.*

Oak Furniture — The British Tradition *by V. Chinnery*

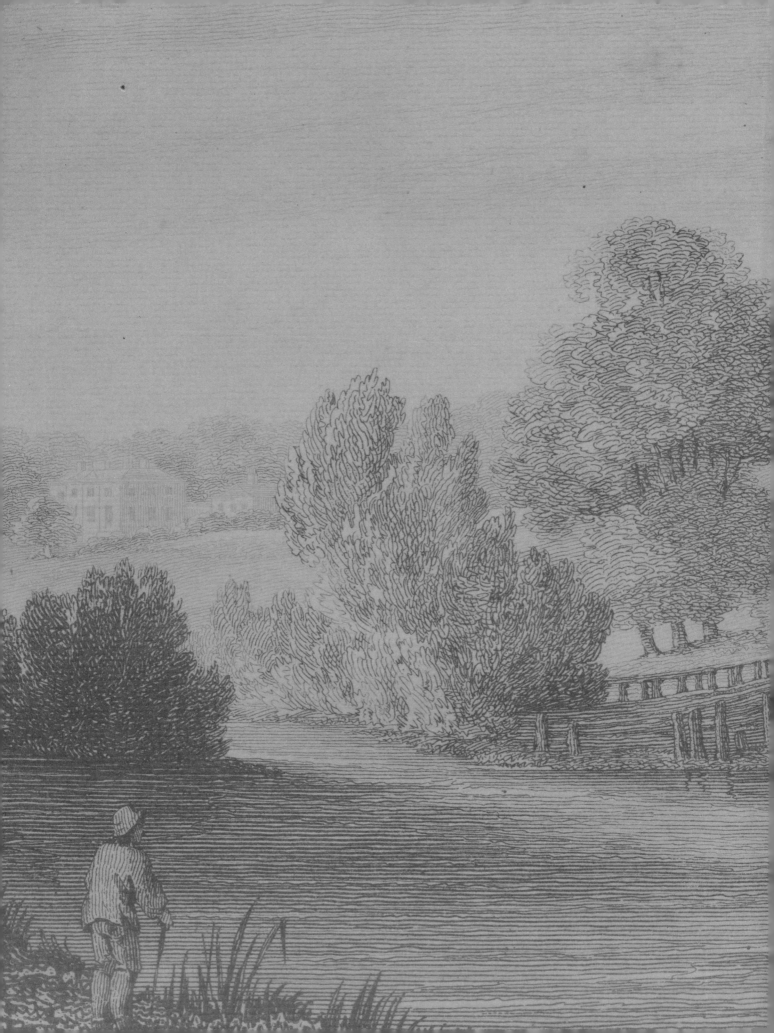